D1245499

Religious Art
in France
of the
Thirteenth Century

Émile Mâle

DOVER PUBLICATIONS, INC.
Mineola, New York

Bibliographical Note

This Dover edition, first published in 2000, is an unabridged reprint of *Religious Art in France in the Thirteenth Century,* translated from the French by Dora Nussey and published by E.P. Dutton & Co., New York, in 1913.

Library of Congress Cataloging-in-Publication Data

Mâle, Émile, 1862–1954.
 [Art religieux du XIIIe siècle en France. English]
 Religious art in France of the thirteenth century / Émile Mâle.—Dover ed.
 p. cm.
 Includes bibliographical references and index.
 Originally published: Religious art in France, XIII century. London : J.M. Dent & Sons ; New York : E.P. Dutton, 1913.
 ISBN-13: 978-0-486-41061-6 (pbk.)
 ISBN-10: 0-486-41061-7 (pbk.)
 1. Christian art and symbolism—Medieval, 500–1500—France. 2. Art, High Gothic—France. 3. Art, French. I. Title.

N7949.A1 M3513 2000
704.9'482'094409022—dc21

00-026393

Manufactured in the United States by Courier Corporation
41061704 2015
www.doverpublications.com

PREFACE

To the Middle Ages art was didactic. All that it was necessary that men should know—the history of the world from the creation, the dogmas of religion, the examples of the saints, the hierarchy of the virtues, the range of the sciences, arts and crafts—all these were taught them by the windows of the church or by the statues in the porch. The pathetic name of *Biblia pauperum* given by the printers of the fifteenth century to one of their earliest books, might well have been given to the church. There the simple, the ignorant, all who were named "sancta plebs Dei," learned through their eyes almost all they knew of their faith. Its great figures, so spiritual in conception, seemed to bear speaking witness to the truth of the Church's teaching. The countless statues, disposed in scholarly design, were a symbol of the marvellous order that through the genius of St. Thomas Aquinas reigned in the world of thought. Through the medium of art the highest conceptions of theologian and scholar penetrated to some extent the minds of even the humblest of the people.

But the meaning of these profound works gradually became obscure. New generations, with a different conception of the world, no longer understood them, and from the second half of the sixteenth century mediæval art became an enigma. Symbolism, the soul of Gothic art, was dead.

The Church was ashamed of the once beloved legends, in which for so many centuries Christianity had been nurtured. The council of Trent marks the end of the old artistic tradition, and we know from a book full of the spirit of the council, that the writer—Molanus the theologian—had lost the key to the art of the Middle Ages.[1]

In the seventeenth and eighteenth centuries the Benedictines of Saint-Maur, when writing of the ancient churches of France, displayed an ignorance which was anything but creditable to their order's reputation for learning. In his *Monuments de la monarchie française* Montfaucon reads into the cathedral façades scenes from the history of France and portraits of her kings.

And what can one say of those who speak of Gothic bas-reliefs and statues as they might speak of the antiquities of India. Some have imagined

[1] Molanus, *De historia sanct. imag. et picturarum.* The first edition was published in 1580. See the Louvain edition of 1771, with Paquot's notes.

PREFACE

that they read the secret of the philosopher's stone in the porch at Notre Dame at Paris.[1] At the end of the eighteenth century Dupuis found in the Zodiac at Notre Dame an argument in support of his famous theory of the solar origin of all religions, and his pupil Lenoir read the legend of Bacchus into a series of bas-reliefs relating to St. Denis.[2]

The true meaning of mediæval art, which had grown more obscure than hieroglyphics, has had to be laboriously re-discovered in our time. To those who come without preparation the portals of Amiens or the north porch at Chartres are a closed book. A guide is a necessity. Since 1830 many mysteries have been solved through the labours of archæologists like Didron or Cahier, but even their researches have left secrets still undisclosed, and their work needs to be co-ordinated and welded into an organic whole.

This book is an attempt to give systematic form to their researches, and wherever possible to complete them. It is hoped that it may prove of service to historians of art, for to study mediæval art, as is sometimes done, without reference to the subject-matter and with attention wholly given to progress in technique, leads to misunderstanding and confusion of the aims of successive periods.[3] Gothic sculptors had a very different conception of art from that of a Benvenuto Cellini. They did not believe that choice of subject was a matter of indifference, and they did not think of a statue as merely intended to give momentary pleasure to the eye. In mediæval art every form clothes a thought ;[4] one could say that thought works within the material and fashions it. The form can not be separated from the idea which creates and animates it. Work of the thirteenth century interests us even when inadequately executed for we feel there is something in it akin to a soul. Some understanding of the aims of the artists must precede the right to pass judgment on them. For this reason the natural introduction to the study of mediæval art is a methodical review of the subject-matter in which that art delighted. It is a vast enterprise, for all that was best in thirteenth-century thought assumed plastic form. All that was laid down as essential by the theologian, the encyclopædist, the interpreter of the Bible, was expressed in sculpture or in painted glass. We shall

[1] Gobineau de Montluisant, alchemist of the seventeenth century. His treatise was published in the *Annales archéologiques,* xxi. pp. 139–199.

[2] Alexandre Lenoir, *Description historique et chronologique des monumens de sculpture réunis au musée des monumens français,* An. X., sixth edition, p. 120.

[3] This for instance is Lübke's error in the chapters which he devotes to mediæval art (*Geschichte der Plastik,* i. and ii., Leipzig, 1880, 8vo).

[4] We do not refer to purely decorative art. In Book I. we shall show that it has no symbolic value.

PREFACE

attempt to show how the craftsman translated the thought of the doctor, and to draw a complete picture of the liberal education which a thirteenth-century cathedral offered to all.

A synthetic work of this kind is open to the objection that it gives no sufficient indication of the slow growth that was going on during the centuries preceding the thirteenth. The thirteenth century is the period when the thought of the Middle Ages was most fully expressed in art—hence our choice of it—but it was very far from originating all the modes of expression which it perfected. It had inherited a multitude of types, of dispositions, and of ideas from previous centuries. The long evolution of Christian art is one of the most interesting, as it is one of the most elusive subjects of research that can be undertaken by the scholar. Nothing could be more instructive than to follow the representation of a given person or scene, from the art of the catacombs to that of the cathedrals. Careful study of the same type, observing its development in chronological order from fifth-century mosaics, through Byzantine miniatures, Carlovingian ivories and Romanesque capitals to the sculpture and glass of the thirteenth century, would reveal a long series of stages in the evolution of Christian thought. It would be seen, for example, that the art of the catacombs does not venture to show to the faithful the image of the crucified Christ, that Romanesque art of the early period represents Him on a jewelled cross, crowned and triumphant, with open eyes and lifted head, and that the art of the thirteenth century, less doctrinal and more human, shows the crucified figure with closed eyes and drooping form. The final appeal is to the heart rather than to the head.

Close study of subtle changes of this kind would show how fluid and mobile, in a word how living a thing mediæval Christianity was, but it would be the work of a lifetime. Didron attempted it, but he only reached a study of the three Persons of the Trinity.[1] Another attempt was made by Count Grimouard de Saint-Laurent,[2] but his wish to include in his *Guide de l'art chrétien* the whole development of art from its origin to his own day condemned him, in spite of his great learning, to superficiality of treatment. We propose to follow another method. We shall consider the art of the thirteenth century as a living whole, as a finished system, and we shall study the way in which it reflects the thought of the Middle Ages. In this way

[1] Didron, *Iconographie chrétienne. Histoire de Dieu*, Paris, 1844, 4to (series of unpublished documents relating to the history of France).

[2] Grimouard de Saint-Laurent, *Guide de l'art chrétien*, 6 vols. 8vo, Paris and Poitiers, 1872–73.

PREFACE

we shall gain some idea of the majesty of the whole, some notion of the truly encyclopædic range of mediæval art in its prime. The thirteenth century is the central point of our study, for it was then that art with admirable daring tried to express all things. The iconography of the richest Romanesque work is poor indeed beside the wealth of Gothic imagery, and the period we have chosen is precisely that in which the façades of the great French churches were thought out and executed. Occasionally it has been necessary to go beyond the limits of the thirteenth century ; the old west porch of Chartres, for example, was carved about the year 1150, and the exterior decoration of Notre Dame at Paris was not finished until the beginning of the fourteenth century. It is evident that it would have been artificial to confine our research to the period between 1200 and 1300.

It is not because we believe that the art of neighbouring nations obeys different rules that we have limited our study to that of French art. On the contrary the character of the art of the thirteenth century was as truly universal as was its Christian teaching. We have satisfied ourselves that the great subjects in which it delighted were conceived of at Burgos, Toledo, Siena, Orvieto, Bamberg, Friburg, just as they were at Paris or at Reims. But we are convinced that Christian thought was not expressed elsewhere so fully or so richly as in France. In the whole of Europe there is no group of works of dogmatic art in the least comparable to that presented by the cathedral of Chartres. It was in France that the doctrine of the Middle Ages found its perfect artistic form. Thirteenth-century France was the fullest conscious expression of Christian thought. There is little to be learned from foreign cathedrals when one knows Chartres, Amiens, Paris, Reims, Laon, Bourges, Le Mans, Sens, Auxerre, Troyes, Tours, Rouen, Lyons, Poitiers and Clermont, but we have occasionally taken examples from Germany, Italy or England to give added force to a demonstration. French art is none the less the subject of our study.

Hitherto there has been no book on this subject.[1] A work of synthesis would have seemed premature to the archæologists who created the science of Christian iconography, but after more than sixty years of detailed research such an attempt may appear to be less rash. Since 1830 several

[1] The following should however be mentioned :— *Iconographie chrétienne*, by the Abbé Crosnier, Caen, 1848, 8vo ; *Institutions de l'art chrétien*, by the Abbé Pascal, Paris, 1858, 2 vols. 8vo ; *Traité d'iconographie chrétienne*, by Mgr. Barbier de Montault, Paris, 1890, 2 vols. 8vo. Detzel's study of iconography also deserves mention (H. Detzel, *Christliche Ikono-graphie*, 2 vols., Friburg-im-Breisgau, 1894–96, 8vo). Reference should also be made to the good summary made by Krauss in the *Geschichte der christl. Kunst*, ii. p. 263 *sq.*, Friburg, 1897. In all these books the works of art are too seldom related to the theological, liturgical, and legendary works of the Middle Ages.

PREFACE

reviews, devoted entirely to mediæval art, have brought a multitude of valuable facts to light, and in addition, the French cathedrals have almost all been the subjects of monographs which, though far from being complete, give a sufficient number of precise and well-observed facts to make it possible to formulate certain broad general principles. We have verified the accuracy of these works by careful study of the originals.

In the first rank must be mentioned the *Annales archéologiques*, a publication which for more than twenty years was inspired by Didron. An enthusiastic admirer of Victor Hugo, Didron belonged to the Romantic age and brought to the study of the past almost as much imagination as learning. But if he were guilty of error, he imparted something of his own enthusiasm to a whole generation of archæologists. The *Bulletin monumental* founded by M. de Caumont and the *Revue de l'art chrétien* founded by Canon Corblet are mines of information.[1] Father Cahier, with the help of assistants and especially with the help of Father Martin's delicate drawing, published two learned collections entitled *Mélanges* and *Nouveaux mélanges d'archéologie*.[2] In the nineteenth century no one was better acquainted with mediæval art than Father Cahier. His *Vitraux de Bourges*[3] and his *Caractéristiques des saints dans l'art populaire*,[4] though unhappily disfigured by a polemical tone and an unnatural style, are works of sound learning. Mention should also be made of reviews such as the *Bibliothèque de l'École des Chartes*, the *Revue archéologique* or the *Gazette archéologique*, although in them mediæval art fills but a small space. Finally, the numerous provincial archæological societies formed since 1830 at the instigation of M. de Caumont, have published a large number of Bulletins and Mémoires of which a list is given by M. de Lasteyrie and M. Lefèvre-Pontalis.[5] One of the oldest French learned societies, the Société des Antiquaires de France, deserves special mention, for its Mémoires, especially those published since 1840, are often of great interest.

These are the sources from which we have drawn much of our material. But works of art have taught us more even than books, and we have seen and seen again all those of which we write. Moreover in

[1] To these should be added the series of the *Congrès archéologiques de France*.

[2] Cahier and Martin, *Mélanges d'archéologie, d'histoire et de littérature*, Paris, 1847–56, 4 vols., folio; Cahier, *Nouveaux mélanges d'archéologie et d'histoire*, Paris, 1874–77, 4 vols., folio.

[3] Cahier and Martin, *Vitraux peints de Saint-Étienne de Bourges*, Paris, 1842–44, folio.

[4] Cahier, *Les Caractéristiques des saints dans l'art populaire*, Paris, 1866–68, 2 vols., 4to.

[5] R. de Lasteyrie and Lefèvre-Pontalis, *Bibliographie des travaux historiques et archéologiques publiés par les sociétés savantes*, Paris, 1888 etc., Imp. Nat., 4to. This contains the index both to the *Bulletin monumental* and to the *Congrès archéologiques de France*.

PREFACE

Paris, where the cast museum at the Trocadéro contains a large number of fragments, one can study at leisure things which *in situ* must be examined more rapidly than one could have wished. Three large collections of photographs and engravings have also been in constant requisition ; one is at the Bibliothèque du Trocadéro (collection of architectural illustrations),[1] another in the Bibliothèque de l'École des Beaux-Arts, a third in the Cabinet des Estampes. The last named, which is known as the "Grande Topographie de la France," is principally composed of engravings and drawings of the seventeenth and eighteenth centuries, but is of great value as giving illustrations of works of art which have disappeared, and in showing the condition of monuments before restoration.[2]

In this way we have been able to give constant and detailed study to the principal statues and bas-reliefs scattered throughout France. It was impossible to study the glass with the same facility, as attempts at photographic reproduction have so far been rare. Fortunately a real *corpus* of the principal windows of the thirteenth century, taken from Father Martin's drawings, is given by Father Cahier in his *Vitraux de Bourges*. Other windows have been reproduced by M. de Lasteyrie in his *Histoire de la peinture sur verre*,[3] and monographs such as Bourassé and Marchand's *Vitraux de Tours*,[4] Hucher's *Vitraux du Mans*,[5] MM. de Florival and Midoux's *Vitraux de Laon*,[6] added a number of new plates to the unhappily far from complete collection.

Manuscripts containing miniatures could not be ignored. Once more we recognised the rules which monumental art obeyed, and at times it seemed almost as though the miniaturists were the true creators of the types adopted later by sculptor and glass-painter. We are convinced that careful study of miniatures would result in numerous discoveries in this direction, but up to the present the work has been difficult. The very summary catalogue of manuscripts in the Bibliothèque Nationale does not allow of really systematic research. A catalogue of the miniatures in Latin manuscripts, begun by M. Bordier on the model of his catalogue of the miniatures in Greek manuscripts, remains unfinished.[7] The work of collating the many illus-

[1] Supplemented by the collection in the Rue de Valois (Commission des monuments historiques).

[2] To these collections should be added that formed by M. Martin-Sabon, so well known to all students of the Middle Ages.

[3] F. de Lasteyrie, *Histoire de la peinture sur verre*, Paris, 1838–58, folio.

[4] Marchand and Bourassé, *Verrières du chœur de l'église métropolitaine de Tours*, Paris, 1849, folio.

[5] Hucher, *Vitraux peints de la cathédrale du Mans*, Le Mans, 1868, folio.

[6] Florival and Midoux, *Les Vitraux de Laon*, Paris, 1882–91, 4to.

[7] It has not been printed, but may be consulted under the head of Nouvelles acquisitions françaises, 5813, 5814, 5815. The summary catalogue of illustrated MSS. in the Bibliothèque Nationale, drawn up by the Comte de Bastard, should be mentioned. It also has not been published, Bibl. Nat., Nouvelles acquisitions françaises, 5811–5812.

PREFACE

trated manuscripts which still await investigation, of tracing their descent and classifying them into schools, will demand the labour of several generations of scholars.[1] On the other hand the Bibliothèque de l'Arsenal, the Bibliothèque Sainte-Geneviève and the Bibliothèque Mazarine now have excellent descriptive catalogues. But we have consulted the miniatures only so far as they throw light on the main subject of our study, the statues and glass of the thirteenth century.

The work we have attempted is beset with many difficulties. For more than two centuries a process of destruction or, what often amounts to the same thing, of restoration has been going on in nearly all the great churches. The façades of Notre Dame at Paris and of the cathedrals at Reims and Bourges bear the mark of such restorations; here a saint has received a new head, there a virtue has changed her attributes. The glass in almost all the churches has suffered from the unskilful restoration of the eighteenth century. The order of subjects has been reversed, or fragments of a scattered window have served to patch up neighbouring glass. At Auxerre, for instance, panels from the legend of St. Eustace and from the lives of St. Peter and St. Paul are found distributed haphazard in several windows of the choir and aisles. We have here a source of endless confusion and error.

From the point of view of the scholar the more intelligent restoration of our own day is almost as vexatious. Mutilated windows have been completed with an ability which makes it difficult at first sight to distinguish the older from the more recent work, and one runs the risk of searching for the laws of mediæval iconography among works of the nineteenth century. Local monographs do not always mention these restorations. Happily the works usually speak for themselves, and some less glowing colour, some less bold design, some unusual feature in the composition warn us that we are dealing with modern work. In order to separate the old from the new and to recover the proper sequence of ideas, a preliminary critical study of thirteenth-century work is indispensable. We trust that we have met the requirements of criticism in this matter.

A second difficulty arises in assigning limits to the treatment of the subject. The length of several chapters might well have been doubled. That on the *Golden Legend*, for instance, might have been indefinitely

[1] See M. Léopold Delisle's study of illustrated books, *Hist. littér. de la France*, xxxi. p. 13 *sq*. He attempts to classify the MSS. containing miniatures. See also G. Vitzthum, *Die Pariser Miniaturmalerei*, Leipzig, 1907.

PREFACE

lengthened had we enumerated all the works of art in which its saints figure. But as we do not claim to have written a complete treatise on iconography it has seemed best to omit all but essentials, and to give only those examples which should serve to illustrate most clearly the dominant ideas which inspired mediæval art.

The study of the theological literature of the Middle Ages has been perhaps the most serious of all the difficulties which have confronted us. One is literally overwhelmed by the enormous volume of the work produced by the doctors of the Church in the course of ten centuries.

But closer examination of the works of the commentators on Scripture, the liturgiologists, and the encyclopædists has shown in a surprising way that they repeat each other indefinitely. Isidore of Seville summarises the Fathers, the Venerable Bede is inspired by Isidore, Rabanus Maurus by Bede, Walafrid Strabo by Rabanus Maurus and so on. In days when communication was difficult, books rare, and ideas slow to spread, it was judged a worthy deed to abridge some celebrated book, to extract the substance of some famous treatise, or even to reproduce almost unaltered the work of some ancient doctor. Literary amour-propre—the pride of authorship—was unknown to the early Middle Ages. It was plain that a doctrine belonged not to him who expounded it but to the Church as a whole. To write a book and so to make known the truth to one's neighbour, was in a sense to practise one of the works of mercy.

It follows that the apparently immense library of the Middle Ages consists after all of a very few works. Ten well chosen books might almost literally be said to take the place of all others. The commentators on the Old and New Testaments are summarised in the *Glossa ordinaria* of Walafrid Strabo, completed in the fourteenth century by Nicolas de Lyra. The whole of the symbolic liturgy is in the *Rationale divinorum officiorum* of Gulielmus Durandus. The spirit and method of the old preachers live again in the *Speculum Ecclesiae* of Honorius of Autun. Sacred history, as then understood, is found in the *Historia Scolastica* of Peter Comestor and in the *Legenda aurea* of Jacobus de Voragine, profane history in the *Speculum historiale* of Vincent of Beauvais. All that was known of the physical world is summarised in the *Speculum naturale*, and all that was known of the moral world in the *Summa Theologica* of St. Thomas Aquinas, epitomised in the *Speculum morale*.

A reader familiar with these works will have penetrated the depths of the mediæval mind. The age which adopted them saw in them its own

PREFACE

reflection, and the esteem in which they were held caused us to choose them as our guide.

The study of these books, whose classical character at once arrested our attention, has provided a point of departure in the midst of this vast mass of literature. In course of time others have gathered round them, but it is to these books that we refer by preference, for they are truly representative. The doctrines they expound, the legends they adopt, were generally accepted by the Church, and thanks to them we have been able to reduce materially the number of our quotations. Father Cahier in his *Vitraux de Bourges* filled whole pages with quotations, not satisfied until he could trace a dogma step by step from Augustine to Aquinas. This is surely the affectation of learning, for in such a case one good testimony would suffice. After reading the *Glossa ordinaria*, it is as a rule of little use to study other commentaries on the Bible.

We have not, however, neglected other resources offered by patristic study. It has sometimes been necessary to multiply instances to prove that a case which to-day seems extraordinary was not really an unusual one. Then too, our guides at times have proved superficial, and it has been necessary to supplement them by other writers. But as a rule we have remained faithful to our method of referring to famous compilations which summarise the learning of the period.

Literature in the vernacular, as one might expect, has been of little service. The Légendes des saints, the Images du monde, the rhymed Bestiaires are merely translations, and often lifeless ones. The finest and most profound books of the Middle Ages were not and could not be translated. The French of the thirteenth century, which tells a story with charm and force, and sings not without grace, was yet incapable of expressing abstract thought. Latin long remained the language of the thinker, and no adequate knowledge of the Middle Age could be gained through popular literature.

We have therefore avoided the timid adaptations of French writers, and have gone straight to the original works.

CONTENTS

xvii

CONTENTS

BOOK IV

CONTENTS

ALPHABETICAL
LIST OF ILLUSTRATIONS

LIST OF ILLUSTRATIONS

LIST OF ILLUSTRATIONS

LIST OF ILLUSTRATIONS

Religious Art
in France
of the
Thirteenth Century

Religious Art of the Thirteenth Century in France

INTRODUCTION

CHAPTER I

GENERAL CHARACTERISTICS OF MEDIÆVAL ICONOGRAPHY

I.—Mediæval Iconography is a script. II.—It is a calculus. The mystic numbers. III.—It is a symbolic code. Art and the Liturgy.

THE Middle Ages had a passion for order. They organised art as they had organised dogma, secular learning and society. The artistic representation of sacred subjects was a science governed by fixed laws which could not be broken at the dictates of individual imagination. It cannot be questioned that this theology of art,[1] if one may so put it, was soon reduced to a body of doctrine, for from very early times the craftsmen are seen submitting to it from one end of Europe to the other. This science was transmitted by the Church to the lay sculptors and painters of the thirteenth century who religiously guarded the sacred traditions, so that, even in the centuries in which it was most vigorous, mediæval art retained the hieratic grandeur of primitive art.

These are the general principles which it concerns us to state at the outset as briefly as possible.

I

The art of the Middle Ages is first and foremost a sacred writing of which every artist must learn the characters. He must know that the circular

[1] Under this title Dr. Piper has written a book in which one can find everything but what one is led to expect. (F. Piper, *Einleitung in die monumentale Theologie.* Gotha, 1867, 8vo.) In it he examines the theological writings of the Middle Ages and the Renaissance, but he does not show the bearing of these books on art, which is really his subject. The same criticism may be made of an otherwise interesting book, J. Sauer's *Symbolik des Kirchengebäudes und seiner Ausstattung in der Auffassung des Mittelalters.* Friburg, i. B., 1902, 8vo.

RELIGIOUS ART IN FRANCE

nimbus placed vertically behind the head serves to express sanctity, while the nimbus impressed with a cross is the sign of divinity which he will always use in portraying any of the three Persons of the Trinity.[1] He will learn that the aureole (*i.e.* light which emanates from the whole figure and surrounds the body as a nimbus) expresses eternal bliss, and belongs to the three Persons of the Trinity, to the Virgin, and to the souls of the Blessed. He must know that representations of God the Father, God the Son, the angels and the apostles should have the feet bare, while there would be real impropriety in representing the Virgin and the saints with bare feet. In such matters a mistake would have ranked almost as heresy. Other accepted symbols enabled the mediæval artist to express the invisible, to represent that which would otherwise be beyond the domain of art. A hand emerging from the clouds, making the gesture of benediction with thumb and two fingers raised, and surrounded by a cruciform nimbus, was recognised as the sign of divine intervention, the emblem of providence. Little figures of nude and sexless children, ranged side by side in the folds of Abraham's mantle, signified the eternal rest of the life to come.

There are also accepted signs for objects of the visible world which the artist must learn. Lines which are concentric and sinuous represent the sky, those which are horizontal and undulating represent water (Fig. 1). A tree, that is to say a stalk surmounted with two or three leaves, indicates that the scene takes place on the earth ; a tower pierced by a doorway is a town, while if an angel watch on the battlements it is the heavenly Jerusalem.[2] Thus we have a veritable hieroglyphic[3] in which art and writing blend, showing the same spirit of order and abstraction that there is in heraldic art with its alphabet, rules and symbolism.

The artist must be familiar with a multitude of precise details. He is not allowed to ignore the traditional type of the persons he has to represent. St. Peter, for example, must have curly hair, a short, thick beard and a tonsure, while St. Paul must have a bald head and a long beard. Certain details of costume are also unchangeable. Over her head

[1] It is not our object, as we have said, to write the history of the nimbus nor of the other attributes passed in review in this chapter. The greater number date back to remote antiquity, and some (like the nimbus) to pagan times. The question has been fully treated by Didron, *Hist. de Dieu*, pp. 25-170.

[2] All these symbols are constantly used in glass-painting.

[3] The word hieroglyphic does not seem too strong if one remembers that the evangelists were sometimes represented in the form of men with the head of the ox, the eagle and the lion (see capital in the cloister at Moissac). Here mediæval art joins that of ancient Egypt, and is perhaps even derived from it through the Christian art of Alexandria.

2

INTRODUCTION

the Virgin must wear a veil, symbol of virginity, and the Jews are known by their cone-shaped caps.[1]

All these figures with their unvarying costume and arrested type have their place in traditional scenes. No matter how dramatic may be the scene in which they play a part, their every action has been previously determined. No artist would be rash enough to dare to modify the arrangement of the great scenes from the Gospel. If his subject were the Last Supper he would not be free to group the figures round the table according to his individual fancy. He would have to show at the one side Jesus and the apostles, at the other Judas Iscariot.[2] If he would represent the Crucifixion he must place the Virgin and the lance-bearer to the right of the Cross, St. John and the man with the sponge to the left.

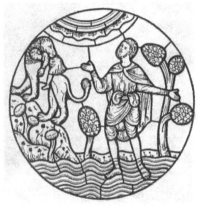

FIG. I.—THE SKY, WATER AND TREES
(From the Legend of St. Eustace. Window at Chartres)

These examples, which it would be useless to multiply, will suffice to show in what sense mediæval art may be called a sacred script.

At an earlier period than that with which we are dealing these signs and conventions were of real service to the artist. By their help he could supplement the inadequacy of his technique. It was obviously easier to draw a cruciform nimbus round the head of the Christ than to show in His face the stamp of divinity. In the thirteenth century art could have done without such assistance. The artists at Amiens who clothed with so great majesty the Christ teaching at the door of their cathedral had no need of it (Fig. 2). The sculptors of Chartres knew how to express sanctity otherwise than by the use of the nimbus; a virginal grace envelops St. Modeste (Fig. 3) and the great soul of St. Martin shines in his face.[3] But faithful to the past the thirteenth century did not relinquish the old conventions, and deviated little from tradition. By that time the canons of religious art had grown to have almost the weight of articles of faith, and we find

[1] Probably the headdress of the Jews in the Middle Ages.
[2] On representations of the Last Supper, see *Bullet. monum.*, 1881, p. 312 *sq.*

[3] St. Modeste is in the north porch (exterior), St. Martin in the south porch (right doorway).

RELIGIOUS ART IN FRANCE

theologians consecrating the work of the craftsmen by their authority. In the *Summa* Aquinas devoted a chapter to the nimbus, and in it he explained why it is the usual symbol of holiness.[1] Art was considered as one form of the liturgy, and Gulielmus Durandus, a liturgiologist of the thirteenth century, introduced several detailed expositions of sacred works of art into his *Rationale divinorum officiorum*.[2]

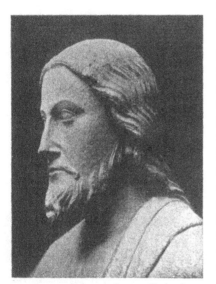

FIG. 2.—HEAD OF CHRIST (Amiens)

It was well for the art of the thirteenth century that it did so piously preserve the rudiments of this ancient symbolism, for by that means it attained the grandeur peculiar to works to which successive centuries had contributed. There was in art a something impersonal and profound, and one might say that such or such an attitude, such or such a symbolic grouping was the common choice. Surely it was not individual choice but the corporate Christian consciousness which lighted upon that sublime gesture of the Saviour when on the Day of Judgment He shows His wounds to mankind. The mind of the theologian, the instinct of the people and the keen sensibility of the artist all collaborated.

Mediæval art is like mediæval literature, its value lies less in conscious talent than in diffused genius. The personality of the artist does not always appear, but countless generations of men speak through his mouth, and the individual, even when mediocre, is lifted by the genius of these Christian centuries. At the Renaissance artists at considerable risk and peril freed themselves from tradition. The lesser men found it difficult to escape platitude and to attain significance in their religious work, while the great ones were no greater than the old masters who had submissively given naïve expression to the thought of the Middle Ages. Following an accepted model it was possible for even a modest artist to produce a work which made a strong emotional appeal. One may well prefer the traditional

[1] *Sum. Theol.*, Supplement to part III. *Quaest.*, 96. See also Vincent of Beauvais, *Spec. histor.*, lib. I., cap. 51.

[2] G. Durandus, *Rat. div. offic.*, lib. I., cap. 3.

INTRODUCTION

Christ of the Gothic cathedrals showing His wounds to mankind to the
vengeful Judge whom the genius of a Michel-
angelo, unhampered by tradition, conceived as cursing
the lost.

II

The second characteristic of mediæval icono-
graphy is obedience to the rules of a kind of sacred
mathematics. Position, grouping, symmetry and
number are of extraordinary importance.

To begin with, the whole church is oriented
from the rising to the setting sun, a custom dating
back to primitive Christian days for it is found even
in the *Apostolical Constitutions*.[1] In the thirteenth
century Gulielmus Durandus cites this as a rule
without exception :—" The foundations must be dis-
posed in such a manner that the head of the church
lies exactly to the east, that is to the part of the
sky in which the sun rises at the equinox."[2] And,
as a matter of fact, from the eleventh to the six-
teenth century it is difficult to find a badly oriented
church. Like other traditions of mediæval art the
rule fell into neglect towards the time of the
Council of Trent, the Jesuits being the first to
violate it.

Each cardinal point has its significance in
churches oriented in this way. The north, region
of cold and darkness, is usually consecrated to the
Old Testament, and the south, bathed in warm sun-
light, is devoted to the New, though there are
many exceptions to the rule.[3] The western façade
—where the setting sun lights up the great scene of the evening of the

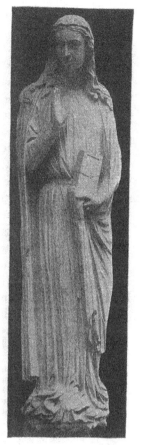

FIG. 3.—ST. MODESTE
(Chartres)

[1] Κατ' ἀνατολὰς τετραμμένος (οἶκος), *Const. apost.*,
II. 57. Migne, *Patrol. gr.*, i., col. 724
[2] G. Durandus, *Ration.* Lyons, 1672, 8vo, lib. I.,
ap. 1.
[3] It was scrupulously observed at Chartres. The
heroes of the Old Covenant are sculptured in the
north porch, those of the New in the south porch.
In Notre Dame at Paris the great rose-window to

the north is devoted to the Old Testament, that to
the south to the New. At Reims the rose-window
to the north (mutilated) again shows scenes from the
Old Testament (the Creation, Adam, Cain, Abel,
&c.), that to the south (restored in the sixteenth
century, but doubtless on the old model) is filled with
figures of Christ and the apostles.

It is curious that the rule is still observed in the

world's history—is almost invariably reserved for a representation of the Last Judgment.[1] The mediæval doctors, with their curiously bad etymology, connected *occidens* with the verb *occidere*, and the west became for them the region of death.[2]

After orientation it was relative position which most engrossed the artist, here again at one with the theologian. In early times certain passages in the Bible led to the belief that the right hand was the place of honour. Is it not written, for example, in the Psalms : " Adstitit regina a dextris tuis in vestitu deaurato ? " In the *Shepherd* of Hermas which belongs to primitive Christian literature, the right is the place given to those who are marked out for honour. In the account of the third vision [3] it is said that the Church caused Hermas to be seated on a bench at her side. When he would have seated himself to her right she signed to him to pass to the left, because the right is reserved for those who have suffered in the name of God. The mediæval theologians in their turn laid great stress on the dignity of the right hand place,[4] and the artists did not fail to conform to so well established a doctrine. When, for example, the Saviour is represented in the midst of His apostles, St. Peter—first in dignity—occupies a place to the right of the Master.[5] In the same way in the scene of the Crucifixion or in that of the Last Judgment, the Virgin is to the right, St. John to the left.

Again, the higher place was considered more honourable than the lower, and from this some curious compositions resulted. Of these the most

fifteenth century. At St. Ouen at Rouen and at St. Serge at Angers the windows to the north portray the prophets, those to the south the apostles. The practice was also known to the East. In the monastery of Salamis the Old Testament is to the left, that is to the north, and the New to the right, the south. See Didron and Durand, *Iconographie chrétienne. Traduction du manuscrit byzantin du Mont Athos*. Paris, 1845, 8vo, p. xi. On the symbolism of the north and south see especially G. Durand, *Ration.*, lib. IV., cap. xxiii., xxiv. ; and Rabanus Maurus, *De Universo*, ix., *Prol.* " auster sancta Ecclesia est fidei calore accensa."

[1] The west front of almost all the great cathedrals, and a few rose-windows to the west (rose-window at Chartres, at St. Radegonde at Poitiers, &c.).

[2] The *Hortus deliciarum* of the abbess Herrade ; see *Bibl. de l'École des Chartes*, vol. I. p. 246. In the Carolingian epoch the *Carmina Sangallensia* place the Last Judgment to the west; see Julius von Schlosser in *Quellenschriften für Kunstgeschichte*, vol. iv. p. 328. Vienna, 1892.

[3] Hermas, lib. I., vis. iii., Latin text in Migne, *Patrol.*

gr., ii. ; Greek text in Tischendorf, Leipzig, 1856. The Middle Age was acquainted with the Latin version of the *Shepherd* of Hermas, and until the fifteenth century it is sometimes found at the end of the New Testament.

[4] See especially Peter Damian, *Opuscula*, xxxv., *Patrol. lat.*, cxlv., col. 589.

[5] There are a few exceptions to prove the rule. In the great porch at Amiens, for example, St. Paul is to the right of Christ and St. Peter to the left. This arrangement takes us back to primitive Christian art. In early times St. Paul was placed to the right and St. Peter to the left of Christ to mark the substitution of the Gentile for the Jew. This is the reason given even in the twelfth century by Peter Damian in a treatise he wrote on representations of the two chief apostles (*Patrol.*, cxlv.). St. Paul, he said, placed the hosts of the Gentiles on the right hand of God. And he adds, St. Paul was of the tribe of Benjamin, and Benjamin means "son of the right hand." The old doctrine is perpetuated in the papal bull, where St. Paul is seen to the right and St. Peter to the left of the Cross.

INTRODUCTION

striking is that of the figure of Christ in Majesty supported by the four beasts of the Apocalypse. The four beasts, symbols of the evangelists as we shall show later, were placed according to the excellence of their natures—man, eagle, lion and ox. When it was a question of disposing them in a tympanum, the dignity conferred by the higher and that conferred by the right hand place had to be taken into consideration. The following arrangement was the one generally adopted. The winged man was placed

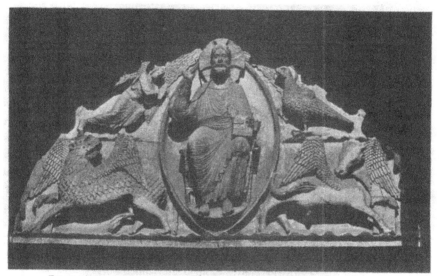

FIG. 4.—THE CRUCIFEROUS NIMBUS, THE AUREOLE, AND THE FOUR EMBLEMS OF THE EVANGELISTS (tympanum at Chartres)

at the top of the composition and to the right of Christ, the eagle at the top to the left, the lion at the bottom to the right, the ox at the bottom to the left[1] (Fig. 4).

Regard for the traditional order is especially evident when it is a question of representing the blessed who compose the Church Triumphant. On the Portail du Jugement of Notre Dame at Paris the saints ranged in the orders of the arch form, as in Dante's Divine Comedy, concentric bands round the figure of Christ. The ranks of patriarchs, prophets, confessors, martyrs and virgins are seen in succession. Such a classification conforms to that adopted in the liturgy.[2] At Chartres the artist went further, and in the right bay of the south porch—which is entirely devoted to confessors—

[1] Old porch at Chartres.　　　[2] At Notre Dame, however, the confessors are placed before the martyrs.

7

RELIGIOUS ART IN FRANCE

the saints round the arches are classified as laymen, monks, priests, bishops and archbishops. A saintly Pope and a saintly Emperor occupy the crown of the arch, and seem to be the two keystones of the structure.[1]

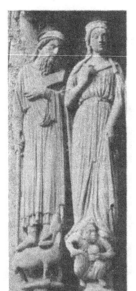

Above the choirs of saints are the choirs of angels. These are frequently ranked by the artists in the order devised by St. Dionysius the Areopagite, who first described the invisible world with the precision and grandeur found later in Dante.[2] His *Celestial Hierarchy*, translated into Latin in the ninth century by Scotus Eriugena, was often expounded by the doctors, notably by Hugh of St. Victor.[3] It inspired the artists who carved the nine choirs of angels in the south porch at Chartres. They are there ranged in the following orders : Seraphim, Cherubim, Thrones, Dominations, Virtues, Powers, Principalities, Archangels and Angels.[4] All these celestial beings, according to the doctrine of the Areopagite, form as it were great luminous circles round the throne of God, their brilliance increasing in measure as they approach the source of all light.[5]

FIG. 5.—BALAAM SUPPORTED BY HIS ASS, THE QUEEN OF SHEBA BY A NEGRO (north porch, Chartres)

So at Chartres the Seraphim and Cherubim carry flames and balls of fire because they dwell nearest to the centre of heat and splendour.

In the art of the Middle Ages care for disposition of parts extended to the smallest detail and led to ingenious devices. For example, a little crouching figure is almost always found under the bracket which supports a large statue. The superficial observer sees in it a piece of pure decoration, but careful study has shown that each of such small figures is in vital relation to the figure above it. Apostles tread under foot the kings who persecuted them, Moses stands on the golden calf, the angels tread on

[1] See Bulteau, *Monographie de la cathédrale de Chartres*, vol. ii. p. 358. Chartres, 1891, 8vo. This fine monograph is in three volumes. The Abbé Bulteau had previously published a complete study of the cathedral of Chartres in one volume, *Description de la cathédrale de Chartres*. Chartres, 1850, 8vo.

[2] Dante placed Dionysius the Areopagite in the Paradiso (x., 115-117).

[3] *Patrol.*, cxxii., col. 638, and clxxv., col. 923.

[4] The Abbé Bulteau (*op. cit.*, p. 313 *sq.*) adopts a rather different sequence, but it is evident that he is mistaken. The figure armed with a lance and shield, treading the dragon under foot, obviously represents the order of Archangels and not the Virtues.

[5] Rabanus Maurus, *De Universo*, i. 5, *Patrol.*, cxi., col. 29. "et ideo quantum vicinius (angeli) coram Deo consistunt, tanto magis claritate divini luminis inflammantur."

INTRODUCTION

the dragon of the abyss, and Christ tramples on the adder and the basilisk. At times the emblem on the bracket does not connote triumph, but relates to some feature in the life or character of the hero. At Chartres Balaam has his ass beneath his feet, the Queen of Sheba has a negro bearing gifts from Ophir (Fig. 5), while beneath the figure of the Virgin is the burning bush[1] (Fig. 6). The connection between the statue and the figure beneath the bracket is so close that at Notre Dame at Paris it has been possible by the help of the storied supports to reconstruct almost to a certainty the large figures in the left doorway.[2]

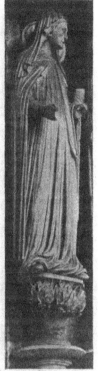

FIG. 6.—THE VIRGIN WITH THE BURNING BUSH BENEATH HER FEET (north porch, Chartres)

But no disposition met with more favour than that controlled by symmetry. Symmetry was regarded as the expression of a mysterious inner harmony. Craftsmen opposed the twelve patriarchs and twelve prophets of the Ancient Law to the twelve apostles of the New,[3] and the four major prophets to the four evangelists. A window in the south transept at Chartres shows—with audacious symbolism—the four prophets Isaiah, Ezekiel, Daniel and Jeremiah bearing on their shoulders the four evangelists, St. Matthew, St. John, St. Mark, St. Luke[4] (Fig. 7). In this way the artist would tell us that although the evangelists rest upon the prophets, yet from their spiritual vantage-ground they have a wider outlook. The four and twenty elders of the Apocalypse frequently correspond to the twelve prophets and the twelve apostles. In the same way parallelism was employed when treating of the Virtues and the Liberal Arts.[5]

Schemes of this kind presuppose a reasoned belief in the virtue of

[1] The Virgin of the Visitation in the north porch.

[2] Façade, porch of the Coronation of the Virgin. On the pedestals in this porch, see Cahier, *Nouv. mél. d'archéol: (ivoires, miniatures,* &c.), p. 237; and Duchalais, *Mémoires de la Société des antiquaires de France,* t. xvi.

[3] On this concordance see the commentary on Genesis attributed to Eucherius (*Patrol.,* l. col. 923) and Isidore of Seville, *Liber numer., Patrol.,* lxxxiii., col. 192. In the windows in the cathedral of Lyons

prophets, apostles and patriarchs are opposed (two patriarchs are missing). Some of these are reproduced in L. Bégule and C. Guigue's *Monographie de la cathédrale de Lyon.* Lyons, 1880, folio.

[4] The same subject was carved on the porch of the cathedral of Bamberg, probably under French influence.

[5] Windows in the apse of the cathedral of Auxerre. The Arts are in one rose-window, the Virtues in another, in equal numbers.

9

RELIGIOUS ART IN FRANCE

numbers, and in fact the Middle Ages never doubted that numbers were endowed with some occult power. This doctrine came from the Fathers of the Church, who inherited it from those Neo-Platonic schools in which the genius of Pythagoras had lived again. It is evident that St. Augustine considered numbers as thoughts of God. In many passages he lays it down that each number has its divine significance. "The Divine Wisdom is reflected in the numbers impressed on all things."[1] The construction of the physical and moral worlds alike is based on eternal numbers. We feel that the charm of the dance lies in rhythm, that is in number; but we must go further, beauty is itself a cadence, harmonious number.[2] The science of numbers, then, is the science of the universe, and from numbers we learn its secret. Therefore the numbers met with in the Bible should be considered with reverent attention, for they are sacred and full of mystery.[3] He who can read them enters into the divine plan.

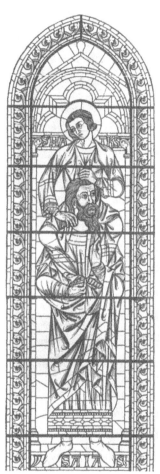

FIG. 7.— ISAIAH BEARING ST. MATTHEW (window at Chartres)

The same ideas are found in the works of almost all the mediæval doctors. Reference to the *Liber formularum* of Eucherius for the fifth century, to the *Liber numerorum* of Isidore of Seville for the seventh, to the *De Universo* of Rabanus Maurus for the ninth, and to the *Miscellanea* of Hugh of St. Victor for the twelfth will suffice to show how the same teaching couched in precisely the same terms was transmitted through the centuries.[4] The symbolic meaning of each number is first dogmatically stated, to be sub-

[1] St. Augustine, *De libero arbitrio*, lib. II., cap. xvi. *Patrol.*, vol. xxxii., col. 1263.
[2] *Id., ibid.*
[3] St. Augustine, *Quaest. in Heptateuch.*; *Patrol.*, vol. xxxvi.-xxxvii., col. 589; see also St. Augustine's treatise *De Musica*, chapter "De numeris spirituali-

bus et æternis," vi. xii., *Patrol.*, vol. xxxii., col. 1181.
[4] Eucherius, *Patrol.*, vol. l.; Isid. of Seville, *Patrol.*, vol. lxxxiii.; Rabanus Maurus, *Patrol.*, cxi.; Hugh of St. Victor, *Patrol.*, clxxvii.

INTRODUCTION

sequently verified by the examination of passages of Scripture in which numbers appear. The interpretations do not vary, and one feels oneself in the presence of a body of doctrine. A few examples will give some idea of the method. From St. Augustine onwards all theologians interpreted the meaning of the number twelve after the same fashion. Twelve is the number of the universal Church, and it was for profound reasons that Jesus willed the number of His apostles should be twelve. Now twelve is the product of three by four. Three, which is the number of the Trinity and by consequence of the soul made in the image of the Trinity, connotes all spiritual things. Four, the number of the elements, is the symbol of material things—the body and the world—which result from combinations of the four elements.[1] To multiply three by four is in the mystic sense to infuse matter with spirit, to proclaim the truths of the faith to the world, to establish the universal Church of which the apostles are the symbol.[2]

Computations of this kind were often more than ingenious, and at times reached real grandeur. The number seven, regarded by the Fathers as mysterious above all others, intoxicated the mediæval mystic. It was observed first of all that seven—composed of four, the number of the body, and of three, the number of the soul—is pre-eminently the number of humanity, and expresses the union of man's double nature. All that relates to him is ordered in series of sevens. Human life is divided into seven ages with each of which is associated the practice of one of the seven virtues. The grace necessary for the practice of these seven virtues is gained by addressing to God the seven petitions of the Paternoster. The seven sacraments sustain man in the exercise of the seven virtues, and guard him from falling into the seven deadly sins.[3] The number seven thus expresses the harmony of man's nature, but it also expresses the harmonious relation of man to the universe. The seven planets govern human destiny, for each of the seven ages is under the influence of one of them. Thus seven invisible threads connect man with the scheme of the universe.[4] Now

[1] St. Augustine, *In Psalm.*, vi.; *Patrol.*, vol. xxxvi.–xxxvii., col. 91. "Numerus ternarius ad animum pertinet, quaternarius ad corpus," and Hugh of St. Victor, *Patrol.*, vol. clxxv., col. 22.

[2] On the number twelve see Rabanus Maurus, *De Universo*, xviii. 3; *Patrol.*, vol. cxi., "Item duodecim ad omnium sanctorum pertinent sacramentum, qui, ex quatuor mundi partibus per fidem Trinitatis electi, unam ex se faciunt ecclesiam"; and Hugh of St. Victor, *De scripturis et script. sacris, Patrol.*, vol. clxxv., col. 22.

[3] On the number seven see Hugh of St. Victor, *Exposit. in Abdiam, Patrol.*, vol. clxxv., col. 400 *sq.*

[4] Subtle and learned Italy connected the planets with the seven ages of man on the capitals of the Ducal Palace at Venice, and in the frescoes in the Eremitani at Padua. *Annales archéol.*, t. xvi. pp. 66, 197, 297. The frescoes, the work of Guarienti, belong to the fourteenth century. After birth the child is under the influence of the Moon, who governs him for four years. Then Mercury adopts him, and influences him for ten years. Venus takes him for seven years.

RELIGIOUS ART IN FRANCE

the beautiful symphony made by man and the world, the music they offer to God, will last for seven periods of time, of which six have already passed. By creating the world in seven days God gave man the key to these mysteries,[1] and the Church celebrates the sublimity of the Creator's plan when she sings His praises seven times a day.[2] Finally, when all is said and done, what are the seven tones of the Gregorian mode but a sensible expression of the universal harmony.[3]

There is no doubt that the mystical schools in particular were led astray by conceptions of this kind. A glance at the *Arca Noe* of Hugh of St. Victor gives some idea of the rapture with which such symbolic numbers were combined.

But apart from the mystics there was hardly a mediæval theologian who did not seek in number the revelation of hidden truth. Some of their computations vividly recall those of the Cabbala. Honorius of Autun, when wishing to explain why the soul unites with the body forty-six days after conception, takes the name of Adam, and shows that the number forty-six is therein written. The transposition into numbers of the Greek letters composing the name gives : $a = 1$, $\delta = 4$, $a = 1$, $\mu = 40$, *i.e.* 46, which represents the time at which the human being may be considered as formed.[4]

Among the doctors, the commentators on the Bible are the richest in mystical interpretations based on numbers. They tell us, for example, that if Gideon went forth with three hundred companions it was not without some hidden reason, for that number hides a mystery. In Greek three hundred is rendered by the letter *tau* (T) ; now T is the figure of the Cross, and so behind Gideon and his companions must be seen the vision of Christ and the Cross.[5]

Many examples of similar deductions might be given, but it is enough to

The Sun then governs man for nineteen years, Mars for fifteen, Jupiter for twelve, and Saturn till his death. All these traditions go back to classical times.

[1] On the symbolism of the seven Days of Creation, see Rabanus Maurus, *De Universo*, ix. 10.

[2] On the symbolism of the seven hours of the office, see G. Durand.s, *Ration.*, v. i.

[3] The seven tones (with the octave) are carved on capitals from the abbey of Cluny (to-day in the museum of that town). They were very probably connected, if one may judge by some other capitals, with the seven virtues and the seven ages of the world. See *Annales archéol.*, t. xxvi. 380, and t. xxvii. 32, 151, 287.

[4] Honorius of Autun, *Sacramentarium, Patrol.*, vol. clxxii., col. 741. The four letters in the name of Adam also (according to Honorius) represent the four first letters of the four cardinal points—anatolè (east), dysis (west), arktos (north), mesembria (south). It is hardly necessary to say that Honorius of Autun was not the inventor of these combinations of numbers and letters, which are very ancient.

[5] Walafrid Strabo, *Glossa ordin. Lib. Judic.*, VII., v. 6. The same doctrine is found in St. Augustine, *Quæst. in Heptat.*, lib. vii. xxxvii.; and in Rabanus Maurus, *Comment. in Lib. Judic.*, lii., *Patrol.*, vol. cviii., col. 1163.

have indicated a peculiar characteristic of mediæval thought. It might truly be said that there was something of this sacred arithmetic in all the great works of the Middle Ages. Dante's "Divine Comedy" is the most famous example, for it is built up on numbers. To the nine circles of Hell correspond the nine terraces of the mount of Purgatory and the nine heavens of Paradise. In that inspired poem nothing was left solely to inspiration. Dante determined that each part of his trilogy should be divided into thirty-three cantos in honour of the thirty-three years of the life of Christ.[1] In adopting the metrical form of the terzina he seems to have wished that the pre-eminently mystic number should enter into the very texture of his poem. He disposed the universe according to the laws of a sublime geometry. He placed the earthly Paradise at the antipodes of Jerusalem so that the tree which caused man's fall was exactly opposite to the Cross through which he gained salvation. The same precision of detail is observed throughout. The most ardent imagination known in literature was also the most submissive. Dante accepted the law of numbers as a divine rhythm which the universe obeyed. But while meditating on the mystery he was seized with a sacred awe from which sprang a marvellous poem. Beatrice herself became a number. She was in his eyes the number nine, which has its root in the holy Trinity.[2]

It was thus that "cum pondere et mensura," Dante raised his invisible cathedral. With St. Thomas he was the great architect of the thirteenth century, and might well be represented holding compass and rule such as may be seen on the tombstone of Maître Hugues Libergier the builder of St. Nicaise at Reims.

After all that has been said it would seem natural to look for traces of this sacred arithmetic in the cathedrals. Though the science of numbers was often at the root of the artists' compositions, yet we are far from seeing symbolic numbers everywhere. For example, nothing goes to prove, as certain adventurous archæologists would have it, that a mystical meaning is to be sought in the triple division of the Gothic window.[3] But neither would we join hands with the opposite school, and by systematically rejecting all symbolism of the kind show misunderstanding of the real genius of the Middle Ages.

[1] The *Inferno* has thirty-four cantos, but the first must be considered as a prologue.

[2] *Vita Nuova.* "This lady was accompanied by the number nine, to give to understand that she was a nine; that is, a miracle whose root is the wondrous Trinity alone."

[3] See J. M. Neale and Benj. Webb, *The symbolism of churches and church ornaments.* 1843.

RELIGIOUS ART IN FRANCE

There are cases in which symbolic intention can hardly be questioned, such is the close agreement between the work of writer and craftsman. The octagonal form of the baptismal font, adopted from the earliest times and persisting through the whole of the Middle Ages, is not due to mere caprice. It is difficult not to see in it an application of the teaching of the Fathers, for the number eight was to them the number of the new life. It comes after seven which marks the limit assigned to the life of man and to the duration of the world. The number eight is like the octave in music with which all begins once more. It is the symbol of the new life, of the final resurrection and of that anticipated resurrection implied in baptism.[1]

We cannot believe that such a doctrine, taught by the early Fathers, persisted without effect. The font in the oldest baptisteries in Italy or Gaul was almost invariably octagonal in form,[2] and in mediæval times the baptismal fonts though frequently circular were still more frequently octagonal.[3]

We believe that it would be possible to find mystical numbers in other parts of the cathedral, but such studies are still in their infancy and so far more imagination than method has been brought to bear on them.

III

The third characteristic of mediæval art lies in this, that it is a symbolic code. From the days of the catacombs Christian art has spoken in figures, showing men one thing and inviting them to see in it the figure of another. The artist, as the doctors might have put it, must imitate God who under the letter of Scripture hid profound meaning, and who willed that nature too should hold lessons for man.

In mediæval art there are then intentions a knowledge of which is necessary to any real understanding of the subject. When for example in scenes of the Last Judgment we see the Wise and Foolish Virgins to

[1] St. Ambrose says, "Quis autem dubitet majus esse octavæ munus, quae totum renovavit hominem." *Epist. class.*, i. xliv., *Patrol.*, vol. xvi., col. 1140. Elsewhere he remarks that the number eight, which under the Old Law related to circumcision, now relates to baptism and to the resurrection. *In Psal. David*, cxviii., *Patrol.*, vol. xv., col. 1198.

[2] For example, the baptisteries at Ravenna, Novara, Cividale in Friuli, Trieste, Torcello, Aix (Provence), Fréjus, &c. See Lenoir, *Architecture monastique*. Paris, 1852, 2 vols. 8vo. No passage on the form of the baptistery is to be found in the Fathers of the Church. I have searched in vain in St. Augustine, St. Ambrose, and St. Gregory the Great. Support from them would settle the question, but their silence by no means condemns our hypothesis.

[3] On mediæval fonts see the study made by M. Saintenoy in the *Annales de la Société archéolog. de Bruxelles*, 1891 and 1892. He studied and classified a large number of baptismal fonts of the eleventh to the sixteenth century in all parts of Europe. Thirty-two are round, but sixty-seven are octagonal. There are other shapes, but they are few in number.

the right and left hand of Christ, we should thereby understand that they symbolise the elect and the lost. Upon this all the commentators on the New Testament are agreed, and they explain it by stating that the five Foolish Virgins typify the desires of the five senses, and the five Wise Virgins the five forms of the contemplative life.[1] To take another example, it is not as rivers that the four rivers of Paradise—the Gihon, Phison, Tigris, and Euphrates—are represented pouring water from their urns towards the four points of the compass, but as symbols of the evangelists who flooded the world with their teaching like four beneficent streams.

An Old Testament personage in the porch of a cathedral is but a type, an adumbration of Christ, the Virgin, or the future Church. At Chartres the form of Melchizedek, priest and king, bearing the bread and wine to Abraham, should remind men of another priest and king who offered bread and wine to His disciples. At Laon Gideon calling down rain from heaven on to the fleece he had laid on the earth, reminds men that the Virgin Mother was this symbolic fleece on whom fell the dew from on high (Fig. 8).

A detail of apparent insignificance may hide symbolic meaning. In a window at Bourges the lion near to the tomb from which the risen Christ comes forth is a type of the Resurrection. It was generally believed in the Middle Ages that for three days after birth the cubs of the lioness gave no sign of life, but that on the third day the lion came and with his breath restored them to life. And so the apparent death of the lion represents the sojourn of Jesus in the tomb, and its birth was an image of the Resurrection.

In the art of the Middle Ages, as we see, everything depicted is informed by a quickening spirit.

Such a conception of art implies a profoundly idealistic view of the scheme of the universe, and the conviction that both history and nature must be regarded as vast symbols. We shall see later that this undoubtedly was the view of the mediæval mind. Further, it should be remembered that such ideas were not the property of the great thirteenth century doctors alone, but were shared by the mass of the people to whom they had permeated through the teaching of the Church. The symbolism of the church services familiarised the faithful with the symbolism of art. Christian liturgy like Christian art is endless symbolism, both are manifestations of the same genius.

[1] We shall return to this subject later, and give references.

RELIGIOUS ART IN FRANCE

The commentaries of Gulielmus Durandus accompanying the account of any of the great Christian festivals—such for example as Easter Eve [1]—show how each ceremony performed on that day is full of meaning.

The day begins with the extinction of all the lamps in the church to show how the Ancient Law which has hitherto given light to the world

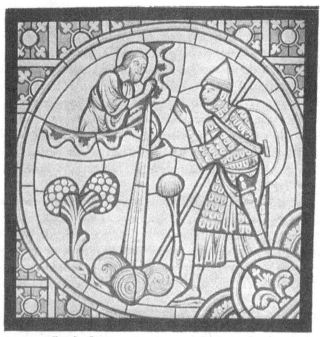

FIG. 8.—GIDEON AND THE FLEECE (window at Laon)
(From Florival and Midoux, by permission of M. de Florival)

is now discarded. The celebrant then blesses the new fire, type of the New Law. This fire must be struck from a flint in remembrance that Christ, as St. Paul says, is the world's cornerstone. Then the bishop, the deacon and the people move towards the choir and stop in front of the paschal candle. This candle, Gulielmus Durandus teaches, is a threefold symbol. When extinguished it typifies at once the pillar of cloud which led the Children of Israel by day, the Ancient Law, and the body of the Lord ; when lighted it signifies the pillar of fire which was Israel's

[1] *Rationale div. offic.*, lib. VI., cap. lxxx.

guide by night, the New Law, and the glorious body of the risen Christ. The deacon alludes to this threefold symbolism when singing the *Exultet* before the candle, but he insists in particular upon the likeness of the candle to the body of the Saviour. He calls to mind that the pure wax was produced by the bee which, like the Virgin who gave birth to the Saviour, is at once chaste and fruitful.[1] To give visible form to the similitude of the wax to the sacred body, he drives five grains of incense into the candle as a reminder both of the five wounds of Christ and of the spices brought by the holy women for His burial. Finally he lights the candle with the new fire, and the lamps are re-lighted throughout the church in token of the illumination of the world by the New Law.

The first part of the ceremony ends here. The second is devoted to the baptism of the neophytes, which the Church ordained should take place on that day because, says Durandus, she saw mystic affinities between the death of Jesus and the symbolic death of the new Christian who in baptism dies to the world to rise again with the Saviour. But before being led to the baptismal fonts the catechumens listen to twelve passages from the Bible dealing with the sacrament they are about to receive. These are, to give examples, the story of the Deluge whose water purified the world, the passage of the Red Sea by the Children of Israel (a figure of baptism), and the verse in Isaiah which speaks of those who thirst for the water of life. The reading ended, the bishop blesses the water. He first makes the sign of the cross above it, then dividing it into four he sprinkles it towards the four cardinal points in memory of the four rivers of the terrestrial Paradise. He next dips the paschal candle, type of Christ, into the water to remind them that Jesus was baptized in Jordan, and by His baptism sanctified all the waters of the world. He dips the candle into the font three times in remembrance of the three days passed by the Redeemer in the tomb. The baptism then begins, and the neophytes in their turn are dipped three times into the font that they may know that with Christ they die to the world, with Him are buried, and with Him rise to the life eternal.

It is evident that in such a ceremony no detail is without symbolic value.

But it is not only on special occasions such as this that the Church makes use of symbols to instruct and move the people. Daily she celebrates the sacrifice of the Mass, and in that solemn drama every detail has its

[1] On the beautiful *Exultet* of the primitive Church see Duchesne, *Les Origines du culte chrétien*. Paris, 1889, 8vo, p. 242.

significance. The chapters which Gulielmus Durandus gives to the explanation of the Mass are among the most arresting in his *Rationale*.

Here, for example, is his interpretation of the first part of the divine sacrifice : [1] The ceremony begins with the *Introït*, that solemn chant which expresses the waiting of patriarchs and prophets. The choir of clergy is the very choir of the saints of the Ancient Law who sigh for the coming of the Messiah whom they will never see. The bishop then enters, appearing as the living type of Christ, and his arrival symbolises the coming of the Saviour awaited by the nations. Before him at great festivals are carried seven lights to recall the seven gifts of the Spirit which rested upon the head of the Son of God, according to the word of the prophet. He advances under a triumphal canopy whose four bearers may be compared to the four evangelists. To right and left of him walk acolytes, typifying Moses and Elias, who were seen on Mount Tabor on either side of the transfigured Lord. They teach men that the authority of both the Law and the Prophets was embodied in Christ. The bishop seats himself on his throne and is silent, appearing to take no share in the first part of the ceremony. His attitude contains a lesson, for by his silence he recalls that the first years of the life of Jesus were passed in obscurity and meditation. The sub-deacon, however, goes to the desk, and turning to the right he reads the Epistle aloud. Here we catch a glimpse of the first act in the drama of Redemption, for the reading of the Epistle typifies the preaching of John the Baptist in the desert. He speaks before the Saviour has begun His mission, but he speaks to the Jews alone, and the sub-deacon—type of the Forerunner—turns to the north, the side of the Old Law. The reading ended, he bows to the bishop as John the Baptist abased himself before his Master.

The Gradual, which follows the reading of the Epistle, also relates to the mission of the Baptist. It symbolises the exhortation to repentance which he addressed to the Jews on the eve of the new era.

At this point the celebrant reads the Gospel. A solemn moment, for it is now that the active life of the Messiah begins, and His word is first heard in the world. The reading of the Gospel is itself the figure of His preaching.

The Creed follows the Gospel, as faith follows the proclamation of the

[1] We give a short résumé, omitting a number of details, of chapter v. and the following chapters of the *Rationale*, bk. iv. The same teaching is found in other mediæval liturgiologists. See Sicard, *Mitrale*, III. 2 ; *Patrol.*, ccxiii.

truth. The twelve articles of the Creed relate to the mission of the apostles.[1]

The Creed finished, the bishop rises and speaks to the people. In choosing this moment to instruct the faithful the Church would remind them of the miracle of her foundation. She shows them how the truth first received by the apostles instantly began to spread throughout the world.

Such is the mystical meaning which Gulielmus Durandus attributes to the first part of the Mass. The foregoing has been in the nature of a prologue to the drama which culminates in the divine sacrifice, but his comments now become so numerous and his symbolism so rich that it is impossible to give any adequate idea in a mere outline, and we would refer the reader to the original. We have said enough, however, to give some notion of the genius of the Middle Ages, and one can divine something of the teaching, the emotional appeal, and the inspiration which religious ceremonial held for the Christian of the thirteenth century. How powerfully would such poetry affect the sensitive soul of a St. Louis, and how readily does it furnish the explanation of his trances and tears. To those who would tear him from his meditation he was wont to say in a low voice, like one half-dreaming, " Where am I ? " He had thought himself with St. John in the wilderness, or walking by the side of the Master.

The works of the old liturgiologists, despised since the seventeenth century, should without doubt be counted among the most extraordinary books belonging to the Middle Ages.[2] Nowhere else is found such forceful radiance of soul, which transmuted things material into things of the spirit.

The vestments worn by the priest at the altar and the objects used in the ritual of the church are so many symbols. The chasuble, worn over the other vestments, is the charity which is above the precepts of the law, and is itself the supreme law.[3] The stole which the priest passes round

[1] Each article of the Creed was attributed to an apostle. From the fourteenth century onwards the apostles are often shown carrying scrolls on which are written the articles attributed to each of them.

[2] Read Amalarius, *De ecclesiasticis officiis*, and *Eclogae de officio missae* (ninth century), *Patrol.*, cv. ; Rupert of Tuy, *De divinis officiis* (twelfth century), *Patrol.*, clxx. ; Honorius of Autun, *Gemma animae*, and *Sacramentarium* (twelfth century), *Patrol.*, clxxii. ; Hugh of St. Victor, *Speculum ecclesiæ*, and *De officiis ecclesiasticis* (twelfth century; the attribution to Hugh of St. Victor is doubtful), *Patrol.*, clxxvii. ;

Sicard of Cremona, *Mitrale* (twelfth century), *Patrol.*, ccxiii. ; Innocent III., *De sacro altaris mysterio* (thirteenth century), *Patrol.*, ccxvii. At the end of the thirteenth century G. Durandus compiled and added to the work of his predecessors in his *Rationale divinorum officiorum*. It is curious that the earlier liturgiologists, such as Isidore of Seville (*De ecclesiasticis officiis*, *Patrol.*, lxxxiii.), give no place to symbolism. The symbolic interpretation of ritual belongs to the Middle Ages, and begins with Amalarius.

[3] G. Durandus, *Ration.*, bk. iii. ch. 7.

his neck is the light yoke of the Master, and as it is written that the Christian should cherish that yoke, the priest when putting it on or taking it off kisses the stole.[1] The bishop's mitre with its two points symbolises the knowledge he should have of both the Old and the New Testaments, while the two ribbons attached to it are a reminder that the interpretation of Scripture should be according to both letter and spirit.[2] The sanctus bell is the voice of the preachers. The frame to which it is suspended is a figure of the Cross, and the cord made of three twisted threads signifies the threefold interpretation of Scripture, in a historical, allegorical and moral sense. When the cord is taken in the hand in order to move the bell, it is a symbolic expression of the fundamental truth that the knowledge of the Scriptures should conduce to action.[3]

Such constant use of symbolism will astonish those unfamiliar with mediæval writers. One should not however affect to see in it, as did the Benedictines of the eighteenth century, nothing but the mere play of individual fancy.[4] Symbolic interpretations were doubtless never accepted as dogma, but for all that it is noticeable that they seldom vary. For example, in the thirteenth century Gulielmus Durandus attributes the same meaning to the stole as does Amalarius in the ninth.[5] But the interest here lies less in the interpretation itself than in the attitude of mind which it presupposes. What is significant is the scorn for things of sense, and the profound conviction that reaching out to the immaterial through the material man may have fleeting visions of God. And herein lies the true genius of the Middle Ages.

For the historian of art there are no books of greater value than the liturgical treatises, as through them he may learn to understand the spirit which moulded plastic art. The craftsmen were as skilful as the theologians in spiritualising material objects. To them were due devices which were at times ingenious, at times touching, at others impressive. They gave, for example, the form of a fortified town protected by towers to the great chandelier at Aix-la-Chapelle. The inscription tells us that this town of light is the celestial Jerusalem. Between the battlements, near to the apostles and prophets who guard the holy city,[6] are personifications of the

[1] *Ration.*, bk. iii. ch. 5.
[2] *Ration.*, bk. iii. ch. 13.
[3] *Ration.*, bk. i. ch. 4.
[4] See the article on Honorius of Autun in the *Hist. litt. de la France*, vol. xii.
[5] From Amalarius to G. Durandus all the liturgiologists consider the stole a symbol of obedience.

Amalarius, *De eccles. officiis*, col. 1097 ; Rupert, *De divin. offic.*, col. 22 ; Honorius of Autun, *Gemma*, col. 605 : Hugh of St. Victor, *De offic. eccles.*, col. 405 ; Sicard, *Mitrale*, col. 75 ; Innocent III., *De sacro alt. myst.*, col. 788.
[6] *Annales archéol.*, vol. xix. p. 70 ; and Cahier, *Mélang. arch.*, vol. iii. p. 1 *seq.*

INTRODUCTION

beatitudes of the soul promised to the elect, a marvellous realisation of the vision of St. John.

The unknown artist who surmounted a censer with figures of the three Children in the fiery furnace was well able to give plastic form to beautiful thought.[1] The perfume which rose from the brazier was as the very prayer of the martyrs. Thus did the pious workman of the time express his deepest feelings in his work.

Another and more subtle artist gave to the crook of a bishop's crozier the form of a serpent holding a dove in its teeth, as a reminder to the pastor of the two virtues proper to his ministry. "Hide the simplicity of the dove under the prudence of the serpent," says a Latin inscription engraved on the pastoral staff.[2] Another crozier shows a serpent threatening the Virgin with his impotent jaws, while in the crook is an angel telling him that this is she whose Son will vanquish the serpent.[3]

The artists frequently gave a literal translation of the doctrine held by the liturgiologists. Against twelve pillars in the choir of the Sainte-Chapelle the sculptors placed twelve statues of apostles carrying consecration crosses. The liturgical writers taught[4] that when the bishop consecrated a church he should mark twelve columns in the nave or choir with twelve crosses in token that the twelve apostles

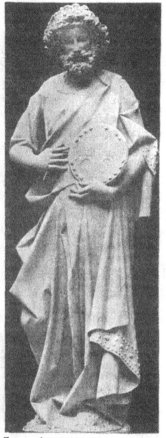

FIG. 9.—AN APOSTLE WITH THE CONSECRATION CROSS (Sainte-Chapelle)

are the true pillars of the temple. This is the symbolism which has been so well expressed in the interior of the Sainte-Chapelle[5] (Fig. 9).

Again, in the thirteenth century, all the church furniture showed the

[1] Censer at Lille, *Annales archéol.*, vol. iv. p. 293, and xix. p. 112.

[2] Cahier, *Nouv. mél. archéol.*, *Ivoires*, p. 28.

[3] In the Louvre, galerie d'Apollon.

[4] See Sicard, *Mitrale*, bk. i. ch. 9; *Patrol.*, tom. ccxiii. col. 34.

[5] With the exception of four, the statues now seen there have been restored (F. de Guilhermy, *Description de la Sainte-Chapelle*. Paris, 1887, 12mo, p. 41). The twelve apostles were also placed against twelve columns in the church of St. Jacques-des-Pèlerins, at Paris (*Rev. de l'art chrétien*, 1896, p. 399).

RELIGIOUS ART IN FRANCE

material fashioned by the spiritual. At the lectern the eagle of St. John spread his wings to support the Gospel.[1] Beautiful angels in long robes bore in procession the crystal reliquary in which reposed the bones of saints and martyrs. Ivory figures of the Virgin opened and where their hearts should be showed engraved the story of the Passion.[2] In the chevet of the cathedral a huge angel which dominated the whole town turned with the sun and gave a spiritual meaning to each hour.

From what has been said it is evident that mediæval art was before all things a symbolic art, in which form is used merely as the vehicle of spiritual meaning.[4]

Such are the general characteristics of the iconography of the Middle Ages. Art was at once a script, a calculus and a symbolic code. The result was a deep and perfect harmony. There is something musical in the grouping of the statues in the cathedral porches, and in truth all the elements of music are present. Are there not here conventional signs grouped according to the law of numbers, and is there not something of the indefinite quality of music in the infinite symbolism dimly discerned behind the outward forms? The genius of the Middle Ages, so long misunderstood, was a harmonious genius. Dante's Paradiso and the porches at Chartres are symphonies. To thirteenth century art more truly perhaps than to any other might be given the title of "frozen music."

[1] In the Chartreuse at Dijon the lectern was a column surmounted by a phœnix. The four beasts placed round it served as desk. If the gospel for the day came from St. Mark the book was placed on the lion, if from St. Luke on the ox, and so on (Moléon, *Voyage liturgique*, p. 156).

[2] A figure of the Virgin which opens formerly found in the collection of ivories at the Louvre, is probably a forgery. However an authentic work exists (much mutilated); see Molinier, *Ivoires*, p. 177, in *l'Histoire générale des arts appliqués à l'industrie*. Paris, 1896, folio. Another has recently been found; see *La Vierge ouvrante de Boubon*, by the Abbé Leclerc and Baron de Verneilh. Limoges, 1898.

[3] In the chevet of the cathedral of Chartres before the fire of 1836. Villard de Honnecourt in his *Album* (fol. 22 v.) explains the mechanism that put the angel in motion.

[4] A question which has given rise to lengthy controversy in mediæval archæology is that of the deviation of the axis of churches, so frequently noticed in the choir. Is such an irregularity due to chance, to necessities of a material order, or has it a symbolic intention? Was it not done in remembrance that Christ, of whom the church is an image, inclined His head when He died on the Cross? Viollet-le-Duc

does not commit himself, though recognising that such an idea would be in harmony with all that we know of the genius of the Middle Ages (*Dictionn. raisonné de l'architect.*, article *Axe*). For my part I was long disposed to interpret the deviation of the axis in a mystical sense. The notable memoir that M. de Lasteyrie devoted to this question (*Mém. de l'Acad. des Inscript. et Belles-Lettres*, vol. xxxvii., 1905) has convinced me that this deviation could have no symbolic meaning. When not due to the necessities of the site, it resulted from an error in measurement, and always corresponds to a break in the work of building. The precise examples given by M. de Lasteyrie must surely remove all doubt. M. Anthyme Saint-Paul, so long one of the champions of symbolic interpretation, almost immediately on the publication of the *Mémoire* signified his adhesion to M. Lasteyrie's theory (*Bullet. monum.*, 1906). This symbolism discarded, what remains of the ingenious deductions of Mme. Félicie d'Ayzac who had tried to show that the small door in the side of Notre Dame at Paris, the *porte rouge*, was the figure of the wound made by the lance in the right side of Jesus (*Revue de l'art chrétien*, 1860 and 1861)? Symbolism has too large a place in mediæval art to leave room for the fancies of modern interpreters.

22

CHAPTER II

METHOD USED IN THE STUDY OF MEDIÆVAL ICONOGRAPHY

The Mirrors of Vincent of Beauvais

The thirteenth century was the century of encyclopædias. At no other period have so many works appeared bearing the titles of *Summa*, *Speculum* or *Imago Mundi*. It was in this century that Thomas Aquinas co-ordinated the whole body of Christian doctrine, Jacobus de Voragine collected the most famous legends of the saints, Gulielmus Durandus epitomised all previous writers on the liturgy, and Vincent of Beauvais attempted to embrace universal knowledge. Christianity came to full consciousness of its own genius, and the conception of the universe which had been elaborated by previous centuries received complete expression. It was believed to be possible to raise the final edifice of human knowledge, and in the universities which had recently been founded throughout Europe—above all the young university of Paris—the work was carried on with enthusiasm.

While the doctors were constructing the intellectual edifice which was to shelter the whole of Christendom, the cathedral of stone was rising as its visible counterpart. It too in its fashion was a *Speculum*, a *Summa*, an *Imago Mundi* into which the Middle Age put all its most cherished convictions. These great churches are the most perfect known expression in art of the mind of an epoch. We shall attempt to show that in them a whole dogmatic scheme found expression in concrete form.

The difficulty lies in grouping in logical sequence the innumerable works of art which the churches offer for our study. Surely we have hardly the right to dispose of the matter according to some arbitrary scheme which appears to us harmonious. It is necessary to discard modern habits of mind. If we impose our categories on mediæval thought we run every risk of error, and for that reason we borrow our method of exposition from the Middle Age itself. The four books of Vincent of Beauvais's *Mirror* furnish us with the framework for the four divisions of our study of thirteenth century art.

If Aquinas was the most powerful thinker of the Middle Ages,

RELIGIOUS ART IN FRANCE

Vincent of Beauvais was certainly the most comprehensive. He might well be called an epitome of the knowledge of his day. A prodigious worker, he passed his life like the elder Pliny in reading and making extracts. He was called "librorum helluo," the devourer of books. St. Louis threw open to him the fine library containing virtually all the books procurable in the thirteenth century, and at times came to visit him at the abbey of Royaumont, where he loved to hear him talk of the wonders of the universe.

It was probably towards the middle of the century that Vincent of Beauvais published the great *Mirror*, the *Speculum majus*, which to his contemporaries seemed the supreme effort of human learning. Even to-day one cannot but admire so stupendous a work.[1]

His learning was immense, yet it did not overwhelm him. The order which he adopted was the most imposing which the Middle Age could conceive—the very plan of God as it appears in the Scriptures. Vincent of Beauvais's work is divided into four parts—the Mirror of Nature, the Mirror of Instruction, the Mirror of Morals and the Mirror of History.

In the Mirror of Nature are reflected all natural phenomena in the order in which they were created by God. The Days of Creation mark the different chapters of this great encyclopædia of nature. The four elements, the minerals, vegetables and animals are successively enumerated and described. All the truth and the error which had been transmitted by antiquity to the Middle Ages are found there. But it is naturally on the work of the sixth day—the creation of man—that Vincent of Beauvais dwells at greatest length, for man is the centre of the universe and for him all things were made.

The Mirror of Instruction opens with the story of the Fall, the recital of the drama which explains the riddle of the universe. Man has fallen, and only through a Redeemer can he hope for salvation. Yet in his own strength he can begin to raise himself, and through knowledge to prepare for grace. There is in knowledge a quickening power, and to each of the seven Arts corresponds one of the seven Gifts of the Spirit. After expounding this large and humane doctrine Vincent of Beauvais

[1] *Speculum majus*, Douai, 1624. 4 vols. folio. This is the reprint made by the Jesuits. We shall constantly refer to this edition.

[2] Vincent of Beauvais had not time to write the *Mirror of Morals*, and the work that bears that title dates from the beginning of the fourteenth century. (See *Histoire littér. de la France*, vol. xviii. p. 449.) But it is evident that the *Speculum morale* was part of his original plan, and that is all that concerns us here.

INTRODUCTION

passes in review all the different branches of knowledge; even the mechanical arts are included, for by the labour of his hands man begins the work of his redemption.

The Mirror of Morals is closely connected with the Mirror of Instruction, for the end of life is not to know but to act, and knowledge is but a means to virtue. Out of this springs a learned classification of the virtues and vices, in which the method, divisions and often the very expressions of Aquinas are found—for the *Speculum morale* is the *Summa* in abridged form.

The last division is the Mirror of History. We have studied human nature in the abstract, and we now turn to man himself, watching his progress under the eye of God. He invents arts and sciences, he struggles and suffers, choosing sometimes vice, sometimes virtue in the great battle of the soul which is the sum of the world's history. It is hardly necessary to observe that for Vincent of Beauvais, as for Augustine, Orosius, Gregory of Tours and all the historians of the Middle Ages, true history is the history of the Church, the City of God, which begins with Abel the first just man. There is a chosen people and their history is the pillar of fire which lightens the darkness. The history of the pagan world is deserving of study only with reference to the other; it has merely value as a synchronism. It is true that Vincent of Beauvais did not scorn to tell of the revolution of empires, and even delighted in speaking of pagan philosophers, scholars and poets, but such subjects are really incidental. The dominant thought of his book—the idea which gives it unity—is the unbroken line of saints of the Old and New Testaments. Through them and them alone the history of the world becomes coherent.

Thus was conceived this Encyclopædia of the thirteenth century. In it the riddle of the universe finds solution. The plan is so comprehensive that the Middle Ages could conceive of nothing which it did not include, and until the Renaissance the following centuries found nothing to add to it.

Such a book is the surest guide that we can choose for our study of the great leading ideas which lay behind the art of the thirteenth century. Striking analogies are noticeable, for example, between the general economy of the *Speculum Majus* and the plan followed in the porches of the cathedral of Chartres. As was first pointed out by Didron in the authoritative introduction to his *Histoire de Dieu*, the innumerable figures which decorate the porches may well be grouped under the four heads

25

of nature, instruction, morals and history. We do not know whether that great decorative scheme was directly inspired by Vincent of Beauvais's book with which it was almost contemporaneous, but it is obvious that the arrangement of the *Speculum Majus* belonged not to him but to the Middle Ages as a whole. It was the form which the thirteenth century imposed on all ordered thought. The same genius disposed the chapters of the *Mirror* and the sculpture of the cathedral. It is then legitimate to seek in the one the meaning of the other.

We shall therefore adopt the four great divisions of Vincent of Beauvais's work, and shall try to read the four books of the *Mirror* in the façades of the cathedrals. We shall find them all four represented, and shall decipher them in the order in which the encyclopædist presents them. Each detail will in this way find its place, and the harmony of the whole will appear.

BOOK I

THE MIRROR OF NATURE

I.—To the mediæval mind the universe a symbol. Sources of this conception. The " Key " of Melito. The Bestiaries. II.—Animals represented in the churches ; their meaning not always symbolic. Symbols of the Evangelists. Window at Lyons. Frieze at Strasburg. Influence of Honorius of Autun ; the Bestiaries. III.—Exaggerations of the symbolic school. Symbolism sometimes absent. Flora and fauna of the thirteenth century. Gargoyles, monsters.

I

THE Mirror of Nature of Vincent of Beauvais is conceived in a spirit of stately simplicity. It is, as has been said, a commentary on the seven Days of Creation in which all created things are studied in the order of their appearance. Vincent of Beauvais brought the learning of the ancients into the framework of the Bible story, and made Pliny, Ælian, Dioscorides, all unwittingly sing the glory of the God of Genesis.

He was not the originator of this plan. The Greek and Latin Fathers present their encyclopædic knowledge of the universe on the plan unfolded in the successive stages of creation, dividing their books into chapters according to the Seven Days. Of all these treatises on the work of God—the Hexaëmeron, the most famous in the west was that of St. Ambrose, which became the model for all works of the kind.[1] Vincent de Beauvais invented nothing, for in this as throughout he remains the faithful interpreter of tradition.

The Mirror of Nature is carved in brief on the façades of most of the French cathedrals. We find it at Chartres (Fig. 10), at Laon, at Auxerre, Bourges and Lyons, treated in a restrained and conventional way.[2] At Chartres a lion, a sheep, a goat and a heifer stand for the animal world, a fig-tree and three plants of indeterminate character represent the vegetable kingdom ;[3] there is an element of greatness in this summing up of the universe in some five or six bas-reliefs. Some naïve details are full of charm. In the representation at Laon the Creator sits in deep reflection

[1] St. Ambrose, *Patrol.*, xiv.
[2] Chartres, north porch, central bay, arch orders ; Laon, west façade, mouldings of the large window to the right ; Auxerre, west façade, basement of porch ; Lyons, bas-reliefs of west porch ; Noyon, *id.* mutilated ; Bourges, *id.* Several windows of the Creation may also be cited : Auxerre, thirteenth century ; Soissons, window in the chevet.
[3] The Creation at Chartres has been studied at some length by Didron, *Annales archéol.*, t. XI. p. 148.

before dividing the darkness from the light, and counts on His fingers the number of days needed to finish His work. Later in the series, when His task is accomplished, He sits down to rest like a good workman at the end of a well-spent day, and leaning on His staff he falls asleep.

One might well feel that these few typical forms were inadequate representations of the wealth of the universe, and might accuse the thirteenth-century craftsmen of timidity and want of power, did the animal and vegetable worlds really occupy no further place in the cathedral scheme. But a glance upward shows us vines, raspberries heavy with fruit and long trails of the wild rose clinging to the archivolts, birds singing among the oak leaves or perching on the pillars. Beasts from far-off lands side by side with homely creatures of the countryside—lions, elephants and camels, squirrels, hens and rabbits —enliven the basement of the porch, while monsters securely fastened by their heavy stone wings bark fiercely at us from above. How little do these old masters with their unequalled, if naïve love of nature deserve the reproach of

FIG. 10.—THE CREATION. THE CREATOR IN THE FIRST ORDER, THE WORK OF THE SEVEN DAYS IN THE SECOND (north porch, Chartres)

lack of power or invention. Their cathedrals are all life and movement. The Church to them was the ark to which every creature was made welcome, and then—as if the works of God were not sufficient for them—they invented a whole world more of terrible beings, creatures so real that they surely must have lived in the childhood of the world.

In this way the chapters of the Mirror of Nature are inscribed everywhere—on pinnacle and balustrade as on the smallest capital. What is the meaning of all the plants, animals, monsters? Are they due to caprice or

have they significance, and do they teach some great and mysterious truth ?
May one not suppose that they too are symbols, clothing some thought
like the statues and bas-reliefs which we shall have occasion to study later ?

In order to answer such questions some attempt must be made to under-
stand the mediæval view of the world and of nature. What is the visible
world ? What is the meaning of the myriad forms of life ? What did
the monk dreaming in his cell, or the doctor meditating in the cathedral
cloister before the hour of his lecture think of it all ? Is it merely appear-
ance or is it reality ? The Middle Ages were unanimous in their reply
—the world is a symbol. As the idea of his work is in the mind of the
artist, so the universe was in the thought of God from the beginning.
God created, but He created through His Word, that is, through His Son.
The thought of the Father was realised in the Son through whom it passed
from potentiality to act, and thus the Son is the true creator.[1] The artists
of the Middle Ages, imbued with this doctrine, almost invariably represent
the Creator in the likeness of Jesus Christ.[2] The absence in the churches
of any likeness of God the Father filled Didron with needless amazement
and Michelet with mistaken indignation.[3] For, according to the theo-
logians, God the Father created *in principio*, which is to say *in verbo*, that
is by His Son.[4] Jesus Christ is at once Creator and Redeemer.[5]

The world therefore may be defined as " a thought of God realised through
the Word." If this be so then in each being is hidden a divine thought ;
the world is a book written by the hand of God in which every creature is a
word charged with meaning.[6] The ignorant see the forms—the mysterious
letters—understanding nothing of their meaning, but the wise pass from the
visible to the invisible, and in reading nature read the thoughts of God.
True knowledge, then, consists not in the study of things in themselves—
the outward forms—but in penetrating to the inner meaning intended by
God for our instruction, for in the words of Honorius of Autun, " every
creature is a shadow of truth and life." All being holds in its depths the
reflection of the sacrifice of Christ, the image of the Church and of the
virtues and vices. The material and the spiritual worlds are one.

[1] Gervase of Tilbury, *Otia imperialia*, I.: Filius
ergo principium temporis, principium mundanae crea-
tionis.

[2] Easily visible at Chartres, in the north porch,
scenes of the Creation.

[3] Didron in his *Hist. de Dieu ;* Michelet in the
preface to the *Renaissance*.

[4] The theologians interpreted the words, " In
principio Deus creavit coelum et terram " in this way.

For them " principium " was the equivalent of
" verbum." Vincent of Beauvais, *Spec. nat.*, bk. I.,
ch. ix. Honorius of Autun, *Hexaemer.*, I.; *Patr.*,
clxxii., col. 253. The idea goes back to Augustine.

[5] " In Christo omnia creata et postmodo cuncta in
eo reparata." Honorius of Autun, *loc. cit.*

[6] Hugh of St. Victor, *Erudit didasc.*, bk. VII. ch. iv. ;
Patrol., clxxvi., col. 814.

RELIGIOUS ART IN FRANCE

How mystical were the thoughts which arose in the minds of the mediæval doctors in the presence of nature. We read how in the refectory of the monastery Adam of St. Victor, holding a nut in his hand, reflects—" What is a nut if not the image of Jesus Christ? The green and fleshy sheath is His flesh, His humanity. The wood of the shell is the wood of the Cross on which that flesh suffered. But the kernel of the nut from which men gain nourishment is His hidden divinity." [1]

Peter of Mora, cardinal and bishop of Capua, contemplates the roses in his garden. Their natural beauty does not move him, for he is intent on thoughts which are unfolding within. " The rose," he says, " is the choir of martyrs, or yet again the choir of virgins. When red it is the blood of those who died for the faith, when white it is spotless purity. It opens among thorns as the martyr grows up in the midst of heretics and persecutors, or as the pure virgin blooms radiant in the midst of iniquity." [2]

Hugh of St. Victor looking at a dove thinks of the Church. " The dove has two wings even as the Christian has two ways of life, the active and the contemplative. The blue feathers of the wings are thoughts of heaven ; the uncertain shades of the body, the changing colours that recall an unquiet sea, symbolise the ocean of human passions in which the Church is sailing. Why are the dove's eyes this beautiful golden colour? Because yellow, the colour of ripe fruit, is the colour too of experience and maturity, and the yellow eyes of the dove are the looks full of wisdom which the Church casts on the future. The dove, moreover, has red feet, for the Church moves through the world with her feet in the blood of the martyrs." [3]

Marbodus, bishop of Rennes, ponders on precious stones and discovers a mystic consonance between their colours and things of the spirit. The beryl shines like sunlit water and warms the hand that holds it. Is this not an image of the Christian life warmed and illuminated to its depths by Christ the sun? The red amethyst seems to send out fire. Here is an image of the martyrs, who as their blood is shed send up ardent prayers for their persecutors. [4]

[1] Adam of St. Victor, *Sequentiæ. Patrol.*, cxcvi., col. 1433.
" Contemplemur adhuc nucem . . .
" Nux est Christus ; cortex nucis
" Circa carnem poena crucis ;
" Testa, corpus osseum,
" Carne tecta Deitas,
" Et Christi suavitas
" Signatur per nucleum.
The same idea had already been elaborated by Augustine.

[2] Petrus of Mora, *Rosa alphabetica*, in the *Spicilegium Solesmense*, III., 489.
[3] Hugh of St. Victor, *De Bestiis et aliis rebus*, bk. I. ch. i., ii., vii., ix., x., *Patrol.*, clxxvii. The *De Bestiis*, though attributed to Hugh of St. Victor, may have been written by Hugh of Fouilloi. See Hauréau., *Œuvres d'Hugues de Saint-Victor*, 1886, p. 169.
[4] Marbodus, *Lapid. pretios. mystica applicat. Patrol.*, clxxi., col. 1771.

OF THE THIRTEENTH CENTURY

The whole world is a symbol. The sun, the stars, the seasons, day and night, all speak in solemn accents. Of what were the Middle Ages thinking in the winter time when the days were shortening sadly and the darkness seemed to be triumphing for ever over the light? They thought of the long centuries of twilight that preceded the coming of Christ, and they understood that in the divine drama both light and darkness have their place. They gave the name of Advent (*Adventus*) to those weeks of December, when by means of the liturgy and lessons from Scripture they expressed the long waiting of the ancient world. It was at the winter solstice, at the time when light begins to reappear and the days to lengthen, that the Son of God was born. Even the round of the year shadows forth man's course upon earth, and recounts the drama of life and death. Spring, which gives new life to the world, is the symbol of baptism which renews the spirit of man at his entrance into life. Summer too is a type, for its burning heat and light are reminders of the light of another world and of the ardent love of the eternal life. Autumn, season of harvest and vintage, is the dread symbol of the last Judgment—that great Day on which men will reap as they have sown. Winter is a shadow of that death which awaits mankind and the universe.[2] Thus the thinker moved in a world of symbols, thronged by forms pregnant with spiritual meaning.

Are these the interpretations of individuals, mystical fancies born of the exaltation of cloistered life, or are we in the presence of an ordered system, an ancient tradition? The answer is found in the most cursory reading of the works of the Fathers and the mediæval doctors. Never was doctrine more closely knit or more universally accepted. It dates back to the beginning of the Church, and is founded on the words of the Bible itself.[3] In the Scriptures, indeed, as interpreted by the Fathers, the material world is a constant image of the spiritual world. In each word of God both the visible and the invisible are contained. The flowers whose scent overpowered the lover in the Song of Songs, the jewels which adorned the breastplate of the high priest, the beasts of the desert which passed before Job are at once realities and symbols. The juniper tree, the terebinth, and the snowy peaks of Lebanon are alike thoughts of God. To interpret the Bible is to apprehend the harmony which God has

[1] This is pointed out by St. Augustine, *Serm. in nat. Dom.*, III. See also Dom Guéranger, *l'Année liturgique, l'Avent.*
[2] Rabanus Maurus, *De Universo*, liv. X. ch. xi.; *Patrol.*, cxi.
[3] In his book on the mediæval conception of the world H. von Eicken fully understood that nature was regarded as a symbol, but he did not see that the whole system was vitally connected with the Bible. See *Geschichte und System der mittelalterlichen Weltanschauung*, Stuttgart, 1887, 8vo, III. ch. vi.

RELIGIOUS ART IN FRANCE

established between the soul and the universe, and the key to the Scriptures is the key to the two worlds.

This mystical interpretation of the Bible begun by the early Fathers was adopted by the doctors and transmitted by one writer to another to the end of the Middle Ages. In the *De formulis spiritalis intelligentiae* of Eucherius, the *De Universo* and the *Allegoriæ in Sacram Scripturam* of Rabanus Maurus,[1] the *De Bestiis* attributed to Hugh of St. Victor, the *Liber in dictionibus dictionum theologicarum* of Alanus de Insulis and in the *Gregorianum* of Garnier of St. Victor, to mention only a few works, this symbolic teaching can be followed step by step through the centuries.[2]

The most curious book of the kind is the collection, made by an unknown writer in the ninth or tenth century, of fragments taken from the Latin Fathers known as the "Key" of Melito. It was attributed to the famous bishop of Sardis, but notwithstanding the evidence brought forward by Dom Pitra the attribution cannot be maintained.[3] Whatever its date, however, the book is of great interest. It is in the form of an encyclopædia of nature, in which man, metals, flowers and animals are studied in turn. Each object is specified with its symbolic meaning, and the interpretation is accompanied by the principal passages in the Bible in which the object is named. In the chapter on plants in this curious volume the pseudo-Melito writes : " Roses signify the blood of the martyrs, and it is in this sense that we must interpret the passage in Ecclesiasticus, '. . . Bud forth as a rose growing by the brook of the field.'[4] Nettles denote the rank growth of evil, as in the verse in Isaiah which says, ' In their palaces shall come up the thorn and the nettle,' or again they symbolise the indulgence of sensual desires, as in another passage in the same prophet, ' I went by the field of the slothful . . . and the face thereof was covered with nettles.'[5] Chaff symbolises sinners. ' They shall be,' says Job, ' as chaff before the wind.' "[6]

The difficulty is—as the author foresaw—that the same object may have

[1] The *De Universo* derived from the *Etymol.* of Isidore of Seville. Rabanus Maurus merely added the mystical sense given to each word.

[2] Dom Pitra has collected a number of proofs in the commentary which accompanies the text of the pseudo-Melito (*Spicil. Solesm.*, II. 4).

[3] The so-called *Clavis* of Melito was published by Dom Pitra in the *Spicil. Solesm.*, Paris, 1855, II. and III. He made an unsuccessful attempt to prove that the work belonged to the second century. In the *Bulletin critique* (1885, p. 47) Rottmanner showed

what the author owed to Augustine. Harnack (*Gesch. der altchristl. Litteratur*, Leipzig, 1893, p. 254) points out that the title of the MS. is by another hand, and has been added too late. The sentence was evidently taken from St. Jerome. "Miletus asianus episcopus hunc librum edidit quem et congruo nomine clavim appellavit."

[4] *Spic. Solesm.*, t. II. p. 414.

[5] *Ibid.*, p. 422.

[6] *Ibid.*, p. 432.

several meanings. The lily, for example, connotes the Saviour or the saints, chastity or the glory of the eternal home according to the context.[1]

There was perhaps no preacher or theologian in the Middle Ages who did not make use of the symbolic method. The imagination of individuals greatly enriched the original theme, as we have seen in the passage on the dove from Hugh of St. Victor, but it was never allowed to wander far from traditional interpretation.[2]

It is evident that the world was to the men of the Middle Ages a book of twofold meaning of which the Bible held the key.

The Bestiaries are certainly the most curious of the symbolic works devoted to nature, for in these extraordinary books paganism and Christianity are inextricably interwoven. Fables of animals collected by Ctesias, Pliny or Aelian are found side by side with mystical commentaries added by the early Christians. The celebrated *Physiologus*, a symbolic Bestiary of which the original text is lost, goes back to primitive Christian days, probably to the second century.[3] Ancient Greek, Latin and Armenian texts show that the *Physiologus* was known through the entire Christian world.[4] Western peoples soon translated it into their own tongues. In the eleventh century it was translated into German, and at the beginning of the twelfth century into French by the Anglo-Norman poet Philippe de Thaon, while a century later a new version was made by Guillaume le Normand.[5] The condemnation pronounced on the Bestiary by Pope Gelasius deterred no one from reading and quoting the *Physiologus*. It carried, moreover, the authority of the Fathers of the Church, for Augustine, Ambrose and Gregory the Great frequently borrowed from it. Preachers like Honorius of Autun, therefore, felt no scruple in drawing symbolic or edifying interpretations from it, while the learned Vincent of Beauvais, Bartolomæus de Glanvilla and Thomas Cantipratanus far from scorning the fables gave them the rank of scientific facts.[6]

In this way the Middle Ages made the old *Physiologus* of the east their own. It mingled with all their conceptions of the world, with their biblical

[1] *Spic. Solesm.*, t. II.. p. 406.

[2] The "Key" of Melito (*Spic. Solesm.*, ii. 484) expressly says that in certain cases the dove signifies the Church ; here the author parts company with the *De Bestiis*.

[3] On this see Dom Pitra, *Proleg. ad Spic. Solesm.*, II. 63 ; Cahier, *Mélanges d'archéolog.*, 1851, II. 85 *seq.*, and *Nouv. Mél. d'arch.*, 1874 (*Curiosités mystérieuses*), p. 106 *seq.* ; Lauchert, *Gesch. des Physiologus*, Strasburg, 1889.

[4] Greek and Armenian texts in Pitra (*Spic. Solesm.*, III.), Latin text in Cahier, *Mél. d'archéol.*, III.

[5] *Le Bestiaire divin* of Guillaume, clerk of Normandy, published by Hippeau (*Mémoires de la Soc. des antiq. de Normandie*, ser. II., vol. viii. 317 *seq.*), and more recently by Dr. Robert, Leipzig, 1890, 8vo.

[6] On the *De proprietatibus rerum* of Bartolomæus and the *De natura rerum* of Thomas Cantipratanus see *Hist. littér. de la France*, xxx.

exegesis, even with their dreams of love.[1] It became in fact part of the very substance of their life.

The following example will give some idea of the composite character of the Bestiaries. The ancients believed that the elephant was the least amatory of beasts and could be induced to mate only after eating of the mandrake. It was said that at sunrise the female herself gathered the plant and gave it to the male. This story, which had beguiled pagan curiosity, is taken over by the Christian author and its hidden meaning disclosed. The elephants are symbols of Adam and Eve in the earthly paradise, and the mandrake is the fruit which the woman gave to the man. After eating it Adam, who till then was a stranger to desires of the flesh, knew Eve and became the father of Cain.[2] Thus is made plain the divine intention that the lesson of the Fall should be written for generations of men to read even in the habits of the animal world. In the Bestiaries, as we see, ancient science of the most suspicious character is found side by side with doubtful Christian exegesis.

The author of the Bestiary, whoever he may have been, must have drawn largely on his imagination. The traditional symbolism founded on the Bible gave him little help, for the animals of the *Physiologus* are fabulous monsters like the griffin, the phœnix and the unicorn, or animals of India unknown to the Old Testament, and he had of necessity to invent most of the moral interpretations accompanying his descriptions of animals. His symbolism was accounted none the less excellent, and was accepted without criticism through the Middle Ages. It occurred to no one, moreover, to verify the accuracy of stories in the Bestiary. In the Middle Ages the idea of a thing which a man framed for himself was always more real to him than the actual thing itself, and we see why these mystical centuries had no conception of what men now call science. The study of things for their own sake held no meaning for the thoughtful man. How could it be otherwise when the universe was conceived as an utterance of the Word of which every created thing was a single word ? The task of the student of nature was to discern the eternal truth that God would have each thing to express, and to find in every creature an adumbration of the great drama of the Fall and the Redemption. Even Roger Bacon, the most scientific spirit of the thirteenth century, after describing the seven coverings of the eye, concluded that by such means God had willed to express in our bodies an image of the seven Gifts of the Spirit.

[1] *Le Bestiaire d'amour*, Richard de Fournival, published by Hippeau, Paris, 1860.

[2] *Spic. Solesm.*, φυσιολόγος, περὶ ζώου ἐλέφαντος, III. 364.

II

We now turn to the discussion as to how far art conformed to this philosophy of the world, and in what measure the animal forms which decorate the cathedrals were intended as symbols. It is a delicate question, and one which archæologists have not always succeeded in treating with due restraint of the imagination.

There are few cases in which it is permissible to assign symbolic meaning to animal forms, but they are of such a kind that through literary references one may reach sure conclusions.

The four beasts surrounding the figure of Christ in Glory, found in the porch of so many churches, form the first class of representations in which the symbolic meaning cannot be mistaken. The motif of the four creatures —the man,[1] the eagle, the lion and the ox—so frequent in the Romanesque period, became more rare in the thirteenth century though not entirely discarded. The four creatures are seen, for example, on the Porte du Jugement of Notre Dame at Paris. It is true they no longer have the breadth, the heraldic boldness which is so striking at Moissac, and they no longer fill the tympanum but hide humbly in the lower portion of the doorway.

From earliest Christian times the man, the eagle, the lion and the ox, first seen in Ezekiel's vision by the river Chebar and later by St. John round the throne of God, were accepted symbols of the four evangelists. In the primitive Church, on the Wednesday of the fourth week in Lent, the significance of the four mystic creatures was explained to the catechumen who was being prepared for baptism. He was taught how the man symbolised St. Matthew, the eagle St. John, the lion St. Mark, the ox St. Luke, and the reasons were given him.[2] In the course of the centuries other interpretations were added to this one, and in the twelfth century it was generally admitted that the four creatures had three meanings, and that they symbolised at once the Saviour, the evangelists, and the virtues of the elect.

It would be far from unprofitable to penetrate into this world of ideas so curiously compounded of theology and the science of the Bestiaries,

[1] The first is not an angel, as is often stated, but a man. It will be seen that he expressly symbolises human nature.

[2] Dom Guéranger, *Année liturgique, Carême.* See the whole passage taken from the *Sacramentarium* of Pope Gelasius. In it none of the subtle interpretations familiar to the twelfth and thirteenth centuries are found.

RELIGIOUS ART IN FRANCE

indeed there could be no better introduction to the symbolism of the Middle Ages. Passages which would furnish the necessary information could be found without difficulty in the writings of the doctors of the day,[1] but appeal can be made to still weightier evidence. In the twelfth century it was the custom in certain churches in France on the festival of St. Luke the Evangelist, to read a curious commentary in which the significance of the four beasts was expounded in elaborate detail. The passage is preserved in the manuscripts of several lectionaries,[2] though in none is its origin given. It has been our good fortune to discover it in a commentary on Ezekiel by Rabanus Maurus.[3] In adopting his interpretation the Church gave it the sanction of her authority.

The four creatures, according to this lectionary, signify in the first place the four evangelists. The emblem of St. Matthew is the man, because his gospel begins with the genealogical table of the ancestors of Jesus according to the flesh. The lion designates St. Mark, for in the opening verses of his gospel he speaks of the voice crying in the wilderness. The ox—the sacrificial animal—symbolises St. Luke, whose gospel opens with the sacrifice offered by Zacharias. The eagle—an echo of the natural history of the Bestiaries[4]—who alone of created things was reputed to gaze straight into the light of the sun, is the emblem of St. John, who from the first transports men to the very heart of divinity. Again, these same creatures are symbols of Christ, for in them may be seen four great mysteries in the life of the Saviour. The man recalls the Incarnation, and reminds men that the Son of God became man. The ox, victim of the Old Law, calls to remembrance the Passion—the Redeemer's sacrifice of His life for mankind. The lion, which in the fabled science of the Bestiaries sleeps with open eyes,[5] is the symbol of the Resurrection, for therein, says the lectionary, is a figure of Jesus in the tomb. " For the Redeemer in virtue of His humanity appeared to sink into the sleep of death, but in virtue of His divinity He was living and watching."[6] Lastly, the eagle is a figure of the Ascension. Christ rose to Heaven as the eagle rises to the clouds. Summing up its teaching in a precise

[1] Mme. F. d'Ayzac gives many such passages in her excellent work, *Les quatre Animaux mystiques*, sequel to *Statues du porche septentrionale de Chartres*, Paris, 1849, 8vo. See also Cahier, *Caractéristiques des Saints*, under " Evangélistes " ; and Darcel, *Ann. Archéol.*," XVII. 139.

[2] See for example, Arsenal, MSS. 162, f. 222 *seq.*, *Lectionnaire* of Crépy.

[3] Rabanus Maurus, *In Ezech.*, I., *Patrol.*, cx., col. 515.

[4] " Quand il (l'aigle) regarde le soleil, il ne flecist mie ses ex par la force del rai." *Best.* of Pierre le Picard. Arsenal, MSS. No. 3516, f. 198 *seq.*

[5] φυσιολόγος, περὶ τοῦ λέοντος. *Spic. Solesm.*, III. 338.

[6] Leo etiam apertis oculis dormire perhibetur ; quia in ipsa morte, in qua ex humanitate redemptor noster dormire potuit, ex divinitate sua immortalis permanendo vigilavit. *Lection.*, in the Arsenal. Lectio II.

36

formula, the lectionary lays it down that Christ was man in His birth, ox in His death, lion in His Resurrection, eagle in His Ascension.[1]

But the four creatures have yet a third meaning, and express the virtues necessary for salvation. Each Christian on his way to divine perfection must be at once man, ox, lion and eagle. He must be man because man is a reasonable animal, and he who treads the path of reason alone deserves that name. He must be ox because the ox is the sacrificial victim, and the true Christian by renouncing worldly pleasures sacrifices himself. He must be lion because the lion is the most courageous of beasts, and the good man having renounced all worldly things fears nothing, for of him it is written, "The righteous are bold as a lion." And he must be eagle because the eagle flies in the heights looking straight into the sun, type of the Christian who with direct gaze contemplates the things of eternity.

This is the Church's teaching on the four creatures, but only one of these interpretations, that likening the apocalyptic beasts to the evangelists, survived mediæval times. The others shared the fate of all the old mystical theology, and at the Reformation fell into oblivion. But Protestants themselves remained faithful to tradition on the first point, and in the seventeenth century Rembrandt painted his sublime St. Matthew of the Louvre listening with all his soul to the words of an angel who, deep in shadow, whispers to him of eternal things.

It would be impossible to doubt that animals at times played a symbolic part in mediæval art, for in the examples taken we have had certain proof of their accepted interpretation. It may be possible to arrive at something of the same degree of certainty in other cases. There is in the cathedral of Lyons a famous window which early attracted the notice of archæologists. Father Cahier who reproduced [2] and attempted to explain it, failed to recognise the book to which it owed its inspiration. In their recent monograph on the cathedral of Lyons MM. Guigue and Bégule were no more successful. This window holds so important a place in the subject of our

[1] The miniaturists gave artistic form to this symbolism. Near to the man (St. Matthew) they sometimes represented the Nativity, near to the ox the Crucifixion, near to the lion the Resurrection, and near to the eagle the Ascension. Examples of this practice are known from the tenth century (*Evangeliarium* of the Emperor Otto *Bull. Monum.*, 1877, p. 220), down to the fourteenth (Bibl. Mazarine, MSS. 167, f. 1, *Postilla* of Nicolas de Lyra).

[2] *Vitraux de Bourges*, plan VIII. The valuable drawing by Father Martin which we reproduce (Fig. 11), shows the window as it was before the restoration by Emile Thibaud, the glass-painter of Clermont-Ferrand, who in 1842 changed the position of the central medallions so that they no longer accurately correspond to the small medallions in the border. On this restoration see the interesting article by M. G. Mougeot in the *Revue d'histoire de Lyon*, I. 1902.

study, and is so closely related to a great theological work of the twelfth century that it calls for detailed description.

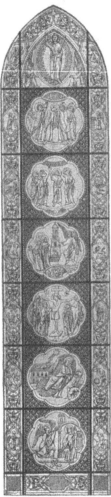

This mystical work was conceived in the following way (Fig. 11). Beginning at the bottom (windows should almost invariably be read in that order) there is first a medallion devoted to the Annunciation, while two smaller medallions in the border—evidently closely related to the principal subject—present the prophet Isaiah with a scroll inscribed " Ecce virgo (concipi)et," and a young girl seated on a unicorn holding a flower (Fig. 12). The Nativity is the subject of the second medallion, and the burning bush and Gideon's fleece fill the cartouches of the border. The Crucifixion fills the third medallion, and is accompanied by the sacrifice of Isaac and by the brazen serpent. The fourth medallion has the Resurrection as subject, together with Jonah thrown up by the whale and a lion with cubs (Fig. 13). The remaining medallions are devoted to the Ascension—Christ ascends to Heaven while the Virgin and the apostles gaze after Him. In the cartouches of the border are seen a bird (named Kladrius in the inscription) by the bedside of a sick man (Fig. 14), an eagle with eaglets (Fig. 15), and finally two angels.

Father Cahier has given an admirable explanation of the window, pointing out that each of the scenes in the small cartouches were types or symbols of the New Testament events which filled the large medallions. For example, the sacrifice of Isaac and the brazen serpent lifted up by Moses in the wilderness are types of the sacrifice of Christ, and in the design have a place near to the Crucifixion.[1] It is also re-

FIG. 11.—SYMBOLIC WIN-
DOW AT LYONS
(*From Cahier and Martin*)

marked very rightly that several of the subjects were taken from the Bestiaries, and that the artist had tried to express the chief mysteries of the Faith through animal forms ;—the eagle was placed near the Ascension, the lion near the Resurrection, and so

[1] The meaning of these figures is explained at length in the chapter on the Old Testament.

on. This is all quite correct, but Father Cahier did not discover the source of the symbolism. For this great scheme was not the vision of some mystical artist evoked by the reading of the bestiaries and theological commentaries, but was drawn in its entirety from one of the most famous books of the Middle Ages—the *Speculum Ecclesiæ* of Honorius of Autun. It is in fact a literal translation into art of that work, and in it may be found the key to the precise meaning of each of the mystic creatures in the window at Lyons.

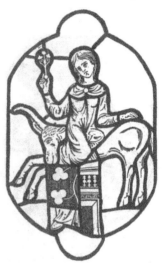

The *Speculum Ecclesiæ* is a collection of sermons for the principal festivals of the year. To engrave it the more easily on the memory of preachers Honorius turned his Latin into a kind of rude verse making each line rhyme with the last. There are in the *Speculum Ecclesiæ* real theological *laisses* comparable to the epic couplets of the chansons-de-geste. Possibly this monotonous music contributed to the success of the book, for though written at the beginning of the twelfth century [1] it was still much read in the thirteenth.[2] Few works better express the habit of mind of a given period. It is, as its title says, the mirror of the Church of the twelfth century. In it the mystical method was chosen in preference to

Fig. 12.—THE MAIDEN AND THE UNICORN (Lyons)

(After a drawing by L. Bégule)

any other, and through the use of ingenious symbolism the whole world was made to bear witness to the truths of the Faith. Honorius of Autun invariably proceeded in the same way. He began his sermons written for the chief festivals by telling of the great event in the Saviour's life which the Church that day commemorated. He next found Old Testament events which might be compared with it as types, and finally he looked for symbols in Nature herself and endeavoured to discern an image of the life and death of Christ even in the habits of animals. This is the method followed by the glass painter of Lyons who, aided by some scholar, took his scheme from certain

[1] Honorius wrote between 1090 and 1120 : B. Pez. *Thesaurus anecdot. noviss. Dissertat.*, t. II., p. 4, Springer in his work, *Ueber die Quellen der Kunstvorstellungen im Mittelalter (Berichte über die Verhandl. der K. Sächs. Gesell. der Wissensch. zu Leipzig. Ph.* hist., cl. xxxi., 1–40, 1879), foresaw the importance of the *Speculum Ecclesiæ* in the history of art.

[2] We shall show later that the *Speculum Ecclesiæ* inspired the decoration of a whole porch at Laon of the early years of the thirteenth century.

sermons of Honorius. In illustration of the mysteries of the Annunciation and the Nativity he chose four symbolic examples from two sermons devoted to those festivals:[1] Isaiah's prophecy of the Virgin who should be with child, the bush which burned yet was not consumed, Gideon's fleece moistened by the dew, a figure of the Virgin Birth,[2] and the fabled history of the unicorn. Honorius saw in the unicorn a symbol of the Incar-

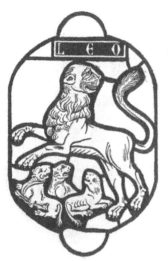

nation. "The unicorn," he says, briefly summarising the Bestiaries, "is a beast so savage that it can only be caught by the help of a young maiden. When he sees her the creature comes and lies down in her lap, and yields to capture. The unicorn is Christ, and the horn in the midst of its forehead is a symbol of the invincible might of the Son of God. He took refuge with a Virgin and was taken by the huntsmen, that is to say, He took on human form in the womb of Mary and surrendered willingly to those who sought him." At Lyons in sign of victory the young girl is mounted on the creature she has just captured, and holds in her hand a flower, emblematic of purity.[3]

FIG. 13.—THE LION AND HIS CUBS
(Lyons)
(*After a drawing by L. Bégule*)

The third medallion, devoted to the Crucifixion, has for commentary two symbolic scenes —the sacrifice of Isaac and the lifting up of the brazen serpent in the wilderness—two of the very types which among others Honorius expounds to his hearers in the two sermons on the Passion.[4]

The illustrations which flank the medallion of the Resurrection are Jonah's whale—an established type of the tomb in which the Saviour passed three days, and a lion with frisking cubs (Fig. 13). Honorius, who also makes use of the two types, explains the second in detail in his sermon for Easter Day.[5] "It is said," (he is quoting the Bestiaries), "that the lioness gives birth to lifeless cubs, but that after three days the roaring

[1] *Specul. Ecclesiæ, Patrol.*, CLXXII., col. 819 and col. 904 (*Sermo de Nativit. et de Annuntiat.*).

[2] We shall return to these figures when we examine the porch at Laon which was drawn from Honorius's sermon on the Annunciation.

[3] This medallion has been restored; possibly in the original the young girl was not seated on the unicorn.

[4] *Spec. Eccles. (Domin. de passione Dom.)*, col. 911, and (*Domin. in Palmis*), col. 922. The meaning of these types will be explained later (Old Testament).

[5] The story of Jonah is found in the *In cœna Dom.*, col. 923; the story of the lion in the sermon *De Paschali die*, col. 935.

of the lion brings them to life.[1] Even so the Saviour lay in the tomb as dead, but on the third day He rose awakened by the voice of His Father." He adds that the phœnix and the pelican also typify the Resurrection, "for from the beginning it was God's will to express through these birds that which should one day come to pass." For want of space the artist at Lyons was unable to introduce the phœnix and the pelican into his window, but they are found elsewhere and in Lyons itself.

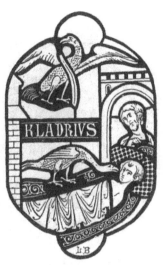

Finally the medallion of the Ascension is devoted to the legends of the eagle and its young and of the bird called *Kladrius* (a corruption of *charadrius*) (Figs. 14 and 15). These two legends are the only ones used in the sermon written by Honorius for Ascension Day.[2] He interprets them in this way : "The eagle is of all creatures that which flies highest, and alone dares to gaze straight into the sun. When teaching his young ones to fly he first flies above them, then takes them up on his widely spread wings. Even so did Christ ascend into Heaven higher up than all the saints to his place on the right hand of the Father. He spreads over us the wings of His Cross, and carries us on His shoulders like lost sheep."

FIG. 14.—THE CHARADRIUS (Lyons)
(After a drawing by L. Bégule)

To turn to the curious legend of the *charadrius*. "There is," to quote Honorius, "a bird named *charadrius* to whom it is given to know whether or not the sick will escape death. Placed near a sick man, if the sickness is unto death the bird turns away its head ; if the man will live it fixes its eyes on him and with open beak absorbs the illness. Then it flies away into the rays of the sun, the evil absorbed streams out of it like a sweat and the sick man recovers. The white *charadrius* is Christ born of a Virgin. He drew near to sick humanity when sent by His Father to save the world. Turning His face from the Jews and leaving them to die, He looked towards us and bare our sickness on the cross, and a sweat of blood

[1] Another explanation is given in some Bestiaries where it is said that the lion raises the cubs by breathing in their mouths. *Spicil. Solesm.*, I. p. 338 ; and Cahier, *Mélang. archéol.*, II. 107. The story comes from Pliny, *Hist. Nat.*, VIII. 17.

[2] *Spec. Eccles. In ascens. Dom.*, col. 958.

RELIGIOUS ART IN FRANCE

streamed from Him. Then returning to His Father with our flesh He brought salvation for all."[1]

After these comparisons it seems impossible to doubt that the Lyons window was inspired by the *Speculum Ecclesiæ*.

Another symbolic work of a similar character has to our thinking the same origin, the frieze of animals carved about the beginning of the four-teenth century on the cathedral tower at Strasburg. A description of it was published by Father Cahier, based merely on Father Martin's rather slight sketches,[2] but a cast has now been taken and may be studied at leisure in the cathedral museum at Strasburg. With the knowledge gained by the study of the Lyons window we may conjecture the intentions of the Strasburg artist from a mere enumeration of the subjects—the sacrifice of Isaac, the eagle and its young, the unicorn taking refuge with a young girl, the lion reviving his cubs, Jonah thrown up by the whale, the brazen serpent, the pelican feeding her young with her life blood, the phœnix in the midst of flames. Are not these so many symbols of the Nativity, Passion, Resurrection and Ascension—the very examples taken by Honorius in his sermons?

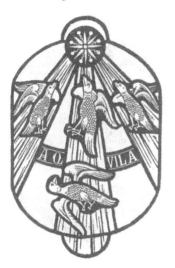

FIG. 15.—EAGLE AND EAGLETS
(Lyons)
(After a drawing by L. Bégule)

It is true the Strasburg artist has not, as at Lyons, represented the historical events typified but his intention is unmistakable. Not content to commemorate the Resurrection—as at Lyons —by the representation of the lion and his cubs, he also borrowed the legends of the phœnix and the pelican. The legends have it that the phœnix burns itself on a pyre and on the third day rises anew from the ashes, and that the pelican, after having killed her young, revives them at the end of three days by opening her breast and sprinkling them with blood, even as on the third day God raised His Son.[3]

[1] Honorius borrowed the story of the charadrius from the Bestiaries. See *Spic. Solesm.*, φυσιολόγος περὶ χαραδριοῦ, v., 342. The legend comes from Ælian, *De anim.*, XVII. 13.

[2] Cahier, *Nouv. mélanges d'arch.* (*Curiosités mystér.*), p. 153. See also *Revue archéolog.*, 1853.

[3] *Spec. Eccles. De Paschali Die*, col. 936. We do not refer to the other part of the frieze at Strasburg, which is made up of purely imaginative scenes (battles of monsters) or of popular scenes (such as men and women tearing their hair, chess-players exchanging playful blows, &c.).

I also find the influence of the *Speculum Ecclesiæ* in four symbolic windows at Bourges, Chartres, Le Mans, and Tours[1] respectively. In these windows, which we shall later have occasion to study in detail, a learned parallel is drawn between the chief events in the life of Christ and Old Testament events which prefigured them. Near to the Resurrection, and side by side with symbolic scenes taken from the Bible, are seen the lion giving life to his cubs and the pelican opening her breast to give life to her young.[2] In the thirteenth century, as we see, it was generally considered on the authority of Honorius that the lion and the pelican had the same title to stand as symbols of the Resurrection as had, for example, the story of Jonah. We are told that the Bestiaries taught the same doctrine. That is true, but Honorius was none the less the first commentator on the Gospel who had recourse both to selected events in the Old Testament and to facts borrowed from current zoology, and apparently in his eyes these two classes of symbols were of equal value. In his hands this kind of demonstration appears as a coherent doctrine which impresses itself alike on the memory and the reason. Preachers nurtured on his book popularised the legends of the lion, the pelican, or the unicorn—indeed it was almost entirely through Honorius that the teaching of the Bestiaries reached the mediæval clergy. It is in any case noteworthy that the symbolic animals painted or carved in the churches are precisely those—and only those—mentioned by Honorius. In the porch at Lyons, for example, there are numberless small medallions of the beginning of the fourteenth century which, among purely imaginary scenes and monsters born of the craftsman's fancy, show animals obviously taken from the Bestiaries. Now the animals presented are the pelican,[3] the unicorn[4] and the phœnix, with the addition of the sirens[5] which appear as the symbol, or rather the very voice, of worldly pleasure in Honorius's sermon for Septuagesima Sunday.[6] On the trumeau of the west porch at Noyons may still be seen, though much mutilated, the pelican, the phœnix and the fragment of an animal, apparently a lion, bending over his cubs.

To take yet another typical example of the influence exercised on art by Honorius of Autun's book. There is in the *Speculum Ecclesiæ* a sermon for Palm Sunday on the verse taken from Psalm xc., "Thou shalt walk

[1] Reproduced by Cahier, *Vitraux de Bourges*, pl. I. and plan IV.
[2] At Chartres the lions have disappeared ; at Tours and Le Mans their position has been changed by restoration.
[3] Reproduced in Guigue and Bégule, *loc. cit.*, pl. II. ch. 2.
[4] *Ibid.*, pl. B., p. 202.
[5] *Ibid.*, series II., pl. IV., ch. iv., and pl. I., ch. i.
[6] *Spec. Eccles. Dominic. in Septuag.*, cols. 855, 856.

upon the adder and the basilisk, thou shalt trample underfoot the lion and the dragon."[1] In accordance with Catholic tradition Honorius applies this text to Christ triumphant over His enemies, and explains in detail the meaning of each creature mentioned by the psalmist. The lion is Antichrist, the dragon is the devil, the basilisk is death, and the adder is sin. He enlarges especially on the adder and its symbolism in these words, "The adder is a kind of dragon which may be charmed by songs ; but it is ever on the watch for charmers, and when it hears them lays one ear close to the ground and stops up the other with its tail, so that it can hear nothing and is safe against incantations. The adder is the image of the sinner who closes his ears to the words of life." On the trumeau of the central doorway of Amiens cathedral is the wonderful statue called by the people " le beau Dieu " (Fig. 16), beneath whose feet are the lion and the dragon. A little lower, to the right and left of the bracket, are carvings of two curious animals (Figs. 17, 18). One, a cock with a serpent's tail, is easily recognised as the basilisk, half bird and half reptile according to the natural history of the day.[2] The other is a kind of dragon which with one ear on the ground, stops the other with the tip of its tail. This is evidently the adder in the words quoted above. The statue at Amiens, commonly called the teaching Christ, is also the victorious Christ who through His words triumphs over the devil, sin and death. It is a beautiful idea magnificently realised, and it should not be forgotten that this fine work owes some of its inspiration to the *Speculum Ecclesiæ*.[3]

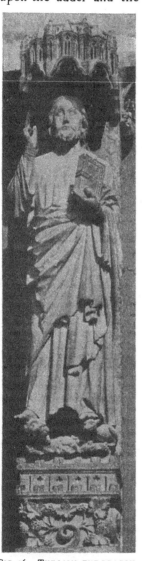

FIG. 16.—THE LION, THE DRAGON, THE ADDER AND THE BASILISK BENEATH THE FEET OF CHRIST (Amiens, central doorway)

[1] *Spec. Eccles. In Dominic. Palm.*, col. 913.

[2] Albertus Magnus, *De animal.*, xxiii. 24 (complete works, vol. VI.). " Basilicus . . . sicut gallus, sed caudam longam serpentis habet."

[3] The influence of Honorius is here unquestionable, for the adder is seen stopping up its ear with its tail. But I must add that the figure of the Christ treading the lion and dragon under foot, while blessing with the right hand and holding a book in the left, dates back to

OF THE THIRTEENTH CENTURY

To sum up, we are of opinion that the Bestiaries of which we hear so much from the archæologists had no real influence on art until their substance passed into Honorius of Autun's book, and from that book into sermons. I have searched in vain for representations of the hedgehog, beaver, peacock, tiger and other animals which figure in the Bestiaries but which are not mentioned by Honorius. It was seldom that artists drew their inspiration direct from the Bestiaries. As a matter of fact, to the rule I have just laid down I know of but two exceptions which cannot be called in question. One is an owl surrounded by birds, on a capital in the

FIG. 17.—THE BASILISK
(Amiens)

FIG. 18.—THE ADDER
(Amiens)

cathedral of Le Mans.[1] There is no doubt as to the meaning of this. The Bestiaries teach that the owl has eyes of a kind which cannot see clearly in the daytime, and that when he ventures into the light the birds chase him. The owl became a type of the Jews, who in their blindness shut their eyes to the Sun and were an object of derision to Christians.[2] It is evident that the subject of this capital at Le Mans was taken direct from the Bestiaries, for the symbolism of the owl is not found in the *Speculum Ecclesiæ*.

I discovered another trace of legendary natural history of which no mention is made by Honorius, on a capital from Troyes now in the

primitive Christian art, and is first found in the Christian catacombs at Alexandria. The Alexandrian ivories reproduced this figure very exactly, as is shown by the ivory in the Vatican. It was through the ivories that this mode of representing Christ penetrated the west. It is probable that the artist at Amiens was inspired by one of them, but that the necessity of representing the adder and the basilisk was explained to him by some theologian who was

acquainted with Honorius's work. The two animals are not seen in this connection in the Alexandrian ivories. I have spoken of this at greater length in a memoir presented to the Congrès archéologique at Cairo, in 1909.

[1] Published by Cahier, *Nouv. mél. d'archéol.*, 1874, p. 141.

[2] On the owl, see *Best. latin*, published by Cahier, *Mél. archéol.*, II. 170.

45

RELIGIOUS ART IN FRANCE

Louvre.[1] A number of birds are perched on a tree while to right and left two dragons watch them, apparently awaiting the moment for seizure. The tree is the " peridexion " spoken of in the Bestiary,[2] the sweetness of whose fruit attracts the doves to come and settle in its branches. But a great danger threatens the birds if they are imprudent enough to leave the tree, for a dragon lies in wait to devour them. Happily this dragon fears the shadow of the peridexion and when it falls on the one side he is compelled to go to the other,[3] and the birds knowing the position of their enemy can avoid him. The peridexion is the image of the tree of life from whose shadow the devil flees, and the birds are souls who find nourishment in the fruit of truth.[4]

We have here two examples of the direct influence exercised by the Bestiaries on art. It would certainly be possible to find others, but I do not imagine they could be numerous. The animals chiefly used in the art of the thirteenth century were the lion, the eagle, the phœnix, the pelican and the unicorn—popular figures of Christ—which were known to most men through the work of Honorius of Autun and the sermons of the clergy.

III

The animals which we have so far studied have their place in the churches by virtue of their symbolism. There is no doubt as to their meaning, and moreover light is constantly thrown on them by reference to contemporary literature. But are we to look for symbolism in the rich fauna and flora of Reims, Amiens, Rouen, Paris and in the mysterious world of gargoyles, and if so in what book is enlightenment to be found ?

We must frankly confess that no help is to be found in books for literature and art are no longer concurrent. No certain conclusions can be reached by comparing them one with the other, nothing comparable to the precise results obtained above.

Ingenious archæologists have, it is true, claimed to leave nothing in the cathedral unexplained. According to them the tiniest flower or smallest grinning monster has a meaning which the mediæval theologians can reveal to us. " In this magnificent church," says one of them, " no detail, neither

[1] Mediæval sculpture, No. 74 (capital from St. Urbain at Troyes).

[2] *Spic. Solesm.*, φυσιολόγος, περὶ δένδρου περιδεξίου, p. 356.

[3] No doubt it is for this reason that there are two dragons on the capital.

[4] Perhaps the large capital at Reims (see the cast in the Trocadéro) which shows dragons and birds among branches has this meaning, but the probability is lessened by the presence of a lion and a goat.

sculptured head nor leaf on capital, but reflects a thought, speaks a language understood by all men."[1]

The Abbé Auber was one of the first and most notable champions of this symbolic school. At Tours at the congress of 1847 he expounded the doctrine[2] which he endeavoured to apply in his *Histoire de la cathédrale de Poitiers* and elaborated in his obscure *Histoire du symbolisme*.[3] In this last work he maintained, amongst other paradoxes, that the carved brackets ornamented with heads of men and animals so often found round mediæval churches contain profound moral teaching. "Those strange visitants are there," he says, "like so many sentinels to proclaim a lesson in virtue to the passer-by."[4] As a matter of fact the Abbé Auber established nothing. Nothing more important than arbitrary statements and forced comparisons between monument and text are found in his book.

Mme. Félicie d'Ayzac was more skilful, and in her *Mémoire sur trente-deux statues symboliques observées dans les parties hautes des tourelles de Saint-Denis*,[5] showed marked ability in the use of literary references. The statues of St. Denis are hybrid monsters which she reduced to their component parts—lion, he-goat, she-goat and horse—then armed with the mystical dictionary of Eucherius or Rabanus Maurus she disclosed their moral significance. Each of these monsters became a minute psychological study, setting forth some state of the soul, and precisely illustrating the combination of passions which may co-exist in a single consciousness.

Madame d'Ayzac believed she had discovered a system and created the science of symbolism. In reality she had demonstrated one thing only—that the old craftsmen were never so subtle as their modern interpreters. What likelihood is there that they would have attempted to express so many and such subtle meanings through figures which are invisible from below except with good glasses?

Nourished as she was on the theological literature of the twelfth century Mme. Félicie d'Ayzac throughout her life looked for the most complex symbolism in the simplest works of art. She contributed a number of ingenious but sterile articles to the *Revue de l'art chrétien*,[6] and died

[1] *Rev. de l'art chrét.*, x. 133 (article by Abbé Auber).

[2] *Congrès scientifiques de France*, 15th session. Tours, 1847, vols. i. 102, and ii. 85.

[3] *Histoire de la cathédrale de Poitiers*, Poitiers, 1849, 8vo; and *Histoire et théorie du symbolisme religieux*, Paris, 1871, 3 vols. 8vo.

[4] *Hist. du symbol.*, III. 127.

[5] Published in Daly's *Revue d'architecture*, VII. p. 6 seq.

[6] Only two of her memoirs will live, *les Statues du porche septentrionale de Chartres*, and *l'Étude sur les quatre animaux mystiques*.

without having finished the *Traité de symbolique* on which she had been engaged for so many years.[1]

Father Cahier, too, who ordinarily applied a rigorously critical mind to archæological study, was unable to resist the temptation to explain the inexplicable. In a volume of his *Nouveaux mélanges d'archéologie* devoted to *Curiosités mystérieuses* he attempted, with the help of " Bestiaries " or of theological passages, to interpret works which are simply due to artistic invention. And the Comte de Bastard fell into the same snare when he wrote his *Études de symbolique chrétienne.*[2]

Thus we see how the most learned and intelligent archæologists failed to escape the mania for symbolism. As to those adventurous spirits who conceived of archæology as a work of the imagination, one can only say that by their articles and memoirs they contributed to the discredit of the study.[3] Didron and De Caumont had made of it an exact science, they turned it into a romance.

In their point of departure, however, they were right ; they perceived that for the great minds of the Middle Ages the world was a symbol. But they were mistaken in their belief that a symbolic meaning was concealed in even the least important work of art. The examples given in the last chapter show that the symbolism was often there, and that the artists did accept and follow the instructions given them. But for the most part they were content to be craftsmen who delighted in nature for its own sake, sometimes lovingly copying the living forms, sometimes playing with them, combining and contorting them as they were led by their own caprice.

It is surprising that the famous passage from St. Bernard on the decoration of the Cluniac churches did not give pause to these over-subtle interpreters of mediæval art.

As he walked in the magnificent cloisters of his order St. Bernard also had reflected on the beasts and monsters carved on the capitals, and like us had asked himself what they might mean. " What are these fantastic monsters doing in the cloisters," he said, " under the very eyes of the brothers as they read ? . . . What is the meaning of these unclean monkeys,

[1] Part of this unfinished work may be seen in the *Revue de l'art chrétien*, 1886, p. 13 *seq.* " De la Zoologie composite."

[2] Comte de Bastard, *Études de symbolique chrétienne* (Paris, Imprim. Imp., 1861, 8vo) ; also in the *Bulletin du comité de la langue, de l'histoire et des arts de la France* (arcl æol. section), IV. 1861.

[3] See, for example, an article on the sculptured flora of the cloister at Moissac in the *Revue de l'art*

chrétien (1876, xix), in which every flower is supposed to represent some virtue or thought. A capital dedicated to SS. James and John is decorated with flowers with five lobes, and the author wonders if these are not the five halting places through which each brother passed. In other countries almost as fanciful a method of interpretation is found. See Menzel, *Christliche Symbolik*, Regensburg, 1854, 2 vols., 8vo.

these savage lions, and monstrous centaurs? To what purpose are here placed these creatures, half-beast, half-man, or these spotted tigers? I see several bodies with one head and several heads with one body. Here is a quadruped with a serpent's head, there a fish with a quadruped's head, there again an animal half-horse, half-goat. . . . Surely if we do not blush for such absurdities we should at least regret what we have spent on them!"[1]

What becomes of Madame d'Ayzac's detailed analyses? It seems that Bernard had less penetration than our ingenious contemporary, for he failed to discern in these hybrid forms such a subtle combination of passions. Here the great mystic, the interpreter of the Song of Songs, the preacher who spoke only in symbols, confessed that he did not understand the fantastic creations of his own day. And moreover he declared them to be not only unintelligible but dangerous, since they attract the soul to themselves and "hinder its meditation on the will of God." Such testimony settles the question. It is evident that the fauna and flora of mediæval art, natural or fantastic, has in most cases a value that is purely decorative.

And how could it be otherwise? In St. Bernard's day—the zenith of the Romanesque epoch—the animals and flowers decorating the cloisters and churches were for the most part copied from classical, byzantine and oriental originals of which the meaning was no longer understood. Decorative art of the Middle Ages began with imitation, and these so-called symbols were often carved from the design of some Persian fabric or Arabian carpet.

As one studies carefully the decorative art of the eleventh and twelfth centuries the manifold elements which compose it gradually emerge, and one begins to understand its composite and derivative character. On Romanesque capitals, for example, two lions are frequently seen symmetrically arranged on either side of a tree or flower. Do the books of the eleventh century theologians furnish an explanation as the Abbé Auber believed? Time spent in such a search would be lost, for those two lions as M. Lenormant has shown, were copied from a fabric woven in Constantinople after an old Persian pattern. They are the two beasts who guard the "hom," the sacred tree of Iran.[2] The Byzantine weavers

[1] *Apologia ad Guilh. Sancti Theodorici abbat.*, ch. xi. *Patrol.*, clxxxii., col. 916.

[2] M. Lenormant traced the origin of this design in an article in *Mélanges d'archéologie* (Martin and Cahier), series i. Springer in his *Ikonogr. Studien* also showed that designs on fabrics were often used as patterns by sculptors; see *Mittheil. der K. K.* *Central commission.* Vienna, 1860, vol. v. p. 66 *seq.* The influence of oriental patterns on mediæval art have been more recently examined by Courajod in *Leçons professées à l'école du Louvre*, I. p. 241, and M. Marquet de Vasselot in *l'Hist. de l'art*, published under the direction of M. André Michel, I. pp. 395 and 882.

no longer understood their meaning, and saw in them simply a pleasing design ; while the twelfth century craftsmen copying the Byzantine carpets brought to France by Venetian merchants, had no thought of any possible significance in their pattern.

Again we sometimes find capitals decorated with a griffin drinking out of a cup. One might easily conclude that this was some eucharistic symbol, for the twofold nature of the griffin—both lion and eagle—might well hide some mystic allusion to the Saviour. It is not so, however, for the griffin and the cup was an ancient decorative motif dear to all Germanic peoples. It is used on a number of brooches and buckles found chiefly in Burgundian tombs.[1] Pieces of this barbaric jewellery preserved to the tenth or eleventh century, or possibly capitals carved after them as early as the sixth or seventh centuries, served as models for Romanesque art.

Elsewhere one finds the embrasure of a door covered with figures of birds, monsters and men, who pursue, attack and devour one another.[2] Does the artist here express the truth that conflict is the law of the world, or do these monsters figure in his thoughts as the army of vices that man must fight to the death? The old sculptor was far from being so literary. He simply had in mind the illustrations in one of those Anglo-Saxon manuscripts which the English miniaturists, brought to Tours in 796 by Alcuin, had helped to spread through Gaul. These Anglo-Saxon miniatures are made up of amazing arabesques, an inextricable network in which warriors and monsters pursue one another as if in the depths of primæval forests.[3] The English monks of the sixth century who half in a dream created this strange decorative art, were Christians with something of the old vague paganism of the Germanic tribes still clinging to them. These ancient monsters lurked in the depths of their consciousness, and under their brushes there came back to life fabulous serpents who dwelt in marshes, and winged dragons who guarded treasure in the forest and defended it against the heroes. A whole unconscious mythology reappears in their manuscripts.[4]

[1] On the art of the Barbarians see Lindenschmidt, *Die Alterthümer unserer heidnischen Vorzeit* (1858) ; De Baye, *Industrie longobarde* (1888), and *Industrie anglo-saxonne* (1889), Barrière-Flavy, *Étude sur les sépultures barbares du midi et de l'ouest de la France* (1893), and above all *Les arts industriels des peuples barbares de la Gaule*, Toulouse and Paris, 1901, 2 vols. folio. The Burgundians who had become Christians sometimes placed a cross or a monogram on the griffin's cup, but this addition did not give the griffin and cup any mystical significance.

[2] *e.g.* at the church at Souillac (Lot) ; see the cast in the Trocadéro.

[3] On Anglo-Saxon miniatures see *Facsimiles of the Miniatures and Ornaments in Anglo-Saxon and Irish Manuscripts* (1868), and the *Album* published by the Palæographical Society.

[4] The craftsmen of Germanic race sometimes repro-

These interlacing designs of men and monsters created by the genius of Anglo-Saxon monks, passed into the French manuscripts, and until the end of the twelfth century reigned in the miniaturist's art. The Romanesque sculptors, who so frequently adapted the illuminator's work, copied these living arabesques, attracted simply by their intricacy of line, for these vague dreams of another race and another world could for them have had no meaning.

These few examples will serve to show the futility of interpreting in a symbolic sense every animal and flower in Romanesque work. It is well to remember that St. Bernard was right, and that one need not be more subtle than he was. True symbolism holds too large a place in mediæval art to make it necessary to look for it where it does not exist.

It might be objected that St. Bernard spoke only of the art of his own day, and that what is true of Romanesque art is perhaps not true of Gothic, for though the decorative art of the twelfth century is composite, combining elements from many sources, decorative art of the thirteenth century is on the contrary wholly original. A new fauna and flora appeared in the churches, just as on the morrow of a great geological cataclysm might emerge unknown beings wholly unconnected with the past. The Gothic sculptors had created this new world ; why should not each and all of their creations be a symbol ? These are specious arguments, but they do not stand examination. The impartial student of the decorative fauna and flora of the thirteenth century finds it purely a work of art, the expression of a deep and tender love of nature. Left to himself the mediæval sculptor did not trouble about symbols, but was simply one of the people, looking at the world with the wondering eyes of a child. Watch him creating the magnificent flora that came to life under his hand. He does not try to read the mystery of the Fall or the Redemption into the budding flowers of April. On the first day of spring he goes into some forest of the Île-de-France, where humble plants are beginning to push through the earth. The fern tightly rolled like a powerful spring still has its downy covering, but by the side of the streams the arum is almost ready to open. He gathers

duced episodes from their epic stories of which the memory still lingered. On a pillar in the crypt of the cathedral at Freisingen (Bavaria) is carved the story of Siegfried fighting with the dragon Fafnir, and delivering the Walkyrie. On his shoulder is seen the lime-leaf which, falling on him, prevented him from being made invulnerable in every part when he bathed in the dragon's blood. The birds which guided the hero are also seen on the capital. (See an article in the *Mélanges d'archéologie*, by Father Martin, iii. p. 163 *seq.*) Germanic or Scandinavian influences were greatly exaggerated by Father Martin, who in his later work saw them everywhere. His view is combatted by Springer, *Ikonogr. Studien, Mittheil. der Centrale*, v. p. 309.

the buds and the opening leaves, and gazes at them with the tender and passionate interest felt by all men in early youth, and which is the artist's birthright through life. The vigorous lines of these young plants which stretch upwards and aspire to be, seem to him full of strength and grandeur by their suggestion of concentrated energy. With an opening bud he makes the ornament which terminates a pinnacle, and with shoots pushing through the earth he decorates the cushion of a capital. The capitals of Notre Dame at Paris, especially the earlier ones, are made of these young leaves, which swelling with the rising sap seem to thrust up abacus and arch as they grow.

Viollet-le-Duc in a fine article in his Dictionary[1] was the first to observe that Gothic art at its rise, about 1180, copied by preference the buds and leaves of early spring.[2] The impression of youth and restrained power which is given by the earlier cathedrals—Sens, Laon and the choir of Notre Dame at Paris—is in part due to this. During the thirteenth century the buds and the leaves open. At the end of the thirteenth and during the whole of the fourteenth centuries we find whole branches, rose-trails and vine-shoots twining round the doorways. The stone flora of the Middle Ages seems to follow the laws of nature. The cathedrals had their springtime and their summer, and when the thistle of the fifteenth century appeared they had their autumn too.

During these three centuries one does not find a single case of symbolic purpose. The leaves or flowers were chosen for their beauty, the art of the twelfth century choosing the buds, the art of the thirteenth the leaves. These leaves were simplified but not distorted, for their structure and general appearance were respected (Fig. 19), and it is easy to recognise a large number of them. Scholars who were both archæologists and botanists have pointed out the plantain, arum, ranunculus, fern, clover, celandine, hepatica, columbine, cress, parsley, strawberry-plant, ivy, snapdragon, the flower of the broom and the leaf of the oak,[3] a typically French collection of flowers loved from childhood. The great sculptors despised nothing, for at the root of their art, as of all true art, sympathy and love are found. They believed that the plants of the meadows and woods of Champagne or the

[1] *Dict. raisonné de l'architect*, article " Flore," v. 285.

[2] This is especially noticeable in the cathedral at Laon.

[3] In addition to the article by Viollet-le-Duc already mentioned, see Dr. Woillez, *Iconographie des plantes aroïdes figurées au moyen âge en Picardie.*

Amiens, 1848. (*Societé des antiquaires de Picardie*, vol. ix.); Lambin, *La flore gothique.* Paris, 1893, 8vo; *Les Eglises des environs de Paris, etudiées au point de vue de la flore.* Paris, 1895, 8vo; *La Flore des grandes cathédrales de France.* Paris, 1897, 8vo. (Library of the " Semaine des constructeurs.")

Île-de-France were worthy to grace the house of God. The Sainte-Chapelle is full of ranunculus,[1] and on the capitals in the cathedral at Bourges are ferns from the plains of Berri, while Notre Dame at Paris is decked with the plantain, cress and celandine.[2] The thirteenth century sculptors sang their "chant de mai." All the spring delights of the Middle Ages live again in their work —the exhilaration of Palm-Sunday, the garlands of flowers, the bouquets fastened on the doors, the strewing of fresh herbs in the chapels, the magical flowers of the feast of St. John—all the fleeting charm of these old-time springs and summers. The Middle Ages, so often said to have little love of nature, in point of fact gazed at every blade of grass with reverence. One flower charmed by its beauty and its shape, another recalled the happy days of childhood, and yet another was the flower of the country-side or the emblem of a province, as when the Burgundian of Semur and Auxerre carved the vine-trails round the porches of his church. We shall never know all the reasons for the artist's

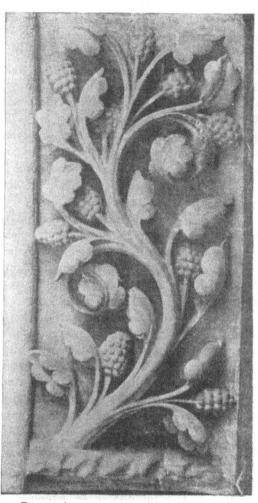

FIG. 19.—A GROWING PLANT (Notre Dame, Paris)

choice of a flower, but each put something of his heart into his work. I suspect too that ancient pagan superstitions bloomed on the

[1] Lambin, *La flore gothique.*
[2] Good examples of the mediæval flora are found in Adams' *Recueil de sculptures gothiques.* Paris, 1856.

capitals into more than one flower. It can hardly be by accident that one finds in so many churches the large leaf of the arum, for instance. It first occurred to Dr. Woillez[1] that this flower, so dear to Gothic sculptors, had been chosen for its mysterious properties. It is still an emblem of fertility to the peasants of the valley of the Oise, and in former days it was used in incantations and witchcraft. We must resign ourselves to ignorance of these curious associations of ideas in the minds of the people, for to-day most of them have passed away, and we must rest satisfied with the statement that the choice of mediæval flora was not affected by the learned symbolism of the theologians. The artists, though under supervision when charged to express the religious thought of their day, happily for us were left free to decorate the churches with innocent flowers at will. How much more their simple love of nature attracts us than the symbolism of scholars, noble no doubt but incapable of further growth.

These ingenuous artists carved animals as they did flowers, simply to express some aspect of nature which appealed to them. We are strongly of opinion that with the exception of the special examples already given —where the influence of Honorius of Autun and of the Bestiaries is indisputable—the animals in the Gothic churches have no more symbolic value than those in Romanesque art.

In the small medallions which cover the basement of the cathedral porch at Lyons a number of creatures of the fields and woods are to be seen. Two chickens scratch themselves, a claw hidden under their feathers,[2] a squirrel leaps from branch to branch of a tree clustered with nuts,[3] a crow settles on a dead rabbit,[4] a bird flies off with an eel in his beak,[5] a snail crawls among leaves,[6] and a pig's head shows between the branches of an oak-tree.[7] These animals have been carefully observed, and their characteristic movements are given. One sees the mediæval artists as subtle and sympathetic observers of animal life, near relations to the trouvères who drew the portraits of Reynard and Isengrin so faithfully, animal lovers after the manner of La Fontaine.

The *Album* of Villard de Honnecourt gives ample proof of their love of observing animals and their delight in studying them from the

[1] Woillez, *loc. cit.*

[2] Reproduced in Guigue and Bégule's *Monographie de la cathédrale de Lyons*, series II., pl. I., B. 1.

[3] Guigue and Bégule, *Monogr. de la cathédrale de Lyons*, series II., pl. I., B. 3.

[4] *Ibid.*, series III., pl. I., B. 3.

[5] *Ibid.*, series II., pl. IV., B. 5.

[6] *Ibid.*, series III., pl. I., A. 3.

[7] *Ibid.*, series III., pl. IV., A. 3.

life. A happy accident has preserved the sketch-book in which this architect of the thirteenth century—famous enough to be sent for to far-away Hungary—noted all the remarkable things he came across on his travels.[1] The opening lines show the old master's fine nature : " Villard de Honnecourt greets you," he says in the rough Picardy dialect, " and begs all those engaged in the various kinds of work noted in this book to pray for his soul, and to remember him." This busy man who built the colle-

giate church at St. Quentin, who travelling in France and Switzerland drew in his notebook the towers of Laon, the windows of Reims, the maze at Chartres, the rose-window at Lausanne, and who built churches through the length and breadth of Christendom, yet found time for the study of the spirals of a snail's shell.[2] On another page he drew from life a bear, and a beautiful swan with curving neck.[3] Elsewhere he

FIG. 20.—TWO PARROQUETS (Album of Villard de Honnecourt)

made careful studies of a grasshopper, a cat, a fly, a dragonfly and a lobster.[4] He availed himself of a visit to a great lord's menagerie " to counterfeit," as he said, a chained lion and a pair of parroquets on a perch (Fig. 20). He wished it to be known that the lion was done from life : " Eh bien saciés que cil lion fut contrefais al vif." [5]

This close observation of nature is seen in all the great nameless sculptors of the thirteenth century, for they carved a whole world of birds and beasts from sheer pleasure of reproducing living forms. Yet we are not surprised if at times there were some special or personal motive behind their work. At Laon, for instance, almost at the top of the towers, the silhouettes of six huge oxen are seen against the sky, and tradition has it that these great

[1] *Album de Villard de Honnecourt,* published by Lassus, Paris. Imprim. Imp., 1858, 4to.
[2] *Ibid.,* pl. III.
[3] *Ibid.,* pl. VI.
[4] *Ibid.,* pl. XIII.
[5] *Ibid.,* pl. XLVI. and I..

RELIGIOUS ART IN FRANCE

forms were placed there to keep green the memory of the unwearying oxen who for so many years dragged the stone for the cathedral from the plain

up to the acropolis of Laon. The local legend seems to be supported by a story told by Guibert of Nogent,[1] who relates that one day as the oxen were dragging up the steep slope a wagon full of materials for the church, one of them fell by the roadside exhausted. The driver was at a loss to know how to continue on his way, when suddenly another ox appeared coming towards him to be yoked, and thus the wagon was able to reach the end of its journey. The task accomplished, the mysterious ox disappeared. Such a legend shows that the people thought feelingly of the valiant beasts who had worked like veritable Christians for the house of God, and that they wished that those who had toiled so long should have an honourable place in the building they had helped to raise.

The oxen of Laon however are an exception. Elsewhere the artist's intention in this lavish use of animal forms was obviously to give vitality to the building. To him the great church was an epitome of the world, and in it he

FIG. 21.—ANIMAL GROTESQUES (Notre Dame, Paris)

wished to place every living thing. Two bas-reliefs in Notre Dame at Paris[2] witness to this longing to embrace the whole universe. One represents the earth in the form of a fruitful mother whose robe dis-

[1] Guibert of Nogent, *De Vita sua*, III., ch. xiii., *Patrol.*, t. clvi., col. 941.

[2] In the north façade, lower portion of left doorway.

life. A happy accident has preserved the sketch-book in which this architect of the thirteenth century—famous enough to be sent for to far-away Hungary—noted all the remarkable things he came across on his travels.[1] The opening lines show the old master's fine nature : " Villard de Honnecourt greets you," he says in the rough Picardy dialect, " and begs all those engaged in the various kinds of work noted in this book to pray for his soul, and to remember him." This busy man who built the colle-

giate church at St. Quentin, who travelling in France and Switzerland drew in his notebook the towers of Laon, the windows of Reims, the maze at Chartres, the rose-window at Lausanne, and who built churches through the length and breadth of Christendom, yet found time for the study of the spirals of a snail's shell.[2] On another page he drew from life a bear, and a beautiful swan with curving neck.[3] Elsewhere he

FIG. 20.—TWO PARROQUETS (Album of Villard de Honnecourt)

made careful studies of a grasshopper, a cat, a fly, a dragonfly and a lobster.[4] He availed himself of a visit to a great lord's menagerie " to counterfeit," as he said, a chained lion and a pair of parroquets on a perch (Fig. 20). He wished it to be known that the lion was done from life : " Eh bien saciés que cil lion fut contrefais al vif." [5]

This close observation of nature is seen in all the great nameless sculptors of the thirteenth century, for they carved a whole world of birds and beasts from sheer pleasure of reproducing living forms. Yet we are not surprised if at times there were some special or personal motive behind their work. At Laon, for instance, almost at the top of the towers, the silhouettes of six huge oxen are seen against the sky, and tradition has it that these great

[1] *Album de Villard de Honnecourt*, published by Lassus, Paris. Imprim. Imp., 1858, 4to.
[2] *Ibid.*, pl. III.
[3] *Ibid.*, pl. VI.
[4] *Ibid.*, pl. XIII.
[5] *Ibid.*, pl. XLVI. and I..

RELIGIOUS ART IN FRANCE

forms were placed there to keep green the memory of the unwearying oxen who for so many years dragged the stone for the cathedral from the plain up to the acropolis of Laon. The local legend seems to be supported by a story told by Guibert of Nogent,[1] who relates that one day as the oxen were dragging up the steep slope a wagon full of materials for the church, one of them fell by the roadside exhausted. The driver was at a loss to know how to continue on his way, when suddenly another ox appeared coming towards him to be yoked, and thus the wagon was able to reach the end of its journey. The task accomplished, the mysterious ox disappeared. Such a legend shows that the people thought feelingly of the valiant beasts who had worked like veritable Christians for the house of God, and that they wished that those who had toiled so long should have an honourable place in the building they had helped to raise.

FIG. 21.—ANIMAL GROTESQUES (Notre Dame, Paris)

The oxen of Laon however are an exception. Elsewhere the artist's intention in this lavish use of animal forms was obviously to give vitality to the building. To him the great church was an epitome of the world, and in it he wished to place every living thing. Two bas-reliefs in Notre Dame at Paris[2] witness to this longing to embrace the whole universe. One represents the earth in the form of a fruitful mother whose robe dis-

[1] Guibert of Nogent, *De Vita sua*, III., ch. xiii., *Patrol.*, t. clvi., col. 941.

[2] In the north façade, lower portion of left doorway.

closes her swelling breasts, while a young woman kneeling before her draws near to drink in life. The other relief, which is much mutilated, symbolises the sea in a figure resembling an antique goddess, who with bit and bridle rides an enormous fish, holding a ship in her hand (Fig. 22).

Elsewhere, as in the medallions of the façade at Sens, this idea takes different form. The immensity of far-off lands and seas is expressed (Fig. 23) in carvings of the Indian elephant with his tower, the griffin—the old-time guardian of Asiatic treasure—and the ostrich and the camel ridden by Africans. A Siren symbolises the mystery of the Ocean.[1] The man lying on his back is the legendary Sciapodes, who lifts his one foot like a huge umbrella to shelter himself from the rays of the sun, an emblem of that unknown east penetrated by none since the days of Alexander. These are chapters from the geography of the world as it was then conceived, and all mediæval writers when describing oriental countries speak of these monsters. One need only men-

FIG. 22.—THE SEA (Notre Dame, Paris)

tion such well-known names as Honorius of Autun in his *Imago Mundi*,[2] Gervase of Tilbury in the *Otia imperialia*, Vincent of Beauvais in the *Speculum naturale*,[4] who collected in their works scattered fables from Pliny and Solinus, from the *De Monstris* and the apocryphal *Epistola Alexandri ad Aristotelum*.[5] There is no doubt that the doorway at Sens was a sort of illustrated map of the world after the manner of an old *portulano*. The Catalan atlas of 1375, one of the oldest documents of this kind that has come down to us, shows elephants, camels, Sirens, and the kings Gog and Magog by the shores of rivers and seas.[6]

It is I believe as a *mappa mundi* that we should interpret the famous doorway at Vézelay. Here all the peoples of the earth are gathered round

[1] There is also a man riding a fish, evidently a symbol of the sea, as on Notre Dame at Paris.
[2] The *Imago Mundi* belongs to the twelfth century, *Patrol.*, clxxii., cols. 123, 124.
[3] The *Otia imperialia* belong to the thirteenth century. They were published in the *Scriptores rerum Brunsvicensium*, Hanover, 1707, folio, vol. I., part I., ch. 3.

[4] *Spec. naturale*, see especially bk. XVIII. ch. cxxix.
[5] On ancient sources of geographical and ethnographical fables of mediæval days see Berger de Xivrey, *Traditions tératologiques*, Paris. Imp. Royale, 1836, 8vo.
[6] The Catalan atlas was published in the *Notices et Extraits des manuscrits*, xiv., part II., 1843.

RELIGIOUS ART IN FRANCE

Christ as He gives the Holy Spirit to the apostles. One is reminded by the curious figures of men with dogs' heads or with ears like winnowing fans (*vannosas aures*)[1] that He came to preach the Gospel to the whole human race, and that the Church must carry the message to the ends of the earth.[2]

It is evident that a strong desire to express every form of life was felt

FIG. 23.—BASEMENT OF THE CATHEDRAL OF SENS (portion)

by mediæval craftsmen, and that an attempt to explain all their work from the Bestiaries would reduce materially the quality of their achievement.

But we have still to account for those nameless creatures which like colonies of monstrous birds have their home overhead among the buttresses and towers. What can be the meaning of the long-necked gargoyles which howl there in the heights, and which if not held by their massive stone wings would swoop down, making in their flight an appalling outline against the sky? No age or race has conceived more terrible spectres, partly wolf, partly caterpillar, partly bat, yet with a strange and horrible

[1] Berger de Xivrey, *loc. cit.*, p. 143. The tiny man who needs a ladder to mount his horse is probably a pigmy.

[2] The same subjects are represented in the mosaics of St. Mark's, Venice. Detailed examination of the Romanesque porch at Vézelay is outside our study, and many of its subjects are still unexplained. The famous column of Souvigny (in the Trocadéro) is also a kind of summary of the world.

appearance of reality. Some of them lie forgotten in a garden behind Notre Dame at Paris where time is rapidly completing their destruction. They might well be some inchoate monsters of the tertiary age which growing less and less are about to disappear.

One may well ask the meaning of these creatures and of the stupendous heads or ominous shrouded birds that project from the façade of Notre Dame at Reims.[1] As we have seen, the interpretation of Madame Félicie d'Ayzac does not hold good, for the abnormal fauna of the cathedrals finds its explanation in no symbolic scheme, and here the Bestiaries do not help us. The fact is that conceptions of this kind are of essentially popular origin. The gargoyles like churchyard vampires, or the dragons subdued by ancient bishops, came from the depths of the people's consciousness, and had grown out of their ancient fireside tales. The powerful and sombre side of mediæval genius found expression in these memories of their forefathers, echoes of a vanished world.[2]

But all the imaginary animals conceived by the thirteenth century are not so terrible ; the greater number bear the mark of a gay invention or good-humoured raillery. A number of amusing little bas-reliefs of this kind are carved in the quatrefoils (Figs. 24, 25, 26) on the porch of Les Libraires and on that of la Calende in the cathedral at Rouen. They offer so many analogies with those in the cathedral at Lyons that they might well be the work of the same company of wandering craftsmen.[3] They swarm with monsters,

FIG. 24.—GROTESQUES ON THE PORTAIL DES LIBRAIRES (Rouen)

[1] It should be remembered that the magnificent creatures on the balustrades of the towers of Notre Dame, Paris, are the creations of Viollet-le-Duc, who sought inspiration from those at Reims. Only fragments remained of the originals.

[2] Springer's hypothesis is not convincing (*Ueber die Quellen der Kunstvorstell.*, loc. cit.). He believes that certain passages in the Psalms explain and justify these figures of monsters, e.g. Ps. xxii. 21. " Salva me ex leonis et a cornibus unicornium," and " et delectabitur infans ab ubere super foramine aspidis et in caverna reguli qui ablactatus fuerit manum suam mittet," Is. xi. 8.

[3] The bas-reliefs at Lyons are later than those at Rouen.

RELIGIOUS ART IN FRANCE

but monsters ingeniously and wittily conceived, as if the work of vigorous young sculptors, vying with and out-doing one another. A rearing centaur wearing a cowl and bearded like a prophet shows two horse's hoofs as forelegs, two human feet in boots behind.[1] A doctor in the cap of the faculty, who like the doctor in Gerard Dou's picture gravely studies a test-tube, is a man to the waist only and then becomes a goose. A philosopher with a pig's head meditates as he holds his snout, a young teacher of music, half man half cock, gives an organ lesson to a centaur, while a calf-headed figure reveals her sex through her half open robe. A man changed by magic into a dog wears a pair of buskins on his feet in memory of his former state, and a woman-bird lifts her veil and holds up a mysterious finger.

If ever works of art were innocent of ulterior meaning surely these are. When left to their own devices the craftsmen of the thirteenth century were like artists of every age, to whom some new combination of line always seems supremely worthy of effort. At Rouen and Lyons the problem reduced itself to this—how best to fill a quatrefoil with a pleasing design, hence the creatures whose supple limbs could be easily twisted to fill a given space. It was obviously a matter of solving a purely artistic problem, and there is no need to ask the meaning of the figures at Rouen, and whether they represent the virtues or the vices.[2] Champfleury in his *Histoire de la caricature*, and after him M. Adeline, were confident that there was no connection between symbolism and these studio carica-

FIG. 25.—GROTESQUES ON THE PORTAIL DES LIBRAIRES (Rouen)

[1] The grotesques on the doorway of Lyons are given by Guigue and Bégule. Those on the Portail des Libraires and the Portail de la Calende, first reproduced by Jules Adeline (*Sculptures grotesques et symboliques*, Rouen, 1879, 12º), have been studied by Mlle. Louise Pillion, who arrives at the conclusion which we share

that these hybrid creatures have no definite meaning. See the interesting study she has published under the title, *Les Portails latéraux de la cathédrale de Rouen*, Paris, 1907, 8vo.

[2] The phœnix used as a decorative motif is seen among the grotesques which we reproduce in Fig. 26.

OF THE THIRTEENTH CENTURY

tures.[1] All attempts at explanation must be foredoomed to failure. The objection that the clergy would not have tolerated such subjects at the very door of their churches had they not conveyed some profound lesson, shows little knowledge of the mediæval mind. Those familiar with liturgical manuscripts of the thirteenth century know how often the fancy of the artist trifled with quite secular figures in the margin of the most solemn offices. In a thirteenth century missal preserved in the Bibliothèque Sainte-Geneviève, thousands of grotesque figures mingle with the sacred text.[2] Capital letters shelter dragons with bishop's heads, and a hanger when prolonged becomes a mouse, a bird, or a demon with outstretched tongue. Books of this kind laid open on a reading-desk shocked no one, and examples are numerous. The Bibliothèque Nationale possesses prayer-books decorated on every page with little figures that are neither more serious nor more instructive than those on the doors at Rouen and Lyons. A thirteenth century psalter is enlivened with two-headed monsters which would have rejoiced Callot,[3] —here a monk plays trictrac with a monkey, there a child pursues a butterfly, here two cocks fight, there an amazing figure comes out from a snail shell. The chef-d'œuvre of the kind is perhaps a book of Hours of the end of the thirteenth century [4] (Figs. 27, 28, 29, 30). Inexhaustible fancy and admirable technique make this manuscript invaluable. It might well have been drawn by the delicate pencil of some Japanese artist. Human and animal forms are ingeniously blended, and gaiety breaks forth

FIG. 26.—GROTESQUES ON THE PORTAIL DES LIBRAIRES (Rouen)

everywhere. A monkey disguised as a monk walks on stilts, or a musician gives a concert by scraping together the jawbones of an ass.

But why multiply examples ?[5] It is obvious that such figures are in no

[1] Champfleury, *Hist. de la caricature au moyen âge*, Paris, 1876, 12⁰; Adeline, *op. cit.*; Louise Pillion, *op. cit.*

[2] Bibl. Sainte-Geneviève, MS. No. 98. The date is 1286. The drawings are poor.

[3] Bibl. Nat., MS. Latin 13260.

[4] Bibl. Nat., MS. Latin 14284.

[5] Reference might also be made to Bibl. Sainte-Geneviève, MS. No. 2690 (thirteenth century Psalter, Paris use); Bibl. Nat., MS. Latin 1328 (thirteenth century), 1394. (fourteenth century).

61

RELIGIOUS ART IN FRANCE

way related to the Hours of the Virgin or to the penitential Psalms which they illustrate. They have no more meaning than the bas-reliefs on the doorway at Rouen which they resemble so closely. The clergy tolerated them in

FIG. 27.—MARGINAL FIGURE (B. N., MS. Latin 14284)

the cathedral as they tolerated them in the choir books. Mediæval Christianity readily sympathised with every side of human nature, and the Feast of Fools and the Feast of Asses prove that laughter or the flights of youthful fancy were never condemned. The good canons of Rouen and Lyons were

FIG. 28.—MARGINAL FIGURE (B. N., MS. Latin 14284)

no doubt the first to smile when they saw what their sculptors had carved as decoration for the doorway on which the Saviour and His saints appeared in glory. The gaiety and childlike serenity of those days sprang from the depth of their simple faith. It should not be forgotten that a circle of Dante's hell was for " those who were sullen in the sweet air, that is gladdened by the sun."

Neither satire nor indecency had any part in the artist's jesting, and the hideous obscenities which have been discovered in the cathedrals exist only in the imagination of a few prejudiced archæologists. The art of the thirteenth century is pure, amazingly pure. In the cathedral at Lyons the artist who had to tell the early history of the world left an empty medallion when he reached the story of Lot and his daughters. It was not until the fifteenth century that there appeared in art a somewhat low realism which does not always stop short of obscenity. Different periods should be carefully distinguished.[1]

Neither is there any trace of satire in connection with matters of worship. The famous capital in the cathedral of Strasburg, decorated with the burlesque funeral of a hedgehog borne to the grave by other animals

[1] This was not done sufficiently by Champfleury in his *History of Caricature and the Grotesque in Art and* the *Histoire de la caricature*, still less by T. Wright in *Literature* in which all periods are confused.

while a stag says mass and an ass chants at the reading-desk, is constantly quoted. But this carving has disappeared, and is known to-day only through a drawing published at the beginning of the seventeenth century

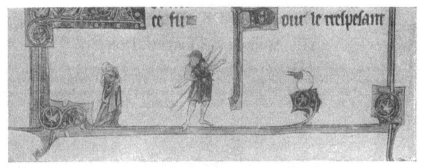

FIG. 29.—MARGINAL FIGURES (B. N., M.S. Latin 14284)

by the Protestant Johann Fischart who, in his search for forerunners of the Reformation, saw in it a satire on the mass.[1] We know neither the century to which the original belonged, nor whether it was precisely like the mediocre copy made by Fischart. Even if the representation be accurate, we need see it in a fancy of no more significance than in such a story as that of *Reynard the Fox*.

To summarise this chapter in a few words. For the theologian of the Middle Ages nature was a symbol, and living creatures were the expression of the thought of God. At times the theologians imposed their conception

FIG. 30.—MARGINAL FIGURE (B. N., MS. Latin 14284)

of the world on art, and a small number of dogmatic works was executed under their direction, works in which each animal has the value of a symbol. But such works are rare, and for the most part the sculptors peopled the churches at will with plants and animals chosen for purely decorative reasons, but with a confused idea that the cathedral is an epitome of the world and so a place in which all God's creatures may find a home.

[1] The drawing is reproduced by Champfleury, *Histoire de la caricature*, p. 157.

BOOK II

THE MIRROR OF INSTRUCTION

I.—Labour and learning; their part in the work of redemption. Manual work. Representations of the labours of the months; illustrated calendars. II.—Instruction; the Trivium and Quadrivium. Martianus Capella and the Seven Arts. Influence of his book on mediæval Literature and Art. III.—Representations of Philosophy. Influence of Boethius. IV.—Conclusion. The Fate of Man. The Wheel of Fortune.

I

THE world has come into being. The work of God is finished and perfect, but the harmony is destroyed for man has misused his liberty. Sin has brought misery into the world, and henceforth mankind is like the wretched Adam and Eve who at the top of Notre Dame at Paris seem to shiver in the mist and the rain.[1]

The Church proclaims through her art that fallen humanity can only be restored through the grace of God and the sacrifice of Christ, but that man must merit grace and must take his part in the work of redemption. In the preface to his *Speculum doctrinale* Vincent of Beauvais expresses the conviction—" Ipsa restitutio sive restauratio per doctrinam efficitur " and, as the sequel shows, by "doctrina," he understands work of every kind, even the humblest. The Middle Age was not only the age of contemplation, it was also the age of work accepted and conceived not as servitude but as enfranchisement. Manual labour—in substance we quote Vincent of Beauvais—delivers man from the necessities to which since the Fall his body is subject, while instruction delivers him from the ignorance which has weighed down his soul.[2] And so in the cathedrals, where all mediæval thought took visible shape, knowledge and manual labour are given a place of equal honour. In the church where kings, barons and bishops fill so modest a place we find representations of almost every craft.[3] At Chartres and Bourges, for example, in the windows given by the guilds, the

[1] The statues of Adam and Eve are modern, but are reproductions of the originals.

[2] *Speculum doctrinale*, I. ix. The same idea is developed by Honorius of Autun in his *De animæ exsilio et patria, Patrol.*, clxxii., col. 1241. The idea is this: the soul's exile is ignorance, the native land is wisdom, the Liberal Arts are so many cities on the road which leads there.

[3] See below for the place which the statues of kings take in the churches (*Mirror of History*, bk. IV. ch. v.).

OF THE THIRTEENTH CENTURY

lower part shows the donors with the badges of their trade—trowel, hammer, wool-carding comb, baker's shovel and butcher's knife.[1] In those days no incongruity was felt in placing these pictures of daily life side by side with scenes from the legends of the saints. The dignity and sanctity of labour were expressed in this way.

This desire to glorify work is especially marked in the church of Notre Dame at Semur. In a side chapel a window given by the cloth-workers shows the processes of cloth-making in a succession of scenes.[2] It is the one subject of the window, in which no saint, no sacred scene has a place. This is neither audacity nor simplicity, for such a subject is its own justification. If work is a divine law, if it is one of the ways leading to redemption, why should it need an apology for its introduction into the house of God? It surely has a place there by virtue of its inherent nobility. Such was the idea of the cloth-workers of Semur who, when they would do homage to our Lady, chose to offer these simple pictures of their daily life.

But it was to the primæval work of tilling the soil, the task which God Himself imposed on Adam, that the Church seems to have given the foremost place. In several French cathedrals the cycle of the year's work is carved round the orders of the arch or on the basement of the porch.[3] A sign of the zodiac accompanies each scene of harvest, tillage or vintage. Here are really "The Works and Days."

The custom of decorating the churches with calendars in stone was well established in primitive Christian times, for we know that the pavements of early basilicas were sometimes engraved with symbolic figures of the seasons. The mosaic from a church at Tyre given to the Louvre by the Renan mission represents scenes of the hunt and vintage accompanied by figures of the months.[4] This work is classical in character, and probably

[1] At Chartres there are as many as nineteen craft guilds. See Bulteau, *Monogr. de la cath. de Chartres,* i. p. 127.
[2] In the north aisle. The window at Semur probably dates from the end of the fourteenth century.
[3] *e.g.* Senlis (west porch); Semur (north porch); Chartres (old porch, north porch, window in choir); Reims (west porch, mutilated series); Amiens (west porch); Notre Dame at Paris (west porch and rose-window to the west); Rampillon (Seine-et-Marne) (west porch). The rose-window in Notre Dame at Paris as reproduced in Lenoir's *Statistique monumentale de Paris,* vol. ii., Pl. XIX., is the outcome of several restorations, but the original state is given by Lasteyrie, *Hist. de la peint. sur verre,* p. 141. Didron

thought to recognise a third Zodiac at Notre Dame at Paris—west façade, left doorway, trumeau. I do not share his view. The artist did not set out to represent the labours of the months, but to make a sort of thermometer. At the bottom there is a man warming himself before a good fire, higher up a man looking for wood, then a man taking a walk but still wearing a cloak, then a curious figure with two heads and two bodies, one body clothed, the other nude, evidently an expression of the sudden variations of temperature in spring. Then one sees a figure clothed only in breeches (Fig. 32), and lastly an entirely nude figure. On the other side of the trumeau there is a ladder of the ages of man.
[4] Reproduced in the *Ann. arch.,* vol. xxiv.

RELIGIOUS ART IN FRANCE

came from some thermæ or villa. The Church did not scruple to borrow pagan forms, and to hallow them by reading into them a Christian meaning. The sequence of the months became a reminder not only of the cycle of labour, but also of the cycle of the Christian year—the round of prayers and festivals.

The Romanesque churches, whose pavements were so often decorated with the signs of the zodiac, show how faithfully the traditions of earlier centuries were preserved.[1] One realises the early origin of the great stone calendars carved on the doorways of Gothic churches. The Christian of the thirteenth century who stopped on the threshold to contemplate them found according to his outlook in life different subjects for meditation. The

labourer recognised the unceasing round of work to which all his life he was destined, but the statues of the Saviour or of the Virgin looking down on these things of earth reminded him that he did not work without hope.[2] The ecclesiastic with his knowledge of the liturgy and of the computation of the Church's calendar reflected that each of the months

FIG. 31.—THE FURRIERS (from a window at Chartres)

corresponded to some event in the life of Christ or of some great saint. To him each month was marked not by common tasks but by a succession of heroic acts, and the year seemed like a garland of the virtues. The mystic meditated on the passing of the days which came from God and lost themselves in Him, and told himself that time was a shadow of eternity.[3] He reflected that the year with its four seasons and its twelve months was a figure of Christ, of whom the four evangelists and the twelve apostles are members.

The finest carved calendars are found at Chartres, Paris and Reims,

[1] See the pavements in the church at Tournus, in Saint Rémi at Reims (now removed), in Saint-Bertin at Saint-Omer, and in the church at Aosta. Suger, faithful to tradition, had the works of the twelve months executed in mosaic on the façade of St. Denis (see fragment in the Musée de Cluny).

[2] This is implied by Rupert, *De Trinitate*, I. xlv., *Patrol.*, clxvii. According to him the sight of the calendars made the people more disposed to the service of God.

[3] Honorius of Autun, *De Imag. Mundi*, II., iii., *Patrol.*, tom. clxxii.

[4] Sicard, *Mitrale. Patrol.*, ccxiii., col. 232. "Annus est generalis Christus, cujus membra sunt quatuor tempora, scilicet quatuor Evangelistæ. Duodecim menses sunt Apostoli . . ."

66

OF THE THIRTEENTH CENTURY

where they are works of true poetry. In these small panels the age-long labour of man is shown to us, for it is not only the French peasant whom the artist represents, it is Man in every age, undying Adam bent towards the earth. There is seldom anything trivial in a thirteenth century bas-relief, for every detail was the outcome of the artist's direct experience of life and nature. At the very gates of the little walled towns of the Middle Ages lay the country with its ploughed land and meadows and the rhythmical sequence of pastoral toil. The towers of Chartres rose above the fields of La Beauce, the cathedral of Reims dominated the vineyards of Champagne and the apse of Notre Dame at Paris the surrounding woods and meadows. And so the sculptors drew inspiration from immediate reality for their scenes of rural life.

FIG. 32.—SUMMER (Notre Dame, Paris)

This beautiful poem of the months, dignified and genial, well deserves study as the Georgic of old-time France. It seems hardly credible that the meaning of these vivid scenes should have escaped the archæologists of the early nineteenth century. Yet in 1806 Lenoir thought he saw the twelve Labours of Hercules in the twelve scenes which illustrate the calendar on the cathedral at Cambrai,[1] and Depuis, the author of the *Origine de tous les cultes*, though he recognised the signs of the zodiac on the façade of Notre Dame at Paris, drew the mistaken conclusion that the cult of the Sun or of Mithra survived until the thirteenth century.[2]

At Chartres[3] and Paris[4] the signs of the zodiac and the rural scenes which accompany them were disposed so as to follow the course of the sun. The signs of the months mount like the sun from January to June and descend from June to December.

[1] Lenoir, *Rapport fait à l'Académie celtique*, September 29, 1806.
[2] Dupuis, *Origine de tous les cultes*, 1795, iii. p. 42.
[3] The archivolts of the north porch.
[4] West façade, Portail de la Vierge ; pillars.

67

RELIGIOUS ART IN FRANCE

It is interesting to note that these calendars do not all begin with the same sign. At St. Savin in Poitou Aries (March) is the first sign,[1] on the façade of the cathedral at Amiens the year opens with the month of December and the sign of Capricorn, while on the two porches at Chartres the year begins with the month of January, accompanied, not by Aquarius strange to say, but by the sign of Capricorn.

These peculiarities may not always be due, as has been thought, to negligence on the part of the workmen charged with placing the panels in position. In the Middle Ages the new year varied according to the locality. Gervase of Canterbury wrote in the beginning of the thirteenth century :—
" Quidam enim annos incipiunt computare ab Annuntiatione, alii a Nativitate, quidam a Circumcisione, quidam vero a Passione." Thus the year began sometimes in March or April (the Annunciation or the Passion), sometimes on December 25 or January 1 (the Nativity or the Circumcision). In neighbouring towns such as Reims and Soissons the year began on the feast of the Annunciation (March 25) and on Christmas Day respectively.[2] This explains why at St. Savin the zodiac begins with the Ram, that is with March.[3] And Amiens probably chose December so that the year might open with Christmastide.[4] An explanation may also be found for the unusual correspondence at Chartres of the month of January and the sign of Capricorn. In mediæval days the signs of the zodiac did not correspond exactly with the length of each month, but were liable to encroach on the following one. We have evidence for this in a poem on the months by the monk Wandalbertus, who in the ninth century wrote of January—" Huic gemino præsunt Capricorni sidera monstro."[5] " The sign of Capricorn presides over the two-headed monster (Janus)," that is over January.

These anomalies are rare. Almost all painted or carved illustrations of the zodiac show the year beginning with January accompanied by Aquarius, the signs corresponding precisely to each month. I know of no deviation from this rule in illuminated manuscripts, and there are few in bas-reliefs. Didron was mistaken when he wrote that on the porch of

[1] Longuemar, *Bulletin monum.*, XXII., 1857, p. 269 seq. St. Savin is a Romanesque church. We have found no calendar beginning with March in Gothic churches.

[2] See the Comte de Mas-Latrie, *Trésor de chronologie*, Paris, 1889, folio, col. 21–22. See also Giry, *Manuel de diplomatique.*" Paris, 1894, 8vo, p. 114.

[3] In Poitou in the Middle Ages the year began either on March 25, (the Annunciation) or on Easter Day which often falls in March. Giry, *op. cit.*

[4] M. de Mas-Latrie, *op. cit.*, states that at Amiens in the twelfth century the year began on Easter Eve, the day of the benediction of the paschal candle. One must therefore suppose either that it was no longer the custom in the thirteenth century, or that there is a mistake in the disposition of the signs.

[5] Wandalbertus, monk of Prüm ; Achery, *Spicil.*, II. p. 57.

Notre Dame at Paris the year is made to open with the month of December. As a matter of fact it opens with Janus and the sign of Aquarius.[1]

At Reims too where as we are told March was reckoned the first month of the year,[2] the calendar on the cathedral begins with January. Long before 1564, when the edict of Charles IX fixed January 1 as the beginning of the year for the whole of France, this date had in point of fact been adopted by the Church. This explains why it was that at the beginning of the thirteenth century Gervase of Canterbury, after pointing out several local exceptions, could write :—" According to the traditions of the Romans and the custom of the Church of God the solar year begins with the calends of January (January 1) and ends with the days following the nativity of the Saviour, that is at the end of December."

FIG. 33.—DECEMBER, JANUARY, FEBRUARY (Amiens)

To turn to the analysis of the bas-reliefs devoted to the labours of the different months. Scarcely a trace of literary influence is shown here, but we find instead definite artistic traditions which had come down through the centuries constantly renewed by contact with reality. In the hands of these craftsmen ancient formulas never became stereotyped. The study of variants, of which the illustrated manuscripts furnish examples, is at times of interest. Prayer-books of the twelfth and thirteenth centuries containing illustrated calendars are legion, and if the study discloses nothing very new, it at least shows the strength of tradition.

To the mediæval peasant January was the month of feasts and of rest. From Christmas Day to Twelfth Night he had more than one pretext for feasting and for indulging those pagan instincts which reappeared in the freedom of the Christian festivals. In certain calendars the first days of

[1] Didron, *Ann. arch.*, xiv. p. 27. At Paris the sign of Aquarius is not visible at the first glance, for it is part of a bas-relief in the next arcade which shows a figure of the Sea riding a fish. But after a little study one distinctly sees the water-carrier and his pot.
 [2] Giry, *op. cit.*

69

RELIGIOUS ART IN FRANCE

January are illustrated by two drinking horns.[1] The sculptors of the thirteenth century show us the regal figure of a man seated before a well-furnished table. Sometimes this figure has two heads, often one of an old and the other of a young man [2] (Fig. 33). This is no doubt the classical "Janus bifrons" whose memory had been kept green by the teaching of the schools. The symbolism of the two faces was popular. One face looked back over the past, the other forward to the future—one belonged to the closing and the other to the opening year.[3] Sometimes for the sake

FIG. 34.—MARCH, APRIL, MAY (Amiens)

of clearness Janus was shown closing a door through which an old man was disappearing and opening another to admit a youth.[4] Sometimes the artists gave Janus a third face to signify the present, but this was an awkward innovation and was not popular, for only two or three examples are known.[5] And so it came about that Janus seated in person at the family table opened the mediæval year with mirth and jollity.

In February work in the fields is not yet resumed. It is true that the sun is already shining in Italy, and as we see in an Italian manuscript in the Bibliothèque Nationale [6] the peasant is beginning to trim the vines. But in northern France—the Île-de-France, Picardy and Champagne, the France of the cathedrals—February is a rough wintry month, and unless obliged to go out the peasant stays at home warming himself at a good log-fire. At Paris and Chartres there is a charming intimacy in these little genre

[1] See Cahier, Caractéristique des saints, under "Calendrier."

[2] See the porch at Amiens; Chartres (west and north porches); Notre Dame at Paris (rose-window); many psalters, e.g. Bibl. Nat., MSS. Lat. 1328, 238, 320, 828, 1394, and Arsenal (Psalter of St. Louis); Sainte-Geneviève, 2200, 2690.

[3] Isidore of Seville, Etymol., v. 33. Patrol., lxxxii., col. 219, "Bifrons idem Janus pingitur, ut introitus anni et exitus demonstretur."

[4] See the porch at St. Denis; also window in the south aisle of the choir at Chartres; Arsenal (Psalter of St. Louis), and Bibl. Nat., MS. Lat. 238.

[5] See the window at Chartres, and Bibl. Nat., MS. Lat. 1076. The sculptors do not seem to have adopted this.

[6] Bibl. Nat., MS. Lat. 320.

pictures (Fig. 33). The villein seems to have just come in from a long walk in the snow, in the teeth of the icy north wind. Scarcely seated, without pausing to loosen his cloak he takes off his shoes that he may warm himself at his ease. One feels that the house is well sheltered from the winter blasts, and that a pleasant warmth and a feeling of security reign there. A ham hangs from the ceiling and a string of chitterlings from the dresser.

In March one can no longer stay by the fireside. On Notre Dame at Paris Aries is surrounded by the first flowers of spring,[1] and the peasant

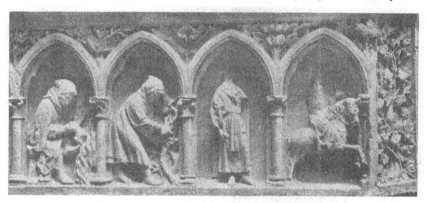

FIG. 35.—FEBRUARY, MARCH, APRIL, MAY (Rampillon)

goes forth to his vineyard. At Chartres, Semur and Rampillon (Fig. 35) he dresses his vines. Elsewhere he digs them, as at Amiens (Fig. 34) which to-day is outside the vine-growing district, though one concludes from the names attached to certain estates that vines still grew there in the Middle Ages. At Chartres, where the wind is cold and the sky changeable, the vine-dresser still wears his winter cloak and hood.[2]

April was the most beautiful month in the year to the man of the Middle Ages, who preferred it even to the month of May. A manuscript shows April in the form of a king seated on his throne, a twig in one hand and a sceptre in the other.[3] April is the month sung by the trouvères. The old poets seem to have felt nature's charm in springtime only, just as in the seventeenth century the painters responded only to autumnal

[1] Also in the zodiac in the west rose-window.
[2] Chartres, the zodiac in the north porch.
[3] Bibl. Nat., MS. Lat. 238, thirteenth century psalter. At the end of the Middle Ages the young men of Soissons were in the habit of electing a " prince

of youth " in April. See Dormay, *Hist. de Soissons*, vi. xxvi. The figure of April as conceived by the artists often seems to be this prince of youth. See the month of April at Rampillon (Fig. 35).

RELIGIOUS ART IN FRANCE

splendour. The first touch of spring, the bright Easter sunshine and the orchards in blossom under a threatening sky, brought more joy to the

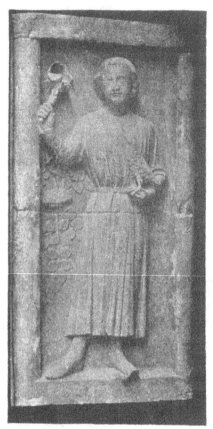

heart of the thirteenth century peasant than the brilliant days of summer. April, with its indefinable charm and capricious nature, was conceived as a youth crowned with flowers. At Chartres, on the edge of La Beauce, April carries ears of corn in remembrance that the ear is forming at this season, and the same emblem appears on the porch of Notre Dame at Paris. During these two months the peasant of La Beauce and of the Île-de-France was apparently content to sit idle and to watch the corn growing, but for the vine-dresser of Champagne no leisure was possible, for the vines must be dug in March and dressed in April.[1]

May brings a knightly train, for it is the month dedicated to the nobleman and his sport, and the carved and painted calendars show him going forth sometimes on foot, sometimes on horseback.[2] At times he carries a lance as at Chartres, more often he bears something less warlike—a branch, a flower, or his falcon on his wrist[3] (Fig. 36). Meanwhile the villein too is enjoying the season and the last hours

FIG. 36.—THE MONTH OF MAY
(Notre Dame, Paris)

of leisure before the summer's heavy toil, and at Amiens he is represented as taking his rest in the shade (Fig. 37).

In June the meadows are mown. At Chartres[4] the work has not yet

[1] Reims, in the porch.
[2] Miniatures invariably show a rider. The baron on horseback is seen in the old porch and a window at Chartres; in porches at Semur and Rampillon (Fig. 35); at Senlis, where he holds his horse by the bridle.

[3] In two porches at Chartres; in the porch at Notre Dame at Paris (the figure in the rose-window there is restored); in the porch at Senlis.
[4] North porch.

begun, but it is clearly the feast of St. Barnabas—the traditional date—for the haymaker is shown going forth to the fields, a round hat on his head, his scythe over his shoulder and a whetstone at his side. At Amiens the mower is in the thick of his work, and is cutting the longest grass (Fig. 37). At Amiens the hay is already dry, and bending under the weight the peasant carries it to the barn. Various manuscripts show slight variations. The Italian manuscript already mentioned,[1] no doubt illuminated by an artist from the scorching Campagna, shows the harvest as beginning in June. In the thirteenth century the motif of sheep-shearing, so frequent in the fifteenth and sixteenth centuries, first appeared in illustrated books.[2]

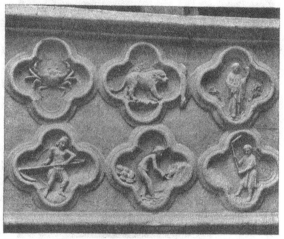

FIG. 37.—JUNE, JULY, AUGUST (Amiens)

July brings the harvest. At Chartres the peasant follows the general custom and cuts the corn with the sickle, but on the porch of Notre Dame at Paris the harvester sharpens a large scythe with lifelike gesture before beginning his work.[3] (Fig. 38.)

As at Paris and Reims, the north porch at Chartres shows that in August the harvest is not yet over. Elsewhere—at Senlis, Semur, Amiens (Fig. 37)—the stir of threshing has begun, and with no comrade to maintain the rhythmical motion of his flail the peasant works alone, nude to the waist.[4]

The peasant has hardly time to take breath before September, the month of vintage, is upon him. The France of those days was apparently hotter than ours,[5] and the grapes were gathered at the end of September, when

[1] Bibl. Nat., MS. Lat. 320.

[2] Bibl. Sainte-Geneviève, MS. 2200 (*Imaige del monde*, thirteenth century).

[3] At Notre Dame at Paris the sign of Leo has been placed in July by mistake.

[4] See the rose-window in Notre Dame at Paris, also MSS. At Amiens he is clothed.

[5] Does examination of the "Zodiacs" point to a change in the time of sowing or harvest? The question was put to the Congrès des Sociétés savantes at Paris by M. de Caumont in 1857 (*Bull. monum.*, xxiii. p. 269 *sq.*). The vintage seems to have been rather earlier.

the vine-treader trod gaily in the vats. Champagne furnishes the solitary exception, for on the cathedral at Reims September sees the threshing of the corn, and not until October do the press and the casks appear. Amiens, instead of the vintage, shows men gathering fruit (Fig. 39).

In the districts famous for their wines October sees the end of the vine-dresser's labours, and in Burgundy (Semur) and Champagne (Reims) the wine fermenting in the vats is transferred to the casks. Elsewhere, as at Paris and Chartres, it is the time for sowing. Once more in his winter cloak,[1] the peasant seems to walk slowly under the chill October sky, scattering with a sweep of the arm the seed he holds in his apron. The beauty of this rhythmical action is admirably realised in thirteenth century art.[2]

In November preparations must be made for the approaching winter. At Reims the peasant gets in his supply of wood. At Paris and Chartres, under the oaks fringing the great

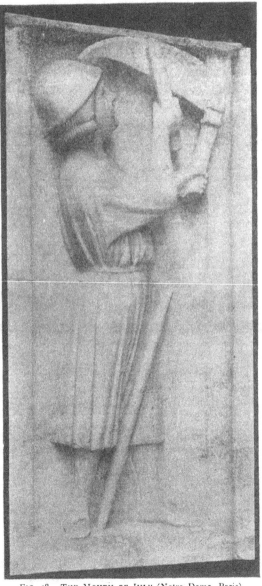

FIG. 38.—THE MONTH OF JULY (Notre Dame, Paris)

[1] In the rose-window, Notre Dame at Paris.

[2] In the porch at Notre Dame at Paris, for example. The bas-relief is unhappily mutilated (Fig. 40).

Druidical forests still dense in the thirteenth century, the swineherd watches his pigs fattening themselves for the December feasts on the acorns blown down by the autumn winds. In more than one place, at Semur and even at Chartres,[1] the pigs were killed and salted in November, and at Paris, Reims and Senlis in the following month. At Amiens, where the calendar is a little behindhand, the peasant is sowing his seed (Fig. 39).

The end of December, like the end of January, is a time of rejoicing and rest. It would seem as though there were no occupation but that of preparing for the gay Christmas feasts. The killing of pigs and cattle[2] and the baking of cakes[3] are the employments given in the bas-reliefs and manuscripts. December like January is sometimes shown as a gay reveller who, glass in hand, is seated with a ham before him.[4] The year begins and ends with jollity.[5]

FIG. 39.—SEPTEMBER, OCTOBER, NOVEMBER
(Amiens)

This is all so simple, so sober, so close to humanity. There is nothing of the somewhat insipid grace of antique frescoes, no cupid masquerading as grape-gatherer, no winged genii in the role of harvester. Neither are there Botticelli's charming goddesses dancing at the festival of the Primavera. It is man alone in his conflict with nature, and though five centuries have passed, the work is so full of life and vigour that it has lost none of its power to move and to attract.

II

From manual labour man rises to instruction which by dissipating error enables him in some measure to raise himself after the Fall. The Seven Arts (the Trivium and the Quadrivium) open out seven paths of human

[1] See the window and old porch ; also MSS., Bibl. Nat., MSS. Lat. 1077, 238, 1320, 1394.

[2] Bibl. Nat., MS. Lat. 1077.

[3] Bibl. Nat., MS. Lat. 1394.

[4] At Chartres, old porch and window. Bibl. de l'Arsenal, breviary of St. Louis ; Bibl. Nat., MS. Lat. 320, 238.

[5] The Middle Ages summarised the occupations of each month in four well-known Latin lines :
" Poto, ligna cremo, de vite superflua demo ;
Do gramen gratum, mihi flos servit, mihi pratum ;
Foenum declino, messes meto, vina propino :
Semen humi jacto, mihi pasco suem, immolo porcos."

activity. On the one side are grammar, rhetoric, dialectic, on the other arithmetic, geometry, astronomy and music. Above the Liberal Arts stands Philosophy, the mother of them all. Philosophy and the Arts contain all the knowledge possible for man to acquire apart from revelation.[1]

The artists of the thirteenth century, intent upon embracing the whole domain of human activity, did not fail to include on the façades of their

cathedrals the eight Muses of the Middle Ages. These queenly figures —youthful and serious—were never denizens of this world; they live enthroned above it like the Ideas of which Goethe speaks. In their hands they hold various attributes, intelligible enough no doubt to men of that day but whose meaning is obscured to us. Their interpretation is thus important, and may easily be traced by going back to the origin of these personifications of the Arts.

When the barbarians threatened to destroy the last remnants of classical civilisation, a few cultivated minds set themselves if possible to save the Arts by presenting them under a concise and ordered form. It was without doubt Augustine who first thought of compiling a manual of the Seven Arts

(whose division into the Trivium and Quadrivium was first due to the ancients), but his Encyclopædia—of which only a fragment survives—was never finished.[2] Boethius wrote a few chapters of the Quadrivium. His *De institutione arithmetica* in two books, the *De musica* in five books, and the *Ars geometrica*,[3] transmitted some meagre fragments of Greek learning to the Middle Ages. About the same time Cassiodorus, with whom the classical tradition comes to an end, produced in his *De artibus ac disciplinis*

[1] Augustine, treatise, *De ordine*, ii. 12. *Patrol.*, xxxii., col. 1011.

[2] Augustine says that while at Milan he wrote six books on Music and one on Grammar, and adds that he later composed treatises on Rhetoric, Geometry, Arithmetic and Philosophy. See *Retractationum libri duo*, i. 6. *Patrol.*, xxxii., col. 585 *sq.*

[3] The attribution of the *Ars geometrica* to Boethius has been questioned.

liberalium litterarum a complete manual of the Liberal Arts.[1] His book was destined for the monks of Vivarium to whom he tried to demonstrate that the Liberal Arts were indispensable to the understanding of the Scriptures. For, as he says, Moses possessed a complete knowledge of the Liberal Arts, the heathen did but steal a few tatters of his learning.

On the threshold of the Middle Ages Isidore of Seville definitely adopted the arrangement of the Trivium and Quadrivium in his "Etymologies."[2]

It is evident that the framework of mediæval thought was made at the close of the classical age. The books quoted above were classics in the twelfth and thirteenth centuries, but in the schools there was one specially celebrated—the famous treatise on the arts by Martianus Capella with the misleading title *The Marriage of Philology and Mercury*. Martianus Capella, an African grammarian of the fifth century, attempted to lighten

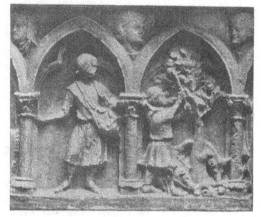

FIG. 41.—OCTOBER, NOVEMBER (Rampillon)

the severity of learning by the graces of the imagination, and his manual opens with a romance. He imagines that Mercury has at last decided to take a wife, and that he asks for the hand of Philology. The young husband presents himself on the wedding-day with a retinue of the Seven Arts. Each paranymph comes forward in turn, and in the presence of the god gives a long discourse which is a complete treatise on the art she represents. Personifications of the arts are here met with for the first time. The bizarre figures born of the African imagination engraved themselves more deeply on the memory of the Middle Ages than did the purer creations of great masters, and until the Renaissance definite traces of their influence are seen in art.[3] And so an obscure rhetorician accomplished what few men of genius have succeeded in doing, for he created types. The mediæval artist it is true had a difficult task in the simplification of these figures, for they were as overloaded with

[1] *Patrol.*, lxx., col. 1149 *sq.*
[2] *Etymol.*, i. ; *Patrol.*, lxxxii.

[3] See the frescoes of the Liberal Arts painted by Botticelli for the Villa Lemmi, now in the Louvre.

RELIGIOUS ART IN FRANCE

ornament as were the Carthaginian women of Martianus Capella's day.

Grammar, the first figure whom he presents, comes forward dressed in the pænula. She holds an ivory case like a doctor's case of instruments, for grammar is a true therapeutic which cures all defects of speech. In her case are seen—among other things—ink, pens, candlesticks, tablets and a file in eight sections marked by gold lines—symbols of the eight parts of speech. There is also a sort of scalpel (scalprum) with which she makes operations on the tongue and teeth to facilitate utterance.[1]

Dialectic follows. She is a thin woman draped in a black mantle, with bright eyes shining in a pale face and hair dressed in elaborate rolls. In the left hand she holds a serpent half hidden under her robe, in the right a wax tablet and a fish-hook.[2] Remigius of Auxerre, who in the tenth century wrote a commentary on Martianus Capella, found no difficulty in explaining the attributes of Dialectic. The subtility of classical rhetoricians did not perplex the mediæval mind. According to him the rolled hair denotes the syllogism, the serpent the wiles of sophistry, and the hook stands for insidious argument.[3]

Rhetoric, an armed maiden, comes forward to the sound of trumpets. She is beautiful, tall and graceful, a helmet covers her hair, and she brandishes formidable weapons. On her breast glitter precious stones and she wears a cloak embroidered with countless figures.[4]

Geometry wears a marvellous robe on which are embroidered the movements of the stars, the shadow that the earth casts on the sky, and the signs of the gnomon. In her right hand she holds a pair of compasses ("radius"), in her left a globe, while before her is a table thick with greenish dust in which she draws her figures.[5]

Arithmetic has the stately beauty of a primitive goddess, and she seems to have come into being with the world itself. From her forehead issues a ray which dividing becomes double, then triple, then quadruple, and after multiplying itself to infinity again becomes one. Her agile fingers move with unthinkable rapidity. Their movements recall those of worms, (" vermiculati ") and symbolise, says Remigius of Auxerre, the rapidity of her calculations.[6]

[1] Martianus Capella, iii. 223. Edit. Teubner, 1866.
[2] *Ibid.*, iv. 328.
[3] Remigius of Auxerre's commentary on Martianus Capella has been published by Corpet in the *Annales archéol.*, xvii. p. 89 *sq.*

[4] Martianus Capella, v. 426.
[5] *Ibid.*, vi. 580 and 587.
[6] *Ibid.*, vii. 729.

Astronomy bursts suddenly forth from an aureole of flame, a crown of stars on her glittering hair. She spreads a pair of great golden wings with crystal feathers, and carries a bent and gleaming instrument (" cubitalem fulgentemque mesuram ") for observing the stars. She has also a book composed of various metals which, according to Remigius of Auxerre, represent the various zones or climata which she studies.[1]

Finally Music, the beautiful Harmonia comes forward with a train of goddesses, poets and musicians. Around her Orpheus, Arion, Amphion, Pleasure and the Graces sing sweetly while she draws ineffable strains from a large shield of gold strung with resounding strings. She is pure harmony, and at each of her movements the little golden discs on her dress tinkle melodiously.[2]

Such are the attributes and appearance of the seven followers of Philology so far as the obscure Latin of Martianus Capella can be understood.

The Middle Age was dazzled by these great figures of radiant women, superhuman as Byzantine mosaics. From the time of Gregory of Tours some knowledge of Martianus Capella's book was thought indispensable to every clerk.[3] In the eleventh, twelfth and thirteenth centuries it had a place in the libraries of most monasteries and cathedrals, as may be seen by the old catalogues edited by M. Léopold Delisle.[4] From that time onwards the poets were not fancy free when they set out to personify the Liberal Arts, for they could not forget the descriptions of the African rhetorician. Proof of this is easily given. Theodulphus, bishop of Orleans in the time of Charlemagne, left a little Latin poem on the Liberal Arts [5] in which he pretends to be inspired by a picture which is before him, and he describes Grammar in these words :—

" . . . læva tenet flagrum, seu dextra machæram."

" Her left hand holds a whip, her right a knife " (or better a scalpel)— two of the attributes given her by Martianus Capella. Dialectic, he says, has

[1] Martianus Capella, viii. 811.
[2] *Ibid.*, ix. 909.
[3] Gregory of Tours, *Hist. Franc.*, last chapter.
[4] L. Delisle, *Le Cabinet des manuscrits*, ii. pp. 429, 445, 447, 530, 536 (St. Armand, Cluny, Corbie, Saint-Pons de Tomières, &c.), iii. p. 9, catal. of the old Bibl. de la Sorbonne. Martianus Capella is found in the chapter library at Rouen in the twelfth century (*Revue de l'art chrétien*, 1886, p. 455); it is twice

found in the catalogue of books belonging to the chapter of Bayeux (*Bullet. archéol. du Comité*, 1896, p. 422), and it is given three times as in the library of the popes at Avignon. (Maurice Faucon, *La Librairie des papes d'Avignon.* Paris, 1886, 8vo, i. p. 185, and ii. pp. 42, 941.)
[5] Theodulphus, " De Septem liberalibus artibus in quadam pictura depictis." *Patrol.*, cv., col. 333.

a serpent which hides under her mantle—". . . corpus tamen occulit anguis."

Geometry carries in her right hand the compasses, in her left a globe—

" Dextra manus radium læva vehit rotulam."

The imitation is evident. Four centuries later Alanus de Insulis, the greatest mediæval Latin poet, in his turn describes the Liberal Arts. He makes additions and improvements, but he too preserves many of the traits inherited from Martianus Capella. In his attempt to embrace in a symbolic poem all the learning of his day Alanus de Insulis[1] fore-shadowed the work of Dante, and made the first sketch of the magnificent edifice which Dante raised. His book, the *Anticlaudianus*, is the noblest effort of monastic art. His verse is melodious, his thought elevated and pure, but his poem lacks freshness and vitality. He imagines that human wisdom—Philosophy (Prudentia)—would, like Dante, mount in quest of God.[2] She needs a chariot such as no man has seen in which to rise to the infinite. At her request the Liberal Arts come to fashion the marvellous car, which we see is a symbol of knowledge. Grammar comes first, a majestic matron whose swelling breasts are founts of knowledge. But to the tenderness of a mother she adds when necessary the severity of a father. In one hand she holds a whip (" scutica "), in the other a scalpel with which to remove the decay from the teeth and so give freedom to the tongue—

". . . linguasque ligitas
Solvit."[3]

She makes the pole of the chariot, carving on it the portraits of Donatus and Aristarchus, the two great grammarians.

Dialectic then advances. She is worn with vigils, but her eyes have lost none of their brilliancy. No comb holds her hair. In her left hand she carries not a serpent but a menacing scorpion.[4] She makes the axle-tree of the chariot.

Rhetoric has a kindling face and an ever-changing expression. Her robe shines with a thousand colours, and she carries a trumpet. She decorates the car with a veneer of gold and silver, and carves flowers on the pole.[5]

[1] Alanus de Insulis, born about 1128, died at Citeaux in 1202. See Hauréau, *Mém. de l'Acad. des Inscript. et Belles-Lettres*, xxxii., 1886, p. 1 *sq.* See also *Hist. littér. de la France*, xvi. p. 396 *sq.*

[2] With Dante all is living, less abstract. Virgil is human Knowledge and Beatrice is Theology.

[3] *Anticlaudianus*, ii. ch. vii. ; *Patrol.*, ccx.

[4] In Alanus de Insulis the serpent is replaced for the first time by the scorpion. Other examples will be found in art.

[5] *Anticlaudianus*, iii. ch. ii.

Arithmetic comes forward in a blaze of beauty. She carries the table of Pythagoras, and points to the "battle of numbers." She makes the first wheel of the chariot.[1]

Music who is playing the cither makes the second wheel.[2]

Geometry holds a rod with which she measures the world :—

> " Virgam virgo gerit, qua totum circuit orbem." [3]

She makes the third wheel.

Astronomy, the last comer, lifts her head towards the heavens. She is dressed in a tunic sparkling with diamonds, and in her hand she carries a globe. She makes the fourth wheel.

The car completed, Philosophy harnesses to it five spirited steeds, the five Senses, and loosening the reins springs upwards towards the heavens.

It is hardly necessary to point out the debt of Alanus de Insulis to Martianus Capella. The imitation is obvious, though it is discriminating and it omits much superfluous ornament.[4]

Need we multiply examples. One remembers that in the thirteenth century Henri d'Andeli wrote in the vernacular a "battle of the Seven Arts," and Jean le Teinturier a "marriage of the Seven Arts," in which the usual personifications appear.

We must remember also that the rather pedantic figures of the Arts had a place even in poems of chivalry, and that in Chrestien of Troyes's romance *Erec et Enide* we find the fairies embroidering a garment with figures of the muses of the Quadrivium.[5]

These examples surely establish the contention that the types created by Martianus Capella were generally accepted by thirteenth century writers. The artists were equally docile. The earliest representations of the Liberal Arts are found on the façades of Chartres [6] and Laon.[7] This is not surprising, for

[1] *Anticlaudianus*, iii. ch. iv.

[2] *Ibid.*, iii. ch. v.

[3] *Ibid.*, iii. ch. vi. Alanus de Insulis translated the word "radius" (used by Capella) not as "compass" but as "rule." The same interpretation is found in Remigius of Auxerre, who explains "radium" as "virgam geometricalem."

[4] We would also cite the Latin poem of Baudri, abbot of Bourgueil (composed before 1107), published by M. L. Delisle. The poet when describing the room of the Countess Adela, daughter of William the Conqueror, supposes that her bed is decorated with figures of the Arts. He takes a number of features from Capella.

[5] *Erec et Enide*, Bibl. Nat., MS. franç. 1376, fol. 143.

[6] Old porch, right doorway.

[7] Laon, façade, round the arches of the left window (second order). It would be difficult to study these figures if they had not been reproduced by Viollet-le-Duc (*Dict. raisonné de l'archit.*, under "Arts libéraux "). A window (rose-window to the north) is also devoted to the Liberal Arts. It has been restored. Reproduced by Cahier and Martin, *Mélanges d'arch.*, iv. See also *Les Vitraux de Laon*, by MM. de Florival and Midoux. Paris, 1882–91.

RELIGIOUS ART IN FRANCE

in the Middle Ages few Schools were as famous as those of Chartres and
Laon. The School of the cathedral of Chartres, whose history has lately
been written, had a brilliant reputation from the end of the tenth cen-
tury.[1] Fulbert, "the venerable Socrates" as he was called by his pupils,
taught the humanities, and already pupils were beginning to gather there
from distant provinces of France and even from England. Later the great
bishop Ivo, Gilbertus Porretanus and John of Salisbury in turn directed this
famous School. These masters, counted amongst the greatest of the Middle
Ages, were distinguished by their encyclopædic knowledge, their respect for
the ancients, and their scorn for those new methods of teaching which
pretended to make the acquisition of knowledge quicker and easier.
Throughout their lives Gilbertus Porretanus and John of Salisbury fought
against those dangerous innovators the Cornificiani, who would have pro-
scribed classical learning and wished to shorten the period of study. During
the twelfth century the Schools of Chartres were the refuge of tradition and
the stronghold of classical learning. No pagan of the Renaissance, intoxi-
cated with the classics spoke in more glowing terms of the ancients than
did Bernard, teacher at Chartres in the twelfth century. "If we see further
than they," he says, "it is not in virtue of our stronger sight, but because
we are lifted up by them and carried to a great height. We are dwarfs
carried on the shoulders of giants."[2]

It is thus not surprising to find a series of the seven Liberal Arts carved
on a porch at Chartres, for nowhere were the seven maidens of Martianus
Capella held in greater honour.

The School at Laon was almost as celebrated as that at Chartres. Under
two masters, Raoul and more particularly under Anselm,[3] it was the leading
School of Christendom for nearly half a century. Anselm of Laon, "the
light of France and of the world" as he is called by Guibert of Nogent,[4] was
the master of William of Champeaux and of Abelard. Students from Italy
and Germany came to study at Laon, and doctors of renown left their chairs
in order to sit once more on the benches and listen to Anselm's lectures.[5]
Nothing discouraged the pupils, neither distance nor tragic events happening
under their very eyes—the burning of the cathedral for instance, the murder
of the bishop, or the banishment of the citizens.[6]

[1] See the complete work on the subject by the
Abbé Clerval, *Les Écoles de Chartres au moyen âge.*
Paris, 1895, 8vo.
[2] Quoted by John of Salisbury in the *Metalogicus*,
iii. 4; *Patrol.*, cxcix., col. 900.
[3] End of the eleventh century.

[4] *De vita sua*, iii., iv.; *Patrol.*, clvi.
[5] On Anselm of Laon, see *Hist. littér. de la France*,
vii. 89 *seq.*
[6] These events occurred in 1112; Anselm died in
1117.

OF THE THIRTEENTH CENTURY

When nearly a century later the Liberal Arts were carved on the façade of the new cathedral and painted on one of the rose-windows[1] one might well believe that it was done in memory of Anselm, "doctor of doctors."

At Auxerre too the Liberal Arts are twice represented.[1] The fame of the cathedral School in the twelfth century is illustrated by the fact that on returning from Bologna, Thomas, afterwards archbishop of Canterbury, thought fit to conclude his studies at Auxerre.[2] One may take it as a general rule that wherever one finds the Trivium and Quadrivium represented in the church there a flourishing School existed. The presence of figures of the Liberal Arts at Sens, Rouen and Clermont may be accounted for in this way.[3]

At Paris, the town called by Gregory IX "parens scientiarum" or "Cariath Sepher,"—the town of books,"[4] it is surprising to find no representation of the Liberal Arts on Notre Dame under whose shadow the young university was growing up. They might, however, have been seen in the central doorway before the sacrilegious mutilations of the end of the eighteenth century. The trumeau which supported the statue of Christ was decorated with the figures of the Arts.[5]

But we will now consider the individual representations of the Liberal Arts as found in the cathedrals, and see to what extent the text of Martianus Capella inspired the craftsmen. Valuable details may be gathered from illustrated manuscripts, and occasionally from buildings in countries other than France.

Grammar is still the venerable woman in a long mantle, but the mediæval artist wisely retained only one of the attributes given her by Martianus Capella, namely the whip. It is obvious that the case of instruments—the scalpel and the file in eight sections—convey no definite idea to the mind. More austere than the poets, the sculptors and painters stripped from the Arts of Martianus Capella their superfluous ornament and discarded all but essentials. Thus the elementary character of the teaching given by Grammar

[1] Sculptured on the west façade, right doorway (much mutilated), and painted in the rose of a window in the choir. The window is given by Cahier and Martin, *Vitraux de Bourges*, pl. XVII.
[2] *Hist. littér. de la France*, ix. p. 43.
[3] At Sens on the west façade, central doorway (reproduced in *Dict. raison. de l'archit.*, Viollet-le-Duc, under "Arts libéraux"); Rouen, Portail des Libraires, on the trumeau—the series is mutilated and incomplete; at Clermont, north façade, upper part

(rose-window in the gable); Soissons, window in the chevet.
[4] Papal bull of 1231. See *Hist. littér.*, xvi. p. 48.
[5] Viollet-le-Duc, *Dict. raisonné de l'arch.*, under "Arts libéraux." Many representations of the Liberal Arts have disappeared. They were to be seen on the pavements in St. Remi at Reims, in the church of St. Irénée at Lyons, in the cathedral at St. Omer. See *Ann. archéol.*, xi. p. 71.

RELIGIOUS ART IN FRANCE

is shown by the two children at her knees with heads bent over their books.[1]

Dialetic has the serpent, the attribute which distinguishes her at the first glance[2] (Fig. 42). Exceptions to this are rare, but it should be mentioned that in the old west porch at Chartres she carries a scorpion. For some reason Alanus de Insulis also substitutes the scorpion for the

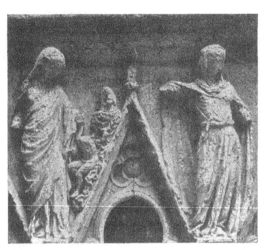

FIG. 42.—GRAMMAR AND DIALECTIC (porch at Auxerre)

serpent. In the fifteenth century the unknown artist who painted the Liberal Arts in the Salle Capitulaire at Le Puy gave the scorpion to Dialectic, and we find it again in Botticelli's fresco from the Villa Lemmi in the Louvre. Both traditions persist in art.

Rhetoric is very simply conceived. Except in a solitary thirteenth century manuscript[3] she never appears with the helmet, lance, or shield. The Rhetoric at Laon, whose right arm is broken, may have carried a spear, but it is more likely that she is making some eloquent gesture. It is in this attitude she most often appears except when she writes on her tablets, as in the rose-window at Laon.

It was obviously impossible to represent Arithmetic with the pencil of luminous rays streaming from her forehead and multiplying to infinity. Another feature in the description caught the artists' attention. Among the qualities distinguishing her was the surprising agility of her fingers, and in the rose-window at Auxerre and on the doorway of the cathedral of Friburg Arithmetic is shown with extended arms, open hands and fingers that seem to move.[4] This gesture must have seemed meaningless to the

[1] She is thus represented in the old porch at Chartres. It is the earliest carved figure of Grammar which has come down to us (Fig. 44). The tradition is still respected in the fifteenth century (see the fresco at Le Puy). In the porch at Auxerre (Fig. 42) the figures of the children are mutilated.

[2] The serpent at Laon and at Auxerre is wound like a girdle round the waist of Dialectic. In the window

at Auxerre Dialectic, unmistakable by the serpent which encircles her, has been called by accident "Alimetica," arithmetic.

[3] Bibl. Sainte-Geneviève, MS. No. 1041-2, fo. 1, vo. (thirteenth century).

[4] She is called "[di]alectica" at Auxerre by mistake. As we have seen Dialectic was called "alimetica," the inscriptions have been transposed.

84

artist at Laon for he has placed the balls of the abacus between her fingers, a clear indication of the complex calculations that she makes. Arithmetic is twice represented in this way at Laon—on the west doorway and in the rose-window in the north transept. Few artists brought so much ingenuity to bear upon their text as the sculptor and glass-painter at Laon. Elsewhere the representation is of a figure seated before a rod with sliding balls [1] or before a table covered with figures. [2]

The Geometry of Martianus Capella has very definite attributes, a tablet on which she traces geometrical figures, a compass or graduated rule (according to the meaning given to the word " radius "), and a globe. These attributes, with the exception of the globe which might confuse Geometry with Astronomy, are found in almost all the cathedrals. At Sens and at Chartres the compasses have been broken and there remains only the tablet on which Geometry draws her diagrams, but on the façade at Laon the figure is intact. The word " radius " was everywhere taken to mean compasses, but as if to reconcile the two meanings Geometry at times has the compasses in one hand and the rule in the other. Examples are found in a window at Auxerre, the porch at Friburg and also in a few manuscripts. [3]

Astronomy no longer has the splendour in which Martianus Capella clothed her, she has no aureole of light and no wings of gold and diamonds. She holds only that bent instrument, " cubitalem mensuram," which serves her in measuring the altitude of the stars, and perhaps the book of various metals which is the symbol of the climata. At Sens, [4] Laon, Rouen and Friburg she holds up an astrolabe, and in a window at Auxerre she carries her book. [5]

Of the personifications only Music has lost all the features which distinguished her in the original.

The pagan Harmonia who playing an unknown instrument advances at the head of a train of poets and of gods, has been replaced by the figure

[1] Manuscript of the *Hortus deliciarum*, tracings in the Cabinet des Estampes, in the collection Bastard de l'Estang. The original at Strasburg was burned during the siege.

[2] Cathedral at Clermont. Window in the chapel Saint-Piat in Notre Dame at Chartres. MSS. Bibl. Nat., MS. franc. 574, fo. 28. (*Image du monde*, fourteenth century, Bibl. Sainte-Geneviève, No. 2200, fo. 58, vo. *Image du monde*, thirteenth century.) Window at Soissons.

[3] *Hortus deliciarum*. and Bibl. Sainte-Geneviève, 2200, fo. 58, vo.

[4] Base of the porch, first row, third figure.

[5] In the old porch at Chartres and in the window at Laon, as in the MS. of the *Hortus deliciarum*, Astronomy is shown with eyes raised to heaven and a bushel (which at Chartres can no longer be seen) in her hand. Does this mean as Viollet-le-Duc guessed that the stars should be studied by reflection (article " Arts libéraux ") or is it as Abbé Bulteau believed a reminder that Astronomy fixes the time of seed-sowing ? (*Monogr. de Chartres*, ii. p. 77.) It is difficult to say in the absence of any literary reference which we have been able to discover.

of a seated woman who strikes with a hammer on three or four bells[1] (Fig. 43). In the Middle Ages Music rarely had other attributes. In the thirteenth century psalters, to recall that King David was the greatest of musicians and so to speak the incarnation of music, the miniaturists represent him with two hammers hitting bells which are suspended above him.[2] We have here traces of a popular mediæval tradition as to the

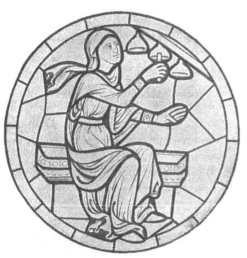

origin of music, for following Peter Comestor Vincent of Beauvais relates that Tubal, the descendant of Cain, invented music by striking resonant bodies with hammers of different weights. " The Greeks," he adds, " erroneously attributed this invention to Pythagoras." [3] There is no doubt that the hammers placed in the hands of Music by mediæval artists were intended to recall her origin.

One realises what possibilities for plastic art are contained in the text of Martianus Capella's poem since the demands of two or even three centuries did not

FIG. 43.—MUSIC (window at Laon)
(*From M.M. de Florival and Midoux*)

exhaust them. The Middle Ages could not conceive the Liberal Arts other than in the guise of seven majestic maidens. The exceptions to this rule are negligible.[4]

In the old west porch at Chartres the artist, conforming still more closely to the text of Martianus Capella, has borrowed a new motif. In his book the Arts are almost always accompanied by a retinue of great men who in their cultivation became famous. At Chartres beneath each of the

[1] In the porch at Auxerre and on the famous bronze candelabrum in the cathedral at Milan (thirteenth century) Music is represented playing the cither; these are exceptions.

[2] There are innumerable examples, *e.g.* Bibl. Sainte-Geneviève, No. 2689, fo. 124, and 2690, fo. 99 (thirteenth century).

[3] *Spec. doctrin.*, xvi., cap. xxv.

[4] The bas-reliefs on the façade of the cathedral at

Reims (left porch, chambranle), which Didron took for the Liberal Arts (*Ann. archéol.*, xiv. p. 25 *seq.*) are very obscure. It seems to me very unlikely that these numerous figures, which though they certainly seem to be engaged in meditation yet have no definite attributes, symbolise the Arts. Canon Cerf (*Hist. de la cathédrale de Reims*, Reims, 1861, 8vo, ii. p. 102) expresses legitimate doubt.

OF THE THIRTEENTH CENTURY

Arts is seen the seated figure of a man engaged in writing or in meditation. It is not easy to name these figures, since Martianus Capella admits not one but many into the train of every Art. Yet with the help of books widely known in the Middle Ages, and by comparison with analogous though later works, we may attempt to identify them.

The figure seated under Grammar can be none other than Donatus or Priscian (Fig. 44). The Middle Age gave the preference sometimes to one, sometimes to the other, but as a rule did not separate them. Isidore of Seville, who mentions by name the inventor of each Art in his " Etymologies," assigns Grammar to Donatus.[1] But at Chartres itself in the twelfth century Thierry, the doctor whose *Heptateuchon* or *Manual of the Seven Liberal Arts* has been preserved, placed Donatus and Priscian in the same rank, using books by both when teaching grammar.[2] According to Vasari, the grammarian Donatus is seated beneath Grammar[3] in the fourteenth century frescoes in the Spanish Chapel in Santa Maria Novella at Florence, where as at Chartres each Art is accompanied by its most illustrious representative. But in the fifteenth century frescoes in the Salle Capitulaire at Le Puy—conceived on the same plan as those at Florence—Priscian (whose name is written in full) is placed at the feet of Grammar.[4] It is thus difficult to assert, as did the Abbé Bulteau, that at Chartres Priscian was represented to the exclusion of Donatus.

FIG. 44.—GRAMMAR WITH DONATUS OR PRISCIAN, AND MUSIC WITH PYTHAGORAS (?) (Chartres)

Beneath Rhetoric one need hardly hesitate to recognise Cicero. Although in twelfth century Chartres he was known only by his most scholastic treatises, the *De Inventione* and the *De partitione oratoria*, and the *Rhetorica ad Herennium* then attributed to him,[5] he was none the less the master of the art of oratory for the men of that day. As Alanus de Insulis has it, " Rhetoric might be called the daughter of Cicero."[6] It is he who sits at

[1] Isidore, *Etym.*, i. ch. vi.; *Patrol.*, lxxxii.
[2] Abbé Clerval, *L'Enseignement des Arts libéraux à Chartres et à Paris, d'après l'Heptateuchon de Thierry de Chartres*, Paris, 1889, brochure.
[3] Vasari, *Vite*, Florence, 1878 (Milan edition), i. p. 580. In such matters Vasari is not a very safe guide, for in the sixteenth century mediæval traditions were almost forgotten.

[4] See Mérimée's account of the paintings at Le Puy which he himself discovered. *Ann. arch.*, x. p. 287 *seq.*
[5] See Clerval, *op. cit.*
[6] *Anticlaudianus*, III., ii.

87

RELIGIOUS ART IN FRANCE

the feet of Rhetoric in the fresco at Le Puy, it is also he no doubt, though Vasari does not say so, who is seen in the fresco at Florence.

Dialectic is accompanied at Chartres by a man who dips his pen into the inkpot, and makes ready to write. One may safely assert that he is Aristotle, the great master of the Schoolmen. At the end of the classical era Isidore of Seville proclaimed Aristotle as the father of dialectic,[1] and the whole Middle Age echoed him. But at Chartres there seems to have been a special reason for connecting Aristotle with dialectic, for it is more than probable that the *Organon* in its entirety was first introduced into France by Thierry, a teacher at Chartres. In 1136 Abelard possessed only the first two treatises of which the *Organon* is composed, the *Categories* and the *de Interpretatione*.[2] About the year 1142 Thierry inserted the others (the *Analytics, Topics* and *Sophistici Elenchi*) into the *Heptateuchon*,[3] while it was his pupils John of Salisbury and Gilbertus Porretanus, later directors of the school at Chartres, who were the first to mention the yet unknown books of Aristotle. So it was in all probability at Chartres that the complete version of Aristotle's famous book was first studied. Chartres is in this sense the true cradle of scholasticism. It is then more than probable that the figure in the bas-reliefs on the old west porch, carved at the very moment when Thierry was finishing his book, was that of Aristotle.[4]

Who is the figure seated beneath Music who is writing so diligently? (Fig. 44). He can scarcely be taken for Tubal (whom as we have seen Vincent of Beauvais gives as the inventor of music) for arguing from Florence or Le Puy he would be shown striking on an anvil with two hammers. The man at Chartres who, pen in hand, reflects as he composes a didactic treatise, bears a closer resemblance to a scholar than to a patriarch of primitive times. He is most probably Pythagoras, and the sculptor at Chartres has followed the tradition of Cassiodorus[5] and Isidore of Seville[6] which attributed to him the discovery of the laws of music.

The figure under Astronomy certainly represents Ptolemy. By Isidore of Seville[7] and Alanus de Insulis[8] he was considered the greatest of astronomers,

[1] *Etymol.*, i. ch. xxii.
[2] See Hauréau, *Hist. de la Philos. scolastique*, i., and Cousin, *Abélard* (preface).
[3] See Clerval, *op. cit.* The date—1142—given by the Abbé Clerval for the redaction of the *Heptateuchon* seems pretty well established.
[4] See Lasteyrie (*Études sur la sculpture française du moyen âge*, fondation Eugène Piot, 1902, 8vo, ch. 7), on the probable date of the old porch at Chartres.

The figures were carved about 1145. See also the articles of M. Lanore in the *Revue de l'art chrétien*, 1899-1900.
[5] Cassiodorus, *De artibus ac discipl. liberalium artium*, v.; *Patrol.* lxx.
[6] *Etymol.* III., xv.; *Patrol.*, lxxxii.
[7] *Ibid.*, III. xxiv.
[8] *Anticlaud.*, I., iv.

88

OF THE THIRTEENTH CENTURY

and moreover at Chartres in 1140 his were the only known books on the subject. Astronomy was studied in the *Tables* and in the *Canons* which the Arabs had transmitted as Ptolemy's to the Christian world.[1]

Although no book of Euclid appears in the *Heptateuchon* of Thierry of Chartres, it is not altogether improbable that Geometry is accompanied on the façade by Euclid, for his was a great name. It is he who represents Geometry in the poem of Alanus de Insulis[2] and who is painted in the Spanish Chapel at Florence.[3]

Beneath the feet of Arithmetic is a scholar in the act of teaching, whose name it is not easy to guess. In the encyclopædias of Isidore of Seville[4] and Vincent of Beauvais,[5] on which the Middle Ages were dependent for their knowledge, Pythagoras is named as the inventor of arithmetic. In Martianus Capella's work Pythagoras holding a torch is the sole escort[6] of Arithmetic. The tradition was that he had invented both arithmetic and music, and he was generally accorded this double glory.[7] It is therefore possible that Pythagoras was represented at Chartres both writing at the feet of Music and teaching at the feet of Arithmetic. One name alone could be substituted with any degree of probability. Boethius, mentioned by Isidore of Seville among the scholars who were distinguished in the science of numbers,[8] was a special subject of study at Chartres where Thierry wrote two books in explanation of his treatise on arithmetic.[9] It was Boethius too, as M. Chasles was able to prove from his study of that same *Heptateuchon*, who made known to the Middle Ages the figures improperly called "arabic" as well as calculation by the position of digits. Boethius has then almost as much right as Pythagoras to figure at the feet of the muse of arithmetic, and it is impossible to choose between the two.

We see that at Chartres the device contrived by Martianus Capella was scrupulously followed, and as in *The Marriage of Mercury and of Philology* each Art was accompanied either by its inventor or by the man who in cultivating it acquired the greatest fame. In the cathedral at Clermont the idea of Martianus Capella is presented in an abridged and original form. Here science and savant have become one, and seated in the *cathedra* Aristotle, Cicero and Pythagoras hold in their hands the usual attri-

[1] *Clerval, op. cit.*, p. 20.
[2] *Anticlaud.*, III., vi.
[3] *Vasari, op. cit.*
[4] *Etymol.*, III., ii.
[5] *Spec. natur.*, xvi.
[6] Martianus Capella, vii.

[7] It should however be remembered that both Peter Comestor and Vincent of Beauvais thought that the honour of the invention of music belonged to Tubal rather than to Pythagoras.
[8] Isidore, *Etymol.*, III., ii.
[9] Clerval, *op. cit.*, pp. 10, 18, 19.

RELIGIOUS ART IN FRANCE

butes of the seven Liberal Arts. But to show that these great masters have now become symbols, and are therefore clothed with the majesty of the Arts, crowns have been placed upon their foreheads.[1]

III

We have up till now discussed the Seven Arts of the trivium and quadrivium, but there still remains Philosophy, the mistress of them all.

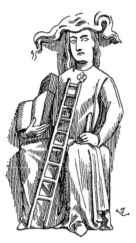

FIG. 45.—PHILOSOPHY (Laon)
(*After Viollet-le-Duc*)

Her image as sculptured at Sens and at Laon[2] is distinguished by curious attributes, especially at Laon where a ladder leans against her and clouds rest upon her head (Fig. 45). In attempting to explain this strange figure Viollet-le-Duc says ;—"This is Philosophy or Theology. The statuette holds a sceptre in her left hand, in her right an open book on which rests a closed one. One presumes that the closed book signifies the Old Testament, the open one the New. Her head is not crowned as at Sens, but loses itself in cloud, and a ladder from her feet reaches to her neck and typifies the succession of rungs that must be climbed to attain to perfect knowledge of the queen of the arts."[3] It is an accurate description, but the interpretation is incorrect. Viollet-le-Duc was not acquainted with the book from which the artists drew this singular picture of Philosophy, for it is certainly Philosophy and not Theology that is before us, and Philosophy with the attributes given to her by Boethius.

In the *Consolation of Philosophy* Boethius relates that he was in prison, and while pondering his sad fate there appeared to him of a sudden a woman whom he describes in the following words ;—"Her countenance was full of majesty, her eyes shone as with fire and in power of insight surpassed the eyes of men, her colour was full of life, her strength was yet intact though she was so full of years that none would ever think that she was subject to such age as ours. One could but doubt her varying stature, for at one moment she repressed it to the common measure of a man, at

[1] In the north porch.
[2] Sens, west porch ; Laon, west front, left window, round the arch.

[3] Viollet-le-Duc, *Dict. raisonné de l'archit.*, under "Arts libéraux," ii. p. 5.

90

another she seemed to touch with her crown the very heavens; and when she had raised higher her head, it pierced even the sky and baffled the sight of those who would look upon it. Her clothing was wrought of the finest thread by subtle workmanship brought to an indivisible piece. This had she woven with her own hands, as I afterwards did learn by her own showing. Their beauty was somewhat dimmed by the dulness of long neglect (as is seen in the smoke-grimed masks of our ancestors). On the border below was inwoven the symbol π, on that above was to be read a θ. And between the two letters there could be marked degrees by which, as by the rungs of a ladder, ascent might be made from the lower principle to the higher. Yet the hands of rough men had torn this garment and snatched such morsels as they could therefrom. In her right hand she carried books, in her left was a sceptre brandished." [1]

This woman, whose strange appearance Boethius has described with so much originality, is no other than Philosophy who comes to console him in his prison. As to the mysterious letters π and θ, the commentators agree in seeing in them a concise way of indicating the two aspects—practical and theoretical—of philosophy.

The statue at Laon corresponds in every detail to this description. The sculptor has merely omitted those features which were not compatible with his art. He has represented Philosophy as Boethius saw her, her head in the clouds, a sceptre in the left hand and books in the right. He has not even hesitated to give plastic form to the symbolism of the ladder (Fig. 45). How could sculpture go further? It is perhaps surprising that he did not engrave the π and θ on the edge of her robe, but I am of opinion that the two letters were originally painted there and have disappeared with the action of time. Mediæval architecture like classical was polychrome. Almost all statues were painted, doubtless with both the reticence and the feeling for effect possessed in so high a degree by the painters of the Middle Age, whose windows witness to their fine sense of colour. Originally the

[1] *Consol. phil.*, lib. I., cap. i.—"Adstitisse mihi supra verticem visa est mulier reverendi admodum vultus, oculis ardentibus et ultra communem hominum valentiam perspicacibus, colore vivido atque inexhausti vigoris, quamvis ita ævi plena foret, ut nullo modo nostræ crederetur ætatis. Statura discretionis ambiguæ : nam nunc quidem ad communem sese hominum mensuram cohibebat, nunc vero pulsare cœlum summi verticis cacumine videbatur : quæ cum altius caput extulisset, ipsum etiam cœlum penetrabat, respicientiumque hominum frustrabatur intuitum. Vestes erant tenuissimis filis subtili artificio indis-solubili materia perfectæ, quas, uti post, eadem prodente, cognovi, suis manibus ipsa texuerat. Quarum speciem, veluti fumosas imagines solet, caligo quædam neglectæ vetustatis obduxerat. Harum in extrema margine π græcum, in supremo vero θ græcum legebatur intextum. Atque in utrasque litteras in scalarum modum gradus quidam insignati videbantur quibus ab inferiore ad superius elementum esset ascensus. Eamdem tamen vestem violentorum quorumdam sciderant manus et particulas quas quisque potuit abstulerat. Et dextera quidem ejus libellos, sceptrum vero sinistra gerebat."

RELIGIOUS ART IN FRANCE

painted statues in the porch of Notre Dame at Paris stood out from a background of gold, forming a sumptuous whole which in the fifteenth century filled the Bishop of Armenia with admiration, accustomed though he was to the magnificence of oriental art.[1] It is then more than probable that the artist at Laon who followed the text of Boethius so closely did not forget the symbolic π and θ.

The two Greek letters moreover are found elsewhere. On the basement of the cathedral at Sens, in the series of Liberal Arts in the central doorway,

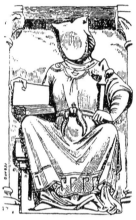

FIG. 46.—PHILOSOPHY (Sens)
(*After Viollet-le-Duc*)

there is a figure carved in low relief. It has been reproduced by Viollet - le - Duc who questioned whether it represented Philosophy or Theology[2] (Fig. 46). Any doubt is removed by close examination of the bas-relief, for it shows conclusively that we are once more in the presence of Philosophy. She has the form of a seated woman who holds, as in the description of Boethius, a book in her right hand and a sceptre in her left. The head, which is mutilated, seems to have been crowned and not partly hidden in the clouds as at Laon, but it should be remembered that to Boethius himself Philosophy did not always appear of heroic height but sometimes of human stature. The artist's sense of fitness led him to choose the figure of Philosophy when reduced to human proportions, and to omit the ladder. He considered that in a carving of low relief such detail would detract from the nobility and strength of the composition. But faithful to Boethius and anxious to retain all essentials, he has carved a line of the letter θ at the top of her garment and a line of π on its lower edge. It is easy to recognise the two Greek letters in the drawing by Viollet-le-Duc, for he has reproduced them with his usual accuracy. But he mistook their meaning, and evidently considered such a succession of π as a kind of Greek key pattern.

In my judgment it is proved up to the hilt that the figures at Laon and at Sens represent Philosophy, and that they represent her after a passage in Boethius.

[1] Description of Notre Dame at Paris by a bishop of Armenia, published in the *Annales archéol.*, i. p. 100 *seq.*

[2] Viollet-le-Duc, *Dict. raisonné de l'archit.*, ii. p. 3, Fig. 3.

The persistent influence of Boethius is not surprising to one even slightly acquainted with the history of the transmission of thought in the Middle Ages. He was revered as the depository of classical learning and as the educator of the modern world. He was at once the last of the Romans and the first of the mediæval doctors, and his position on the confines of the two worlds invested him with something of the mystery which surrounded Virgil. His defects no less than his qualities contributed to his fame. His vast learning no doubt aroused admiration, but it was the vague sadness, the subtle symbolism, the sudden bursts of poetry which mingle so strangely with his dialectic, in short all that there was of disquietude in this latter-day philosophy, which made the strength of his appeal to men. One can see at a glance that Boethius is almost always to be found in the catalogues of the monastic and episcopal libraries of the Middle Ages.[1] Everything goes to prove that his *Consolation of Philosophy* was received as a classic, and it is not surprising to find that the characteristics and attributes of Philosophy were fixed by him once for all. He had seen Philosophy and had talked with her, the Middle Age took him at his word and had no wish to represent her otherwise.[2]

But in the course of the thirteenth century other figures were added to those of Philosophy and of the seven Liberal Arts. Men were consumed with a desire to explore all fields of knowledge. The universities classified the whole of human knowledge, and the great books of the thirteenth century inevitably took the form of encyclopædias. The Middle Age believed that the limits of knowledge had been reached, and that its own task was one of co-ordination. And so in the thirteenth century new figures appear side by side with the seven maidens of the trivium and the quadrivium. Medicine is seen at Sens,[3] Laon,[4] Auxerre [5] and Reims.[6] Even the occult sciences had their place in the cathedral, for astrology and alchemy then hovered on the borderland of science and of dreams. In the

[1] See L. Delisle, *Le Cabinet des manuscrits*, i. p. 511, and ii. pp. 429, 447, 448, 487, 493, 513, 530, 536; iii. pp. 1–9 (10 copies of Boethius in the Sorbonne). See also Maurice Faucon, *La librairie des papes d'Avignon*, i. p. 70, and ii. 132. As to Laon in particular, we know that his book was in the chapter library there in the tenth century. See the *Catal. des MSS. des Bibl. des départements*, i. p. 232, No. 439. See also Montfaucon, *Biblioth. des Biblioth. des manuscrits*, ii. p. 1292.

[2] In the *Anticlaudianus* Alanus de Insulis describes Philosophy, " Prudentia," as follows, borrowing several features from Boethius. He says (I., vii.) :

" Canone sub certo dimensio nulla retardat
Corporis excursum, vel certo fine refrenat,
Nunc magis evadens cœlestia vertice pulsat,
Nunc oculos frustrans cœlestibus insidet, ad nos
Nunc redit. . . ."

[3] West porch.

[4] West façade (window moulding), and glass.

[5] Rose of a window.

[6] West front, right doorway. Medicine is found among the Vices. She has evidently not been recognised.

north porch at Chartres a figure named " Magus " symbolises the pursuit of alchemy. In his hand is a scroll probably once covered with cabalistic signs, at his feet crouches the winged dragon whose name occurs so frequently in magic formulæ.

The arts which were then making such enormous strides are not forgotten. Architecture is represented in the north porch at Chartres by the form of a man holding rule and compass.[1] A painter stands by his side palette in hand.

In this porch as in the *Speculum doctrinale* of Vincent of Beauvais, the mechanical arts and the crafts accompany the sciences. Tubal striking his anvil stands for metallurgy, Adam delving and Cain ploughing represent agriculture, Abel tending his flocks the raising of cattle.[2]

One feels that there is here an attempt to widen the somewhat narrow bounds of the trivium and quadrivium, and a desire to embrace every science and every art.

IV

The cathedral teaches that work of any kind demands respect. Another lesson she would teach men is to expect neither riches from manual labour nor fame from learning. Work and knowledge are the instruments of man's inner perfection, and the things which his activities gain for him are of a material and fleeting nature.

In the cathedral at Amiens a curious figure embodies this moral truth. There is in the upper part of the south porch a kind of half-wheel round which seventeen small figures are arranged. Eight of them seem to be carried up with the wheel, and eight others descend with it. At the top a man is seated, his head crowned and a sceptre in his hand, motionless while all around him moves (Fig. 47). Is this, as Didron tried to prove, an allegory of the different ages of man ?[3] We do not think so. The figures descending so abruptly with the wheel are dressed in rags, and have bare feet or shoes through which their toes appear. This surely must convince one with Jourdain and Duval that this symbolic half-circle is not the wheel

[1] Architecture is, I think, also to be seen on the façade at Laon. She is symbolised by a man who, a plane-table on his knee, seems to trace a diagram.

[2] The crafts are represented in the same way at Reims (in the mouldings of the rose-window in the north porch). Tubalcain is hammering, Jabal working in the tent, &c. See also the same figures on the Campanile at Florence.

[3] Didron, *Iconographie chrétienne. Guide de la peinture du Mont-Athos*, p. 408, note. This theme of the ages of man is not unknown in French mediæval iconography. I believe they are to be seen at Notre Dame at Paris (west front, left porch, to the right on the trumeau). There are six ages beginning with adolescence (" infantia " is missing).

OF THE THIRTEENTH CENTURY

The persistent influence of Boethius is not surprising to one even slightly acquainted with the history of the transmission of thought in the Middle Ages. He was revered as the depository of classical learning and as the educator of the modern world. He was at once the last of the Romans and the first of the mediæval doctors, and his position on the confines of the two worlds invested him with something of the mystery which surrounded Virgil. His defects no less than his qualities contributed to his fame. His vast learning no doubt aroused admiration, but it was the vague sadness, the subtle symbolism, the sudden bursts of poetry which mingle so strangely with his dialectic, in short all that there was of disquietude in this latter-day philosophy, which made the strength of his appeal to men. One can see at a glance that Boethius is almost always to be found in the catalogues of the monastic and episcopal libraries of the Middle Ages.[1] Everything goes to prove that his *Consolation of Philosophy* was received as a classic, and it is not surprising to find that the characteristics and attributes of Philosophy were fixed by him once for all. He had seen Philosophy and had talked with her, the Middle Age took him at his word and had no wish to represent her otherwise.[2]

But in the course of the thirteenth century other figures were added to those of Philosophy and of the seven Liberal Arts. Men were consumed with a desire to explore all fields of knowledge. The universities classified the whole of human knowledge, and the great books of the thirteenth century inevitably took the form of encyclopædias. The Middle Age believed that the limits of knowledge had been reached, and that its own task was one of co-ordination. And so in the thirteenth century new figures appear side by side with the seven maidens of the trivium and the quadrivium. Medicine is seen at Sens,[3] Laon,[4] Auxerre[5] and Reims.[6] Even the occult sciences had their place in the cathedral, for astrology and alchemy then hovered on the borderland of science and of dreams. In the

[1] See L. Delisle, *Le Cabinet des manuscrits*, i. p. 511, and ii. pp. 429, 447, 448, 487, 493, 513, 530, 536; iii. pp. 1–9 (10 copies of Boethius in the Sorbonne). See also Maurice Faucon, *La librairie des papes d'Avignon*, i. p. 70, and ii. 132. As to Laon in particular, we know that his book was in the chapter library there in the tenth century. See the *Catal. des MSS. des Bibl. des départements*, i. p. 232, No. 439. See also Montfaucon, *Biblioth. des Biblioth. des manuscrits*, ii. p. 1292.

[2] In the *Anticlaudianus* Alanus de Insulis describes Philosophy, "Prudentia," as follows, borrowing several features from Boethius. He says (I., vii.) :

"Canone sub certo dimensio nulla retardat
Corporis excursum, vel certo fine refrenat,
Nunc magis evadens cœlestia vertice pulsat,
Nunc oculos frustrans cœlestibus insidet, ad nos
Nunc redit. . . ."

[3] West porch.

[4] West façade (window moulding), and glass.

[5] Rose of a window.

[6] West front, right doorway. Medicine is found among the Vices. She has evidently not been recognised.

RELIGIOUS ART IN FRANCE

north porch at Chartres a figure named "Magus" symbolises the pursuit of alchemy. In his hand is a scroll probably once covered with cabalistic signs, at his feet crouches the winged dragon whose name occurs so frequently in magic formulæ.

The arts which were then making such enormous strides are not forgotten. Architecture is represented in the north porch at Chartres by the form of a man holding rule and compass.[1] A painter stands by his side palette in hand.

In this porch as in the *Speculum doctrinale* of Vincent of Beauvais, the mechanical arts and the crafts accompany the sciences. Tubal striking his anvil stands for metallurgy, Adam delving and Cain ploughing represent agriculture, Abel tending his flocks the raising of cattle.[2]

One feels that there is here an attempt to widen the somewhat narrow bounds of the trivium and quadrivium, and a desire to embrace every science and every art.

IV

The cathedral teaches that work of any kind demands respect. Another lesson she would teach men is to expect neither riches from manual labour nor fame from learning. Work and knowledge are the instruments of man's inner perfection, and the things which his activities gain for him are of a material and fleeting nature.

In the cathedral at Amiens a curious figure embodies this moral truth. There is in the upper part of the south porch a kind of half-wheel round which seventeen small figures are arranged. Eight of them seem to be carried up with the wheel, and eight others descend with it. At the top a man is seated, his head crowned and a sceptre in his hand, motionless while all around him moves (Fig. 47). Is this, as Didron tried to prove, an allegory of the different ages of man?[3] We do not think so. The figures descending so abruptly with the wheel are dressed in rags, and have bare feet or shoes through which their toes appear. This surely must convince one with Jourdain and Duval that this symbolic half-circle is not the wheel

[1] Architecture is, I think, also to be seen on the façade at Laon. She is symbolised by a man who, a plane-table on his knee, seems to trace a diagram.

[2] The crafts are represented in the same way at Reims (in the mouldings of the rose-window in the north porch). Tubalcain is hammering, Jabal working in the tent, &c. See also the same figures on the Campanile at Florence.

[3] Didron, *Iconographie chrétienne. Guide de la peinture du Mont-Athos*, p. 408, note. This theme of the ages of man is not unknown in French mediæval iconography. I believe they are to be seen at Notre Dame at Paris (west front, left porch, to the right on the trumeau). There are six ages beginning with adolescence ("infantia" is missing).

of Life, but the wheel of Fortune.[1] A miniature in an Italian manuscript of the fourteenth century supports this interpretation.[2] Near to the figure which seems to mount the wheel is written "regnabo," near to that enthroned at the summit "regno," near to those descending on the other side "regnavi" and "sum sine regno." The subject is certainly power, riches, glory, the pomps and vanities of the world, and the wheel expresses the instability of these things.

The example at Amiens is not unique. On the north porch of St. Étienne at Beauvais and in the porch of the cathedral at Basle the same

FIG. 47.—THE WHEEL OF FORTUNE (from a rose-window (south) at Amiens)

little figures mount and descend with a wheel. It is probable that the same motif was employed in parts of the cathedral which have since been destroyed, as for example in the glass of the rose-windows. One may gather from a sketch in Villard de Honnecourt's *Album* how wide-spread was the representation of this subject in the Middle Ages,[3] while the following significant words occur in the *Somme le Roi*: "In these cathedral churches and royal abbeys is Dame Fortune who turns topsy-turvy faster than a windmill."[4]

It seems at first sight as if this idea, at once so naïve and so profound,

[1] Jourdain and Duval, *Le Portail Saint-Honoré ou de la Vierge dorée à la cathédrale d'Amiens.* Amiens, 1844, 8vo.

[2] The miniature was published by G. de Saint-Laurent, *Guide de l'art chrétien,* iii. p. 346.

[3] *Album* of Villard de Honnecourt, pl. XLI. The chief wheels of Fortune have been enumerated by G.

Heider, *Das Glücksrad,* in *Mittheilungen der K. K. Centralcommission,* Vienna, 1859.

[4] *Somme le Roi* (Lausanne edit. 1845), p. 67. In the twelfth century an abbot of Fécamp had a wheel of Fortune made which turned mechanically, that his monks might ever have before them the spectacle of human vicissitudes. See *Bibl. de l'École des Chartes,* 1859, p. 154.

was of popular origin, but reflection shows that it is the distortion of an ancient metaphor. The Middle Ages had heard of the wheel of Fortune, but imagined the goddess not carried round on a winged wheel as represented in classical times, but placed inside the wheel and taking part in its movement. It is thus that Honorius of Autun pictures her : " Philosophers," [1] he writes, " tell us of a woman fastened to a wheel which turns perpetually, so that they say she is sometimes rising and sometimes falling with its movement. What is this wheel ? It is the glory of the world which is carried round in perpetual motion. The woman fastened to the wheel is Fortune, whose head alternately rises and falls because those who have been raised by their power and riches are often precipitated into poverty and misery." [2]

How closely this resembles Fortune as conceived by the Italian miniaturist to whom we have referred. He placed her in the midst of the spokes of the wheel (" rotæ innexa " to quote Honorius) to which she apparently communicates the movement. This new and curious manner of representing Fortune and her wheel is derived from certain passages in the *Consolation of Philosophy*, where the second book is entirely devoted by Boethius to the fickleness of Fortune. In a prosopopoeia recalling that of Death in Lucretius, Fortune herself explains to Boethius that he has no right to complain of her changing moods. Philosophy, who is present at the interview, speaks in her turn, and armed with the usual arguments of the stoic philosophy concludes the demonstration. But the matter of special interest which this second book holds for us is the constant recurrence of the subject of the wheel of Fortune. Now Boethius, curiously enough, had already represented men as fastened to Fortune's wheel and perforce rising and falling with her. The chief passage runs : " I cause a rapid wheel to turn ; I love to raise the fallen and to abase the proud. Mount, then, if thou wilt, but on condition that thou dost not wax indignant when the law that presides at my Games demands that thou shalt descend." [3] The origin of the idea under discussion is to be found in this and similar passages. The Middle

[1] It will shortly be seen that the philosophers of whom Honorius speaks somewhat vaguely, amount to one—Boethius.

[2] Honorius of Autun, *Spec. Eccles.*, col. 1057. *Patrol.*, clxx. ii.

[3] Boethius, *Consol. phil.*, Teubner's edition, 1861, ch. ii. " Rotam volubili orbe versamus, infima summis, summa infimis mutare guademus. Ascende, si placet, sed, ea lege, ne uti, cum ludicri mei ratio poscet, descendere injuriam putes," and " Tu vero volventis rotæ impetum retinere conaris ?

" Haec cum superba verterit vices dextra,
Exaestuantis more fertur Euripi.

Dudum tremendos sæva proterit reges
Humilemque victi sublevat fallax vultum."

A passage from Alanus de Insulis (*Anticlaudianus*, bk. VIII., ch. 1) shows how the Middle Ages improved upon Boethius by whom they were inspired. It speaks of Fortune :

" Præcipitem movet illa rotam, motusque laborem
Nulla quies claudit . . .
Hos premit, hos relevat, hoc dejicit, erigit illos.
Summa rotæ dum Cresus habet, tenet infima Codrus,
Julius ascendit, descendit Magnus, et infra
Sylla jacet, surgit Marius, sed, cardine verso,
Sylla redit. . . ."

Ages, which took everything in a literal sense and loved to clothe the most abstract thought in concrete form, gave artistic expression to the metaphor of Boethius. From the twelfth to the fifteenth century this symbolic wheel on which man rises and falls, was used to illustrate the sudden changes of fortune.[1]

And so the Wheel of Fortune at Amiens offers a new subject for medita-

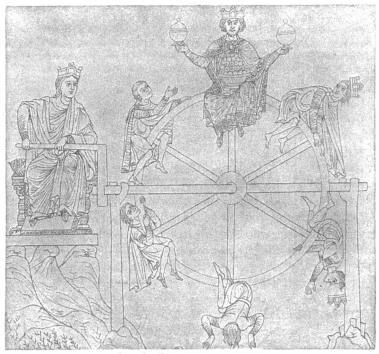

FIG. 48.—THE WHEEL OF FORTUNE
(After the Hortus deliciarum, twelfth century)

tion. The dignity given by riches, glory, power, endures but for a moment. The king whom we envy is seated on a wheel, to-morrow his place will have been taken by another. Man's work, man's knowledge, man's effort should not be for the possession of any such transient good. He needs a stronger impulse than this world can give, and this he finds in God alone.

Virtue is the goal of all work and of all knowledge.

[1] The miniature in the *Hortus deliciarum* (twelfth century) which we reproduce, shows Fortune placed outside the wheel, and causing its revolution (Fig. 48). A miniature in a MS. of Boethius of the end of the fifteenth century shows the philosopher in prison talking to Philosophy, side by side with Fortune with her wheel on which men mount and descend. *Boethius* belonging to the Sieur de la Gruthuyse, miniature reproduced by Molinier in *Les Manuscrits*, 1892. 12°, p. 288.

BOOK III

THE MIRROR OF MORALS

I.—Representations of the Virtues and Vices in mediæval Art. The Psychomachia of Prudentius and its influence. II.—The Virtues and Vices seen under new forms in the thirteenth century. The twelve Virtues and the twelve Vices at Notre Dame at Paris, Chartres and Amiens. III.—The Active and the Contemplative Life. Statues at Chartres.

I

NATURE, knowledge, virtue—that is the order in the *Speculum majus*. It will be remembered that these are the three worlds of Pascal, the world of material things, the world of mind and the world of love. The unity of Christian thought is so marked that one finds it unchanged through the centuries. Virtue is higher than knowledge or art, said the Middle Ages, it is man's goal. But curiously enough the artists have sometimes placed the highest in the lowliest position. At Paris and Amiens the twelve pensive maidens who symbolise the virtues are not enthroned above the doorway with the angels and the blessed, but are placed at the level of men's eyes so that in passing to and fro they may learn to know them well. Age after age, worn by the rubbing of countless hands, covered with the dust from countless feet, they stand indeed one with the life around them. It would be difficult to express more clearly that the perfection which the Gospel demands can and should be attained.

From primitive Christian times the Virtues took concrete and living form, and were conceived as heroic maidens, beautiful and simple. As early as the *Shepherd* of Hermas they appeared as female figures, a little later we see them as armed maidens. Apparently it was Tertullian who first represented the Virtues as warrior-maidens struggling with the Vices in the arena. "See," says he, "wantonness overthrown by chastity, perfidy killed by honesty, cruelty thrown down by pity, pride conquered by humility ; these are the games in which we Christians receive our crowns." [1] Like Martianus Capella who later made the arts to live, move and speak, Tertullian, who was also of African birth, could not refrain from clothing

[1] Tertullian, *De Spectaculis*, xxix. On this subject see Puech, *Prudence*, Paris, 1888, 8vo, p. 246.

RELIGIOUS ART IN FRANCE

his thought in concrete form. He was the first to give naïve expression to the profound teaching that Christianity had not brought peace to the world but a sword, and that the soul had become a battlefield. In its ignorance of the true nature of man the ancient world tried to establish a harmony which is not of this world, for so long as man lives will the conflict between his two natures exist. The drama which to the ancients was the struggle of man with Fate is in reality a conflict raging within the soul.

The idea of an inner battle, or Psychomachia, does not indeed belong to Tertullian since it is one of the fundamental ideas of Christianity, but to his imagination is due its concrete embodiment. Tertullian's words might well serve as argument for the poem of Prudentius. The *Psychomachia* tells of the battle of the Virtues and Vices in Virgilian verse,[1] and often resembles a cento of the Æneid. So new an idea was worthy of a more original form, and it is surprising to find Prudentius at once so inventive and so imitative. But it should not be forgotten that even the painters of the Catacombs were obliged to borrow traditional figures from classical art in order to give adequate expression to their thought. Such as it is, the poem of Prudentius gave endless pleasure to the age that followed him. It was felt that he gave a definite picture of the inner conflict. Mediæval art went to him for inspiration, and it was from him that Romanesque and even early Gothic sculptors took their representations of the virtues and vices. It is therefore necessary to have some knowledge of the characteristic episodes of his poem.

He shows us the armies of the Virtues and the Vices confronting each other, while from the ranks champions come forth, challenge one another according to the rule of epic poetry, and engage in single combat. First Faith (*Fides*), with generous rashness, rushes into the field.[2] Disdaining to shelter herself with breastplate or shield, she advances with bare breast against her enemy, old Idolatry (*vetus Cultura deorum*). The fight is short. Wounded as she is, Faith overthrows Idolatry and proudly places a foot upon her head.

Chastity (*Pudicitia*), a young girl in shining armour, encounters the sudden shock of Lust (*Libido*),[3] a courtesan who brandishes a smoking torch. She overturns the torch with the blow of a stone,[4] and drawing her

[1] Prudentius, *Patrol.*, lx., col. 19 *sq.*
[2] *Psychom.*, v. 22 *sq.*
[3] *Ibid.*, v. 41 *sq.*

[4] The stone, as the commentators hold, probably symbolises Christ.

99

RELIGIOUS ART IN FRANCE

sword slays Lust, who as she dies vomits turgid blood which taints the purity of the surrounding air. Pitiless as a Homeric warrior, Chastity apostrophises the corpse of her enemy, extolling Judith in whom chastity first triumphed, then she washes her polluted sword in the sacred waters of Jordan.

Patience (*Patientia*), grave and quiet, stands awaiting the attack of Anger (*Ira*).[1] Immovable as a rock she receives the blows which rain down upon her breastplate. At last Anger rushes forward sword in hand and strikes her enemy on the head, but the helmet is invulnerable and splinters the sword. In her rage she seizes a javelin that is at her feet and thrusts it into her own breast. Thus Patience triumphs over her enemy without even drawing sword.

Now Pride (*Superbia*), mounted on a spirited horse, caracols in front of the enemy's army.[2] Her hair is piled up towerlike on her forehead, her mantle is blown by the wind. This impetuous warrior addresses the enemy, insolently accusing the impassive Virtues of cowardice. Suddenly horse and rider disappear in a trap that Dishonesty (*Fraus*) has dug on the battlefield. Humility (*Mens humilis*) then advances, takes the shield which Hope holds out to her and cuts off the head of Pride. Then the beautiful maiden spreads her golden wings and soars heavenwards.

Self-indulgence (*Luxuria*) with perfumed hair, graceful and languishing, appears mounted on a marvellous car. The axle is of gold, the wheels are silver-gilt, and the whole car sparkles with precious stones. The beautiful enemy fights after another manner, for instead of arrows she flings violets and rose-leaves. The Virtues are confused, but Temperance (*Sobrietas*) armed with the standard of the cross steps in front of the chariot. The horses rear, the car is overturned, and Luxuria rolls in the dust. Her retinue desert her. Petulantia flies dropping her cymbals, while Cupid abandons his bow. With a single blow of a stone Temperance overcomes her helpless foe.

During this combat Avarice (*Avaritia*), ever on the watch, gathers with her claw-like fingers the gold and jewels that Luxuria in her flight has scattered on the sand.[3] She first hides them in her bosom, then fills up the purses and bags hidden under her left arm.[4] Ratio dares to attack her, but

[1] *Psychom.*, v. 109 *sq.*
[2] *Ibid.*, v. 178 *sq.*
[3] *Ibid.*, v. 455 *sq.*
[4] The verses should be quoted for they inspired the artists—

". . . nec sufficit amplos
Implevisse sinus : juvat infercire crumenis
Turpe lucrum, gravidos furtis distendere fiscos,
Quos læva celante tegit, laterisque ministri
Velat operimento."

OF THE THIRTEENTH CENTURY

she cannot triumph single-handed. Beneficence (*Operatio*)[1] must come to her aid. She kills Avarice and distributes the gold to the poor.

The battle seems at an end. Concordia crowned with a branch of olive, gives the order to carry the victorious standard back to the camp,[2] but while she is speaking an arrow from the enemy's ranks strikes her following in the flank. It is Discord or Heresy (*Discordia* or *Hæresis*) who refuses to lay down her arms, so the combat rages anew till Discord vanquished by Faith has her tongue pierced through by a lance.

The Virtues, at length victorious, celebrate their triumph by raising a temple like that of the new Jerusalem in the Apocalypse.

Such is the poem to which writers and artists so often came for inspiration. The Carlovingian poets Theodulphus and Walafrid Strabo follow Prudentius in telling of the battle of the Virtues and Vices. Rather later Alanus de Insulis took the same subject, and the ninth book of his *Anticlaudianus* is entirely occupied with a psychomachia.

Poets who wrote in the vulgar tongue, like the trouvère Rutebeuf, also occasionally worked at the time-worn theme.[3] The theologians themselves are full of the poem of Prudentius, where the battle of the Virtues and Vices seemed to them like a drama. Isidore of Seville pictured their struggle in a chapter of his *Book of Sentences*.[4] Gregory the Great—if indeed he be the author of the treatise *De conflictu vitiorum et virtutum*—opposed the Virtues and Vices in pairs, making them challenge each other like Homeric combatants.[5] Part of this treatise was reproduced by Vincent of Beauvais who doubtless admired its life and movement.[6] Doctors as serious as Hugh of St. Victor[7] and Gulielmus Arvernus,[8] when treating of the Virtues and Vices, felt bound to show them in action and to make them speak. In each case the impulse came from Prudentius.

The artists soon began to struggle with the text. It may be that the first illustrated manuscript of Prudentius dates back to the very century in which the poet lived, for the tenth century manuscript in the Bibliothèque Nationale[9] is decorated with drawings of quite classical design, evidently copied from some very early original. The old designs slightly retouched and adapted to the taste of the day reappear in a Prudentius of the thirteenth century.[10]

[1] *Operatio* evidently includes both Charity and her "Works."
[2] *Psychom.*, v. 645 *sq.*
[3] *Rutebeuf*, ed. Jubinal, 1839, vol. ii. p. 56.
[4] *Sentent.*, lib. II. ; *Patrol.*, lxxxiii. col. 658.
[5] Bibl. de l'Arsenal, MS. No. 250.
[6] Vincent of Beauvais, *Spec. histor.*, lib. XXII. cap. l.

[7] Hugh of St. Victor, *Appendix : De Anima*. *Patrol.*, CLXXVII., col. 185.
[8] Gulielmus Arvernus, *De moribus*, Orleans edition, 1674, fol., vol. i. p. 119.
[9] MS. Latin 8318, f. 49 *sq.*
[10] Bibl. Nat., MS. Latin 15158 ; see, for example, Cupid throwing his darts (f. 48) and compare it with

RELIGIOUS ART IN FRANCE

The most interesting of all illustrations to Prudentius are certainly those in the *Hortus deliciarum*.[1] In this crude manuscript, which is in no way connected with the preceding group, the drawings show the Virtues under the aspect of twelfth century knights. The warrior-maidens who in Prudentius bear the breastplate of Aeneas and Turnus, have become Frankish barons, clothed in coats of mail, wearing helmets with nose-pieces, and carrying the large triangular shield and the long sword of the first crusade. The battle is rude like some feudal tournament or Judgment of God. The artist has followed the text closely, illustrating it episode by episode.

It is in this form that the Virtues appear on the capitals and in the porches of Romanesque churches. Armed with a lance they tread under foot their vanquished foe, which at times takes the form of a monster. They are seen thus for example on one of the capitals of the church of Notre Dame du Port at Clermont,[2] in the cathedral at Tournai, and on the porches of a number of churches in the west,—at Notre Dame de la Coudre at Parthenay, St. Hilaire at Melle, St. Nicolas at Civray,[3] at Aulnay,[4] Fenioux in Charente-Inférieure and at St. Pompain in the Deux-Sèvres. At Aulnay (Fig. 49) the Virtues and Vices are named : Ira et Patientia, Luxuria et Castitas, Superbia et Humilitas, Largitas et Avaritia, Fides et Idolatria, Concordia et Discordia, the very contrasts given by Prudentius. Pudor and Libido are missing, but for reasons of symmetry the artist at Aulnay as elsewhere is limited to six couples. The varied engagements of Prudentius are here portrayed in a uniform fashion, each Virtue triumphing over her enemy in precisely the same way. Characteristic detail has disappeared,[5] and the stir of conflict is replaced by the calm of victory. If one may so express it, the dynamic conception of the poet has yielded to the static realisation of the artist. The somewhat turbulent heroines of Prudentius have been frozen into figures of majestic immobility. The late twelfth and the early thirteenth century sculptor well understood the exigencies of his art.

Love in MS. 8318, f. 58, v. We would refer the reader to M. R. Stettiner's detailed study of illustrated manuscripts of Prudentius. (*Die illustrirten Pruden-tiushandschriften.* Berlin, 1895, 8vo. A collection of the illustrations which accompany the text has just been published.) The illustrated manuscripts of Prudentius in all the libraries in Europe have been classified by M. Stettiner. He too (p. 152 *sq.*) sees an original of the fifth century behind the Carlovingian manuscripts.

[1] Traced copy in the Cabinet des Estampes (de Bastard collection).

[2] Cast in the Trocadéro.

[3] Willemin, *Monuments français inédits*, pl. XLVII.

[4] R. de Lasteyrie, *Étude sur l'Église d'Aulnay.* *Gazette archéologique*, 1886.

[5] Some of these characteristics are found in decorative art. On the cross commonly known as Ragenfroid's (probably of the twelfth century ; Willemin, *Mon. franç. inédits*, pl. XXX., and F. de Mély, *Gazette archéol.*, 1888) Discord's tongue is pierced with a lance as in Prudentius. This and similar characteristics (Sobrietas breaks Luxuria's teeth, &c.), are also seen on Melisenda's Ivory (twelfth century) ; Cahier, *Nouv. mél. archéol.*, vol. ii. pl. I.

The Gothic sculptors do not show the predilection of the Romanesque artists for the poem of Prudentius. They found, as will be seen, new forms for the Virtues, though they did not at once abandon the old theme of the psychomachia. A very early presentation of the conflict of Virtues and Vices is seen round the arch of one of the porches of the cathedral at Laon.[1] The artist has taken liberties with the

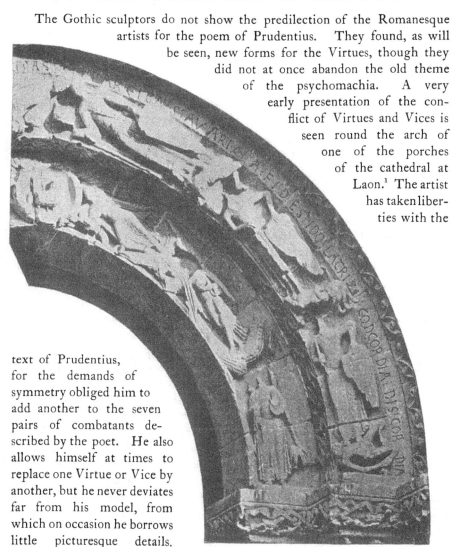

text of Prudentius, for the demands of symmetry obliged him to add another to the seven pairs of combatants described by the poet. He also allows himself at times to replace one Virtue or Vice by another, but he never deviates far from his model, from which on occasion he borrows little picturesque details. Libido, for example, holds a

FIG. 49.—PSYCHOMACHIA (Aulnay, twelfth century)

flaming torch with which she threatens Castitas, and Avaritia hugs her purse to her bosom. The inscriptions, of which several are mutilated,[2] give the

[1] West front, left porch.
[2] They have been carefully restored by the Abbé Bouxin. *La cathédrale Notre-Dame de Laon.* Laon, 1890, 8vo, p. 64.

name of the combatants [Sobriet]as and Hebeta[tio], Luxuria and Castitas, Pati[entia] and Ira, Caritas and Paup[er],[1] Fides and Idolatria, Superbia and [Humilitas], Violentia and [Mansuetudo ?], Largitas and Avaritia. There is no doubt that the sculpture at Laon dates from the early years of the thirteenth century.

In the course of the century this poem of Prudentius gradually lost its creative force. The artists retain some memory of it for episodes similar to those invented by the Latin poet still appear in their works, but it is evident that the dominant idea, the idea of a battle between the Virtues and Vices, was losing ground. The north porch at Chartres[2] shows the old artistic tradition in process of transformation. The Virtues still triumph over the Vices, but there is no conflict. The enemy, at whom they do not even deign to look, lies prone beneath their feet. The battle is ended in fact, so the Virtues have discarded their warlike costume and hold in their hands only attributes of peace.[3] The artist wished to portray not conflict but victory. This is a noble spectacle, but one that does not touch men so closely, for the triumphant Virtues no longer seem to belong to this world.[4] At Chartres the very choice of Virtues and Vices is no longer that of the poet. Prudence is opposed to Folly, Justice to Injustice, Fortitude to Cowardice, Temperance to Intemperance, Faith to Infidelity (in the form of the Synagogue), Hope to Despair, Charity to Avarice, Humility to Pride. Here we find no longer that rather disordered company, apparently chosen haphazard by Prudentius, in which the Virtues have no accepted rank. We recognise at once the four cardinal and the three theological virtues. The necessity for filling a vacant place and for placing four Virtues in each arch explains the presence of Humility and Pride ; a happy choice, for to contemporary theologians pride was the root of all the vices. Certain details however show that this work is indebted to some extent to Prudentius. Pride, for example, tumbles head foremost into the ditch that has opened beneath her feet. Avarice, not content with filling her purse and coffers, hides her riches in her bosom. Despair (in Prudentius it is Anger) falls on her own sword.

We have here one of the last representations of the psychomachia, and it is an enfeebled one. The artists had already conceived an entirely new way of representing the Virtues and Vices, yet in the eastern district—

[1] Charity is not opposed to a vice. She is shown giving alms to a poor man.
[2] On the arch, left doorway.
[3] These attributes will be examined later.

[4] Notice that at Chartres they are placed by the side of the Beatitudes of the soul in the future life. See the chapter on the Last Judgment.

OF THE THIRTEENTH CENTURY

in Alsace, so long faithful to Romanesque traditions and to the past, the old theme is preserved until much later. In the doorway of Strasburg cathedral the Virtues, charming youthful figures of the late thirteenth century, despatch with their lances the Vices beneath their feet, and a fourteenth century window in the church is devoted to the symbolic conflict of twelve Virtues and twelve Vices.[1] It is a fuller and more systematic choice than that of Prudentius, and the cardinal and theological Virtues are accompanied by a certain number of accessory Virtues.[2] The genius of the mediæval doctors had not been applied in vain to distinguishing, defining, and classifying the virtues.

Again at the close of the fourteenth century, almost at the end of the Middle Ages, the conflict of the Virtues and Vices is seen for the last time in the porch and the windows of the church of Niederhaslach in Alsace.[3]

II

From the twelfth century onwards the theologians, and after them the artists, began to see the opposition of the virtues and the vices under new aspects. Honorius of Autun, one of the perennial sources of inspiration for mediæval art, conceives virtue as a ladder which links earth to heaven.[4] He interprets the vision of Jacob in a moral sense. Each of the fifteen rungs of the ladder is a virtue, and he gives their names—patientia, benignitas, pietas, simplicitas, humilitas, contemptus mundi, paupertas voluntaria, pax, bonitas, spirituale gaudium, sufferentia, fides, spes, longanimitas and perseverantia.

It was a difficult task to realise this metaphor, for it did not lend itself to pictorial art. The miniaturist who illustrated the *Hortus deliciarum* made the attempt with the help of a Byzantine original. He gives a faithful representation of the mystic ladder which resting upon earth loses itself in heaven, and on it he places the race of men (Fig. 50).[5] Clerk and layman climb painfully from rung to rung, while the vices, which remain on the ground, beckon to them from below. A bed, symbol of idleness,

[1] Near the entrance.
[2] In his *Histoire de la peinture sur verre* (p. 241) F. de Lasteyrie has restored their names. (Prudentia) et Stultitia, (Justicia) et Iniquitas, Sobrietas et Gula, Simplicia et Fraus, Fides et Idolatria, Humilitas et Superbia, Caritas et Invidia, Largitas et Avaritia, Castitas et Luxuria, Concordia et Discordia, Fortitudo et Acidia, Spes et Desperatio.

[3] F. de Lasteyrie, *Ibid.*, p. 263.
[4] Honorius of Autun, *Scala cœli minor*, col. 869; *Spec. Eccles.*, col. 869; *Patrol.*, clxxii. He did not invent the metaphor, but took it from St. Joannes Climacus.
[5] See copy in the Cabinet des Estampes (collection de Bastard).

invites them to come and rest from their labours, and Luxuria smiles at them. The gold in the baskets, the food on the dishes, the horses and the shields, all arouse their eager desire. Some cannot resist the temptation, and from the heights to which they have attained return with a sudden drop to the earth. But one woman, a religious no doubt, hearing and seeing nothing, mounts towards the crown which awaits her at the summit. Could more dramatic rendering be given to an allegory ? How it must have affected the child-like souls of the nuns for whom it was designed, and even to-day its evident sincerity makes an appeal.

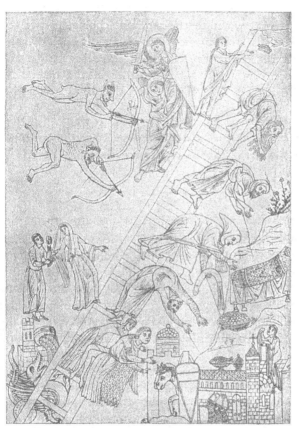

FIG. 50.—THE LADDER OF VIRTUE
(*After the Hortus deliciarum*)

About the same time another metaphor appeared. The theologians of the twelfth and thirteenth centuries who studied the connection between virtues and vices with such diligence, frequently compared them to two vigorous trees.

Hugh of St. Victor, one of the first to present this new idea in fully developed form, gives a name to each branch of the two trees.[1] One is the tree of the old Adam and has pride as its root and main stem. From the trunk spring seven great boughs, envy, vainglory, anger, sadness, avarice, intemperance, luxury. In its turn each bough divides into secondary branches. For example, from sadness grow fear and despair. The second tree is the tree

[1] Hugh of St. Victor, *De fructibus carnis et spiritus. Patrol.*, clxxvi., col. 997.

OF THE THIRTEENTH CENTURY

of the new Adam with humility for its trunk, and the three theological and the four cardinal virtues as its seven main branches. Each virtue is sub-divided in its turn. From faith grow the shoots of chastity and obedience, from hope come patience and joy, from charity concord, liberality, peace and mercy. The first of these trees was planted by Adam and the second by Christ, it is for man to choose between them.[1] One of the most famous of thirteenth-century books, the *Somme le Roi* written in French for Philip the Bold by Brother Laurent, his Dominican confessor,[2] presents Hugh of St. Victor's idea under new forms. The author begins by showing the two trees of good and of evil, but with a deeper knowledge of human nature he gives love, that is charity, as the root of the first tree, and desire, that is egoism, as the root of the second.[3] Thus all the vices spring from love of self, as all the virtues from forgetfulness of self. He might well have adhered to this beautiful parallel, so simple and true, but Brother Laurent belonged to his age and desired a subtler symbolism. Later in his book the seven virtues no longer appear as the seven branches of one tree, but as seven different trees planted in a beautiful orchard which is the Eden of the soul. Seven limpid streams—the seven gifts of the Holy Spirit—gush out at the foot of the seven trees, and from the fountain head seven maidens draw water in seven vessels, the seven petitions of the Paternoster.[4] The vices too have a new symbolic form. Brother Laurent believed that the seven haughty heads of the dragon of the Apocalypse were an image of the seven Deadly Sins, and over each head he has inscribed the name of one of the vices.

Conceptions of this kind were not without their influence upon art. They explain certain enigmatic drawings in manuscripts of the thirteenth century. To take an example. In the *Miroir de vie et de mort* in the Bibliothèque Sainte-Geneviève a curious miniature represents a great tree with spreading roots.[5] These roots have the peculiarity of ending in the form of a serpent with a woman's head. Most of these women hold some emblem or make some gesture which would permit of recognition even were their names not written near them. The first (*Radix luxuriæ*) looks at herself in her mirror, the second (*Radix gulæ*) holds a glass in her

[1] The two trees are drawn in a few manuscripts, but in very diagrammatic fashion. See, for example, No. 1116 (thirteenth century), f. 185 in the Bibliothèque de l'Arsenal.
[2] See *Hist. littér.*, vol. xix. p. 397, and P. Paris, *Les MSS. français*, vol. iii. p. 388.
[3] *Somme le Roi* (Lausanne edition, 1845, in the fourth volume of *Mémoires et Documents*, published by the Société d'hist. de la Suisse remande, p. 23).
[4] *Ibid.*, p. 241. The MSS. show the orchard and the seven maidens. See MS. No. 870, f. 61 v. in the Bibliothèque Mazarine.
[5] Bibl. Ste.-Geneviève, MS. 2200, f. 164 (1276 is the date of the MS.).

hand, the third (*Radix avaritiæ*) closes a strong box, the fourth (*Radix acidiæ*) turns away from the altar, the fifth (*Radix iracundiæ*) tears out her hair, the sixth (*Radix invidiæ*) bears an animal in her bosom, while the seventh (*Radix superbiæ*)[1] has no special attribute. The tree thus rooted in sin flourishes greatly. At its summit sits a queen, crown on forehead, sceptre in hand, surrounded by black birds. This insolent figure is as it were an anti-Virgin, a Virgin of evil, and the white doves which rest on the Virgin Mary become the black ravens of hell. A ladder leans against the tree, and while musicians tune their instruments, a woman clothed in white like a corpse mounts slowly, carrying under her arm the lid of her coffin.

Several metaphors dear to the theologians of the twelfth and thirteenth centuries are here cleverly blended. The tree is evidently the Tree of Evil of the doctors conceived in a slightly different manner. The vices are at its roots, and these roots are at the same time the seven heads of the dragon of the Apocalypse. The ladder reminds one of the ladder which Honorius of Autun set up between earth and heaven. But that one leads to life, this to death, and those who scale it believe that they are alive, while they are already clothed in their shrouds. All the ideas of virtue and vice which a cultivated mind of the day could frame, and all the similes current in the schools, here find expression.

Monumental art never sought inspiration in so subtle a symbolism, but left such refinements to the detailed work of the illuminator. The sculptors of the thirteenth century represented neither the tree of the vices nor the mystic ladder of the virtues, neither did they adopt the psychomachia, although as we shall see later more than a trace of it is left in their work.[2] It is true they placed the virtues and vices in opposition, but after an entirely new fashion. The Virtues of the bas-reliefs are seated women, serious, tranquil, majestic, who bear on their shields a heraldic animal in sign of their nobility. The Vices are no longer personified but are shown in descriptive scenes in medallions beneath the Virtues; a husband beating his wife is a figure of Discord, a monk flying from his convent and discarding his frock is an emblem of Inconstancy. The Virtue is thus represented in its essence, and the Vice shown in its results. On one side all is quietness, on the other side movement and conflict, and the contrast evokes in the mind

[1] There is no name, but it is not difficult to see that they are the seven Deadly Sins.

[2] In the rose-window at Notre Dame at Paris the Virtues though calm and serene yet carry a lance, a sign of the persistent influence of Prudentius. (See reproductions below, Figs. 58 and 61.)

the idea that the artist would express. These serene figures teach men that virtue alone can unify the soul and give it peace, and that without it all is discord. In discarding the psychomachia so dear to the preceding age, the thirteenth-century artist seems to wish to go deeper. The Romanesque sculptor proclaims : " The life of the Christian is conflict," while the Gothic sculptor would tell men : " The life of the Christian in whom virtue reigns supreme is peace itself, it is already rest in God."

The earliest example of this mode of representation is to be seen on the façade of Notre Dame at Paris.[1] One cannot doubt that it was a craftsman of Paris who with the help of some theologian worked out this novel arrangement during the early years of the thirteenth century. It is these bas-reliefs which, although during the eighteenth century they suffered from the clumsy restoration of Soufflot's workmen,[2] must be the point of departure for our study. The large rose-window in the west front of Notre Dame shows the same subject treated in an almost identical way.[3] The bas-reliefs at Amiens[4] were executed several years after those at Paris of which they are almost exact reproductions. Those at Chartres,[5] sculptured in the second half of the thirteenth century, remain absolutely faithful to their prototype (Fig. 51) ; a window at Auxerre,[6] almost contemporaneous with the porch at Chartres, though less complete, obviously derives from the same original ; and lastly, at Reims a series of bas-reliefs of the Virtues and Vices executed about the same time, show some traces of the original idea in spite of mutilations and many gaps.[7]

A study of these different series will show the way in which one completes and interprets the other. The bas-reliefs at Paris, Amiens and Chartres, where this mode of presentation found its full development, show twelve Virtues and twelve Vices arranged in precisely the same order: Faith and Idolatry, Hope and Despair, Charity and Avarice, Chastity and Luxury, Prudence and Folly, Humility and Pride, Strength and Cowardice, Patience and Anger, Gentleness and Harshness, Concord and Discord, Obedience and Rebellion, Perseverance and Inconstancy.

[1] The façade of Notre Dame at Paris dates from the early years of the thirteenth century. The rare documents which permit of establishing any chronology are in V. Mortet's *Étude hist. et archéol. sur la cathédrale et le palais épiscopal de Paris.* Paris, 1888, 8vo. Amiens and the porches at Chartres are later.
[2] F. de Guilhermy, *Descript. de Notre-Dame de Paris*, Paris, 1856, 12°, p. 31.
[3] See Lenoir, *Statist. monument. de Paris*, vol. ii. pl. xix. This plate is not entirely trustworthy, for several panels are modern. Happily F. de Lasteyrie

(*Hist. de la peint. sur verre*, p. 138) shows the condition of the window before restoration.
[4] West porch, central door, basement. It is known that the cathedral at Amiens was begun in 1220.
[5] South porch. The bas-reliefs decorate the pillars in the porch. The porches at Chartres were not finished until about 1280.
[6] The rose of a window in the choir (reproduced in *Vitraux de Bourges*, plan XVIII.).
[7] West front, right doorway.

RELIGIOUS ART IN FRANCE

What general idea has dominated this choice is the first question that arises, for all the virtues should have been present and some of the principal ones are absent.[1] One easily recognises that the series begins with the three theological virtues—Faith, Hope and Charity—whose nature St. Paul was the first to define.[2] They are in the very order assigned them by the theologians; for " Faith builds the foundations of the spiritual edifice, Hope raises it, and Charity crowns it," or again " It is because we believe that we hope, and because we hope that we love." [3]

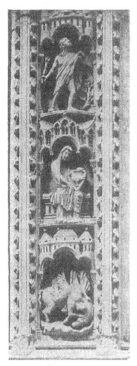

After these three we expect to find the four cardinal virtues, Temperance, Fortitude, Prudence and Justice, which taken by St. Ambrose from Plato's *Republic* and adapted to Christian thought,[4] were admitted from the fourth century into the theological literature of the west. Saint Augustine sanctioned this division of the virtues,[5] which was transmitted to the Middle Ages by Isidore of Seville and after him by Rabanus Maurus.[6] The theologians whose study of the virtues was most profound, Peter Lombard in the twelfth century and Aquinas in the thirteenth, conformed to the accepted classification. The divisions of the *Summa* are marked by the three theological and four cardinal virtues, and St. Thomas applies himself especially to showing how from these seven chief virtues all others spring.[7]

FIG. 51.—FOLLY, HUMILITY AND PRIDE (Chartres, south porch)

The system of Aquinas is adopted in the *Speculum morale*, added to the

[1] Justice, for example.

[2] 1 Corinthians, xiii.

[3] Peter the Precentor, *Verbum abbreviativum.* *Patrol.*, ccv., col. 271.

[4] Ambrose, *De Paradiso*, iii. ; *Patrol.*, xiv., col. 279. He compares the four virtues with the four rivers of Paradise. The Phison which flows over gold is Prudence, the Gihon which bathes Ethiopia (whose name signifies impurity) is Temperance, the Tigris (in Hebrew the swift) is Fortitude, and the Euphrates (the Fertile) is Justice. To St. Ambrose each of the four ages of man also corresponds to a virtue. The first age, from Abel to Noah, is that of Prudence; the second, from Abraham to Jacob, that of Chastity ; the third, from Moses to the prophets, that of Fortitude;

the fourth, which begins with Jesus, is that of Justice. The baptismal fonts at Hildesheim (thirteenth century) show the four rivers of Paradise symbolising, in conformity with the doctrine of St. Ambrose, the four cardinal virtues, *e.g.* near to the Euphrates is written : " Frugifer Euphrates est justitia quæ notatur." The cardinal virtues are represented above.

[5] Augustine, *De libero arbitrio*, lib. I., cap. xiii. *Patrol.*, xxxii., col. 1235, and *De Moribus Ecclesiæ cathol.*, lib. I., cap. xv. ; same volume, col. 1322.

[6] Isidore of Seville, *Differentiarum*, lib. II., cap. xxxix. and xl.; *Patrol.*, lxxxiii., col. 95. Rabanus Maurus, *Tractatus animæ ; Patrol.*, cx. col. 1109.

[7] Aquinas, *Summa theolog.*, sec. secundæ, q. I., a. 1 *sq.*

OF THE THIRTEENTH CENTURY

Speculum majus after the death of Vincent of Beauvais, and while some of the apparatus of scholastic logic is omitted, the same general results are reached.

It is natural therefore to expect the cardinal Virtues to follow the theological in these series of sculptured Virtues. Canons Jourdain and Duval, who first attempted an explanation of the bas-reliefs at Amiens, manage at all costs to find Temperance, Fortitude, Prudence and Justice following Faith, Hope and Charity.[1] They argue as men familiar with mediæval art, and convinced that the bas-reliefs of the cathedrals were infallible books of instruction in invariable conformity with the teaching of the schoolmen. But in this instance they were labouring under a delusion, and their prejudiced eyes could not discern the true meaning of the figures they wished to interpret. In the works of art now under consideration it must be admitted that there is not that scrupulous fidelity to dogma to which mediæval art has accustomed us. The nine Virtues which acccompany the three theological Virtues seem to be chosen and arranged haphazard. A Virtue takes precedence of or even replaces another from which it is derived. Justice, for example, does not appear at all, and its place is taken by its derivative virtue, Obedience.

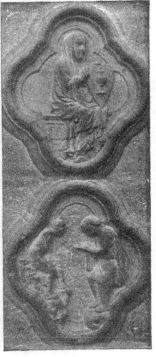

FIG. 52.—FAITH AND IDOLATRY
(Amiens)

The question arises whether this apparent lack of system does not hide some deeper order. As it is at Notre Dame that we find the earliest series of twelve Virtues and twelve Vices, we have sought for the justification of the choice in the theological works of the period which belonged to the clergy of that cathedral. The manner of disposing certain figures reveals details which certainly point to the collaboration of some scholar. Unfortunately our quest was unsuccessful. The *Sentences* of Peter Lombard, bishop of Paris at the end of the twelfth century, the *Verbum abbreviativum* of Peter the Precentor, professor of theology at the cathedral school at the very

[1] Articles by Jourdain and Duval in the *Bulletin monum.*, xi. 430 *sq.*, on the porches at Amiens.

RELIGIOUS ART IN FRANCE

time when the new church was rising,[1] the treatise *De moribus et de virtutibus* of Gulielmus Arvernus,[2] who occupied the episcopal throne of

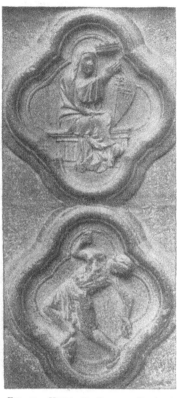

FIG. 53.—HOPE AND DESPAIR (Amiens)

Paris at the beginning of the thirteenth century, give no hint of a classification of virtues and vices which throws light on the work of art which we would interpret. The innumerable books dealing with the virtues and vices which began to appear in such large numbers in the thirteenth century, works such as the dogmatic summaries of Brother Laurent or Gulielmus Peraldus,[3] poems in the vernacular such as the little tracts on the virtues and vices [4] and the romance of *Fauvel*,[5] and simple lists of virtues and vices opposed in pairs such as are met with in manuscripts [6]—these too are differently conceived and differently arranged.

Our research has had no success, but others will perhaps be more fortunate.[7] It is difficult to believe that so important a work as the series of Virtues and Vices at Notre Dame at Paris, deemed worthy of imitation at Amiens and Chartres, was not seriously thought out on some definite plan. One remembers the tabernacle of Or San Michele at Florence, where Orcagna has borrowed his scheme from Aquinas.

In this wonderful work of art where the scholastic philosophy is crystallised

[1] He died in 1198.

[2] Gulielmus Arvernus, elected bishop of Paris in 1228, died in 1249 (*Hist. littér. de la France*, vol. xviii. p. 357). His works were published at Orleans in 1674, 2 vols., fol.

[3] Gulielmus Peraldus, Bibl. Sainte-Geneviève, MS. No. 1448.

[4] Bibl. Nat., MSS. franç. 24429, f. 69 and 17177. These are two thirteenth century poems on the Virtues.

[5] The two books of *Fauvel*, Bibl. Nat., MS. franç. 146 (fourteenth century).

[6] See Bibl. de l'Arsenal, MS. No. 903, fo. 136 (thirteenth century).

[7] We formerly accepted the theory, put forth by the Abbé Lebeuf in his description of Notre Dame at Paris (*Hist. de tout le diocèse de Paris*, edit. Cocheris, p. 9), that the twelve Virtues on the doorway were executed after a list found in a life of St. Geneviève, patroness of Paris. But reference shows that the list and the bas-relief do not agree. The following are the twelve virtues enumerated by the hagiographer (*Acta Sanct.*, Jan. vol. i. p. 239, edition of 1643), fides, abstinentia, patientia, magnanimitas, simplicitas, innocentia, concordia, caritas, disciplina, castitas, veritas, prudentia.

in marble as in Dante's poem it is transmuted into light, each of the cardinal virtues is accompanied by an accessory virtue taken from the list drawn up by St. Thomas, a list which reveals a profound knowledge of human nature.[1] Fortitude, for instance, is flanked by Patience and Perseverance, Prudence by Docility and Ability. If in fourteenth-century Florence the classification of the virtues was so precise, it can hardly be supposed that in the Paris of the thirteenth century, the zenith of the theological era, the order was left to chance.[2]

However that may be, we must now study these figures of the Virtues and Vices one after another, and endeavour with the help of theological literature to explain them in detail. Faith has the place of honour on the right hand of Christ. She is seated on a bench, holding a shield on which at Paris a cross is seen,[3] at Chartres a chalice,[4] at Amiens a cross in a chalice (Fig 52).[5] In the north porch at Chartres Faith fills the chalice with the blood of the Lamb slain on the altar. The Faith of the Middle Ages is the belief in the virtue of the sacrifice of the Cross, but it is also (as the chalice proves) faith in the perpetuity of that sacrifice, day by day miraculously renewed on the altar. Thus Faith as represented by the artists was in entire agreement

FIG. 54.—ANGER (from a window at Lyons)
(*After L. Bégule*)

with the definition of Augustine, adopted by Peter Lombard and accepted throughout Christendom. " Faith is the virtue by which we believe in that which we do not see."[6] Its perfect symbol is found in the Eucharist.

Beneath the figure of Faith at Paris, Amiens (Fig. 52) and Chartres is a man in the attitude of adoring a hairy idol resembling a monkey.[7] This is Idolatry, for such was the naïve form given by the Middle Ages to the

[1] See Surigny, *Le Tabernacle d'Or San Michele, Annal. arch.*, vol. xxvi.

[2] It is easy to see why there are twelve virtues only in Notre Dame at Paris ; there were twelve places to fill beneath the twelve apostles. At Chartres there are twelve although the architectural arrangement was different, because an accepted model was followed. But this does not explain why one virtue was chosen in preference to another.

[3] The cross was restored in the eighteenth century. There was probably a chalice originally.

[4] She holds the cross in her hand.

[5] In the rose-window of Notre Dame at Paris Faith also carries a cross in a chalice, but the medallion has been restored. In Italy (Pisano's door of the Baptistery at Florence, and on the Campanile) Faith again has the cross and chalice.

[6] " Fides est virtus qua creduntur quæ non videntur." *Spec. mor.*, lib. I., divis. xvii., pars. iii., after Peter Lombard.

[7] At Paris the bas-relief, restored in the eighteenth century, shows a man adoring a kind of picture. At Amiens the remains of horns point rather to a demon than a monkey.

gods of paganism.[1] To the minds of men of that day the statues of ancient deities were haunted by dangerous demons who at times showed themselves in all their hideousness. He who worshipped them worshipped Satan himself. In the north porch at Chartres a different conception is presented.

Beneath Faith is the Synagogue with blindfold eyes. We have here one of the episodes in the dramatic conflict between the two religions which, as we shall see, so often inspired the art of the thirteenth century.

When with Beatrice as his guide Dante reached the eighth sphere of Paradise, a voice issuing from a light questioned him on hope. The poet recognised St. James, who in his famous epistle was the first to write of this virtue. And Dante " eager as a pupil who followeth his teacher " gave word for word the definition he had read in the *Sentences* of Peter Lombard : " Hope is the certain expectation of future bliss, coming from the grace of God and from preceding merits."[2] And for this reason Hope at Paris, Amiens (Fig. 53) and Chartres gazes steadfastly to heaven, and reaches out her hand towards a crown, symbol of the future glory that awaits her.[3] A shield on which is drawn a standard surmounted with a cross is near by. I am of opinion that the meaning of this symbol has not been entirely understood. Archæologists see in it a sign of

FIG. 55.—CHARITY AND AVARICE
(Amiens)

victory, but it is in reality a symbol of resurrection, for a standard surmounted by a cross is admittedly the attribute of Christ rising from the tomb. The Middle Ages conceived the sublime idea of transforming the instrument of ignominy in the hand of the Saviour into a sign of victory. The confidence radiant in the face and whole attitude of Hope is founded on the certainty of the resurrection of the body. The theologians, after adopting

[1] An illustration in the romance *Fauvel* (Bibl. Nat., MS. franç. 146, fourteenth century) shows Idolatry holding a monkey by the hand (f. 12 v.).

[2] Dante, *Paradiso*, xxv. 67-9. P. Lombard, *Sentent.*, III., dist. xxvi. " Est enim Spes certa expectatio futuræ beatitudinis veniens ex Dei gratia et meritis præcendentibus."

[3] The crown is only preserved at Amiens. In the north porch at Chartres a hand emerges from a cloud to encourage Hope.

phrases from the actual epistle of St. James go on to make Hope declare : " I know that my Redeemer liveth and that in the last day I shall rise from the womb of the earth, and shall be clad anew with my flesh, and shall with my eyes behold God, my Saviour." [1] Thus by means of the cross and the crown the mediæval bas-relief would teach in its own language that man will receive his reward on the Day of Resurrection.

Over against Hope stands Despair (Fig. 53) who with a sword deals her own death blow.[2] This figure, which is sometimes that of a man, is no doubt traditional and directly connected with the poem of Prudentius, where as has been seen Anger despairing of victory over Patience kills herself. The thirteenth century had the habit of attributing to Despair what the poet had said of Anger. Certain works mark the transition. A window at Lyons in which the spirit of early days still lives (Fig. 54) shows " Ira " piercing herself with her sword in front of " Patientia,"[3] but at Auxerre it is " Desperatio " who kills herself opposite to " Patientia."[4] The sculptor at Paris, more logical than the artist at Auxerre, opposes " Desperatio " to " Spes " while giving her " Ira's " ancient form.

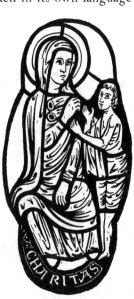

FIG. 56.—CHARITY (from a window at Lyons)
(*After L. Bégule*)

Next comes Charity, greatest of the three theological virtues. " Now there remain," says St. Paul, " faith, hope and charity, these three ; but the greatest of these is charity," [5] and he defines charity in the wonderful words : " If I speak with the tongues of men and of angels, and have not charity, I am become as sounding brass, or a tinkling cymbal. And if I should have prophecy, and should know all mysteries, and all knowledge ; and if I should have all faith, so that I could remove mountains, and have not charity, I am nothing. And if I should distribute all my goods to feed the poor, and if I should deliver my body to be burned, and have not charity, it profiteth me nothing." [6]

[1] Peter the Precentor, *Verbum abbreviativum,* col. 271 ; *Patrol.,* ccv.
[2] Paris (rose-window), Chartres (north porch), Auxerre (rose-window).
[3] Guigue and Bégule, *Monogr. de la cathédrale de Lyon,* p. 132 *sq.*

[4] At Auxerre, as at Lyons, the names of the Virtues and Vices are written in full.
[5] I Cor. xiii. 13.
[6] I Cor. xiii. 1-4.

RELIGIOUS ART IN FRANCE

This sublime virtue is love of God and love of one's neighbour for the sake of God and in God.[1] The greatness of charity, what places her above the other theological virtues, lies in this, that she alone will have a place in the future life. Faith and hope were given to man for his pilgrimage here below (*in via*), and at the end of his journey (*in patria*) they will be merged in charity.[2] Charity is then not only· the greatest of virtues, but is in reality the one virtue, and the words of St. Paul become clear.

FIG. 57.—CHASTITY AND LUXURY
(Amiens)

It must be confessed that in representing the queen of virtues the thirteenth-century craftsmen were unequal to their task. The charity they portray is simply alms-giving, which is an effect of charity and moreover a wholly outward effect.[3] At Chartres[4] and Amiens (Fig. 55), as in windows at Auxerre and Lyons (Fig. 56), Charity is a woman who deprives herself of her cloak to give it to a poor man. At Paris[5] she simply carries a shield bearing a sheep.[6] A sheep, it is true, is a touching symbol of unselfishness, for to quote Rupert of Tuy: "The sheep gives her flesh for food to those who are strong, her milk to those who are weak ; with her fleece she clothes the naked, and with her skin she shelters the cold."[7] But notwithstanding this, charity's highest quality, the love of God, finds no expression in French art, and it remained for the Italians of the fourteenth century to bring home to men her twofold nature. In Giotto's fresco in the Arena Chapel at Padua Charity with one hand is presenting her heart to God, while with the other she is about to take from a basket gifts for the poor.[8] The Charity of Orcagna's Tabernacle in Or San Michele

[1] Peter Lombard, *Sentent.*, III., dist. xxvii. " Charitas est dilectio qua diligitur Deus propter se et proximus propter Deum vel in Deo."

[2] See *Spec. mor.*, lib. I., dist. xxii., pars. iii., c. 244, and Peter Lombard, *Sentent.*, lib. III., dist. xxvii. An echo of St. Paul's words is heard in the scholastic teaching,—" Charity never falleth away, whether prophecies shall be made void, or knowledge shall be destroyed " (1 Cor. xiii. 8).

[3] Following St. Thomas, the *Spec. mor.* divides the effects of Charity into inward and outward effects.

The former are peace, joy, compassion, while one of the latter is beneficence. Lib. I., dist. xxvi., pars. iii.

[4] In both the north and south porches.

[5] In both a porch and a rose-window.

[6] The same escutcheon is also seen at Chartres and at Amiens.

[7] Rupert, *In Eccles.*, lib. I. ; *Patrol.*, clxviii., col. 1212.

[8] G. de Saint-Laurent (*Guide de l'art chrétien*, vol. iii. p. 419 *sq.*) first interpreted the attributes of Giotto's Charity.

is a still finer conception, for while she suckles a child she presents her flaming heart to God.[1] These beautiful figures give adequate expression to the words : " Thou shalt love thy God with all thine heart and thy neighbour as thyself." French art is nearer to earth. Is this a national characteristic? The greatest French saints, if one thinks of it, were men of action rather than mystics. The Charity who holds out to God her flaming heart is of the land of St. Francis of Assisi, the Charity who gives her mantle to the poor is of the land of St. Vincent de Paul.

FIG. 58.—CHASTITY (Rose-window in Notre Dame, Paris)

In the churches the figure of Avarice is opposed to Charity or, to be precise, to Beneficence. She is a woman who either fills her coffers or with energetic gesture lowers their lids.[2] Sometimes she puts her hand in her bosom to hide her gold,[3] showing once more the influence of Prudentius.[4] This and other examples which will be seen later show how the Psychomachia remained deeply imprinted on men's minds.

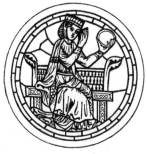

FIG. 59.—LUXURY (Rose-window in Notre Dame, Paris)

The two bas-reliefs which follow have been wrongly interpreted (Fig. 57). Canons Jourdain and Duval, convinced that the theological virtues would necessarily be followed by the cardinal virtues, thought to recognise there Justice and Injustice. M. de Guilhermy, who adopted their interpretation, explained the two bas-reliefs at Paris—which by the way are almost entirely restored—in the same fashion, and the erroneous explanation was accepted by G. de Saint-Laurent in his *Guide de l'art chrétien*. But doubts of its validity soon appeared. The Comte de Bastard put forward the theory that the two medallions at Amiens represented Chastity and Luxury,[5] and M. Duchalais proved it in an article in the *Bibliothèque de l'École des Chartes*.[6]

[1] Surigny, *op. cit.*

[2] See the Avarice on the west front of the cathedral of Sens which is opposed to a fine figure of Liberality (Fig. 76), a queen who lays bare all her treasures. She is thus described by Alanus de Insulis, *Liber de planctu naturæ*, Patrol., ccx., col. 474.

[3] At Chartres (in two porches), Amiens, Paris (rose-window). In the porch of Notre Dame at

Paris Avarice has been unintelligently restored, and seems to hide her hand in a muff.

[4] " . . . Nec sufficit amplos
Implevisse sinus."

[5] Tracings and MSS. papers in the Cabinet des Estampes (Collection Bastard de l'Éstang), the Virtues in art.

[6] *Bibl. de l'École des Chartes*," vol. v., series 2, p. 31.

RELIGIOUS ART IN FRANCE

We in our turn will study these two bas-reliefs. At Paris, Amiens and Chartres Chastity is a maiden " whose lips," to quote Alanus de Insulis, " have not been kissed." [1] On her head is the veil of virginity, in one hand she carries a palm and in the other a shield bearing an animal in the midst of flames. Is it a salamander? M. Duchalais thought so, and with the Bestiaries to hand had no difficulty in proving that the salamander which was reputed to live in flames and even to have the property of extinguishing them, was the symbol of chastity. He might have added that to the naturalists of the thirteenth century the salamander was a sexless animal.[2] But a more careful study of the heraldic animal at Chartres and Amiens, and in the rose-window in Notre Dame at Paris (Figs. 57, 58) made it plain that it was not a salamander but a bird. A bird surrounded with flames can only be a phœnix, which from primitive Christian days has been a figure of immortality. If that be so, the attributes of Chastity are ill defined. The palm and the phœnix simply signify that she will be rewarded in another world. We must admit that our own explanation is not wholly satisfactory. The emblematic animal, elsewhere so precise, is in this case too general in character. It is conceivable that the artist at Paris inadvertently gave the appearance of a bird to the salamander, and that his mistake was reproduced at Amiens and Chartres.[3] But without labouring the point we will turn to the study of the group

FIG. 60.—PRUDENCE AND FOLLY (Amiens)

[1] Alanus de Insulis, *Liber de planctu naturæ, Patrol.*, ccx., col. 472. Several descriptions of the Virtues are found in this book.

[2] Vincent of Beauvais, *Spec. nat.*, lib. XX., cap. xliii., " In his non est masculinum genus aut femineum."

[3] The confusion may have been increased by the frequent representations in the thirteenth century, —especially in miniatures—of Chastity with a turtle-dove on her shield. Alanus de Insulis shows her thus in his *De planctu naturæ*, and he explains that the turtle-dove deprived of her mate scorns to console herself with new loves. Several MSS. of the *Somme le Roi* (Bibl. Mazarine, No. 870, f. 147; Arsenal, No. 6329, f. 167 v.; Bibl. Nat., MS. franç. 938, f. 120 v.) illustrated at the end of the thirteenth century, and deriving from one original copied with greater or less fidelity, show representations of Chastity conforming to this idea. On a sort of round shield which she holds in her hand is the figure of a bird which can only be a turtle-dove. As Brother Laurent, in the *Somme le Roi*, does not mention any emblem of Chastity, the miniaturists must have been inspired by some well-established studio tradition. In this way the substitution of a bird for a salamander at Paris, Chartres and Amiens may be explained. It is also possible that the mediæval artists imagined that the salamander was a bird. M. Gaston Paris tells us that he found several examples of this error in literature.

OF THE THIRTEENTH CENTURY

contrasted with Chastity. At Chartres and Amiens[1] (Fig. 57) a young man embraces a woman who holds a sceptre in one hand and a mirror in the other, while in the rose-window in Notre Dame at Paris we find simply a woman who gazes at herself in a glass (Fig. 59). This is Luxury in the form of a courtesan, and the sceptre and the mirror are evidently symbolic. The sceptre expresses the omnipotence of woman and her sensuous rule over man. By it the mediæval sculptors indicated what the Italian story-tellers of the Renaissance intended to convey in the fine names such as " Violante " and " Imperia," which they gave to their courtesans. The mirror is the emblem of the coquetry of woman and her

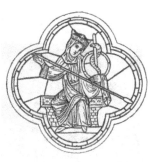

FIG. 61.—PRUDENCE (Rose-window in Notre Dame, Paris)

genius for seduction.[2] The finely carved ivory boxes containing mirrors left to us by the thirteenth century celebrate the invincible power of woman. On them women are represented as successfully defending the Castle of

FIG. 62.—FOLLY (Rose-window in Notre Dame, Paris)

Love, or receiving the submission of the vanquished lover whom they crown with roses.[3] Some of these dainty mirrors no doubt belonged to the courtesans of the thirteenth century. At Chartres the group is both charming and restrained. It belongs to the age of chivalry, the age which placed woman on a pedestal, so that the artists charged with warning men of her wiles could not bring themselves to detract from her fair fame. It is a far cry from the terrible figures of Luxuria carved on the doorways of Romanesque churches such as Moissac and Toulouse, where toads devour the organs of a naked woman and cling tightly to her breasts. The thirteenth century with its finer sensibilities could not endure the crude symbolism of a ruder age.[4] The later artists were well

[1] At Paris the bas-relief of Luxuria, like that of Chastity, has been completely restored. In place of Luxuria there is now a woman who appears to be holding scales.

[2] Luxuria has no attribute but a mirror in a window at Auxerre, a rose-window in Notre Dame at Paris and in a window at Lyons, as also in one of the illustrations to the *Somme le Roi* (Bibl. de l'Arsenal, MS. 6329, f. 167 v.). Elsewhere Luxuria appears to be

offering fetters (Bibl. Nat., MS. franç. 938, f. 120 v., and Mazarine, MS. 870, f. 147).

[3] See the collections in the Cluny Museum and in the Louvre.

[4] I have however found an example belonging to the early thirteenth century. It is on the tympanum of the Last Judgment from St. Yved at Braisne, now in the museum at Soissons.

RELIGIOUS ART IN FRANCE

aware that in representing vice in such hideous guise they deprived virtue of all nobility.

After Chastity comes Prudence (Fig. 60) who at Paris and Chartres can be recognised at the first glance by her attribute. Her shield bears a serpent

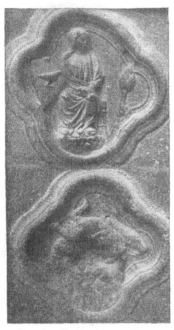

which in some cases is twined round a pole (Fig. 61). There is no nobler blazon, for it was Christ Himself who gave it to Prudence —" Be ye wise as serpents." [1]

Folly who is opposed to Prudence needs fuller mention. In the porches at Paris [2] and Amiens (Fig. 60) and in the rose-windows at Paris and Auxerre (Fig. 62) Folly appears in the form of a scantily-clad man armed with a club, who walks among stones and at times receives one thrown at his head. He almost invariably has some shapeless object in his mouth. It is obviously the picture of an idiot at whom invisible boys throw stones. This realistic figure which seems to be taken direct from everyday life, has in fact a popular origin. Following an old tradition, mediæval representations of idiots showed them carrying a club—later to become a fool's bauble—and eating a cheese. In several poems in the vernacular, notably the *Folie Tristan*, idiots are so described. [3] The artist no doubt fol-

FIG. 63.—HUMILITY AND PRIDE (Amiens)

lowed tradition in conceiving this figure at Paris and elsewhere. [4]

After Prudence and Folly come Humility and Pride. [5] In her arms Humility holds a bird, an emblem which is faithfully reproduced in glass, [6] bas-reliefs [7] (Figs. 63 and 51), and even in miniatures. [8] One may say con-

[1] St. Matthew, x. 16. Peter the Precentor does not fail to refer to this text in the article he devotes to prudence. *Verbum abbreviat., Patrol.*, ccv., col. 305.

[2] The figure of Folly in the porch of Notre Dame at Paris has been touched up. The object he seemed to be eating is replaced by a horn which he blows, and the club has become a sort of torch.

[3] I owe this explanation to M. Gaston Paris and to my friend Joseph Bédier.

[4] This traditional figure of an idiot is met with in many psalters, and illustrates Psalm liii., which speaks

of the foolish man (see Bibl. Nat., MS. Lat. 10434 ; Sainte-Geneviève, No. 2689).

[5] Not Temperance and Intemperance as thought by Jourdain and Duval.

[6] See rose-windows at Notre Dame at Paris and at Auxerre.

[7] At Amiens and Chartres (south porch). In the north porch at Chartres Humility holds the bird in her hand. In the porch at Notre Dame at Paris the bird has been restored and looks like an eagle.

[8] *Somme le Roi*, Bibl. Nat., MS. franç. 928, f. 74. There is a mistake in the MS. in the Mazarine (No.

fidently that the bird is a dove. " Be simple as doves," said Jesus to His disciples, and according to the commentators by simplicity must be understood that simplicity of the heart which is the antithesis of pride. And so St. Bernard could say of the dove that she was the true symbol of humility.

FIG. 64.—PRIDE (Rose-window in Notre Dame, Paris)

Pride appears in the familiar form of a rider thrown by his horse, rolling with it in a ditch[1] (Figs. 63, 64, and 51). No effort is needed to recognise here an episode from the *Psychomachia.* It is evident that even when the artists of the thirteenth century would be innovators they could never wholly free themselves from the influence of Prudentius. The figure of Pride seems to be inviolable. Villard de Honnecourt reproduced it in his *Album* as an accepted model from which no one could depart.[2] He writes in the margin, " Orgueil, si cume il trébuche "—this is how Pride trips—by which should be understood when you have to make a figure of Pride this is how it should be done.

FIG. 65.—COWARDICE (Rose-window in Notre Dame, Paris)

The second series of Virtues, those to the left of Christ on the doorways at Paris and Amiens, begins with Fortitude in the form of a mailed and helmeted warrior, sword in hand. The long robe descending to her feet shows that this warrior is a woman. Seated in an attitude full of repose and dignity,[3] Fortitude is by no means a threatening figure. She challenges no one, but waits with clear mind and direct gaze, ready for any turn of fortune. On her shield is drawn a lion or a bull. No presentation of Fortitude has been conceived with truer nobility, none comes closer to the theological definition " a force of soul which ever acts in accordance with reason." [4] No conception could be more natural to artists who lived in the age of chivalry. The Christian soldier, disciplining his strength and dedicating it to the service of the

870, f. 89 v.). The artist has inadvertently contrasted Pride with Virginity, recognisable in the maiden on her shield and the unicorn at her feet.
[1] In a window at Lyons Pride is falling into the abyss, but the horse is omitted for want of space.

[2] *Album* of Villard de Honnecourt, pl. V.
[3] See especially the admirably poised figure of Fortitude in the south porch at Chartres.
[4] *Spec. Morale*, lib. I., dist. lxxx., pars. iii. The same definition is found in St. Bernard.

RELIGIOUS ART IN FRANCE

Church, was then the highest of human ideals. But this image of Fortitude may equally well have derived from some words of St. Paul. The valiant Christian seemed to him like a warrior clothed with the virtues as with so many pieces of armour. " Be strengthened in the Lord.

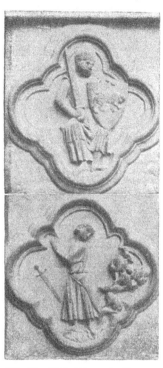

FIG. 66.—FORTITUDE AND COWAR-
DICE (Amiens)

. . . Put you on the armour of God, that you may be able to resist . . . taking unto you the breastplate of justice and the shield of faith . . . the helmet of salvation and the sword of the spirit which is the word of God." [1] Taken alone the passage may appear to have little significance for Fortitude is not mentioned by name, but it is noteworthy that in the Middle Ages it was applied especially to this virtue. In the *De Anima* where the Virtues speak in turn, Hugh of St. Victor puts St. Paul's words into the mouth of Fortitude.[2] It may be therefore that the idea of presenting this virtue armed like a knight really comes from the Pauline description. The significance of the lion on the shield is evident. It is unnecessary to multiply texts to prove that in the eyes of the mediæval symbolists the lion was one of the types of courage.[3] " The lion," says Rabanus Maurus, " is by his courage the king of beasts. It is said in the book of Proverbs that there is none he fears to meet." [4] In the twelfth century the *De Bestiis* repeated verbatim the words of Rabanus Maurus.[5]

To Fortitude is opposed Cowardice, and it is represented at Paris [6] (Figs. 65 and 70), Amiens (Fig. 66), Chartres [7] and Reims in a scene full of popular humour. Seized with panic a knight throws down his sword and runs with all speed from a hare which pursues him. It is night no

[1] Ephes. vi. 10–18.
[2] Hugh of St. Victor, *Appendix de Anima, Patrol.*, clxxvii., col. 185. The authorship of the work has been called in question, but that does not affect our purpose.
[3] The bull was another type of courage. In the rose-window in Notre Dame at Paris Fortitude has a bull's head on her shield.
[4] Rabanus Maurus, *De Universo*, lib. VIII.
[5] *De Bestiis* (attributed to Hugh of St. Victor), *Patrol.*, clxxvii., col. 23.
[6] In both a porch and a rose-window.
[7] At Chartres the hare has almost completely disappeared.

doubt, for a screech-owl sitting in a tree seems to utter its melancholy cry. This is surely some old proverb or faibliau that I would readily believe was one of those which preachers loved to tell to their flocks. It is true that Stephanus de Borbone does not refer to anything of the kind, but there is in Brother Laurent something with a strong resemblance to our bas-relief. He says in the *Somme le Roi* when speaking of the coward : " He is like those who dare not enter the straight and narrow way for fear of the snail which shows its horns."[1] Some similar comparison, constantly repeated from the pulpit, must have been the source of our artist's inspiration.[2]

The meaning of the Virtue and the Vice which follow is not clear.

FIG. 67.—KNIGHT FRIGHTENED BY A HARE (B. N., MS. Lat. 14284)

Except the ox on her shield (Fig. 68) the Virtue has no distinctive attribute. The Vice is figured by a man[3] who advances, sword in hand, on a monk who stands unmoved[4] (Fig. 8). According to the generally received interpretation the Virtue in question is Patience (symbolised by the ox), and the Vice is Impatience[5] or Anger, for the layman who threatens the cleric with his sword may well be some intractable penitent who will not stand correction. The explanation is not improbable, but it is not supported by any text. Something remains to be discovered, and we must confess that in our turn we have been no more successful than our predecessors.

The next two bas-reliefs have given rise to controversy. The Virtue carries a shield blazoned with a lamb (Fig. 69), the Vice is presented in a lively fashion. A lady, apparently of noble birth, richly dressed and

[1] *Somme le Roi*, Lausanne edit., p. 126.
[2] On the façade of the Maison du Miroir at Dijon, dating from the thirteenth century and known to us only through a drawing of the eighteenth, there was a knight fighting with a snail. (Chabeuf, *Revue de l'art chrétien*, 1899, p. 112 *sq*.). A manuscript (B. N., Lat. 14284) shows the knight frightened by the hare (Fig. 67). The subject was evidently popular.

[3] It is a woman at Chartres and Amiens.
[4] In the rose-window at Notre Dame at Paris it seems to have been a layman.
[5] The opinion held by Jourdain and Duval (*Étude sur le portail d'Amiens*), F. de Guilhermy (*Descript. de Notre-Dame de Paris*), Bulteau (*Monogr. de Chartres*).

seated on an embroidered chair, greets with a kick full on the chest a humble figure who presents a cup (Figs. 69 and 71). Canons Jourdain and Duval saw here Violence as opposed to Gentleness. This interpretation, accepted by other scholars,[1] was questioned by M. Duchalais[2] who believed that

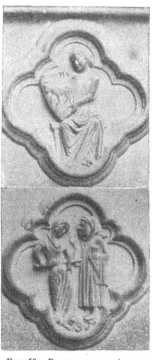

the two bas-reliefs represented Nobility and Baseness. When studying an illustrated manuscript of that curious symbolic work the poem of *Fauvel*, in which the horse (man's lower appetite) is enthroned on high in a court of Vices, he discovered a fourteenth-century miniature which precisely reproduces the scene of violence represented at Paris,[3] Amiens and Chartres. Now this miniature was placed close to a discourse on Nobility and Baseness, which seems a strong argument in favour of M. Duchalais's theory. On referring to the manuscript of *Fauvel*,[4] we were able to ascertain the close likeness of this miniature to the bas-relief we are considering—the same noble lady kicks her servant with the same brutality, the cup is not forgotten and the analogy is complete. But further study of the text gives no ground for affirming that the miniature illustrates the verses devoted to baseness. The poet's picture of this vice is extremely indefinite, and contains no feature which could refer to the drawing.[5] On the other hand the verses that immediately precede the miniature and have ingratitude as

FIG. 68.—PATIENCE AND ANGER
(Amiens)

subject, though vague, suggest a similar idea to that expressed by the artist. They read as follow :—

> " Amprès li sist ingratitude
> Qui est très mauvaise et très rude
> Car el ne veust nul recognoistre." [6]

[1] By Guilhermy and Bulteau.
[2] *Biblioth. de l'École des Chartes*, vol. v., second series.
[3] See porch and rose-window.
[4] Bibl. Nat., MS. franç. 146, f. 14 v. (fourteenth century).
[5] The following are the most characteristic details : " She thinks she is noble and wise because she has great possessions, but she is deceived and mistaken, for nobility is not of the earth."

> " Elle cuide estre noble et sage
> Pour ce qu'elle a grand héritage,
> Mais el se deçoit et meserre
> Car noblesse n'est pas pour terre."

[6] Translation : " In him there is ingratitude which is very bad and base, for he does not wish to be grateful to anyone."

The lady who rewards with a kick the servant who offers her a cup deserves the poet's epithets, and it is true to say of her that "el ne veust nul recognoistre," that is, she has no thanks for anyone. It seems to me evident that the miniature was placed in the position it occupies to illustrate the verses on ingratitude and not the passage on baseness. The miniaturist, moreover, made use of a pounced drawing which had been handed on from studio to studio for at least a hundred years. The old design seemed to him to tally fairly well with the text of *Fauvel*.

Thus it is probable that for a century the little scene of the chatelaine and the vassal, whose origin is unknown, served to express ingratitude or more exactly hardness of heart, for the sheep carved on the contrasted Virtue's shield symbolised gentleness rather than gratitude. For the theologians the sheep was the perfect symbol of gentleness because she surrenders her most precious possessions, her wool and her milk.[1] The whole Middle Age followed Isidore of Seville in connecting "ovis" with "oblatio."[2] There are, therefore, in spite of M. Duchalais's views, no grounds for modifying the names proposed by Canons Jourdain and Duval and for adding nobility and baseness to the list of virtues and vices.

Next comes Concord or Peace, recognisable

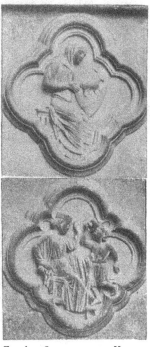

FIG. 69.—SWEETNESS AND HARSHNESS (Amiens)

by her attribute and in opposition to Discord. On her shield Concord bears a branch of olive (Fig. 72),[3] reminding us of the olive wreath with which Prudentius crowned her, and the flowering olive-branch Alanus de Insulis placed in her hand at a date slightly earlier than that of the bas-relief.[4]

[1] Rabanus Maurus, *De Univ.*, lib. VIII. *Patrol.*, cxi., col. 201, and Vincent of Beauvais, *Spec. Nat.*, lib. XVIII., cap. lxix. and lxx.
[2] Vincent of Beauvais, *Ibid.*
[3] M. G. Durand (*La Cathédrale d'Amiens*) remarks that at Amiens the branch bears a graft. Some symbolic meaning probably lies in this.
[4] *Anticlaud.*, *Patrol.*, cxx., col. 502 :

"Virginis in dextra, foliorum crine comatus,
 Flore tumens, fructus exspectans, ramus olivæ
 Pubescit . . ."

In a window at Auxerre, Concord (without attribute) is seen with clasped hands before a cross, teaching us that the Concord at Paris, Amiens and Chartres is not a social virtue but expresses the concord of the soul, the inward peace found in faith.

RELIGIOUS ART IN FRANCE

Discord is figured by a scene of domestic life—a woman and her husband seize one another by the hair, while a pot or jug rolls to one side and a distaff to the other[1] (Fig. 72).

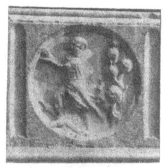

FIG. 70.—COWARDICE (Porch, Notre Dame at Paris)

Surely Brother Laurent had this bas-relief in mind when in the *Somme le Roi* he wrote of anger[2] : " The third quarrel which the angry man has is against those who are beneath him, that is to say, against his wife and household. For he is sometimes so angry that he beats and strikes both wife and dependants and children, and breaks bowls and cups." In fact theologian and artist both drew from the storehouse of popular sermons in which vivid images of daily life abounded.

The two next bas-reliefs represent respectively a woman whose shield bears a kneeling camel (Figs. 73 and 75) and the figure of a man who strikes a bishop (Fig. 73). The camel kneeling to receive its burden is the symbol of humility and submission,[3] and the Virtue whose blazon he is, no doubt is Obedience.[4] The contrasted vice can only be Rebellion. Brother Laurent explains what rebellion is in the following words : " It is when a man rebels against those who wish for his welfare ; if they correct him he defends himself, if they chastise him he is angered."[5] Who should they be who desire a " man's welfare," who have the wisdom to correct him and the right to punish him if it be not the bishops, his true spiritual lords ? Rebellion then appeared to the Middle Ages

FIG. 71.—HARSHNESS (Porch, Notre Dame at Paris)

under one aspect only—disobedience to the Church. The man who lifts his hand against his bishop is not only guilty of an act of violence, but is in conflict with reason and law. There is a curious detail in the rose-window in Notre Dame at Paris, for the man who rebels against the bishop wears the

[1] The bas-relief of Notre Dame at Paris (restored) shows a quarrel between two men, but the medallion in the rose-window shows a domestic quarrel similar to those at Chartres and Amiens.

[2] We follow the text of MS. 938 in the Bibl. Nat. (fonds français) f. 16, v., which is clearer than that given by M. Chavannes (p. 111) after the Lausanne MS.

[3] Rabanus Maurus, *De Universo*, col. 211, *Patrol.*, cxi. " Camelus autem Christi humilitatem significat."

[4] And not Temperance as Bulteau believed. (*Monogr. de Notre-Dame de Chartres*, ii. 386.)

[5] *Somme le Roi*, Lausanne edit., p. 64.

conical cap of the Jews. There can be no doubt as to the interpretation of an idea so familiar to the Middle Ages. The Jew, who for so many centuries refused to listen to the voice of the Church, seemed to be the very symbol of stubbornness and rebellion.

The two final bas-reliefs show Perseverance and Inconstancy. It was a fine idea to place perseverance at the end of the series, not as the humblest but as the most indispensable of the virtues which man must retain till the last ; as we have seen Honorius of Autun made perseverance the last rung of the mystic ladder which led to heaven. On her shield she bears a crown (Figs. 74 and 75), for says St. John in the Apocalypse, " Be thou faithful unto death, and I will give thee a crown of life."[1] Two further attributes, less clear at first sight, complete her characterisation. A lion's head, apparently cut off from his body, appears at the top of the composition and a lion's tail is on the shield.[2] The head and the tail are the beginning and the end—a naïve hieroglyphic by which the artists would say perseverance is needed from the first day of life until the last.

Fig. 72.—Concord and Discord (Amiens)

Inconstancy is represented by a monk who with averted face flees from his convent (Fig. 74). He gives one last look at the monastery church and at the vacant cell where his habit lies.

The composite character of these little pictures is evident. We find in them lingering memories

Fig. 72.—Concord and Discord (Amiens)

of Prudentius, emblems taken from the Old Testament, the Gospels or the Bestiaries, traces of the theological teaching of the schools, and popular scenes which were perhaps merely illustrations used in contemporary sermons. A multitude of ideas which were familiar in the thirteenth century gathered round these figures of the Virtues and Vices. There can be no doubt that the hand of the artist was directed by some scholar.

The whole constitutes a profound commentary on the moral life. The figures of the Virtues appeal to us by their purity and restraint. In the

[1] Apoc. ii. 10.
[2] These details are still visible at Amiens and

Chartres. At Amiens the head appears to be that of a lion, not that of an ox.

RELIGIOUS ART IN FRANCE

terrible feudal world where men's blazons bristled with talons and claws, they (with the exception of Fortitude who took a lion) chose as ornament for their shields the humblest and gentlest of beasts, the sheep and the dove, the ox and the camel, animals of the Gospel parables which Christian usage had sanctified. It is a return to the pleasant pastoral scenes of the Catacombs in which artists so long delighted.

We have pointed out that this selection of virtues does not conform

FIG. 73.—OBEDIENCE AND RE-
BELLION (Amiens)

FIG. 74.—PERSEVERANCE AND IN-
CONSTANCY (Amiens)

to the divisions adopted by the theologians, but it is none the less interesting on that account. Whoever he may have been, the man who determined the choice was a true Christian, for he gave the place of honour to the humblest, the least evident, the most hidden virtues—to humility, patience, unselfishness, obedience, perseverance. In his preoccupation with the inner life of the soul, the idea of including a social virtue such as justice did not even occur to him. A soul possessing the virtues which are thus suggested would be a soul beautiful indeed as that of a great mediæval saint. That ideal life—humble, patient, unselfish, in a word Christian—conceived by

those centuries of faith, remains to-day written on the façades of the cathedrals. The teaching of our unknown theologian and of the author of the *Imitation* is in close harmony.

To feel the tremendous vitality of mediæval art it is only necessary to compare cold modern allegories of courage or justice with these little figures tense with meaning, breathing the very spirit of holiness. They still make an appeal to all who study them with sympathy. To the man of the Middle Ages they seemed to say : "Thy days pass, and thou feelest the approach of old age and of death. Look at us, we do not grow old nor

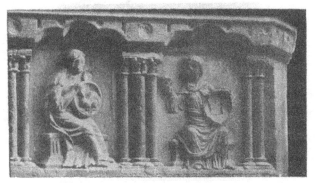

FIG. 75.—OBEDIENCE AND PERSEVERANCE (Porch, Notre Dame at Paris)

die for our purity gives us eternal youth. Receive us into thy soul it thou too wouldst not age nor die."

III

The cathedral also has an answer to the momentous question whether the attainment of these virtues entails separation from the world, or whether they may be attained in everyday life. The cathedral of Chartres would say that the active and the contemplative life are of equal sanctity. In the north porch, close to the order of the arch on which the Virtues are represented, twelve charming little figures symbolise the twofold form of human activity.[1] To the left six maidens with smiling faces are engaged in manual tasks. One washes wool, another combs it, the third bruises flax while others card and spin it, and the last winds it into skeins. A large figure, which unfortunately disappeared at the time of the Revolution,[2] completed

[1] The last order but one. [2] See Bulteau, *Monogr. de Chartres*, ii. p. 225.

and summed up the whole series. She was busy sewing and symbolised the active life.

To the right are statuettes of six maidens veiled and occupied in reading, meditating, praying. One of them in ecstasy lifts her eyes to heaven. A large statue which was placed beneath the same sculptured order and was also destroyed during the Revolution, represented a woman reading, type

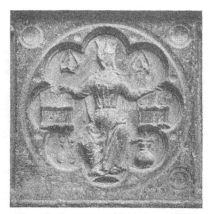

FIG. 76.—LIBERALITY (Doorway at Sens)

of the contemplative life. The two large statues may have more definitely symbolised Martha and Mary or Leah and Rachel, who for the doctors were familiar types of the active and the contemplative life.[1]

It is true that at Chartres the Active Life has the place of honour, though one cannot help feeling that they are equal in the sight of God.

And so, and this is the sum of the cathedral teaching, let no one seek pretext or excuse, for virtue is binding on all men and under all conditions, and the ways are many which may lead men to God.

[1] See, for example, Honorius of Autun, *Spec. eccles.*, *Patrol.*, clxii., col. 1020.

BOOK IV

CHAPTER I

THE MIRROR OF HISTORY. THE OLD TESTAMENT

I.—The Old Testament regarded as a figure of the New Testament. Sources of the symbolic interpretation of the Bible. The Alexandrian Fathers. St. Hilary. St. Ambrose. St. Augustine. Mediæval Doctors. The *Glossa Ordinaria*. II.—Old Testament types in mediæval art. Types of Christ. Symbolic windows at Bourges, Chartres, Le Mans and Tours. III.—Old Testament types of the Virgin. The porch at Laon. Influence of Honorius of Autun. IV.—The Patriarchs and the Kings. Their symbolic function. V.—The Prophets. Attempts in mediæval art to give plastic form to the Prophecies. VI.—The Tree of Jesse. The Kings of Judah on the façade of Notre Dame at Paris, at Amiens, and at Chartres. VII.—Summary. The symbolic medallions in Suger's windows at St. Denis. The statues of the north porch at Chartres.

So far the subject of our study has been man in the abstract—man with his virtues and his vices, with the arts and sciences invented by his genius. We now turn to the study of humanity living and acting. We have reached history.

The cathedral recounts the history of the world after a plan which is in entire agreement with the scheme developed by Vincent of Beauvais. At Chartres, as in the *Speculum historiale*, the story of humanity is virtually reduced to the history of the elect people of God. The Old and the New Testament and the Acts of the Saints furnish the subject-matter, for they contain all that it is necessary for man to know of those who lived before him. They are the three acts in the story of the world, and there can be but three. The course of the drama was ordained by God Himself. The Old Testament shows humanity awaiting the Law, the New Testament shows the Law incarnate, and the Acts of the Saints shows man's endeavour to conform to the Law. These three great books, each marking an epoch in history, will form the subject of our study in the several chapters.

I

From the time when it occurred to the mosaicists of Santa Maria Maggiore to take as their subject-matter a series of historical pictures from the Bible, the Old Testament was a constant source of inspiration

RELIGIOUS ART IN FRANCE

to mediæval art, though the great narrative compositions which embrace the whole history of the people of God are not found before the thirteenth century. The windows of the Sainte-Chapelle, for example, offer a complete illustration of the different books of the Bible from Genesis to the Prophets. The light falling through the eleven great windows with their thousand medallions gives a sense of mystery to the history of the heroes of the Ancient Law. These countless compositions, treated after the manner of miniatures, make the Sainte-Chapelle the most wonderful of pictured bibles. In the south porch of Rouen cathedral there is a long series of small bas-reliefs of the same narrative character. Here as in the Sainte-Chapelle the artist has followed step by step the story of the first books of the Old Testament, until at length he was stopped by want of space.

It would be not only a lengthy but a quite useless task to attempt to deal with all the compositions of the thirteenth century, windows and bas-reliefs, which illustrate different parts of the Bible, and it is sufficient for our purpose to note that certain touching and popular subjects, such as the history of Joseph, recur the most frequently.[1] All these compositions devoted to the Old Testament are told in the direct style of a simple story.

Had mediæval artists confined themselves to historical cycles there would be no reason to dwell on them further, but there was in the thirteenth century another and infinitely more curious reading of the Old Testament. The artists preferred for the most part to adhere to the spirit rather than to the letter. To them the Old Testament seemed a vast figure of the New. Following the guidance of the doctors, they chose out a number of Old Testament scenes and placed them in juxtaposition with scenes from the Gospel in order to impress on men a sense of the deep underlying harmony. While the windows in the Sainte-Chapelle tell a simple story, those at Chartres and Bourges show forth a mystery.

Such a method of interpretation was entirely orthodox. But since the Council of Trent the Church has chosen to attach herself to the literal meaning of the Old Testament, leaving the symbolic method in the background. And so it has come about that the exegesis based on symbolism of which the Fathers made constant if not exclusive use, is to-day generally ignored. For this reason it seems useful briefly to set forth a body of doctrine which so often found expression in art.

[1] There are windows devoted to the story of Joseph at Chartres, Bourges, Auxerre, and in the cathedral at Poitiers.

132

God who sees all things under the aspect of eternity willed that the Old and New Testaments should form a complete and harmonious whole ; the Old is but an adumbration of the New. To use mediæval language, that which the Gospel shows men in the light of the sun, the Old Testament showed them in the uncertain light of the moon and stars. In the Old Testament truth is veiled, but the death of Christ rent that mystic veil and that is why we are told in the Gospel that the veil of the Temple was rent in twain at the time of the Crucifixion.[1] Thus it is only in relation to the New Testament that the Old Testament has significance, and the Synagogue who persists in expounding it for its own merits is blindfold.[2]

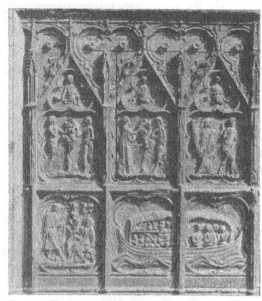

FIG. 77.—EARLY CHAPTERS OF GENESIS (portion of base of doorway at Auxerre)

This doctrine, always held by the Church, is taught in the Gospels by the Saviour Himself, "As Moses lifted up the serpent in the wilderness, even so must the son of man be lifted up,"[3] and again, "Even as Jonah was three days and three nights in the belly of the whale, so shall the Son of man be three days and three nights in the depths of the earth."[4]

The apostles taught the early Christians the mystic harmony of the Old and New Law. It is insisted upon more especially in the epistle to the Hebrews. The newly converted Jews, still attached to the letter of the Law, are told how the ceremonies of the Old Covenant were merely figures destined to shadow forth the New,[5] and that Melchizedek, king and priest, was an image of the Son of God, who was both pontiff and king. Several

[1] On the symbolism of the veil of the Temple see H. of Autun, *Gemma animæ*, *Patrol.*, clxxii., col. 657.
[2] As we shall see the Synagogue was represented in this way in thirteenth-century art.

[3] St. John iii. 14.
[4] St. Matthew xii. 40.
[5] Hebrews ix. and vii. 3.

passages in the first epistle to the Corinthians and in the epistle to the Galatians, as also several verses in the first epistle of St. Peter, show that the allegorical method of interpretation was known to the apostles.[1]

But it was in Alexandria in the third century that this manner of biblical interpretation became a definite system. This is not surprising when one remembers that from the first century the Jews of Alexandria, imbued as they were with the Hellenic spirit, saw in their sacred book a symbol only. In order to make his system accord with the Bible, Philo makes the literal meaning of Scripture entirely disappear. In his commentary he interprets Genesis very much as Homer was interpreted by the Stoics, to whom the Iliad and Odyssey were profound allegories clothing the highest philosophy. Thus the Greek genius coalesced with the eastern in that extraordinary city of Alexandria. In some respects Philo may be considered as the first of the Fathers, and it cannot be doubted that both Clement and Origen were his pupils.

It is in Origen that the allegorical interpretation of the Old Testament first appears as a finished system. He begins by laying down as an axiom that the meaning of Scripture is threefold. For Scripture is a composite whole made like man after the image of God. Even as there are in man three components, body, vital principle and soul, so there are in Scripture three meanings, the literal, moral and mystical.[2] But, he adds, all passages of Scripture do not lend themselves to a triple interpretation ; to some it is convenient to attach a literal meaning only, to others a moral or mystic sense. Origen challenges the literal sense in particular, for to him the letter seemed to contain absurdities and contradictions which had given rise to every heresy. "Who is stupid enough," he says, "to believe that God like a gardener made plantations in Eden, and really placed there a tree named the tree of life which could be seen by the bodily eye ? "[3] Eden is nothing, he explains, but an allegory of the future church.[4] In his commentaries on Scripture the letter entirely disappears. When interpretating the passage in Genesis in which it is said that God made for Adam and Eve tunics of the skins of beasts, he says, "Where is one to find the mean intelligence, the old woman who would believe that God slaughtered animals in order to make clothing after the manner of a currier ? " To avoid such an absurdity it should be understood that the tunics of skins designate the mortality which followed the sin. "It is thus," he adds, "that one should learn to find hidden treasure beneath the letter."[5]

[1] 1 Cor. x. 1–6, Gal. iv. 24, 1 Peter iii. 20–21.
[2] Περὶ ἀρχῶν, lib. IV., *Patrol. gr.*, xi., col. 363.
[3] *Patrol. gr.*, xi., col. 375.
[4] Εἰς τὴν γένεσιν, *Patrol. gr.*, xi., col. 99.
[5] *Id., ibid.*, xi., col. 101.

Origen attempted to justify this intrepid method ; the kind of interpretation he adopted had come from the apostles and been orally transmitted down to his time. But it is evident that he allowed himself to be carried away by his vivid imagination. In the flame of a genius which has been compared to a furnace in which even brass liquefies, the literal meaning of Scripture vanishes. Celsus and the mediocre minds who adhering to the letter of Scripture saw in it only contradictions, found themselves refuted, but Origen himself at times went beyond the limits of orthodoxy and in his turn ran the risk of being accused of heresy. From Origen and from the other Greek Fathers the allegorical method passed into western thought. According to St. Jerome no one did more to familiarise the Latin world with it than St. Hilary.[1] Sent into exile to Asia Minor by the emperor Constantine, Hilary for four years had leisure to study Greek and to read the works of the doctors of the Eastern Church. On his return to Gaul he wrote a commentary on the Psalms in which the spirit of Origen lives again.

Brought from the east by St. Hilary this method of allegorical interpretation only became popular through the teaching of St. Ambrose. It was by his preaching that he spread the doctrine of Clement and Origen, for it can hardly be doubted that his treatises on Cain and Abel, on Noah's Ark, and on Abraham and Isaac were in their original form popular sermons. He set out in these homilies to make known the spiritual meaning of the Scriptures and to explain all the hidden truths to the people. On this we have the valuable testimony of Augustine. " Often," he says in his *Confessions*, " did I rejoice to hear Ambrose telling the people in his popular discourses that ' the letter killeth and the spirit maketh alive,' and interpreting in a spiritual sense passages which taken literally seemed to be an exhortation to vice." [2] It was in this way that Ambrose finally won over Augustine, who was still intrenched behind difficulties of biblical interpretation. In his turn Augustine took up his master's method and made it known to the whole of the Christian world. But at the same time he laid it down for the centuries to come as the fundamental principle of symbolic exegesis, that the literal meaning so often scoffed at by Origen is sacred. " Brothers," he says, " I warn you in the name of God to believe before all things when you hear the Scriptures read that the events really took place as is said in the book. Do not destroy the historic foundation of Scripture,

[1] Jerome, *Epist. ad Vigilant*, lxi.; *Patrol.*, xxii., col. 603. [2] *Confess.*, lib. V., cap. iv.

RELIGIOUS ART IN FRANCE

without it you will build in the air. Abraham really lived and he really had a son by Sarah his wife. . . . But God made of these men heralds of His Son who was to come. This is why in all that they said, in all that they did, the Christ may be sought and the Christ may be found. All that the Scriptures say of Abraham really happened, but he is at the same time a prophetic type. The apostle teaches us this when he says, ' It is written ' (Gal. iv. 22–24) ' that Abraham had two sons, the one by a bondmaid and the other by a free woman. Which things are an allegory, for these are the two Testaments '." [1] St. Augustine then does not admit that the letter of Scripture may vanish, he teaches on the contrary that historical fact furnishes the only secure basis for allegory. He wrote his long commentary, *Genesis ad litteram*, to prove that even if the facts give rise to a multitude of mystical interpretations they for all that came to pass as the sacred book relates. The principle once laid down, he does not hesitate to make constant use of the allegorical method. The *City of God* is full of mystical interpretations. Noah's ark becomes a type of Christ on the Cross because the length of man's body is six times as great as its width, and these are precisely the proportions of the ark. [2] The nakedness of Noah symbolises the Passion, [3] Abraham's sacrifice of Isaac foreshadows the sacrifice of the Son of God, [4] Saul is rejected by God and replaced by David to teach men that the Old Law will give place to the New. [5] A sentence in the *City of God* would serve as motto for all St. Augustine's exegesis ;—" The Old Testament is nothing but the New covered with a veil, and the New is nothing but the Old unveiled." [6]

Exposition of a similar character is found in those sermons in which he comments on some passage of the Old Testament. Here, for example, is the explanation of the story of David and Goliath which he gives to the people of Hippo. " Brothers," he says, " ye are here struggling, on the one side is the devil in the form of Goliath, on the other is Christ typified by David. Now David took five stones from the brook, and placing them in the vessel which he used in collecting the sheep's milk, he went forth armed against the enemy. David's five stones represent the five books of the Law of Moses, which Law in its turn is made up of ten salutary precepts from which all others proceed. The Law is thus figured by the number five and the number ten, and this is why David fought with five stones and sang,

[1] *Sermo*, ii. ; *Patrol.*, xxxviii., col. 30.
[2] *De civit. Dei*, lib. XV., cap. xxvi.
[3] *Ibid.*, lib. XVI., cap. ii.
[4] *Ibid.*, lib. XVI., cap. xxxii.
[5] *Ibid.*, lib. XVII., cap. iv.

[6] *Ibid.*, lib. XVI., cap. xxvi. "Quid enim quod dicitur Testamentum Vetus, nisi occultatio Novi ? Et quid est aliud quod dicitur Novum nisi Veteris revelatio ? " See also his treatise *Contra Faustum*, *Patrol.*, xlii.

as he said, to an instrument of ten strings. Mark, moreover, that he threw
not five stones but one only ; that single stone is charity, the unity which is
the fulfilling of the Law. Mark once again that he took the five stones from
the bed of a river. What does that river signify if not the light and incon-
stant whose violent passions sweep them into the sea of the world ? Now
such were the Jewish people. They had received the Law, but as the river
flows over stones so did they pass it by. So the Lord took the Law that
He might raise it to grace, as David took the stones from the bed of the
river and placed them in his milk-vessel. And where is there a more fitting
figure of grace than in the abundant sweetness of milk." [1]

Ingenious and surprising comparisons abound in Augustine, but they are
never more than tentative and are not imposed as dogma. " We sound
as we may the secret depths of Scripture. Others may do so with more
success ; but one thing alone is certain, that there will ever be depths
too great for our reason to fathom." [2]

After St. Augustine further mystical interpretations were interwoven
by St. Gregory, the last of the Fathers. In his commentary on the book
of Job, so renowned in mediæval days, he continually makes use of the
allegorical method.

The vast legacy of symbolism inherited from the early Christian cen-
turies was received with deep respect by the Middle Ages, which changed
nothing and made but few additions.

Isidore of Seville summarised all the commentaries of the Fathers of
the Church for the rude centuries that were to follow, and his *Quæstiones
in Vetus Testamentum* is one of the essential links in the long chain
of Catholic tradition. In the preface to his commentary he states that he
has drawn largely from Origen, Ambrose, Jerome, Augustine, Fulgentius,
Cassian and Gregory the Great. Although all the learning of the early
doctors is condensed in his manual, it is their allegorical interpretations
that especially attract him. He compares books to a lyre with cords of
infinite resonance.

In order to make the allegorical character of the Bible more evident
Isidore wrote a small pamphlet entitled *Allegoriæ quædam Scripturæ Sacræ*,
which is a sort of key to the Scriptures. He there enumerates the
chief personages of the Old Testament, briefly indicating in what sense each,
according to the Fathers, foreshadows the Messiah. Adam, Abraham and
Moses appear as sacred symbols. All the patriarchs, heroes and prophets

[1] *Sermo*, XXXII., cap. v. and vi. [2] *De civ. Dei*, lib. XVI., cap. xxxii.

RELIGIOUS ART IN FRANCE

become with him the letters of that mystic alphabet used by God to write the name of Christ in history.

The works of Isidore of Seville gave definite form to the mystical commentaries on the Old Testament. The allegorical interpretations of the Fathers, henceforth sacrosanct, were repeated for centuries by mediæval writers. The "torrent des docteurs," as the seventeenth century put it, flowed on ceaselessly repeating the same doctrine. It is surprising when one glances through the commentaries of Bede or Rabanus Maurus to see how little originality there is in their books. If they did not merely copy Isidore of Seville, they copied the Fathers of the Church. It is evident, too, that their commentaries are designed for teaching and make no pretence to any originality. On the contrary they take every care to remain scrupulously faithful to tradition.

It was from the school of Rabanus Maurus that there issued in the tenth century the *Glossa ordinaria*, the book which bewitched the Middle Ages by its quality of precision and remained famous until the Renaissance.[1] The author, Walafrid Strabo, had no pretentions other than those of a clever compiler. The allegorical explanations which he gives of each verse of the Bible are in entire conformity with tradition. For the most part he even contents himself with verbatim quotations from the Fathers, or from Bede, Isidore of Seville or Rabanus Maurus. The vogue enjoyed by the *Glossa ordinaria*[2] makes it an invaluable book for us, taking as it does the place of all other mediæval commentaries. Similar works written in the eleventh and twelfth centuries add nothing of moment. The same doctrine somewhat further developed is found in the *Allegoriæ in Vetus Testamentum*, an anonymous work of the school of St. Victor.[3] Again the same doctrine, put in this case into mnemonic verse, is met with at the end of the twelfth century in the *Aurora* of Petrus de Riga, canon of Reims.[4] One might cite a host of other names.

It would obviously be trivial to assert that in interpreting the Bible the scholars to whom the artists looked for guidance consulted one commentary rather than another, but it is probable that the *Glossa ordinaria* was most frequently used, for it was a convenient manual for teaching and widely

[1] *Patrol.*, cxiii. and cxiv. See also the large Antwerp edition of 1634 which is more complete.
[2] " For the twelfth century," say the Benedictines in their *Hist. littér. de la France*, " the whole understanding of Scripture was in the *Glossa ordinaria* (*Hist. littér.*, vol. ix. p. 21). M. Samuel Berger remarks that in the thirteenth century the commen- taries on the French Bible were borrowed in great measure from the *Glossa ordinaria* of Walafrid Strabo. (*La Bibl. française au moyen âge*, Paris, 1884, 8vo, p. 122.)
[3] *Patrol.*, clxxv. A work long attributed to Hugh of St. Victor.
[4] *Patrol.*, ccxii.

known in the monastic and cathedral schools. In any case it remains one of the most valuable books transmitted to us by the Middle Ages, for by its help may be solved almost all the difficulties presented by allegorical representations of the Bible.

Thus at the beginning of the thirteenth century, at the very time when the artists were decorating the cathedrals, the doctors were teaching *ex cathedra* that Scripture was at one and the same time fact and symbol. It was generally admitted that the Bible might be interpreted in four different ways, and have historical, allegorical, tropological and anagogical meaning. The historical meaning made known the reality of the facts, the allegorical showed the Old Testament as a figure of the New, the tropological unveiled the moral truth hidden within the letter, and the anagogical —as the name implies—foreshadowed the mystery of a future life and eternal bliss. For example the name of Jerusalem which recurs so often in the Bible, could according to circumstances receive one of the four following interpretations. "Jerusalem," says Gulielmus Durandus, "in the historical sense is the town in Palestine to which pilgrims now resort ; in the allegorical sense it is the Church Militant ; in the tropological it is the Christian soul ; and in the anagogical it is the celestial Jerusalem, the home on high."[1] All passages of the Bible do not admit of a fourfold interpretation. Some can be understood in three ways only. The sufferings of Job, for instance, have first of all the value of historical fact, they are then an allegory of the Passion, and finally in the anagogical sense they typify the trials of the Christian soul.[2] Other passages permit of but two interpretations, while many must merely be taken literally.

This was the method adopted by the schoolmen.[3] All that has gone before goes to show that in such matters the Middle Ages merely conformed to the tradition of the earlier centuries, and that they were neither more intrepid nor more subtle than the Fathers of the Church. The allegorical interpretation of the Bible is thus seen to be in the true line of Christian tradition.

It was necessary to recall briefly the transmission of allegorical methods of exegesis, in order to understand the influences which prevailed at the time of the creation of the works of art we are about to examine.

[1] Durandus, *Ration. Proem.*, 12.
[2] Hugh of St. Victor, *De scripturis et script. sacris*, cap. III. *Patrol.*, clxxv., col. 10 *sq.*

[3] This method was summed up in memoria technica lines which were famous in mediæval times :
"Littera gesta docet, quid credas allegoria,
Moralis quid agas, quo tendas anagogia."

RELIGIOUS ART IN FRANCE

II

It early occurred to Christian artists to take as subjects a number of famous passages in the Old Testament which had been interpreted by the commentators as figures of the New. From Merovingian times the painters contrasted the two Testaments for the instruction of the faithful. In his "History of the Holy Abbots of Wearmouth and Jarrow" the Venerable Bede relates that Benedict Biscop went to Rome to ask for pictures to decorate the churches of his monasteries, and that the pictures he brought back were arranged in such a way that a scene from the Old Testament was explained by a scene from the New. Isaac carrying the wood for sacrifice was opposite to the figure of Christ bearing the Cross, and the brazen serpent lifted up by Moses in the wilderness was a counterpart to the scene of the Crucifixion.[1] Concordances familiar to Biblical interpreters are here recognised. In the palace chapel at Ingelheim there are Carlovingian paintings which represent twelve scenes from the Old Testament opposed to twelve scenes from the New.[2] Behind the thirteenth-century artist's love of relating the two Testaments there was a long tradition.

It is in glass that we find the most important works devoted by Gothic art to the concordance of the two Testaments.[3] The famous windows at Bourges[4] (Fig. 78), Chartres, Le Mans, Tours, Lyons and Rouen all present the same doctrine in an almost identical manner. The disposition of the great symbolic compositions we are about to study is invariably the same. In the central medallion is seen the event as a matter of history, in adjacent medallions are seen its types.[5]

The allegorical scenes taken from the Old Testament group themselves naturally round the great drama of the Passion. Round the scene of the Bearing of the Cross the thirteenth-century windows show Isaac carrying

[1] *Vita beat. abbat. Wiremuthens, Patrol.*, xciv., col. 720.

[2] Ermoldus Nigellus, *In honor. Lodovic.*, lib. IV., v. 191-242. On this subject see F. Piper, *Ueber den Christlichen Bilderkreis*, Berlin, 1852, 8vo, p. 46 *sq.* See also Julius von Schlosser, *Schriftquellen zur Geschichte der karolingischen Kunst*, and his *Quellenbuch zur Kunstgeschichte*, Vienna, 1896.

[3] Only one important piece of sculpture of this kind remains, the statues in the interior of the cathedral of Reims (doorway, to the left on entering). It is true that the symbols only are there (Abraham and Isaac, Moses and the serpent, the Israelites marking the lintels of their doors with the *tau*, the widow of Sarepta).

[4] Constant reference to Fig. 78 will elucidate the following pages.

[5] These symbolic windows were reproduced by Cahier and Martin in the *Vitraux de Bourges*. In addition to Cahier's fine exposition in this book, the following should be consulted : *Mélanges archéol.*, P. Cahier (*Curiosités mystér.*, p. 91 *sq.*), the *Annal. Archéolog.*, vol. xviii. (*Étude sur la Croix de Saint-Bertin*), and the *Guide de l'art chrétien*," G. de Saint-Laurent, vol. iv. p. 59 *sq.* See also *Zeitschrift für christliche Kunst*, 1893, p. 82 *sq.*

the wood for the sacrifice, the Jews marking the doors of their houses with
the mysterious *tau*, the widow of Sarepta
picking up the two pieces of wood in the
presence of the prophet Elijah, and the pa-
triarch Jacob blessing Ephraim and Manasseh,
the two sons of Joseph.

These scenes from the Old Testament
were in fact recognised by the commentators
as figures of the Passion. The *Glossa ordi-
naria* teaches first of all that Isaac is a figure
of God the Son, as Abraham is a figure of
God the Father. God, who gave His Son
for mankind, willed that the people of the
Old Covenant should catch a faint gleam of
the great sacrifice yet to be. The whole
of the biblical passage which tells of the
sacrifice of Isaac is full of mystery, and every
word of it should be weighed. The three
days' journey which separates Abraham's
dwelling from Mount Moriah signifies the
three epochs in Jewish history — from
Abraham to Moses, from Moses to John the
Baptist, and from John the Baptist to the
Saviour. The two servants who accompany
Abraham are Israel and Judah, the two
divisions of the Jewish people. The ass
which bears the implements for the sacrifice,
not knowing what it does, is the blind and
undiscerning Synagogue. Finally, the wood
that Isaac bears on his shoulder is the very
Cross itself.[1]

A figure of the Cross was also found in
the sign which was traced with the blood of

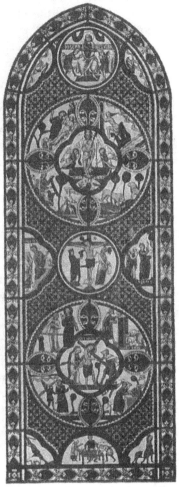

Fig. 78.—Symbolic window at Bourges

the paschal lamb on the lintel of Jewish houses. It was the commentator's
custom to compare the passage in question in the book of Exodus with
a passage in Ezekiel in which the prophet tells how he had seen the
angel of God marking the letter *tau* on the foreheads of the just. It was

[1] *Glossa ordinaria*, lib. Genes. xxii. v. 4, 5, 8.

RELIGIOUS ART IN FRANCE

believed that the *tau* of Ezekiel was the identical sign that the children of Israel when in Egypt were commanded to trace on the doorways of their houses. As in addition to this the form of the letter *tau* (T) had some resemblance to that of a cross, the conclusion was drawn that these two passages alluded to the Crucifixion.[1]

The same mystery is also foreshadowed in the medallion of the prophet Elijah and the widow of Sarepta. Elijah, pursued by the Jews, is sent by God into the country of the Gentiles to the house of a widow of Sarepta, in the territory of Sidon. When he arrives the widow has been drawing water, and is about to pick up two pieces of wood. In this story there is nothing that is not symbolic. Elijah driven away by the Jews and later taken up to heaven in a chariot of fire is a figure of Christ ; the widow of Sarepta is the church of the Gentiles welcoming the Saviour whom the Synagogue would not receive. She has drawn water to show her belief in the virtue of baptism, and she gathers two pieces of wood to show that she looks to the Cross for salvation.[2] At Bourges (Fig. 78) and Le Mans the artist has put an actual cross in her hands in place of the two pieces of wood.

At Tours and Le Mans the Bearing of the Cross is accompanied by yet a fourth symbolic scene—the blessing of Ephraim and Manasseh by the patriarch Jacob. According to the interpreters this was a figure of the Cross for, to quote the text, Jacob blessed his grandsons " with crossed arms," a circumstance which seemed significant to all the commentators.[3] The glass-painter at Bourges presented this scene, but he put it at the top of the window in the place of honour (Fig. 78). By doing this he sought to give expression to a wider and profounder thought than that of the artists of Tours and Le Mans. The Fathers had pointed out that in blessing his grandsons with crossed arms Jacob wished to show that he preferred the younger to the elder, for it was on Ephraim that he placed his right hand. Jacob's blessing thus became a type of the New Covenant, the Jews being represented by Manasseh and the Gentiles by Ephraim. By this choice Jacob, who was an accepted type of Christ, announced that through the mystery of the Cross the Messiah would substitute a new race for the ancient people of God.[4] This doubtless was the idea of the artist of

[1] *Glossa ordinaria*, lib. Exod. xii. 7.
[2] *Glossa ordinaria*, Reg. xvii. 8–13.
[3] *Glossa ordinaria*, lib. Genes. xlviii. 12–15. See also Isidore of Seville, *Quæst. in Vet. Testam.*, cap. xxxi. ; *De benedictionibus patriarcharum*.

[4] See Isidore of Seville, *loc. cit.*, and *Allegor. quædam Script. sacræ*, under the names Jacob, Manasseh, and Ephraim.

Bourges who, in placing this scene at the culminating point of his window, expressed the belief that it was not for a chosen people but for all men that Christ died on the Cross.[1]

After the Bearing of the Cross the Crucifixion furnished the occasion for the richest symbolism. In the medallions which surround this scene we find the spring that gushed forth from the rock when struck by the rod of Moses,[2] the brazen serpent,[3] the death of Abel,[4] and the marvellous grapes from the Promised Land[5] (Figs. 78 and 79).

Since the days of St. Paul the Church has looked upon the rock struck by Moses as a type of Christ,[6] but the analogy briefly indicated by the apostle was maintained at some length by commentators on the book of Exodus. According to the *Glossa ordinaria*, an epitome of them all, the spring that gushed from the rock is the water and the blood which flowed from the side of Christ when pierced by the centurion's lance. The crowd which murmured against Moses when waiting for the miracle symbolises the new peoples who would no longer submit to the Judaic law and who came to quench their thirst at the living spring of the New Testament.[7] Far removed as they seem at first sight, the connection between this scene and that of the Crucifixion is intelligible.

The brazen serpent which Moses lifted up for the healing of the people is given in the Gospel itself as a figure of the Crucifixion. The commentators explain this passage of the Old Testament more briefly than was their custom, no doubt supposing it to be better known. Isidore of Seville, quoting the *Glossa ordinaria*, contents himself with recalling that Christ is the new serpent who has vanquished the old one, and he adds that it was for the consistent and durable qualities of brass that it of all metals was chosen by Moses to express the divinity of Christ and the eternity of His reign.[8]

The death of Abel, first of the just and type of the future Messiah, seems to the interpreters a transparent figure of the Crucifixion. They are satisfied to remind men that Cain, the elder of Adam's children, was an

[1] See Cahier, *Vitraux de Bourges*, p. 25.
[2] Bourges, Tours and Le Mans.
[3] Bourges, Tours, Le Mans, Saint-Denis and Lyons.
[4] Tours (at Tours the panel had been displaced and is near the Bearing of the Cross).
[5] Cross from St.-Bertin (reproduced in the *Annales arch.*, xviii.) and the reliquary from Tongres (Cahier, *Nouv. mélang. arch.*, in *Curiosités mystér.*, p. 91). The fragment of the window at Le Mans which we

reproduce (Fig. 79) shows Moses striking the rock and lifting up the brazen serpent. The pelican (spoken of in the Psalms) accompanying David is also a type of the Crucifixion. The lions are displaced and should be by the side of the medallion of the Resurrection.
[6] 1 Cor. x. 3-4.
[7] *Glossa ordinaria*, lib. Exod., cap. xvii. 3-4.
[8] *Ibid.*, lib. Numer., cap. xxi. 8.

undoubted symbol of God's ancient people, and that Abel killed by Cain was a figure of Jesus put to death by the Jews.[1]

On the other hand the bunch of grapes from the Promised Land was a figure less easy to interpret, and the commentators expatiate at length on the famous passage from the book of Numbers. The twelve spies sent by Moses into the land of Canaan, who declared on their return that the Promised Land could not be possessed, are the scribes and Pharisees who dissuaded the Jews from belief in Christ. Yet He was even in the midst of them in the form of the marvellous bunch of grapes. The grapes which the spies brought back from the land of Canaan suspended to a pole signify the Saviour hanging on the Cross, for He is the mystic grape whose blood fills the chalice of the Church.[2] The two bearers also show forth a mystery. He who walks in front turning his back on the grapes is the type of the Jews, blindly and ignorantly refusing to see the truth, while he who goes behind with eyes fixed on the grapes is the type of the Gentiles who move forward with eyes fixed on the Cross.[3] This mystical interpretation given in the *Glossa ordinaria*, was taken literally by the unknown artist who designed the symbolic subjects seen on the shrine of the True Cross at Tongres.[4] That it may be quite clear that the first bearer symbolises the Old Covenant he even wears the conical cap of the Jews. The fidelity with which mediæval art translated the thought of the Church may be gauged by this example.

The Resurrection was also foretold in biblical types which found a place in the windows. The most famous of these types was taken from the story of Jonah. The prophet emerging alive from the jaws of the great sea monster prefigured the victory of the Son of Man over death. The analogy, as we have seen, is pointed out in the Gospel itself. The commentators observed that Jonah remained three days in the belly of the whale as Jesus remained three days in the tomb.[5] The windows at Bourges, Le Mans and Lyons show Jonah thrown up by the monster in close proximity to the medallion of the Resurrection (Fig. 78).

Another biblical figure which at times [6] accompanies the Resurrection is

[1] *Glossa ordinaria*, lib. Genes., cap. iv. 8.

[2] *Ibid.*, Numer., cap. xiii. 24. The *Gloss* says: "Calicem Ecclesiæ propinavit," a passage which is very important for the history of art. This figure in the *Gloss* (which comes from Isidore of Seville) was later used in art. Near to the Cross is seen the Church filling her chalice with the blood which flows from the side of Christ.

[3] *Ibid.*

[4] See Cahier, *op. cit.*

[5] *Glossa ordinaria*, in Matt. xii. 39-41.

[6] At Bourges and Le Mans.

the story of the widow's son resuscitated by Elisha.[1] This has a more subtle interpretation. The stress is not so much on the Resurrection of Christ as on the resurrection of humanity which rose with Him. To

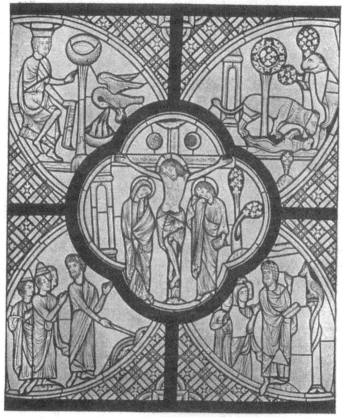

FIG. 79.—FROM A SYMBOLIC WINDOW AT LE MANS
(*From Hucher*)

quote the *Glossa ordinaria*,[2] Elisha is a type of Jesus Christ. When he learns that the widow's son is dead he first sends his servant with his staff to revive the child, but the servant lacks the divine power which will accomplish the miracle. This is an image of God's servant Moses who could not save the people, although God had given him a rod that

[1] It is Elisha, and not Elijah to whom the Bible attributes an analogous miracle elsewhere. " Eliseus " can be read in the window at Le Mans.

[2] *Glossa ordinaria*, lib. Reg. II. iv. 32-37.

145

he might accomplish it. Like Elisha Christ came to finish the work of salvation. He laid himself on the body and touched its members, that is to say, by taking a mortal body he united himself to human nature. Seven times he breathed the spirit of life on the dead to signify that he gave the seven gifts of the Holy Spirit to dead humanity, and lastly he rose with the living child as humanity rose from the tomb with Christ.

In a window at Chartres a new type of the Resurrection is seen in Samson carrying away the gates of Gaza. Samson enters Gaza, and the Philistines, persuaded that they can hold him prisoner, close the gates upon him. But during the night the hero bursts the doors off their hinges, puts them on his shoulder and deposits them on the top of a mountain. Samson is a figure of Christ and Gaza is the tomb in which the Jews believed they had confined the Saviour for ever. But before the break of day, like Samson He breaks open the doors of the sepulchre and carries them away with Him to the mountain, that is to say, to heaven, whither He ascends to show that He has vanquished death for ever.[1]

These are a few examples of the parallels drawn by art between the Old and the New Testaments. One sees how intimately the artists entered into the thought of their time.[2]

III

The scenes taken from the Old Testament do not always group themselves round the figure of Christ. At times they relate to the Virgin Mary. The doctors had early allowed that certain biblical incidents might be considered as references to the virgin Mother, and to these the thirteenth century, which offered her such tender worship, could not fail to give artistic form. The artists were inspired by two Old Testament passages in particular, the story from Exodus of Moses's vision of God in the midst of a burning bush,[3] and the story in the book of Judges which tells how Gideon called down the dew from heaven on to the fleece that he had spread on the threshing floor.[4]

The doctors taught that the burning bush was a figure of the Virgin;

[1] *Glossa ordinaria*, lib. Judic., xvi. 1.
[2] The symbolism of the lion, the pelican and the charadrius, which are seen in the windows we are about to study by the side of Old Testament scenes, was discussed in Book I. (*The Mirror of Nature*).
[3] Exod. iii. 1–2.
[4] Judges vi. 36–40.

the bush which burned yet was not consumed, and which disclosed the form of God in the midst of the fire was an image "of her who received the divine flame in her womb yet was not consumed."[1] Although another interpretation is given by the *Glossa ordinaria*, this one was most generally accepted and it was adopted by the Church in the Office of the Virgin. Gideon's mysterious fleece, first considered as a figure of the Church,[2] became a type of the Virgin Mary, especially as the thirteenth century approached. St. Bernard to whom one should always turn when speaking of the cult of the Virgin in the Middle Ages, elaborates the allegorical meaning of Gideon's fleece in one of his sermons. The dew which fell from heaven on to the fleece beneath is to him a transparent image of the virgin birth.[3]

The thirteenth-century glass at both Laon (Fig. 8) and Lyons shows these two symbolic scenes in close proximity to scenes from the life of the Virgin.

The porch of the façade of Laon cathedral, to the left of the spectator, is the most remarkable symbolic work devoted to the glorification of the Virgin. It is perhaps permissible to lay stress on this important group of sculpture, for up to the present it has neither been accurately described[4] nor has its full significance been grasped.

The scenes from the life of the Virgin (the Annunciation, the adoration of the Magi, and the Nativity) which are carved on the lintel and tympanum lead one to infer that the whole doorway is dedicated to the mother of God. The presence of angels in the first order of the arch, and of the Christian virtues usually attributed to her by the doctors in the second order, confirm this first impression.[5] But examination of the third order plunges the observer into perplexity. It is true that he recognises Gideon and his fleece[6] and Moses and the burning bush, but why is Daniel here treading a dragon under foot[7] and then receiving the basket brought by Habakkuk to the lions' den?[8] What can be the meaning of the ark of the Covenant—called by name ARCHA DEI—and of a closed door with a prophet standing by it? The fourth order again presents scenes just as diverse and as difficult to connect with any one leading idea. One there sees a young girl with an animal

[1] See Rabanus Maurus, *De Universo*, lib. XXIII. *Patrol.*, cli., col. 513.
[2] *Glossa ordinaria*, lib. Judic., vi. 36–40.
[3] St. Bernard, *Super Missus est angelus hom. Patrol.*, clxxxiii., col. 63.
[4] See *La Cathédrale Notre-Dame de Laon*, by the Abbé Bouxin, p. 60 *sq.*

[5] This curious Psychomachia at Laon was discussed in Book III. (*The Mirror of Morals*).
[6] Close to this figure is written VELLVS.
[7] And not Susanna as the Abbé Bouxin thought.
[8] One there reads ABACVC : AFFERENS : ESC[am].

RELIGIOUS ART IN FRANCE

(a unicorn as we shall see later) in her lap, with the inscription CAPITVR [1];
Balaam recognised by his inscription, B[alaa]M : ORIETVR STELLA EX
JACOB ; then king Nebuchadnezzar lying on his bed, and seeing in a dream
the statue of gold, silver, brass, iron and clay which is shown above him with
the inscription STATVA ; then a figure anointing a king ; then a woman
carrying a tablet with the enigmatic inscription ET : P : SECLA : FVTVRVS ;
and finally the three children in the fiery furnace with a completely pre-
served inscription TRES : PVERI : IN : FORNACE.

We have here yet another example of the wide influence exerted by the
Speculum Ecclesiæ in the Middle Ages, for the sermon which is there given
for the feast of the Annunciation explains and gives coherence to the figures
in the doorway at Laon.[2] Honorius sets out to show that the mystery of
the virgin birth was foretold by the prophets, and is pre-figured in the Old
Testament. He expresses it as follows.[3] Moses saw a burning bush
which the flames could not consume, and in the midst of it God
appeared. Herein is a figure of the Holy Virgin ; for never burning with
the fire of concupiscence she yet received within her the flame of the Holy
Spirit. . . . At God's command Aaron placed a dry rod in the ark of the
Covenant,[4] and on the day following the stick budded and bore flowers and
fruit. The sterile branch bearing fruit is the Virgin Mary who brought
into the world Jesus Christ, at once God and man. . . . Gideon, a judge in
Israel, spread a fleece on the threshing floor and on it the dew of heaven
descended, yet the floor around it remained dry. The fleece on which fell
the dew is the virgin Mother ; the floor is her virginity which suffered no
hurt. . . . In a vision Ezekiel saw an ever-closed door through which no
man might enter. Yet the King of kings passed through that closed door,
and He alone. Mary is the door of heaven which before, during and
after childbirth remained untouched. . . .[5] King Nebuchadnezzar saw in his
vision a statue whose head was of gold, the breast and the arms of silver,
the belly of brass, the legs of iron, and the feet of clay. A stone cut without
hands from the mountain struck the image and reduced it to powder ; then
the stone grew large as a mountain and filled the whole earth. The
divers metals composing the statue are the different kingdoms. The stone

[1] Two subjects follow which we have not been
able to identify ; first a figure with the inscription
PLEX : VIA : NO : MITT, then an old and a young man
without inscription.
[2] *Spec. Eccles. In Annuntiat. Patrol.*, clxxii., col.
904 *sq.*

[3] The essential passages only are translated.
[4] The artist at Laon has not represented Aaron,
but only the ark : ARCHA DEI.
[5] One sees that the figure near to the door is the
prophet Ezekiel.

torn from the mountain without human touch is Christ born of an unsullied virgin. He will subjugate all the peoples and will reign for ever and ever. . . .[1] This same Nebuchadnezzar made a statue of gold forty cubits high and sixteen cubits wide which he commanded the people to worship, but Ananias, Azarias and Misael refused to bow their heads before it. The angry king loaded them with chains and ordered that they should be thrown into a furnace seven times heated; but by the will of God the flames escaping from the furnace burnt those without and touched not a single hair of those who were within. Moreover they were heard singing in the midst of the fire, and with them the king saw one like to the Son of God. Even so the Holy Spirit impregnated the Holy Virgin with His inner fire, while without He protected her against all concupiscence. . . . Again, authorised by the king, Daniel destroyed the idol of the Babylonians and killed a dragon which they worshipped.[2] That is why the angry Babylonians threw him into the den of lions and shut the den until the seventh day with a large stone bearing the king's seal. Then the angel of the Lord sent the prophet Habakkuk from Judæa with a basket of food, and without breaking the seal Habakkuk passed the food into the den to Daniel. On the seventh day the king found the seal untouched and Daniel alive. Praising God, he ordered that Daniel should be brought up out of the den, and his enemies devoured by the lions. It is even thus that Christ entered the womb of His mother with breaking the seal of her virginity, and left the virginal dwelling without touching that seal."

One cannot but be struck with the parallelism between the work of scholar and artist. They take as examples precisely the same incidents, and in the history of Daniel especially, the artist has followed the text so closely that he has not hesitated to represent episodes (such as the death of the serpent) which do not go directly to prove the virgin birth. It is evident that Honorius's sermon for the feast of the Annunciation was the scheme given to the artist, but as there still remained empty places on the arch order two more symbolic scenes were borrowed from Honorius, drawn from two other sermons devoted to the Virgin. The first bas-relief shows

[1] This is the explanation of the scene of anointing found next to the dream of Nebuchadnezzar. It must be regarded as a figure of the kingship of Christ. The woman who follows, and who is accompanied by the inscription ET : P : SECLA : FVTVRVS, alludes to the eternity of Christ's reign. She is in fact a sibyl, as the words engraved near her show. These very words are taken from the famous acrostic lines quoted by St. Augustine in which the sibyl announces both the day of judgment and the eternity of the reign of Christ:

"Judicii signum ; tellus sudore madescet,
E Cœlo rex adveniet *per secla futurus.*"

[2] It is the subject of the first scene which shows Daniel treading under foot a dragon with a human head.

a young girl who welcomes a unicorn to her lap.[1] The meaning given to this by Honorius is already known to us ; he sees in it yet another image of the Incarnation. The second bas-relief represents the prophet Balaam announcing, as an inscription testifies, that a star shall come out of Jacob. Here again is a reference to the birth of Christ—a reference which Honorius had no difficulty in showing and which is clear enough to us.[2]

We have dwelt at length on the doorway of Laon because the real meaning of that great ordered whole had not been elucidated, and because the close connection between mediæval art and literature is clearly shown in this example.

One might cite other compositions of the thirteenth century in which the person of the Virgin Mary is foreshadowed in Old Testament types.[3] In the front rank stand the bas-reliefs of the west porch of the cathedral of Amiens, which is entirely devoted to the mother of God.[4] Below the two great statues representing the Virgin and the angel of the Annunciation on the right wall are four bas-reliefs whose subjects are familiar to us (Fig. 80),—the stone which was cut without hands from the mountain before the eyes of Daniel, Moses and the burning bush, Gideon's fleece and Aaron's rod. We have here four of the very scenes found in the porch at Laon. From this one may infer that the sculptor at Amiens, like his brother artist at Laon, sought inspiration in Honorius's sermon on the Annunciation. The representation of the Annunciation which accompanies the bas-reliefs at Amiens goes to support our view.

A window in the collegiate church of Saint Quentin[5] seems to come from the same source. The scenes from the life of the Virgin are brought into relation with the same types from the Old Testament. The Annunciation is accompanied by the figures of Nebuchadnezzar beholding the statue in a dream and of Aaron clothed in priestly garments ;[6] the Nativity is related to the stories of Gideon's fleece and Moses and the burning bush ;

[1] The horn is broken. Close to this little figure one reads the inscription CAPITVR, the final word of one of Honorius's lines.

"Ad quam capiendam virgo puella in campum ponitur,
Ad quam veniens, et se in gremio ejus reclinans, capitur."

Spec. Eccles. De nativ. Domini, col. 819.

[2] *Spec. Eccles. De Epiphania Domini*, col. 846.

[3] We would also point out a twelfth-century example in the porch of the church of Ydes (Cantal),

built by the Templars in the second half of the twelfth century. On one side is the Annunciation, on the other Daniel in the lions' den and near him the prophet Habakkuk held by the hair by an angel—a representation which here, as at Laon, derives from Honorius's sermon on the Annunciation.

[4] Doorway to the right.

[5] In the apse, in a chapel situated in the axis of the church (third window to the left).

[6] One can hardly doubt that the figure of the high priest wearing the breastplate is Aaron.

the adoration of the Magi to the prophecy of Balaam whom one sees mounted on his ass. The striking resemblance between the glass at St. Quentin and the porches of Laon and Amiens leads to the conclusion that they derive from the same three sermons of Honorius of Autun.

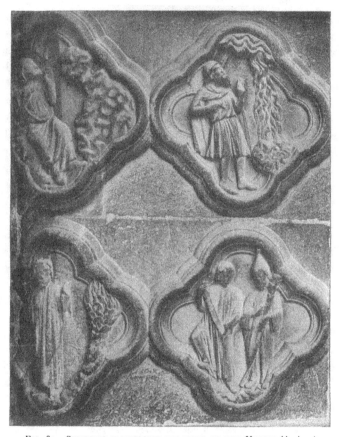

FIG. 80.—SYMBOLIC BAS-RELIEFS RELATING TO THE VIRGIN (Amiens)

The three great works of symbolic art we have examined are so many fresh proofs of the devotion offered by the Middle Ages to the mother of God. It was to the Virgin that the artists would turn men's thoughts when they painted or carved these episodes from the Old Testament which on the surface seem so remote from her.

RELIGIOUS ART IN FRANCE

IV

The Middle Ages, as we have seen, loved to foreshadow the New Testament in scenes chosen from the Old. But from the twelfth century the artists conceived a simpler way of showing forth Christ. They took personages of the old Covenant, and at the entrance to the cathedral they erected statues of the patriarchs and kings whom the Fathers had regarded as types. Thus on the very threshold the saints of the Old Testament proclaimed the Messiah and became, as says St. Augustine, " heralds of God ". In the north porch at Chartres Melchizedek, Abraham, Moses, Samuel and David stand at the entrance to the church. These great figures must be counted among the most extraordinary of mediæval statues (Fig. 95). They seem to belong to another and a more than human race, primitive beings coeval with the dawn of the world. The art of the beginning of the thirteenth century, unskilful in rendering individual character, gave noble expression to all that there is of universal or eternal in the human form. The patriarchs and prophets of Chartres seem like true fathers of the race, pillars of humanity, but how much do they gain in grandeur and mystery as precursors of a greater than themselves. They form as it were a *via sacra* which leads up to Christ. The same symbolic personages are found at Reims, in the right bay of the west porch, where they are arranged approximately as at Chartres and offer the most astonishing analogies (Fig. 81). They are found again at Senlis, but unskilful restoration precludes the identification of all the figures there.[1] Again, some of them are found in the doorway of St. Benoît-sur-Loire, where among several mutilated statues one easily recognises those of King David and of Abraham placing his hand on the head of his son. Up to the last century a similar series was seen in the doorway of the collegiate church of the Madeleine at Besançon.[2] The statues which are seen in the upper part of the cathedral of Lyons[3] and the small figures on the arches of the Portail St. Honoré at Amiens also stand for the chief personages of the Old Covenant, though the choice is not in every case identical.

The manual which Isidore of Seville entitled *Allegoriæ quædam Scripturæ*

[1] One can however recognise Abraham with Isaac at his feet, also Moses bearing the brazen serpent (restored as David), Jeremiah carrying the cross, and Simeon carrying the Child.

[2] See *Bullet. arch. du comité*, 1895, p. 158.

[3] On the south side the mutilated statues at Lyons seem to represent Moses, Aaron, Joshua, Othoniel (?), Samuel anointing David, David.

[4] It is hardly necessary to point out that the figures of patriarchs at Laon (façade, left porch) are modern.

sacræ is the best commentary on the works of art just enumerated.[1] In this little book he passes in review the chief persons of the Old Testament, and makes known their mystical significance. The few lines he devotes to each of them are often so concise that they might well be written on phylacteries and placed in the hands of the statues. We will take our interpretation of the symbolic statues at Chartres, Reims, Amiens, Senlis and Lyons from this manual, for in it are solved all the difficulties that arise from the

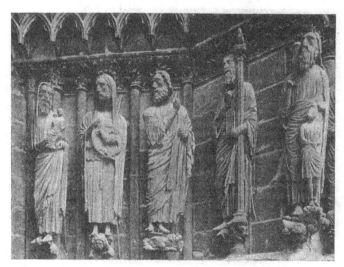

FIG. 81.—SIMEON, JOHN THE BAPTIST, ISAIAH, MOSES, ABRAHAM (Reims)

presence of an Old Testament personage in any work of the thirteenth century.

Adam is the first and most significant type of Christ,[2] for Christ is the second Adam. The first Adam was formed on the sixth day, and the second Adam was incarnate in the sixth age of the world. Even as the one ruined man by his sin so the other saved man by His death, and in dying restored him once more to the image of God.[3] One can readily understand why the Middle Ages so often placed Adam at the foot of the Cross, and why too they imagined that the tree of the Garden of Eden, miraculously preserved through the centuries, provided the wood of which it was made. The

[1] *Patrol.*, lxxxiii., col. 96.

[2] Adam figures in the Portail Saint-Honoré at Amiens (Fig. 82). The porch at Amiens shows in the first order (after the angels) Adam tilling, Noah building the ark, Melchizedek bearing the bread and wine, Abraham preparing to sacrifice Isaac, Jacob and Isaac.

[3] Isidore of Seville, *Allegor.*, col. 99.

RELIGIOUS ART IN FRANCE

legend was beautiful and striking, and it gave popular form to the dogma of the Fall and the Redemption.

Abel is the second type of Christ.[1] He symbolises the Saviour not only in his death but also in his life, for he was a shepherd and from the beginning of time he announced Him who said, " I am the good shepherd who gives his life for his sheep." [2] And so in mediæval art a lamb is the attribute of Abel.

Noah too is a type of Christ, and his ark a type of the Church.[3] The ark, like the Cross, was made of wood, and by means of mystic numbers its dimensions prefigured the dimensions of the Cross. The ark was built by Noah, the only just man of the ancient world, as the Church was built by Christ, the supremely just man. Lastly the ark floated on the waters of the deluge to teach men that the Church finds her safety in the waters of baptism—a truth signified once again by the eight persons saved in the ark, for eight is the number of regeneration and eternal life.[4]

Melchizedek whose name occurs in the canon of the Mass, has in consequence become the most famous of all types of Christ.[5] The Bible speaks of him in mysterious words as at once pontiff and king, two titles which belong to Christ alone. And in his offering of the bread and wine to Abraham, Melchizedek foreshadows in the childhood of the world the institution of the Eucharist.[6] The mystical idea evoked by the name of Melchizedek is happily expressed at Chartres. The crown surmounted by the tiara is placed on the head of the ancient king of Salem, and the chalice is placed in his hand. The artist at Reims—still more daring—shows

Fig. 82.—Patriarchs and prophets round the arch of the Portail St. Honoré at Amiens

[1] The figure holding a lamb in the porches at Reims and Senlis is not Abel, as is often said, but Samuel. Abel certainly appears as a type of Christ on the famous niello plaque of the end of the twelfth century which was reproduced by Didron. (*Annales archéol.*, vol. viii.)

[2] Isidore of Seville, *Allegor.*, col. 99.

[3] Noah and his ark is seen at Amiens (Fig. 82) and on the twelfth-century plaque.

[4] Isidore, *Allegor.*, col. 102.

[5] Melchizedek is represented at Chartres, Amiens and Reims (in the interior of the cathedral, central doorway) (Fig. 83).

[6] Isidore, *Allegor.*, col. 104.

Melchizedek giving Abraham the bread in the form of the consecrated wafer [1] (Fig. 83).

Abraham, who at Chartres, Reims, Amiens and Senlis is represented about to sacrifice his son,[2] is too transparent a type to make insistence necessary, and it is sufficient to point out that it is here not Abraham but Isaac who typifies Christ. At Chartres a ram is seen under the bracket which supports the statues of Abraham and Isaac. According to the biblical story the patriarch found a ram caught in the thicket by its horns and offered it in place of his son. The commentators saw a hidden meaning in the incident, and regarded it as a new figure of the sacrifice of Christ. The ram's horns by which it was held fast in the bushes became a symbol of the two arms of the cross, and the thorns in which its head was entangled an allusion to the crown of thorns.[3]

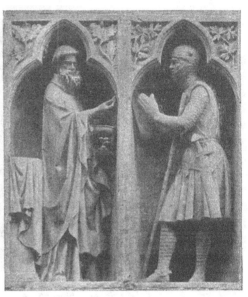

FIG. 83.—MELCHIZEDEK AND ABRAHAM (Reims)

The patriarch Joseph typifies Christ not in an isolated act but by his whole life. Isidore of Seville contents himself with the general observation that like Christ he was betrayed by his friends, and like Him was received by strangers.[4] This would fully explain the presence of Joseph in the porch at Chartres,[5] but not content with the somewhat vague comparison made by Isidore of Seville, the thirteenth century pushed it much further. A window at Bourges, for example, represents a few typical scenes from the life of Joseph. It would be admissible to see here nothing beyond the simple story did not the seven stars which dominate the composition

[1] I do not think it can be doubted that the priest who communicates the warrior (statues in the interior of the cathedral of Reims, central doorway, at the base) is Melchizedek. One must not be surprised to see Abraham in the armour of a thirteenth-century knight. The Psalter of St. Louis (Bibl. Nat., MS. Lat. 10525) shows him thus attired.

[2] His knife is often broken.

[3] *Glossa ordinaria*, lib. Genes., XXII., 9–11.

[4] Isidore, *Allegor.*, col. 107.

[5] North porch, statue in the right bay.

RELIGIOUS ART IN FRANCE

and are as it were the blazon of Christ, warn us that to the artist the life of Joseph is merely a figure of the life of the Saviour.[1] Little doubt remains as to the intention of the author of the window at Bourges after one has read the chapters devoted to Joseph in the *Glossa ordinaria*.[2] From it one may legitimately conclude that in accordance with the exegesis of the time Joseph's dream, the first subject in this window, is an allusion to the reign of Christ, and that Joseph dreamt that the sun and moon worshipped him because it was said of the Saviour, "The sun, the moon and all the stars will adore thee". His brothers were provoked against him when he told them his dream, even as the Jews among whom Jesus was born and whom He called His brothers, were provoked against their Saviour. In other compartments of the window Joseph is seen deprived of his cloak, thrown into the pit, and sold for thirty pence to the Ishmaelite merchants, a type successively of the betrayal, passion and death of Christ. The coat that was taken away from him is the humanity which clothed the Saviour, and of which He was deprived in dying on the Cross. The pit into which Joseph was thrown after his garment had been taken from him is Hades, where Christ descended after His death, and lastly the thirty pence paid by the Ishmaelite merchants as the price of Joseph recall the thirty pence of the betrayal. The story of Joseph and Potiphar's wife, seen in the subsequent medallions, is a further allusion to the Passion. Potiphar's wife is the Synagogue, accustomed to commit adultery with strange gods. She endeavours to tempt Christ who rejecting her teaching finally leaves in her hands his cloak, that is the body of which He divests Himself on the Cross. The triumph of Joseph which crowns the window typifies Christ's victory over death and His kingdom which shall have no end.

Such is the hidden meaning of the window at Bourges. What to the people was merely a moving story to the theologian was a symbol.

After Joseph, Moses is one of the most marked types of Christ.[3] He gave the first law to the Jews as Jesus gave the second, and at Chartres, Reims and Amiens he is seen with the tables of the Law in his hands. According to the Fathers many features in his history foreshadow Christ,[4] but in general only the lifting up of the brazen serpent is retained

[1] *Vitraux de Bourges*, pl. X. Father Cahier saw clearly that the window at Bourges was in the main symbolic.

[2] *Glossa ordinaria*, lib. Genes., cap. xxvii. *sq.* The miniaturists for their part expressly relate the life of Joseph with that of Christ. See Bibl. Nat.,

MS. Lat. 9561, f. 22 *sq.* (twelfth and thirteenth centuries).

[3] Isidore, *Allegor.*, col. 109.

[4] In his *Allegoriæ in vet. Testam.* (*in Exod., Levitic.*) Isidore compares the lives of Moses and of Christ at some length.

by the sculptors, who all place in his hand a pillar surmounted by a winged dragon.[1]

David and Solomon were also popular types of Christ. The reasons for this are as usual numerous, but a few of them seemed conclusive to the thirteenth-century artist. At Chartres and Amiens his aim was to remind men that Samuel's consecration of David was a figure of a more august occasion,—the anointing of Him who was called " the Lord's anointed." At Amiens Samuel is seen pouring the oil on to the head of David,[2] at Chartres the statues of Samuel and David are simply placed together.

It is not without reason that at Chartres, Amiens and Reims[3] the statue of Solomon is placed near that of the queen of Sheba. In accordance with ecclesiastical doctrine this signifies that Solomon is a type of Christ and the queen of Sheba a type of the Church who came from the ends of the earth to hear the word of God.[4]

These are some of the more famous types of Christ in art. They are those to which the Middle Ages attached the most importance and represented with the greatest dignity, but it would not be difficult to cite many others. There is every reason to suppose, for example, that the scenes from the lives of Job, Tobias, Samson and Gideon which fill the arches and tympanum in the right bay of the north porch at Chartres were portrayed with intent to do honour to Christ, of whom these biblical personages are types. Job by his sufferings and triumph is a type of the Passion and victory of Christ,[5] as also is Gideon though for more mystical reasons. The victory Gideon gained with his three hundred companions prefigures the victory which the Saviour was to gain in dying on the Cross, for the number three hundred (T) is as we have seen the hieroglyph for the Cross.[6]

Tobias restoring his old father's sight is Christ giving light to the people of God who had become blind.[7] Samson, as we have already

[1] At Chartres, Reims, Amiens (Portail Saint-Honoré) and Senlis where the serpent has disappeared.

[2] Portail Saint-Honoré.

[3] At Amiens the statues of Solomon and the queen of Sheba are not in the Portail Saint-Honoré, but in the right bay of the west doorway. At Chartres the two statues are in the right bay of the north porch. At Reims they are found as counterparts on the west façade, central bay, buttresses.

[4] The visit of the queen of Sheba to Solomon was also considered in mediæval times as a type of the Adoration of the Magi. The queen of Sheba, who came from the east, symbolises the Magi, and king Solomon seated on his throne symbolises the eternal Wisdom seated on the knees of Mary. (Ludolph of Saxony, *Vita Christi*, cap. xi.) This is why the façade at Strasburg (central porch, gable) shows Solomon on his throne guarded by twelve lions and above him the Virgin with the Child on her knee.

[5] Isidore, *Allegor.*, col. 108.

[6] *Ibid.*, col. 111.

[7] *Ibid.*, col. 116.

observed, was generally considered the type of Christ as victor over death.

These examples serve to show that the mind of the mediæval Christians perpetually dwelt upon the figure of Christ. It was He they sought, it was He they found everywhere. They read His name on every page of the Old Testament. Symbolism of this kind is the key to many works of the Middle Ages both literary and artistic which without it remain unintelligible. The mediæval use of symbolism, for instance, can alone explain the economy of a work as desultory in appearance as the *Mistère du Viel Testament*.[1] Why did not the unknown poets of the fifteenth century who composed this great sacred drama believe they should give equal importance to all parts of the Old Testament story? Why choose out one person rather than another, or dilate upon Adam, Noah, Abraham, Joseph, Moses, Samson, David, Solomon, Job, Tobias, Judith, Susanna and Esther except that these biblical heroes and heroines were the most popular types of Christ and the Virgin Mary. The authors, moreover, would not let men ignore their intention, and at the beginning of the story of Joseph they make God the Father Himself say that all the misfortunes of the patriarchs were but figures of the sufferings reserved for His Son.[2] The whole Mystery is ordered like a cathedral porch. The characters in the drama are the very same that for analogous reasons were represented at Chartres and Amiens.[3]

In the Middle Ages, as we see, all the arts united in giving the people the same religious teaching.

V

After the patriarchs and kings who typified Christ in their lives, the Middle Ages represented the prophets who proclaimed Him in their words. Of all Old Testament figures these are the most strange. The inspired men whom God caught away from their flocks and their sycamores, who wrestled with the spirit, who felt themselves seized by the hair, who cried, "Ah, Lord God, I cannot speak for I am a child," who moved by

[1] *Mistère du Viel Testament*, published by the Société des anciens textes français, 6 vols., 1878–91.

[2] " . . . C'est seulement
Pour figurer les Escriptures
Et monstrer par grosses figures

L'envye que les Juifs auront
Sus mon fils. . . ."
(*Dialogue between God and Mercy*, in vol. ii.,v. 16936 *sq.*)

[3] It should not be forgotten that at Chartres as in the *Mistère du Viel Testament*, the stories of Judith and Esther (north porch, right doorway) are seen by the side of those of Samson, Tobias and Gideon.

an unknown force stood at the gates of cities and announced unparalleled calamities, who prophesied from the bottom of dungeons, who shaved off their hair and eyebrows, rent their garments and walked barefoot in the desert,—these more than human seers were subjects well fitted to inspire the great thirteenth-century artists. It must, however, be confessed that it needed the power of a Michelangelo to draw an adequately impressive portrait of them. That truly biblical genius could alone express the hopes and fears of the ancient world, the infinite sadness of Jeremiah who lets his head fall sadly on his hands or the enthusiasm of the young Daniel who feels his hair raised by the breath of the spirit. No such attempt was made by the Middle Ages.[1]

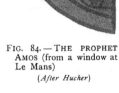

The purpose of the serious artists of the thirteenth century when representing the prophets was once again dogmatic. They were wholly engrossed in expressing the theological truth that the prophets were the apostles of the Old Law who announced the same facts in scarcely different form. Taking that as their point of departure, they opposed the four major and the twelve minor prophets to the four evangelists and the twelve apostles, as for example in the windows of the apse at Bourges.[2] They gave them the same garment, the same book, the same nimbus as the apostles, distinguishing them only by the Jewish cone-shaped cap placed on the heads of some of the prophets.[3] It seems as if they would ask men to draw the parallel for themselves. Lacking in individuality as they are, these figures make none the less a profound impression.

FIG. 84.—THE PROPHET AMOS (from a window at Le Mans)

(*After Hucher*)

[1] The fine figures of prophets on the "Puits de Moïse" at Dijon should not be forgotten.

[2] See *Vitraux de Bourges*, pls. XX., XXI., XXII.

[3] In the glass at Chartres they have gone so far as to represent them with bare feet like the apostles.

RELIGIOUS ART IN FRANCE

With their sameness of appearance and rude and clumsy outlines, at that height stately and imposing, the prophets in the windows at Bourges appear like a solemn assemblage of witnesses. Under their feet their names are written — Amos, Joel, Nahum, Zephaniah, and coming down from so remote a time the names themselves seem to add to the mystery which surrounds the great figures.

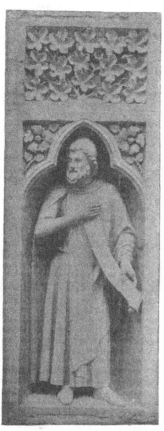

FIG. 85.—A PROPHET (Reims)

This conception of the function of the prophets explains why the Middle Age concerned itself so little with their individual characteristics. They were merely the shadow of the apostles. The men of that day were less impressed by the wonderful poetry of the prophetic books than by the commentaries of St. Jerome, Walafrid Strabo, or Rupert. To them the lamentations of Jeremiah or the maledictions of Ezekiel were tedious works, devoid of meaning unless the name of Christ could be read into every line. Thus they treated the prophets as symbols, valueless except in so far as they related to Christ and to the apostles.

The Portail Saint-Honoré at Amiens is one of the rare works of the thirteenth century in which an attempt was made to characterise some of the prophets[1] (Fig. 82), and here their distinctive features were borrowed less from their works than from their legendary history. Isaiah with cleft head suffers martyrdom, Jeremiah lies on the ground stoned by his enemies, Daniel defends Susanna when accused by the elders, and Hosea gives his hand to the symbolic prostitute whom he marries.[2] The artist has sought inspiration in the little historical manuals in current use, in which were

[1] A few figures in the cathedral of Reims (interior, central doorway) should be mentioned ; Zephaniah with a lantern, and Habakkuk with the manger.

[2] The second order (Fig. 82), beginning at the bottom to the left, shows Hosea marrying the symbolic prostitute, Joel sounding the trumpet and announcing the Day of Judgment, Amos seeing fire fall from heaven, Obadiah feeding the prophets whom he had hidden in his house, Jonah thrown up by the whale, Micah beating the swords into ploughshares.

summarised legends dating back to remotest antiquity. I have no doubt that the short treatise *De ortu et orbitu Patrum* attributed to Isidore of Seville, was the main source of all that the Middle Ages related of the prophets.[1] It is a kind of biographical dictionary in which history and legend blend, and contains a brief account of the life and death of the biblical heroes. The Jewish apocryphal stories which St. Jerome, especially through his letters to Pope Damasus, had done so much to make known in the west, here carry the same weight as historical fact. We are told, for instance, that in the reign of Manasseh Isaiah was cut in two with a saw, and that Jeremiah, captive in Egypt, was stoned by men and women near to the town of Tahapanes. The legends collected in Isidore's book were a mine of wealth for the Middle Ages. In the twelfth century they are found in Peter Comestor's famous *Historia scolastica*[2] in which almost all the traditional stories are repeated, and in the thirteenth century in Vincent of Beauvais's *Speculum historiale* which merely amplifies the work of Comestor. Iconography, however, owes little to these legends.

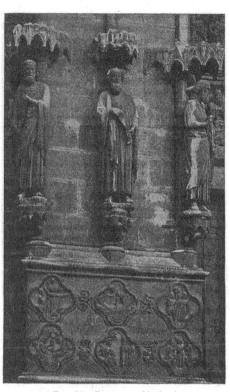

FIG. 86.—PROPHETS (Amiens)

The apocryphal history of the prophets is far from having the importance in mediæval art of the apocryphal history of the apostles.

The thirteenth century, moreover, had another manner of distinguishing the prophets. In their hands it placed phylacteries on which were inscribed a few lines from their books[3] (Fig. 85). In this way they made the prophetic word of more importance than the prophet,—an artistic expression

[1] Isidore of Seville, *Patrol.*, lxxxiii., col. 130. The treatise *De ortu et obitu Patrum* is completed by appendix xx.

[2] P. Comestor, *Hist. Scolast., Patrol.*, cxcviii. ; see

the death of Isaiah, col. 1414, and the death of Jeremiah, col. 1440.

[3] Reims, gallery of the prophets to the south, and figures in the interior, on the west wall (Fig. 85).

RELIGIOUS ART IN FRANCE

of the belief that all the great seers of the Old Testament were merely sonorous voices by which God had spoken. The prophecies formerly painted on the stone labels have been effaced by time. They were related in all probability with the positions assigned to the statues of the prophets in the great doctrinal schemes. One may believe, for instance, that the figure of Isaiah near to the statue of the Virgin in the north porch at Chartres, announced through the inscription on his scroll that there should come forth a rod out of the stem of Jesse. The Fathers had long before classified the passages in the prophetic books which related to the birth, the life, the passion and the death of Christ, and the artist had only to choose out those proper to his subject.[1] But the book to which he seems to have referred by preference was the famous discourse *contra Judæos, Paganos et Arianos*[2] attributed to St. Augustine, in which the unknown speaker makes the prophets file past one after another, each reciting some verse of his own which referred to the divinity of Christ. The sermon of the pseudo-Augustine was recited at matins on Christmas-day and became famous throughout Christendom. M. Marius Sepet has shown, as one knows, that out of it grew the drama of the liturgy,[3] and more recently M. Julien Durand has pointed out that several great mediæval art-cycles are equally closely connected with it. The very words which are given to the prophets in the sermon are written on the scrolls held by the statues at Notre Dame-la-Grande at Poitiers, and by those which decorate the façades of the cathedrals of Ferrara and Cremona.[4]

At Amiens, where the prophets are ranged on the west façade, the lines usually engraved on the phylacteries are ingeniously replaced by small bas-reliefs carved beneath the statues (Fig. 86). An attempt is here made to present some of the more famous biblical prophecies in plastic form. Below Zephaniah, for example, is seen the Lord visiting Jerusalem, a lantern in His hand ; below Haggai are the parched earth and the ruined temple.[5] These little pictures in the quatrefoils are as simple and

[1] One of the sources may have been the *De fide catholica contra Judæos* of Isidore de Seville, *Patrol.*, lxxxiii., col. 450. Events in the life of Christ and Christian dogmas are related to the prophecies that bear on them. On the words which the artists usually gave the prophets see Cahier, *Caractère des Saints*, vol. II., article *Prophètes*.

[2] *Patrol.*, xlii., col. 1117. This is especially true of the Romanesque artists.

[3] Marius Sepet, *Les prophètes du Christ*, Paris, 1877, 8vo.

[4] See Julien Durand, *Bullet. monum.*, 1888, p. 521 *sq.*

The following are the words written on the scrolls of the prophets at Poitiers. Moses : " Prophetam dabit vobis de fratribus vestris." Jeremiah : " Post hæc in terris visus est et cum hominibus conversatus est." Daniel : " Cum venerit Sanctus Sanctorum cessabit unctio." On turning to the sermon of the pseudo-Augustine one finds that these are the words he assigns to each of these prophetic figures.

[5] Fig. 86 represents Obadiah to the right, Jonah in the middle, Hosea to the left. Jonah is bald, after a tradition which goes back to Byzantine times.

charming as the naïve woodcuts which decorate a French book of Hours of the end of the fifteenth century, but it must be admitted that they retain nothing of the grandeur of the originals which they profess to translate. The matchless poetry of the Bible, aglow with the light of the east and sparkling with metaphor, and the magnificent visions which succeed one another with the awful clearness of reality seem pre-eminently calculated to be a source of inspiration for art. This however is not the case. The prophet's dream, definite as it sometimes was, refused to lend itself to the limitations of plastic art. The thirteenth-century artists made the attempt, and to-day it is the defects of their work which strike us rather than its

FIG 87.—EZEKIEL'S VISION (Amiens)

qualities. Is it possible to believe, for example, that the sculptor of Amiens who represented Ezekiel with his head on his hands in meditation before a paltry little wheel (Fig. 87), professed to illustrate the following passage from the prophet : " Now as I beheld the living creatures, there appeared upon the earth by the living creatures one wheel with four faces. And the appearance of the wheels, and the work of them, was like the appearance of the sea ; and the four had all one likeness ; and their appearance and their work was as it were a wheel in the midst of a wheel. . . . The wheels had

FIG. 88. — THE PROPHECY OF ZEPHANIAH (Amiens)

also a size, and a height, and a dreadful appearance : and the whole body was full of eyes round about all the four. And when the living creatures went, the wheels also went together by them. And over the heads of the living creatures was the likeness of the firmament, the appearance of crystal to behold." [1]

All the sacred awe of such a vision vanishes when the attempt is made to give it plastic form.

A small Gothic building is seen in a medallion a little further on. A hedgehog enters at the open door while a bird is perched on the lintel (Fig. 88). One of Æsop's fables is called to mind rather than the terrible passage

[1] Ezekiel i. 15 *sq.*

in Zephaniah which the artist would illustrate : " And he will stretch out his hand upon the north, and will destroy Assyria ; and he will make the beautiful city a wilderness, and as a place not passable, and as a

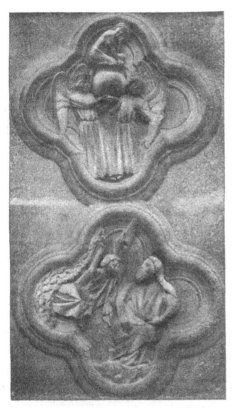

desert. And flocks shall lie down in the midst thereof, all the beasts of the nations : and the bittern and the urchin shall lodge in the threshold thereof : the voice of the singing bird in the window, the raven on the upper post, for I will consume her strength." [1]

Beneath the statue of Zechariah a medallion shows two winged women lifting a vessel in which another woman is seated. This forms a graceful and symmetrical composition (Fig. 89), but what has become of the strangeness of the sacred text : " And the angel went forth that spake in me ; and he said to me : ' Lift up thy eyes, and see what is this that goeth forth.' And I said : ' What is it ? ' And he said : ' This is a vessel going forth.' And he said : ' This is their eye in all the earth.' And behold a talent of lead was carried, and behold a woman sitting in the midst of the vessel. And he said : ' This is wickedness. . . . '

FIG. 89.—THE VISION OF ZECHARIAH (Amiens)

And I lifted up my eyes and looked : and behold there came out two women and wind was in their wings, and they had wings like the wings of a kite ; and they lifted up the vessel between the earth and the heaven. And I said to the angel that spake in me : ' Whither do these carry the vessel ? ' And he said to me : ' That a house may be built for it in the land of Senaar.' " [2]

The definition of sculpture dispels on a sudden the mystery of the prophetic vision.

Gothic art rarely attempted to contend with this markedly oriental

[1] Zephaniah ii. 13 *sq.* [2] Zechariah v. 5 *sq.*

poetry. It is doubtful whether the sculptors of Amiens had read the original prophecies and taken their subjects direct from the text. They were possibly acquainted with the prophets only through such little treatises as the *De ortu et obitu Patrum* of Isidore of Seville, where side by side with their lives the salient features of their prophecies were briefly summarised.[1] This would explain both the choice and the inadequate treatment of the small scenes represented at Amiens.

VI

Of all the prophecies one alone inspired art in any lasting fashion : " And there shall come forth a rod out of the root of Jesse, and a flower shall rise up out of his root. And the Spirit of the Lord shall rest upon him : the spirit of wisdom, and of understanding, the spirit of counsel, and of fortitude, the spirit of knowledge, and of godliness. And he shall be filled with the spirit of the fear of the Lord. . . . In that day shall be the root of Jesse, who standeth for an ensign of the people. . . ." [2]

It is sufficient to consult any commentator on Isaiah to find a symbolic interpretation of this passage which has not varied since the time of St. Jerome. " The patriarch Jesse," wrote the monk Hervæus in the twelfth century, " belonged to the royal family, that is why the root of Jesse signifies the lineage of kings. As to the rod, it symbolises Mary as the flower symbolises Jesus Christ." [3]

The mediæval artist was not daunted by so abstract a subject.[4] He gave a naïve yet magnificent rendering to the words of Isaiah when, with the candour of a child, he interpreted the prophecy literally. On the façade of the cathedral he raised a genealogical tree similar—but how much more imposing—to the tree over the fireplace in a feudal castle. Combining the verses of Isaiah with the genealogy given in St. Matthew's gospel and recited on Christmas-day and on the feast of the Epiphany,[5] he represented a great tree growing from the side of the sleeping Jesse.[6] In the branches he put figures of the kings of Judah, and at times

[1] Isidore of Seville, *Patrol.*, lxxxiii., *Append.* XX. See also a summary of the prophecies in the same volume, col. 166 *sq.*
[2] Isaiah xi. 1, 2, 10
[3] Hervæus, *Patrol.*, clxxxi., col. 140.
[4] The tree of Jesse first appeared in art at the end of the eleventh century. See Rohault de Fleury, *La sainte Vierge*, vol. i. p. 17. From one passage it might be inferred that the motif was invented in the east.
[5] See Durandus, *Ration.*, lib. VI., cap. xiii. and xvi.

[6] Why is Jesse represented asleep ? The Abbé Corblet (*Revue de l'art chrétien*, 1860) gives a very ingenious reason. On page 54 he says, " Would it not be by analogy with Adam who slept when God drew Eve from his side. A new Eve, repairer of the faults of the first, must come from the root of Jesse." It is true that he quotes nothing in support of this interpretation, but it harmonises with the mystical ideas of the Middle Ages. I have no doubt that support could be found, although so far I have been unsuccessful in my search.

their descendants to the twenty-eighth generation. On the topmost branch he placed the Virgin, and above her Christ with an aureole of seven doves, in remembrance that on Him rested the seven gifts of the Holy Spirit. It is in fact the genealogical tree which shows His noble descent. And in order to give further significance to the composition the thirteenth century placed the ancestors after the spirit side by side with the ancestors after the flesh. Close to the kings of Judah in the windows at Chartres (Fig. 90) and in the Sainte-Chapelle are seen the prophets, with uplifted finger heralding the Messiah who should come. Here art equals if not surpasses the poetry of the text.[1]

FIG. 90.—TREE OF JESSE (window at Chartres)
(*From Lassus's Monograph*)

There is on the façade of almost all the great thirteenth-century cathedrals a gallery on which colossal statues are ranged, called the gallery of the kings. These kings are not as was long thought kings of France ;[2] they are the kings of Judah. The error is far from new, for a thirteenth-century fabliau tells of a villein pointing out Pepin and Charlemagne on the façade of Notre Dame, while behind him a cutpurse steals his wallet.[3] The author of the fabliau was no doubt better in-

[1] The Trees of Jesse are numerous in the thirteenth century. They are to be seen on the arches of several doorways (Laon, Chartres and Amiens), and in several windows (St. Denis, Chartres, Le Mans, Sainte-Chapelle). We refer the reader to the list drawn up by the Abbé Corblet (*Rev. de l'art chrétien*, 1860). Towards the close of the Middle Ages the Virgin appeared in the calyx of a flower at the summit of the tree, carrying the infant Jesus in her arms.

[2] Guérard, in the Introduction to the *Cartul. de Notre-Dame de Paris* (*Docum. inédit. de l'hist. de France*), vol. I. p. clxix, gave an appearance of truth to

this mistake. He pointed out that as we learn from a MS. in the Bibl. Nat. (MS. Lat. 5921, f. 47, v.), the names of the kings of France were inscribed on the door of Notre Dame at Paris in the thirteenth century According to him these names corresponded to the great statues of the façade. His argument is destroyed by a single fact. On the façade of Notre Dame there are twenty-eight statues of kings, and on the door there were thirty-nine names from Clovis to St. Louis.

[3] *Les XXII manières du vilain*. See also Viollet-le Duc, *Dict. de l'archit.*, vol. ii. p. 389.

formed than the villein at whose crass stupidity he scoffed. The gallery of the kings is another form of the tree of Jesse. Close study of the statues of the kings which ornament the south façade of the cathedral of Chartres leaves no doubt on the subject. The patriarch Jesse and the shoots of the

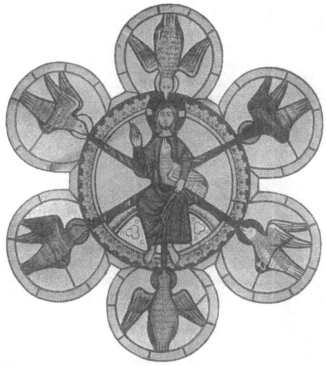

FIG. 91.—CHRIST WITH THE SEVEN GIFTS OF THE HOLY SPIRIT (Le Mans)
(*From Hucher*)

symbolic tree are found below a statue that is evidently David, so that it is impossible not to see in the eighteen kings of Chartres the eighteen kings of Judah.[1] Neither is there any difficulty in showing that the twenty-eight figures on the façade of Notre Dame at Paris correspond exactly to the twenty-eight ancestors of Jesus as enumerated by St. Matthew from Jesse to

[1] See Bulteau, vol. ii. p. 401. It is astonishing that this did not enlighten the Abbé Bulteau on the meaning of the gallery of the kings on the west front. (See vol. ii. p. 26.) M. G. Durand, who has lately taken up the old theory of the kings of France (*Cathédrale d'Amiens*) and who has examined our arguments, does not mention this decisive point. It is impossible to deny that the eighteen kings of Chartres are the kings of Judah. These kings at Chartres are like those at Amiens and like them wear gloves,—a detail that convinced M. Durand that the kings at Amiens could not be biblical personages.

RELIGIOUS ART IN FRANCE

Joseph.[1] All have the crown and sceptre, for if not kings they were all of royal lineage.[2] The number twenty-eight is not always scrupulously observed. On the façade at Amiens, for example, there are only twenty-two kings.[3] At Reims there are as many as fifty-six,[4] showing that the artist adopted St. Luke's genealogy which, starting from Adam and including Jesse himself, gives exactly fifty-six names from Abraham to Jesus.[5] The lion seen under the feet of one of the kings is not as has been said the lion of Pepin the Short,[6] but is the lion of the tribe of Judah.

FIG. 92.—KING OF JUDAH HOLDING A ROD OF THE TREE OF JESSE (Amiens)

It is also interesting to find that galleries of the kings are found on the façades of those cathedrals which are dedicated to Our Lady, that is, on the façades of the cathedrals of Paris, Reims, Amiens and Chartres. One may well believe that these royal ancestors are there at least as much to honour the Virgin as to do honour to her Son. The Middle Ages accepted the genealogy given by St. Matthew as that of both Joseph and Mary for, as Gulielmus Durandus tells us, the men of David's line might not marry outside the royal family, so that husband and wife had the same ancestors.[7] It was evidently in virtue of being ancestors of the Virgin that the kings of Judah formed part of the decoration of the façade of cathedrals which were dedicated to her.

Such was the fine rendering given to the prophecy of Isaiah in thirteenth-century art. The kings of Judah on the façades of the cathedrals mark as it were periods in the history of the world, and symbolise the waiting of successive generations of men.

One sees how important a place the prophets and their prophecies held

[1] The statues at Notre Dame at Paris, mutilated at the Revolution, have been restored.

[2] St. Matthew mentions fifteen kings only, but the artists gave the royal costume to a far larger number of persons. For example, the tree of Jesse on the porch at Amiens (central bay, arch, seventh order) has twenty-four kings.

[3] One of these kings, whom we reproduce (Fig. 92), carries a shoot of the tree of Jesse. It can hardly be a conventionalised royal sceptre.

[4] See Cerf, *Notre-Dame de Reims*, vol. ii. p. 169.

[5] St. Luke iii. 23 *sq.*

[6] Cerf, *Études sur quelques statues de Reims*, 1886. 8vo.

[7] *Ration.*, lib. VI., cap. xvii.

in the imagination of the men of the Middle Ages. The seers of Israel were to them the most solemn of witnesses, and the artists loved to place them in ordered ranks on façade or porch, and to put in their hand scrolls bearing their testimony to the divine mission of Christ. Even the illiterate would have been at no loss to tell what were the words displayed on those scrolls. Every year at Christmas time or at the feast of the Epiphany, they saw the prophets file past in the form of old men with white beards, dressed in long robes. The procession went into the church, and in answer to his name each prophet came forward in turn to testify to the truth.[1] Isaiah spoke of the rod that should come forth from the root of Jesse, Habakkuk proclaimed that the child should be recognised between the two animals, David prophesied the universal reign of the Messiah, and the ancient Simeon thanked God that before he died he had seen the Saviour.[2] Even the Gentiles were called to bear witness. Virgil recited a verse of his mysterious eclogue,[3] while in her acrostic lines the Sibyl sang of the end of time. Nebuchadnezzar proclaimed that he had seen the Son of God in the midst of the flames of the furnace,[4] and Balaam came forward on his ass to announce that a star would arise out of Jacob. The ass herself had a rôle, for by her presence she testified that the spirit of God speaks at times through the humblest of mouths, and that the angel invisible to the eye of man may be seen by the eye of the beast.

The faithful recognised in the porch the prophets whom they had seen file past in the church. This procession from which religious drama arose—itself already drama—was doubtless not without its influence on art. The artists took part in it, mingled in the crowd and admired like the rest. It would have been difficult for them to imagine the prophets other than they had there seen them. It may well be that the fine statues at Reims or Amiens reproduce something of the costume and appearance of the actors in the sacred drama. References in contemporary manuscripts are unhappily too slight to be of use.[5] Information as to the dress and attributes of personages in the Mysteries does not become detailed until a much later date than that with which we are concerned. I do not doubt, for instance, that the magnificent costumes of the prophets at Auch [6] or Albi [7]—marvellous cloaks powdered with large flowers, oriental turbans, gorgeous hats from

[1] See Marius Sepet, *Les prophètes du Christ.*

[2] One saw and heard much of the other prophetic personages—Moses, Aaron, Jeremiah, Daniel, Hosea, Joel, Obadiah, Jonah, Micah, Nahum, Zephaniah, Haggai, Zechariah, Simeon, Elizabeth, John the Baptist.

[3] " Jam nova progenies cœlo demittitur alto."

[4] A furnace was lighted in the church.

[5] See, however, Marius Sepet, *op. cit.*, p. 43.

[6] We refer to the famous glass at Auch (beginning of the sixteenth century).

[7] Statues of the choir ambulatory, fifteenth century.

RELIGIOUS ART IN FRANCE

which hang pendants of diamonds and chains of pearls—are an echo of the representation of some Mystery play.[1]

One sees how liturgy, drama and art teach the same lesson, make manifest the same thought. They reveal the perfect unity of the Middle Ages.

VII

It follows from what has been said that the Middle Age was less responsive to the narrative and picturesque qualities of the Bible than to its dogmatic significance. The thirteenth-century attitude was far too Christian for men to seek in the stories of Genesis merely interesting subjects for illustration. The heroic episodes in the books of the Judges or the Maccabees—so calculated to delight the crusaders —were not even represented. The serious-minded artist of that time would have been amazed with Benozzo Gozzoli's delightful frescoes in the Campo Santo at Pisa, where Noah gathers grapes in beautiful Italian vineyards and the tower of Babel rises among cypresses and orange trees in the Florentine countryside, making a Bible pleasing as a fairy tale.

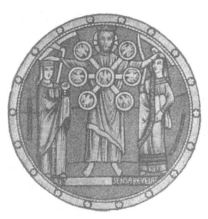

FIG. 93.—CHRIST STANDING BETWEEN THE OLD AND THE NEW LAW (medallion in a window at St. Denis)

In dealing with such a subject the earlier artist's aim was not to please but to instruct. The work, though often clumsy, is always strong and significant and permeated with the spirit of the Fathers of the Church.

Some medallions in a window at St. Denis, for which the Abbé Suger furnished both the subjects and the inscriptions, summarise in striking fashion the theological teaching of the Middle Ages with respect to the Old Testament. These medallions are not all extant, but those that are missing are known by the description left by Suger himself.[2] Three of them in particular seem to contain the idea which dominates the whole.

[1] On the magnificence of the costumes of this period see Giradot, *Le Mystère des Apôtres de Bourges* (sixteenth century), *Ann. archéol.*, vol. xiii. We have written at length on the connection between art and the Mysteries in *L'Art religieux de la fin du moyen âge.*

[2] The description of the windows is found in the *De Rebus in administratione sua gestis* (Suger, *Œuvres*, Ed. Lecoy de la Marche, Paris, 1876).

In the first medallion (Fig. 93) Christ is seen bearing on His breast a kind of aureole formed by seven doves, which symbolise the seven gifts of the Spirit. With the right hand He crowns the Church, and with the left removes the veil that covers the face of the Synagogue. What can this allegory mean but that in coming into the world and proclaiming the New Law He revealed all the mystery of the Old Law which had been hidden as it were behind a veil? A verse, mutilated in the window but given in its integrity in Suger's text, explains the meaning of the composition with great precision :

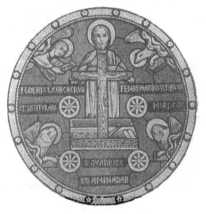

FIG. 94. — THE SYMBOLIC QUADRIGA OF AMINADAB (medallion in a window at St. Denis)

"Quod Moyses velat Christi doctrina revelat."

"What Moses covered with a veil is unveiled by the teaching of Christ."

The second medallion represents the ark of the Covenant borne on four wheels and resembling a triumphal chariot (Fig. 94). Inside are seen Aaron's rod and the tables of the Law, but dominating both there rises from the depths of the ark a great crucifix upheld by God the Father Himself. Near the wheels are the four emblems of the evangelists, which are so to speak the team of the symbolic car. This is a yet more subtle presentation of the same idea. The ark, the tables of the Law and Aaron's rod, which mark God's first Covenant with man, are merely the symbols of another and more lasting Covenant. The ark is seen to be the pedestal of the Cross. The ark surmounted by the Cross is indeed, as the inscription says, the quadriga of Aminadab, the triumphal chariot of the Song of Songs which the evangelists must draw to the ends of the earth.[1]

The third medallion, known to us only by Suger's description, once more expressed the same idea but in a less theological and more popular

[1] The words "Quadrige Aminadab" are seen by the side of the following lines :—
"Fœderis ex arca Christi cruce sistitur ara
Fœdere majori vult ibi vita mori."
The commentators on the Song of Songs, notably Honorius of Autun (a contemporary of Suger), explain that Aminadab standing in the car represents the Crucifixion, and that the four horses of the quadriga are the four evangelists (Honorius of Autun, *In Cantic. Cantic., Patrol.*, clxxii., col. 462). A Limoges enamel, now in the Cluny museum, also represents the triumphal car of Christ, whose wheels are the evangelists. *Catalogue*, 4491.

form. In it the prophets were shown pouring grain into a mill, while St. Paul turned the grindstone and received the flour. It is a way of saying that the Old Testament if interpreted after the manner of St. Paul would wholly resolve itself into the New. And in the process it would be purified for, as Suger's Latin lines say, the chaff will have disappeared and the flour alone will remain :

> " Tollis agendo molam de furfure, Paule, farinam,
> Mosaicæ legis intima nota facis ;
> Fit de granis verus sine furfure panis
> Perpetuusque cibus noster et angelicus." [1]

Nothing better expresses the mind of the mediæval doctors than these medallions. It is evident that to them the commentaries on the Bible are of as much value as the Bible itself. Although the entire Old Testament had been translated by the university of Paris at the beginning of the thirteenth century, one can understand that the Church had never specially commended the reading of it to the faithful. At that time the Bible was not held to be an edifying work that the father of a family might explain to his children of an evening. More deference was shown to a book so full of enigmas, which could be understood only with the help of all the Fathers of the Church. The clergy were satisfied with conveying either by direct teaching or through the medium of art, all that it was essential for the people to know.

Inspired by the theologians, the artists too were biblical commentators after their fashion. The same method of interpretation obtains from bas-reliefs and windows to illustrated manuscripts. [2] At a later date the early printers when publishing the famous *Biblia Pauperum* tried to make the mysteries of the Old Testament intelligible to the most ignorant. [3] Their wood engravings are conceived after the manner of the medallions in the old glass.

[1] On the façade of St. Trophime at Arles St. Paul holds a scroll on which is written : " Lex Moisi celat quæ sermo Pauli revelat. Nam data grana Sinai per eum sunt facta farina," an inscription that presents singular analogies with Suger's lines. At the Renaissance the motif of the mill is replaced by that of the winepress. Patriarchs and prophets put the grapes into the vat, the pope and the cardinals receive the wine (window in Ste. Étienne-du-Mont and a window —now disappeared—in St. Hilaire at Chartres, 1520). See Lindet, *Les Représent. allégor. du moulin et du pressoir* (*Revue archéol.*, 1900), and E. Mâle, *L'Art religieux de la fin du moyen âge*, p. 113 *sq.*

[2] The famous *Credo* of Joinville offers an in-

teresting example of the concordance of the two Testaments. Opposite the Descent into Limbo and the Resurrection are seen Jonah thrown up by the whale ; opposite the Last Judgment, the judgment of Solomon, &c. (Bibl. Nat., Nouv. acq. franç. 4509).

[3] See, for example, Bibl. Nat., MS. franç. 188, and especially Nouv. acq. lat. 2129. The last MS., ornamented with very crude figures, is of German origin (1471). Two scenes from the Old Testament, and two figures of plants or animals considered as symbols, are opposed to each of a series of New Testament subjects. The method of Honorius of Autun is here seen once more.

To each important event in the New Testament correspond two symbols taken from the Old. The Nativity, for example, is accompanied by the burning bush and Aaron's rod, and the descent into Limbo by David's victory over Goliath. The incredulity of St. Thomas is ingeniously commented on by Jacob wrestling with the Angel and by Gideon's reluctance to recognise the messenger of God. If it were not outside our subject we

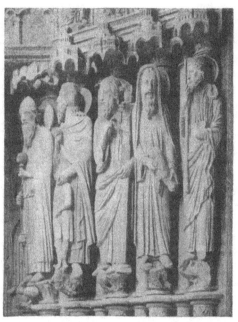

FIG. 95.—MELCHIZEDEK, ABRAHAM, MOSES, SAMUEL, DAVID (Chartres)

could cite many works of the period inspired by the same spirit—Kerver's *Horae*, the *Speculum humanæ Salvationis*, the tapestries which illustrate the story of the Virgin in the cathedral at Reims. Until its close the Middle Age remained faithful to the old method of exegesis.[1]

Briefly to sum up. In interpreting the Bible the Middle Age attached itself to symbol rather than to fact.

Historical scenes, as we have shown, are much rarer than symbolic representations. There are, however, cases in which both symbol and history meet, and of these works of twofold meaning the most profound is certainly seen in the central bay of the north porch at Chartres (Figs. 95

[1] On this subject see *L'Art religieux de la fin du moyen âge*, E. Male, p. 244 *sq.*

RELIGIOUS ART IN FRANCE

and 96). Twelve statues of patriarchs and prophets ranged in chronological order there stand as types or heralds of Christ, while they at the same time recount the history of the world. Melchizedek, Abraham and Isaac represent an era in history ; they recall the time in which, to speak like the doctors, men lived under the law of circumcision. Moses, Samuel and David represent the generations which lived under the written law and

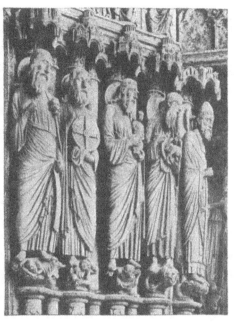

FIG. 96.—ISAIAH, JEREMIAH, ST. JOHN THE BAPTIST, ST. PETER (Chartres)

worshipped God in the Temple. Isaiah, Jeremiah, Simeon and John the Baptist express the days of prophecy which were prolonged until the coming of Christ. Lastly St. Peter, wearing the dalmatic and the papal tiara and carrying the cross and the chalice, proclaims that Christ has abolished the law and the prophets, and in founding the Church has established the reign of the Gospel for ever.[1] At the same time each of these great figures at Chartres bears a symbol which heralds Christ or is the Christ Himself. Melchizedek holds the chalice, Abraham places his hand on the head of Isaac, Moses holds the brazen serpent and Samuel the sacrificial lamb. David has

[1] These divisions of the world's history are often Honorius of Autun, *In Cantic. Cantic., Patrol.,* indicated in mediæval times. See, for example, clxxii., col. 460.

174

the crown of thorns,[1] Isaiah the rod of Jesse,[2] Jeremiah the cross. Simeon holds the divine Child, the Baptist holds the lamb, and finally St. Peter has the chalice. The mysterious chalice which at the beginning of history appears in the hands of Melchizedek is found once more in the hands of St. Peter[3] with whom the cycle ends. Like a guild of christophers these holy men transmit the mystic symbol of Christ from age to age.

We have here the great divisions of a universal history in which everything speaks of the Christ, and which form the very chapters of Vincent of Beauvais's *Speculum historiale*. The Bible here presents itself to us as it did to the men of the Middle Ages, a succession of types of Christ whose meaning grew ever clearer. The patriarchs who symbolise the Messiah and the prophets who proclaim Him form an unbroken chain from the first to the second Adam.

[1] Broken. [2] Mutilated. [3] Only the foot of St. Peter's chalice remains.

CHAPTER II

THE GOSPELS

I

THE age of symbols is followed by the age of the realities hitherto only foreshadowed. We have reached the central point in history, for all leads up to Christ as all begins anew in Him.

Nowhere has this philosophy of history found clearer expression than in the porch at Amiens where the Christ is literally the central figure of the immense façade. Clothed in divine beauty, treading the lion and the dragon under foot, He raises the right hand in blessing and in the left holds the book of the Gospels (Fig. 16). Round Him are ranged prophets and apostles representing the Old and New Testaments, while martyrs, confessors and doctors stand for the history of Christianity—a magnificent realisation of Bossuet's *Discours sur l'histoire universelle*. The same lesson is taught in the south porch at Chartres (Fig. 97), and again in the windows of the nave at Bourges.

The whole New Testament is so forcibly summed up in the figure of the teaching Christ on the trumeaux of the French cathedrals that to the Middle Ages it did not seem necessary to depict the Gospel scenes at any length.

So far it has occurred to no one to point out that in thirteenth-century churches the life of Christ fills a smaller place and is told with far less complacence than are the lives of the saints. Yet this is a striking fact. One or two windows and pieces of sculpture, representing a very few incidents from the Gospels, are all that is offered us by such cathedrals as Chartres, Bourges and Amiens. It is even more astonishing when on comparing sculpture and glass, it is found that the scenes taken from the Gospel are invariably

the same, and that many seem to have been deliberately neglected. The miracles which fill so large a place in the art of the catacombs—the healing of the paralytic, of the woman with the issue of blood and of the man born blind, the raising of the widow's son and of the daughter of the centurion, rarely or never appear in thirteenth-century art.[1] Neither do

we meet with famous scenes calculated to inspire great works—scenes, for instance, such as the preaching of Jesus, His popular teaching in the Temple and by the lake, the meeting with the apostles or the meal with the Pharisee. All the human, tender or simply picturesque side of the Gospels does not seem to have touched the mediæval artist. He evidently did not see in the New Testament the things which appealed to a Veronese or a Rembrandt. Here as elsewhere he was the docile interpreter of the theologian.

If the life of Christ be divided into three parts—the childhood, the public life, and the passion—it becomes evident that the first and last alone have been represented with any wealth of detail. The public life is dismissed in four scenes, the Baptism, the Marriage at Cana, the Temptation and the Transfiguration, which moreover it is rare to find all together.[2]

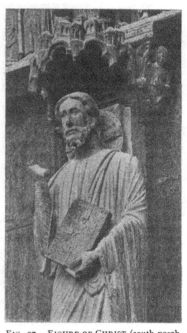

FIG. 97.—FIGURE OF CHRIST (south porch, Chartres)

There is scarcely any exception to this rule, for should one come across such episodes in the public life as the calling of the apostles or the raising of Lazarus, they will be found to have been introduced incidentally into a window dedicated to St. Peter or to Mary Magdalen.[3]

[1] Among the very rare exceptions should be noted the bas-reliefs at Reims (interior, left doorway on entering) which show Jesus healing Peter's mother-in-law, and side by side with it Jesus and the Samaritan woman. This sculpture is unique in other respects, e.g. the Christ has no beard. I am inclined to believe that they were copied from a sarcophagus of primitive Christian times.

[2] In the appendix we enumerate the principal works devoted to the life of Christ in French art of the thirteenth century.

[3] The window in the apsidal chapel at Chartres seems to be an exception. It represents John the Baptist and his disciples, the calling of the apostles, Jesus and Philip, Jesus and Nathaniel, the miraculous draught, Jesus talking with the apostles, the Last Supper, the washing of the disciples' feet, Jesus in the Garden of Gethsemane (the apostles asleep), Jesus arrested by the soldiers (in the background the apostles

RELIGIOUS ART IN FRANCE

This general rule is followed even in illuminated manuscripts. It may seem that the artist who illustrated a book might well have had more freedom than the sculptor who carved a bas-relief, but this was not the case. I have examined a sufficiently large number of illuminated manuscripts of the twelfth to the fifteenth centuries to affirm that detailed illustration of all parts of the Gospel is rare.[1] The miniatures in the famous Evangeliarium of the Sainte-Chapelle offer perhaps the only example of a complete series of the Gospel stories.[2] The artist for the most part contented himself with showing the scenes of the childhood and the Passion, sometimes adding to them the few scenes of the public life which it was then customary to represent.

I should like to give a characteristic example. The French manuscript No. 1765 in the Bibliothèque Nationale contains a collection of the gospels for all the Sundays of the year, and numerous miniatures accompany the text.[3] The book opens with the gospels for Christmas-time, which relate the stories surrounding the childhood of Jesus. Faithful to his text the artist illustrates in turn the Flight into Egypt, the Circumcision and the Adoration of the Magi. The gospels which refer to the public life follow, and here the artist shows the Baptism, the Marriage at Cana, the Temptation and the Transfiguration. Then suddenly he stops, and half the book is left without illustrations, until the work is begun again in Holy Week with the Passion, the Resurrection and the Appearances of Christ as subjects for the pictures. It is evident that the artist has used pounced tracings of older drawings whose number was strictly determined. Where tradition offered him no model it did not occur to him to invent, he did but what others before him had done and no more. In the greater number of illustrated psalters, breviaries, missals and evangeliaria the scenes of Christ's public life disappear altogether, the cycle of the childhood and of the Passion alone being treated with the customary detail.[4] In manuscripts which are not lavishly illustrated, it even happens at times that the whole of the life of Christ is summarised in two scenes—the Nativity standing for the cycle of the childhood, the Resurrection for the cycle of the Passion.

lamenting), the appearance to the apostles after the Resurrection, and the Ascension. It is evident that such a window is not devoted to the life of Christ but to the apostles, one or more of whom are found in every scene represented. It should also be noted that the chapel containing this window (now called the Chapel of the Communion) was in the thirteenth century called the Chapel of the Apostles. See Bulteau, *Descript. de la cath. de Chartres* (ed. of 1850), p. 173.

[1] In the appendix references are given to a number of manuscripts.

[2] Bibl. Nat., MS. Lat. 17326, thirteenth century.

[3] MS. 1765 (franç.) belongs to the fourteenth century.

[4] See the appendix.

As one might well expect in the Middle Ages this strict rule came from the Church. It was, as we shall see, the liturgy which determined the choice of certain scenes to the exclusion of all others.

The Church would not offer the Christian the whole of the life of Christ any more than she would place the four Gospels in his hands, but she chose out a few events of profound significance as suggestions for the meditation of the faithful. These events are precisely those which the Church celebrates each year in the cycle of her festivals. Sculptors, glass-painters and miniaturists simply illustrate the liturgical calendar. The books of the liturgiologists of the twelfth and thirteenth centuries will be found to support our statement.

The cycles of the childhood, the public life, and the Passion as presented in both sculpture and glass consist of the following scenes :—the Nativity, the Announcement to the shepherds, the Massacre of the Innocents, the Flight into Egypt, the Presentation in the Temple, the Adoration of the Magi, the Baptism, the Marriage at Cana, the Temptation, the Transfiguration, the Entry into Jerusalem, the Last Supper, the Washing of the disciples' feet, the different scenes of the Passion, the Crucifixion, the Entombment, the Resurrection, the Appearances after death, and last of all the Ascension. We shall find in Rupert, Honorius of Autun, or Gulielmus Durandus that these are just those mysteries celebrated by the Church at Christmas, the Epiphany, and during Lent, Holy Week and the weeks that follow. Even to-day the painters of Mount Athos, who have retained some of the more characteristic mediæval traditions, paint on the walls of their convents in unvarying order " the fifteen great festivals of the Church." [1]

To examine them in detail. The representations of the Nativity and the bringing of the good tidings to the shepherds correspond so exactly to the most solemn hours of the Christmas festival, the midnight mass and the mass at dawn, that further comment is unnecessary.

The massacre of the Innocents, which at first sight seems a secondary incident, is yet closely related to the Christmas festival. In the three days following the feast of the Nativity, the Church celebrates the Massacre of the Innocents and the festivals of St. Stephen and St. John. She wishes, say the liturgiologists, to gather round the cradle of Jesus the sinless children and the spotless proto-martyr deacon who were the first to shed their blood

[1] See Didron, *Iconogr. chrét.* (*Guide de la peinture du Mont-Athos*), 1845, p. 159, and Rohault de Fleury, *La sainte Vierge*, vol. i. p. 86 (with reference to the Byzantine painting of the Church festivals in the Vatican). The festivals adopted by the west differ slightly from those adopted by the east.

for the faith. She includes St. John because he was the well-loved disciple who alone among men laid his head on the Saviour's breast.[1] This poetical association inspired numerous works of art whose motif has hitherto escaped notice. Thirteenth-century glass in the apses of the cathedrals of Lyons and Troyes shows the history of St. Stephen and St. John together with the Christmas scenes and the Massacre of the Innocents.[2] The windows at Lyons and Troyes shine out like an old Christmas festival, for in them is celebrated the whole of the Christmas week. The people who feasted so gaily during the last days of December, and who loved to see the deacons playing ball in the cathedral[3] on St. Stephen's day, had no difficulty in understanding works of art which to us are unintelligible. Other works inspired by the same idea might no doubt be discovered.[4]

The Circumcision and the Presentation in the Temple, two scenes which the artists sometimes confused, again correspond to two solemn days. These festivals, one celebrated on the first of January and the other at the beginning of February under the popular name of Candlemas, fill as large a place in art as in the liturgy. They were both intended to remind men that the Son of God who came to bring the New Law first submitted Himself to the Old Law.[5]

The Adoration of the Magi, the Baptism and the Marriage at Cana correspond to three very different times in the life of Christ, and yet the Middle Age with its poetic feeling for mystic analogies has linked them by a common thought. All three were celebrated on the same day, and the festival bore the name of the Theophany until that of the Epiphany prevailed. They were in fact the three first manifestations of God to man. The Magi when they worshipped Jesus were the

[1] G. Durandus, *Ration.*, lib. VII., cap. xlii. Honorius of Autun, *Gemma animæ*, lib. III., cap. xi., xii., xiii. *Patrol.*, clxxii., col. 646.

[2] At Lyons the story of John the Baptist is added because the Middle Age rarely separated them, frequently representing both stories in the same window (at Tours, for example), and because the death of St. John the Evangelist was reputed to fall on the same day as the birth of St. John the Baptist.

[3] Honorius of Autun gives a symbolic meaning to the deacons' game. According to him it signifies the glorious contest (palæstra) of St. Stephen. Like the martyred saint, the victorious deacon received a crown (*Gemm. anim.*, col. 646).

[4] I am inclined to believe that the sculpture of the porches at Reims (interior), which at first sight seems so confused, presents the same idea. One there sees

not only the prophets who foretold the birth of Christ, but the Massacre of the Innocents, the story of St. Stephen, St. John and the Apocalypse, and finally the life of John the Baptist. At Chartres (south porch, left doorway, in the tympanum and round the arches) the martyrdom of Stephen and small statues of children bearing palms (the Holy Innocents) are grouped together. In the Sainte-Chapelle it is noticeable that the window devoted to the childhood of Christ, which includes the Nativity and the Massacre of the Innocents, also contains the life of St. John the Evangelist. At St. Julien-du-Sault (Yonne) the childhood of Christ (Massacre of the Innocents) is placed in a thirteenth-century window together with the legends of St. John the Evangelist and the Baptist.

[5] G. Durandus, *Ration.*, lib. VI., cap. xv.

first among Gentiles to recognise His divinity. On the day of the Baptism a voice from on high proclaimed His divinity for the second time. Lastly, at the marriage feast at Cana Jesus showed His divinity by a miracle, the first of the many He was yet to perform. To complete the parallel the Middle Ages decreed that the three events had occurred on the same date. The liturgiologists asserted that the Baptism took place thirty years to the day, and the miracle at Cana thirty-one years to the day after the Adoration of the Magi.[1] Hence the exceptional importance in art of these three scenes.[2] The predilection of the thirteenth-century artist for the Marriage at Cana cannot be otherwise explained. Had he been less submissive to liturgical rules, and more free to follow his own fancy, he would no doubt have chosen some miracle more calculated to reach men's hearts. But here again the art of the thirteenth century was not subject to individual caprice, but was the visible embodiment of accepted doctrine.

The Temptation and the Transfiguration are the central events in the life of Christ as it is represented in art. These two scenes with in addition the Baptism and the Marriage at Cana summarise the whole of the public life. Once more the liturgy furnishes the explanation of this singular privilege. The Temptation and the Transfiguration were intended to call to mind another season of the Christian year. There are between Christmas and Easter no weeks of greater significance for the faithful than the six weeks of Lent. Struggle with temptation and victory over the flesh, that is the meaning of these two scenes from the life of Christ which the Church offers for men's edification. The Christian is one with Christ, he must enter into the trials of his divine Master if he would be associated with His triumph. The forty days of lenten abstinence are an image of the forty days of fasting and struggle passed in the wilderness, and so the gospel appointed to be read on the first Sunday in Lent gives an account of the Temptation, the symbol of the conflict which the Christian must wage.[3]

[1] Honorius of Autun, *Gemm. anim.*, lib. III., cap. xviii. Rupert, *De divin. offic.*, lib. III., cap. xxiv. G. Durandus, *Ration.*, lib. VI., cap. xvi.

[2] These three scenes are connected in a window at Troyes (reproduced by Gaussen, *Portefeuille archéol. de la Champagne*), where the Temptation is added to them. Austria offers a curious example. The Romanesque church of Schöngrabern is decorated on the outside with sculptured figures of the Virgin and Child. Near them six water-pots symbolise the marriage at Cana, the dove which hovers above them and the hand of God the Father in benediction commemorate the Baptism, while the Child holds the gifts of the three Magi. See Springer, *Berichte über die Verhandl. der königl. Sächsischen Gesellschaft*, 1879. The Baptism and the Magi are seen on the baptistery at Parma.

[3] Durandus explains at length the symbolism of fasting, of Lent, and of the Temptation, *Ration.*, lib. VI., cap. xxxii. In manuscripts the Temptation is chosen to illustrate the beginning of Lent, *e.g.* Bibl. Sainte-Geneviève, MS. No. 102, f. 199 v. (thirteenth century).

RELIGIOUS ART IN FRANCE

But at the end of this first week, on both Saturday and Sunday, the gospel of the Transfiguration is read that the faithful may not be unduly discouraged. The Transfiguration was a kind of exaltation of fasting in the eyes of the mediæval liturgiologist. He pointed out amongst other things that Jesus showed Himself to the apostles between Moses and Elias, who had also fasted in the desert for forty days and who had appointed a fast under the Old Law, as Jesus appointed it under the New Law.[1] So to the Christian in the midst of his struggles the Transfiguration was a promise of victory. In certain churches, at Paris for instance, the gospel of the Transfiguration was read after the account of Jacob wrestling with the angel.[2] Symbolism of this kind, better understood in the thirteenth century than to-day, explains the presence of the Temptation and the Transfiguration in a number of works of art of that period.

With them end the representations devoted to the public life of Christ. The scenes of the Passion immediately follow, a sure proof that the artist took as his guide not the chronological order of events but the order of the liturgical feasts.

The Easter cycle almost invariably opens with the triumphal entry into Jerusalem,[3] and corresponds to Palm Sunday.[4] We have next the Last Supper followed by the Passion (in the strict sense) treated with a fulness that is sufficiently accounted for by the importance of the ceremonies of Holy Week. Finally the Resurrection displays to men the Easter mystery, and the cycle ends. There is in all this nothing that does not readily explain itself to us to-day.

The greater number of these Gospel series close with the scene of the Resurrection, but a few go further. The famous bas-reliefs in the choir of Notre Dame at Paris present all the appearances of Christ after the Resurrection, treated in detail such as is not found elsewhere. One there sees the appearance to the holy women, to the disciples at Emmaus, to St. Thomas, to the apostles assembled in the guest-chamber, and to St. Peter and his companions by the sea of Tiberias. This must not be taken as a fancy of Maître Le Bouteiller, carver of images. Representations of the kind are

[1] See Honorius of Autun, *Sacram.*, cap. v., and Durandus, *loc. cit.*

[2] G. Durandus, lib. VI., cap. xxxix.

[3] In the window at Bourges the Passion begins with the raising of Lazarus. This marks the beginning of the Passion because it was after this miracle that the Jews resolved to put Jesus to death. Giotto, too, in the Arena Chapel at Padua began the frescoes of the Passion with the raising of Lazarus.

[4] In the art of the twelfth and thirteenth centuries the apostles who follow Christ are shown with palms, a sure sign that the mode of representing the Entry into Jerusalem was fixed by the liturgy. Though the Gospel says that the Jews received Jesus with branches of trees, it does not say that the disciples carried them. The palm in their hands was intended to commemorate the Palm Sunday procession (*e.g.* a capital at Chartres, and a window at Bourges).

closely related to the Easter festival. In the thirteenth century the whole of Easter week was filled with a succession of festivals, and the offices were followed assiduously by the faithful. Popular curiosity was roused by a strange and symbolic ceremony in which a serpent at the end of a pole was carried in triumphal procession to the baptismal fonts.[1] The gospel appointed to be read on each day of this week contained the account of one of the appearances of Christ.[2] The festival of Easter was thus prolonged to the following Sunday, and it is precisely this octave which the artist had been charged to record in the choir enclosure in Notre Dame at Paris. In most works of art the Gospel story closes quite naturally with the Ascension.

To sum up. It is evident that representations of the life of Christ group themselves round the Nativity and the Resurrection. Two windows devoted to His life are almost sure to be met with in cathedrals of the thirteenth century ; one might be called the Christmas, the other the Easter window. The same series of scenes occurs, though less frequently, in sculpture. But it is necessary to observe that the number of painted or carved representations of the Christmas cycle is appreciably greater than the number of representations of the Easter cycle. The reason is not far to seek. The account of the childhood of Jesus includes part of His mother's life, and one and the same work pays homage to both. The greater number of windows which we call windows of the Childhood might equally well be called windows of the Virgin. In certain cases the artist himself has taken care to acquaint us with his meaning. At Strasburg under a window devoted to the childhood of Jesus are written the words " Ave, Maria, gracia plena ", an inscription which leaves no doubt as to the author's intention. In the rose-window in the north transept of the cathedral of Soissons all the scenes of the Childhood are seen, but the presence of the Virgin in the central medallion is sufficient indication that the work is dedicated to her. Up to the fifteenth century the books of Hours bear the same testimony, and show the persistence of tradition. These books invariably begin with a number of prayers collected under the title " Hours of Our Lady." And this portion devoted especially to the Virgin is in every case illustrated by scenes taken from the childhood of Jesus, which at first sight might mislead one as to the exact nature of the book.[3]

[1] See G. Durandus, *Ration.*, lib. VI., cap. lxxxix., and J. de Voragine, *Leg. aurea*, cap. lxx. The serpent must have resembled the dragon at the top of the column which Moses holds at Chartres and at Reims. Tow was burned in the dragon's jaws during the pro- cession at Chartres. See Lépinois, *Hist. de Chartres*, I., Appendix, p. 549.

[2] G. Durandus, *Ration.*, lib. VI., cap. lxxxix.

[3] The following are typical examples : Bibl. Nat., Heures, Lat. 1158, 921 ; franç., 1874, 13167 ; Maza-

RELIGIOUS ART IN FRANCE

Further, in the thirteenth century windows which tell of the Childhood some scene is frequently introduced which suggests that the intention was to honour the Virgin equally with her Son. The Annunciation and the Visitation, for instance, are rarely omitted. The Middle Age expressed its devotion to her in works of this kind. To recount the first years of the life of Jesus was surely to extol the devotion and tenderness of her whose protection and gentle influence enveloped the childhood of the Son of God. How glorify her better than by showing that she was essential to the work of salvation, that through her lived and grew the frail infant on whom rested the hope of the world.

The windows and the sculpture devoted to the childhood of Jesus in reality bear witness to the ardent worship which the thirteenth century offered to the mother of God.[1]

Such was the spirit which determined the choice of scenes from the life of Christ. Nowhere is more apparent the profoundly dogmatic character of mediæval art which is theology and the liturgy embodied in concrete form.

II

There are yet other surprises in store for the student of the Gospel story ; some detail, attitude, or figure before unnoticed may suggest a whole world of symbols. Taught by the theologian, the thirteenth-century artist saw in the Gospel not a collection of picturesque or affecting scenes, but a succession of mysteries.

To us who know so little of mediæval books it may seem that the Gospel permits of no symbolism. If the Old Testament be regarded wholly as a figure, surely the New Testament must be considered as the reality so long prefigured. What is there to look for behind the facts there related ? Can one do other than read the story in all simplicity ? But this is not the view of the mediæval doctor. For him the Gospel is indeed the supreme historical fact, yet the inspired word of the evangelists has an infinite range of interpretation. Every act of Christ, every word that He spoke holds a meaning for the present, the past and the future. The

rine, No. 491. The miniatures found in the Hours of the Virgin represent with few exceptions the following scenes : the Annunciation, Visitation, Nativity, Adoration of the shepherds, Adoration of the Magi, Presentation in the Temple, Flight into Egypt and Coronation of the Virgin.

[1] The desire to glorify the Virgin is also shown in representations of the scene where Jesus is found by His parents disputing among the doctors—a scene which is sometimes met with in the thirteenth century.

Fathers of the Church disclose something of this mystery when they state that the New Testament is as symbolic as the Old, and that historical, allegorical, tropological and anagogical interpretations may as properly be sought in the one as in the other. The *Glossa ordinaria* of Walafrid Strabo applies the same method of interpretation to both the Old and New Testaments. If we continue to follow this famous guide we are sure to be in the true line of Christian tradition.

There are among the scenes we have already enumerated, some four or five which are the occasion for much curious symbolism.

First of all the Nativity. The thirteenth century, faithful in other respects to the tradition of previous centuries, represents the birth of Jesus after a fashion which could not fail to strike us as curious did we but take the trouble to observe it. This scene, so often reproduced in windows, has in it nothing tender, one might almost say nothing human. The Madonna of the Italian quattrocentists kneels before the child, gazing at Him with clasped hands, the personification of infinite love. In thirteenth-century art Mary, lying on her bed and regardless of her Son, looks intently before her at some invisible object. The child does not lie in a manger, but curiously enough on a raised altar, which occupies the whole central portion of the composition. Above His head a lamp is seen hanging between parted curtains. The scene appears to take place not in a stable but in a church (Fig. 98). It is indeed to a church that the artist-theologian of the Middle Ages would direct men's minds, for it seems he would tell us that from the moment of birth Jesus must have the semblance of a victim. The cradle in which he sleeps, says the *Gloss*, is the very altar of sacrifice.[1]

Before such a mystery even maternal love is stilled. Mary keeps a religious silence and ponders, say the commentators, the words of prophets and angels which had even now come to pass. St. Joseph shares her silence, and motionless, with fixed gaze, the two are wrapt in solemn contemplation. So imposing and entirely theological a conception is far removed from the picturesque " cribs " which made their appearance at the beginning of the fifteenth century, and which mark the end of great religious art.[2]

[1] *Glossa ordinaria*, in Luc., cap. ii.: " Ponitur in praesepio, id est corpus Christi super altare."
[2] A French MS. of the thirteenth century, now in the Vatican, shows the figure of Christ crucified above the Child lying on the altar. The tree of the Cross grows out of the very altar on which the Child lies. Here symbolism speaks to men's eyes. This miniature given by d'Agincourt was reproduced by J. C. Broussolle, *Le Christ de la légende dorée*, p. 10.

RELIGIOUS ART IN FRANCE

The thirteenth century, here as always, gives its supreme form to earlier thought.[1] Numerous manuscripts of the tenth, eleventh and twelfth centuries show the Child lying, not in a manger, but on an altar, while Mary's gaze is turned away from her Son.[2] This symbolic treatment was evidently conceived at an early date by monks who were at once artists and theologians. The monastic workshops passed it on to the lay artists of the thirteenth century.

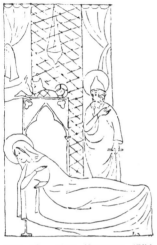

After the Nativity it is, as might have been expected, the Crucifixion which offers to art the richest symbolism. In the thirteenth century the aim of the artist who represented the Crucifixion was far less to move men's hearts by the sufferings of the God-man than to illustrate two great dogmatic truths. First he desired to teach that Christ was the second Adam who had come into the world to wipe out the guilt of the first Adam, and secondly that in founding the Church He had abolished for ever the authority of the ancient Synagogue.

FIG. 98. — THE NATIVITY (Bibl. Nat., MS. Lat. 17326, thirteenth century)

The idea of Christ as the second Adam was then so familiar to mediæval men that they presented it under every possible form, pushing to its utmost limits that love of symmetry which with them was a passion. They would have it that it was in the very same place where God had fashioned Adam out of the dust of the ground[3] that the angel announced to Mary that she would bear the Saviour of the world, and they continued to believe, in spite of the scruples of doctors,[4] that Jesus died on the very spot where Adam

[1] The Nativity is represented in this way in a number of thirteenth-century works, notably windows at Tours (central chapel in the apse), at Sens (choir), at Lyons and Chartres, &c.

[2] The following are the references for a number of MSS. which show the succession of types : Bibl. Nat., MSS. Latin 9428 (9th cent.), 17325 (11th), 17961 (12th), 10434 (12th), 833 (12th), 1077 (13th), 17326 (13th), 11560 (13th), 1328 (13th), 1394 (14th). Bibl. Sainte-Geneviève, 1130 (14th). After the fourteenth century the tradition changed. In the famous *Bré:iaire des Frères prêcheurs*, called the *Bréviaire de Belleville* (Bibl. Nat., MS. Latin 10484, fourteenth century), the Virgin is seen caressing the Child. On the other hand the old symbolic type is found well into the fifteenth century. (See Forgeais, *Plombs historiés*, vol. iv. p. 22.)

[3] In the treasury at Monza there are some eulogia made of little wafers of pressed earth brought from the spot where the Annunciation took place, and where Adam was formed. (See Barbier de Montault, *Bullet. monum.*, 1883, p. 135.) Ancient calendars give both the creation of Adam and the Incarnation on March 25th. The idea of placing the Creation and the Annunciation on the same spot is an old one, which was pointed out as early as the pseudo-Abdias, *Vie de saint Barthélemy* (see Migne, *Dict. des apocryphes*, t. ii., col. 154).

[4] See the *Glossa ordinaria*, in Matth., cap. xxvii. " Golgotha interpretatur Calvariæ, non ab calvitium Adæ quem mentiuntur ibi sepultum."

was buried, so that His blood should flow over the bones of our first parent.[1] The Cross was not fashioned from any chance wood but from the Tree of the Knowledge of Good and Evil. Its trunk, after having served as the bridge over which the Queen of Sheba passed when she entered Jerusalem, had been miraculously preserved at the bottom of the Temple reservoir. So by the will of God the instrument of the Fall became the means of the Redemption.[2] And lastly, the day and hour of the Crucifixion were not without mystic significance. Jesus was put to death on Friday, the day of the week on which Adam was created, and He gave up His spirit at the third hour, that is at the very hour when Adam committed the sin through which the human race had fallen.[3]

It was certainly not easy to realise in art the wealth of poetic thought which had gathered round the Cross, but the artists succeeded in doing so. They rendered in plastic form one of the strangest ideas of the doctors con-cerning the new Adam. Even as Eve

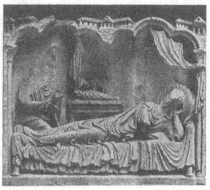

FIG. 99.—THE NATIVITY (porch of Laon cathedral)

came out of the side of Adam while he slept, to the undoing of the human race, so the Church (say the Fathers) came from the wounded side of Christ when He died—or rather slept—upon the Cross, for the salvation of mankind. From the second Adam came the second Eve. The blood and water which flowed from the wounded side of Christ are symbols of the two chief sacraments of the Church, Baptism and the Eucharist.[4] The artists took the idea

[1] A window at Angers (thirteenth century) and one at Bourges (*Vitraux de Bourges*, plan IV.) show Adam and Eve receiving the blood which flows from the Cross.

[2] See *Leg. aur.*, *De invent. sanct. cruc.* (*Golden Legend*, iii. 169), and Honorius of Autun, *Spec. Eccles.*, *De invent. sanct. cruc.* See also du Méril, *Poésies latines du moyen âge*, 1847, p. 321.

[3] See the *Glossa ordinaria*, in Marc., cap. xv., and H. of Autun, *Hexaemer.*, cap. vi., *De Incarnat. Christi* ; " Et qua hora terrenus homo invasit pomum, humanum genus interempturus, eadem hora toleravit crucem et mortis amaritudinem cœlestis homo, universum mundum redempturus." See also V. of Beauvais, *Spec. hist.*, lib. I., cap. lvi. and lib. VII., cap. xlv. ; J. de Voragine, *Leg. aurea, De passion. Christi*, cap. liii.

The *Legenda aurea* also enumerates (cap. li.) the great events in sacred history which took place on the same day—the Annunciation, the Visitation, the creation of Adam, the Fall, the death of Abel, the offering of Melchizedek, the sacrifice of Isaac.

[4] See *Glossa ordinaria*, in Joan., xix. The idea goes back to the Fathers of the Church. Augustine wrote, " Dormit Adam ut fiat Eva, moritur Christus ut fiat Ecclesia. Dormienti Adæ fit Eva de latere ; mortuo Christo lancea percutitur latus, ut prufluant sacramenta quibus formetur Ecclesia." (*Tract. in Joan.*, ix. 10.) See also Avitus's poem, *De spirit. hist. gestis*, I., v. 160. Mediæval examples are very numerous. See Honorius of Autun, *Spec. Eccles.*, col. 910, et V. of Beauvais, *Spec. histor.*, lib. VII., cap. xlvi.

RELIGIOUS ART IN FRANCE

literally, and realised it not without grandeur. They first imagined that the lance with which Christ's side was pierced entered not at the left but at the right side, as the comparison necessitated. They placed the wound on the right side of Jesus in order to teach men that it is before all things symbolic ; it is the wound in the side of Adam, or again it is the mysterious door which opened in the side of the ark.[1] Near to this wound they placed the new Eve—the Church—in the form of a queen who receives the blood and water in her chalice. Finally, as in the windows at Sens (Fig. 101, lower medallion) and Rouen, there is an attempt to make the idea still clearer by representing close to the Cross the seraph who drove our first parents from the terrestrial Paradise. Here however the angel is no longer the minister of the vengeance of God, but by returning his flaming sword to its sheath he announces that this second Adam has cancelled the debt of the first and so satisfied divine justice.[2]

In thus representing the Crucifixion the thirteenth-century artist thought less of stirring the emotions than of recalling the dogma of the Fall and the Redemption, the central conception of Christianity.

But another idea of equal value seemed to him worthy of expression at the same time. By His death Jesus not only founded the Church, but abolished the authority of the Synagogue. At the very hour when He gave up His spirit on Calvary, the Jewish church with her sacrifices of blood which were symbols and with the Bible whose meaning she did not understand, faded away before the newly created church of Christ. From that moment the Church alone had power to celebrate the Sacrifice, and she alone could explain the mysteries of the Book.[3] The defeat of the Synagogue and the victory of the Church at the foot of the Cross had been too often celebrated by theology for the thirteenth-century artists (always obedient to tradition) to fail to include them in their representations of the Crucifixion.[4] To the right of the Cross they placed the Church, to the left the Synagogue. On

[1] *Glossa ordinaria*, in Joan., xix.
[2] The windows at Sens and Rouen are given in the *Vitraux de Bourges*, pl. XXII. and pl. XII. See also what Cahier says of the cycle of the two Adams, *Vitraux de Bourges*, p. 205 *sq.* The miniaturists are even bolder than the glass-painters. They represent the Church emerging from the right side of Christ. See Bibl. Nat., MS. fr. 9561, f. 6 and f. 7, v. Near to the miniatures is written : " Eve qui yssi hors del coste Adam senefie Sainte Église qui ist fors del coste Jhucrist."
[3] See Ludolph of Saxony, *Vita Christi*, cap. liii.
[4] The impressive idea of personifying the two religions is not Byzantine. M. de Linas has made it clear that the two figures of the Church and the Synagogue arose in Austrasia in Carolingian times. (*Revue de l'art chrétien*, 1885, p. 212.) The earliest example known is found in the *Sacramentarium* of Drogo, which belongs to the middle of the ninth century. The origin of all these representations is perhaps to be found in the *Altercatio Ecclesiæ et Synagogæ*, attributed to Augustine (*Patrol.*, xlii., col. 1131). On this subject see P. Weber, *Geistliches Schauspiel und kirchliche Kunst in ihrem Verhältniss erläutert an einer Iconographie der Kirche und Synagoge*, Stuttgart, 1894, 8vo.

188

the one side the Church, crowned and wearing a nimbus and with a triumphal standard in her hand, receives in a chalice the water and blood that flow from the Saviour's side. On the other side the Synagogue with blindfold eyes, her crown falling from her head, still grasps in one hand the broken staff of her standard, and lets fall from the other the tables of the Law (Fig. 100).

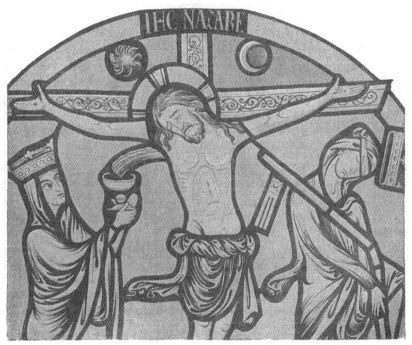

FIG. 100.—THE CHURCH AND THE SYNAGOGUE (window at Bourges)
(From Martin and Cahier)

The attributes given to the Synagogue were taken from a passage in Jeremiah which was applied to her by the Middle Ages : " Woe to us," said the prophet, " for we have sinned, *our eyes are covered with darkness*, our heart has become sad, and *the crown has fallen from our head*." Sometimes, as in the fragments of a window at Le Mans, the opposition of the old and the new priesthood is marked by the figures of St. Peter who stands by the side of the Church and of Aaron who supports the swooning figure of the Synagogue.[1]

It would be difficult to give clearer and more graphic form to an abstract

[1] *Vitraux de Bourges*, plan VI.

RELIGIOUS ART IN FRANCE

idea. But the triumph of the Church over the Synagogue at the foot of the Cross is not always represented in so explicit a fashion. Art at times had recourse to a more elusive symbolism, whose meaning we could not even conjecture were it not for the help of the commentators. It sometimes happens that the Church's place by the side of Christ is taken by the centurion, and the Synagogue's place by the man with the sponge.[1] These two figures, symmetrically opposed, appear from the earliest times, and the barest acquaintance with mediæval thought precludes the idea that they are merely historical. Such honour would not have been paid to secondary characters in the drama of the Passion, and above all they would not have been invariably placed on each side of the Cross. They are both symbols. The Roman centurion, who after piercing the right side of Jesus with his lance, recognised that He was indeed the Son of God and loudly proclaimed his belief, stands for the new Church. He is there to teach men that on that day the faith passed from the blind Jews to the Gentiles who recover their sight.[2] The man with the sponge, whom tradition has always reputed to be a Jew, is the Synagogue, and the vinegar with which he filled the sponge is the old and now unsound doctrine. From henceforth the Church alone will offer the generous wine of divine knowledge.[3]

But that is not all. In many instances the artists were content to represent the Virgin and St. John at the foot of the Cross instead of the symbolic figures we have described. There is nothing surprising in the presence of the mother of Jesus and of the beloved disciple, for they fill the place assigned to them in the Gospel. But the subtle genius of the Middle Ages would find a mystery even here. In the eyes of the theologians Mary is not only the mother of Jesus but is also the personification of the Church, while St. John, strange as the symbolism may appear to us, represents the Synagogue. No one acquainted with the patristic literature of the Middle Ages can doubt that in certain cases the Virgin symbolises the Church. Isidore of Seville sums up the doctrine of the early centuries in a word when he says in the *Allegoriæ*, " Mary is the figure of the Church ".[4] The whole Middle Ages repeated it after him.

[1] A fine window in the cathedral at Poitiers, for example.

[2] *Glossa ordinaria*, in Luc., xxiii. Legend relates that Longinus was blind and that he was cured by a drop of the blood of Jesus. One sees how a dogmatic idea can give rise to a legend of apparently popular origin. Manuscripts sometimes show Longi-

nus receiving a drop of blood on his eyes. He hastily puts up his hand and seems to rub in the blood. See for example, Bibl. Nat., MS. Latin 17326 ; Evangeliarium of the Sainte-Chapelle, thirteenth century.

[3] *Glossa ordinaria*, in Joan., xix.

[4] Isidore, *Allegor.*, 138, 139. See also Ambrose, *Comm. in Luc.*, i. 27.

Mary, they taught, symbolised the Church in almost all the circumstances of her life, but especially at the moment when she stood at the foot of the Cross. At the Crucifixion all men, not excepting St. Peter, lost their faith, Mary alone remained constant. The whole Church, says Jacobus de Voragine, took refuge in her heart.[1] Mary then is the Church, and in virtue of this she has her place to the right of the Cross, while as the second Eve she is entitled to stand to the right of the second Adam. In the Middle Ages she was so frequently compared to Eve that to labour the point is unnecessary. One may recall that the name " Eve " changed into " Ave " by the angel of the Annunciation was taken as one of the many proofs of the resemblance.

There can, then, be no doubt as to the mystic significance of the figure of the Virgin at the foot of the Cross, but that St. John can be a type of the Synagogue is more perplexing. The Fathers give the following explanation. It is true that only once in the Gospels does St. John symbolise the Synagogue, but that is sufficient to justify the artists in placing him to the left of the Cross. St. John tells in his Gospel how on the morning of the Resurrection he ran to the tomb at the same time as St. Peter. He was the first to arrive there but would not enter, and allowed Peter to pass in before him. What can this act signify, says Gregory the Great, if not that the Synagogue which was first must henceforth give place to St. Peter, that is to say to the Church?[2] Thus once in his life St. John typified the Synagogue, and might properly be contrasted with Mary, type of the Church.

It is evident that to the thirteenth century the presence of the Virgin and St. John to right and left of the Cross was of more than historical significance. If this be questioned, a glance at the window at Rouen in which the Church is seen by the side of the Virgin and the Synagogue near to St. John in the Crucifixion scene, or reference to the reproductions of the glass at Tours and Le Mans published by Father Cahier, will be found to support our statement. In these two windows all the scenes which are grouped round the Cross illustrate the one thought that in dying Jesus substituted the Church for the Synagogue. It is then legitimate to suppose

[1] Jacobus de Voragine, *Mariale I, Sermo* 3. It was also pointed out that the Virgin did not carry spices to the tomb on Easter Eve because she alone never lost hope in the Resurrection. In those sad days she alone was the Church.

[2] See Gregory the Great, *Homel.* xxii., in Evang. Joan., xxii. 1–9, and the *Glossa ordinaria*, in Joan.,

xxii. The account of the two disciples running to the tomb in St. John's Gospel was read on the Sunday after Easter, and was followed by a homily of St. Gregory's which was a mystical commentary on it. See Bibl. Sainte-Geneviève. *Lectionn.*, MS. 138, f. 6.

that the Virgin and St. John are also intended to recall the Church and the Synagogue.

The idea of a new alliance, a transmission of authority effected at the foot of the Cross, was so familiar to mediæval men that every circumstance of the Passion recalled it. Even the two thieves crucified the one on the right hand the other on the left, were considered as symbols of the new Church and the ancient Synagogue.[1]

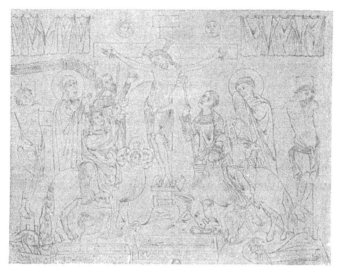

FIG. 101.—SYMBOLIC CRUCIFIXION
(Miniature in the *Hortus deliciarum*)

The absolute symmetry, the mathematical perfection which the mediæval mind demanded is seen in the symbolic Crucifixion as then conceived.

All that we have said is so happily summarised in a work of the twelfth century that it is perhaps permissible to quote it, although it does not belong to our period. A miniature in the *Hortus deliciarum* represents the Crucifixion in all its symbolic detail[2] (Fig. 101). To the right of the Cross are seen the centurion, the Virgin Mary, the penitent thief and lastly the Church, figured as a woman riding a hybrid animal in whose

[1] Isidore, *Allegor.*, col. 247: "Duo latrones populum exprimunt Judæorum et Gentium." *Glossa ordinaria*, in Joan., xix. 18: "Latro qui permansit in perfidia significat Judæos."

[2] A tracing was made by Bastard (Cabinet des Estampes). See also in the Collection Bastard (Cabinet des Estampes), vol. vii., a symbolic Crucifixion of the twelfth century similar to that in the *Hortus deliciarum*.

four heads the emblems of the evangelists can be recognised. To the left are the man with the sponge, St. John, the impenitent thief and lastly the Synagogue mounted on an ass, that obstinate beast which when it should go forward draws back. The general meaning is given by the rent veil of the Temple placed at the top of the composition, clearly showing that the subject is the substitution of the New for the Old Law. The interest of this miniature lies in the fact that in it are seen grouped together elements which are usually found isolated. All doubt as to the symbolic significance of any one person must vanish when confronted with such a connected scheme.

Why were the Middle Ages so fond of this symbolic Crucifixion which later lost all meaning? The reason may perhaps be found in a desire to convince the Jews of the futility of their faith, or rather to reassure the faithful in the face of a proud and stiffnecked people who alone claimed to be able to expound the Scriptures. The great figures of the Church and of the Synagogue with veiled eyes on the façade of Notre Dame at Paris[1] proclaimed to the Jew that the Bible had no longer any meaning for the Synagogue, and to the Christian that it held no riddle for the Church. This at any rate served Isidore of Seville and Petrus Alphonsi as a basis of reasoning in their apologetics written to convert the Jews.[2] A legend which was very popular in the Middle Ages forcibly sums up these ideas. It was said that the Cross was placed in such a position that Rome was in front of the Saviour and Jerusalem behind Him. In the hour of death He turned away from the city which had killed the prophets to look towards the Holy City of the new era.[3]

The Nativity and the Crucifixion offer, as we have seen, the richest material for symbolic interpretation, but other Gospel scenes also lend themselves to it. In the presentation of the Resurrection, for example, we find art attempting to embody in visible form a theological idea familiar to

[1] They have been restored. The Church and the Synagogue are seen twice at Reims, near to the rose-window in the south porch and under two turrets near to the Crucifixion in the west porch. The Church and the Synagogue in the south doorway of the cathedral of Strasburg are justly famous. At St. Seurin at Bordeaux, as formerly at Paris, the Synagogue has her eyes veiled not by a bandage but by the tail of a dragon which stands behind her head.

[2] Isidore of Seville, *De fide catholica . . . adv. Judæos ;* Petrus Alphonsi, *Dialog.,* tit. XII., lib. II., cap. xxvii. See also the works of Peter Damian, *Opusc.,* III., *Dialog. inter Judæum et Christianum.* M. Paul Weber,

op. cit., rightly connects the conflict between the mediæval Church and Judaism both with works of art and with a certain number of dramatic works in which the Church and the Synagogue figure. Viollet-le-Duc (*Dict. de l'archit.,* under " Église ") goes so far as to say that the figure of the Synagogue is only found in towns in which the Jews were numerous—Paris, Reims, Strasburg, Bordeaux.

[3] See Ludolph of Saxony, *Pass. Christi,* LXIII. Old ivory diptychs show the Roman wolf below the Crucifixion. See Gori, *Thesaurus veter. diptych.,* iii. p. 22 (Diptych of Rambona).

the doctors. The scene of the Resurrection from which early art had shrunk [1] was conceived in a curious manner by the thirteenth century. In contrast to the Gospel narrative which tells how, after the Resurrection,[2] the stone was rolled away by an angel on the morning after the sabbath, Christ is almost invariably shown rising from a tomb from which the stone has already been removed. The old masters, ordinarily so scrupulous and so faithful to the letter, had a reason for thus uniting two distinct events. There is not the least doubt that they wished to recall the deep significance which was attached by the Fathers to the removal of the stone. The stone before the tomb was in fact a symbol. It is, says the *Glossa ordinaria*, the table of stone on which was written the Ancient Law—it is the Ancient Law itself. As in the Old Testament the spirit was hidden beneath the letter so Christ was hidden beneath the stone. He rose from the dead and the Law had no longer any meaning.[3]

The Ascension offers another example of symbolism of a similar kind. No passage in the Gospels states that the Virgin was present at the Ascension, and in the early Middle Ages it was not customary for her to be included in representations of the scene. But from the twelfth century onwards she is frequently shown as in the midst of the apostles,[4] and further she is given the place of honour in the centre of the composition. Here again she is a symbol. She is a figure of the Church, and her presence signifies that in ascending to heaven Christ left to men the Church that they might not be without guidance and support.[5]

It would be possible to find symbolic purpose in other scenes from the Gospel, but our attention must be drawn to them by some arresting feature. One may take for example the window devoted to the marriage at Cana in Canterbury cathedral. All the commentators on the Gospel of St. John are agreed that the miracle at Cana contains mystic teaching. The six stone jars which were filled with water and were found full of wine are the six ages of the world. This water, in which unknown to men invisible wine

[1] It is often stated that the Resurrection is not met with in art before the thirteenth century, and it is in fact very rarely represented in the Romanesque period. Two examples may be quoted however ; a miniature in the Bibl. Nat. for the eleventh century (MS. Latin No. 17325, f. 30 v.), and a capital in the museum at Toulouse for the twelfth century. Early art did not dare to represent the mysterious rising from the tomb because it was not described in the Gospel. It was content to show simply the holy women at the tomb. In the thirteenth century the old formula is still met with (see window at Laon, chevet ; and at

Lyons, apse). It was the influence of the liturgical drama and of the scene that was acted in the church on Easter Day that led the artists to represent Christ rising from the tomb.

[2] St. Matt. xxviii. 2-3.

[3] *Glossa ordinaria*, in Matth. xxviii., in Marc. xvi., in Luc. xxiv.

[4] In the window of the Ascension at Le Mans (right aisle), and in a window at Laon (central window of chevet).

[5] Honorius of Autun, *Spec. Eccles.*, in Pentecos.

was hidden, is the ancient Law behind whose letter Christ may be found. The Scriptures according to the letter are but tasteless water, but according to the spirit they are a generous wine. Christ was hidden from the world, as the wine in the water, during the six ages marked by Adam, Noah, Abraham, David, Jechonias and John the Baptist. He revealed Himself in the seventh age, and His reign will last until the Day of Judgment, that is until the beginning of the eighth age which shall have no end.[1] It is evident from examination of the scenes surrounding the marriage at Cana that symbolism of the kind was accepted by the master glass-painter of Canterbury. First of all one sees there the six ages of human life : infantia, pueritia, adolescentia, juventus, virilitas, senectus. Next come the six ages of the world marked, as by milestones, by the figures of Adam, Noah, Abraham, David, Jechonias and Jesus.[2] Finally two Latin lines remove all doubt ;—

> " Hydria metretas capiens est quælibet ætas :
> Lympha dat historiam, vinum notat allegoriam."

"The water-pots which hold the measures of water symbolise the ages. The water contains the historical, the wine the allegorical meaning."

Symbolic purpose is here evident.

III

We will now turn to the sayings of Christ as illustrated in art. The forty parables sometimes depicted by the painters of Mount Athos did not meet with equal favour in mediæval art, though it is difficult to say why all of these beautiful stories did not inspire the Gothic artists. Why, for instance, in the thirteenth century do we not meet with the parable of the Good Shepherd which was so dear to the painters of the catacombs and gave to primitive Christianity something of the air of a gentle idyll ? Four parables to the exclusion of all others are represented in the cathedrals, the stories of the Good Samaritan, the Wise and Foolish Virgins, the Prodigal Son, and Dives and Lazarus. These four are, it must be confessed, among the most dramatic, the most touching, and the most truly popular in the Gospels.

It is at first sight surprising that a place can be found for symbolism in stories so direct and simple. What need to look for mystery ? The true

[1] *Glossa ordinaria*, in Joan., cap. ii.
[2] John the Baptist is missing in the window at
Canterbury. See Didron, *Annales archéol.*, vol. i. p. 435.

meaning of the parable of the Good Samaritan surely stands out plainly enough to make it unnecessary to seek for anything beyond its lesson in charity. But a glance at the windows at Sens (Fig. 102) or at Bourges[1] shows that the mediæval artist thought otherwise. He widened the meaning of the story of the poor traveller who went down from Jerusalem to Jericho until it became the story of humanity itself. That traveller is man, and that there may be no doubt of this the glazier at Sens has written the symbolic name "Homo" beneath him. It is hardly necessary to state that the artist invented nothing, he simply repeated the lesson of the schoolmen. The traveller who went down from Jerusalem to Jericho, says the *Glossa ordinaria*, is the type of fallen man leaving paradise. Jerusalem, it continues, is frequently in the Scriptures the symbolic name for Eden, while the name of Jericho which in Hebrew signifies "the moon," should remind us of the failings of humanity whose light, like the moon, from time to time suffers eclipse.

The man is attacked by robbers who steal his cloak, that is to say, all the sins which are sent by the devil fall on him and deprive him of his garment of immortality. As he lies naked and wounded by the wayside a priest and a Levite pass by ; both glance away and continue on their road. They are the image of the Old Law, the Law of Moses which was powerless to cure sick humanity. Then the Good Samaritan appears, binds the wounds of the dying man, puts him on his horse and takes him to the inn. The Good Samaritan is Christ. In Hebrew Samaritan means "keeper", and what more fitting name for Him who binds the wounds which Moses was not able to heal, and leads man to the hostelry of the Church.

Such is the theological interpretation which was given to the parable of the Good Samaritan[2] from the time of Augustine. The Church's teaching is reproduced in the window at Sens, where it is embodied in a composition admirable in its lucidity.

Three lozenge-shaped medallions in the centre of the composition give the Gospel story (Fig. 102), while circular medallions grouped round each of these central scenes interpret them and give their symbolic meaning. They are the glossary to the text. Thus round the first medallion, which

[1] Reproduced in *Vitraux de Bourges*, plan VI. and plan XX.

[2] *Glossa ordinaria*, in Luc. x., and Honorius of Autun, *Spec. Eccles. Domin.* xiii., *post Pentecost.* Consult also Hugh of St. Victor, *Allegor. in Nov.* *Testament*, IV., xii. This book is mainly devoted to the interpretation of the parables, and gives a clear summary of traditional teaching. A number of references have been collected by Cahier, *Vitraux de Bourges*, p. 191 *sq.*

shows the traveller despoiled of his riches by the robbers, is seen the creation of man and woman, their sin and expulsion from the earthly paradise.[1] Round the second medallion, which shows the wounded traveller lying between the unconcerned priest and the Levite, are Moses and Aaron before Pharaoh, Moses receiving the Law from God, the brazen serpent dimly prefiguring a greater victim, and the golden calf which proclaims the insufficiency of the Old Law. Round the third medallion, which shows the Good Samaritan taking the wounded man to the inn, are placed the Passion, the Crucifixion and the Resurrection.[2] It would hardly be possible to give clearer expression to a scheme of abstract ideas. The meaning of the parable is apprehended at a glance, and in arrangement the work of art excels its literary source.

The windows at Bourges and Chartres which treat the same subject in an almost identical manner are perhaps less happily composed. The glass at Rouen has suffered a good deal, but it is still possible to recognise some of the scenes we have mentioned. The presence of the parable of the Good Samaritan in four of the great cathedrals testifies to its popularity and to its constant interpretation in the Middle Ages.

But the story of the Wise and Foolish Virgins is the parable which

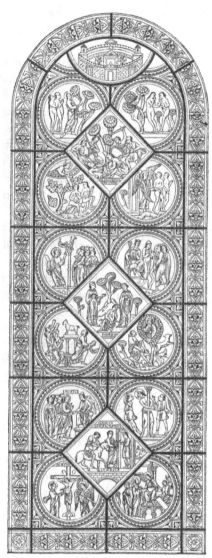

FIG. 102.—PARABLE OF THE GOOD SAMARITAN
(window at Sens)
(*From Cahier and Martin*)

[1] The city of Jerusalem fills the upper part of the composition. The creation of Adam is seen at Bourges.

[2] The holy women at the tomb typify the Resurrection.

197

met with most favour in the thirteenth century. At Amiens, Bourges,[1] Notre Dame at Paris,[2] Reims,[3] Sens, Auxerre and Laon they are seen on the west doorway, some to the right, some to the left of the sovereign judge. They have their place in the scene of the Last Judgment for, according to the theologians, they symbolise the elect and the lost, and their mysterious and terrible story is that of humanity's final hour.

On this subject the *Glossa ordinaria* first of all states what the five Wise Virgins symbolise and why there are five, for there are in Scripture no fortuitous numbers. They are five because they typify the five forms of mystical contemplation, which are so to say the five senses of the soul. They are thus the perfect image of the Christian soul which is turned to God. The oil which burns in their lamps is charity, the supreme virtue. The five Foolish Virgins are symbols of the five forms of the lusts of the flesh, the pleasures of the senses which cause the soul to forget all holy thoughts and extinguish the flame of heavenly love. The bridegroom, whom all alike await at the door of his house, is Christ ; and they await Him for long, so long that they fall asleep. This sleep is itself symbolic. It is a figure of the waiting of successive generations of men who sleep the sleep of death, to awake after long centuries at the second coming of Christ. "But at midnight," says the parable, "there was a cry made." This terrible cry in the night is the voice of the archangel, the trump of God which shall sound in the silence when none shall expect it, for "the Lord shall come like a thief in the night." And lastly, the Virgins awake and arise as the dead shall waken and shall rise from their tombs. Those whose lamps burn with the love of God shall enter with the bridegroom ; the others shall stay without the closed door, and the bridegroom shall say to them, "In truth, I know you not."[4]

We now understand why the Wise and Foolish Virgins are always associated in the thirteenth century with the Last Judgment. Their presence gives the warrant of the divine words to the terrible scene, for they remind the Christian that under the transparent veil of symbolism it was foretold in all its detail by Christ Himself.

Faithful to their traditions of symmetry and order, the Middle Ages did not fail to range the Wise Virgins to the right and the Foolish

[1] They are in a graceful rose-window on the west façade.

[2] They have been restored.

[3] An exception. At Reims they are on the north porch (round the arch) with the scene of the Last Judgment.

[4] *Glossa ordinaria*, in Matt. xxv. The same teaching is found in the other commentators on St. Matthew. The chief of these are St. Hilary, Bede, Rabanus Maurus, Paschasius Radbertus, Bruno of Asti, Hugh of St. Victor (in the *Allegor. in Nov. Testament.*, lib. III., cap. xxxiv.).

Virgins to the left of Christ. The former wear the nimbus and stand before an open door, the latter are without the nimbus and the door before them is closed.

In parables such as those of the Good Samaritan and the Wise and Foolish Virgins the symbolism is transparent, and there can be no doubt as to the artist's intention. It is not quite the same with the parables of the Prodigal Son and of Dives and Lazarus with which we must now deal.

The story of the Prodigal Son was a favourite one in mediæval art. It is told in windows at Bourges, Chartres, Sens and Poitiers, while at Auxerre it is seen not only in a window but carved in charming medallions in the porch, which are unhappily almost effaced by time. Nowhere, whatever may be the view of Father Cahier,[1] can any symbolic intention be found in these compositions.

It is true that the doctors who wrote commentaries on St. Luke interpret the whole mystery of the story of the Prodigal Son. The son who left his father to wander about the world and live with courtesans while his elder brother stayed at home, is according to them a figure of the Gentiles who forsook God while the Jewish people faithfully kept His law. But in his indulgence the father pardoned his erring son, and put him in the place of honour in the banqueting-hall in spite of the protests of his brother.[2]

As in the case of the Good Samaritan it would have been possible to give plastic form to symbolism of this kind, but no attempt to do so can be found. Father Cahier is of opinion that the eight small figures of kings which powder the field of the Bourges window were intended to represent the eight princes spoken of by the prophet Micah [3] as chosen by God to overthrow the infidel and convert the Gentiles. His theory is too problematic. The allusion would surely have been too obscure, too remote to be understood. The truth is that this beautiful story was sufficient in itself, and in it the people saw a father forgiving his son and nothing more. It is also noteworthy that the artist's fancy, usually so restrained, is here given free play. The same liberties are taken with the sacred text as with the *Golden Legend*. The prodigal son is shown playing dice in a tavern, taking a bath before his meal,[4] greeted by courtesans who stand before their doors, crowned with their flowers and finally driven away when he has nothing left

[1] *Vitraux de Bourges*, p. 179.
[2] *Glossa ordinaria*, in Luc. xv., and Hugh of St. Victor, *Allegor. in Nov. Testament.*, lib. IV., cap. xxiv.
[3] Micah iii. 12.
[4] This detail is seen on the doorway at Auxerre.

RELIGIOUS ART IN FRANCE

to give them but his cloak. These are surely so many little genre pictures in which the artist delighted. It would seem that the theologians had given up this pathetic story to the people's use.

Much the same might be said of the parable of Dives and Lazarus. The commentators do not fail to tell us that Lazarus symbolises the Gentiles, Dives the Jews.[1] But they themselves recognised the interpretation as secondary, and believed that in such a subject the literal reading had more force than the symbolic interpretation. The story of Lazarus, they said, is less of a parable than a narrative.[2]

Belief in the historical truth of the story was so strong that the poor leper was canonised under the name of St. Lazare or Ladre. He became the patron of beggars, lepers and all to whom in Italy the name of *lazzaroni* was given, a name which in its origin was one of Christian pity. It is indeed difficult to see anything but exaltation of the poor and condemnation of the rich in this intensely realistic story. No commentator interposed himself between the sacred text and the artist, who rendered it literally even to the metaphor which speaks of the soul of Lazarus as gathered into Abraham's bosom.[3] The window at Bourges in which Lazarus appears in the likeness of a thirteenth-century leper, clapper in hand to warn the passer-by, is purely narrative.[4] The very position which the subject occupies in certain mediæval buildings proves that the Church had no other intention in representing the parable than to give the faithful a lesson in charity. It is seen in the porches at Moissac and La Grolière (Corrèze) and on the capitals of the south transept door of St. Sernin at Toulouse. That is to say, it is above the very spot where the poor were accustomed to sit and beg for alms. The beggars with outstretched hands at the door of the church were transfigured in the eyes of the faithful, for carved above their heads they saw the old-time triumph of Lazarus.

These four are the parables which served as subjects for pictorial representation in the thirteenth century.

In those centuries of unquestioning faith the artists strove above all to demonstrate the great dogmatic significance of the New Testament. They made few attempts to bring home to men the Gospel story. The wholly human tenderness sought by centuries of weaker faith rarely ap-

[1] *Glossa ordinaria*, in Luc. xv., and Hugh of St. Victor, *Allegor. in Nov. Testament.*, lib. IV., cap. xxiv.

[2] *Ibid.*, "Magis videtur narratio quam parabola."
[3] In the porch at Moissac for example.
[4] See *Vitraux de Bourges*, plan IX.

pears in their work. Theirs was the time when the Virgin at the foot of the Cross, so unlike the later representation of the Spasimo of Our Lady, bears her grief without fainting.[1] It is true that these touching Italian pictures made a strong appeal, but it was an appeal to the heart in striking contrast to the appeal to the head made by thirteenth-century art. We must remember that the Gothic artists were contemporaries of St. Thomas Aquinas. Their art is as austere as the summaries, the commentaries and the sermons of the time, in which little but doctrine is found.

The same impression of grandeur is given by thirteenth-century art as by certain pages of Bossuet's *Élévations sur les mystères*. They have beauty of the same order. After them nothing of the kind is seen, for in the fourteenth century art grows more human and the Virgin presses her child to her heart, smiles at him and offers him a bird or flowers. The symbolic apple carried by the grave Virgin of the thirteenth century, in remembrance that she is the second Eve, becomes in the fourteenth century a plaything for the infant Jesus. Such art is more tender, but how much less impressive. Even Fra Angelico, who of all artists was most affected by his Gospel subjects, might at times have seemed to the old Gothic masters somewhat lacking in gravity of treatment.

[1] The Virgin fainting at the foot of the Cross is, however, seen once in a window at Bourges (the Good Samaritan), an anticipation of fourteenth-century art.

CHAPTER III

APOCRYPHAL STORIES; OLD AND NEW TESTAMENT

OUR study of mediæval art has not yet disclosed all the hidden meaning of subjects which were inspired by the Bible. We have seen the artists interpret theological teaching, we shall now see them give plastic form to popular legend. The words of the Bible, the Church's commentaries and the people's naïve dreams unite to form a beautiful harmony in the complex works which to-day we cannot understand without laborious analysis. Neither symbol nor legend can really be separated from the sacred text.

To take an example. The scene of the Nativity as conceived by the thirteenth century first of all puts before us the simple historic fact. But in substituting an altar for the crib the artist makes himself the interpretator of the commentators and gives concrete form to the doctrine of the Redemption. And then by putting near the Child the ox and the ass of which there is no mention in the canonical books, he shows that he does not wish to separate history from a legend which has charmed the hearts of many.

Such works are charged with both thought and dreams. How much finer they are than the poor conceptions of modern painters who claim to give fresh life to Christian art.

We will now complete our analysis, and having shown the grandeur that was given to scenes from Scripture by symbolism, we will try to show something of the naïvety and tenderness which were added by legend.

RELIGIOUS ART IN FRANCE

I

An immense popular literature relating to the Bible arose in the east. These legends have a very different character according as they refer to the Old or the New Testament. The traditions relating to the Old Testament, which first claim our attention, are full of marvels, and introduce us to a fairy world as strange as that of the *Thousand and one Nights*. The rabbis with their commentaries and the Arabs with their stories created a new Bible, all dream and phantasy ; [1] amendment and expansion of the sacred text occur in every line. The rabbis taught, for example, that after the creation of Adam God fashioned from the same clay a woman called Lilith, and gave her to him as companion. But Lilith would not obey Adam on the pretext that being formed from the same clay she was his equal. God was then constrained to create a new woman named Eve, whom he took from Adam's side that she might have no cause to boast of her origin.

Curious legends of this sort abound in the books of the rabbis, but it is the great figures of the Bible—Moses, David, Solomon—which are difficult to recognise. Kings and prophets become learned magicians who understand the language of birds, and know the virtue of precious stones. All the fancy of the east played round the figure of Solomon, and his memory, so dear to the Jew, at the same time stirred the imagination of the Arab. In these legends Solomon holds sway over angels and demons, and shuts up djinns in copper pots. He causes the twelve golden lions which decorate the steps of his throne to roar, and holds converse with ants and birds. His ring gives him authority over all creatures, so that the whole universe which he disposes at will seems under a magic spell.

Such stories bear the mark of their origin. In the burning deserts of the east the imagination seems to have something of the nature of that light which creates the unreal world of mirage.

All of these marvellous stories were not known to the Middle Ages, though some travelled as far as the west and were accepted by the commentators. Some of them were inserted by Peter Comestor in the *Historia Scolastica* and by Vincent of Beauvais in the *Speculum historiale*.[2]

At times the artists drew inspiration from them. There is one in

[1] The Jewish and Arabic traditions relating to the chief persons of the Old Testament are collected in Migne's *Dictionnaire des apocryphes*, 2 vols. 4to, 1858.
[2] The *Testaments of the Twelve Patriarchs*, one of the apocryphal books of the Old Testament quoted by Vincent of Beauvais, had been recently translated from the Greek by Robert Grostête, bishop of Lincoln. See *Spec. hist.*, lib. I., cap. cxxv.

RELIGIOUS ART IN FRANCE

particular for which they showed marked predilection, for we find it painted or carved in several of the cathedrals. We refer to the story of the death of Cain as related in the apocryphal books. Cain, said the rabbis, was killed by Lamech, who in that way involuntarily punished Abel's murderer. Lamech, blind in his old age, nevertheless followed the chase under the guidance of a child named Tubalcain, and one day as he was hunting in a wood the child caused him to direct his arrow towards a bush in which he thought he had seen a wild beast. Lamech drew his bow, and killed Cain who was hiding among the branches. When he knew of his deed

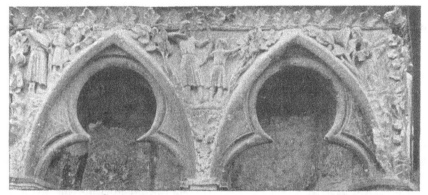

FIG. 103.—LAMECH KILLING CAIN (porch at Bourges)

he became violently angry, and slew the child who had counselled him so ill.

This legend, only briefly alluded to by St. Jerome,[1] first appeared in complete form in the *Glossa ordinaria* of Walafrid Strabo,[2] who had found it in a book, now lost, belonging to his master, Rabanus Maurus. The story of the death of Cain, not known in detail to the early Fathers, does not really appear in mediæval literature until the ninth century. It is probable that Rabanus Maurus had it from some rabbi. Intercourse between Jews and Christians was more frequent and more friendly in the Middle Ages than is often believed. The doctors of the Church were acquainted with some of the rabbinical traditions long before the converted Jew, Nicolas

[1] In one of his letters to Pope Damasus on difficult questions in the Old Testament (*Ep. ad Damas.*, cxxv). "Lamech, qui septimus ab Adam, non sponte, ut in quodam Hebræo volumine scribitur, interfecit Caïn." He adds nothing to this brief reference.

[2] *Glossa ordinaria*, in Genes. v. 23. "Aiunt Hebræi Lamech diu vivendo caliginem oculorum incurisse, et adolescentem ducem et rectorem itineris habuisse. Exercens ergo venationem, sagittam direxit quo adolescens indicavit, casuque Caïn inter fruteta latentem interfecit . . . unde et furore accensus occidit adolescentem." (Rabanus Maurus.)

de Lyra, made them known in his works on the Old Testament.[1] The story of the death of Cain was received by the schoolmen on the authority of the *Glossa ordinaria*, and in the twelfth century Peter Comestor inserted it in his account of the beginning of the world.[2]

The artists seldom painted or carved the story of primitive man without showing the death of Cain. In the thirteenth century they liked to illustrate the first chapters of Genesis, and it became a tradition which extended even to illustrated manuscripts to place the Creation, Adam's disobedience, and the Deluge before the eyes of the faithful. The craftsmen contented themselves with showing the people the story of the remotest times, and rarely went beyond the story of Noah, but however short this story might be a place was found for the legend of Cain. It is sculptured on the façade at Auxerre (Fig. 104) in the lower part of the left doorway, and in the porch of the cathedral of Bourges[3] (Fig. 103), and it can be recognised among the innumerable medallions that decorate the façade of Lyons cathedral. It is also to be found in windows, as in

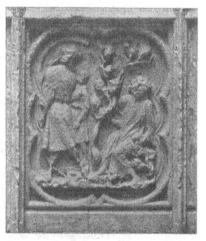

FIG. 104.—LAMECH KILLING CAIN (façade at Auxerre)

two panels in a window at Tours devoted to the early history of the world[4] and in the Genesis window in the Sainte-Chapelle.

These examples, which no doubt could be multiplied, show that in the thirteenth century the legend was already popular. Later it became widely known through the mystery plays, and it was frequently taken as subject matter for art even as late as the sixteenth century.[5]

Of all the rabbinical legends this alone gained real vitality in art, though it is probable that others might be found in mediæval buildings. Among the numerous medallions devoted to the Genesis story on the façade of the cathedral of Lyons there is one which might well come from Jewish legend. A workman on a tower throws an object which looks like a brick

[1] Nicolas de Lyra wrote in the fourteenth century.
[2] *Hist. Scolastica*, lib. Genes. cap. xxviii.
[3] In the arcading on the basement. The heads of Cain and the child are modern restorations.

[4] Reproduced by Bourassé and Marchand, pl. XII.
[5] We have given some examples in the *Revue archéologique*, 1893.

on to the head of one of his companions. This is the tower of Babel and the legend of the confusion of tongues as told in the synagogues. In the Jasher—that book of strange traditions—one reads, " From that day none understood the language of another, and when from the hand of his companion a mason received materials which he had not asked for, he threw them at his head and killed him ; and a great number of them died in this way." [1]

But apocryphal stories relating to the Old Testament never filled a large place in art. The Middle Age contented itself almost invariably with the text of the Bible, which fully satisfied its curiosity.

II

This was not the case with the Gospels. The apocryphal stories of the Saviour's life, always tolerated by the Church, were welcomed warmly by art.

These legends go back to the days of primitive Christianity. They grew out of love and the longing for more intimate knowledge of the life of Jesus and of all who were with Him. The people found the Gospels too short, and could not resign themselves to their silences. They took the words of St. John in a literal sense—" There are also many other works which Jesus did, the which, if they should be written everyone, I suppose that even the world itself could not contain the books that should be written." [2]

The desire to conjecture the untold incidents in the life of Christ is found in all ages. The revelations of St. Bridget and of Mary of Agréda, and the amazing stories of Sister Catherine Emmerich, prove that the tender curiosity which gave birth to the apocryphal gospels has not entirely disappeared even in our day.

The little Christian communities of the east never wearied of hearing stories of the life of Jesus. His infancy, of which the canonical books say so little, had special power to stir the popular imagination. Marvellous legends arose, born no doubt among the fellahs and watermen of the Nile and brought by caravans to Palestine, and later to the heart of Arabia. [3] During halts in the desert it was related how as a child Jesus fashioned

[1] A translation of the book of Jasher is found in Migne, *Dict. des apocryphes*, II., col. 1069 *sq.*
[2] St. John xxi. 25.
[3] It is known that the life of Christ was known to Mahomet almost entirely through the stories in the apocryphal gospels.

birds of dried clay and made them fly away by clapping His hands, how at school He read the letters of the alphabet without learning them, or how with a masterly hand He helped His adopted father to make ploughs.

These stories of the childhood of the Saviour are not always of a gracious character. Some of the miracles are childish, some are cruel. In Egypt He restored to his former shape a man who had been changed into a mule by a spell, but on the other hand in Judea to show His power He changed children into goats. He shrivelled up the hand of a schoolmaster who would have beaten Him, and He struck dead a child who had pushed Him in running. Some chapters in the apocryphal gospels are like the *Life of Apollonius of Tyana* or even like the *Golden Ass*, permeated with the belief in witchcraft and magic, for the credulous eastern peoples made these legends in their own image. They are usually characterised by ingenuity and simplicity, though from time to time one recognises the wish to justify some gnostic theory.

Sometimes the anonymous writings reach real grandeur. The " Gospel of Nicodemus " in particular, written by a man of Jewish blood familiar with the Bible, has passages which compel one's admiration. The account of Christ's triumphal descent into Limbo could rank with the finest pages in the canonical books.

All the legends which go to form what are called the apocryphal gospels were no doubt originally written in the Greek of Egypt and Syria, though those which have come down to us are in various languages—Arabic, Coptic, Greek and Latin. We have no need to seek the origin of the legends, nor need we trouble about any links between them. The inquiry has been partially made by the editors of the apocryphal gospels, Fabricius, Thilo and Tischendorf,[1] and the one thing which concerns us is to discover how far the old oriental traditions were known to the Middle Ages.

Of the narratives relating to the Saviour there are two in particular which seem to have been used by the writers of the twelfth and thirteenth centuries, in spite of the Gelasian decree which placed them among the number of apocryphal books. The first is the " Gospel of Pseudo-Matthew," or *Evangelium de nativitate Mariæ et infantia Salvatoris*,[2] which has come down to us in the form of a Latin translation. The Middle Ages

[1] Fabricius, *Codex apocryphus Novi Testamenti*, Hamburg, 1719. Thilo, *Codex apocryphus Novi Testamenti*, Leipzig, 1832. Tischendorf, *Evangelia apocrypha*, Leipzig, 1853. Brunet's translation of the apocryphal gospels is found, revised and completed, in the first volume of Migne's *Dict. des apocryphes*.

[2] First published by Thilo.

RELIGIOUS ART IN FRANCE

appear to have held it in high honour, for it was mentioned with respect by Fulbert of Chartres,[1] and it furnished Vincent of Beauvais with some of the legends which he collected in his *Speculum historiale*.[2]

The second of the apocryphal gospels known to the Middle Ages is that which under the name of the " Acts of Pilate " or the "Gospel of Nicodemus " is devoted to the Passion of Christ and His descent into Limbo. This book, of which the Greek text alone has been preserved, must early have spread to the west through a Latin translation, for we have it quoted by Gregory of Tours to whom Greek was unknown.[3] In the thirteenth century Vincent of Beauvais transcribed it almost entirely in his *Speculum historiale* and Jacobus de Voragine in the *Golden Legend*.[4]

From these two gospels derive the greater number of apocryphal stories found in thirteenth-century art and literature, but they do not explain everything. There are, in the *Golden Legend* especially, stories which do not originate in these two gospels. Jacobus de Voragine tells, for example, that on the night of the Saviour's birth the vines flowered throughout Palestine ; and he gives interesting particulars of the journey of the Magi, how they were guided by a star with the face of a child—which was in reality an angel—and how they left on a vessel for Tarsus to escape from the anger of Herod. We cannot point to the source of these legends or say whether they also originated in the east, for we have found nothing like them in the apocryphal stories of the New Testament published up to the present time. Their origin matters little to us as it is not our object to trace their descent, and it is enough for our purpose to study the legendary cycle in the complete form found in the mediæval encyclopædias of history, and to show how much or how little art borrowed from it. We shall have constantly before us not only the apocryphal gospels themselves, but Comestor's *Historia Scolastica*, Vincent of Beauvais's *Speculum historiale*, and the *Golden Legend* in which later traditions mingle with the old eastern stories. To these famous books should be added Ludolph of Saxony's great *Vita Christi*, for although it dates from the middle of the fourteenth century,[5] it contains almost all the earlier legends and is the most complete summary left us by the Middle Ages.

[1] *Sermo* III.
[2] *Spec. histor.*, lib. VI., cap. xciii.
[3] *Hist. Franç.*, lib. I., cap. xxi.
[4] *Spec. histor.*, lib. VII., cap. lvi. *sq.* and *Legenda*

aurea, De resurrectione Domini. [*Golden Legend*, i. 98. T. C.]
[5] Ludolph of Saxony died in 1378. His book was written about 1350.

III

The scenes of the childhood of Christ as portrayed in the art of the thirteenth century include several apocryphal features. Legend and gospel story are so closely interwoven that it is difficult to separate them. We are so accustomed to see the ox and the ass in representations of the Nativity that it hardly occurs to us that their presence near to the manger is not mentioned by any of the evangelists, and is found only in the "Gospel of Pseudo-Matthew."[1] The legend, which no doubt originated in a desire to justify a prophesy of Isaiah and a misreading of a passage in Habakkuk, was accepted from the beginning of the Christian era. It has lived through the centuries because it touched the hearts of the people to see their God ignored by men and welcomed by the humblest of beasts, and the tradition was definitely consecrated by the mention of the animals in a response at the Christmas festival.[3] Like the writers of the old Christmas carols, the artists of the thirteenth century never forgot the ox and the ass.

Another and a very ingenuous legend relating to the birth of Christ is also seen at times in the cathedrals. Near to the Virgin who is lying on her bed two women, one of them sometimes with her arm in a sling,[4] are assiduously caring for the Child, perhaps washing Him in a basin.[5] They are the midwives spoken of in the "Gospel of Pseudo-Matthew," where it is related that Joseph had gone to seek a midwife and when he returned to the cave the Virgin was already delivered of the Child. "And Joseph said to Mary, 'I have brought with me two midwives, Zelemie and Salome, who wait at the entrance of the cave.' Hearing this she smiled, and Joseph said to her, 'Smile not but take heed, for fear thou shalt have need of help,' and he told one of the midwives to come in. Now when Zelemie came near to

[1] *Evang. de Nativ. Mariæ et Infant. Salvat.*, xiv. "Tertio autem die Nativitatis Domini egressa est beata Maria de spelunca et ingressa est stabulum et posuit puerum in præsepio, et bos et asinus adorabant eum."

[2] Isaiah i. 3. "Agnovit bos possessorem suum et asinus præsepe domini sui"; and Hab. iii. 2. "ἐν μέσῳ δύο ζώων γνωσθήσῃ." St. Jerome corrected this passage in the Alexandrian version, translating it—"In medio annorum vivifica illud." But the old interpretation, "In medio duorum animalium cognosceris", obtained none the less. See the "Sermon" of the pseudo-Augustine published by Marius Sepet (*Les Prophètes du Christ*). Jacobus de Voragine (*Leg. aurea, de Nativit.* cap. vi.) [*Golden Legend*, i. 25, T.C.] and Ludolph of Saxony (*Vita Christi*) explain the presence

of the ox and the ass; the ass had carried the Virgin from Nazareth to Bethlehem, the ox was intended for sale by St. Joseph.

[3] "O magnum mysterium et admirabile sacramentum ut animalia viderunt dominum jacentem in præsepio." The response is found in breviaries of the thirteenth and fourteenth centuries, *e.g.* Bibl. de l'Arsenal, No. 107, f. 107, *Bréviaire de Poissy*.

[4] On the shrine at Aix-la-Chapelle see Cahier and Martin, *Mélanges d'archéologie*, series I., vol. i.

[5] It is possible that as G. de Saint-Laurent believes (*Guide de l'art chrétien*, t. iii. p. 407) the scene originally had a symbolic meaning. It is noteworthy that the basin in which the midwives wash the Child is always a baptismal font. His bath may prefigure His future baptism.

RELIGIOUS ART IN FRANCE

Mary, she said to her, 'Wilt thou suffer that I touch thee?' And when Mary had given her permission, the midwife cried with a loud voice, 'Lord, Lord, have pity on me! never did I imagine the like. Her breasts are full of milk, and she has a male child although she is a virgin. No defilement was at the birth, and no travail at the bringing forth. Virgin she conceived, virgin she gave birth, and virgin she remains.' The other midwife, Salome, hearing the words of Zelemie, said, 'I cannot believe that which I hear unless I assure myself.' And Salome drew near to Mary and said, 'Wilt thou suffer me to touch thee that I may see whether Zelemie says truly?' And Mary having given her permission, Salome touched her, and immediately her hand withered. And feeling the great pain, she began to weep very bitterly, and to cry aloud and to say, 'Lord, Thou knowest that I have ever held Thee in awe. . . . And behold by reason of my incredulity I am become wretched, because I dared to doubt Thy virgin? When she had spoken thus, there appeared a young man of great beauty, who said to her, 'Approach the Child and adore Him, then touch Him with thy hand and He will heal thee, for He is the Saviour of the world and of all those who hope in Him.' And immediately Salome drew near to the Child, and adoring Him she touched the edge of His swaddling clothes, and immediately her hand was healed." [1]

This ingenuous story in which the midwives testified to the miraculous birth soon roused the indignation of the Fathers of the Church,[2] but St. Jerome's anger against the foolishness of the apocryphal books, " deliramenta Apocryphorum," did not prevent the legend from becoming popular. In mediæval times it was accepted by Jacobus de Voragine, who changed the name of one of the midwives, the Zelemie of the apocryphal gospel becoming the Zebel of the *Golden Legend*.[3] The popular imagination working on the old theme continually added to and embroidered it. In several poems of the twelfth and thirteenth centuries, notably in a Provençal mystery play, the midwives are replaced by an infirm woman named Anastasia or Honestasia. She was born without arms, but her arms grew as soon as she testified to the Virgin Birth.[4]

The mediæval Church, ever indulgent to popular legend and in this at one with the people, more than once gave the artists an order to

[1] *Evang. de Nativ. Mariæ et Infant. Salvat.*, cap. xiii. Taken from Brunet's translation.

[2] " Nulla ibi obstetrix, nulla muliercularum sedulitas intercessit. Ipsa [Maria] pannis involvit infantem, ipsa et mater et obstetrix fuit." St. Jerome (*Contra Helvid.*).

[3] *Leg. aurea, De Nativ.*, cap. VI. [not found in Caxton's version. Trans.].

[4] P. Meyer, *Romania*, 1885, vol. xiv. p. 497.

represent the story of the midwives. It is found on a capital in the apse in the cathedral of Lyons, and on one of the capitals forming the long frieze which recounts the life of Christ on the west front of the cathedral of Chartres.[1] It is found again in a window in the chevet of Laon cathedral (Fig. 105), and at Le Mans in a window in the chapel of the Virgin which is

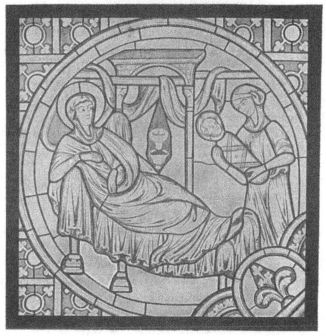

FIG. 105.—THE VIRGIN AND ONE OF THE MIDWIVES (window at Laon)
(From MM. de Florival and Midoux)

devoted to the childhood of Jesus (Fig. 106). To these examples many others might be added, but they are only to be found in early work. The capitals at Chartres and Lyons belong to the twelfth century, the glass at Laon and Le Mans to the early part of the thirteenth. After that time the legend of the midwives is no longer met with in the cathedrals, neither have I succeeded in discovering it in the illustrated manuscripts of the thirteenth and fourteenth centuries which I have glanced through. It seems as if the extreme simplicity of the old story at last became a cause of offence to the Church, and although for long afterwards she allowed the

[1] At Chartres the midwives are not washing the Child.

RELIGIOUS ART IN FRANCE

midwives to appear in the Mysteries, she excluded them from the church. It was during the thirteenth century that the artists relinquished the old motif of the midwives and the Child which went back to primitive Christian art.[1]

No scene of the childhood of Christ furnished richer matter for the popular fancy than the adoration of the Magi. Those mysterious figures so slightly sketched in the Gospel story roused the liveliest curiosity, and legend did not fail to relate all that St. Matthew had passed over. It gave the names of the Magi, the incidents on their journey, the story of their whole life and even of their death. It told how baptized by St. Thomas on his voyage to India they died true Christians, and how the cathedral of Cologne piously received their relics. In the Middle Ages noble families counted the Magi among their ancestors, and even to-day the arms bearing a star which testify to the noble origin of an illustrious house may be seen in the ruins of the castle of Les Baux near Arles. The people, too, honoured the Magi after their fashion when they associated their names with sorcery and witchcraft ; the three names written on a ribbon and worn on the wrist was considered a cure for the falling sickness.[2]

Mediæval traditions relating to the Magi are both numerous and picturesque. The far east whence they came induced dreams, and fanciful stories of the land of the Queen of Sheba, that land of gold and spices, were no longer to be kept in bounds. The Magi were reputed to be descended from Balaam, and to have inherited the secrets of ancient magic.[3] It was said that the pieces of gold they brought to the Child were struck by Terah, father of Abraham, and that they were given to the people of Sheba by Joseph, son of Jacob, when he went among them to buy the spices for embalming his father's body.[4]

It is a curious fact that the apocryphal gospels ignore these legends and add little to the story in the canonical books. The chapter in the " Gospel of Pseudo-Matthew " has the brevity which characterises early work.[5] The legends of the Magi arose elsewhere, and the legendary cycle formed slowly. In the thirteenth century Jacobus de Voragine grouped some of the current stories of the Magi in two chapters of the *Golden Legend*.[6]

[1] Rohault de Fleury (*La sainte Vierge*) believes that the scene of the midwives first appeared in the seventh century in the Bible of the Armenians of San Lazzaro near Venice.

[2] See Thiers, *Traité des superstitions*, and B. de Montault, *Bullet. monum.*, 1884, p. 722.

[3] Ludolph, *Vita Christi*, cap. XI.

[4] On these legends and their origin see Migne, *Dict. des apocryphes*, I., col. 470, and II., col. 1023–1025.

[5] Cap. XVI.

[6] *Leg. aurea. De Innocent.*, X., and *De Epiphania Domini*, xiv. [*Golden Legend. The Holy Innocents*, ii. 176, and *The Epiphany*, i. 41.]

It is there related that the Magi were three in number, that their names were Jaspar,[1] Balthasar and Melchior, and that they were not only magi but kings. In their different countries they were in the habit of climbing to the mountain tops to observe the stars ; the star that guided them to Bethlehem had the face of a child, and in fact was the angel seen by the shepherds.[2]

The greater number of the particulars recorded by Jacobus de Voragine are to be found in thirteenth-century art. The number of the Magi, still indeterminate in the earlier centuries, never goes beyond three in the churches ; they invariably wear crowns—an allusion to their rank—and at times the star has the face of an angel. In their *Monographie de la cathédrale de Lyon* MM. Guigue and Bégule published a fourteenth-century miniature of the scene of the adoration of the Magi, taken from a French missal belonging to the treasury of St. Jean, in which an angel's head is seen in the centre of the star. In the choir enclosure in Notre Dame at Paris the artist found a more graceful way of translating the same legend when he placed the star in the hands of an angel who seems to direct its course (Fig. 107).

FIG. 106.—THE MIDWIVES WASH-ING THE CHILD (from a window at Le Mans)

None of these legends were treated with more deference than that which assigns a different age to each of the Magi. In windows, bas-reliefs and manuscripts the first king invariably appears as an old man, the second as a middle-aged man, and the third as a young and beardless man. The adoration of the Magi in the choir enclosure in Notre Dame at Paris is one of the most famous of the many examples. The tradition is an ancient one which was held in respect by the miniaturists of the

[1] Later he was called Gaspard.

[2] A careful study of the legend of the Magi in literature and art has lately been made by M. Hugo Kehrer, *Die Heiligen drei Könige in Litteratur und Kunst.* Leipzig, 1908, 2 vols., 4to. He shows that the number of the Magi, at first indeterminate, was soon reduced by the Fathers to three. Origen was the earliest ecclesiastical writer to speak of the three Magi. (*In Genesim. Homilia* xiv. 3, *Patrol. Gr.*, xii., col. 238.) In early times two, three, four, or even six Magi appear in art, and it was not until the fourth century that the number three became general. The title of king which became inseparable from the names

of the Magi, is first alluded to by Tertullian who teaches that the kings of Arabia and Sheba spoken of in the Psalms are a figure of the Magi (*Adversus Marcionem*, III., xiii., *Adversus Judæos*, ix., and *De idolatria*, ix.). But it was not until the fifth century in a treatise of Maximus of Turin and in the sixth in Caesarius of Arles that they really became kings. And it was not until the tenth century that artists began to represent the Magi as crowned kings, the earliest example being in the famous menology of Basil II. in the Vatican, which dates from about 976. Before that time they wear the Phrygian cap and the anaxy-rides of the Persians and the priests of Mithra.

eleventh century,[1] and goes back to a much earlier date.[2] The first mention of it is found in a curious passage attributed to Bede which is included in the *Collectanea* which accompanies his works.[3] "The first of the Magi," says the pseudo-Bede, "was Melchior, an old man with long white hair and a long beard. . . . It is he who offered gold, symbol of the divine kingdom.

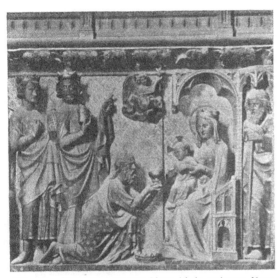

The second named Caspar, young and beardless, with a ruddy countenance . . . honoured Christ in presenting incense, an offering pointing to His divinity. The third named Balthazzar, with dark skin ("fuscus") and a full beard, testified in his offering of myrrh that the Son of man must die."[4]

Mediæval compilers seem to have taken little notice of the portraits traced by the pseudo-Bede, and did not transcribe them in their books. But the artists were less scornful, and for centuries the tradition relating to the ages of the Magi was passed on in the studios.[5]

FIG. 107.—ADORATION OF THE MAGI (choir enclosure, Notre Dame at Paris)

It should also be noted that in the thirteenth century the term "fuscus" applied to Balthazzar by the pseudo-Bede, was never taken literally, and it

[1] Bibl. Nat., MS. Latin 17325 (eleventh century).

[2] The first representation of the three Magi as an old man, a middle-aged man, and a young man is seen in an eastern MS., the evangeliarium of Etschmiadzin, which dates from about 550. In the west the practice does not appear until the end of the Carlovingian period (Ivory in the Musée at Lyons, about 900).

[3] *Patrol.*, xciv.

[4] As certain curious words show (milenus, hyacinthinus, mitrarium), this passage of the pseudo-Bede has certainly been translated from the Greek. It seems to come from some very early "Guide to Painting." See Kehrer, i. 66-67. It thus appears certain that the idea of assigning a different age to

each of the Magi came from the east. Their mysterious names are first found in a Greek chronicle of the beginning of the sixth century, translated into Latin by a Merovingian monk (*Excerpta Latina Barbari*). The names are in this form—Bithisarea, Melichior, Gathaspa.

[5] Men went so far as to state the exact age of each of the Magi. It was said in the Middle Ages that the eldest was sixty, the youngest twenty, and the other forty; which might be taken as the enthusiasm of youth, the developed reasoning power of middle age, and the experience of old age doing homage to Christ. These precise ages are found in the *Catalogus Sanctorum* of Petrus de Natalibus, published at the end of the fifteenth century.

was only in the fourteenth and still more in the fifteenth centuries that the third king has the appearance of a negro.[1] The artists were led to this new interpretation by the commentaries of the theologians. It was stated in the sermons of the day that the three Magi, prefigured in the Old Testament by Shem, Ham and Japheth, the three sons of Noah, stood for the three races of mankind coming to render homage to Christ.[2]

Mediæval buildings show certain strange scenes in the lives of the Magi

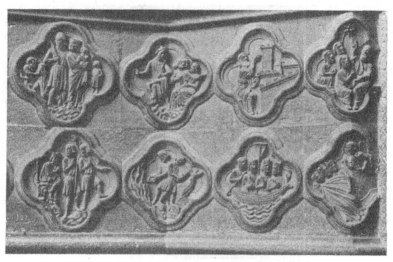

FIG. 108.—THE STORY OF THE MAGI (bas-reliefs at Amiens)

which have often embarrassed their interpreters. Beneath the large statues of the three Magi in the right porch of the façade of Amiens cathedral, are several small medallions which recount their history (Fig. 108). In one they are all three in a boat and seem to be sailing towards their homes, and in another a figure is giving the order to fire a ship.[3] Men of the Middle Ages, familiar with the legend, had no difficulty in recognising in the Amiens bas-reliefs an episode in the return of the Magi as related by Jacobus de Voragine.

"And Herod even as he had ordered the slaying of the Innocents was

[1] The earliest known example is seen in the carved tympanum in the church of Thann, a work of about 1355. See Kehrer, ii. 224. Examples are much more numerous in Germany than in France, where they are later.

[2] This kind of symbolism goes back to early times, for it is found in Bede's Commentary on St. Matthew, lib. I., cap. II.

[3] Maury (*Essai sur les légendes*, p. 207) was the first to point out the bas-reliefs at Amiens, but without explaining them.

RELIGIOUS ART IN FRANCE

cited to appear before Caesar to answer to the accusation made against him by his son. And as he passed by Tarsus, he learned that the three kings had embarked on a vessel in that port, and in his anger he fired all the ships in the harbour, according as David had said :—" He shall burn the ships of Tarsus in his wrath." [1]

This legend, like many others, had its rise in a verse in the Old Testament.[2] It was evidently popular in the thirteenth century, for it served more than once as inspiration for art.[3] The Magi returning home in a boat are seen in the panels of the rose-window at Soissons,[4] and again in the window dedicated to the childhood of Christ in the apsidal chapel of the cathedral of Tours.[5]

Herod also entered into the legendary cycle of the Magi, but all the stories which Peter Comestor, Vincent of Beauvais and Jacobus de Voragine tell of the horror of his last years do not appear in art ; one feature alone is retained. In the left porch of the façade at Amiens a nude figure whom two servants are placing in a bath is seen under the statue of Herod with the three Magi. This is Herod who when old tried to postpone death by taking baths of oil. " Herod when he was seventy years old he fell into a grievous malady, for strong fever took him within and without, his feet swelled and became of a pale colour. The plants of his feet under began to rot, in such wise that vermin issued out." He was terribly tormented, and following the advice of the doctors he was put into oil from which he was taken half dead.[6] Herod lived long enough to learn that his son Antipater had not disguised his joy when he heard the story of his father's agony. The divine anger is manifested in this story of Herod's death, made famous by Comestor when he inserted it in his *Historia Scolastica*." [7] The sculptor of Amiens showed his ingenuity in foretelling the future and heralding the coming retribution when he placed Herod aged and broken beneath the feet of Herod triumphant.

The Flight into Egypt, so briefly referred to by the evangelists, was one

[1] *Legenda aurea. De Innocent.*, X. [not found in Caxton's version. Trans.] ; Vincent of Beauvais, *Spec. histor.*, vii. 93 ; Ludolph, *Vita Christi*, XI.
[2] The town of Tarshish mentioned in the Old Testament was identified with Tarsus.
[3] Until the eighteenth century the return of the Magi was celebrated in Italy on March 1st.
[4] Reproduced by F. de Lasteyrie, *Hist. de la peinture sur verre*, pl. XXV.
[5] Figure 108 represents, first line—the massacre of the Innocents, Herod consulting the doctors, Micah announcing that the Messiah will come from Bethlehem,

Balaam showing the star ; second line, from the right, the Magi wakened by the angel, the Magi returning by sea, the ships of Tarsus burning, Herod giving the order to fire the ships.
[6] *Legenda aurea. De Innocent.*, X. (from Brunet's trans.). [*Golden Legend, Holy Innocents*, ii. 180. The bath of oil is not mentioned in Caxton's version. Trans.]
[7] P. Comestor, *Hist. Scolast. in Evang.* xiv., after Josephus. See also Vincent of Beauvais, *Spec. hist.*, vi., cap. c., and *Legenda aurea. De Innocent.*, X.

216

of the subjects round which popular imagination most readily played. The divine Child lives in the midst of miracles in these legendary stories. He overcomes dragons and savage beasts, and disarms brigands. The water in which His swaddling-clothes have been washed revives the dead. Local traditions preserved by the Copts, and numerous stories invented by the Arabs, were added to the legends collected in the apocryphal gospels.[1]

The Middle Ages drew with discretion from this storehouse of legend. Vincent of Beauvais was satisfied with transcribing the " Gospel of the Birth of Mary and the Infancy of the Saviour," the least charged with fabulous circumstance,[2] and Jacobus de Voragine, contrary to his habit, was circumspect in his use of them.[3] The artists were even more careful, and out of so many legends only retained the story of the fall of the idols.

It is related in the " Gospel of Pseudo-Matthew "[4] and repeated by the mediæval writers, that on entering the temple in the town of Sotinen, called by others Hermopolis, Jesus caused the idols to fall, that the words of Isaiah might be fulfilled : " Behold, the Lord riseth upon a swift cloud. . . . And the idols of Egypt shall be moved at His presence." On hearing of the miracle Aphrodosius, the governor of the town, went to the temple, and when he saw the broken statues he worshipped Jesus. Tradition adds that Aphrodosius later came to Gaul and preached the gospel in the Narbonnaise, and that he was said to have been the first bishop of Béziers.

The story of the fall of the idols, which like so many apocryphal stories arose from an attempt to justify a prophetic passage, was adopted by the Church who authorised its representation in art. It is found in all carved or painted series of scenes of the childhood of Christ. The thirteenth-century version of the legend is so condensed as to become almost a hieroglyph. Neither town, priest, nor temple is seen as in earlier works, but two statues breaking in half as they fall from their pedestals suffice to tell of the miracle. A curious feature is found in a window at Le Mans. The Egyptian idols are parti-coloured ; their heads are of gold, their chests of silver, their bellies of copper, their legs painted blue—apparently of iron, their feet the colour of clay.[5] The painter was evidently thinking of the statue in Nebuchadnezzar's dream, which for him was the typical idol.

This is all that legend contributed to art. It is, however, possible that a detail of apparent insignificance, frequently found in representations of the

[1] *Dict. des apocryphes*, t. i., col. 995–996.
[2] *Spec. histor.*, VI., xciii.
[3] *Legenda aurea. De Innocent.*, X. [*Golden Legend*, II., T. C.].

[4] Cap. XXIII.
[5] Reproduced by Hucher, *Vitraux du Mans*. It is in the window devoted to the Childhood, in the chapel of the Virgin.

RELIGIOUS ART IN FRANCE

Flight into Egypt, commemorates another legendary story. A tree is often seen near to the Holy Family when on their journey. Must this be taken as merely a symbol intended to recall the countryside through which the travellers passed, or is it not more probably a picture of the marvellous tree mentioned in the apocryphal account? The " Gospel of Pseudo-Matthew " tells how on the third day of the journey the Virgin was weary, and sitting down beneath a palm-tree she longed for some of its fruit. St. Joseph pointed out to her the great height of the tree, " then the Child Jesus who was in the arms of the Virgin Mary, His mother, said to the palm-tree, ' Tree, incline thy branches and nourish my mother with thy fruit.' And at the sound of His voice the palm-tree lowered its topmost branches to Mary's feet, and they were able to gather the fruit it bore and to feed on it. The next day at the hour of departure Jesus said to the palm-tree, ' Palm-tree, I command that one of thy branches be carried away by my angels, and be planted in the paradise of my Father. To recompense thee, I will that it be said to all those who shall conquer in the fight for the faith, ' Ye have deserved the palm of victory.' As He spoke thus, behold the angel of the Lord appeared in the palm-tree, and taking one of the branches in his hand he flew up to heaven with it." [1]

This story is reproduced by Vincent of Beauvais,[2] and is found with slight modifications in the works of several mediæval writers. But relying upon a passage in Cassiodorus they have all replaced the palm-tree by a peach,[3] and Vincent of Beauvais, although he follows the " Gospel of Pseudo-Matthew " in every other respect, on this point shares the view of Cassiodorus. This substitution of the peach-tree for the palm is not without significance. In the choir enclosure in Notre Dame at Paris one sees near to the figure of the Virgin mounted on an ass (Fig. 109), a tree laden with fruit, which has the appearance of a peach-tree. The artist, if we conjecture rightly, wished to commemorate the legend of the tree in the desert. The presence of the tree in several works of art of the same period—as in windows in the cathedrals at Lyons [4] and Tours [5] which illustrate the Flight into Egypt—lends support to our theory.

These are the only apocryphal features which the thirteenth century appears to have admitted into representations of the Flight into Egypt.

[1] *Evang. Nativ. Mariæ et Infant. Salvat.*, xx. and xxi. (from Brunet's translation).

[2] *Spec. hist.*, VI., cap. XCIII.

[3] See for example Honorius of Autun, *Spec. Eccles.*, *Patrol.*, clxxii., col. 837 (he calls the tree " persicus "),

and *Legenda aurea. De Innocent.*, X. [*Golden Legend, Holy Innocents*, ii. 182.]

[4] Cahier, *Vitraux de Bourges*, plan VIII.

[5] Bourassé and Marchand, *Vitraux de Tours*, pl. VII. At Chartres on a capital in the west porch ; the tree is not seen, but the Virgin holds a palm.

There is in work of that date practically no trace of certain legends which later became popular, and which from the end of the fourteenth century were a frequent source of inspiration for artists, and more especially for miniaturists.[1] We would now refer to the legend of the robbers and the cornfield.

An incunabulum of the fifteenth century relates the two legends one after the other, as follows : "Mary and Joseph had no money, and they must needs carry the Child and flee into strange countries and wild deserts by terrible roads. They there encountered robbers, one of whom gave them good cheer and showed them on their road most sweetly, and they say he was the penitent thief who was saved at the Crucifixion of our Lord. And after that they had journeyed, they fell in with a labourer who was sowing wheat. The Child Jesus put His hand into the sack, and threw a handful of seed on to the road, and immediately the wheat was as large and ripe as if it had

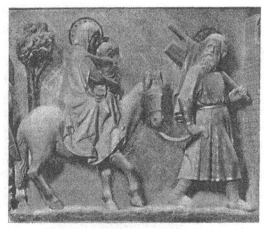

FIG. 109.—THE FLIGHT INTO EGYPT (choir enclosure, Notre Dame at Paris)

grown for a year. And when the soldiers of Herod who sought the Child for to kill Him, came to that labourer who was reaping his wheat, they asked him if he had seen a woman carrying a child. 'Yes,' said he, 'when I was sowing my corn.' Then the murderers thought that he knew not what he was saying for this corn had been growing for nigh on a year, and they turned back."[2]

These two incidents, the first taken from the apocryphal gospels[3] and the second from a source which we have not been able to discover, were not adopted by the encyclopædists of the thirteenth century, and are found neither in Vincent of Beauvais nor in Jacobus de Voragine. No doubt the legends were not unknown at that time, but they had not yet taken any real place in art or literature. I have never seen the episode of the

[1] See for example, Bibl. Nat., MS. Latin 1158, Horae of fourteenth century, and MS. Latin 921, Horae of fifteenth century.

[2] *De quelques miracles que l'Enfant Jésus fit en sa jeunesse* (29 leaves). Lyons, no date (Bibl. Nat.).

[3] *Evang. Infant*, XXIII. The penitent and impenitent thieves are called Titus and Dummachus.

cornfield in any of the thirteenth-century cathedrals. If I am not mistaken it is seen for the first time in the fourteenth-century sculpture which decorates the south doorway of the fine church of Notre Dame at Avioth, in the Meuse. The legend of the thief is not found in art between 1200 and 1350.[1]

IV

As we have seen, the apocryphal stories relating to the Childhood rarely appear in thirteenth-century art. Such stories appear even more rarely in scenes of Christ's public life. Who would dare to tamper with the most solemn passages in the sacred text or do violence to the majesty of the Gospel ? Here even the apocryphal writings are silent.

But the passion for the marvellous, the delight in devising romantic relations, was irresistible in the Middle Ages. Although one might not change a single word, a single gesture of the Son of God, at least one might make a thousand guesses as to the sick He cured, the disciples whom He had about Him, the unknown people with whom He talked, and in this way reverently supplement the silence of the Gospels.

The Middle Ages were reluctant to admit that those who had seen and heard the great Teacher remained obscure men, and did not later become illustrious Christians and great saints. French churches were especially rich in traditions of this kind, and almost all of them claimed to have been founded by one of those—however humble—who had walked in the shadow of the Master. From them the great metropolitan churches derived their patent of nobility. St. Martial, for example, who founded the see of Limoges, was the child of whom Christ had said, " Whosoever shall not receive the kingdom of God as a little child, he shall not enter therein.[2] Martial later served at table on the occasion of the Last Supper, and it was he who brought the water with which Christ washed the disciples' feet.[3] St. Sernin of Toulouse had held His garment while St. John was baptizing Him in Jordan, St. Restitutus, first bishop of Saint-Paul-Trois-Châteaux,

[1] The episode of the thief is perhaps seen in a window in the chevet of the cathedral of Laon (to the right). The Flight into Egypt there receives unique treatment. St. Joseph carries the Child, the Virgin rides on the ass, which is led by a man who carries a small barrel. This may well be the thief acting as guide to the Holy Family. A similar scene is shown on a Limoges enamel in the Cluny Museum (thirteenth century).

[2] Vincent of Beauvais, *Spec. hist.*, VII., cap. xxiv.
[3] See Ademarus, *Epistol. de Sancto Martiali, Patrol.*, cxli., col. 95 (eleventh century) ; Pseudo-Bonaventura, *Meditat.*, lx. ; Ludolph, *Passio Christi*, LIII. The tradition concerning St. Martial was received by the Church. I have found it in a MS. lectionary of the twelfth century ; Bibl. Sainte-Geneviève, No. 554, f. 69 v.

was the man born blind whom the Saviour cured, and Zacchæus, the publican who from the branches of the sycamore had seen Jesus pass by, went to Gaul in search of solitude, and spent long years on the wild mountain on which men later built Notre Dame of Rocamadour. And lastly, one knows that Provence gloried in having received the gospel from the mouth of Lazarus himself, when he came to that country with Martha and Mary Magdalen.

Some traces of these traditions are to be found in art. In the museum at Toulouse a Romanesque capital which represents the Last Supper, shows a serving-man with the nimbus, carrying a plate. He is evidently St. Martial. At Tours a window dedicated to St. Martial shows the young saint pouring water over the hands of Christ, and serving Him and the apostles at table,[1] and in a window at Laon St. Martial is again seen assisting at the Last Supper in the capacity of servant.[2]

The most curious of these legends relates to the husband and wife in the story of the marriage at Cana. A tradition, found as early as Bede, gives names to the betrothed pair of whom the Gospel says so little. It was believed that they were St. John and Mary Magdalen. The presence of Christ and His mother at the wedding was explained in the following ingenious way. The Virgin and her Son had been invited by Salome, sister of Mary and mother of St. John, and were there as relatives of the young husband. It was also said that St. John left his wife on the very day of his marriage, for after the repast the Master said to him, "Leave thy wife and follow me," and John choosing a celibate life followed Him.[3]

This strange story was not unknown to the artists. A proof of this is seen in the choir enclosure of Notre Dame at Paris where it is noticeable that one of the betrothed wears the nimbus, and as in mediæval iconography the nimbus is given to saints alone, the artist by this attribute evidently points to St. John.[4] Careful study of works of art of this date, and manuscripts in particular, would certainly result in the discovery of other examples.[5]

[1] Bourassé and Marchand, *Vitraux de Tours*, pl. IV.

[2] Florival and Midoux, *Vitraux de Laon*. The presence of thirteen apostles wearing halos surprises M. de Florival. The thirteenth is not an apostle, but St. Martial.

[3] Honorius of Autun, *Spec. Eccles.*, col. 834 ; Vincent of Beauvais, *Spec. hist.*, VII., cap. XI. ; Pseudo-Bona-ventura, *Meditat.*, XXI. On this legend see Molanus, *De historia sanctarum imaginum*, III., XX.

[4] The nimbus has been re-painted, but one can be sure that it was not invented by a modern restorer.

[5] I have noted one in a manuscript of the fourteenth century ; Bibl. Nat., MS. franç., 1765, f. 6. Only one of the betrothed couple wears a nimbus, as at Notre Dame.

RELIGIOUS ART IN FRANCE

V

Legend does not touch the other great Gospel scenes, for a certain reverence restrained the imagination. It is met with again, as one might well expect in these mystical centuries, when one reaches the story of the Passion, for the twelfth and thirteenth centuries dreamed ceaselessly of that marvellous drama. The death of a God, mystery of mysteries, is the very soul of mediæval art, and the Cross is seen everywhere, even in the symbolic plan of the cathedral. "Life," says one doctor, "is but the shadow thrown by the cross of Christ, outside that shadow is death."[1]

Consummate works of art like the *Stabat Mater*, the Meditations attributed to St. Bonaventura, the liturgy for Holy Week, the cycle of poems on the Holy Grail, and the great figure of Christ in the window at Poitiers, dying on a cross "red with royal purple,"[2] all these sprang from constant meditation on the mystery of the Passion.

The Passion was in fact the one subject of compelling interest to men of the Middle Ages. St. Francis of Assisi, the incarnation of his age, was filled with so intense a love that he actually realised the Passion in himself, no longer distinguishing himself from his Master but suffering with His wounds. "O Lord," cried St. Bernard, "who can console me who have seen Thee hanging on the cross!"[3]

Such ardent souls could not fail to dream over the sacred text, whose margin they illuminated with the flowers of legend. In the story of the Passion there are details, beautiful and no longer trivial, which come from one knows not where, but must surely have sprung from the hearts of the people. The Virgin tears the veil from her face to cover the nakedness of her Son on the Cross,[4] and the disciples receive His blood in the cup used at the Last Supper, the sacred cup of which poets later tell the marvellous story. The centurion Longinus recovers his sight through the falling of the drops of the sacred blood upon his eyes.[5] The devil, perched like some sinister bird on the arm of the Cross, awaits the passing of the Redeemer's soul to see if he can find some fault, and finding none flees confounded.[6]

[1] *De laudib. beatæ Mariæ Virg.*, lib. I., cap. VII.
[2] An expression of Fortunatus: "crux ornata regis purpura."
[3] *Lamentat. in passione Christi, Patrol.*, clxxxiv., col. 769.
[4] Pseudo-Bonaventura, *Meditat.*, LXV.; Ludolph, *Passio Christi*, LXIII.

[5] Vincent of Beauvais, *Spec. hist.*, VII., cap. XLVI.; Ludolph, *Passio*, XLVI. The centurion bears the name of Longinus in the "Gospel of Nicodemus," ch. X.
[6] Vincent of Beauvais, *Spec. hist.*, VII., cap. XLIII.; Ludolph, *Passio*, I.XIII.

OF THE THIRTEENTH CENTURY

The Cross itself aroused curiosity, and men desired to know its form and its dimensions. Tradition said that it was made of four kinds of wood—cedar, cypress, palm and olive—a marvellous secret known to the craft-guilds only, and passed on with mystic rites to new members.[1] It was also related that the eclipse of the sun which occurred at the time of the Crucifixion, was observed at Athens by Dionysius the Areopagite, and that moved by this inexplicable phenomenon he—though still a pagan—erected an altar " to the unknown God."[2]

Some of these legends which had saturated the popular consciousness, found expression in art. The Holy Grail—the cup used at the Last Supper—is sometimes represented at the foot of the Cross in twelfth-century art,[3] and a little later the sacred blood is received by the angels themselves. Sometimes again, as in a window at Angers, the Redeemer's blood falls in a stream upon the earth as if to water the world and, as Origen thought, to flow even to the stars. The two modes of representation are interesting. In the first the chalice which receives the Saviour's blood reminds men that the sacrifice is eternal, not limited in time for it is daily renewed ; in the second, the stream which flows from the Cross reminds men that the sacrifice is sufficient for the universe without limitations of space.[4]

The legend of the centurion Longinus, who was cured at the foot of the Cross, is sometimes portrayed. To help us to understand the miracle the artists had recourse to an expressive gesture—Longinus lifts his hand to his eyes like a man dazzled by the light.[5]

It was not easy to give concrete form to the legend of the four trees of which the Cross was fashioned. The glass-painters attempted it, however, and I seem to recognise it at Bourges in a window [6] devoted to the Passion, where the painter has given four different colours to the wood of which the Cross is composed.[7] This in all probability points to something more than coincidence.

[1] Vincent of Beauvais, *Spec. hist.*, VI., cap. XLII. ; Ludolph, *Passio*, LXIII. The following memoria technica line is found in mediæval writers : " Ligna crucis : palmes, cedrus, cupressus, oliva." Even in the present century the memory of these ancient legends survives in the charcoal-burner's guild (Simon, *Histoire des compagnonnages*). The tradition of the four woods of the Cross contradicts that of the tree of paradise, preserved in the Temple reservoir.

[2] Vincent of Beauvais, *Spec. hist.*, VII., XLIV.

[3] In a window at Reims, *Album* of Villard de Honnecourt (thirteenth century).

[4] Carlovingian ivories show the Earth and the Sea as present at the Crucifixion. A piece of thirteenth-century goldsmith's work, the foot of the cross at St. Omer, represents the four elements, to signify that they participated in the Redemption.

[5] Bibl. de l'Arsenal, MS. 570, f. 31 v. (thirteenth century), Heures de Metz ; and Bibl. Nat., MS. franç. 183, f. 9 v. (thirteenth century).

[6] *Vitraux de Bourges*, pl. V.

[7] One must, it is true, count the props which support the Cross.

RELIGIOUS ART IN FRANCE

The legend of Dionysius the Areopagite observing the eclipse was seldom represented before the fifteenth century.[1]

But of all the legends which gathered round the Passion of Christ that of the descent into Limbo was the most impressive, and was destined to take an unequalled place in the history of art. Its origin is well known. It is first found in fully developed form in the " Gospel of Nicodemus," which was transcribed by Vincent of Beauvais, Jacobus de Voragine and other thirteenth-century compilers.[2] This gospel, at least in its second part, has a certain grandeur which makes it one of the finest works in primitive Christian literature.[3]

The mysterious story is said to have been written by two men whose silent shades had risen from the dead when the graves opened on the day of the Crucifixion. Carinus and Leucius by name, they were sons of the ancient Simeon who had received the Child Jesus in his arms in the Temple. After their resurrection they lived in the town of Arithmathae, and prayed night and day. "Sometimes their cries were heard, but they spoke to no man, and remained silent as the dead." When the priests learned that they were risen from the dead, they caused them to come to the Temple and conjured them to reveal their mystery. Carinus and Leucius asked for parchment, and on it they wrote what they had seen in the other world.

Their story begins : " When we were with our fathers in the depths of the darkness of death, we were of a sudden enveloped in a golden light like that of the sun, and a regal glory illumined us. And immediately Adam, father of the human race, trembled with joy, and with him the patriarchs and prophets, and they said, 'This light is the author of eternal light, who promised to send us a light which should have no lessening and no end.' And all the righteous of the Old Law rejoiced while waiting for the accomplishment of the promise. But Hell was disquieted, and the prince of Tartarus feared the arrival of the One who in raising Lazarus had already defied his power. 'When I heard the power of his words,' said he, 'I trembled. This Lazarus we were not able to keep, for escaping with the swiftness of an eagle, he departed from among us.'

" As he spoke thus, a voice was heard like the voice of thunder, like the

[1] A window at Bourges (fifteenth century) shows Dionysius observing the eclipse, and in the next compartment the altar raised to the " unknown God."

[2] Vincent of Beauvais, *Spec. hist.*, VII., cap. LVI. ;

Legenda aurea, LIV. [*Golden Legend ; The Resurrection*, I., 98 *seq.*]

[3] According to Tischendorf the " Gospel of Nicodemus " may belong to the second century.

sound of the storm. 'Lift up your gates, O ye princes, and be ye lifted up, O eternal gates, and the King of Glory shall enter in. . . .' And the prince of hell said to his impious ministers, 'Shut the doors of brass and push to the bolts of iron, and resist valiantly.'"

"Again was heard the voice like that of thunder, saying 'Lift up your gates, O ye princes, and be ye lifted up, O eternal gates, and the King of Glory shall enter in.' And the Lord of Glory appeared in the form of a man, and he lighted the eternal gloom, and he broke the bonds, and his invincible virtue visited us who were sunk in the depths of the darkness of sin, and in the shadow of the death of sinners."

"The prince of Tartarus, Death and all the infernal legions seized with fear cried, 'Who art thou? Whence comest thou?' But he did not deign to answer them."

"Then the King of Glory, in his majesty treading Death under foot, and laying hold on Satan, deprived hell of its power, and led Adam to the light of the sun. And the Lord said, 'Come to me, all my saints, who have borne my image and likeness.'

"And all the saints, reunited in the hand of God, sang his praises. David, Habakkuk and all the prophets recited the ancient songs in which in mystic language they had announced that which had that day come to pass. And led by St. Michael the archangel they all entered paradise, where awaited them Enoch and Elijah, the two just men who did not taste death, and the penitent thief who bore on his shoulders the mark of the Cross."

Such was the story written on the parchment by Carinus and Leucius, who when their work was ended placed it in the hands of Nicodemus and Joseph. "And suddenly they were transfigured, and appeared as if clothed in a garment of a dazzling whiteness, and they were no more seen."[1]

This early Christian epic, worthy of Dante or Milton, reads as a magnificent paraphrase of the words :—"Oh, Death, where is thy victory? Oh Death, where is thy sting?"[2] Although known to be apocryphal, the work contained so much that was beautiful that both the Fathers and the mediæval doctors overlooked its lack of canonicity, and often found in it a source of fine inspiration.[3]

Art followed them, and the descent into Limbo as conceived by the

[1] Taken from Brunet's translation of the "Gospel of Nicodemus."

[2] It was also believed that St. Paul alluded to the descent into Hell in a passage in one of his epistles (Coloss. ii. 15). "Exspolians principatus et potestates (scilicet infernales)." See *Spec. hist.*, VII., xlix.

[3] The legend even enters into literature in the vulgar tongue. It is found in French manuscripts of the Passion (P. Meyer, *Romania*, 1877, p. 226), and was also the subject of poetry (P. Meyer, *Romania*, 1887, p. 51).

RELIGIOUS ART IN FRANCE

thirteenth century, is an almost literal translation of the "Gospel of Nicodemus." The Saviour comes as a conqueror carrying the cross of victory—to which the fourteenth century attached a white oriflamme like the pennon on a knight's lance—and He treads on the gates torn from their hinges, which falling had overwhelmed Death and Satan. Before Him hell opens in the form of the jaws of a monster, the gaping jaws of the biblical Leviathan

which seem ready to devour Him.[1] But in them He plants the foot of the cross, and holds out His hand to Adam.[2] The Italian trecentists sometimes depict the patriarchs and saints of the Old Covenant behind Adam,[3] but the French glass-painters, more concise, are content to show Adam and Eve alone. As if clothed in a new innocence both are nude.[4]

FIG. 110.—APPEARANCES OF CHRIST TO ST. PETER (choir enclosure, Notre Dame at Paris)

The artists' debt to the apocryphal writings does not end here, for they were acquainted with some of the legendary accounts of Christ's appearances after death. It is true that the famous appearance to His mother on Easter morning, so frequently portrayed in Renaissance glass and miniatures, is not met with in the thirteenth century. It may, however, have figured in that part of the choir enclosure of Notre Dame at Paris which has been destroyed, for it is evident that the artist had undertaken to represent all the appearances of Christ, authentic or legendary, step by step following the *Golden Legend* which includes His appearance to the

[1] The origin of the monster's jaws is explained later. See below, bk. IV., ch. vi., The Last Judgment.

[2] Examples are too numerous to be enumerated. We can only quote a window at Bourges (*Vitraux de Bourges*, pl. V.) and one at Tours (*Vitraux de Tours*, pl. VIII.).

[3] In the Spanish Chapel in Santa Maria Novella, for example.

[4] One or two figures without special attributes are sometimes seen by the side of Adam and Eve. Demons are generally present at Christ's victory. In the tympanum at St. Yved at Braisne (to-day in the Soissons Museum) a chain is fastened to the neck, feet and hands of the devil. Reproduced in Fleury, *Antiquités de l'Aisne*, iv. 23.

Virgin.[1] This same series of bas-reliefs, moreover, shows the apocryphal story of the appearance of Christ to St. Peter (Fig. 110). It was said that after the Crucifixion Peter took refuge in a mountain cave, and there wept over the Master's death and his own cowardice, and that the risen Lord showed Himself to him and consoled him. A rock in the form of a grotto from which St. Peter is seen emerging commemorates the legend at Notre Dame at Paris.[2]

These are, as near as may be, all the apocryphal incidents which art introduced into the story of the childhood, public life, Passion and Resurrection of Christ.

VI

We have up to now referred only to legends which for centuries were passed on from book to book, and were transmitted with equal fidelity in art. But when examining certain mediæval works of art one is tempted to think that there was an oral tradition as to the chief events in the life of Christ which left no trace in books. For example, the principal representations of the Last Supper left to us by the twelfth and thirteenth centuries show Christ and all the disciples almost invariably seated on one side of the table, while Judas is alone on the other. In front of the Master is a plate containing a fish.[3] The motif was so scrupulously respected by three or four generations of artists, and was reproduced with such fidelity in very diverse works of art, that one is led to infer the presence of some once popular but now forgotten legend. This same question constantly arises during careful study of mediæval art. Why for three centuries at least are the three Magi represented asleep in one bed, under one cover, when the angel comes to warn them not to return to Herod? This curious motif can be followed step by step from an ancient capital in the cloisters at St. Trophime at Arles,

[1] *Leg. aurea, De resurrectione*, LIV. (*Golden Legend, The Resurrection*, i. 93 *seq.*) Comparison of the order of the appearances after death in the *Golden Legend* and at Notre Dame at Paris shows that it is the same. We have already (bk. IV., ch. II.) observed that the bas-reliefs at Paris were in harmony with the liturgy of the week following Easter-day.

[2] *Legenda aurea, ibid.* At Notre Dame at Paris, by the side of the scene of the appearance of Christ to St. Peter in the cave, is another scene which seems curious (Fig. 110). John and Peter have reached the tomb, Peter enters first and sees Christ risen in the tomb. This can only be understood with the text of the *Golden Legend* in one's hand. Jacobus de Voragine says, " He appeared to St. Peter, but when or in what place it is not known, but if it were by ad-

venture when he returned from the monument with St. John . . . *or when he was alone in the monument* . . . or peradventure in a cave or fosse on the mountain which is called the mountain of the cock." It is evident that the artist, leaving aside the first hypothesis, has not been able to choose between the others.

[3] To give examples, the Last Supper is thus represented in windows devoted to the Passion at Bourges, Laon and Tours. The same formula is seen in manuscripts : Bibl. Nat., MS. Latin 1077 (thirteenth century), and Nouv. acq., Latin 1392 (fourteenth century), and again on a gilded and repoussé plaque from Limoges, to-day in the Cluny Museum (thirteenth century).

RELIGIOUS ART IN FRANCE

through windows at Lyons[1] and Le Mans,[2] to a tympanum in the north porch of the cathedral at Chartres (Fig. 111) and to the beautiful fragment of the old jubé, now in the crypt (Fig. 112). Why again is Jesus represented as fastened to the Cross by four nails until the end of the twelfth century, and from the thirteenth by three only? Books give no answer, and all traces of any oral tradition have disappeared. It is in fact no longer a question of popular legend, but merely of studio traditions.

A few of these motifs are of very early date, invented perhaps in primitive Christian days in some convent in Syria, Egypt or Constantinople.

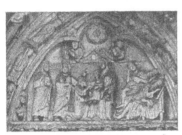

FIG. 111.—ADORATION OF THE MAGI. THE MAGI ASLEEP IN ONE BED (tympanum in the north porch at Chartres)

Others are much more recent, and when studying the art of the twelfth and thirteenth centuries some of them seem to grow beneath one's eyes.

For example, in 1200 there is still some uncertainty in the representation of the Adoration or the Magi, but a formula soon imposed itself on art. The first of the Magi, an old man, kneels (Fig. 113). He has just removed his crown, and is presenting his offering to the Child. The second, a man in middle life, stands by his side. He wears his crown and in one hand holds a vase, while instead of gazing at the Child he turns his head in the direction of the king who follows, and with his free hand shows him the star which stays its course over the stable. The third king, a young and beardless man, is also standing and crowned. In his right hand he holds his offering, and he seems to listen to the words of his companion. This picturesque formula is a happy one, for it gives movement and a certain dramatic quality to the conventional scene.[3]

This mode of representing the Adoration of the Magi devised a little before 1200 was henceforth inviolable.[4] Bas-reliefs, windows and miniatures

[1] *Vitraux de Bourges*, study VIII.

[2] Hucher, *Vitraux du Mans*, pl. VI.

[3] This formula, of which a forecast is seen on the façade of St. Trophime at Arles, appeared in the tympanum of St. Gilles at a date which cannot be much earlier than 1200. But the sculpture of the left porch of the façade at Laon (beginning of the thirteenth century) does not follow it in every respect, and it is not until we reach the north porch at Chartres (Fig. 111) that we find the formula really fixed.

[4] The artists who invented this new mode of re-presenting the Adoration of the Magi were inspired by the liturgy. The characteristic gesture of the king who points to the star comes from the liturgical drama of the twelfth century. In the drama of the Magi at Limoges the following scenic direction is given : " Unus eorum elevat manum ostendentem stellam," and at Besançon : " Rex ostendens stellam aliis." In the same way the attitude of the old man who kneels is found in the Laon direction : " Accedunt magi et genuflexo primus dicit. . . ." On this subject see Kehrer, *op. cit.*, I., p. 55 *seq.*

show it unchanged not only throughout the thirteenth century, but for the greater part of the fourteenth.[1] From France it spread almost throughout Europe, coinciding with the diffusion of French Gothic art.

Other innovations of the same kind are due to the thirteenth-century artists who, while retaining a profound respect for tradition, strove to introduce life into the still somewhat rigid art of the twelfth century. One happy movement satisfied them. For example, in the twelfth-century representations of the Flight into Egypt Joseph, leading the ass by the

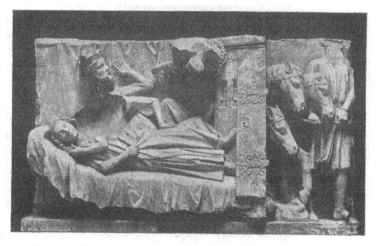

FIG. 112.—THE MAGI ASLEEP IN ONE BED (part of the jubé at Chartres)

bridle, walks straight before it carrying his goods on his shoulder at the end of a stick; in the thirteenth century nothing is changed except that Joseph turns his head, casting a look of solicitude on mother and child [2] (Fig. 109). Again, in the scene of the Visitation the Virgin and Elizabeth no longer

[1] The following are examples: Sculpture, choir enclosure at Notre Dame, Paris (Fig. 107). Glass, Sens, in the apse (*Vitraux de Bourges*, plans XV. and XVI.), Tours (Bourassé and Marchand, pl. VII.). Ivories, in the Louvre, A 34, A 35, A 40, 51, 54 (diptychs of the fourteenth and beginning of the fifteenth centuries); Cluny Museum, No. 1074 (fourteenth century), No. 322 (fourteenth century), No. 1077 (fourteenth century). Manuscripts, Bibl. Nat., MSS. Latins 10434 (thirteenth century), 1328 (thirteenth century), 1077 (thirteenth century), 1394 (fourteenth century); Sainte-Geneviève, No. 102, f. 129 v. (thirteenth century), No. 103, f. 18 v. (fourteenth century), No. 1130, f. 175 (fourteenth century);

Arsenal, No. 280 (thirteenth century), 279 (thirteenth century), 595 (fourteenth century), 572 (end of the the fourteenth or beginning of the fifteenth century). The type begins to lose its form in this last example— the youngest king points to the star.

[2] Choir enclosure, Notre Dame at Paris (early part of the fourteenth century). Glass at Lyons (*Vitraux de Bourges*, plan VIII.), Châlons-sur-Marne (*ibid.*, pl. XII.), Sens (*ibid.*, plans XV. and XVI.). Manuscripts: Bibl. Nat., MSS. Latins 1077 (thirteenth century), 1394 (fourteenth century), Franç. 1765 (fourteenth century); Arsenal, 288 (fourteenth century), 595 (fourteenth century).

stand motionless face to face, but in thirteenth-century representations Elizabeth gently places her hand on Mary's bosom, marvelling to feel her swelling breasts [1] (Fig. 114).

Such innovations were both touching and judicious. They were favourably received and gave a new character to thirteenth-century art.

The new features which then appeared in art derived as we see neither from written legend nor from oral tradition ; conceived by unknown artists they were handed on from studio to studio for more than a century.

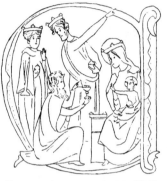

FIG. 113.—ADORATION OF THE MAGI (B. N., MS. Lat. 17326, second half of the thirteenth century)

One may well ask whether these conventions were not put into writing, and whether they did not form a sort of " Summa " which it behoved every artist to know. The extraordinary likeness between works of art executed for cathedrals often far distant from one another, leads one to suppose that to be the case. There can be no doubt that a manual of iconography, a guide for painters and sculptors, was passed on from generation to generation in the cathedral workshops, those permanent studios which the Italians call " opera del duomo."

A treatise of the kind must have resembled the book of the monk Denys which Didron discovered on Mt. Athos. This famous " Guide to Painting " written by a Greek monk dates, it is true, only from the eighteenth century, but in it the most ancient traditions are perpetuated. Nothing changes in the unmoving east. Even to-day the painters of Mt. Athos when decorating their chapels observe the rules transmitted to them by the monk Denys, and paint exactly as did their predecessors in the Middle Ages. It must have been through some such book that the rules of iconography and the unity of religious art were maintained over the long period which is the subject of our study.

We do not possess that book, but through close study of the art of the thirteenth century one could almost rewrite it. It would not be difficult to reconstruct the principal chapters after having compared a number of bas-reliefs, windows and miniatures. One may well imagine, for example, that the " Guide " described the scene of the Resurrection something after this

[1] Tours, glass (*Vitraux de Tours*, pl. VII.). Manuscripts, Bibl. Nat., MSS. Latins 1328 (thirteenth century), 1394 (fourteenth century). Choir enclosure at Notre Dame at Paris (fourteenth century).

fashion :—" The tomb is open. Christ, standing, places His right foot [1]
outside the tomb. He blesses with the right . hand, and in the left
holds the triumphal cross with the long staff. Two angels stand
to right and left, one carrying a torch, the other a censer.[2] Below the
tomb in a trefoiled arcading small figures of
three sleeping soldiers are shown." [3] That is
in fact the way in which the Resurrection scene
was represented in art for close on a hundred
and fifty years.

Had we a *corpus* of thirteenth-century
glass and miniatures we should then be in a
position to reconstruct the canons of mediæval
art and to rewrite the " Guide to Painting."

The apocryphal writings, as we see, do not ex-
plain the whole of mediæval art. It is necessary
to take into consideration what might be called
artistic tradition, and to guard against the temp-
tation to find accepted legends in simple
studio formulæ. Yet some slight change of
gesture, attitude or look was all that was due
to artistic invention, for in a reverent century
like the thirteenth there could be little devia-
tion from the text of the Bible or from the legends
tolerated by the Church. While faithful to
rule and to established tradition the artist gave

FIG. 114.—THE VISITATION (choir
enclosure, Notre Dame at Paris)

restrained expression to the emotion he felt on hearing the Gospel story.

VII

No figure in the New Testament owes more to legend than that of the
Virgin. The Gospel account in which she rarely appears, and still more
rarely speaks, soon seemed inadequate to men who would know of her
family, her childhood, the circumstances of her marriage, her latter years
and her death. And so there arose in primitive times the apocryphal stories
which charmed the Middle Ages. The figure of the Virgin is seen against

[1] Seldom the left leg.
[2] Sometimes they each have a torch.
[3] For example; windows at Bourges (Cahier, pl. I.),
Le Mans (Hucher), St. Géréon at Cologne (Cahier,

Vitraux de Bourges, study XII.) ; manuscripts in the
Bibl. Nat., Nouv. acq., Latin 1392 (thirteenth century);
Bibl. Sainte-Geneviève, 102 (thirteenth century) fo.
255 ; Arsenal, 570 (thirteenth century), f. 41 v.

RELIGIOUS ART IN FRANCE

a background of legend, as in the pictures of the old German masters she is seen against a hedge of roses.

These traditional stories of the life and death of Our Lady are found everywhere in the churches. It is a curious fact that in the thirteenth century either her legendary or Gospel story was sculptured in the porches of all the cathedrals. There is nothing surprising in finding her in the

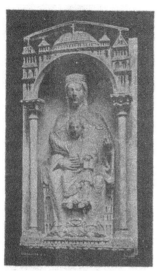

FIG. 115.—THE VIRGIN OF THE PORTAIL SAINTE-ANNE (Notre Dame at Paris)

place of honour in those which are dedicated to her, in Notre Dame at Paris, Reims, Amiens, Chartres, Laon and Senlis, but it is surprising to find that she also has her porch at St. Étienne at Bourges, at St. Étienne at Sens and Meaux, and at St. Jean at Lyons.[1] In striking contrast to the Romanesque period, when as at Arles, Moissac, Vézelay and Autun the porches were devoted to representations of Christ and the apostles, the Virgin is then seen everywhere. From the thirteenth century a large and noble chapel was dedicated to her in the axis of the cathedral, not far from the altar. One may infer that she also had a place of honour in men's hearts.

The cult of the Virgin which grew up in the twelfth century developed in the thirteenth. The bells of Christendom began to ring the angelus,[2] the Office of the Virgin was recited daily,[3] and the finest cathedrals arose under her patronage. Christian thought, meditating through the centuries on the mystery of a virgin chosen of God, anticipated the dogma of the Immaculate Conception, and as early as the twelfth century the mystical church of Lyons celebrated that festival. The monks ever thinking of the Virgin in their solitude extolled her perfections, and more than one of them deserved the title of Doctor Marianus, which was given to Duns Scotus. The new orders, Franciscans and Dominicans, true knights of the Virgin, spread her cult among the people.

[1] MM. Guigue and Bégule (*Cathédrale de Lyon*, 72) are right in their conjecture—based on remaining fragments—that one of the mutilated porches of Lyons cathedral was dedicated to the Virgin.

[2] Only the morning angelus, and at the end of the thirteenth century. See Vacant and Manjenot, *Diction. de théologie catholique*, under "Angélus."

[3] On the daily use of the Office of the Virgin, which is of monastic origin, see Battifol, *Hist. du bréviaire romain*, Paris, 1894, 12°, p. 162.

In order to gain an adequate notion of the sentiments which the twelfth and thirteenth centuries professed for the Virgin one should read the *Sermones* of St. Bernard, the *De Laudibus beatæ Mariæ*[1] and the *Speculum beatæ Mariæ*.[2] Bernard who wrote at length on the *Song of Songs* applied all its metaphors to Mary.[3] He endowed her with all the gracious or mysterious names which he found in the Bible. She is the Burning Bush, the Ark of the Covenant, the Star, the Rod which budded, the Fleece, the Bridechamber, the Door, the Garden, the Dawn, the Ladder of Jacob.[4] He shows her as heralded in every page of the Old Testament.[5]

The author of the *Speculum beatæ Mariæ* wrote a whole volume on the two words " Ave Maria," in which he unveils the profound mystery contained in each of them. In this curious book scholasticism and bad etymology[6] do not manage to stifle the poetry, for the theologian often becomes a lyric poet with a wealth of beautiful metaphors. Mary, he says, is the dawn which heralded the sun of righteousness. She appeared at the end of the long night of ancient days, and as at dawn we pass from darkest night to the full light of day so with Mary we pass from sin to grace. She is the intermediary between God and man. " Mary," he cries, " is our dawn. Let us follow the example of the workman who starts at sunrise, let us work when our dawn appears."[7]

The *De laudibus beatæ Mariæ* shows more of the influence of the schoolmen.[8] The author of this long " Summary" in twelve books in

[1] Wrongly attributed to Albertus Magnus.

[2] Attributed, also without proof, to Bonaventura.

[3] The whole of the Middle Ages saw in the Virgin the bride of the *Song of Songs*. See Honorius of Autun, *Sigillum beatæ Mariæ*, *Patrol.*, clxxii.; Guibert de Nogent, *Liber de Laudibus beatæ Mariæ*, *Patrol.*, clvi.; P. Comestor, Sermon on the Assumption, *Patrol.*, cxcviii.; Alanus de Insulis, *Elucidat. in Cantic. Cantic.*, *Patrol.*, ccx. On the day of her birth (sometimes on the feast of the Assumption) the *Song of Songs* was read. *E.g.* Bibl. Ste.-Geneviève, MS. 138, f. 223 (a lectionary of the thirteenth century); No. 131, f. 186 (lectionary of the thirteenth century); No. 124, f. 123 v. (lectionary of the twelfth to thirteenth century); No. 125, f. 148 (lectionary of the thirteenth century).

[4] St. Bernard, *Patrol.*, clxxxiv., col. 1017. The following lines in the prologue to Gautier de Coinci's *Miracles de Notre-Dame* seem to be reminiscent of St. Bernard. (Ed. Poquet, Paris, 1857).

" Elle est la fleur, elle est la rose
En cui habite, en cui repose
Et jour et nuit Sainz Esperiz.
.

C'est la douceur, c'est la rousée
Dont toute riens est arousée ;
C'est la dame, c'est la pucèle.
.
C'est la fontaine, c'est le doiz
Dont sourt et viens miséricorde,
C'est le tuyau, c'est le conduiz,
Par où tout bien est aconduiz ;
C'est la royne des archanges,
C'est la pucèle à cui li anges
La haut salu dist et porta."

[5] The *Biblia Mariana*, attributed to Albertus Magnus, also traces Mary through the Old Testament.

[6] " Ave " for him came from " a " privative and " vae," which signifies unhappiness. Mary heard the word " ave " three times that the three woes (vae ! vae ! vae !) spoken by the angel of the Apocalypse might be effaced (*Spec. beatæ Mariæ*, lect. II., of St. Bonaventura, Mayence ed., works 1609, vol. vi.). The same doctrine is found in the *De laudib. beat. Mariæ*, attributed to Albertus Magnus.

[7] *Spec. beatæ Mariæ*, lect. XI.

[8] *De laudib. beatæ Mariæ*. In the works of Albertus Magnus, Lyons, 1651, vol. xx.

which tripartite and quadripartite divisions are numerous, passes in review

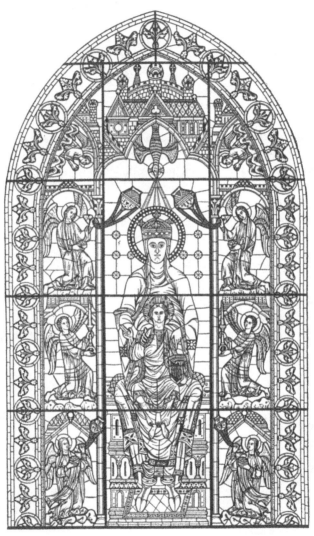

FIG. 116.—WINDOW AT CHARTRES ("Notre-Dame de la belle verrière")
(*Beginning of the thirteenth century*)

all the virtues of Our Lady, and all her symbolic names. But touched
by her humility the grave doctor is often roused from his absorption in

technicalities. It is this humility, he says, which did violence to God and drew the Lord of heaven to earth.[1]

The Virgin as *queen* is the idea which perhaps most frequently recurs in these books composed in her honour. Mary, says the *Speculum beatæ Mariæ*, is at once queen of heaven where she is enthroned in the midst of the angels, queen of earth where she constantly manifests her power,

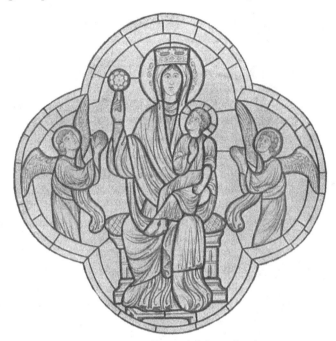

FIG. 117.—THE VIRGIN (window at Laon)
(*From MM. de Florival and Midoux*)

and queen of hell where she has all authority over the demons.[2] And elsewhere it compares her to a queen entering her palace with a king.[3]

Amid the host of ideas and sentiments which then gathered round the figure of the Virgin, the idea of majesty was that which art best comprehended and expressed with the greatest force and beauty. The Virgin of the twelfth and early thirteenth centuries is a queen. She appears in the west porch at Chartres and in the Porte Sainte-Anne at Notre Dame at

[1] *De laudib. beatæ Mariæ*, I., cap. V.
[2] *Spec. beatæ Mariæ*, lect. III.
[3] *Ibid.*, lect. XIII. See also *De laudib. beatæ Mariæ*, V., cap. XIII. The famous hymn, "Salve Regina," which perhaps dates from the end of the eleventh century, should not be forgotten in this connection.

RELIGIOUS ART IN FRANCE

Paris seated on her throne in regal state[1] (Fig. 15). She has a crown on

her forehead, a flowering sceptre in her hand, and holds the Child on her lap. She is seen again under this aspect in the window at Chartres known as *la belle verrière* (Fig. 116), and in a fine window at Laon[2] (Fig. 117). Art seems to be trying to realise the saying of the doctors : "Mary is the throne of Solomon,"[3] for the Child rests on her as on a throne,[4] and she is thus the queen who carries the king of the world. At no other period did it impart so much dignity to the image of the mother of God.

On the threshold of the fourteenth century men felt that this Virgin, conceived by the theologians with the majesty of an impersonal idea, had become too remote from humanity. All the miracles which the thirteenth century had attributed to her, the many occasions on which she had shown herself to the sinner, smiling and compassionate, ended in drawing her nearer to men. It was then that art, faithfully interpreting popular sentiment, conceived the figure of the Virgin radiant with maternal pride seen in the north porch at Notre Dame at Paris (Fig. 118) and the "Vierge dorée" of Amiens. The Virgin at Amiens is a lithe young girl who carries the Child with ease, and gazes at Him with a gracious smile (Fig. 119). Angels hold her nimbus, and the high crown seems too heavy for the youthful head. She has become a woman and a mother.

By the middle of the fourteenth century the group of the mother and child had lost the solemnity of earlier art, and had become merely human and intimate. The theological ideas for which the Virgin stood had become more and more inaccessible to the artists. It was to no purpose that

FIG. 118.—THE VIRGIN (Notre Dame at Paris)

[1] These two tympanums are of the same school.
[2] Florival and Midoux, *Vitraux de Laon*, pl. I.
[3] *De laudib. beatæ Mariæ*, X., cap. II.
[4] This is clearly seen in the Portail Sainte-Anne, and in the window at Chartres. In the window at Laon, which is of rather later date, her attitude is already less dignified.

they still heard it recited in the Office of the Virgin that "the infinite God willed to unite Himself to a virgin, who bore in her womb Him whom the whole world could not contain," for they no longer knew how to create the superhuman figure of the past, and were satisfied with representing a mother who smiles at her child.[1]

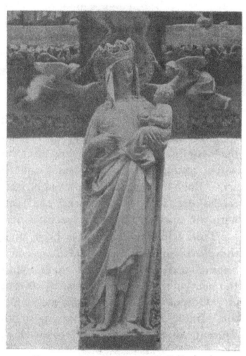

Before long their presentation of the Virgin, a woman old before her time, who weeps over the bleeding face of her Son, became even more purely human, but the figure of the "Mater dolorosa" which inspired so many masterpieces in the fifteenth century does not belong to the period of our study. On this point art is a little behind literature, for the faithful had long sung the *Stabat Mater*, had commemorated the seven sorrows of Our Lady, and had repeated with the doctors that she was "martyr of martyrs."[2] Art had not yet dared to express this poignant grief, though here and there some isolated window shows the symbolic sword piercing her heart as she stands at the foot of

FIG. 119.—"LA VIERGE DORÉE" (Amiens)

the Cross,[3] or some carved ivory shows the lance reaching from the side of Christ to the heart of His mother.[4]

Although art early freed itself from theological conceptions it remained faithful to legend, and it was from apocryphal writings that almost all the episodes in the Virgin's life were taken. For this reason it is interesting to show which books and which traditions served to inspire it.

It did not occur to the artists of the thirteenth century, as it did subsequently to those of the Renaissance, to represent the Virgin as an abstract

[1] On this subject see *L'Art religieux de la fin du moyen âge*, p. 145 *seq.*
[2] *De laudib. beatæ Mariæ*, III., xii.

[3] Window at Friburg im Breisgau (*Vitraux de Bourges*, plan XII.).
[4] On representations of the Mater dolorosa, see *L'Art religieux de la fin du moyen âge*, p. 118 *seq.*

idea. In this alone they were less mystical than their successors. It is not until the end of the Middle Ages that one finds in windows, tapestries and books of Hours the figure of the young girl with flowing hair surrounded by the rose, the star, the mirror, the fountain, or the enclosed garden. Here the Virgin is not a historical fact, but a spiritual conception existing outside of time. She is the eternal thought of God. This lofty conception so well fitted to inspire contemporaries of Bonaventura and of Dante was, however, unknown to the artists, although already in the Office of the Virgin the words were daily read : " I was created from the beginning and before the centuries." [1]

Neither did the thirteenth-century artist go back to the parents of St. Anna in the genealogy of the Virgin. He did not relate the strange story of St. Fanuel nor that of the mother of St. Anna who conceived her daughter in smelling a rose,[2] but he went back no further than Anna whose traditional three husbands and three daughters at times appear in art.[3] Such representations, though frequent in the fifteenth century, are rarely seen in the thirteenth,[4] the Gothic artist concerning himself only with the story of Anna and Joachim, her first husband.

This celebrated story has been preserved in three apocryphal gospels, the *Protevangelium Jacobi*, the *Evangelium de Nativitate Mariæ* of which the original text was attributed to St. Matthew and the Latin translation to Jerome, and the *Evangelium de Nativitate Mariæ et Infantia Salvatoris* or " Gospel of Pseudo-Matthew." Of these three books, all known to the Middle Ages,[5] the last was most often cited,[6] and it was from it that Vincent of Beauvais [7] and Jacobus de Voragine took the greater number

[1] " Ab initio et ante sæcula creata sum." Bibl. de l'Arsenal, MSS. 106 and 107 (fourteenth century).

[2] In his poem on the feast of the Conception Wace tells the curious story of Fanuel. On this subject see Meyer, *Romania*, 1877, p. 235. See also Douhaire, *Cours sur les Apocryphes*, in the *Université catholique*, IV. and V.

[3] We give below one of Vincent of Beauvais's memoria technica verses. It tells of the three husbands, Joachim, Cleophas and Salome, whom Anna successively married by command of an angel and by whom she had three daughters, the three Marys, and of their children. The Marys were respectively the mother of Jesus, of James (the Greater) and John the Evangelist, and of James the Less, Simon, Jude and Joseph the Just.
" Anna viros habuit Joachim, Cleophæ, Salomeque ;
Tres parit : has ducunt Joseph, Alphæus, Zebedæus ;

Christum prima ; Joseph, Jacobum cum Simone, Judam
Altera ; quæ restat Jacobum parit atque Joannem." (*Spec. hist.*, VI., vii.)

[4] See a window at Bourges (the rest are dedicated to St. John the Evangelist).

[5] The Abbess Hrotswitha put the two first into Latin verse, *Patrol.*, cxxxvii.

[6] Quoted by J. de Voragine, *Legend. aur.*, De annonciat. [*Golden Legend*, V., 99], and in the *De laudib. beatæ Mariæ*, V., ii.

[7] The *Evangelium de Nativitate Mariæ* is, however, quoted twice by Vincent of Beauvais (*Spec. hist.*, VI., lxiv. and lxxii.). He gives the name of " Gospel of James " to the " Gospel of the Birth of Mary and the Infancy of the Saviour," because it begins with the words—" I, James, son of Joseph, filled with the fear of God, have written." This should not be confused with the *Protevangelium Jacobi*.

of apocryphal events which they blended with the life of the Virgin. It was from it above all that art sought inspiration,[1] hence it is from it that we shall borrow the story of the immaculate conception of the Virgin.

"There was in Israel a man of the tribe of Judah, named Joachim, and he kept his sheep, fearing God in simplicity and uprightness of heart." The story begins in this biblical tone. Joachim had been married to Anna for twenty years, and they had no child. And one day when he had gone up to the Temple to make his offerings to the Lord, he was repulsed by a scribe who said, "It is not fitting that thou shouldst have a part in the sacrifices offered to God, for He has not blessed thee, since He has given thee no offspring in Israel." Joachim withdrew weeping ; and not daring to return home he went into the mountains and lived in the midst of his flocks among the shepherds. For five months Anna waited for him lamenting, not knowing whether he were alive or dead. And one day as she was praying, she saw a sparrow's nest on a bay-tree. She groaned aloud and said, "Lord, God Almighty, Thou who hast given posterity to all creatures, to beast and serpent, fish and bird, and makest them to rejoice over their little ones, I thank Thee that Thou hast willed that I alone should be excluded from the favours of Thy goodness. For Thou knowest, Lord, the secret of my heart, that from the first day of my marriage I vowed that if Thou gavest me son or daughter I would dedicate him to Thee in thy holy Temple." And when she had spoken thus, suddenly the angel of the Lord appeared before her and said, "Fear not, Anna, for thy offspring is in the counsel of God, and that which shall be born of thee shall be held in wonder to the end of time. And when he had spoken he vanished from before her eyes."[2] . . . This same angel appeared to Joachim in the midst of his flocks, and commanded him to return to Jerusalem. "'Know,' said he, 'that thy wife shall conceive a daughter who shall be in the Temple of God, and the Holy Spirit shall rest upon her.' And he commanded him to offer sacrifices to God, and it was so that when Joachim offered the sacrifice the angel of the Lord returned to heaven with the odour and the smoke of it. Then Joachim threw himself on his face on the ground and stayed there from the sixth hour until the evening."[3]

[1] The "Protevangelium of James" must be set aside, for there is in it no reference to the meeting at the Golden Gate which is always represented in art, also the "Gospel of the Nativity of Mary," for in its description of the meeting Anna is not accompanied by her servant nor Joachim by one of his shepherds— figures which the Gothic artists and still more the Italian trecentisti loved to represent.
[2] *Evangelium de Nativitate Mariæ et Infantia Salvatoris*, II.
[3] *Ibid.*, III.

RELIGIOUS ART IN FRANCE

"Thereupon he started with the shepherds on his homeward journey, and walked for thirty days. As he approached Jerusalem the angel again appeared to Anna and said, "Go to the gate which is called the Golden Gate and there await thy husband, for he will return to thee to-day." And she immediately arose and started with her servants, and remained near to the gate weeping, and after that she had waited a long time and was nigh to swooning for very weariness, she saw Joachim coming with his flocks, and Anna ran and threw herself on his neck, thanking God."[1]

Then Anna conceived, and after that nine months were accomplished she brought forth a daughter to whom she gave the name of Mary.

This story, apocryphal as it is, was not rejected by the mediæval Church, and it was customary to read it to the faithful on the feast of the Nativity of the Virgin. From time to time some bishop showed scruples. "I would read this book to you to-day," said Fulbert of Chartres, "were it not condemned by the Fathers."[2] This however did not prevent him from relating the whole of the story of Joachim and Anna in another sermon for the same occasion.[3] Some churches treated the legend so leniently that they introduced it into their lectionaries. It was read on the feast of the Nativity especially in the churches of Normandy, as witness a lectionary of Coutances and a breviary of Caen.[4]

It is then not surprising to meet with the story of Joachim and Anna in the churches. Fulbert's successors at Chartres did not share his scruples, for they allowed it to be carved in full on the capitals of the west porch.[5] Later it appeared in the north porch, but treated with more reserve— Joachim is seen in the midst of his flocks beneath the large statue of Anna.[6] One finds the same legend in Notre Dame at Paris on the lower lintel of the Portail Sainte-Anne and continued round the arches to the right, showing Joachim among the shepherds and the meeting at the Golden Gate. Part of the story is represented in a window in the chapel of the Virgin at Le Mans[7] (Fig. 120).

The meeting at the Golden Gate is the subject which is most frequently

[1] *Evangelium de Nativitate Mariæ et Infantia Salvatoris*, III.

[2] Fulbert of Chartres, *Sermo* IV., *Patrol.*, cxli.

[3] *Ibid, Sermo* V. It is also used in a sermon of Honorius of Autun's (*Spec. Eccles., Patrol.*, clxxii., col. 1001.

[4] Bibl. Sainte-Geneviève, MS. 131 (Coutances or St. Lô (?), thirteenth century); Arsenal, MS. 279, f. 465 v. (breviary from Caen, thirteenth century).

[5] For a description see Bulteau, II., p. 36 *seq.*

[6] It is mutilated.

[7] The window at Le Mans—which we reproduce—represents at the bottom Joachim driven from the Temple and the presentation of the Virgin, then the Virgin mounting the Temple stair, the meeting at the Golden Gate, an angel conversing with the Virgin in the Temple, and the Virgin in Glory.

found.[1] At the end of the Middle
Ages art showed a marked pre-
dilection for this scene, which in
fact was the customary way of
representing the Immaculate Con-
ception.[2] It was generally held,
although the error had been con-
demned by the doctors,[3] that Mary
was conceived at the moment
when Anna kissed Joachim. This
is why an exquisite Italian fresco
of the fourteenth century shows
an angel drawing together the
heads of husband and wife for
this holy kiss.[4]

In works of art the story of
the Virgin's early years and mar-
riage almost invariably accom-
panies the story of her birth. At
Chartres, as at Paris and Le Mans,
the journey to Jerusalem and the
presentation of Mary in the
Temple follow the legend of
Joachim and Anna. Except at
Le Mans, where a window shows
the converse of the Virgin and an
angel (Fig. 120), I have found no
attempt to portray her life in the
Temple, so graciously told in the
"Gospel of the Nativity of
Mary."[5] The pages of the anony-
mous author have the delicate

FIG. 120.—WINDOW OF ST. ANNE AND ST. JOACHIM
(Le Mans)
(*From Hucher*)

[1] The meeting at the Golden Gate is found
in windows dedicated to the childhood of Christ
(Le Mans, Beauvais).
[2] See Hucher, *Bullet. monum.*, 1885, and
Rohault de Fleury, *La sainte Vierge*, I. The
confraternity of the Immaculate Conception, in-
stituted at St. Séverin, seems from the thirteenth
century to have adopted the Golden Gate as
badge.
[3] St. Bernard, *Epist.* 174 *ad canon. Lugdun.*
[4] Small cloisters at Santa Maria Novella, Florence.
[5] Cap. vi.

RELIGIOUS ART IN FRANCE

charm of some of Fra Angelico's pictures; the radiant beauty of Mary's face can hardly be endured, she is so serious that her young companions dare not laugh or speak loudly in her presence, she is so pure that the angels descend from heaven to hold converse with her and to bring her food.

The episodes in the story of the marriage of the Virgin are easily recognised at Paris and at Chartres, and in a window in the chapel of the Virgin at Le Mans.[1] The legend is a familiar one. When she was fourteen years old the high-priest wished that she should marry, but she refused to do so. He then resolved to confide her to the care of a man of the tribe of Judah, and made known to all those of the tribe who were unmarried that on the following day they should come to the Temple with a rod in their hands. These rods would be placed in the Holy of Holies, and then returned to each one of them. He who had been chosen by God would see a dove come forth from his rod. The rods were brought to the Temple, but the dove did not appear. Then the angel came to warn the high-priest that he had forgotten to place Joseph's rod in the sanctuary, and as soon as he had placed it there a white dove flew out into the Temple.[2]

There is no mention of the anger of the suitors, and it does not appear in art until later.[3]

At this point Mary emerges from the twilight of legend and enters the light of the Gospel. The Annunciation, the Visitation—all the scenes in which she appears—are too sharply outlined in the New Testament for it to occur to the artist to seek models elsewhere, and in thirteenth-century work we see no sign of daring to depart from the sacred text. Yet in certain districts in which old traditions was strong a few legendary features slipped into even the most solemn scenes. In the cathedral of Lyons where the windows, although of the thirteenth century, are curiously reminiscent of much earlier art, a distaff is seen in the Virgin's hands in the scene of the Annunciation.[4] This is an echo of the apocryphal gospels. According to

[1] Window of the money-changers. This window is almost entirely devoted to the apocryphal history of the Virgin. Several scenes are obscure (the three young girls before a king; a young girl imprisoned, to whom a man speaks from the other side of a wall).
[2] "Gospel of Pseudo-Matthew." The "Gospel of the Nativity of Mary" relates that the rod flowered and a dove settled on it.
[3] The earliest example is met with in fourteenth-century Italian work—Orcagna's Tabernacle at Or San Michele. See Surigny, *Ann. arch.*, t. xxvi. p. 79. A curious difference between the French and the Italian for-

mulæ is noticeable in scenes of the marriage of the Virgin. In France the betrothed simply hold each other's hands, in Italy Joseph places a ring on the Virgin's finger. This is because from the tenth century Italy boasted of possessing the Virgin's ring, long preserved at Chiusi. It was stolen in 1473, and brought to Pérouse where it remained.
[4] Guigue and Bégule, *La Cathédrale de Lyon*, 116. See also Cahier, *Vitraux de Bourges*, plan VIII. The Virgin of the Nativity lying on a mattress as in Byzantine miniatures, and the holy women going towards a round tomb very like those on Carlovingian ivories, are features which it is surprising to find in this thirteenth-century glass at Lyons.

the " Gospel of the Nativity of Mary ", she continued to spin for the Temple after she had been affianced to Joseph, and the high-priest gave her companions to work with her, although she alone was chosen for the honour of weaving the purple veil for the Holy of Holies. She was working when the angel appeared to her for the second time.[1] " The third day as she wove the purple with her fingers there appeared before her a young man

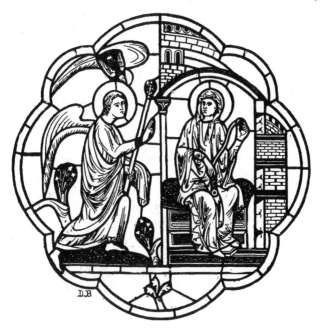

FIG. 121.—THE ANNUNCIATION (window at Lyons)
(*From L. Bégule*)

of indescribable beauty. On seeing him Mary was affrighted, and began to tremble ; and he said, " Fear not, Mary, thou hast found favour with God. Behold thou shalt conceive, and thou shalt bear a king whose empire shall extend over the whole earth." [2] It is in this thirteenth-century work at Lyons that the legend is found for the last time (Fig. 121), but it is frequently found in earlier art. M. Rohault de Fleury has shown conclusively that the basket full of wool, or simply the distaff alone, almost invariably figured in the scene of the Annunciation before the thirteenth century.[3] We have

[1] The angel first appeared to her at the well (*Hist. Nativ. Mariæ*, IX.). Early ivories represent the scene.

[2] *Hist. Nativ. Mar.*, IX.

[3] Rohault de Fleury, *La sainte Vierge*, vol. i., pl. VII., IX., X., XI.

RELIGIOUS ART IN FRANCE

here an example of the influence of the apocryphal gospels in early days. And the people have never entirely forgotten the old tradition, for even to-day the gossamer threads which in autumn float in the meadows are called the Virgin's threads.

A twelfth-century window in the cathedral at Angers has borrowed another feature from legend, and contrary to all probability shows a young girl by Mary's side at the time of the Annunciation. The presence of this figure can only be explained by the stories in the apocryphal gospels. " The Gospel of the Nativity of Mary "[1] relates that the high-priest gave Mary five young girls—Rebecca, Sephora, Suzanna, Abigail and Zahel as companions in Joseph's house. The artist at Angers has supposed that one of them was present at the Annunciation.

Thirteenth-century art returned to the dignified simplicity of the Gospel account. The Virgin and the angel stand face to face and are alone. She betrays her emotion only by a slight movement of her hand. It is a scene as solemn as the mystery it presents, and one in which all elaboration would be out of place. In the thirteenth century we find neither the delicate loggia in which the Italian Virgin prays, nor the pure little room, the cell of a beguine, in which the Flemish Virgin meditates. There is nothing to distract the attention from the two actors.

In the course of the century, however, there appeared a symbolic detail whose meaning, to my mind, has been misunderstood. A flower with a long stalk is placed in a vase between the Virgin and the angel. This flower is not as yet a lily, and it does not symbolise purity as might easily be supposed, but it commemorates another mystery. Led by St. Bernard, the mediæval doctors taught that the Annunciation took place in the spring-time, "at the time of flowers," and they thought to find support for this in the name Nazareth, which signifies a "flower." So that St. Bernard could say : "The flower willed to be born of a flower, in a flower, at the time of flowers."[2] This flower appears in many thirteenth-century windows, but it will serve our purpose to mention examples at Laon (Fig. 122), Sens and Bourges.[3] It is also almost always found in miniatures of the same period. When absent it is due to a slip of the artist's, for the arrangement of the scene was rigidly fixed, and for more than a century nothing in it was changed. The angel stands with folded wings and raises his right hand,

[1] *Hist. Nativ. Mariæ*, cap. VIII.
[2] " Nazareth interpretatur flos, unde dicit Bernardus, quod flos nasci voluit de flore, in flore, et floris tempore." *Legenda aurea*, li., *De Annonciat.* [Not found in Caxton's version.—Trans.]
[3] *Vitraux de Bourges*, plan XV. and XVI., pl. XXVII.

244

his left holds a scroll on which is written "Ave Maria." The Virgin also stands, holding a book in her left hand, and making a gesture of astonishment with the right. Between them is the vase and the flower.[1] We have here the origin of the marvellous flowers which in early Italian

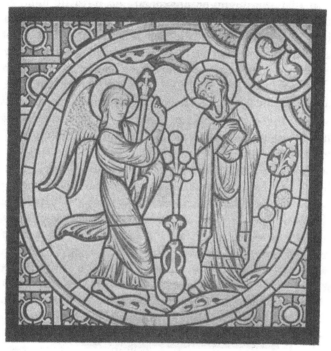

FIG. 122.—THE ANNUNCIATION (window at Laon)
(*From MM. de Florival and Midoux*)

paintings stand out on a background of gold between the Virgin and the angel of the Annunciation.

Thirteenth-century art wisely omitted from the life of the Virgin some of the apocryphal circumstances dear to the east. It did not, for instance, make the mistake of representing the ordeal of the bitter water, as was done in the twelfth century at St. Mark's at Venice under Byzantine influence. There is some impropriety in supposing that to prove her virginity Mary had to submit to the test of drinking the water, and after

[1] For example: Bibl. Sainte-Geneviève, MS. 102, f. 291 v. (thirteenth century), and MS. 103 (fourteenth century). In this last the flower, till then indeterminate, becomes a lily. Arsenal, MS. 279, f. 54 and f. 382 (fourteenth century).

walking seven times round the altar, of showing the high-priest that no sign appeared on her face.[1]

In the life of the Virgin as represented in the thirteenth century I find one legendary feature only. It was said that her visit to Elizabeth was prolonged so that she might be present at the birth of John the Baptist.[2] Men would have it that on entering the world the Forerunner was welcomed by her, and carried in her arms. In works of art of that period the figure of a woman with a nimbus, who is none other than the Virgin herself, is sometimes seen by the bedside of Elizabeth.[3] Thus were first brought together the Saviour as yet unborn and the Precursor at the moment of his birth. The Middle Ages held to this tradition, and never represented the two children playing together in the care of the Virgin and of angels, as was done by Leonardo, Raphael and the other Renaissance artists.

It is not until we reach the Virgin's last moments that legend reappears. The stories of her death, ascension and coronation are entirely apocryphal, but they were so popular that there is probably no single cathedral in which at least one episode is not found. The churches which are dedicated to her almost invariably give her coronation the place of honour in tympanum, roof gable, or smaller gable of the façade.[4] The coronation of the Virgin is carved as many as three times on the cathedral of Paris alone,[5] and five bas-reliefs are devoted to her death and assumption.[6]

No subject was then more popular, though the Church which allowed the legends to be carved in all the cathedrals, did not admit them to her liturgical books. I have searched for them in vain in lectionaries of the end of the twelfth century—as a rule so hospitable to apocryphal stories— and in the breviaries of the thirteenth century. A letter on the death of the Virgin, reputed to have been written by St. Jerome to Paula and Eustochia, was read on the feast of the Assumption.[7] This letter is grave

[1] *Hist. Nativ. Mariæ*, cap. XII.

[2] *Leg. aur. De Nativ. Sanct. Johan. Bapt.*, LXXXVI. [*Golden Legend, The Nativity of St. John he Baptist*, iii. 257] (after Peter Comestor), and Ludolph of Saxony, *Vita Christi*, VI.

[3] In a window at Saint-Père at Chartres (fourteenth century).

[4] Chartres, tympanum in the central doorway of the north façade; Reims, gable of central doorway; Laon, central doorway; Bourges, to the right of central doorway; Sens, *ibid.*; Rouen, in the gable above the rose-window in the Portail de la Calende; Auxerre, façade, tympanum of left doorway; Paris, façade, tympanum of the left doorway; Noyon, right

doorway, in the tympanum which is hardly visible; Meaux, right doorway. Windows also give the place of honour to the coronation of the Virgin, as in the middle window of the apse at Lyons and a window in the apse at Troyes.

[5] Paris, left doorway (west façade); Portail Rouge (tympanum), bas-reliefs in the north wall.

[6] Tympanum in the left porch of the west front, and bas-reliefs of the north wall.

[7] Several features, the use of Leo the Great's works in particular, show that this letter cannot have been written by Jerome. It is not earlier than the beginning of the seventh century.

and a little cold, and the writer speaks with much reserve of the legendary stories current in his day : "Nothing is impossible with God, but for myself I would prefer to make no assertions."[1] The ardent piety of the people had need of absolute conviction, any doubt would have seemed impious. Then too, the tomb which the Virgin had left at the voice of her Son had been seen in the valley of Jehoshaphat by the crusaders,

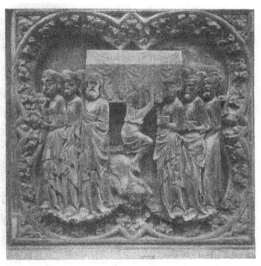

FIG. 123.—BURIAL OF THE VIRGIN (Notre Dame at Paris)

who had beautified it and decorated it with golden lamps. It was dear to them as a spot sanctified by the most beautiful of the miracles of Christ.

Accordingly the Church would not deprive the faithful of the joy they had in their belief in the beautiful story of the death and assumption of the Virgin. This story was attributed to Melito, a disciple of St. John or sometimes to St. John himself, and the text as we have it is of very early date. The fame of the legend spread to distant countries, for Arabic and Coptic versions have been found which give it in more or less altered form.[2] Gregory of Tours summarised it and made it known to the Gallican Church,[3] and in the thirteenth century Vincent of Beauvais and Jacobus de Voragine reproduced it from the Latin version with very slight modifications.[4]

Intimate knowledge of this story is necessary to any understanding of the subtle works of art which take it as their subject-matter. It is a vivid drama which ends in a most magnificent epilogue. Art found in it as many as six plastic themes.

[1] Bibl. Sainte-Geneviève, MS. No. 554, f. 163 (Lect., twelfth century) ; No. 555, f. 223 (Lect., twelfth century) ; No. 131, f. 147 v. (Lect., thirteenth century). Arsenal, MSS. No. 162, f. 181 v. (Lect., twelfth century), and No. 279, f. 319 v. (Lect., thirteenth century).

[2] Migne (*Dict. des apocryphes*, II., col. 503 *seq.*) gives a translation of the Arabic manuscript.

[3] Gregory of Tours, *De Gloria martyrum*, cap. IV.

[4] Jacobus de Voragine, *Leg. aur., De Assumpt.* [*Golden Legend. The Assumption*, iv. 234], and Vincent of Beauvais, *Spec. hist.*, VII., lxxv. *seq.* He ends by saying, "Hæc historia licet inter apocryphas scripturas reputetur, pia tamen videtur esse ad credendum"—precisely the feeling of the mediæval Church.

RELIGIOUS ART IN FRANCE

The first theme is the appearance of the angel to the Virgin. Mary was sixty years old,[1] and longed to be re-united to her Son, and one day " an angel came before her with a great light, and saluted her honourably as the mother of his Lord, saying :—' All hail, blessed Mary, receive the blessing of him that sent his blessing to Jacob ; lo ! here a bough of

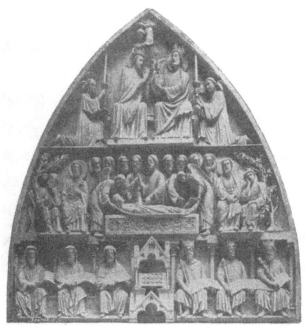

FIG. 124.—THE RESURRECTION AND THE CORONATION OF THE VIRGIN
(Notre Dame at Paris)

palm of paradise, Lady, which thou shalt command to be borne tofore thy bier. For thy soul shall be taken from thy body the third day next following, and thy Son abideth thee, his honourable mother. . . .' The angel mounted to heaven with great light, and the palm shone by right great clearness, and was like to a green rod whose leaves shone like to the morrow star." [2] This supreme salutation, which must not be confused with that of the Annunciation, is shown in windows at St. Quentin [3] and Soissons.[4]

[1] According to another tradition, which to Jacobus de Voragine seemed more probable, she was seventy-two.

[2] Legend aurea, De Assumpt. [Golden Legend, The Assumption, IV. 234.]

[3] Chapel of the Virgin.

[4] Window in the chevet.

This is but the prelude to the great event which was to come. The apostles, who were then dispersed throughout the world preaching the Gospel, felt themselves of a sudden ravished by a mysterious force, which brought them together in Mary's room where she lay awaiting death. "And about the third hour of the night, Jesus Christ came with sweet melody and song, with the orders of the angels, the companies of patriarchs, the assembly of martyrs, the convents of confessors, the carols of virgins. And

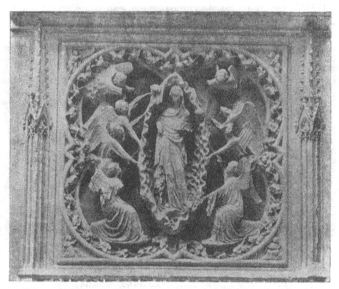

FIG. 125.—THE ASSUMPTION OF THE VIRGIN (Notre Dame at Paris)

tofore the bed of our blessed Lady the companies of all the saints were set in order and made sweet song and melody. . . . Jesus Christ began to say :—'Come, my chosen, and I shall set thee in my seat, for I have coveted the beauty of thee.' And our Lady answered : 'Sir, my heart is ready. . . .' and she said : 'I come, for in the beginning of the book it is written of me that I should do thy will. . . .' And thus in the morning the soul issued out of the body and fled up in the arms of her son. And the choirs of the blessed returned to heaven and they carried in their arms the soul of her who bare their King, and they sang : 'Who is this that ascendeth from the desert ? . . . This is the right fair among the daughters of Jerusalem.'"

This is the chief scene in the story and it was seldom that any other was

represented by the earlier artists, the miniaturists of the tenth and eleventh centuries.[1] The apostles are shown ranged round the bed on which lies the body of the Virgin, and in His arms Christ holds the soul of His mother in the form of a little child. This conception of the scene is frequently found in thirteenth-century work, as in a window at St. Quentin and, though mutilated, in the tympanum over the central doorway of the north façade at Chartres. The porch (restored) of the cathedral of Laon and a window at Angers[2] present the same subject with some slight variation in detail. One of the fourteenth-century bas-reliefs let into the north wall at Notre

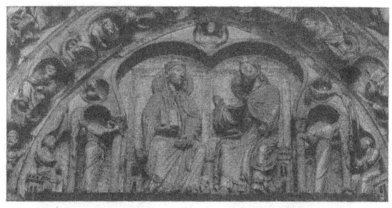

FIG. 126.—CORONATION OF THE VIRGIN (Senlis)
(*Photograph belonging to M. E. Lefèvre-Pontalis*)

Dame at Paris shows the same scene, but the dignity of early art is already gone, for although the apostles express their grief in realistic gestures, Christ is no longer present to receive His mother's soul.[3]

The burial of the Virgin follows. Her body, from which issues a dazzling light, is placed in the coffin and the apostles take their places and form the funeral procession. St. John walks first, holding the celestial palm which the Virgin had confided to his care. St. Peter and St. Paul bear the bier on their shoulders ; Peter in front, Paul behind for did he not declare himself the least of the apostles. They go forward singing " In exitu Israel," and in the heights the angels accompany them. On hearing the

[1] See examples in Rohault de Fleury, *La sainte Vierge*, I., ch. XI.
[2] Reproduced by Rohault de Fleury, *La sainte Vierge*, vol. I., pl. LXVII. See also F. de Lasteyrie, *Hist. de la peint. sur verre*, p. 106. The glass at Angers belongs to the twelfth century.

[3] The bas-relief belongs to the first quarter of the fourteenth century. See Courajod and Marcou, *Catalogue raisonné du Musée du Trocadéro*. Paris, 1892, 8vo, Nos. 601-609.

celestial music the Jews gather together, and when they find that Mary, mother of Jesus, is being buried they would stop the procession and take and burn the body. The high-priest goes so far as to try to seize the coffin. Then suddenly both his hands wax dry and cleave to the bier. Vainly does he supplicate St. Peter. " 'Thou canst only be whole,' says the apostle, ' if thou believest in Jesus Christ and in her who bore Him.' The prince of the priests then cries aloud, ' I believe our Lord Jesus Christ to be the Son of God and that this is His right holy mother,' and anon his hands are loosened from the bier, but yet the dryness and the pain cease not in him. And Peter says to him, ' Kiss the bier and say, I believe in Jesus Christ and in Mary who bore Him in her womb, yet remained virgin after the childing.' And when he had so said he is anon all whole perfectly." [1]

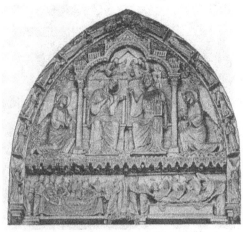

FIG. 127.—CORONATION OF THE VIRGIN (Chartres)

All the details of the scene are rarely met with in the same work, but they are found separately, scattered in windows, bas-reliefs and miniatures. Thus in a window at Angers St. John bears the palm, in thirteenth-century miniatures St. Peter is at one side of the bier and St. Paul at the other,[2] in bas-reliefs at St. Ouen at Rouen and at Notre Dame at Paris [3] (Fig. 123) the miracle of the withered hands appears. In the bas-relief at Paris it is noticeable that two figures seem to wish to seize the coffin ; one rushes forward to take it, the other rolls on the earth while his hands are still fast to the pall. These two figures are in reality one, and represent a sequence of events which the artists had wished to depict. In the Middle Ages, this convention was by no means unusual either in art or in the theatre. The Mysteries frequently present a whole succession of events as if they occurred simultaneously.[4]

[1] *Legenda aurea, De Assumpt.* [*Golden Legend, The Assumption,* iv. 234 *seq.*].

[2] Bibl. Sainte-Geneviève, MS. No. 131, f. 147 (thirteenth century) ; Arsenal, MS. No. 279, f. 319 v. (thirteenth century). These miniatures, in which the funeral of the Virgin is presented in very shortened form, are often placed in the lectionaries at the feast of the Assumption. Curiously enough they illus-

trate Jerome's letter which condemns apocryphal stories.

[3] St. Ouen (south porch), Paris (north wall).

[4] Examples are numerous. A twelfth-century ivory (No. 1049) in the Cluny Museum represents the death of the Virgin. Christ is shown holding the soul of His mother in His arms, while an angel flies off to heaven bearing that same soul.

RELIGIOUS ART IN FRANCE

After the apostles have accompanied Mary to the tomb, they by God's command watch there for three days. On the third day, accompanied by a multitude of angels and by the archangel Michael who bears her soul, Christ comes to raise the body of His mother. "And the Saviour said:

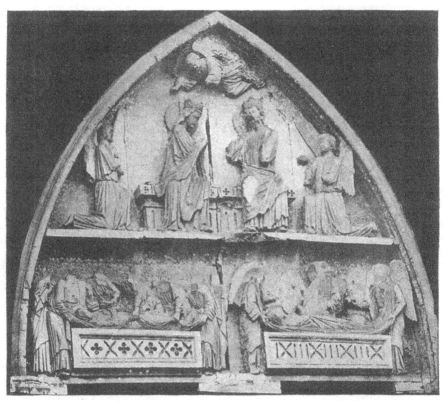

FIG. 128.—BURIAL, RESURRECTION AND CORONATION OF THE VIRGIN (Abbey of Longpont)

'Arise up, haste thee, my dove, tabernacle of glory, vessel of life, celestial temple, and like as thou never feltest conceiving by none atouchment, thou shalt suffer in the sepulchre no corruption of body.' And anon the soul came again to the body of Mary."[1]

This scene of the resurrection of her body has often been confused with that of the death of the Virgin, and at the first glance might easily be mistaken for it. The fine tympanum at Notre Dame at Paris (Fig. 124), for

[1] Legend aur., De Assumpt. [Golden Legend, The Assumption, iv. 241].

example, does not represent as is usually stated[1] the death of Mary but her resurrection. Two angels trembling with reverence lift the Virgin from the tomb, and bear her gently upon a long veil, for they dare not touch the sacred body. Christ raises his hand in blessing, and the pensive apostles meditate on the mystery. Mary is beautiful. Old age has not dared to touch

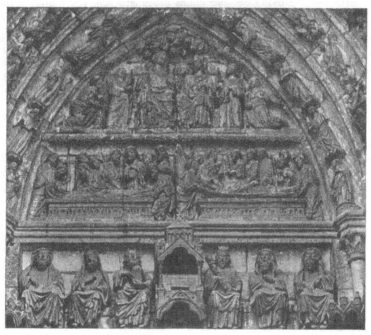

FIG. 129.—BURIAL, RESURRECTION AND CORONATION OF THE VIRGIN (Amiens)

her, and she is clothed in eternal youth ; on this point alone art would not follow tradition in the *Golden Legend*.[2] At Chartres the text received even more precise interpretation than at Paris, for near to her tomb two archangels bear reverently on a napkin the soul of the Virgin about to be reunited to her body. At Senlis[3] the artist has endeavoured to portray the multitude of angels of which the legend speaks, and they fly down near to the tomb, all darting forward to do the will of God.

The assumption follows the resurrection. Upheld by angels, Mary's body re-united to its soul mounts to heaven. In a window in the choir at

[1] Viollet-le-Duc, *Dict. raisonné de l'archit.*, ix. p. 372.
[2] This also applies to the tympanum at Amiens
(west façade) which bears so strong a likeness to that at Notre Dame at Paris.
[3] Cast in the Trocadéro.

Sens and in one in the apse at Troyes, Mary triumphantly bears a palm,[1] the sign of victory spoken of in the hymn to the Assumption, "palmam præfert singularem."[2] More frequently she carries a book, and supported by angels rises in an aureole.[3]

The episode of the Virgin's girdle has here its place. St. Thomas arrived after her resurrection had taken place and saw the empty tomb, but true to his character refused to believe in the miracle ; to convince him Mary threw her girdle down from heaven. The legend was specially dear to the

FIG. 130.—CORONATION OF THE VIRGIN (Porte Rouge, Notre Dame at Paris)

Italians who gloried in possessing "la sacra cintola" at Prato, and at first it is almost entirely confined to Italian art. In an Italian miniature of the thirteenth century, copied by the Comte de Bastard, we have perhaps the earliest example.[4] It is evident that the sculptor of the tympanum at Notre Dame at Paris was either unacquainted with the legend or did not wish to represent it, for in his work all the twelve are present at the resurrection of the Virgin.

When borne by angels Mary reaches heaven, Christ seats her on the throne at His right hand and places a crown on her head. It is the coronation of the Virgin, which the *Golden Legend* does not describe but indicates in a word : "Come from Lebanon, my spouse, come thou shalt be

[1] Sens (*Vitraux de Bourges*, plan XV.) ; Troyes (*ibid.*, plate XIII.).

[2] *Leg. aur.*, *De Assumpt.* [*Golden Legend, The Assumption*, iv. 234 *sq*.].

[3] Sens, tympanum in the south porch, façade (Fig. 131) ; Notre Dame at Paris, bas-relief outside the chapels on the north side (Fig. 125).

[4] Archæological documents in MS. of the Comte de Bastard, III., f. 21 (Cabinet des Estampes).

crowned," and Jacobus de Voragine adds that filled with joy the choirs of the blessed accompanied her to heaven, where *she seated herself on the throne of glory* to the right of her Son. No more was needed to stir the artists' imagination, while the words of the psalmist, " Upon thy right hand did stand the queen in vesture of gold," [1] and " Thou settest a crown of precious stones on his head," [2] applied to Mary on the feast of the Assumption, sug-

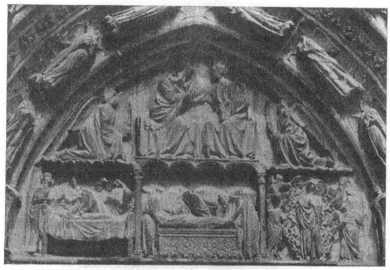

FIG. 131.—THE DEATH, RESURRECTION AND CORONATION OF THE VIRGIN (Sens)
(Photograph belonging to M. E. Lefevre-Pontalis)

gested a more definite picture to their minds. It was not, however, until the twelfth century that it occurred to them to give plastic form to the words of the liturgy, and in his careful study of the early Middle Ages M. Rohault de Fleury never once met with the scene of the coronation.[3] It appears for the first time, very properly, in the century of St. Bernard, and the earliest example known to us is found in the porch of the cathedral of Senlis. The following century proclaimed the royalty of Mary, and inscribed it on the front of all the cathedrals. This scene of the coronation of the Virgin is seen under three different aspects during the course of the thirteenth century.

[1] " Astitit regina a dextris tuis in vestitu deaurato " (Ps. xlv. 9). These words passed into the Hours of the Virgin. See Bibl. Sainte-Geneviève, MS. 274, f. 27 (Heures de Notre-Dame).

[2] " Posuisti in capite ejus coronam de lapide pretioso." (Ps. xxi. 3.)

[3] Rohault de Fleury, *La sainte Vierge*, I., ch. xi.

RELIGIOUS ART IN FRANCE

The earliest formula is found in the bas-relief at Senlis (Fig. 126) where the Virgin is seated to the right of her Son, and angels cense her or carry torches. But the remarkable point here is that she already wears her crown, and her Son is content to raise His hand in blessing ; the coronation has already taken place, and the Virgin takes possession of the throne for all eternity. Such is the Coronation seen at Laon, a mere copy of that at Senlis, and such also is the Coronation at Chartres,[1] a yet archaic work dating back to the early years of the thirteenth century (Fig. 127).

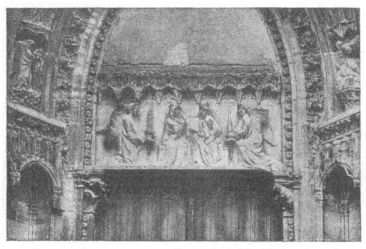

FIG. 132.—CORONATION OF THE VIRGIN (lintel of the right door, Auxerre)

At Notre Dame at Paris the scene bears a new aspect. It is really a representation of the coronation, though it is not Christ who crowns His mother, but an angel who comes from heaven to place the crown on her head (Fig. 124). Mediæval art can show nothing finer than this tympanum at Notre Dame.[2] Seated by the side of her Son, the Virgin turns her pure face towards Him, gazing at Him with clasped hands while the angel places the crown on her forehead. Radiant in divine beauty, He blesses her and gives her a sceptre which bursts into flower, symbol of the power which He will henceforth share with His mother. Wonder, gratitude and modesty are all expressed in the attitude of the Virgin. This group was once gilded, and like the queen of the psalmist, Mary appeared clothed in a

[1] In the north porch.
[2] This fine piece of sculpture, the *chef-d'œuvre* of the school of the Île-de-France, can be studied at close quarters in the Trocadéro.

mantle of gold ; to-day the setting sun and the light of a summer evening give her back something of her ancient splendour. Grouped in the arches round her are angels, kings, prophets, saints, the court of the queen of heaven.

One can not fail to admire the exquisite picture in the Louvre in which Fra Angelico shows Mary crowned by her Son in the midst of the choirs of virgins, saints and martyrs clothed in celestial colours. But

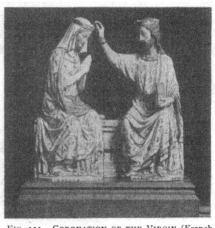

justice should be done to the old masters of two centuries earlier, whose treatment of the same subject was even finer than Fra Angelico's. Round the Virgin they ranged all Paradise in concentric circles, like Dante revealing heaven to men's eyes and showing them Mary as the centre of things divine, "And at that mid point, with outstretched wings, I saw more than a thousand Angels making festival, each one distinct in law and art." [1]

The tympanum at Notre Dame at Paris was placed in position about the year 1220. The new formula for

FIG. 133.—CORONATION OF THE VIRGIN (French ivory of the thirteenth century, in the Louvre)

the Coronation of the Virgin which it inaugurated obtained for a quarter of a century, for it is found on the Portail Rouge at Notre Dame itself (Fig. 130), and again at Longpont (Fig. 128). It is also found at Amiens (Fig. 129), where imitation of Paris is evident but where the details of the composition are less happy.[2] The sceptre which the Christ at Paris presents to His mother, is already placed in her hand, the artist believing that in this way he did the Virgin greater honour. But his group has lost the delicate feeling which breathes through the Parisian master's work, for at Amiens the intimate converse of mother and Son is ended.

At a date which it is not easy to determine accurately, but which must have been about the year 1250, there appeared a third formula for the scene of the coronation. It is no longer the angels who place the crown on the Virgin's head, but Christ Himself, a sign of the growth of reverence for her. Of this kind are the representations at Sens, Auxerre and Reims.

[1] *Paradiso*, xxxi. 130–132. [2] The same formula is seen in the cathedral of Léon in Spain.

RELIGIOUS ART IN FRANCE

The beautiful group of the mother crowned by her Son, popularised in other countries through French ivories (Fig. 133), captivated the whole of Europe and is found in Italy, Spain and Germany. It marks the apogee of the cult of the Virgin in the thirteenth century.[1]

The artists as we see found an unfailing source of inspiration in legends relating to the Virgin. These simple stories which we no longer read, enthralled the people for four hundred years, and to them we owe half at least of the mediæval works of art in France. We will content ourselves with observing that of the three great porches at Notre Dame at Paris, two—those dedicated to St. Anne and to the Virgin—are almost entirely decorated with subjects taken from the apocryphal books.

VII

After her legends, nothing was more famous in the thirteenth century than the miracles of the Virgin. She was to the people as grace supreme over law. She is seen in the tympanums of the cathedrals kneeling near her Son who is about to judge the world, and she reassures the sinner who on entering dare not so much as look at his Judge. She was the "advocate" who pleaded desperate causes,[2] and whose hands held the treasures of God's mercy.[3] " Lady, thou art so great and hast such worth, that if there be who would have grace yet betaketh not himself to thee, his longing seeketh to fly without wings."[4] And yet the Virgin of the Middle Ages remained very woman. She had regard neither to good nor ill, but in love she pardoned all. To be saved it was enough to have daily recited half the Ave Maria. Vainly was Satan king of logicians, for at the last moment his arguments were silenced by her French *finesse* and the grace and charm of her manner. She disguised herself, and appeared at times and places where the devil hardly expected to see her. She was present at the weighing of souls, and caused the scales to dip on the right side.

The *Miracles de Notre-Dame*, versified by Gautier de Coinci, canon

of Soissons, is the book of mercy, in which Mary saves all whom justice human and divine had condemned. It is also the most varied of romances. The poet transports his reader into a world as marvellous as that of a Breton lay ; lighted candles appear on the ship's great mast during a storm, or descend on the vielle of the jongleur of Rocamadour, shipwrecked men float on the waves upheld by the Virgin's mantle, and sacred images bar the lion's way and rescue pilgrims travelling through the desert.

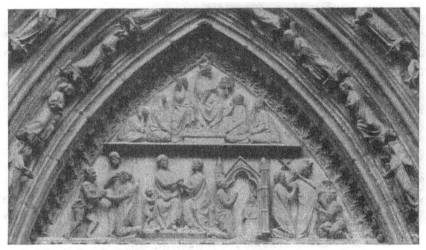

FIG. 134.—MIRACLE OF THEOPHILUS (north porch, Notre Dame at Paris)

These stories had captivated many a soul before they were put into verse by Gautier de Coinci, some having been famous for a century.[1] Many great churches had their collection of miraculous stories. Hugo Farsitus, canon of Saint-Jean-des-Vignes, compiled an account of all the cures by means of which Notre Dame of Soissons had manifested her power during the plague at the beginning of the twelfth century.[2] The monk Hermann recounted all the miracles which had marked the passage of the reliquary of Notre Dame of Laon[3] in both France and England. Later, Jean le Marchand celebrated the all-powerful intercession of Notre Dame of Chartres, not without pilfering some of Gautier de Coinci's stories for the greater glory of his revered patroness.

These books had not the influence on art which we might expect

[1] On collections of miracles before Gautier de Coinci and on his Latin sources, consult the complete account, which, beginning in 1886, was published in the memoirs of the Académie de Vienne by

M. Mussafia (*Studien zu den mittelalterlichen Marienlegenden*).
[2] Hugo Farsitus, *Patrol.*, clxxix.
[3] *Patrol.*, clvi.

RELIGIOUS ART IN FRANCE

Neither in sculpture or glass is there any trace at Chartres, Laon or Soissons of the miracles of the famous images of the Virgin, but it is of course possible that the innumerable windows which are lost to us, may have been devoted to some of these local legends.[1]

With the one exception of Le Mans, it is a remarkable fact that only one of the Virgin's miracles, the miracle of Theophilus, is found in the cathedrals.

This story is carved twice at Notre Dame at Paris.[2] It is seen in a mutilated window at Chartres, it is recounted at length in windows at Laon, Beauvais and Troyes, and in two windows at Le Mans, and it is briefly commemorated in a bas-relief on the west porch of the cathedral of Lyons.

It is a truly dramatic story. The piety and virtue of the clerk Theophilus, vidame to the bishop of Adana in Cilicia, was such that at the death of the bishop the people with one voice chose him as his successor. But so great was the modesty of Theophilus that he refused this honour, and remained

FIG. 135.—MIRACLE OF THEOPHILUS (bas-relief, exterior, Notre Dame at Paris)
(*Fourteenth century*)

merely vidame to the new bishop. The devil, however, did not despair of losing so holy a soul, and by tempting his humility soon made him long for the power he had refused. Theophilus then went to seek out a Jew learned in magic arts, and bound himself to deliver up his soul to hell if in exchange Satan would give him the glory of the world. The compact was drawn up in due form, written on parchment, and Theophilus signed it. In response to the necromancer Satan appeared and took away the paper. From that day the vidame succeeded in all that he did. It was not long before he supplanted his bishop in the people's favour, and to him came all

[1] A mutilated window in the cathedral of Chartres (south aisle) shows an image of the Virgin venerated by pilgrims (no doubt the famous Virgin of Chartres). The rest of the window contains episodes in the history of Theophilus. It may be that some of the miracles of Notre Dame of Chartres are there also. It is known that windows were devoted to the miracles of Our Lady. Joinville tells us that he had painted in his chapel at Joinville and " ès verrières de Blahecourt ", the story of how one of his companions when returning from the Crusades fell into the sea and was saved by the Virgin, who held him up by the shoulder.

[2] In the north porch (Fig. 134) and among the bas-reliefs inserted into the north wall (Fig. 135).

the honours and all the gifts.[1] But in the midst of the delights of power the pangs of remorse assailed him. The memory of his crime haunted him, tortured him, plunged him into despair. One night, after having prayed for long before the statute of the Virgin, he fell asleep in the church, and dreamed that she appeared to him clothed in dazzling light, pardoned his sin and returned to him the parchment which she had wrested from the devil. On waking he found that it was no dream, but that in his hand he held the parchment. After having returned thanks to Mary, Theophilus went to confess his sin to his bishop, and not content with that he told the people the story of the crime and the pardon. A few days after his public confession he died in the odour of sanctity.

This story, which seems like a rough draft of the legend of Faust, was of eastern origin, but early found its way to the west.[2] It was translated from the Greek by Paulus Diaconus, the abbess Hrotswitha and bishop Marbodus put it into verse, and in the thirteenth century Rutebeuf used it for a mystery play.

A drama such as this, played on the confines of two worlds, was well calculated to appeal to the people, and its success is easily understood. But it was really because the Church chose it from among many other legends that it became popular. In the eleventh and twelfth centuries the story of Theophilus had become an " example," and was used in sermons in honour of the Virgin. Honorius of Autun, who in his *Speculum Ecclesiæ* summarised all the religious teaching which the clergy of his time gave to the people, did not fail to recount the story of Theophilus in the model sermon for the feast of the Assumption.[3]

Lastly, in the eleventh century the miracle of Theophilus received the solemn consecration of the liturgy. In the Office of the Virgin the following words were sung :—

> " Tu mater es misericordiæ
> De lacu fæcis et miseriæ
> Theophilum reformans gratiæ." [4]

We have here the true reasons for the presence of the miracle of Theophilus in so many churches, and it is vain to seek for others.[5]

[1] It is noticeable that at Laon, as at Beauvais, Troyes and Le Mans, one compartment of the window shows some of the people bringing a fish to Theophilus. I can find this detail neither in the *Legenda aurea* (*De Nativitate*), nor in Honorius's sermon which merely says : " Sibi divitias affluere " (*Patrol.*, clxxii., col. 993), nor in the poems which Marbodus and Hrotswitha devoted to Theophilus, nor in the chronicle of Sigebert of Gembloux which tells his story (*Patrol.*,clx., col. 102). It is evidently simply a studio tradition—a fresh proof of the existence of a " Guide to Painting."

[2] The year 537 was taken as the date of Theophilus's adventure.
[3] *Patrol.*, clxxii., col. 993.
[4] Ulysse Chevalier, *Poésies liturgiques traditionnelles de l'Église catholique en Occident*, Tournai, 1893, 12vo, p. 134.
[5] Much learning has been vainly expended on this subject. See *Annales archéol.*, xv. 283 ; xxii. 276 ; xxiii. 81. Also *Gazette archéol.*, 1885. M. Ramée there points out one of the earliest known examples of representations of the legend, in the porch at

RELIGIOUS ART IN FRANCE

It was felt, no doubt, that this famous miracle in itself bore ample witness to the power of the Virgin, for in general, art does not represent the others.

The cathedral of Le Mans alone shows new legends side by side with the story of Theophilus, which is there represented as many as three times. Two windows call for description, one in the chapel of the Virgin and the other in the choir triforium.

We there see first of all two workmen—then two children—trying to raise the columns of a basilica, then we see a burning house, and lastly some monks who appear to be receiving presents at the hands of the Virgin (Figs. 136 and 137). No one up to the present time has given a satisfactory explanation of these detached scenes. C. Hucher, deceived by the presence of a bishop whom an inscription names "S. Gregori[us]," was convinced that they related to St. Gregory the Great, and saw in the windows at Le Mans some of the mystical symbols of the Virgin Birth.[1]

Through study of twelfth-century lectionaries I have been able to solve the riddle. On the feast of the Assumption in the mediæval Church, it was the custom, after reading the famous letter attributed to St. Jerome, to read the story of four or five miracles of the Virgin taken from the *De Gloria martyrum* of Gregory of Tours.[2] This book was in fact the earliest collection of the miracles of Our Lady known to the Gallican Church, and, as we see, it remained long in use.

We will now give the legends in the order in which they are recounted by Gregory of Tours. The first tells how the Emperor Constantine was building a magnificent church to the Virgin, but when the time came for placing the columns in position no one was able to raise them. The Virgin appeared to the architect in a dream, and counselled him to get help from three children on their way home from school. The architect obeyed, and the children had no difficulty in raising the pillars of the basilica.

There was at Marciacum in Auvergne an oratory containing relics of the Virgin. One night Gregory of Tours went to keep vigil before the shrine, and on arriving he saw so bright a light streaming from the windows that he thought thousands of lamps must be burning in the church. As he approached the door opened to him, but as soon as he entered it the church was plunged in darkness, and he was lighted only by his torch.

Souillac (Lot). A large number of works of art which illustrate the legend of Theophilus is enumerated in the *Revue des traditions populaires*, 1890, p. 1 *seq.*

[1] Hucher, *Vitraux du Mans* (unpaged).
[2] Gregory of Tours, *Libri miracul.*, I., *De Gloria martyrum*, IX., X., XI., *Patrol.*, lxxi., col. 713 *seq.*

In a town in the east [1], a Jewish glass-blower had a son who was in the habit of going with the young Christians to their church. One day the child communicated, and when his father heard of it he became so enraged that he threw his son into the furnace which he had just lighted. His mother's cries attracted the whole town. The child was thought to be burnt to death, but was seen lying in the midst of the flames " as sweetly as on a bed of down." He told how that the lady whose image was in the church had covered him with her mantle, and men attributed the miracle to the Virgin.

One day food was lacking in a rich monastery at Jerusalem, and the monks came to complain to the abbot. " Let us pray, my brothers," he replied. They passed the night in prayer, and in the morning their granary was so full that the door could not be shut. Some years later there befell a second dearth, and the

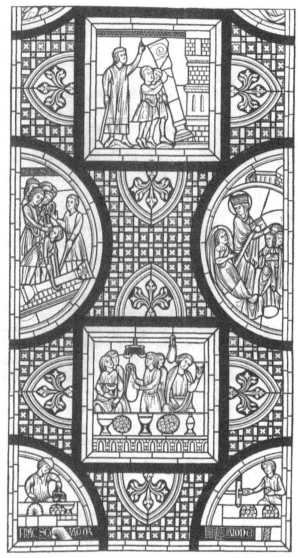

FIG. 136.—THE MIRACLES OF THE VIRGIN (window at Le Mans, lower portion)
(*From Hucher*)

[1] This celebrated miracle was afterwards localised at Bourges.

263

abbot and his monks again passed the night in prayer, until the hour of matins. When they had left the church, there came an angel who placed a large number of pieces of gold on the altar. The sacristan who guarded the church door had seen no one enter, and the miracle was again attributed to the Virgin.

When walking across the fields, Gregory of Tours saw a burning farm and peasants who were vainly trying to extinguish the flames. On his breast the bishop wore a cross which contained relics of the Virgin. He held it up to the flames and suddenly the fire died down.

These five miracles, which are met with in several lectionaries,[1] must certainly have had a place in the liturgical books of the church of Le Mans,[2] for the two windows we have mentioned reproduce the stories in every detail.[3] The first window[4] shows all the miracles recounted by Gregory of Tours except the story of the Jewish child. The second[5] shows the two miracles of the raising of the columns and of the convent famine at Jerusalem, with the addition of the famous story of the painter whom the devil caused to fall from his scaffolding, but who was upheld by the arms of the Virgin in the fresco which he had just painted on the wall.

A few mutilated medallions in a neighbouring lancet suggest another legend of which the Virgin is heroine. A warrior and a bishop are seen conversing at the door of a church, while a knight armed *cap-à-pie* is plunging his sword into the breast of a crowned figure who sits at table. M. Hucher, who described these medallions, thought he saw in them an incident in the life of St. Bernard, but in reality they present another miracle of Our Lady, often associated with the preceding. It was said that the emperor Julian when passing by Cæsarea, was received by the bishop, St. Basil, who offered him three barley-loaves. Scorning so modest a gift,

[1] See, for example, Bibl. Ste.- Geneviève, MSS. 554, f. 163 v. *seq.* (twelfth century), and No. 555, f. 223 *seq.* (twelfth century). The stories of the miracles of the columns and of the Jewish child passed into Vincent of Beauvais's *Spec. hist.*, VII., cap. LXXXI. *seq.*, where they are again placed after the story of the Assumption.

[2] The lectionaries of the cathedral of Le Mans have not been preserved. See *Catal. génér. des MSS. des bibliothèques publiques de France*, vol. xx.

[3] The following are the scenes in the window in the chapel of the Virgin (Fig. 136) :—1. The changers (donors). 2. The workmen try to raise the columns. 3. The Virgin appears to the sleeping architect and shows him the three school-children (one holds a book). 4. The children raise a column. 5. (Fig. 137) The Virgin pours corn into three re-

ceptacles (not an angel as in the story but the Virgin herself, near to the nimbus her name is written, " Sancta Maria "). 6. The monks come to find their abbot. 7. The Virgin places gold on the altar. 8. St. Gregory of Tours (his name is there " Gregorius ") holds up an object surmounted by a flame before a house. This is no doubt the reliquary which extinguished the fire, and which appears to quench the last flames. 9. A house from which rise great flames (perhaps the same as the preceding, or perhaps the church of Marciacum from which issued a dazzling light). 10. Two figures kneeling before the Virgin, who dominates the composition.

[4] In the chapel of the Virgin. Reproduced in Figs. 136 and 137.

[5] Window in the choir triforium (thirteenth window).

Julian sent in derision some hay to the bishop, at which Basil said to him,
" We sent thee that which doth nourish men, thou hast sent us that which thy beasts do eat." Irritated Julian answered, " I will destroy this city and raze it to the ground, so that it may produce wheat instead of sheltering men." But that very night the Virgin Mary raised from the dead a knight named Mercury, who had been put to death by Julian for the faith of Christ. Mercury appeared fully armed before Julian, and pierced him with his lance ; then the apostate emperor died, saying, " Thou hast conquered, Galilaean." This legend, first found in the life of St. Basil, passed both into the *Speculum historiale*[1] and into the *Golden Legend*,[2] and became widely known through poems in the vernacular.[3]

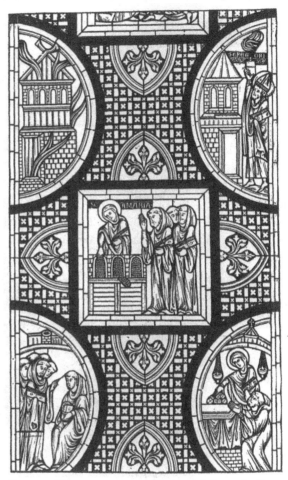

FIG. 137.—THE MIRACLES OF THE VIRGIN (window at Le Mans, upper portion)
(From Hucher)

The story of the Jewish child is found at Le Mans, in two neighbouring windows both alike dedicated to the Virgin.[4] It should be noted that in these windows the story

[1] Vincent of Beauvais, *Spec. hist.*, XIV., ch. xliii.
[2] *Legenda aurea*, *Vita S. Juliani* [*Golden Legend*, iii. 15]. The likeness of name caused Jacobus de Voragine to add this legend to the account of the life of St. Julian.
[3] See Paul Meyer, "Notice sur un manuscrit d'Orléans contenant d'anciens miracles de la Vierge," in *Notices et Extr. des Manuscr.*, xxxiv., 1895, p. 31 *seq.*
[4] Choir triforium, fourth and twelfth windows.

accompanies the miracle of Theophilus, and in fact the first of the two legends was almost as celebrated as the second, and also furnished an "example" for sermons. It is recounted by Honorius of Autun on the feast of the Purification.[1]

In the church at Le Mans where windows dedicated to the Virgin are numerous, there is one, the only one known to us, which tells of a local miracle of Our Lady. It was certainly given by the abbey of Évron, for one there sees the story of the miraculous foundation of the monastery. A pilgrim returning from the Holy Land brought in his wallet a relic of the Virgin, and when near to Le Mans he stopped at the foot of a tree, hung his wallet on one of the branches, lay down in the shade and slept. On waking he found that the tree had grown so high that it was impossible for him to reach his sack. The whole countryside was troubled. Woodmen tried to cut down the tree, but in vain for their axes were blunted. In his turn the bishop came, and hardly had he made the sign of the cross, when the tree bent down to him and presented the sacred relics. It was believed that the Virgin would be held in remembrance on that spot, and an abbey was raised in her honour.

The miracles of the Virgin which we have mentioned are the only ones which appear in mediæval churches, and except at Le Mans the artists were content to paint or carve the story of Theophilus alone. In spite of the fame of the miracles of Our Lady, they concerned themselves by preference with relating the stories of her life and death.

In the Middle Ages, as we see, the apocryphal Gospels were a fertile source of poetry and art. Without their help the whole of the life of the Virgin, and part of the life of Christ as recounted by the thirteenth-century artists would be unintelligible. In closing this chapter we would reiterate, that without some knowledge of the apocryphal writings, at least half the mediæval works of art would be to us a closed book.

[1] *Spec. Eccles., Patrol.,* clxxii., col. 852.

CHAPTER IV

THE SAINTS AND THE GOLDEN LEGEND

I

THE history of the Christian world is presented in the cathedrals as it is in Vincent of Beauvais's *Speculum historiale*, where periods are reckoned not by the deeds of emperors and kings but by the lives of saints. The windows and statuary of the churches proclaim that since the coming of Christ the really great men are the doctors, confessors and martyrs. Conquerors who filled the world with their fame appear in the humblest of attitudes ; tiny figures smaller than children, they kneel at the feet of the saints.

We know from the *Speculum historiale* that such was the mediæval conception of history. Nothing could be more surprising than the scheme of the great work from which so many generations of men—and the kings themselves—learned history. At the beginning of each chapter Vincent of Beauvais mentions the emperors of the East and of Germany and the kings of France, and devotes a few lines to their battles and their treaties. He then reaches his subject, the story of the saints who were contemporaries of these kings and emperors. His heroes are abbots, anchorites, young shepherdesses, beggars. The translation of relics, the founding of some monastery, the healing of a demoniac, the retreat of a hermit to the desert, are to him the most important facts in the history of the world.

Vincent of Beauvais shows neither surprise nor interest in the appearance among the barbarians of Boethius and Symmachus, the last of the Romans. He turns his eyes away from Rome, and serenely marshals the only events of the time which to him seemed worthy of men's knowledge— the miracles of St. Leonard in Limousin, the miracles of St. Maxentius

RELIGIOUS ART IN FRANCE

in Poitou and the journeys of St. Malo.[1] The life of St. Die in the forests of the Vosges engages the historian longer than the doings of the emperor Heraclius.

In this way mediæval history becomes merely a record of a few pure souls who lived far from the haunts of men. One gets the impression that the world in the ninth and tenth centuries was inhabited by saints, a world like that landscape in the Campo Santo at Pisa where one sees only anchorites at prayer. With the exception of the crusades, even great contemporary events never take the foremost place in Vincent of Beauvais's book. The battle of Bouvines passes almost unnoticed between the stories of St. Mary of Oignies and of St. Francis of Assisi. The saints form a spiritual chain reaching from St. Louis to the apostles, and from them through the patriarchs and prophets to Abel, the first of the just.

In the eyes of the thirteenth century the real history of the world was the story of the city of God. It is necessary to bear in mind such a conception of history in order to understand the innumerable legends of saints which are painted or carved in the cathedral of Chartres, where each window or bas-relief is like a chapter from the *Speculum majus*. In this reading of history the enormous number of images of saints which decorate the churches find at least partial explanation.

But for the Christian of the Middle Ages the saints were not only the heroes of history, they were also his intercessors and patrons. There was more than a relic of classical paganism in the honour they received, and they mingled in the lives of men and cities like the indigenous gods of ancient Rome. The Christian received at baptism the name of the saint who was to be his patron and example. These names were not chosen at hazard, but were preferably those of ancient local bishops or monks whose relics worked wonders, and many baptismal names, to-day proper names, point to the native district of the family who bear them.[2] When the child grew up, chose a trade and entered a guild, a new saint welcomed him. If he were a mason he celebrated the feast of St. Thomas the apostle, if a wool-carder the feast of St. Blaise, if a tanner the feast of St. Bartholomew. On that occasion he forgot the hard work and the long days, and proud as a knight walked behind the banner of his patron saint, went to mass with the master

[1] *Spec. hist.*, lib. XXI., cap. XXII., XXX., LIV.

[2] The family of Fulcran comes from Languedoc (St. Fulcran of Lodève), the Foucauds from Burgundy (St. Foucaud of Auxerre), the Gérauds from Cantal (St. Géraud of Aurillac), the Léonards or Liénards from Limousin (St. Leonard is the great saint of Limousin), the Lubins from Chartres, &c. On this subject see Giry, *Manuel de Diplomatique*, Paris, 1894, p. 368.

and wardens, and later sat at table with them. The name of a saint was associated with the happiest memories of his youth. The patronal festival was the great festival when the town gave itself up to spectacle ; splendid processions passed by, bearing gorgeous reliquaries, and mystery plays were performed. In the rudest little town in the France of that day men were gay at least once in the year, and they danced under the elm-tree near the cemetery on the feast-day of the saint whose relics were in the church. In provinces in central France the village festival is still called the " apport," a name reminiscent of the offering which on that day every good Christian should present at the altar of the local saint.

In the Middle Ages by the influence of the saints men were torn away from their monotonous lives, and compelled to take a staff and set out through the world. All travellers were then pilgrims. The poorest went from abbey to abbey, from hospice to hospice, as far as the shrine of St. James at Compostella, while those who could not undertake a long journey contented themselves with offering a candle to St. Mathurin of Larchant or St. Faron of Meaux. The roads in France were crowded with travellers who wore in their hats the leaden image[1] of St. Michel du Péril or of St. Gilles of Languedoc. These pilgrim signs were worth a king's safe-conduct, and these peaceable men who travelled " for the good of their souls " were unmolésted by hostile armies.

Then, too, in each province there were sacred spots, consecrated by some bishop, hermit or martyr. The springs formerly inhabited by a primitive goddess, or the rocks of the plain haunted by fairies, had been blessed by a famous saint. The peasant of the Morvan came yearly to drink at the spring which had gushed forth at the touch of St. Martin's crosier, or dragged himself on his knees round the rock on which the great bishop's mule had left the impress of its shoe.[2] The saints took the place of the genii of mountains, valleys and forests. The hill-tops formerly dedicated to Mercury were now consecrated to St. Michael, the messenger of heaven who shows himself on the heights. As in Celtic times, France became a great sanctuary in whose remotest parts the memory of some man of God was venerated.

Sanctuaries, hermitages and sacred wells made up the geography of the day. The lore of the saints was the only learning, and it influenced every thought and action. It was to the saints that a man looked for healing in

[1] See Forgeais, *Plombs historiés.* Paris, 1861. Second series, *Enseignes de pèlerinages.*

[2] See Bulliot and Thiollier, *La Mission et le culte de saint Martin dans le pays Éduen.* Paris, 1892.

sickness. Against fever he invoked St. Geneviève of Paris, against diseases of the throat St. Blaise. St. Hubert, the great huntsman who lived for so long among the hounds, cured hydrophobia by means of a horse-shoe, first blessed in his chapel, then applied red-hot to the wound. St. Apollina, whose jaw was broken by her persecutors, cured the toothache. St. Sebastian, St. Adrian, and from the fourteenth century St. Roch, were the protectors of towns against the plague, which never entered a house bearing the three protective letters V. S. R. (vive Saint Roch).[1] A patron overflowing with kindness had pity to spare for all the weaknesses and fears of poor humanity. The girdle of St. Foy or of St. Margaret relieved the expectant mother of the weariness of her condition, a ribbon bearing the name of St. Amable of Riom worn on a child's wrist prevented nightmare, St. Servatius sustained feeble souls in fear of death. St. Christopher guarded men from sudden death, and it was enough to have seen his great figure at the entrance to the church to be sure of a safe return from a journey : [2]

" Christophorum videas, postea tutus eas."

The virtue of prayers recited in honour of the saints extended to the plants, the animals, to all nature. St. Cornelius protected the oxen, St. Gall the hens, St. Antony the pigs, St. Saturninus the sheep,[3] and St. Medardus sheltered the vines from the frost.

In men's profound ignorance of the laws of nature, this passionate longing for support, healing or safety is peculiarly touching.[4] In the crises of life, in times of sickness of body or of soul, the comforting name of some saint came to mind. The traveller who had lost his way at nightfall prayed to St. Julian the hospitaller. Desperate causes were confided to St. Jude. Knights keeping vigil before entering the lists invoked the aid of St. Drausinus, bishop of Soissons. Thomas à Becket passed the night at the bishop's tomb before starting for England to fight as God's champion against Henry II.[5] Men imprisoned in deep dungeons confided themselves to St. Leonard, promising like Bohemund to hang silver chains in his chapel on the day of their deliverance.

[1] In the south of France and the north of Spain.

[2] The bas-relief of St. Christopher is still to be seen in the cathedral at Amiens (entrance). The huge statues of St. Christopher at Auxerre and at Notre Dame at Paris only date from the fifteenth and sixteenth centuries.

[3] On protectors of cattle see Rolland (Eug.), *Faune populaire de la France*, V., III.

[4] The trivial side is that the virtues attributed to the saints were often only justified by a pun. St. Lié cured rickety children, St. Fort strengthened them, St. Vat made them walk, St. Claire cured eye maladies.

[5] See Michel Germain, *Hist. de Notre-Dame de Soissons*, III., i. The tomb of St Drausinus is now in the Louvre.

OF THE THIRTEENTH CENTURY

The now forgotten proverbs which for centuries passed from mouth to mouth, blended the names of saints with the counsels of popular wisdom. The church calendar was so familiar that one could say :

> " A la Saint-George
> Sème ton orge ;
> A la Saint-Marc
> Il est trop tard."

or

> " A la Saint-Barnabé
> La faux au pr.
> A la Saint-Leu
> La lampe au cleu." [1]

In the little calendars carved by unlettered peasants the chief dates of the year were marked by the attributes of some saint. An arrow stood for St. Sebastian's day, a key for St. Peter's, a sword for St. Paul's,[2] and such hieroglyphs were universally understood.

The saints marked the rhythm of the year. Like constellations they seemed to rise in turn above the horizon. They retained something of the pagan charm of nature and of the seasons. St. John's day, celebrated at the time " où toute herbe fleurit," was in some measure the festival of the sun. St. Valentine's day, marking the end of winter, was (especially in England) the festival of early springtime. It was said that on that day the birds mated in the woods, and every youth should place flowers at the window of the beloved.

In popular thought the saints not only marked the return of the seasons, but regulated their progress. Like the old Germanic gods they distributed fair and bad weather at will. In Provence, St. Caesarius of Arles had power over storms, and his glove full of air taken into the valley of Vaison had there let loose the winds.[3] St. Servatius kept three days of snow in reserve even in the middle of May. St. Barbara averted the lightning, and the bells which were sounded during a storm bore her likeness.[4] St. Medardus was the master of the rain. Several saints shared this privilege with him ; and irritated by the uselessness of their prayers during long droughts, the people more than once drenched the statue of the saint whom they had vainly invoked.[5]

[1] See Leroux de Lincy, *Le livre des proverbes français*. "On St. George's day sow thy barley (April 23), on St. Mark's it is too late (April 25) ; on St. Barnabas day the scythe to the fields (June 11), on St. Leu's the lamp on the nail " (September 1).

[2] See Cahier, *Caractéristiques des Saints*, II. Article, " Calendrier."

[3] G. of Tilbury, *Otia imperialia*, part III., ch. xxxiv.

[4] See *Bullet. monum.*, XXIV., p. 227 *seq.*

[5] Molanus, *De sanct. imagin.*, II., xxxiii.

RELIGIOUS ART IN FRANCE

All nature proclaimed the glory of the saints. The Milky Way was called " St. James's path," the phosphorescence of the sea " St. Elmo's fire." In Flanders the little hedgerow berries which ripen in winter were known as "lamps of St. Gudule," and in the north of France the plantain which cured the king's evil as " herb of St. Marculphus." [1]

And thus under cover of the saints the old paganism lived on. One must imagine the whole of mediæval France much as one now sees Brittany with its chapels, wells and pardons.

II

One can well understand how it is that the figures of the saints fill so large a place in the churches, and why so many windows are dedicated to them. The people never wearied of seeing their protectors and friends, for they felt to be on more familiar terms with them than they could be with an omnipotent and far-off God. Neither did they weary of hearing them spoken of, and famous miracles and illustrious examples from the lives of the saints were commemorated in poems in the vernacular, in popular drama and in sermons. The Church was the faithful depository of almost all this endless history. Each cathedral or monastery kept the Acts of the saints of the diocese, and solemnly read them on their festivals, while the lives—more or less abridged—of the saints famous throughout Christendom were contained in the lectionary. For centuries the saints lived in the memory of the Church through the lectionary, and when in the course of the thirteenth century the various old liturgical books were replaced by one book,[2] the lessons of the lectionary passed into the breviary. The lectionary was made up of extracts from the more famous legends. The *Historia apostolicæ* of Abdias, the *Historia Erimitica*, translated by Rufinus of Aquileia, the "Dialogues" of St. Gregory, the " Martyrology " of Bede, and many anonymous stories were all requisitioned with great simplicity and a complete absence of the critical spirit. It was a summary of the lives of the saints, invaluable at a time when books were scarce.

Thus it was no new departure when at the end of the thirteenth century Jacobus de Voragine wrote the famous *Golden Legend*,[3] for in it he simply

[1] On plants which have the names of saints consult the old book, Bauhin's *De plantis a divis sanctisve nomen habentibus*, Basle, 1591, 12°. St. Marculphus cured the king's evil, and it was said that it was he who gave the power to the kings of France. After their sacring they visited the abbey of Corbeny (near Laon) where he was buried.

[2] See Battifol, *Hist. du Bréviaire*, ch. IV. p. 193 *seq.*

[3] Jacobus de Voragine, a Dominican and bishop of Genoa, was born about 1230 and died about 1298.

popularised the lectionary, preserving even its sequence.[1] His compilation is in no sense original. He is content with completing the stories by recourse to the originals, and with adding new legends here and there. The *Golden Legend* became famous throughout Christendom, because it put into the hands of all men stories which until then had hardly been found outside the liturgical books. The baron in his castle, the merchant in his shop could now enjoy the beautiful tales at will.

The attack made on Jacobus de Voragine by scholars of the seventeenth century misses its mark. The *Golden Legend*, which they accused of being a "legend of lead,"[2] was not the work of a man but of the whole of Christendom. The candour and the credulity of the writer belonged to his time. The stories of St. Thomas's voyage to India or of St. James's miraculous cloak, recounted so naïvely in the *Golden Legend*, though displeasing to the strict theologians trained in the school of the fathers of the Council of Trent, were universally accepted in the thirteenth century. They were read in public in the churches, and they were illustrated in the windows. To condemn Jacobus de Voragine is to condemn all the ancient lectionaries, and with them the clergy who read them and the faithful who listened.

The *Golden Legend* remains one of the most interesting books of its time for those who seek in mediæval literature for the spirit of the age to which it belonged. Its fidelity in reproducing earlier stories, and its very absence of originality make it of special value to us. It is an admirable representative of a number of works which for our purpose it renders almost superfluous. By its aid can be interpreted nearly all the bas-reliefs and windows which deal with legends, and in re-editing it Graesse rendered a valuable service to the history of art, if not also to the history of religion.[3] So we will take the *Golden Legend* as our chief guide, seeking in that popular book the interpretation of the works of art made for the people.

One can easily imagine the charm such a book had for the Middle Ages, and the moral sustenance men found in it.

To begin with, the numerous biographies presented a varied picture of human life. To know the lives of the saints was to know life from many sides, for in them every age and every condition could be studied. Modern novels or French *comédies humaines* are less varied and less rich in their presen-

[1] The legends are told in the order of the church calendar, beginning with Advent.

[2] The Bollandists in their preface, and Molanus (II., xxvii.) : "Tolerat Ecclesia legendam auream Jacobi de Voragine quam alii plumbeam vocant."

[3] *Legenda aurea*, Ed. Graesse, Wratislaw, 1890, 8vo. Brunet translated the *Leg. aurea* into French, Paris, 1843, 2 vols. 12vo. Th. de Myzewa has made a more recent translation. [See Caxton's version, published in the Temple Classics.]

tation of life than the immense collection of the *Acta Sanctorum*, and of this great storehouse the *Golden Legend* gives us the essential part. There was no business or profession which had not had its saint. Saints had been kings like St. Louis, popes like St. Gregory, knights-errant like St. George, shoemakers like St. Crispin, beggars like St. Alexis. Even a canonised lawyer could be found, and in the hymn sung in honour of St. Yves the people showed their good-humoured surprise :

> " Advocatus et non latro,
> Res miranda populo."

In that great company deemed worthy to sit at the right hand of God there were shepherds, cattle-drovers, carters, serving men of all kinds, and the lives of these humble Christians showed the seriousness and the depth of which all human life is capable. For the student in the Middle Ages it was a rich storehouse of wisdom. To the simplest it offered a model after which to fashion his life.

The *Golden Legend* taught the Christian something not only of life but of other times and other countries. It is true that the universe is there presented after a vague and chaotic fashion, distorted as in the old maps, but still it was an image of reality, and it gave the Middle Ages some dim notion of history and geography. According to the day of the week the book transported the reader to the desert of the Thebaid, among the tombs which the hermits inhabited in company with the jackals, or to the Rome of St. Gregory, deserted, in ruins, devastated by the plague. At another time the story-teller led the reader to the banks of the rivers of Germany, or made him fly with him to the " Isle of the saints." By the end of the Christian year all countries and all times had been traversed in imagination, and the humble peasant who knew nothing of the world beyond the street in which he lived and its clock-tower, had shared the life of the whole of Christendom.

But the book's greatest charm lay less in the true than in the marvellous. The lives of many of the saints equalled the most romantic of novels, and the legends of eastern saints compiled by Greek or Coptic hagiographers read like fairy-tales. Among them the stories of St. Eustace, St. George and St. Christopher are remarkable for their strange and unexpected features.

The legend tells how one day when pursuing a stag, Placidas, Trajan's general, saw the figure of the Christ between its horns. The miracle converted him. He was baptized with his wife, and took the name of Eustace (Fig. 138). Then God brought him to ruin, that he might prove him as

OF THE THIRTEENTH CENTURY

He had proved His servant Job. Eustace, penniless, took ship with his family and reached Egypt, but he had no money to pay his passage and the owner of the boat kept his wife as hostage. Overcome with sorrow Eustace plunged into the unknown country, and arrived with his two children on the bank of a river. One of them he carried over, and he was returning to

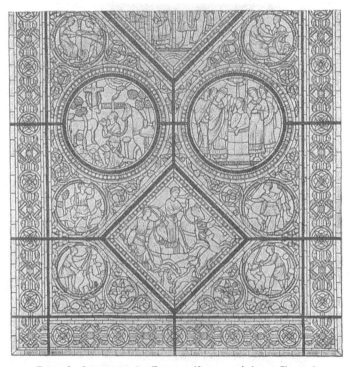

FIG. 138.—LEGEND OF ST. EUSTACE (first part, window at Chartres)

fetch the second, when as he was half-way across the river, he saw one child being carried off by a wolf and the other by a lion (Fig. 139). The wretched Eustace found his way to a neighbouring village, and found work as a labourer. There he stayed for some years, lamenting the sons whom he believed to be dead, while all the time they were living not far from him with the peasants who had saved their lives. The story ends like the classical romances and comedies. The dramatic device to which Menander and Terence so often had recourse, the recognition, the ἀναγνώρισις, is skilfully handled by the hagiographer. Some of Trajan's soldiers passing through the village in

275

which Eustace had taken refuge, saw and recognised their general. Eustace, whom it seems the emperor had reinstated at the head of the legions,

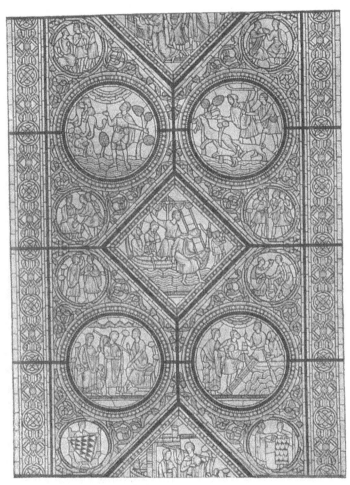

FIG. 139.—LEGEND OF ST. EUSTACE (second part, window at Chartres)

recognised his long-lost sons among the soldiers. In their turn the two young men are recognised by their mother, who had overheard them in an inn telling tales of their childhood. And so after many trials Eustace was at last reunited to his wife and children. But their happiness was short-lived. On learning that Eustace was a Christian, Trajan's successor imprisoned him

276

with his wife and children in a bull of bronze, and inflicted on them the torment devised by Phalaris (Fig. 140).

For the man of the Middle Ages such stories had all the charm of our tales of adventure.[1]

The legend of St. George, which arose in the Greek world, is the frag-

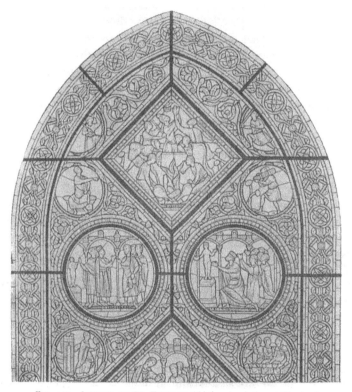

FIG. 140.—LEGEND OF ST. EUSTACE (third part, window at Chartres)

ment of an epic, for in Greece the epic spirit had never lost its vitality. St. George is the Perseus of the Christian east. The story goes that near to Silenus in Libya there was a pond inhabited by a monster to whom the town regularly sent a tribute of sheep. If by misadventure they failed to do so, the monster came even to the walls of the city and poisoned the

[1] The legend of St. Eustace was a favourite one with the mediæval artist (see the windows at Sens, Auxerre, Le Mans, Tours). At Chartres two windows are dedicated to him, in addition to a bas-relief in the south porch.

air with its breath. When there were no more sheep young men and maidens were offered to the monster. Now it happened that the lot fell on the king's own daughter. Nothing could save her, and after a week's delay, clothed in royal apparel she walked towards the pond, watched by the whole town. St. George, who was passing by, saw that she was weeping and asked her whither she went. "Young man," she said, "I believe that thou hast a noble and great heart, but haste thee to depart." And George replied, "I will not depart until thou hast told me the cause of thy tears." When she had told him all, he answered, "Fear nothing, for I will come to thine aid in the name of Jesus Christ." "Brave knight," she said, "do not seek death with me. It is enough that I should perish, for thou canst neither help me nor deliver me, but will succumb with me." At this moment the monster came out of the water. Then the maiden trembling said, "Flee with all speed, knight." For reply George mounted his horse, made the sign of the cross, and advanced towards the monster. Then commending himself to God he charged it bravely, flinging his lance with such force that it passed through the dragon and pinned it to the ground. Then turning to the princess he told her to fear nothing, and to put her girdle round the monster's neck. When this had been done the dragon followed her like a friendly dog.[1] Surely this romantic story equals the finest adventure of Lancelot or Gawain, for what knight-errant could compare with St. George?

The story of St. Christopher is even more amazing. Christopher was a giant twelve cubits high and of a terrible appearance, who lived in the land of Canaan. He entered the service of a king because it was said that this king was the most powerful in the world. One day, however, the king crossed himself on hearing the name of the devil, and thereby Christopher knew that there was in the world one more powerful than his master. So he set forth and put himself at the service of the devil. He met him in a desert place and accompanied him on his way. On reaching the cross-roads they came on a crucifix, and the devil suddenly fled. When Christopher rejoined him, he would fain know the cause of this sudden terror, and when pressed with questions the devil had to confess that there was one more powerful than he, and that one was Jesus Christ. Without loss of time Christopher went forth to seek this master who was more powerful than the devil, and he met a hermit who taught

[1] *Leg. aur.*, taken from Brunet's translation [*Golden Legend*, iii. p. 126 *sq.*]. St. George is represented three times at Chartres (see the statue in the south porch, window in the nave, window in the choir). At Lyons two bas-reliefs in the porch are devoted to him.

him the truths of the Christian faith and baptized him. Then the hermit, desirous of advancing him on the path of perfection, recommended him to fast, but of this the good giant was quite incapable. He then enjoined the reciting of prayers, but Christopher became confused and could not remember them. Being now better acquainted with his convert, the hermit established this man of goodwill on the bank of a fast-flowing river, where year after year many travellers were drowned. Christopher took the passers-by on his back, and with the help of a stick he managed to carry them across the stream. One day he heard himself called by a child ; he came out of his hut, and taking the child on his shoulders he began to ford the stream. But when he was in the midst of it, the child became so heavy that the giant, bent double with his weight, could hardly struggle to the other side. When he had reached the bank he asked the child who he was. " So great was thy weight," he said, " that had I carried the whole world on my shoulders I should have had no heavier burden." " Be not surprised, Christopher," was the answer, " for thou hast carried on thy shoulders not only the whole world but the creator of the world. Know that I am Jesus Christ." And the child disappeared, and Christopher, who had stuck his stick into the sand, saw that it was covered with flowers and leaves. A short time after this Christopher died the death of a brave martyr in the town of Samos in Lycia.[1] If St. George was the Perseus, St. Christopher was the Hercules of Christendom, like him born to serve. The old-time heroes, who were believed to be dead and gone, lived again under new forms in mediæval Greece.

Primitive people delighted in these stories. Almost all the legends of saints of eastern origin read like romances. Saint Theodora disguises herself as a monk, and for twenty years lives unsuspected in a monastery ; St. Alexis goes to beg at his father's palace door, sleeps under the stairs with the dogs, and is recognised by no one. The legend of the Seven Sleepers of Ephesus is as charming as a tale from the " Thousand and one Nights," for in it neither cave nor treasure is forgotten.

The stories of the western saints were less rich in adventure, but a few biographies of saints of Germanic or Celtic origin stirred men's imagination. The legend of the saintly king Gontran of Burgundy, who guided by rats found a subterranean passage filled with gold, was no doubt a popular song

[1] *Leg. aur.*, *De Sanct. Christoph.* Window at Chartres. Figures of St. Christopher became numerous at the end of the Middle Ages.

RELIGIOUS ART IN FRANCE

of the Burgundian tribes.[1] The life of St. Patrick of Ireland and that of St. Brandon were apparently written by Celtic bards not long converted to Christianity.[2] The poet (he deserves the name) constantly transports his reader to the confines of the known world. Before the time of Marco Polo St. Brandon's adventures on the sea was the only book of travels possessed by the Middle Ages, and even fifteenth-century navigators dreamed over the magic islands which the Irish saint was reputed to have discovered in the ocean.

If there were fewer adventures in the lives of the western saints, there were at least as many miracles. Even in the Middle Ages the Church held as suspicious several of the miracles in the *Golden Legend*, though the people accepted them all and attributed new ones to their favourite saints.[3] A St. Vincent de Paul or a St. François de Sales would have hardly been acceptable to the Christian of the thirteenth century. A true saint was a man who saw angels and demons face to face. The story that the devil extinguished her candle at one side while an angel relighted it at the other, was the one episode in the legend of St. Geneviève which the people of Paris remembered.

The continual intervention of angels gives a great charm to these legends. The angels come to serve the saints in all humility, for through conflict and suffering these heroic men have become greater than they. Angels gently bear the old St. Peter Nolasco, founder of the Mercedarians, to the choir stalls, when his limbs will no longer support him. They finish the furrow which St. Isidore had left in order to pray, and after her martyrdom they carry the body of St. Catherine to Mount Sinai. Earth and heaven meet. Christ descends to His prison, and communicates St. Denis with His own hands.

The miracles in which the saints showed their power over nature were the people's favourites. The world seemed to regain its primitive innocence, and the hermits who lived in the forests of Gaul lived in Eden. St. Calais's companion on the plain of Le Perche is an auroch, the wild bull of ancient Gaul. St. Gilles is fed by a hart, and his hand is pierced with an arrow in defending it against the king's huntsmen, for many a time when hunting the Merovingian kings found themselves face to face with the hermits. St. Blaise cures the sick beasts, but before approaching him they wait until he

[1] The legend of Gontran, like that of several saints of whom we shall have occasion to speak in this chapter, does not appear in the *Golden Legend*, but as we have already pointed out the name "Golden Legend" is for us a convenient title for all the collections of lives of the saints in use in the Middle Ages.

[2] St. Patrick changed a king of Ireland into a fox.

[3] The miracle of the three school-children resuscitated by St. Nicholas is, as we shall presently show, a popular invention.

has finished his prayers, and St. Bridget caresses the swans of the northern seas which fall on the frozen pond at Kildare.

In the Vitae Sanctorum man is reconciled with nature and the most savage of beasts becomes the gentlest. A lion follows St. Gerasimus in the desert,[1] a wolf leads the blind St. Hervaeus through Brittany, and when St. Gervase sleeps in the open air an eagle hovers over his head to shelter him from the rays of the sun.

Virtue, it seems, proceeds from the saints, and even inanimate nature leaps with joy as they pass by. The trees, stripped of their leaves by the winter winds, suddenly become green at the passage of the relics of St. Firmin, and nowhere is the grass so fine as where St. Ulphia of Picardy goes by on her way to church. Everywhere about them the saints re-establish the world's ancient harmony. Many of the legends which had sprung from the hearts of the people testify to a profound feeling for nature, and they are to the honour both of those who created and of those who adopted them.

Such is the charm of the *Golden Legend*. In the thirteenth century men found there all that they loved best: a picture of human life, a summary of the world's history, strange adventures, and wonderful miracles.

Since the Council of Trent the Church has dealt severely with these simple stories, judging no doubt that so many marvels tended to hide the true greatness of the saints. The seventeenth-century scholars understood their time, and they were anxious that the lives of the saints should not become an occasion for scandal to minds made critical by Protestant influence. The formidable Launoi deserved his nickname of *dénicheur de saints*, and as he bowed low before him the curé of St. Eustache trembled for his church's patron. Such scruples could not occur to the mediæval Church. And, moreover, under the trappings of legend the people's insight almost always divined the truly sublime. The endless stories of St. Martin's miracles did not blind the craftsmen to the most human feature of his life, and they immortalised the heroic action of the young Roman soldier who took his sword to cut in half his military cloak, that he might clothe a poor man.

III

We will now see how art interpreted the *Golden Legend*, which for so many reasons was a favourite book in the Middle Ages.[2]

[1] The painters early confused St. Gerasimus with St. Jerome, and the latter is also painted with a lion as companion.

[2] It will not be necessary to remind the reader that the majority of the thirteenth-century windows were executed before Jacobus de Voragine made his collection. But the *Golden Legend* was already contained in the lectionaries and in Vincent of Beauvais's *Speculum historiale*.

RELIGIOUS ART IN FRANCE

In the thirteenth-century cathedral the great saint is glorified in two ways ; either his whole life is recounted in a series of scenes, or his likeness with well-defined characteristics is placed before men's eyes.

The first manner was the favourite with master glass-painters, and glass was narrative during the thirteenth century. The marvellously preserved windows in the aisles of the cathedral of Chartres are splendid pages of a *Golden Legend*, the whole forming one of the finest illustrated books which ever prince purchased at its weight in gold. Every scene can be deciphered without difficulty with Jacobus de Voragine's text at hand.[1] Beginning at the bottom, the artist follows the legend step by step until he reaches the top of the window. The story of St. Eustace, for example, is unfolded in twenty medallions, from the appearance of the miraculous stag to the martyrdom of the saint and his wife in the brazen bull. The essential only is retained in each episode, and only a small number of figures in lifelike attitudes is placed in one medallion. From a distance their gestures are expressive, though seen at close quarters they seem exaggerated to the point of caricature. Decoration is reduced to a minimum—a tree, the gate of a town, or undulating lines which stand for rivers or the sea, mere signs to suggest the place in which the scene takes place. There is no local colour. Roman soldiers have the shield and the coat of mail which belong to the thirteenth century, emperors seated on a throne like the famous bronze chair at St. Denis have the crown and sceptre of the French kings. One king resembles another, one soldier another. They are almost like symbols. There is no wish to go beyond the subject and develop some brilliant episode, none of those digressions, scenes of family life, elaboration of decorative or architectural detail, in which the glass-painters of the Renaissance delighted. These little pictures have the remarkable quality of lucidity and abstraction which we associate with the French classical drama. Though the legends of the saints are often diffuse and lengthy, the artists who interpreted them were rarely guilty of those faults.

The second manner of doing honour to the saints was to present them for the people's respect not actively engaged, but standing motionless in some dignified attitude. The saints are seen under an almost superhuman aspect in the clerestory windows or the statues in the porches. While the thousand compartments in the aisle windows tell of the conflict and suffering of this

[1] A few windows are devoted to lives of local saints which do not appear in the *Golden Legend*, others to Old Testament characters (Noah, Joseph). All of them are explained in Bulteau's *Descrip. de la cath. de Chartres* (edit. of 1850, 1 vol.), and *Monographie de la cathédr. de Chartres*, vol. iii.

life, these great figures breathing deathless serenity represent the blessed, transfigured by the light of another world. The first are consecrated to the Church militant, the second to the Church triumphant.

The craftsmen, in particular the sculptors, whose business it was to represent these great figures were face to face with one of the most difficult problems in art. Each face must express a different virtue. Nothing could be less monotonous than the personality of the great saints, and in the *Golden Legend* each has his characteristics. St. Paul is the man of action and St. John the contemplative. St. Jerome is the scholar whose eyesight has grown dim in poring over books, and St. Ambrose is the typical bishop, the guardian of the flock. There is no sentiment or shade of sentiment which is not incarnate in some saint. St. George has the courage which rushes into the jaws of death, St. Stephen the resignation which awaits it. St. Agnes, St. Catherine and St. Cecilia all personify virginity ; but St. Agnes is the simple maiden, ignorant and defenceless, whose emblem is a lamb, St. Catherine is the wise virgin to whom both good and evil are known, who disputes with the doctors, St. Cecilia is the virgin-wife who voluntarily embraces chastity. The life of the saints offered all these fine shades to the artist's consideration, with the result that an art which rarely represented any but saints is idealistic above all others. Its task was to depict souls. Fortitude, love, justice, temperance, these should be written on the faces of the statues, no cold abstractions but living reality. To speak like the doctors, there was in the saints more true life than in all other men ; they alone lived.

FIG. 141.—ST. THEODORE (Chartres)

At the same time each saint had his physical type and characteristics. Instead of representing "Eloquence" in the form of some orator, the artist had to carve the portrait of St. Paul, a small man with a bald head and a long beard, transfigured by his genius.[1] This art, at bottom so idealistic, was never divorced from reality, and in this lies the true greatness of mediæval art.[2]

[1] For example, the St. Paul in the Musée at Toulouse (fourteenth century).
[2] Especially in the second half of the thirteenth century. The artist of the beginning of the century was not so skilful in expressing the character of the individual.

It did not pursue the academic ideal, the canons of beauty laid down by the schools, colourless as pure water, but taking the most sorry forms made them radiant with meaning. The craftsman proceeded as

did the saints themselves when they carved out their lives after the image of God, until the vulgarity or the merely human beauty of their faces was transfigured by love, chastity and spiritual force. The artist, as the mediæval theologian might have put it, did what God Himself will do on the Last Day. He left to the elect the features which each had in life, but penetrated with the light of a pure soul and participating in the eternal beauty.

These were the principles which guided the hand of the artist in the thirteenth century, but they were dimly felt, guessed at rather than reduced to any set formulæ. All the mediæval statues of saints are not masterpieces, but the same endeavour is seen in all. Some of them are very fine. The St. Martin of the south porch at Chartres (Fig. 143) with pastoral staff in hand, energetic and severe, is a commanding figure. St. Modeste in the same porch seems the personification of chastity, while St. Theodore is the image of the true knight (Fig. 141). At Reims, though his head has gone, St. Nicasius walks with heroic serenity between two angels who smile at him. In the porch at Amiens St. Firmin (Fig. 142), clothed in celestial light, makes a gesture which is of all time. This figure is perhaps the

Fig. 142.—St. Firmin (Amiens)

finest expression in art of the depths of being ; the St. Firmin of Amiens is a soul. The apostles at Chartres and Amiens were conceived by men of genius. They almost all resemble their Master as though His spirit in passing into them had moulded them.

Mediæval art owes its inimitable quality to the obligation which for three centuries bound the craftsman to represent men superior to man.

One can now understand the influence of the *Golden Legend* on the history of French art.

Were this the place we could show how the study of the legends

284

OF THE THIRTEENTH CENTURY

of the saints refined the sensibility of the Italian artists, and gave them knowledge of man's spiritual life. At the end of the fourteenth century with the help of painting—a subtle instrument of analysis—the attempt was made to portray souls of the most widely different kinds. In the fifteenth century Fra Angelico found his most delicate shades of feeling in the lives of the saints. Even the pagans of the sixteenth century painted the saints, putting all their knowledge of life into the faces, radiant with thought or with dreams, of a Magdalen or a Baptist in the desert.

IV

But in spite of all their endeavour, all their impassioned desire to represent clear-cut personality, the thirteenth-century artist could not contrive that men should unhesitatingly give a name to each of his statues. How would it be possible to prevent the confusion of two saintly knights—St. George and St. Theodore—or two maidens—St. Barbara and St. Agnes? In the thirteenth century men still sought the solution of the problem.

At Chartres it was solved in an ingenious way. A little scene which recalled some famous episode in the life or death of the saint was placed beneath his feet.[1] For example, beneath the bracket on which stood the statue of St. Denis, was carved one of the lions to which the martyr was exposed, and beneath the bracket of St. George's statue, a wheel which recalled the manner of his death. Above the instruments of their torture or above their persecutors, stand the saints in triumph.

But the artists wished to arrest the attention still more completely, and they began to place the instrument of torture in the hand of the saint. First the apostles appeared in the cathedral porches carrying the cross on which they had been fastened, the lance or the sword with which they had been pierced, the knife with which their bodies had been gashed. From the fourteenth century almost all the saints are represented holding a special attribute. In the Portail des Libraires at Rouen St. Apollina holds the pincers with which her teeth had been drawn, St. Barbara holds the tower with the three windows (symbol of the Trinity) in which she had

<hr/>

[1] See Fig. 143 which represents the embrasure of the right doorway of the south façade at Chartres. Under St. Martin, on the left, are the hounds which he stopped with a single word as they were about to seize a hare. St. Jerome has a Bible in his hand, and under his feet is the Synagogue, blindfolded, vainly trying to decipher a scroll (the text of Scripture).

St. Gregory the Great, on the right, has a dove (head broken) on his shoulder; under his feet is his secretary writing behind a curtain. He seems to be peeping through a hole as the legend recounts, and to be amazed at the sight of the dove speaking into the pope's ear (Fig. 144).
[2] We shall return to this.

been imprisoned by her father. Proud and triumphant the saints bear the instruments of torture which had opened to them the gate of heaven.

Sometimes the attribute was furnished by some famous episode in the life of a saint. St. John is recognised by the cup surmounted by a serpent, for it recalls that after making the sign of the cross the apostle drank a poisoned cup unharmed.[1] St. Gregory the Great is distinguished among other popes by the dove on his shoulder. It was said that the dove dictated his books to him, and hidden behind a curtain his secretary one day saw it whispering in his ear (Figs. 143 and 144). St. Mary of Egypt cannot be confused with any other penitent, for she carries the three loaves of bread which she bought before retiring to the desert and on which she was nourished for forty years. Here the whole life of the saint is gathered up in one distinctive feature. Such was the people's familiarity with these attributes that they were never mistaken in their reading of the saints in the porches and windows. We have here a fresh proof of the popularity of the *Golden Legend* which furnished the emblems.

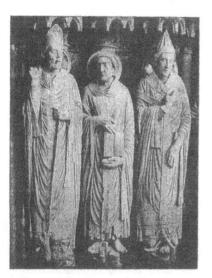

FIG. 143.—ST. MARTIN, ST. JEROME AND ST. GREGORY (Chartres)

But the *Golden Legend* does not account for them all. Closely connected with men's daily life, the saints received strange attributes in popular art. St. Martin, for example, is sometimes represented accompanied by a wild goose. No incident in his legendary history justifies this emblem. The goose is in fact intended as a reminder that the feast of St. Martin at the beginning of winter coincides with the migration of the birds.[2] In this case art has given form to an old saying.

Sometimes the attributes given by the artists created new legends, a proof of the influence on the people of their art. Here it is no longer art

[1] The little winged dragon often seen over St. John's cup symbolises the strength of the poison.

[2] In the *Caract. des saints*, vol. ii., art. " Oie," Father Cahier explains the emblem of the goose. See also *Saint Martin*, by Lecoy de la Marche, Tours, 1890, second edition, p. 606. St. Martin's goose is carved in the porch at St. Martin's at Worms. The goose is also seen on the seal of a canon of St. Martin's at Tours.

OF THE THIRTEENTH CENTURY

which borrows from the *Golden Legend*, but the *Golden Legend* which is inspired by artistic invention. This obscure process can be guessed at rather than explained, for the movements which take place in the depths of the popular consciousness are always half hidden in mystery. One knows that St. Denis is always represented carrying his head. He is seen in this attitude in twelfth-century and even earlier lectionaries.[1] The artists had no further intention than to recall the manner of his death, and the head in his hands was a hieroglyph which signified that St. Denis was decapitated. Though a little crude their idea is not without a certain grandeur, for the saint appears to offer his head to God. The people never really understood the artistic conventions, but interpreted what they saw according to their light. They imagined that St. Denis had actually carried his head after it had been cut off. The mediæval genius for myth-making is here seen at work, for before long this is found as a statement in the written lives of the saint, and unconsciously art had collaborated with the *Golden Legend.*[2]

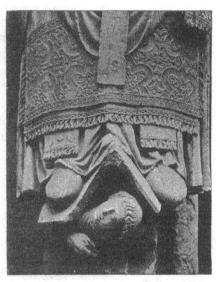

FIG. 144.—LOWER PART OF THE STATUE OF ST. GREGORY, SHOWING HIS SECRETARY BE-NEATH HIS FEET (Chartres)

In the same way the legend of St. Nicholas was enriched with a new miracle. From the twelfth century nothing was more famous than the story of the three children who after being killed by an inn-keeper, cut into pieces and put into a salting tub, were brought back to life through the intercession of St. Nicholas. This miracle is not found in early lives of the saint, nor curiously enough did Jacobus de Voragine consider it sufficiently substantiated for insertion in his collection of legends, and in the fourteenth century it does not yet appear in the lesson in the breviaries.[3] But during the whole of the thirteenth century the miracle of the three children

[1] Bibl. de l'Arsenal, MS. No. 162, f. 220 (*Lectionnaire*, twelfth century).

[2] Father Cahier believes that the acts of St. Denis were retold in the eleventh century. *Caract. des saints*, vol. ii. p. 776.

[3] Bibl. de l'Arsenal, *Bréviaire des Frères prêcheurs*, MS. No. 193, f. 64 *sq.* (fourteenth century). Each lesson in the Breviary is like a compartment of a window.

RELIGIOUS ART IN FRANCE

was represented in art. It is seen in a window at Bourges dedicated to
St. Nicholas, in two windows at Le Mans,[1] in a window at Troyes and one
at Chartres. The same story is illustrated on the numberless bas-reliefs
which decorate the Portail Saint-Jean at Lyons. We are evidently face to
face with a legend which was orally transmitted long before it was committed
to writing. Father Cahier's theory as to its origin seems so entirely in line
with mediæval custom that one may take it as established.[2] It is related in
the *Golden Legend* that St. Nicholas delivered three of the Emperor Con-
stantine's officers who had been unjustly imprisoned, tearing them away
from the hands of the executioner at the moment when they were to be
put to death. This story was early taken as a subject for art, especially in
the east where the cult of St. Nicholas arose. In accordance with mediæval
custom, which in the east as in the west showed its respect for the saints
by making them of superhuman stature, St. Nicholas was represented as
very tall. The three officers at his feet appeared smaller than children, and
with the naïvety of the time their three heads were shown emerging from
the top of a tower to signify that they had been delivered from prison. In
the west, where the cult of St. Nicholas was introduced in the eleventh
century,[3] men were not familiar with his story, and they invented one to
explain what they saw. The three officers became three children, the tower
became a salting-tub, while the inn-keeper and his wife were figures which
lived in the popular fancy. One finds them in all stories ; they are Perrault's
ogre and ogress. This fairy-tale was added to the legend of St. Nicholas,
passing from mouth to mouth, and though found in no book the artists had
no scruples in illustrating it.[4] Moreover the story of the three officers, once
more reinstated, appears in windows (at Bourges, for example) concurrently
with the story of the three children.

The legend of St. George has a similar history. The delightful story
of the princess whom a knight saved from a dragon probably arose from
a misunderstanding of some picture. The west adopted the eastern custom
of representing idolatry as a monster. In his " Ecclesiastical History "

[1] In one of the windows at Le Mans the three
children wear the dress of a clerk. St. Nicholas was
the patron of clerks.
[2] *Vitraux de Bourges*, study of the window of St.
Nicholas.
[3] When the Italian merchants brought his body
to Bari.
[4] The legend of the three children raised by St.
Nicholas became very popular in the thirteenth century
because it was the subject of dramatic treatment.

A little Latin play based on this legend is preserved
in manuscript (thirteenth century) at Orleans. The
manuscript came from the monastery of Fleury, where
the play was acted by the pupils whose patron saint
was St. Nicholas. See Édelstand du Méril, *Origines
latines du théâtre moderne*, Paris, 1849, 8vo, p. 262. A
play based on a similar miracle was acted by the
pupils of the abbey of Einsiedeln in Switzerland.
See Creizenach, *Geschichte des neueren Dramas*, vol. i.
p. 104.

Eusebius relates that Constantine caused himself to be depicted piercing the dragon of paganism with his lance. The dragon became a symbol, and accompanied the figures of the valiant saints who like St. George had carried the faith to new countries. On the other hand, in the fifth and sixth centuries when the warrior-saint was first painted in eastern art the old traditions of classical art still lingered, and the allegories and personifications of pagan cults had not disappeared. An instance is seen in the mosaics at Ravenna where the figure of an old man crowned with reeds symbolises the river Jordan. It is more than likely that the figure of a maiden placed near to St. George and the dragon in the old paintings stood for the province of Cappadocia, which had been evangelised by the martyr. When this symbolism was no longer understood, the Greeks called to mind an epic story which accounted for every detail of the scene. It was written down by some monk and spread throughout Europe.[1]

The legend of St. George throws light on all the legends in which the dragon appears. Originally a symbol and so presented in art, it was soon taken literally. According to early Acts of the saints almost all the old-time bishops of France, and the founders of episcopal sees in particular, had to fight with monsters. Legend relates that St. Romanus of Rouen chained up the " gargouille " which desolated Normandy, St. Marcel of Paris put to flight a horrible serpent which inhabited a cemetery, St. Julian of Le Mans and one of his successors—St. Pavatius—killed the monsters which guarded a spring. The same thing was told of St. Front of Périgueux, of St. Lô, bishop of Coutances, of St. Loup, third bishop of Bayeux, of St. Germain, bishop of Auxerre. In Brittany as many as ten saints were credited with the adventure, in particular the two great bishops St. Brieuc and St. Pol de Léon. All these victories over monsters signify victories over idolatry, and legends of dragons are not later than the sixth century, that is to say the time when France became Christian.[2] In this way a mere metaphor became a vivid story on its passage through the people's creative mind.[3]

Whenever popular art touches a subject every detail becomes alive, and takes on concrete form. Where does St. Geneviève's candle come from if not from a metaphor ? The saint holds the flame of the Wise Virgins, the

[1] This explanation of the legend of St. George was suggested by the Bollandists (*Acta Sanct.*, April, III., p. 404). It was put forward more explicitly by G. de Saint-Laurent (*Guide de l'art chrétien*, V., p. 282), and Cahier (*Caract. des saints*, vol. i., art. " Femme ").

[2] It is true that it was at the height of the Middle Ages that St. Bertrand of Comminges was reputed to have killed a dragon. Father Cahier ingeniously supposes that the legend is derived from the designs on the casket in which his relics are contained. These represent men fighting with dragons (*Caract. des saints*, vol. i. p. 418).

[3] Originally the story of the dragon was a metaphor invented by the clergy, as is shown by the fact that as a rule the dragon is defending a spring which seems to be a symbol of baptism.

RELIGIOUS ART IN FRANCE

symbolic lamp spoken of in the Gospel. Unless guarded by an angel a breath of the evil spirit might well extinguish that flickering light. An illustration used in sermons became the scene full of humour found in the porch of Notre Dame at Paris, where on one side the devil blows out the saint's candle, on the other an angel re-lights it.[1] The mystical simile of the lamp of the Wise Virgins was also used in Flanders, where St. Gudule is seen on the seal of the chapter of Brussels carrying her lantern between the devil and an angel.[2]

Critical tact is needed to arrive at the real source of such legends, for the point of departure is not always in a metaphor but is sometimes in some misread fact. One wonders why from the end of the fourteenth century St. Antony, the hermit, is always accompanied by a pig wearing a bell. The people soon came to the conclusion that the saint had lived in the desert with this faithful companion, but one reads of nothing of the kind in the *Historia Eremitica*. In point of fact the legend probably took its rise in a misunderstanding of a confraternity image. There was in Dauphiny a religious order under the patronage of St. Antony, founded by two gentlemen in 1095. The Antonines were hospitallers who devoted themselves to the care of the sick and of pilgrims.[3] The order was protected both by individuals and by the state, and had houses in many French towns. Police regulations which forbade men to allow their pigs to wander at will in the streets, made an exception for the Antonines, and wearing their bells the pigs belonging to the hospital were allowed to seek food in the gutters. This privilege is commemorated in designs—probably for seals—which show St. Antony, patron of the order, accompanied by a pig with a bell. The image impressed itself on the popular memory, and lived on from century to century although the original meaning had been lost.[4] One finds a further proof that this was the origin of the attribute, in the crutch in the form of a T which is invariably drawn on St. Antony's cloak. This crutch was, so to say, the blazon of the order, and recalled that the brothers consecrated their lives to the infirm. Like the pig with the bell it persisted in works of the fifteenth and sixteenth centuries, when all memory of the old order of hospitallers had been lost.[5]

[1] The *Legenda aurea* (De Sanct. Genovef.) merely says that a candle, blown out by the wind, was relighted in her hand. The statue at Notre Dame has been restored.
[2] Cahier, *Caract. des saints*, i. p. 197. The same story is told of another Flemish saint, St. Wivine (twelfth century).

[3] See Advielle, *Histoire de l'ordre hospitalier de Saint-Antoine*, 1883.
[4] See Collin de Plancy, *Dict. des reliques*, 1821, i. p. 33, *Rev. archéol.*, 1855, eleventh year, and Cahier, *Caract. des saints*.
[5] From 1297 the Antonines became a congregation of canons regular and retained none of their attributes as hospitallers. (Advielle, *op. cit.*)

OF THE THIRTEENTH CENTURY

The mediæval faculty for creating legend is amazing. St. Erasmus, or Elmo, was the favourite saint of the Mediterranean sailors, and his image was seen on the prow of the feluccas. As patron of sailors he carries a capstan on which a cable is coiled. The emblem was not understood inland, and the people of eastern France, who held St. Erasmus in high honour, imagined that like other saints he held the instrument of his martyrdom. It was related that the torturers had opened his stomach, and with a refinement of cruelty had rolled his intestines round a windlass. The popular story was included in the Acts of the saint, and henceforth St. Erasmus was invoked against the colic. In the little church of Huys, near Braisne in the Soissonnais, mothers hung skeins of thread round the neck of his statue, and prayed for the recovery of their children.[1]

As we see, art often unconsciously collaborated with the *Golden Legend*, and the life of more than one saint was based on ancient symbolic forms of which the meaning had been lost. When one is told that St. Ronan beat the devil with his stick, one must understand that in the old chapel some Breton artist had carved the holy bishop symbolically placing his crosier on a demon prone at his feet,[2] and that the simple peasants took this as fact. It is evident that both learning and the critical spirit are necessary to the real understanding of the emblems which art placed in the hands of the saints. For archæologists the task has been simplified by Father Cahier's work. There is scarcely an attribute which he has not fully explained in the great dictionary which he called *Caractéristiques des saints dans l'art populaire*.[3] Scholars will add little to a book which not only utilised but outstripped all previous work. Pen in hand, Father Cahier read not only the whole collection made by the Bollandists, but all that had been written on the cult of the saints since the seventeenth century.[4] The only criticism one can make is that he has given too small a place in his huge catalogue to works of art. He was better acquainted with books than with monuments, and to make his work perfect he had need of his usual collaborator, Father Martin. As it is, his book makes it possible for us to recognise, almost without hesitation, most of the saints who figure in works of art, especially from the end of the Middle Ages down to the present day.

[1] Cahier, *Caract.*, i. p. 362. The skein, no doubt, symbolised the intestines. St. Erasmus was known at Huys under the name of St. Agrapard.

[2] Cahier, *Caract.*, i. p. 308.

[3] *Caractéristiques des saints dans l'art populaire*, Cahier. Poussielgue, 1867, 2 vols. fol.

[4] This dictionary supersedes · books like Helmsdorfer, *Christliche Kunstsymbolik und Iconographie*, Frankfurt, 1839; Mrs. Jameson, *Sacred and legendary art*, 2 vols., 1874; Guénebault, *Dict. Iconographique* (coll. Migne), 1850.

RELIGIOUS ART IN FRANCE

V

It is in fact at the end of the Middle Ages, the extreme limit of the period we are considering, that the multiplication of attributes is found. Custom then set apart a special emblem for each saint.

Nothing contributed more to the preservation and the diffusion of these signs than the craft guilds. All the guilds, as we have seen, had their patrons, and although documents are scarce and Étienne Boileau's book barely mentions this point,[1] one may conclude that they acknowledged in the thirteenth century the patrons they acknowledged at a later date. For the fourteenth century, and even more for the fifteenth and sixteenth, there is abundant information.[2] If one may judge by the lasting character of the worship of the guild saints for at least two hundred years, it seems probable that patrons changed little in any one district, and some of the texts and the monuments of the fifteenth and even the sixteenth century will throw light on the Middle Ages. The reasons which determined the guilds in the choice of a saint were often very simple ; St. Eloy was naturally the patron of goldsmiths, St. Crispin of shoemakers. But the reasons are not always so obvious. The carpenters, for instance, whose business it sometimes was to make the tabernacle in which the ciborium was placed, chose St. Anne as patron, on the ground that she had made the first of tabernacles, that is to say the holy Virgin who bore within her the Son of God.[3] The sawyers celebrated the feast of the Visitation, because on that day the Virgin and St. Elizabeth bent towards one another as do two workmen when using a saw.[4]

Some of the ideas which governed the choice are not lacking in beauty and a sort of touching simplicity. The porters recognised St. Christopher as patron because he had borne the child Christ on his shoulders.[5] The pin-makers chose the Nativity as their guild festival, because it was said that during the Christmas night the Virgin had fastened the Child's swaddling-clothes with pins, after the manner of nurses.[6] Servants invoked the active

[1] We are told, however, that the buckle-makers celebrated St. Leonard's day from the thirteenth century, and that the masons paid fines to the chapel of St. Blaise (St. Blaise continued to be the patron of masons).

[2] See especially *Les Métiers et corporations de la ville de Paris*, by R. de Lespinasse, 2 vols. (the first published in 1886) in the series issued by the city of Paris.

[3] They gave the name "brain of St. Anne" to the mixture of glue and sawdust which they used to fill up holes and to conceal the uneven surface of a plank of wood. See Forgeais, *Plombs historiés*, series I., *Méreaux des corporations de métiers*, 1861, p. 91.

[4] Cahier, *Caract. des saints*, II., article "Patrons."

[5] Lespinasse, i. p. 251, and Cahier, *op. cit.*

[6] Forgeais, *op. cit.*, p. 63.

and humble Martha, perfume-sellers Mary Magdalen who had poured a vase of precious ointment over the Saviour's feet, innkeepers St. Julian who had not refused to receive even the lepers.

In other cases the connection is not in the best taste. St. Bartholomew, who was flayed alive, was the patron of the tanners, and St. John, who was plunged in boiling oil, was the patron of the chandlers.[1] Many of these analogies are childish, and some are based on bad puns. A play on words made St. Clare the patroness of glass-makers. Although no episode in his life qualified him for it, St. Vincent was the chosen patron of the vine-dressers because V was the first letter of his name.[2]

Childish or touching, the cult of the patron saint had, as we see, its roots deep in the people's life. The demand of the guilds for the images of their protectors had its influence on art, and some of the attributes seen in their hands find justification in their position as patron rather than in their lives. St. Honoré carries an oven-shovel solely because he was the chosen patron of the bakers.[3] St. Vincent's bunch of grapes, seen on tokens issued by the guild of vine-dressers in the late Middle Ages,[4] has a similar explanation. It would be useless to seek the interpretation of such emblems in the *Golden Legend*.

The guilds did not always suggest new attributes to the artists, but they insisted on a clear rendering of the established ones. The carders, whose patron was St. Blaise, desired that the iron comb which had been his instrument of torture should be clearly distinguishable in his hands. An image of St. Eloy without his pincers would have found no favour with the gold-smiths. In this way the craft guilds contributed towards the custom of representing the saints with some characteristic and permanent emblem.[5]

A proof of this is found in the curious collection of figured leaden medals in the Cluny Museum. These little relics of popular art were found in the Seine, and during the reign of Napoleon III when the quays were being rebuilt, they were carefully collected by an antiquary, M. Forgeais, who then made them known. He supposed, with much probability, that these coins of the thirteenth to the sixteenth centuries came from the shops which in those days covered the old wooden bridges of the Cité. The bridges of Paris fre-

[1] Forgeais, *op. cit.*, p. 45.
[2] See Cahier, *Caract.*, articles " Calembour," vol. i., and " Patron," vol. ii.
[3] Forgeais, *op. cit.*, p. 32.
[4] *Ibid.*, p. 146.
[5] M. de Linas (*Mém. de la Société des Antiq. de France*, vol. xlv. 1884) believes that on a Limoges reliquary of the thirteenth century (now in the Vatican) he saw St. Joseph, patron of carpenters, holding the long measure which the members of the Devoir still carry during their tour of France. This seems a little premature in the thirteenth century, though by no means improbable.

quently broke down or were burned in the Middle Ages, and on each occasion a number of these small coins fell into the bed of the Seine, where they were preserved in good condition. Of all these coins, medals, and tokens which have come down to us, the most interesting are the tokens struck by the craft guilds. Each has on the one side the image of the patron saint, on the other the name or emblem of the guild. Some of them go back to the thirteenth, but the greater number of them belong to the fourteenth or fifteenth century. On all alike one sees the image of the saint—crude, childish, with all but essentials eliminated. But the outstanding feature, and that by which one immdiately recognises the patron, is the attribute he holds. It is evident that this emblem was the chief interest both of the man who struck the coin and of those for whom it was destined.

In the fourteenth century the patron saint and his emblem became hieroglyphic signs which could not be changed. At the end of the Middle Ages the attributes of the saints are seen everywhere, and on the coins issued by the towns and the blazons of certain religious orders the people had them constantly before their eyes. The arms of the Dominicans, for instance, was the dog with a torch in his mouth, which commemorated the prophetic dream of Dominic's mother before his birth. The blazon of the Carthusians showed the seven stars which announced the arrival of St. Bruno and his six companions, as seen in a dream by the bishop of Grenoble. The attributes of the saints passed into proverbs. It was said of two friends—they are inseparable as St. Roch and his dog.[1]

VI

It is evident to those who know Chartres, Amiens or Notre Dame at Paris[2] that the Middle Ages placed the apostles in the forefront of the host of saints whom they worshipped. For they are placed on either side of the principal doorway, and they surround the figure of Christ. They are painted or carved two or three times in all the cathedrals, and we too must give them a place of honour.

Sometimes the lives of the apostles are represented in art and sometimes their images alone. A number of windows at Chartres, Bourges, Tours and Poitiers are dedicated to the lives of the apostles, and few legendary works of the Middle Ages are more extraordinary. One would understand nothing

[1] Collin de Plancy, *Dict. des reliques*, art. "Proverbes."

[2] The apostles of the porch of Notre Dame at Paris have been restored.

of the miracles of St. John or the voyage of St. Thomas which are seen in the windows were one only acquainted with the Acts of the Apostles. For at least three hundred years their history was told after another fashion. These stories, definitely discarded by the Church after the council of Trent, were formerly famous. They came from the apocryphal books condemned by the Gelasian decree but nevertheless tolerated by custom. The east could not resign itself to the silence of the canonical books about most of the apostles. No doubt a few oral traditions worthy of belief still existed in the early Christian communities, but history was soon stifled by legend. Truth and fiction mingle in the "Acts," attributed to a certain Leucius, of St. John, of St. Peter, of St. Paul, of St. Thomas.[1]

More than one heretical sect took part in the composition of these stories, covering their errors under the authority of an apostle's name.[2] An unknown compiler, probably of the fifth century, collected almost all that had been written on the subject into a book entitled *Historiae apostolicae* which he attributed to Abdias, bishop of Babylon and contemporary and companion of St. Simon and St. Jude. The work of the pseudo-Abdias was reputed to have been first drawn up in Hebrew, then translated into Greek and finally done into Latin by a certain Julius Africanus. The Latin version was a mine of wealth to the Middle Ages. Vincent of Beauvais made use of it when writing his *Speculum historiale*, and in the *Golden Legend* Jacobus de Voragine usually contented himself with summarising it and with abridging the long speeches.[3]

In the mediæval Church the pseudo-Abdias enjoyed considerable authority. Not only was he tolerated but, as one knows by twelfth-century lectionaries which have come down to us,[4] portions of his work were read in the choir on the feasts of the apostles. In the thirteenth and fourteenth centuries the legends of the apostles were included in the first breviaries.[5] Thus the clergy had no grounds for forbidding the representation of these apocryphal lives in the church windows.

[1] See Battifol, *Anciennes littérat. chrétiennes.* Paris, 1897, 12°, p. 41.

[2] Notably in the "Acts of St. Thomas," a gnostic composition in which marriage is condemned. See Renan, *L'Église chrétienne,* p. 523. The apocryphal acts of the apostles have been published by Tischendorf, *Acta Apostolorum apocrypha* (Leipzig, 1851); several are translated in Migne's *Dict. des apocryphes*, vol. ii.

[3] The Latin text of the pseudo-Abdias was published by Fabricius, *Codex apocryphus Novi Testamenti.* Hamburg, 1719, vol. i.

[4] For example MS. No. 1270 (antiphonary and lectionary, twelfth century) in the Bibl. Sainte-Geneviève, in which may be read the whole apocryphal history of St. John, and the struggle of Peter and Paul with the magician at Rome (f. 155). See also Bibl. Sainte-Geneviève, MS. No. 132 (lectionary, twelfth century), the whole apocryphal story of James (f. 127 v.).

[5] See Battifol, *Histoire du bréviaire romain,* p. 209.

RELIGIOUS ART IN FRANCE

It was in large measure due to art that every circumstance in the lives of the chief apostles was known to the faithful. It was generally said that each had evangelised a different country. St. Peter brought the faith to Rome, St. Paul carried it from Jerusalem to Illyria, St. Andrew made it known to Achaia, St. James the Great to Spain, St. John to Asia, St. Thomas to India, St. James the Less to Jerusalem, St. Matthew to Macedonia, St. Philip to Galatia, St. Bartholomew to Lycaonia, St. Simon to Egypt and St. Jude to Mesopotamia.[1]

The journeys and miracles of all the apostles were not equally famous, and only the lives of St. Peter, St. Paul, St. John, St. Thomas, St. James, St. Jude and St. Simon were related in detail. The master glass-painters so frequently sought inspiration in these apocryphal stories that it is necessary to be acquainted with their chief features.

The legend of St. Peter is never found without that of St. Paul, and the two saints commemorated by the Church on the same day are found in the same window.[2] It was felt that the two apostles who had fought the same fight, and who it was said had embraced one another before going to their death,[3] must not be separated. And so the incidents in their sojourn at Rome, and the scenes in which they united in prayer to overcome Simon Magus were chosen for illustration in the windows.

The *Golden Legend* succeeded in transforming the apocryphal Acts of Peter and Paul. The Rome to which Jacobus de Voragine transports his readers is the mythical city beloved of the Middle Ages, the Rome embellished by Virgil the magician. Nero reigns there surrounded by sorcerers, and as the effect of a magic potion a frog is born to him and is brought up in the palace. Seneca the wise dare not oppose the folly of his pupil. Nero amuses himself by brandishing a sword over his tutor's head in order to terrify him. One day he even goes so far as to show him a tree and to ask him, "On which branch wilt thou be hanged?" His jest is so realistic that the wretched Seneca ends in killing himself, and by his death justifies his name (Se necans).[4]

It was before this legendary Nero that St. Peter and St. Paul were summoned to appear. The emperor had heard of their miracles, and had even

[1] Isidore of Seville, *De Ortu et obitu Patrum. Patrol.*, t. lxxxiii., col. 147 *sq.*

[2] The legend of St. Peter is found with that of St. Paul in windows at Bourges (Cahier and Martin, pl. XIII.), at Chartres (window in the choir), at Lyons (chapel of St. Peter), at Sens (apsidal chapel, mutilated and restored), at Poitiers (near the chevet), at Troyes

(apse of the cathedral), and in two windows at Tours (one in one of the apsidal chapels and one in the choir).

[3] The window at Bourges represents this last scene.

[4] *Leg. aurea. De sancto Petro. De sancto Paulo.*

heard that St. Paul had raised from the dead his cupbearer Patroclus.[1] But he was not convinced. The apostles had a formidable rival in the person of Simon the magician, who by means of his spells had gained great hold on Nero. Simon boasted that he could cause serpents of brass to move, make bronze statues to laugh and dogs to sing. He gave orders to a reaper's scythe and it did more work than ten harvesters. The appearance of his face changed with great rapidity, so that sometimes it seemed to belong to a young man and sometimes to an old one. One day he had his head cut off by the executioner, but through some art he substituted a ram for himself, and the third day after he appeared before Nero. That is why a statue with the inscription *Semoni deo sancto* was raised to his memory by the Romans.[2]

The emperor desired that his wonder-worker and the apostles should meet face to face ; and when they were in his presence St. Peter said to Nero, " If divinity be with him truly, then let him tell me my thoughts, and I will tell thee in thine ear of what I am thinking." And Peter said quietly to Nero, " Command that a barley-loaf be brought and be given me in secret." When Peter had received the bread he blessed it, and placed it in his tunic and said, " Let Simon who gives himself out as God, tell me of what I am thinking, what I have said, and what I have done." Then Simon answered, " Let it be Peter who tells me of what I am thinking." And Peter answered, " I will show that I know of what Simon is thinking." Filled with wrath Simon cried, " Let dogs come and devour thee." And immediately huge dogs appeared and threw themselves upon Peter, but he gave them the bread which he had blessed and immediately they fled away.[3]

But Simon did not consider himself vanquished, and he strenuously endeavoured to raise to life a young man who had just died. But in vain did he pronounce his most efficacious formulæ ; he could only cause him to move his head. Then the apostles drew near the bed, and St. Peter said, " Young man, in the name of Jesus Christ of Nazareth who was crucified, rise and walk." And the dead man arose and walked.[4]

Then the people murmured against Simon, and the magician declared that he would leave a town which was no longer worthy to be his dwelling-place, and announced that he was about to ascend to heaven. On the appointed day, crowned with laurel, he went up to the Capitol, and in the presence

[1] The window at Chartres shows St. Paul raising Patroclus.

[2] It is really the inscription " Semoni Deo Sanco " misunderstood. Semo Sancus was an old Sabine god.

[3] *Golden Legend*. Legend of St. Peter. (Taken from Brunet.) This episode is to be seen in the window at Chartres and in a window at Angers.

[4] Window at Bourges and window at Lyons.

of the whole city threw himself from the top of a tower and began to fly. Filled with admiration Nero said to the apostles, "This man hath spoken truly ; as for ye, what are ye but impostors ? " Then the apostles began to pray, and suddenly the demons who upheld Simon left him, and he fell down breaking his neck.[1]

Inconsolable for the loss of his magician, Nero had the apostles imprisoned in the Mamertine, but they converted their gaolers who thereupon set them free. Peter, fearing the death with which he was threatened, resolved to flee, and when without the walls of the city and arrived at the place where now stands the church of Santa Maria ad Passus, suddenly he saw Jesus Christ coming towards him. " Lord," said Peter, "whither goest thou ? " And He answered, " I go to Rome to be crucified anew." St. Peter understood the lesson which his Master would teach him, and weeping for his weakness he returned to Rome to die.[2]

The governor Agrippa immediately seized the apostles, and when they had been brought before him he condemned them to death. Before going to their torment they embraced one another. St Peter as a Jew was placed on a cross, and in his humility he begged to be crucified head downwards. At the moment of his death the eyes of his executioners were opened and they saw angels holding crowns of lilies and roses and surrounding Peter as he hung on the cross.[3] St. Paul as a Roman citizen was condemned to have his head cut off. On the way to execution he met a Christian named Platilla, and prayed her to lend him her veil that his eyes might be bandaged, promising to return it after his death. The soldiers began to laugh, calling him a false magician, and in derision they allowed Platilla to do as she wished. Near to the road to Ostia Paul was decapitated, pronouncing the name of Jesus Christ, and on the same day he appeared to Platilla clothed in matchless splendour, and returned to her the veil stained with blood.[4]

There are in these stories which we have summarised, echoes of the miracles of Apollonius of Tyana mingled with childish fables which belong to a late date. One fine episode only, the sublimely simple story of the *Domine, quo vadis*, recalls the great Christian literature of primitive days.

[1] Windows at Chartres, Bourges, and Tours. Rose-window at Reims dedicated to St. Peter. Window at Poitiers. Window in St. Père at Chartres (clerestory windows in the choir, fourteenth century).
[2] The famous episode of the *Domine, quo vadis* is represented in a compartment of the windows at Bourges and at Lyons, and in a bas-relief in the porch of Lyons cathedral.
[3] See the crucifixion of St. Peter in the cathedral of Rouen (Portail des Libraires), cast in the Trocadéro, *Catal.*, 610.
[4] *Leg. aurea. De sancto Paulo.* The episode of Platilla's veil appears in the window at Chartres.

OF THE THIRTEENTH CENTURY

Such legends as these gratified the dominant passion of the Middle Ages, their love of the marvellous, and they were naturally preferred to the serious contents of the Acts of the Apostles. The small number of works of art inspired by the canonical book in the thirteenth and fourteenth centuries is remarkable. Art preferred the turbid source of the apocryphal stories.[1]

The story of St. John is also almost entirely taken from the *Golden Legend*. His biography gave rise to more fables than the account of the life of any other apostle. By no means all the old stories were made use of by Jacobus de Voragine. He did not know, for example, the curious story of St. John which was reputed to have been written by his disciple Prochorus,[2] a story which deluded the Greek Church by its air of sincerity and its extreme precision of detail,[3] though it does not appear to have penetrated to the west before the sixteenth century.[4] Jacobus de Voragine did not even insert the events recounted by the pseudo-Abdias. The dramatic story of the love of Callimachus for Drusiana which in the tenth century was used by the Abbess Hrotswitha in one of her tragedies, does not appear in the *Golden Legend*. Yet, abridged though it is, Jacobus de Voragine's version is a sufficient explanation of thirteenth-century art.

St. John, says the legend, after he had been plunged in boiling oil near the Porta Latina at Rome, was exiled to Patmos where he wrote the Apocalypse. On the death of Domitian he was set at liberty and returned to Ephesus. As he entered the city he met the funeral of Drusiana, a Christian who had longed for his return but who had died without sight of him. Filled with compassion St. John stopped the funeral procession and raised her from the dead.[5]

On the following day he saw in the forum at Ephesus a philosopher named Craton who was giving the people a lesson in renunciation. Acting on his advice, two young men who were his disciples had sold all their goods and had converted the value into precious stones. Craton commanded them to

[1] Works of art taken from the Acts are so rare that it seemed proper to attach this study of the apostles to the chapter on the *Golden Legend* and not to that on the New Testament. Among the few works inspired by the Acts the following should be mentioned : at Semur a window in the chapel of the Virgin, dedicated to St. Peter (Peter before the judge, Peter in prison, Peter delivered by the angel) ; at Auxerre, a window of St. Peter and St. Paul fragments of which appear in several windows (St. Peter and the sheet filled with beasts, Ananias and Sapphira, St. Paul at Malta bitten by the viper) ; at Amiens, a window in the chapel of the Virgin showing the history of

St. Stephen and the conversion of St. Paul according to the Acts. The story of the conversion of St. Paul from the Acts (ix. 1-19) is also found on the lintels of the right and left porches of the façade at Reims. Left porch—St. Paul on the road to Damascus ; right porch—St. Paul struck with blindness and cured by Ananias.

[2] Migne, *Dict. des apocryphes*, II., col. 759 *sq.*

[3] See the episodes of the shipwreck (col. 762) and of St. John in the thermae (col. 765).

[4] Published by Néander at Basle in 1567.

[5] Windows at Chartres, at Bourges, and in the Sainte-Chapelle.

RELIGIOUS ART IN FRANCE

take a hammer and before witnesses to pound the jewels to powder. St. John censured this ostentatious scorn of riches in which he saw nothing but pride, and he said to them : " It is written, if thou wilt be perfect sell all that thou hast and give to the poor." " If thy master be the true God," answered Craton, " cause the stones once more to become whole, that the price in gold may be given to the poor." Then St. John prayed and the stones became whole as before, and the two young men and the philosopher believed in God.[1]

Touched by their example two other young men sold their goods, and after giving all to the poor followed the apostle. But before long they waxed sad and regretted their former condition. St. John perceived this, and one day as they were by the sea-shore he caused them to pick up some wood and pebbles, which he changed into gold and precious stones before their eyes. " Go, buy back your lands," he said, " for ye have lost the grace of God. Be sumptuously clothen that ye may be beggared for eternity." And the young men were sore ashamed, and after that they had done penance the gold and jewels became pebbles and wood once more.[2]

St. John's miracles stirred up against him the priests of the great Diana of the Ephesians, and they dragged him to the temple and would have forced him to offer sacrifice. But St. John prayed and suddenly the temple fell down. The " bishop of the idols ", Aristodemus by name, was not convinced even by so great a marvel. " I will believe in thy God," he cried, " if thou wilt drink the poison I give thee." " Let it be as thou wilt," answered the apostle. The strength of the poison was tested on two condemned men, who after that they had drunk it fell down dead. But undismayed, St. John took the cup in the presence of all the people, and after making the sign of the cross drank the poison yet sustained no hurt. Aristodemus was still incredulous. " I will believe," he said, " if thou canst raise the dead." Disdaining to approach the corpses of the two men, St. John told Aristodemus to lay his cloak over them, and when he had so done the dead were revived through the virtue of the apostle's mantle. Then St. John baptized Aristodemus, and the governor of the town and all his family, and founded a church.[3]

St. John was exceeding old, and being no longer able to walk, his disciples

[1] *Leg. aur., De sanct. Johan.* Windows at Bourges, Chartres, in the Sainte-Chapelle, at Tours (clerestory windows in the choir).

[2] Window at Chartres. Remembering that he had changed pebbles into gold, the mediæval alchemists believed that St. John knew the secret of the philosopher's stone. (*Hist. littér. de la France*, xv. p. 42.)

[3] This episode has been more frequently illustrated than any other, and is the origin of the cup which St. John holds. Windows at Bourges, Chartres, Tours, Troyes (window in the apse), Sainte-Chapelle, window at St. Julien-du-Sault (see Gaussin, *Portefeuille arch. de la Champagne*, 1861, pl. VIII.), Reims (in the small rose of the window in the choir dedicated to St. John), also at Reims (bas-relief of the south wall, near to the west porch, dedicated to the Apocalypse).

carried him to the church. And for all instruction he repeated the words, "My children, love one another." And when the brothers asked him why he repeated the same words, he said, "Because it is our Lord's command, and if this one be fulfilled it will suffice." St. John was ninety-nine years old ; and while writing his gospel a profound stillness had reigned over all nature and for respect the winds had not blown. And Christ appeared to

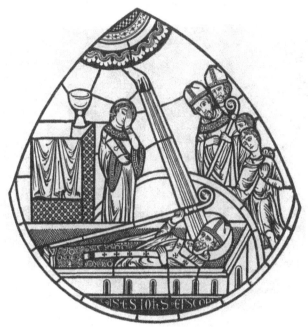

FIG. 145.—DEATH OF ST. JOHN (window at Lyons)
(*After L. Bégule*)

him and said, "Come to me, my beloved, for it is time that thou satest at my table with thy brethren." And on the Sunday following, when the faithful were assembled in the church, St. John exhorted them to obey the commandments, then he caused a grave to be dug at the foot of the altar (Fig. 145). Into this he descended, and joining his hands he prayed ; and he was enveloped in a light which no man could suffer. When the light had vanished the apostle was no more seen, and those who bent over the grave found it filled with sweet-smelling manna.[1]

[1] Chartres, Bourges, Tours, Reims, St. Julien-du-Sault, Lyons (window in the apse). In the window at Lyons only the death of St. John is taken from the apocryphal books, the other scenes are devoted to his

RELIGIOUS ART IN FRANCE

The life and death of St. John as told in the apocryphal books are not without elements of beauty. In the mind of the early editors the story of the precious stones was no doubt a sort of ingenious apologue in which Christian charity was opposed to Stoic pride. The legend of the death, or rather the mysterious disappearance of St. John, is due to the widespread belief among the early Christians that the well-loved disciple would not taste death. In the Middle Ages the truth of the legendary history of

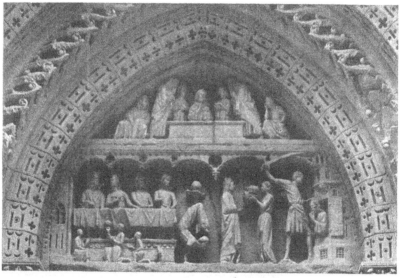

FIG. 146.—DEATH OF ST. JOHN THE EVANGELIST AND BEHEADING OF ST. JOHN THE BAPTIST
(porch at Rouen)

St. John was so firmly held that certain windows dedicated to him, such as those at Chartres and Bourges, contain not a single feature taken from the canonical books.

The legend of the adventures of St. Thomas in India was simply a romance, and was severely condemned by St. Augustine.[1] It was none the less dear to the people and to art. There was a certain charm in following Thomas to the confines of the known world, even to the kingdom of the mysterious Gondoforus. It was related that the eastern king had sent for

vision at Patmos. As Mlle. Louise Pillon (*Rev. de l'art chrétien*, 1894) has shown, the scene which is carved in the upper portion of the tympanum in the left porch of Rouen cathedral presents the mysterious death of St. John the Evangelist (Fig. 146). The other band of the tympanum is devoted to the beheading of John the Baptist.

[1] Augustine, *Contra Faustum*, XXII., cap. lxxix. *Patrol.*, xlii., col. 452. He saw in the legend of St. Thomas a work of the Manichæans.

him to come as architect that he might build him a palace "like those at Rome." The apostle embarked, and reached a town where a wedding was being celebrated. And being invited to it, he sat with the guests at the banquet. A young girl who had come from Judæa played the flute and sang, and guessing that St. Thomas was a Jew she began to sing in his own tongue, "It is the God of the Hebrews who hath created all things, and who hath hollowed out the seas." The apostle listened with eyes raised to heaven. Then the cupbearer, seeing that Thomas neither ate nor

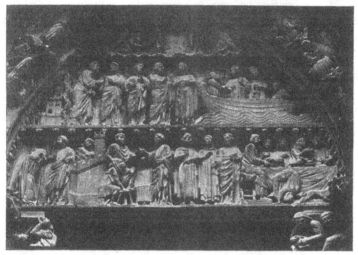

FIG. 147.—LEGEND OF ST. THOMAS (porch at Semur)

drank, was enraged and gave him a blow. But God would not let the insult go unpunished, and when the cupbearer went forth to draw water at the well he was killed by a lion. And the dogs tore him to pieces, and carried his hand into the banqueting hall. Then those which were present understood that there was in the stranger some unknown force, and the flute-player fell down at his feet. Then Thomas spoke, and such was his eloquence that the husband and wife begged to be baptized and vowed to live in continence. From there the apostle went to the capital, and the king presented him with the plan of the palace which he would build, laid open to him his treasure and went into another province. Then St. Thomas set about preaching the gospel, and he converted part of the city. When the king returned and learned what the apostle had done in his absence, he cast him into prison and condemned him to be

RELIGIOUS ART IN FRANCE

flayed alive. But on the day before the execution the king's brother, who was at the point of death, recovered from his sickness, and he said to the king, " Brother, I have seen the palace of gold and silver and precious stones which this man has built. It is in paradise, and it is thine if thou wilt." Then was Gondoforus troubled, and he sent for the apostle. And Thomas said to the king and to his brother, " Believe in Jesus Christ and

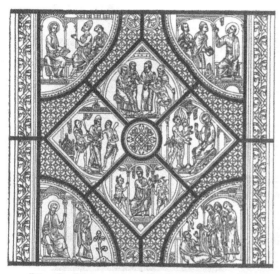

FIG. 148.—THE LEGEND OF ST. JAMES (from a window at Chartres)

be baptized, for in heaven there are countless palaces which have been prepared since the beginning of the world." [1]

The origin of such a legend is evident. It took its rise in a metaphor. The apostles built the edifice of the faith, a temple made of living stones, which is the Church, and even to-day the word "edify" has a spiritual meaning. Starting from that point some writer of lively imagination made St. Thomas an architect.[2] In the thirteenth century men took such things literally, without comment or examination. Nothing surprised such simple souls. Certain legends in which the apostles appear as skilful magicians seem

[1] *Leg. aur.*, *De sancto Thoma*.
[2] The legend of St. Thomas is illustrated in full in windows at Chartres (choir), Bourges (choir), Tours (clerestory windows in the choir). The whole of the tympanum in the north porch of the church at Semur is devoted to it. We would lay stress on the porch at Semur because the tympanum has hitherto been mis-interpreted. Local archæologists still suppose that it represents the story of the murder of Dalmace, assassinated by order of Robert, Duke of Burgundy. (Ledeuil, *Notice sur Semur-en-Auxois*. Semur, 1884, p. 56.) The *Guide Joanne* (*Bourgogne et Morvan*, 1892 ed., p. 172) sees in it the conversion of the people to Christianity. The various scenes should be in-terpreted as follows (Fig. 147) : Line 1, beginning from the left—St. Thomas putting his hand into Christ's side ; the provost of King Gondoforus meeting St.

Thomas and a disciple in the market-place at Cæsarea ; St. Thomas in a ship sailing to India. Line 2, be-ginning from the right—a feast, a dancer walking on her hands, and a dog holding the cupbearer's hand in its mouth ; St. Thomas receiving orders from King Gondo-forus ; instead of building the palace he distributes the king's treasures to the poor (one of the poor is sitting on a stool, another is holding a calabash and is of a pronounced negro type) ; St. Thomas in prison ; St. Thomas speaking to a kneeling figure whose head has disappeared, perhaps Gondoforus, though the garment seems to be that of a woman and it may be Migdomia asking forgiveness for having been the cause of his imprisonment. The presence of this legend of St. Thomas in the church at Semur is no doubt to be explained by the possession of some relic of the saint, but records are lacking.

to have been especially popular. Illustrations of a version of the story of St. James the Great which appears to have been taken from some book of magic are often reproduced in the windows.

It was said that when St. James was preaching in Judæa a magician named Hermogenes, not condescending to go himself, sent a disciple, Philetus, to convict the apostle of error. But it so happened that Philetus

was converted by St. James's words and miracles, and when Hermogenes learned of it he was so enraged that he cast a spell on him, and held him prisoner so that he could move neither hand nor foot. Philetus then sent a servant to acquaint St. James of his plight. And the apostle gave him his cloak (Fig. 148) saying, " Let him take this and say, ' God raises those who are fallen and delivers those who are captive.' " And immediately that Philetus had touched the cloak he was delivered from the captivity in which he was held by the magic spell, and he hastened to find St. James. Full

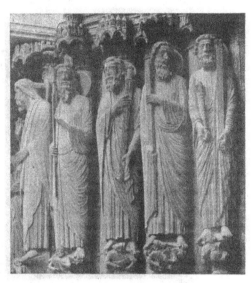

FIG. 149.—APOSTLES AT CHARTRES

of wrath Hermogenes called together many demons, and commanded them to bring to him James and Philetus bound, that he might be revenged on them. The demons flying through the air sought and found James, and said to him, " James, apostle of God, have pity on us, for we burn before our time is come." And he said to them, " Why are ye come to me ? " And they replied, " Hermogenes sent us to thee that we might take thee and Philetus to him, but as we came the angel of the Lord made us fast with chains of iron, and tormented us cruelly." And James said to them, " Return to him who sent you and bring him to me bound, but do him no hurt." And the demons took Hermogenes and binding him hand and foot took him to St. James. Then after that James had spoken to him kindly and had explained to him that Christians must render good for evil, he set him free. But Hermogenes dared not go. " I know the fury of the demons," he said,

RELIGIOUS ART IN FRANCE

"unless thou givest me something which doth belong to thee they will assuredly kill me." And James gave him his staff, and some time afterwards Hermogenes threw all his books of magic into the sea and was baptized.[1]

In the *Golden Legend* almost all the apostles have to contend with magicians. But it is St. Simon and St. Jude who strive with the most

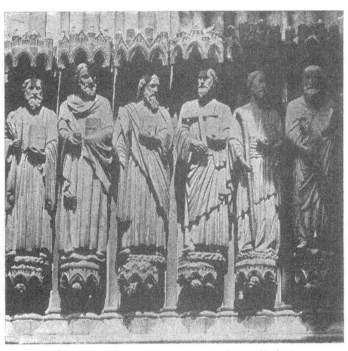

FIG. 150.—APOSTLES TO THE RIGHT OF CHRIST (Amiens)

formidable of sorcerers, and they challenge him even in the very sanctuary of the magic art, the temple of the Sun at Suanir, near Babylon. Undismayed by the science of Zoroaster and Aphaxad they foretell the future, they cause a new-born child to speak, they subdue tigers and serpents, and from a statue they cast out a demon, which shows itself in the shape of a black Ethiopian and flees uttering raucous cries.[2]

St. Andrew must surpass all the marvels of the magicians before he

[1] *Leg. aur., De sancto Jacobo Maj.* Windows at Bourges (choir), Chartres (to the left of the choir) (Fig. 148), Auxerre (right aisle, near the choir), two windows at Tours (one in one of the chapels in the choir, and the other in the choir clerestory).

[2] *Leg. aur., De sancto Simone et Juda.* Window at Chartres (choir), window at Reims (choir, rose of the window to St. Jude).

can convert Asia and Greece. He drives away seven demons who in the shape of seven great dogs desolate the town of Nicaea, and he exorcises a spirit which dwells in the thermae and is wont to strangle the bathers.[1]

Repellent as these legends may appear to us, they have historical value. They indicate a certain attitude of mind, and furnish a valuable record of the

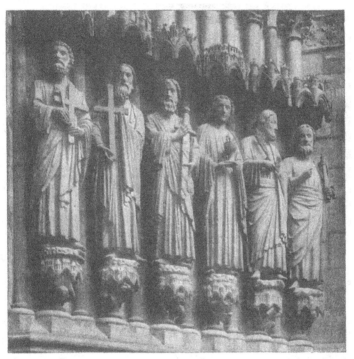

FIG. 151.—APOSTLES TO THE LEFT OF CHRIST (Amiens)

ancient world and the time in which they arose. They are a reminder that paganism did, in fact, attempt to wrestle with the Christian Church by means of magic arts, opposing Apollonius of Tyana to Christ, and that Julian and the philosophers attempted to answer miracle by miracle.

The Middle Age for its part delighted in works which might well have been written especially for it, and which shared its own conception of the marvellous. To this is due the number of windows for which the pseudo-Abdias furnished the subject-matter.

[1] *Leg. aur.*, *De sancto Andrea*, and the pseudo-Abdias (Migne, ii., " André "). Window at Troyes (apse), at Auxerre (left aisle).

RELIGIOUS ART IN FRANCE

These windows are without doubt the strangest works devoted to the apostles by the Middle Ages, but they are not the most beautiful. The small figures have not the majestic appearance of the great single figures of the porches or the clerestory windows.

At Chartres, and perhaps still more in the great porch at Amiens, one is struck by the nobility of the statues and the spiritual beauty of their faces. As we have already said, the artists were happily inspired in giving them some measure of resemblance to their Master. Radiant with understanding they gaze before them with profound serenity. One cannot better describe them than by taking the portrait of St. Bartholomew from the *Golden Legend*. " His face is white, his eyes large, his nose straight and regular, and a few white hairs mingle with his full beard. He wears a purple robe covered with a white cloak embellished with precious stones, and although he has worn the same garments for twenty years they are neither worn nor soiled. Angels accompany him on his journeys; his face is ever the same, affable and serene. He foresees and knows all things. He understands and speaks the language of all peoples, and that which I am saying at this moment he knows it." [1]

St. Peter, St. Paul and St. John are alone recognisable by traditional features. St. Peter has short curly hair and a tonsure, and St. Paul is bald. From primitive times the types of the two chief apostles have not changed.[2] St. John, the youngest of the apostles, is represented without a beard, even in extreme old age.[3] The other apostles are solely recognisable by the attributes they hold in their hands. At first these attributes were given only to certain of the apostles, but as time went on they were given to them all.

Some slight study of the principal figures of the apostles found in the churches will indicate the manner in which the artists proceeded.

In Romanesque times the attribute of an apostle is a book, though St. Peter has the keys in memory of the power given him to bind and to loose. In the thirteenth century, when the figures of the apostles were ranged on either side of the porch, it became customary to place in their hands the instrument of their martyrdom. But there was not complete

[1] Pseudo-Abdias (Migne, ii., " Saint Barthélemy," and *Leg. aur.*, *De sancto Barthol*. The cloak covered with precious stones is found only in Romanesque art.
[2] On this subject see the weighty chapter which M. G. de Saint-Laurent has devoted to St. Peter and St. Paul in the *Guide de l'art chrétien*, vol. v., and in the *Annal. archéol.*, vols. xxiii., xxiv., xxv.

[3] In the Greek Church St. John is almost always represented with a beard. The apostle has a beard in the deathbed scene in the window at Lyons; yet another sign of the curious Byzantine influence noticeable in the windows at Lyons.

agreement as to their manner of death, and at the end of the thirteenth century traces of this uncertainty are found in Jacobus de Voragine.[1] Agreement was first reached with regard to the death of St. Paul, of St. Andrew, of St. James the Less and of St. Bartholomew. St. Paul is given a sword, because there was no doubt that he had been decapitated. St. Andrew carries a cross, because it is said in his Acts that he was crucified.[2] St. James the Less holds a club, because it was said that he had been beaten to death at the foot of the Temple at Jerusalem by a fuller armed with his stick. And, in spite of disagreement among compilers, it was generally received from the first half of the thirteenth century that St. Bartholomew had been flayed alive, and a knife was therefore placed in his hand.[3]

In the south porch at Chartres[4] (Fig. 149) only the apostles we have just named are recognisable by their attributes. The others either carry books as in the Romanesque period, or swords to symbolise a violent manner of death.

Before long three more apostles received distinctive attributes. As we see in the west porch at Amiens (Fig. 151) St. John sometimes carries the poisoned cup which Aristodemus had given him to drink.[5] St. James, while retaining the sword of martyrdom,[6] has in the other hand a staff such as is used by pilgrims to Santiago, and his tunic or wallet is decorated with the shells brought back from

FIG. 152. — ST. JAMES (porch ot the cathedral at Bayonne)

the shore of Galicia, the famous " scallop-shell of St. James " (Fig. 152). The apostle is given the appearance of a pilgrim returning from his church at Compostella, and at the end of the fourteenth century with his staff, his great hat and his cloak decorated with shells, he is the perfect image of the mediæval pilgrim.[7] St. Thomas, seen thus perhaps first

[1] See especially *Leg. aur.*, *De sancto Barthol.*

[2] In the thirteenth century St. Andrew's is almost always a Latin cross, not x.

[3] There was agreement in the thirteenth century. See the table on p. 311. The St. Bartholomew at Amiens had a knife, but it was replaced by a hatchet when the statue was restored. See G. Durand, *La Cathédrale d'Amiens*, vol. i.

[4] Judging from the character of the statues, the south porch at Chartres offers one of the earliest series of figures of apostles that we possess. Only half of it is seen in the illustration.

[5] The cup at Amiens has been restored, but it seems

to have existed before restoration. See G. Durand, *La Cathédrale d'Amiens*, vol. i. On the great shrine at Aix-la-Chapelle (Cahier, *Mélanges d'archéologie*, first series, vol. i. p. 20), St. John carries the tun of oil into which he was plunged before the Porta Latina. This does not occur elsewhere.

[6] As in the north porch at Reims, which is one of the oldest in the cathedral, and in the porch of La Couture at Le Mans (the sword is sheathed).

[7] The beautiful figure of St. James in the Musée at Toulouse (fourteenth century) has exactly the appearance of a pilgrim.

on the west façade at Amiens (Fig. 150), carries the architect's square in memory of the palace in India which he was charged to build for King Gondoforus.[1] But a glance at the table opposite, where the works are classified in approximately chronological order, shows that St. John's cup, St. Thomas's square, the staff of St. James the Great and even the club of St. James the Less were by no means permanent emblems. In fact the only attributes invariable throughout the Middle Ages are those of St. Peter, St. Paul, St. Andrew and St. Bartholomew ; while the attributes of St. Philip, St. Matthew, St. Simon, St. Jude and St. Matthias were never fixed, because their personality was less clear-cut and their legend less definitely known. It was only during the course of the fifteenth century that it became imperative to represent St. Philip and St. Jude with a cross, St. Matthew with an axe, St. Simon with a saw, and St. Matthias with a halberd[2] as a sign of the death they suffered.

It is rare to-day to find a complete series of apostles ranged in a church porch, for many were destroyed either during the wars of religion of 1562 or at the time of the Revolution of 1793, but one may safely say that formerly they were ranged on either side of the great doorway of almost every cathedral.

VII

After the apostles, it is not easy to say which saints were preferred in the Middle Ages, or what motives led to the representation of one saint rather than another. What idea dominated the choice of the hosts of legends which are seen in the glass at Tours, Le Mans, Chartres, Bourges, and why for instance does one so often meet the story of St. Nicholas ? In spite of scholarly research there will always be mysteries in the mediæval cathedral, but a partial solution may be attempted.

Works of art devoted to the saints in the thirteenth century may be grouped under four or five heads.

One is struck first of all by the pious wish felt in each diocese to do honour to its local saints. After the apostles the local saints hold the foremost place in the churches, and a whole porch is often devoted to their lives, their miracles and their death.

The religious history of Picardy is writ large in the left porch of the great façade at Amiens. On the lintel is St. Firmin, who brought the faith

[1] That is if the square is not a mutilated cross.
[2] St. Matthias is the apostle who took the place of

Judas. He is seldom represented. St. Paul, although not one of the twelve, is generally substituted.

ORDER OF THE CANON OF THE MASS	XIIIth CENTURY										XIVth CENTURY		
	CHARTRES SOUTH PORCH	AMIENS WEST PORCH	CHARTRES WINDOWS	REIMS NORTH PORCH	LE MANS LA COUTURE, STATUES IN THE PORCH	BORDEAUX ST. SEURIN, STATUES	BOURGES WINDOWS	REIMS WINDOWS	TOURS WINDOWS	CHARTRES SOUTH PORCH, ORDERS OF THE ARCH	REIMS SOUTH PORCH	REIMS BUTTRESSES	CHARTRES ST. PÈRE, WINDOWS
St. Peter	Keys and cross	Keys and cross	Keys	Keys (broken)	—	Keys	Keys and cross	Keys, book	Keys	Keys	Keys	Keys	—
St. Paul	Sword	Sword (restored)	Sword	Sword and book	Sword	Book	Sword	Sword	Sword	Sword, book	Sword	—	Book
St. Andrew	Latin cross (broken)	Latin cross	—	Latin cross	Cross (broken)	Latin cross	—	Latin cross	Latin cross in X position	Latin cross	—	Cross	Axe
St. James	Sword and shells	Sword and shells	Shells	Sword and shells	Sword, staff and wallet	Staff and shells	Staff	Bird of passage	—	Staff	Staff, hat		Book
St. John	Book	Cup (restored)	Book	Book	—	—	—	Book	Palm	Vestments	Palm, book		Book
St. Thomas	Sword	Square or cross (broken)	—	—	—	Graduated rule ?	Sword, hook	Sword	—	Square	—	—	Square and book
St. James the Less	Club	Club	Palm	—	Club	—	Book	—	—	Bishop's robes	—	Club	Club
St. Philip	Sword	—	—	—	—	—	Book	—	Sword	—	—	—	Lance and book
St. Bartholomew	Knife	Knife (modern axe)	Knife	Knife	—	—	Knife	Knife	Knife	Knife	Knife	—	Knife
St. Matthew	Sword (broken)	—	—	—	—	—	Book	—	—	Sword	—	—	Book
St. Simon	Book	—	—	—	—	—	Book	—	—	—	—	—	—
St. Thaddeus or Jude	Book	—	—	—	—	—	—	Listel	—	—	—	—	—
St. Matthias	—	—	—	—	—	—	—	—	—	Axe	—	—	Sword

to the ancient Samarobriva of the Ambiani. Round him is his guard of honour ; St. Gentien, St. Fuscien and St. Victoric, the first martyrs—St. Honoré and St. Salvius, the first bishops—St. Domice, St. Geoffroy, and the virgin saint Ulphia, the most famous saints of the diocese.[1] In the tympanum is seen the story of the relics of St. Firmin, and of the miraculous passage of his shrine, and in the south porch is a detailed representation of the chief features of the life of St. Honoré, Amiens' greatest bishop.

In the same way one of the north porches at Reims shows the saints of

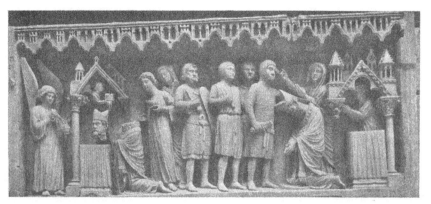

FIG. 153.—MARTYRDOM OF ST. NICASIUS AND OF ST. EUTROPIA (Reims)

the province. Like St. Firmin at Amiens, St. Sixtus has the foremost place at Reims, for it was he who brought the Gospel to Champagne. On either side of him are his successors—martyrs or illustrious bishops ; St. Nicasius who was massacred by the Vandals on the threshold of his church and left the stain of his blood on a stone,[2] his sister, St. Eutropia, who was killed while defending him,[3] and St. Remi who received the sacred oil brought by the dove.[4] The memory of St. Remi was so intimately associated with the coronation church that art could not fail to tell his history to the Rémois, and his legend with its principal miracles are seen in delightful bas-reliefs in the tympanum of the north porch.[5]

[1] See Corblet, *Hagiographie du diocèse d'Amiens*.

[2] The stone of St. Nicasius was still worshipped in the cathedral in the seventeenth century. It was surrounded by an iron grating. Cerf, *Histoire de Notre-Dame de Reims*, vol. i. p. 375.

[3] Another bas-relief represents the death of St. Nicasius. St. Eutropia, according to Flodoard, slapped her brother's murderer in the face.

[4] I am not sure that the figure next to St. Remi represents Clovis, as is usually supposed.

[5] The story of Job is grotesquely mingled with that of St. Remi (third row beginning from the bottom). It is impossible not to recognise Job on his dunghill, with his three friends and his wife holding her nose. There is nothing in Flodoard's *Histoire de Reims*, from which the whole tympanum is taken, to justify

OF THE THIRTEENTH CENTURY

Two of the five porches of the cathedral of Bourges are dedicated to the saints of the district. The right porch recalls the memory of St. Ursin, the apostle of Berri and the Bourbonnais, the left the memory of St. Guillaume, the bishop famed for his miracles and for his victories over the devil.[1] The statues in these two porches were mutilated by the Protestants, but they no doubt represented the canonised bishops of the church of Bourges, St. Oustrille and St. Sulpice, in a word those whose images accompany the figures of the apostles in the nave windows.

Although at Notre Dame at Paris no porch was entirely devoted to the images of the saints of the Île-de-France, several large statues and a few remarkable bas-reliefs made it impossible for the people of Paris to forget St. Denis, St. Geneviève,[2] and above all St. Marcel. On the trumeau in the early Portail Sainte-Anne the famous bishop of Paris is seen piercing the dragon with his crosier,[3] and round the arch of the Portail Rouge, which is at least a century later, part of his legend (Fig. 154), and in particular his contest with the cemetery vampire, is told in groups of exquisite workmanship.

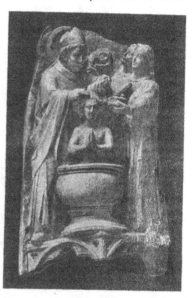

FIG. 154.—ST. MARCEL BAPTIZING (arch of the Portail Rouge, Notre Dame at Paris)

At Chartres windows and statuary rival one another in celebrating the first confessors of the faith in the country of the Carnutes. There is St. Potentian, who built his church over the grotto which for centuries had been dedicated by the druids to the virgin who should be with child, "virgini pariturae;" St. Modeste, daughter of the Roman governor Quirinus, who was thrown by her father into a well with other martyrs;[4] St. Chéron who like St. Denis carries his

the presence of Job. These scenes seem to have been inspired by a Christian sarcophagus of an early date, some fragments of which are preserved in the museum.

[1] The Portail Saint-Guillaume was restored in the sixteenth century after the falling of the tower.

[2] Left porch (west front). The statues have been restored, but Lebeuf had already described them

(*Histoire de la ville et de tout le diocèse de Paris*, vol. i., new edition, 1884, p. 3). The bas-reliefs below the statues alone survive (beheading of St. Denis, St. Geneviève and her mother).

[3] Restored. The original is in the Cluny Museum.

[4] It was long celebrated at Chartres as the "puits des Saints-Forts" (see Bulteau, *Monographie de Notre-Dame de Chartres*, vol. i. p. 16). The statues of St.

313

RELIGIOUS ART IN FRANCE

head ;[1] St. Lubin the herdsman who became bishop of Chartres,[2] and St. Laumer, monk of the forest of La Perche.[3]

It was the same in all the cathedrals. In many mutilated churches which have lost the greater number of their statues and windows, there yet remain more than a few monuments of their first bishops or martyrs.

In the cathedral of Le Mans the large twelfth-century window of Julian, the apostle of the Cenomani still exists. The life of St. Crispin and St.

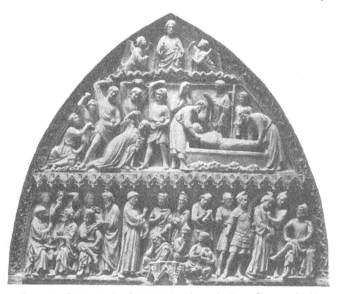

FIG. 155.—STORY OF ST. STEPHEN (south porch, Notre Dame at Paris)

Crispianus is still seen in windows at Soissons, the life of St. Martin at Tours, the lives of St. Pothinus, St. Irenaeus and St. Polycarp at Lyons. At St. Quentin bas-reliefs (restored) in the choir ambulatory tell the story of the first apostles of the Vermandois, and in the Portail de la Calende at Rouen, bas-reliefs which were long a mystery, recount the legend of two great Norman saints, St. Romanus and St. Ouen.[4]

In this way each province found something of its past history in its cathedral. Those who, according to the ideas of the time, deserved to be saved

Potentian and St. Modeste are in the north porch ; a window is also dedicated to them (second chapel in the choir, to the left).

[1] Window in the choir and bas-relief in the south porch.

[2] Window in the left aisle.

[3] Bas-relief and large statue in the south porch.

[4] They have been deciphered by Mlle. Louise Pillion, *Les Portails latéraux de la cathédrale de Rouen*, Paris, 1907, 8°, p. 106 *sq.*

OF THE THIRTEENTH CENTURY

from oblivion in the annals of their town, were carved there for eternity. From these great monuments the people gained some slight idea of their history, and grew conscious that they too had their ancestors and were firmly rooted in the soil. Each cathedral grew up like an indigenous plant which owes its colour and perfume to its native earth.

The thirteenth century seems to have possessed this cult of the past in a high degree. The Parisian artists who adapted a door of the twelfth century to a façade of the thirteenth showed their respect[1] for memories of the past. In building the new cathedral of Notre Dame this was expressed still more clearly. It was necessary to destroy the old church of St. Étienne which was near to the basilica of the Virgin and almost as ancient,[2] but in order to preserve its memory a fine bas-relief of the martyrdom of St. Stephen (Fig. 155) was placed in the tympanum of the south porch, on the very spot where the church had formerly stood.

VIII

After the local saints come the saints famed throughout Christendom.

We began to compile a list of the images of saints found to-day in thirteenth-century cathedrals, but we soon realised that it was an impossible task. The number of statues without name or attribute makes identification too uncertain. And even were such a catalogue possible no certain conclusions could be drawn, for the gaps in the series of windows and statues are numerous. One must be content with approximations.

One fact—valuable though general—emerges from our very incomplete survey, and that is that the thirteenth century chose for representation the saints who were famous enough to have a place in the liturgical books of the whole of Christendom. From a number of antiphonaries and breviaries drawn from many sources, M. Ulysse Chevalier has compiled an extremely interesting calendar in which are found only those saints who were honoured in all or almost all mediæval churches.[3] With the exception of some of

[1] The Portail Sainte-Anne. I have tried to prove (*Revue de l'art ancien et moderne*, October, 1897) that it dates from the time of Maurice de Sully, and that it was preserved on account of the portraits in the tympanum of the bishop who founded the cathedral and of King Louis VII.

[2] See Lebeuf, *Histoire du diocèse de Paris*, p. 8; and Mortet, *Étude historique et archéologique sur la cathédrale de Paris et le palais épiscopal du VIᵉ au XIIᵉ siècle*, Paris, 1888, 8°, p. 29, note, and p. 39. Lebeuf has rightly pointed out that the statues of St. John the Baptist, St. Denis, and St. Stephen in the left

porch of the façade of Notre Dame at Paris were "like a memorial of the two little neighbouring churches of St. Jean and St. Denis, and of the old St. Étienne" (*op. cit.*). All these churches were really annexes of Notre Dame. It was the same with several cathedrals, which virtually included a church of Notre Dame, a church of St. John the Baptist (the baptistery), and a church dedicated to St. Stephen.

[3] Ulysse Chevalier, *Poésie liturgique traditionnelle de l'Église catholique en Occident*. Tournai, 1894, 8°, Introduction, p. 65 sq.

the martyrs and confessors of the Church at Rome who out of respect for the holy city had been adopted by the whole Christian world, the greater number of these saints is found in the glass or porches of the churches. The calendar gives a list of the saints honoured in all the churches : the deacons Vincent, Stephen and Lawrence, the martyrs Sebastian, Blaise, George, Gervase, Protasius, Hippolytus, Denis, Christopher and Thomas à Becket, the confessors Marcel, Gregory, Jerome, Nicholas, Martin, the virgins Agnes and Cecilia. It is the images of these saints which even to-day most often strike the eye.

The desire to honour the saints in the order prescribed by the liturgy is very evident in the south porch at Chartres. The central door is dedicated to the apostles, the right door[1] to the martyrs, the left to the confessors. Numerous bas-reliefs giving scenes of martyrdom and miracles (which are not always easy to decipher) decorate the pillars of the porch. It is more than likely that not only the general scheme, but even the details of this great composition were inspired by the litanies in use in the diocese of Chartres.[2]

But this fine scheme is by no means universal. At Chartres itself the choice of the lives of the saints represented in the windows seems to have been accidental. Why is the same saint found in three windows ? What is the connection between two legends found in the same chapel ? What is the real reason for this choice or grouping ? Some of these questions it is possible to answer.

IX

In the first place, it is certain that the relics possessed by the churches contributed more than anything else to the multiplication of images of the saints.

A really fine study of relics would be one of the most curious chapters of mediæval history, and one which the historian of civilisation and the historian of art would find equally instructive. The subject demands more learning and greater insight into the past than can be found in Collin de Plancy's *Dictionnaire des Reliques*, a dull pamphlet written by a belated disciple of Voltaire who had neither the mind nor the style of his master.[3] To study the Middle Age in order to mock at it instead of trying to enter into its spirit, is the folly of a past age.

[1] To the left of the spectator, but to the right of the figure of Christ on the trumeau of the central door.

[2] See Bulteau, *Monographie de Notre-Dame de Chartres*, vol. ii. p. 287.

[3] Collin de Plancy, *Dictionnaire critique des reliques et images miraculeuses*, Paris, 1821, 3 vols.

OF THE THIRTEENTH CENTURY

The first accurate work undertaken on this important subject, and one which has already proved of value, is the interesting study of the religious spoils taken from Constantinople in the thirteenth century which was made by M. le Comte Riant.[1]

It should be realised that the relics which excited the passionate devotion of so many generations, form a serious subject of study. The announcement of the jubilee at Aix-la-Chapelle, with the assurance of at least a distant sight of the holy cloth which had covered the Saviour on the Cross,[2] drew some forty thousand pilgrims from all parts of Europe. Relics possessed a supernatural virtue. Wherever the arm of an apostle or the blood of a martyr was known to be, there grew up some village or rich abbey. The girdle of St. Foy created Conques, in the mountains of Aveyron. The presence of a holy body at the altar determined the shape of the church which contained it, and obliged the architect to find new forms, to enlarge the choir and the transepts.[3] The most ingenious creations of mediæval goldsmiths were due to the necessity of enshrining some sacred bone in crystal or in gold.[4] Around these frail reliquaries gathered a whole world of hopes and longings, and they appeal to us to-day as do all things on which men's thoughts have lingered.[5]

The historian of art has no right to scorn the relics. It should be remembered that the Sainte-Chapelle, the most perfect of thirteenth-century buildings, was a shrine destined to enclose the crown of thorns. And the most beautiful mystic dream of the Middle Ages, the sangrail itself, what is it but a reliquary ?

Calvin dissipated all this poetry in a breath. With his reasoning and his rude vigour he demonstrated to the " poor world " that God is everywhere, and that it is not necessary to make long journeys and like pagans to adore doubtful relics. " Pray," he says in his *Traité des reliques*, " has not the world gone mad to travel five or six score miles at great cost and pains to see a flag (the holy shroud at Cadouin) about which one can have no assurance, but rather be constrained to doubt." [6] Nothing finds mercy at

[1] Comte Riant, *Exuviæ Sacræ Constantinopolitanæ*, Geneva, 1878, 2 vols. 8º. By the same author, *Dépouilles religieuses enlevées à Constantinople au XIIIᵉ siècle*, in the *Mémoires de la Société des Antiquaires de France*, vol. xxxvi. 1875.

[2] Martin and Cahier, *Mélanges d'archéologie*, vol. i. p. 1 *sqq.*

[3] As, for example, at Saint-Sernin at Toulouse. The people had to be allowed to see the holy bodies on the altar.

[4] See Viollet-le-Duc, *Dictionnaire du mobilier*, article : *Reliquaire*.

[5] Legacies were left to some of the shrines. Great ladies and clerics gave pearls and golden collars to the shrine of the " sainte chemise " at Chartres. See *Cartulaire de Notre-Dame de Chartres*, published by E. de Lépinois and L. Merlet. Chartres, 1862–65, 4º, vol. iii. pp. 58, 93, 141, 150.

[6] Calvin, *Traité des reliques* (reprinted by Collin de Plancy in the third volume of his *Dictionnaire critique des reliques*).

the hands of this terrible iconoclast ; none of those memories which should be dealt with tenderly, neither the water-pot of the marriage at Cana which was shown at Angers, nor the tear shed by Christ for Lazarus which was enshrined at Vendôme, nor the pictures which had been painted by angels —" for one knows that it is not the métier of angels to be painters."

The world emerged from the age of poetry.[1] The enthusiasm of the Crusaders who went to defend an empty tomb, and brought back a little holy earth as the greatest of treasures, henceforth appeared as inexplicable folly. " As a matter of fact," said Calvin, " they consumed their bodies and their goods, and a large part of their countries' substance, in order to bring back a pile of foolish little things with which they had been gammoned, believing them to be the most precious jewels in the world."

Such was, in fact, the feeling of the Crusaders who in the thirteenth century sent a host of relics to the churches of Champagne, the Île de France and Picardy, from Constantinople. These matchless treasures, which were enclosed in precious wallets,[2] had a certain influence upon art.[3]

In 1206 one of the most famous of Christian relics reached Amiens, the back portion of the head of St. John the Baptist, found in the ruins of an ancient palace at Constantinople.[4] The new cathedral, of which the first stone was laid in 1220, contains two works of art which commemorate the famous relic. A thirteenth-century window illustrates the life of the Baptist,[5] and fine scenes from the story of St. John carved towards the end of the fifteenth century, are found in the choir ambulatory.[6]

The front portion of the head of the Baptist, which had been left at Constantinople, was acquired in the reign of St. Louis by the Sainte-Chapelle[7] and was, after the relics of the Passion, the most precious of its possessions. Two windows in the place of honour at the end of the apse,

[1] It is true that some time before Calvin, at the zenith of the Middle Ages, Guibert of Nogent had expressed doubts as to the authenticity of certain relics. His *De Pignoribus Sanctorum* (*Patrol.*, vol. clxv. col. 607), especially the third book, is directed against the monks of Saint-Médard who pretended to possess a tooth of Jesus Christ. He had no difficulty in showing that the body of Christ had been glorified at the time of the Resurrection. He speaks somewhat irreverently of the two heads of St. John the Baptist, one at Saint-Jean at Angély and the other at Constantinople : " Quid ergo magis ridiculum super tanto homine prædicetur, quam si biceps esse ab utrisque dicatur ? " (lib. I. cap. iii. § 2).

[2] For one of these wallets see Montfaucon, *Monuments de la Monarchie française*, vol. ii. pl. XXXI.

[3] Riant gives a list of these relics (*Mém. des antiq.*).

[4] Du Cange wrote a *Traité du chef de saint Jean-Baptiste* (Paris, 1665, 4°) to prove the authenticity of the relic at Amiens.

[5] The window, one half of which is dedicated to St. John and the other to St. George, was formerly in the chapel of St. John the Baptist.

[6] The fact that one of these bas-reliefs shows Herodias striking John the Baptist's head with her knife proves that this later work was also inspired by the relic. The skull preserved at Amiens shows the mark of a knife ; this is mentioned in no legend.

[7] See Morand, *Histoire de la Sainte-Chapelle*, Paris, 1790, 4°, p. 47.

constantly recalled the presence of these venerated but rarely exposed relics. One was dedicated to the Passion, the other to the life of St. John.

Chartres had a share in the relics from Constantinople. In 1205 the Count of Blois sent the head of St. Anne to the cathedral of Notre Dame. "The head of the mother," as the cartulary has it, "was received with great joy in the church of the daughter."[1] The north porch of the cathedral was probably begun about 1210,[2] and one of the statues seems in our view to commemorate the recent acquisition of this precious relic. On the trumeau of the central doorway there is a figure of St. Anne carrying the Virgin, instead of the customary figure of the Virgin carrying the Child. This peculiarity is found again in the interior, where St. Anne bearing the Virgin in her arms is found in one of the windows placed under the north rose-window (Fig. 156). A desire to give special honour to the mother of the Virgin is evident, and the presence of the relic in the church can alone explain the unusual place which she occupies.

Many difficulties of this kind could be solved did we possess a full list of the relics which belonged to the cathedral of Chartres in the thirteenth century. For example, the great statue of St. Theodore, which is found in the south porch, long passed for a figure of St.

FIG. 156.—ST. ANNE CARRYING THE VIRGIN (window at Chartres)

Victor, and Didron believed that

[1] *Cartulaire de Notre-Dame de Chartres*, vol. iii. pp. 89, 178. Riant, *Exuviæ*, vol. ii. p. 73.

[2] See Bulteau, vol. i. p. 128.

RELIGIOUS ART IN FRANCE

the Roman legionary was more widely known in the French churches than the Greek soldier of Heraclea. At that time it was not known that in 1120 St. Theodore's head had been brought from Rome to Chartres. From the cartulary published in 1862 [1], it is now possible to name with certainty the dignified statue of the knight who is the pendant to the figure of St. George.

A fine window dedicated to the story of St. Thomas à Becket is seen in the choir ambulatory in the cathedral at Sens. The reason for this is that the cope and the mitre of the illustrious archbishop, who had lived for four years in the monastery of St. Colombe near Sens, was preserved in the treasury. In 1173, when the martyr was canonised by the pope, these vestments became its most precious relics.

The importance of accurate knowledge of the relics preserved in any ancient church, however modest, is illustrated by the little church of Valcabrère,[2] one of the oldest and most curious religious buildings in the Pyrenees. It was known that the church was dedicated to St. Justus and St. Pastor, whose martyrdom was carved on the capitals in the porch, but there was no explanation for the presence of the story of St. Stephen. In 1886 a happy chance led to the discovery of some relics in a cavity in the altar. With them was a parchment which gave the names of three saints, St. Justus, St. Pastor and St. Stephen, as patrons of the church.[3] The little problem which had worried archæologists was solved.

We are of opinion that the relics preserved in chapels in the great cathedrals frequently explain the windows. In the case of the chapels in the apse of Notre Dame at Chartres there is no doubt of this. By rare good fortune the old names of the chapels were preserved by Rouillard, the lawyer who at the beginning of the seventeenth century published a description of the cathedral with the title *Parthénie*.[4] The windows correspond exactly to these names. Beginning at the left, the first chapel contains the relics of St. Julian the Hospitaller and bore his name. This name has since been changed, but the life and death of St. Julian are still to be seen in a compartment of the central window. The second was dedicated to St. Stephen and the Martyrs, and the story of Stephen is found in a window in the place of honour, while three other windows are

[1] *Cartulaire de Notre-Dame de Chartres*, vol. i. p. 60.
[2] Haute-Garonne; at the foot of Saint-Bertrand in Comminges.
[3] *Bullet. monum.*, 1886, p. 506. Again at Moissac the story of St. Cyprian, whose relics were brought to

the abbey about 1126, is carved on the capitals of the cloister (*Bibl. de l'École des Chartes*, third series, vol. i. 1849–50).
[4] *Parthénie, ou Histoire de la très auguste église de Chartres*, by Sébastien Rouillard of Melun, 1608, p. 140 *sq.*

dedicated to St. Savinian, St. Potentian, St. Modeste, St. Chéron and St. Quentin who all died martyrs' deaths. The third chapel was known as the Chapel of the Apostles, and here again the central window represents the calling of the twelve and the scenes in which Jesus speaks to the whole number of the apostles.[1] The neighbouring windows give the stories of St. Simon and St. Jude, and of St. Peter and St. Paul at Rome. The fourth chapel was called the Chapel of St. Nicholas or of the Confessors, and both St. Nicholas and St. Remi are found in a window. It is certainly puzzling to find here St. Catherine, St. Margaret and St. Thomas à Becket, who are not confessors but martyrs.[2] The fifth chapel is called by Rouillard the Chapel of St. Loup and St. Gilles, but to-day it has only windows in grisaille belonging to a later period.

This exact correspondence between the subject in the window and the name of the chapel was probably found in all the cathedrals. Unhappily this is not easily proved, for sometimes the name of the chapel is lost, sometimes the glass has disappeared.

The few windows at Amiens which have escaped the vandalism of later centuries hint at an exact arrangement such as we have noticed at Chartres. In a chapel in the apse, now dedicated to the Sacré Cœur but formerly to St. James the Great,[3] there is still a window in which the story of the apostle is told. Another chapel of the apse, dedicated to St. Theodosia, contains a window of the thirteenth century in which the life of St. Augustine is told, and in the Middle Ages he was doubtless the titular of the chapel.[4]

It is needless to multiply instances.[5] Those given above show that the chapel windows were not placed at hazard, but that the choice of the pious donor was directed by the relics of the saint to whom the chapel was dedicated.

X

But relics do not explain everything, for all the windows are not in chapels. Great figures of the saints are seen in the clerestory windows, and

[1] This is not the window " du Seigneur Jésus," as Bulteau calls it, but the Apostles' window.

[2] Possibly the scenes from the lives of St. Martin and St. Sylvester in the neighbouring windows were intended for this chapel.

[3] See the Abbé Roze, *Une visite à la cathédrale d'Amiens*, Amiens, 1887, 12°, p. 55.

[4] *Id., ibid.*, p. 60.

[5] There are several others. One of the chapels in the collegiate church of Saint-Tudual at Laval had a window representing the life of St. Tudual, because the relics of the saint were preserved in this chapel (*Bull. monum.*, 1895, p. 453). In the apsidal chapels at Clermont windows devoted to the legends of St. George, St. Austremonius and the Magdalen, &c., are to be found in the chapel bearing the name of the saint in question. (See Thibaud, *De la peinture sur verre*, p. 18; and F. de Lasteyrie, *Histoire de la peinture sur verre*, p. 205.)

RELIGIOUS ART IN FRANCE

stories from the *Golden Legend* fill the windows of the aisles. The mediæval Church left nothing to chance, and some reason must have governed the choice of saints.

These windows were given to the cathedrals by guilds or by individuals who wished to perpetuate the memory of their generosity. The figure, and often the name of the donor, is generally seen in the lower division [1] of thirteenth-century windows—monks engaged in prayer, bishops carrying a model of the window, knights armed to the teeth and recognisable by their crests, money-changers testing their coin (Fig. 136), furriers selling their wares (Fig. 31), butchers killing oxen, sculptors carving capitals. These scenes of the life of yesterday, so valuable in themselves, partially help us to solve the problem before us.

It is often not difficult to guess why a certain donor chose a certain saint. A window representing St. Denis exposed to the lions was given to Chartres by St. Louis, because the king of France wished to do honour to the protector of the French monarchy.[2] When St. Ferdinand of Castile offered to the cathedral of Chartres a window dedicated to St. James, the famous conqueror of the Moors was testifying his devotion to the Matamoros, as he was called, who had been seen fighting in the forefront of the Christian army.[3]

It is easy to understand why a bishop of Nantes offered a window dedicated to St. Peter and St. Paul to the cathedral of Tours, for from the earliest times the two apostles had been patrons of the church at Nantes. Neither is it difficult to guess why an abbot of Cormery gave a window dedicated to St. Martin to the cathedral of Tours, for the abbey of Cormery was dependent on St. Martin's at Tours, and held the great apostle of Gaul in special veneration.[4] Again, one may accept as probable M. Hucher's theory that the three windows of the cathedral of Le Mans which are devoted to St. Vincent, St. Calais, and to the miraculous appearance of the Virgin at Évron, were given by the three great abbeys of Saint-Vincent, Saint-Calais, and Évron.

Sometimes the donor of a window simply offered the image of the saint

[1] Sometimes in the upper part, especially if the window contains a small rose.
[2] This window disappeared in 1773. It was replaced by clear glass. But a splendid figure of St. Louis dressed as a knight is still to be seen in the rose. He rides a white horse and holds an azure pennon semé de lis or (Bulteau, *Descript. de la cath. de Chartres*, 1850, p. 208; et Montfaucon, *Monum. de la Monarchie franç.*, vol. II. pl. XXI.).

[3] The window has disappeared, but it was described by Pintard. His manuscript is in the library at Chartres (see Bulteau, p. 207). The inscription ran, "Rex Castiliæ." The figure of St. Ferdinand is given by Montfaucon, *Monum. de la Monarchie franç.*, vol. II. pl. XXIX.
[4] *Verrières du chœur de l'église métrop. de Tours*, Bourassé and Marchand, p. 51.

whose name he bore. Jeanne de Dammartin, second wife of Ferdinand of Castile, gave to the cathedral of Chartres a large window devoted to the story of her patron, St. John the Baptist.[1]

The guilds took the story of their protector, the saint whose image was seen on their banners and tokens. At Bourges, the window of St. Thomas, patron of architects and of all who worked under them, was given by the masons. At Chartres, at their own cost, the grocers put up a window to their patron St. Nicholas, and the basket-makers one to St. Antony.[2]

When the donors did not offer an image of their patron, it is sometimes possible to guess the reason for the choice of some other saint. It is not surprising to find that the windows given by three knights, Pierre de Courtenay, Raoul de Courtenay and Julian de Castillon, to the cathedral of Chartres represented the soldier-saints St. Eustace, St. George and St. Martin, models of true chivalry.[4] Amaury de Montfort, recognisable by his shield bearing a lion rampant, argent on a field of gules, is seen at Chartres in the rose of a window dedicated to St. Paul, surely because the apostle who carries a sword was also in the Middle Ages the patron of soldiers. Gulielmus Durandus tells us in his *Rationale* that the knights stood during the reading of an epistle taken from St Paul.[5]

The same thing happened with the guilds. Instead of giving the story of their patron, who no doubt was St. Catherine, the coopers of Chartres gave the Noah window, apparently because that patriarch planted the vine. At Tours the window given by the labourers was dedicated to Adam, who first dug the earth by the sweat of his brow.

But it is not always that the names of the donors offer satisfactory explanations, and one has often to confess to complete ignorance. Why did the armourers at Chartres choose the story of St. John, the tanners the story of St. Thomas à Becket, the weavers that of St. Stephen and the porters

[1] It was destroyed in 1788, but is described in Pintard's manuscript (see Bulteau, p. 206). It is somewhat curious that the thirteenth and fourteenth-century donors seldom gave the images of their patron saints. This, on the contrary, was the custom in the fifteenth and sixteenth centuries. For example, the west rose-window (sixteenth century) of the cathedral of Auxerre given by the canons Jacques Vautrouillet, Christophe Chaucuard, Claude de Bussy, Sébastien Le Royer, Nicolas Cochon, Charles Legeron, Jean Chevallard and Eugène Motel, represents eight saints :—St. James, St. Christopher, St. Claud, St. Sebastian, St. Nicholas, St. Charlemagne, St. John and St. Eugene. (Bonneau, *Vitraux d'Auxerre*, p. 9.) The fifteenth and sixteenth-century windows at Bourges offer

numerous examples of the same custom (see Des Meloizes, *Vitraux de Bourges postérieurs au XIIIᵉ siècle*. Lille.)

[2] St. Antony, superior of the monasteries in the Thebaïd where the monks earned their living by basket-weaving, was the patron-saint of basket-makers in the Middle Ages.

[3] Of the first two of these windows we have only Pintard's description (Bulteau, p. 210).

[4] In the clerestory (on the left) at Chartres there is another window representing Eustace, which was also given by a knight, the seigneur de Beaumont-sur-Risles. (See F. de Mély, *Rev. de l'art chrétien*, 1888.)

[5] Gulielmus Durandus, *Ration.*, lib. IV., cap. xvi.

that of St. Gilles ? Our knowledge of the old guilds offers no explanation.

In many cases, no doubt, the cathedral chapter suggested to the donor the subject of the window he wished to offer. This is obvious when one remembers that the window of the Good Samaritan was given at Bourges by the weavers, and at Chartres by the shoemakers. It is hardly conceivable that it occurred to artisans to offer this parable with its profound theological commentary. The canons asked of the donors either the story of some famous saint like Thomas à Becket,[1] or some theological subject similar to that seen in windows in other cathedrals, whose fame had reached them.

It may be that the homage rendered to certain saints by the craft guilds was not perpetuated in later centuries. Our knowledge of the organisation of the mediæval guilds is very inadequate, and we know little of consequence, for instance, of the workmen at Chartres. M. de Lépinois who has sketched their history, found no documents earlier than the end of the thirteenth century ;[2] and those found in the *Ordonnances des rois de France* belong to the fifteenth.[3] In these little is said about the patrons of the guilds. Moreover it appears that certain of the guilds were subdivided into pious confraternities each of which venerated a particular saint. At Chartres for instance the weavers gave three windows dedicated to St. Stephen, St. Savinian and St. Potentian, and St. Vincent. At the bottom of the window of St. Vincent, near to the medallions in which the weavers are represented, the following inscription is found :—

TERA : A CEST : AVTEL : TES : LES : MESSES :
QEN : CHARE : SONT : ACOILLI : EN : TO
ERET : CESTE : VERRIE : CENT : CIL : QUIDO
LI : CONFRERE : SAINT : VIN

The meaning of this obscure inscription can only be guessed at. M. F. de Lasteyrie proposes to read it as follows : " A cet autel toutes les messes qui en charge sont accueillies . . . et donnèrent cette verrière . . . ceux qui sont les confrères de St. Vincent."[4] From this confused sentence

[1] Chartres must have held St. Thomas à Becket in special veneration, for John of Salisbury—one of its bishops in the twelfth century (from 1176 to 1180)—was at the martyr's side in Canterbury cathedral when he was assassinated, and was sprinkled with his blood. He collected a few drops in two vases which he gave to the cathedral of Chartres (*Cartulaire de* *Notre-Dame de Chartres*, vol. iii. p. 201). John of Salisbury wrote a life of Thomas à Becket.

[2] Lépinois, *Histoire de Chartres*, Chartres, 1854, 8°, vol. I. p. 384 *sq.*, and vol. II., appendix.

[3] *Ordonn. des rois de France*, vol. xix. p. 633.

[4] F. de Lasteyrie, *Histoire de la peinture sur verre.* The inscription was published in facsimile by M. F. de

one gathers that the weavers formed a confraternity of St. Vincent, and that they had masses said (no doubt for members who had died) in the chapel of the saint. St. Vincent is nowhere mentioned as the patron of the weavers, who were generally under the protection of St. Blaise. It may have been the same at Chartres, and that the great guild was divided into small pious societies which venerated special saints. Windows given by artisans and dedicated to saints other than the ordinary patrons of the guild can be explained in this way.[1]

If we are ignorant of all the special devotions of the craft guilds, we are naturally still more ignorant of those of individuals. Why for instance did a knight, Guillaume de la Ferté-Hernaud, give a window dedicated to St. Bartholomew to the church at Chartres? A thousand small matters which we can never know—the hereditary devotion of a family, some sacred image preserved in a private oratory, some relic guarded as a talisman in the pommel of a sword, some vow made during battle, any one of these would no doubt explain the donor's choice.

XI

Among the many mysterious reasons which might influence the choice of a saint to be represented in the church, the gratitude of a pilgrim on his return from such famous sanctuaries as Compostella, Bari or Tours, must not be ignored. It is a remarkable fact that of all the saints venerated in the Middle Ages the figures of St. James, St. Nicholas and St. Martin should most often be found in the churches.

At Chartres, where the glass is almost complete, there are as many as four windows dedicated to St. James.[2] The thirteenth century was the heyday of pilgrimages to Compostella. The enthusiasm of Christendom had been roused by a book which appeared in the twelfth century, in which an account was given of the numerous miracles with which the apostle had rewarded the faith of pilgrims. The author of the book was, as has been proved, a certain Aimeri Picaud, and not Pope Callixtus II to whom it was

Mély in the *Revue de l'art chrétien*, 1888, p. 422. Some of the syllables have been displaced.. Join VIN and CENT and read SAINT: VINCENT; and join DO and ERÊT and read DOERÊT.

[1] It is known that a guild or a religious confraternity could have several patrons. In 1882 some frescoes were found in the church of St. Michael of Vaucelles at Caen. They represented St. Michael, St. John the Baptist, St. Peter, St. Paul, St. James, St. Christopher, St. Martin, St. Mathurin, St. Eustace, St. Catherine, St. Andrew, St. Nicholas, St. Sebastian and St. Anne. A document dated 1446 which has recently come to light, shows that there was a confraternity of St. Michael connected with the church, which acknowledged as its patrons not only the archangel but all the above-mentioned saints. (See Beaurepaire in the *Bullet. monum.*, 1883, p. 689 *sqq.*)

[2] There are two at Tours, one at Bourges, and one at Auxerre.

ascribed in the thirteenth century.[1] The recital ot the miracles of St. James
is followed by a guide for the use of pilgrims,[2] in which are indicated all the
famous sanctuaries that the traveller may pass on his way. He has the
choice of four roads. If he goes by Provence he should in passing visit the
cemetery of Les Alyscamps, the shrine of St. Gilles, and the church of St. Sernin
at Toulouse. If he follows the road over the mountains, he should not fail to
stop at the church of Notre Dame at Le Puys, at the monastery of Aubrac,
at St. Foy at Conques, and at Moissac. If he crosses Limousin he should
stop at St. Léonard, at St. Front at Périgueux and at La Réole. If he starts
from Paris he should pay his devotions at the tomb of St. Martin at Tours,
at the tomb of St. Hilaire at Poitiers and at the tomb of the palladin Roland
(beatus Rotolandus) at Blaye. These famous churches are like milestones
on the highway to the shrine at Compostella.[3]

From the end of the twelfth century travelling became easier and safer.
Houses of shelter received the traveller at every halting-place.[4] When
crossing the Pyrenees the hostel of St. Christina suddenly appeared at the
end of the sombre mountain passes where the man of the plains was over-
come by fear, where everything alarmed him—the mountains " which seemed
to touch the heavens," the foaming water of the torrents which he believed
to be poisoned, the encounters with the Aragonese with their long knives, or
with the Basques " clever in imitating the cry of the wolf or the screech-
owl." [5] The old Roman road which led into Galicia was repaired. In the
twelfth century St. Domingo de la Calzada had passed his life in re-
building the bridges between Compostella and Logroño which had been
carried away by torrents, and for this holy work he had been canonised
by the Church. From 1175 the knights of St. Jacques de l'Epée-Rouge[6]
patrolled the roads and defended travellers. The pious journey was under-
taken by the greatest personages. Charlemagne, if the pseudo-Turpin
is to be believed, was the first pilgrim to Galicia when he set out
from France, following the direction of the Milky Way which has ever

[1] See V. Le Clerc's article on Aimeri Picaud in the
Histoire littéraire de la France, vol. xxi. p. 272 *sqq.*, and
M. Léopold Delisle's in the *Cabinet historique*, 2nd series,
vol. ii., 1878, p. 1 *sq.* The error arose from the fact
that from the beginning of the twelfth century Pope
Callixtus II was noted for his devotion to St. James.
He made obligatory the festivals of the Translation of
St. James (December 30) and the Miracles of St. James
(October 3). See *Patrol.*, clxiii., col. 1391.

[2] Aimeri Picaud's fourth book is a real travellers'
guide. It was published for the first time by Father

Fita under the title *Codex de Compostelle*, Paris,
1882, 12°.

[3] It is very remarkable that the churches of St.
Foy at Conques, of St. Sernin at Toulouse, and of St.
James at Compostella are almost identical.

[4] See Lavergne, *Les chemins de Saint-Jacques en Gas-
cogne*, Bordeaux, 1887, 8° ; see also Pardiac, *Histoire
de Saint-Jacques le Majeur*, Bordeaux, 1863, 12°.

[5] See Fita, *Codex*, p. 18.

[6] They had as device : " Rubet sanguine Arabum."

since been called "the path of St. James." Following the example of the great emperor, Louis VII also visited the sanctuary at Compostella.[1]

St. Louis was unable to make the pilgrimage, but he had a special devotion to the apostle, and Joinville tells us that on his death-bed he pronounced the name of "Monseigneur saint Jacques." The people, in whom still lived the spirit of the Crusades, also undertook this immense journey without hesitation. Staff in hand, the pilgrims chanted the "song of St. James" as they journeyed, taking up in chorus the old refrain *ultreia*, forward![2] Confraternities of St. James sprang up in many towns. At first only the pilgrims who had undertaken the journey to Galicia were members, but at the close of the Middle Ages it was only necessary to pay a sum of money to be received. Of these confraternities[3] that at Paris is best known to us, for its history was sketched by the Abbé Lebeuf[4] and written by M. Bordier.[5] The association of the pilgrims of Paris dates back to the thirteenth century, but is hardly known except through documents of the fourteenth. Members of the confraternity were still numerous in the fourteenth century, for at a great banquet given on July 25, 1327, in honour of their patron saint, 1536 persons were present. Étienne Marcel was inscribed as a brother of the confraternity of St. James.

Did confraternities of this kind exist at Chartres, Tours, Bourges? In the absence of written documents, an answer may almost be found in the windows. At Chartres, for example, excluding three windows dedicated to St. James—a sign of peculiar veneration—there is a fourth which shows nothing but six pilgrims accompanied by Robert de Berou, chancellor of the church at Chartres, whose name is written in full.[6] Moreover, one of the pilgrims wears St. James's cockle-shell. This is surely the window of a confraternity analogous to that at Paris, of which Robert de Berou was the senior member.

At Bourges a window devoted to St. James's contest with Hermogenes[7] bears no donor's name, but it is mutilated. The great shell so dear to

[1] *Cartulaire de Saint-Père de Chartres* (published by Guérard in the *Doc. inéd. de l'hist. de France*, vol. ii. p. 397).

[2] See Le Clerc, *op. cit.*, and the *Pèlerinage d'un paysan picard à Saint-Jacques de Compostelle au XVIII⁰ siècle*, published by Baron Bonnault d'Houet. Montdidier, 1890, 8°.

[3] See Ouin-Lacroix, *Hist. des anciennes corporations d'arts et métiers de Rouen.* Rouen, 1850, 8°, p. 471, and Forgeais, *Plombs historiés* (4th series): *Imagerie religieuse*, p. 151, and 3rd series, p. 105.

[4] Lebeuf, *Hist. du diocèse de Paris*, vol. i. p. 127 (ed. Cocheris), and vol. ii. p. 310.

[5] Bordier, *La Confrérie des pèlerins de Saint-Jacques*, in the *Mém. de la Société de l'hist. de Paris*, vol. i. 1875, p. 186 *sqq.*, and vol. ii., 1876, p. 342 *sqq.* The Confraternity of the pilgrims of St. Jacques of Rouen is also well known through documents, though it is true they are of a later date. See Ouin-Lacroix, *op. cit.*, p. 473 *sqq.*

[6] Clerestory in the choir, second window to the left.

[7] *Vitraux de Bourges*, pl. XV.

RELIGIOUS ART IN FRANCE

pilgrims, " St. James's scallop-shell," is powdered on the background, and leads one to ascribe the window to a confraternity.

One of the two windows at Tours which relate the story of St. James is for us of quite peculiar interest.[1] After the contest of St. James and Hermogenes, it presents a miracle taken from Aimeri Picaud's book. It is the story of an inn-keeper of Toulouse, who caused a young pilgrim to be condemned to death by accusing him of the theft of a golden cup which he had himself placed in his wallet. But happily the injustice of men was repaired by St. James, who for several weeks supported with his own hands the young man as he hung from the gibbet. He then gave him back alive to his father, who had his innocence proclaimed.[2] The introduction of this episode into a window at Tours indicates the intention to give special honour to St. James of Compostella, and for this reason it is perhaps not rash to attribute the gift of this window to a confraternity of pilgrims.[3] Finally, it was certainly the influence of the confraternities of St. James which caused the artists of the thirteenth century to represent the apostle in his familiar guise, with the staff and wallet and the cloak ornamented with shells.

Much less is known of the confraternities of St. Martin and St. Nicholas, and it can only be said that in the thirteenth century such confraternities existed.[4] St. Martin and St. Nicholas were venerated as the greatest of miracle-workers. One was the thaumaturge of the west, the other of the east, and in the south porch at Chartres they are placed with obvious intention opposite to one another.

Figures of St. Nicholas are constantly seen in all the French mediæval churches. At Chartres, where the work is practically complete, St. Nicholas is painted or carved no less than seven times, and the very incomplete windows at Auxerre, like those at Le Mans, tell his legend twice. It is found again in the cathedrals of Rouen, Bourges and Tours, in St. Julien-du-Sault in Burgundy and in St. Remi at Reims, and it was formerly to be seen in the cathedral of Troyes.[5] In a word, St. Nicholas

[1] Bourassé and Marchand, pl. III.
[2] Under the supposed authorship of Callixtus II Aimeri Picaud's story passed into the *Legenda aurea*, *De sanct. Jacob maj.*, and into the *Spec. histor.* of Vincent of Beauvais, lib. XXVI., cap. xxxi.
[3] The supposition is confirmed by the towers of Castile seen in the border, unless they are to be taken as the arms of the donor, Blanche of Castile, who was desirous of honouring the great saint of Spain. In either case it is St. James of Compostella.

[4] For the confraternities of St. Martin see *Bibl. de l'École des Chartes*, 1881, p. 5 *sq.*, and Lecoy de la Marche, *Saint Martin*. Tours, 1890, 2nd ed., p. 603. For the confraternities formed by the pilgrims of St. Nicholas, see Forgeais, *Plombs hist.*, 3rd series, p. 105.
[5] Fragments of a window to St. Nicholas have been found in the loft of the cathedral at Troyes (*Rev. de l'art chrétien*, 1891, p. 116. Article by the Abbé Laroche on the iconography of St. Nicholas).

is almost always met with where windows of the thirteenth century still exist. Although venerated among us from the eleventh, possibly from the tenth century,[1] his cult did not become popular until after the translation of his relics from Myra to Bari in 1087. The report of the miracles at the famous sanctuary in southern Italy spread his fame. In the twelfth century Peter Damian, in one of his sermons, enjoins the invocation of St. Nicholas immediately after that of the Virgin. He regards him as the most powerful protector whose aid the Christian can invoke, and he rejoices to see the faithful of all the countries of Europe flocking to his tomb.[2]

It was to St. Nicholas that one turned when in imminent peril. Joinville tells how in 1254 the queen, when in danger from a furious storm in the Mediterranean, promised a silver ship to St. Nicholas.

The pilgrimage to Bari, although less famous than that to Santiago, also stirred men's imagination. The marvel which pilgrims flocked to see was the stream of sweet-smelling oil flowing from the tomb of the saint. Leaden ampullae were filled at this exhaustless stream and the oil was used for healing. It was said that this miraculous oil also flowed from a relic of St. Nicholas, which at the end of the thirteenth century was brought to Varangeville in Lorraine.[3] There a church arose which soon became famous under the name of St. Nicholas du Port, and to it flocked the French pilgrims who were alarmed by the long journey to Bari.

The two celebrated pilgrimages to Bari and Varangeville no doubt influenced the numerous works of art dedicated to St. Nicholas in the Middle Ages. In the absence of written records one must be satisfied with probabilities, but it is more than likely that windows in honour of St. Nicholas were given by the pilgrims.

In the south porch at Chartres, a bas-relief in the tympanum[4] is devoted to the famous miracle of Bari. There one sees the sarcophagus on which the bishop lies, and from which the miraculous oil trickles down. Below, the faithful receive the precious balm in vessels or use it to anoint the sick. This sculpture may well have been commissioned by a confraternity of St.

[1] Dom Joseph de l'Isle gives several proofs of the antiquity of the worship of St. Nicholas in his *Histoire de la vie et du culte de saint Nicolas.* Nancy, 1745, p. 64.
[2] Petrus Damianus, *Sermo* 59. *Patrol.*, cxliv., col. 853.
[3] Dom. de l'Isle, *op. cit.*, p. 125.
[4] Right doorway (Fig. 157). The tympanum is devoted to St. Nicholas and to St. Martin. On the right is the tomb of St. Nicholas, from which flows the sweet-smelling oil, and below it St. Nicholas throwing a purse into the room of the poor man whose misery almost constrains him to sell his three daughters. On the left is St. Martin giving half his cloak to the beggar, and below it Christ appearing to St. Martin in a dream (St. Martin's servant is sleeping near him).

Nicholas, and it in any case indicates the prepossession of the thirteenth-century mind.

In France, if not elsewhere, St. Martin was as celebrated as St. Nicholas. In Merovingian times the sanctuary of St. Martin at Tours was the true centre of the religious life of Gaul. The rude pilgrims of the eleventh century went there to touch with their foreheads the bronze balustrade which sur-

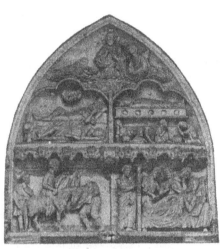

rounded his tomb, or to drink the water into which had fallen the dust that had gathered on the lid of his sarcophagus. In the thirteenth century this ancient devotion to St. Martin had even more vitality, if one may judge by the works of art inspired by the great apostle of the Gauls. For the story is represented no fewer than seven times at Chartres, while two windows are dedicated to him at Tours, at Bourges and also at Le Mans. Another is seen at Angers, and it has lately been dis-covered that a window at Beauvais,

FIG. 157.—TYMPANUM DEVOTED TO ST. NICHOLAS AND ST. MARTIN (Chartres)

until now unintelligible, contains the whole history of the saint.[1] We can hardly doubt that at one time no cathedral was complete without a window to St. Martin.

Here again the influence of the confraternities can be seen. The windows dedicated to him in the cathedral of Tours may well have been given by the confraternity of St. Martin, which had existed from the end of the seventh century.[2] It appears that the confraternity of Tours extended its generosity to neighbouring churches, for at Chartres, in a window dedicated to St. Martin one reads :

VIRI : TVRONV : DEDERV̄T : HAS : III.

It is probable that many windows dedicated to St. Martin were offerings either of pilgrims or of some confraternity. The knight who before setting forth on a long journey nailed a horseshoe to the door of the church in

[1] In the chapel of the Virgin in the apse, left window. See A. Pigeon, *Gazette des beaux-arts*, 1895, vol. ii. p. 233.

[2] Lecoy de la Marche, *op. cit.*, p. 603.

honour of St. Martin,[1] on his return offered a window in homage to the saint who had protected him. All this is little more than conjecture, for unhappily in the absence of written records one cannot arrive at any degree of certainty.

In this chapter we have considered the saints who are most frequently venerated in the mediæval churches of France. Relics, pilgrimages, confraternities, the special devotion of an individual or a district, a thousand reasons of which many escape us altogether, all these determined the choice of a saint.

The life of the saints was, as we see, an inexhaustible source of inspiration to art for more than three hundred years. After the Gospels, the story of the lives of the saints is of all human documents that which has had the most profound influence upon art.

[1] Horseshoes were nailed to the door of St. Martin's at Amiens. They may still be seen on the door of the little church of Palalda (eastern Pyrenees). See Lecoy de la Marche, *op. cit.*, p. 601. We would also point out the horseshoes nailed to the door of the church at Chablis (Yonne). This was a daughter-church of the abbey of St. Martin at Tours, and in the ninth century the relics of the saint reposed there for some time.

CHAPTER V

ANTIQUITY. SECULAR HISTORY

I.—Antiquity. The great men of antiquity rarely represented in the cathedrals. Aristotle and Campaspe. Virgil in the basket. The Sibyl as the symbol of antiquity. The sibyl Erythraea alone represented in the thirteenth century. Reasons for this. II.—Symbolic interpretation of classical myths. Ovid moralised. III.—History of France. Kings of France. Their figures less frequent than often supposed. Montfaucon's error. IV.—Great scenes in the history of France. Baptism of Clovis. Story of Charlemagne (window at Chartres). The Crusades. Life of St. Louis.

THE cathedral is as we have seen the city of God. In it the righteous, and all who from the beginning of the world have worked at the building of the holy city have their place. But those who are descended, as St. Augustine has it, not from Abel but from Cain, are not found there whatever the part they may have played in life. There is no place for Alexander or for Cæsar.

The Christian kings themselves are rarely seen there. The honour was not given to all, but was reserved for those who were pre-eminent as workers for the kingdom of God—for Clovis, Charlemagne and St. Louis. And so profane history when it does appear in thirteenth-century glass may in a sense also bear the name of sacred history.

I

It is at first surprising to find in Gothic cathedrals so few traces of antiquity. The thirteenth century, nourished as it was on Aristotle and Virgil, seems a little ungrateful to its masters. Though ignorant of Greek, its knowledge of Latin was profound, almost as great as that of the classical sixteenth century. A slight acquaintance with Vincent of Beauvais is enough to convince one that, in spite of defective knowledge of detail, the broad outlines of the histories of Greece and of Rome were known, and that the principal Latin writers, Virgil, Horace, Ovid, Lucan, Cicero and Seneca, were both read and enjoyed.[1] From their works Vincent of Beauvais made extracts of passages which seemed to him worthy to be engraved on the memory.

[1] See Boutaric, *Vincent de Beauvais et la connaissance de l'antiquité classique au XIII^e siècle (Revue des questions historiques*, vol. xvii., 1875, p. 1 *sq.*).

RELIGIOUS ART IN FRANCE

And yet the cathedral of Chartres alone shows some of the great men of antiquity. We have already seen Cicero carved at the feet of Rhetoric, Aristotle beneath Logic, Pythagoras beneath Arithmetic, and Ptolemy beneath Astronomy.

Byzantine art was far more ready than Gothic art to welcome the great men of classical times. It became in the east a tradition to paint in the churches the pagans who had expressed the finest conception of God, and whose works might be considered as a " præparatio evangelica." The Manual of Mount Athos, whose formulæ certainly date back as far as the Middle Ages, directs the painter to represent near to the prophets the figures of Solon, Plato, Aristotle, Thucydides, Plutarch and Sophocles,[1] and to give each of them a phylactery on which is written some line referring to the " unknown God." On Plato's scroll is to be written : " The old is new, and the new is old. The father is in the son and the son is in the father : unity is divided into three and trinity reunited into one." Aristotle says : " The Divine generation is by its nature eternal, for the Logos himself draws his essence from himself," and Sophocles : " There is an eternal God ; one in nature, the creator of heaven and earth." Didron saw the figures of some of these pagan sages painted on the outer porch of the church of the Panagia Portaïtissa in the monastery of Iveron on Mount Athos, as if through them were access to the Christian sanctuary.[2] Thus the Greek Church, like St. Justin, affirms that the ancient sages had their own revelation, and that all that is beautiful in their works is Christian. We have here a foretaste of the wide and humane spirit of the Renaissance. Raphael also reconciled ancient philosophy with Christianity, and opposite to his " Dispute of the Sacrament " he painted the " School of Athens."

The French artists seem at first sight far from equalling in breadth of mind either the Byzantine or the Renaissance artists, but one must not hastily pronounce judgment.

It is true that in the thirteenth-century churches all memory of the classical age seems to be lost,[3] for except at Chartres the sages of the pagan world never appear. Aristotle and Virgil alone are at times represented,

[1] Didron, *Manuel d'iconographie chrétienne (Guide de la peinture)*, p. 148 *sqq.*

[2] *Ib. ibid.*, p. 151.

[3] In the thirteenth century, however, an artist decorated the basin of the fountain in the cloister at St. Denis (now in the court of the École des Beaux-Arts) with figures of Jupiter, Juno, Hercules, Sylvanus, Fauns, Neptune, Diana, Ceres, Bacchus, Pan, Venus, Paris and Helen. Some of them have a naïve paganism which is not without charm—Neptune wears a fish on his head, Sylvanus has oak leaves for hair. For memories of classical art in mediæval art see Springer, *Das Nachleben der Antike im Mittelalter* (in *Bilder aus der neuern Kunstgeschichte*, Bonn, 1886, 2 vols. 8vo) ; and E. Muntz, *Journal des Savants*, October, 1887, and January to March, 1888.

but in what a position ! Aristotle walks on all fours carrying on his back the courtesan Campaspe (Fig. 158), and Virgil is suspended in a basket.[1] The two legends are so well known that it is hardly necessary to recall them.

Aristotle tried to wean Alexander's love from the beautiful Campaspe, and she vowed to avenge herself on the philosopher. So one morning as

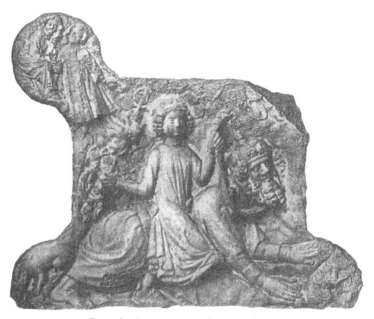

FIG. 158.—ARISTOTLE AND CAMPASPE (Lyons)

Aristotle was working in his room, Campaspe wearing simply a violet robe, passed under his window as she gathered flowering mint. The philosopher, overcome by the sight, went into the garden and swore to Campaspe that he loved her. But the beautiful Indian demanded that he should prove it by allowing himself to be bridled and saddled, and by carrying her on his back. Alexander, who had seen all, arrived at this juncture and surprised his master in the humiliating position, but unabashed he himself drew the moral :

[1] Five bas-reliefs which date from the latter part of the thirteenth or the beginning of the fourteenth centuries are given to the legend of Aristotle. Two are found on the façade of the cathedral of Lyons (see the *Revue d'architecture*, vol. i., 1840, col. 385 *sqq.*, the *Annal. arch.*, vi., 145 ; and Guigue and Bégule, pl. B. 2). The third is in the Portail de la Calende in the cathedral at Rouen (see Adeline, *Sculpt. grotesq.*, pl. xxxix.), the fourth is on a capital in the nave of the church of St. Pierre at Caen (see *Caen illustré*, by Eug. de Robillard de Beaurepaire, Caen, 1896, fo., p. 180), and the fifth is on a thirteenth-century choirstall at Lausanne (*Ann. arch.*, vol. xvi. p. 56). On this fabliau see J. Bédier, *Les Fabliaux*, 1893, p. 170 *sqq.*

" How greatly should a young prince mistrust love when he sees how an old philosopher may be ensnared."

This delightful story had no pretensions to historical fact, and it was never taken seriously, for it passed neither into the Latin biographies of Aristotle nor into the legend of Alexander.[1] Its presence in the cathedrals was in fact due merely to the use made of it by contemporary preachers.[2] Like Æsop's Fables, which are also sometimes represented on the capitals and porches of churches,[3] the fable of Aristotle was used to illustrate a moral truth ; both were equally dear to the preachers.[4] The story was in no sense intended to recall the Aristotle of history, the great master of the schoolmen.

The same might be said of the legend of Virgil, which is found on a fourteenth-century capital in the church of St. Pierre at Caen.[5] The absurd adventure with which the poet was credited in the Middle Ages is well known. Virgil accepted an assignation given him by a malicious Roman lady who lived at the top of a tower. She one day persuaded him to get into a basket, when after drawing him up halfway she ceased to pull, and left him hanging between heaven and earth. The next day the whole city gathered to see the famous magician, the sage who knew everything but the nature of woman.[6] The story, of which no mention is made by serious historians,[7] is merely an amusing fable, a pendant to the legend of Aristotle, for both were excellent examples with which to illustrate a sermon on the malice of woman. The names of Aristotle and Virgil are in fact only there to embellish the story and add to its efficacy. What is woman if she is able to place the two greatest scholars in the world in so ridiculous a position !

There is no reason to dwell on representations of this kind, which after all are scarcely relevant to our subject. It is clear that no deep thought underlay these little stories, and that it was not as witnesses that these great classical figures were introduced into the house of God, as was the custom in Byzantine art.[8]

[1] The story of Campaspe was unknown to Vincent of Beauvais. He speaks of Aristotle (*Spec. histor.*, lib. III., cap. lxxxii.) and of Alexander (lib. IV., cap. i. *sqq.*). It is not included in the Latin history of Alexander, Bibl. Nat., MS. Latin 8865 (thirteenth century).

[2] It is found in the *Promptuarium exemplorum*, taken from Jacobus de Vitriaco's sermons.

[3] Porch at Amiens ; the wolf and the swan, the crow (or perhaps the cock) and the fox.

[4] Vincent of Beauvais (*Spec. histor.*, lib. III., cap. viii.) collected some of Æsop's fables because he thought they would be useful to preachers.

[5] *Caen illustré*, p. 179.

[6] Comparetti, *Virgilio nel medio evo*.

[7] Vincent of Beauvais, who recounts all the wonders attributed to Virgil as magician, does not include this adventure (*Spec. histor.*, VI., lxii.).

[8] We are not here speaking of certain objects of domestic use on which classical personages are represented ;—the fountain at the Bibl. Nat. on which is seen the history of Achilles as told by Statius (Maurice Prou, *Gaz. archéol.*, 1886, p. 38), a thirteenth-century ivory on which the story of Pyramus and Thisbe is seen (*Jahrbücher des Vereins von Altersthumsfreunden in Rheinland*, Bonn, 1847, pl. V.), a thirteenth-century fountain which shows Campaspe riding Aristotle

RELIGIOUS ART IN FRANCE

Yet antiquity is represented, and in noble fashion, in the thirteenth-century cathedral, for although the sages of classical times are not there, the sibyl is found in several churches. The sibyl to mediæval men is a profound symbol. She is the voice of the classical world. Through her mouth the whole of antiquity speaks, and she testifies that the Gentiles themselves were not left without visions of Christ. While the prophets were announcing the Messiah to the Jew, the sibyl was promising a Saviour to the pagan, and the two peoples were filled with the same desire. So the words of the sibyl were worth all the wisdom of the philosophers, and she alone deserved to represent antiquity, for she alone in calling Him by name had clearly heralded the Saviour of mankind.

The ancient prophetess is seen to-day both at Laon and Auxerre. She may possibly have been carved in the porches of all the cathedrals, but time has effaced her name on the scrolls and she is no longer to be recognised.

What name must be given to the sibyl of Auxerre and Laon, for ten sibyls were known to the thirteenth century ? Vincent of Beauvais, repeating Lactantius,[1] Augustine,[2] Isidore of Seville [3] and the Venerable Bede,[4] gave the following names to them ; Sibylla Persica, Libyca, Delphica, Cymeria, Erythraea, Samia, Cumana, Hellespontia, Phrygia, Tiburtina,[5] but of these ten Erythraea alone was really famous. " Erythraea," says Vincent of Beauvais, " was the most famous and illustrious of them all. She prophesied at the time of the founding of Rome, Achaz, or according to others Ezekias, being king of Judah.[6] The celebrity of the sibyl came from a passage in the *City of God*. St. Augustine attributed to her the famous acrostic verses on the Day of Judgment [7] in which the first letters of each line form the name Jesus Saviour, and Erythraea was from that time considered as the greatest

(Guigue and Bégule, p. 203), a thirteenth-century ivory treating the same subject (Montfaucon, *Antiq. expl.*, III., part II., pl. CXCIV.), &c. These do not belong to religious art. Neither do we include the legends of Alexander borne to heaven by two griffins or of Trajan giving justice to the widow, because these subjects are not once met with in the French cathedrals. They belong to Italy and Germany. Alexander is seen for example at St. Mark's, Venice (J. Durand, *Ann. arch.*, vol. xxv. p. 141), on a dalmatic at Anagni (B. de Montault, *Ann. arch.*, xviii. p. 26), at Basle and at Friburg in Breisgau (Cahier, *Nouv. mélanges d'archéol.*, p. 165 *sq.*). The justice of Trajan is seen on a capital in the ducal palace at Venice.

[1] Lactantius, *Divin. Instit.*, lib. I., *Patrol.*, vi., col. 141.

[2] St. Augustine, *De Civit. Dei*, *Patrol.*, xli., col. 579.

[3] Isidore, *Etymol.*, VIII., cap. viii., *Patrol.*, lxxxii., col. 309.

[4] Bede (*Dubia et Spuria*), *Patrol.*, xc., col. 1181.

[5] Vincent of Beauvais, *Spec. histor.*, II., cap. c., ci., cii. The French poets of the thirteenth century adopted the number of ten for the sibyls. See Bibl. Nat., MS. fr. 25407 (thirteenth century).

[6] *Spec. histor.*, II., cap. cii. What Vincent of Beauvais says of the celebrity of Erythraea was taken from Isidore of Seville, *Etym.*, viii. 8. *Patrol.*, lxxxii., col. 309.

[7] St. Augustine, *De Civit. Dei*, xviii. 23. *Patrol.*, xli., col. 579.

and most divinely inspired of all the sibyls. Clearly it is she who is spoken of in the *Dies Irae*.

> " Dies irae, dies illa,
> Solvet saeclum in favilla,
> Teste David cum sibylla."

It remains to show that the sibyls of Auxerre and Laon represent the sibyl Erythraea. With regard to the sibyl of Auxerre, her name " Sibylla " [1] is written close to her. The absence of any adjective seems to indicate that the artist was thinking of the sibyl of the *Dies Irae*, and this hypothesis is supported by the presence near to her of the crowned head of a king, who may well be King David. In this way the sculptor may have tried to translate a line of the well-known verse.

At Laon there is no room for doubt, although the sibyl in the arch of the left porch of the façade (Fig. 159) has not yet received her true name.[2] The Abbé Bouxin in his description of the cathedral of Laon calls her " Divine Law." [3] He misreads the inscription, which he restores in this form, " aeterna per saecla futura " and translates " she (the divine law) will endure to the end of time." It should read, " (adveni)et per saecla futurus," and it is the end of the second line of the acrostic poem which Augustine attributed to the sibyl Erythraea. The lines begins thus :

> " Judicii signum : tellus sudore madescet,
> E coelo rex *adveniet per saecla futurus,*
> Scilicet in carne praesens ut judicet orbem."

There can be no doubt that the figure on the porch at Laon stands for Erythraea, the representative sibyl.

A sibyl is seen opposite to the prophets in the fourteenth-century frescoes in the palace of the popes at Avignon.[4] She displays a phylactery on which is written : " Judicii signum tellus sudore madescet | e coelo rex adveniet per saecla futurus | scilicet in carne (prae)sens | sibilla." One at once recognises Erythraea, the typical sibyl in the fourteenth as in the thirteenth century.

The celebrity of the Erythraean sibyl in the Middle Ages unquestionably came to her from the part she played in the famous sermon of the pseudo-Augustine. In it she is described as following the prophets, wearing a crown on her head, and pronouncing the acrostic lines on the end of the

[1] The figure of the sibyl is carved in the interior of the cathedral, in the choir ambulatory, following the custom in Burgundian art.

[2] A cast has been taken, and is in the Trocadéro (No. 120). The head has disappeared. In her hand she holds tablets which resemble the tables of the Law.

[3] Abbé Bouxin, *La Cath. de Laon*, p. 72.

[4] In the hall of the consistory.

world which are quoted above, " Judicii signum . . .". The artists who took from this sermon the idea of the line of Hebrew prophets displaying messianic writings on their scrolls,[1] also borrowed from it the figure of the sibyl, as symbol of the expectation of the Gentiles.

It is an interesting fact that the Guide to Painting from Mount Athos mentions one sibyl only. The prophetess is given the vague name of " the wise sibyl,"[2] but after reading the words which the Guide attributes to her, it is easy to see that here again the typical sibyl is Erythraea. In her hand should be placed a phylactery on which is written : " There shall come from heaven an eternal king who shall judge all flesh and all the universe," a prophecy which is merely a free translation of two of the acrostic lines given above, " E coelo rex adveniet . . .". There is, as we see, an exact correspondence between the Byzantine sibyl and the

FIG. 159.—THE SIBYL ERYTHRAEA (Laon)

western sibyl at Laon and Auxerre. Didron was mistaken when he contrasted the one sibyl of the east with the twelve sibyls of the west, for in France as in Greece one sibyl alone, Erythraea, was represented in the thirteenth century. The others do not appear until later.[3]

[1] See above, bk. IV., ch. I (the Old Testament).
[2] Didron, *Guide de la peint.*, p. 150.
[3] In a Latin thesis entitled " Quo modo Sibyllas recentiores artifices repræsentaverint ", I have shown that beside the sibyl Erythraea mediæval Italy knew the Tiburtine sibyl, made so famous by the legend of the Ara Cœli. She was reputed to have shown the Virgin and Child to the Emperor Augustus. The

II

And so antiquity is represented in the cathedral by the mysterious figure of the sibyl Erythraea.

Yet in the mind of the thirteenth century a curious idea grew up. The literature of the ancient world began to seem to the scholar as in some sort a dim revelation, in which as through a veil the Christian faith from time to time was seen. The *Metamorphoses* of Ovid in particular, were interpreted by the symbolic method applied to the Bible, and in them the same teaching was discovered. The view so constantly put forward, that classical mythology was merely a corrupt form of biblical tradition, was scarcely that held by the scholars of the thirteenth century. In their eyes the heathen fables were of the nature of a special revelation made by God to the Gentiles, in which, as in the Old Testament, was outlined the story of the Fall and the Redemption. Among the myriad forms in Ovid's crowded tapestry Christian eyes discerned the figures of Christ and the Virgin, which as he threw his shuttle the poet had unwittingly woven in.

Nothing of the kind is more curious than a manuscript of the *Metamorphoses* in the Bibliothèque de l'Arsenal.[1] Among miniatures illustrating the stories of Medea, Æsculapius or Achilles, one unexpectedly finds pictures of the Crucifixion, the Annunciation, or the Descent into Limbo, and the rhymed commentary which accompanies each story from Ovid explains and justifies the presence of the Christian subject. We learn, for example, that Æsculapius, who suffered death because he had raised the dead, is a type of Christ,[2] and that Jupiter, changed into a bull and carrying Europa on his back, also typifies Christ, the sacrificial ox who bore the burden of the sin of the world.[3] Theseus who forsook Ariadne for Phaedra prefigures the choice which Christ made between the Church and the Synagogue.[4] Thetis

legend was localised at Rome, but was not unknown to the rest of Christendom. Thus it is not surprising to find two sibyls in a Jesse window at Soissons (clerestory windows in the choir, thirteenth century). Near to each of them is written " Sibylla," and one soon sees that the second sibyl was placed there as pendant to the first. The Tree of Jesse has two main branches which are perfectly symmetrical, a king corresponding to a king, a prophet to a prophet, so a sibyl must of necessity face a sibyl. I noticed the same feature at Notre Dame at Paris, where round the arch of the left porch (west façade) there is also a Tree of Jesse. The first order is given to the prophets, the second to the kings of Judah, and among the kings are two crowned women who in my opinion are—as at Soissons—two sibyls. The name formerly written on their scrolls has disappeared.

[1] Bibl. de l'Arsenal, MS. 5069. *Le Roman des fables d'Ovide le Grand* (beginning of the fourteenth century), by Chrestien Legouais of Sainte-More, near Troyes. Both translation and commentary are in French verse. The Bibl. Nat. has six MSS. of Legouais :—Fr. 373, 374, 870, 871, 872, 24306. On Legouais, see Gaston Paris, *Hist. litt. de la France*, vol. xxix., 1885, p. 445.

[2] Arsenal, No. 5069, fo. 21.

[3] *Ibid.*, fo. 27.

[4] *Ibid.*, fo. 111.

who gave her son Achilles arms with which to triumph over Hector, is no other than the Virgin Mary who gave a body to the Son of God, or as the theologians have it, gave Him the humanity with which He must be clothed in order to conquer the enemy.[1]

These examples will give some idea of works of this nature, in which the whole of mythology becomes prophetic and, so to say, sibylline. With the exception of the miniaturists, the mediæval artists do not seem to have been acquainted with interpretation of this kind, for they never draw a parallel between a scene in a fable and a scene in sacred history. But the artists of the Renaissance had no scruples in comparing Hercules to Samson,[2] Eve to Pandora,[3] and Hercules burning on the pyre on Mt. Oeta for excessive love of Deianeira,[4] to Adam condemned to die for the sin of a woman.

To begin with, there was in all this nothing but ingenuousness. But humanists and scholars began to laugh at such simplicity, and Rabelais said : " Do you believe, on your honour, that in writing the Iliad and the Odyssey Homer ever thought of the allegories with which since his time Plutarch and Heraclides Ponticus have overlaid him ? If you believe it, you do not in any way approach my opinion, which is that these things were thought of as little by Homer as Ovid, in his *Metamorphoses*, thought of the sacraments of the Gospel,—as that true hypocrite brother Lubin strives to show, if perchance he meet people as foolish as himself, and (as says the proverb) a lid worthy of the pan." [5]

The great art of the thirteenth century showed its wisdom in admitting only the sibyl Erythraea as representative of pagan times.

III

But the Messiah is come, the Crucifixion is an accomplished fact and the story of the Christian centuries begins. From this time forward the true hero will be a saint, and he alone will appear in the cathedrals. The Christian kings, great as they may have been, will rarely be judged worthy of the honour.

At Reims, however, the cathedral of sacring, the kings of France are

[1] Arsenal, No. 5069, fo. 177.
[2] Jubé at Limoges (cast in the Trocadéro). E. Piper alludes to some of these comparisons in his *Mythologie der christlichen Kunst*, Weimar, 1847. 8vo, vol. i. p. 91 and p. 143 *sq.*
[3] We refer to the famous picture attributed to Jean Cousin, " Eva prima Pandora."

[4] Pilasters on the tomb of Philippe de Commines (École des Beaux-Arts).
[5] Prologue to *Gargantua*. Brother Lubin is the English Dominican, Thomas Walleys, author of a book entitled *Metamorphosis ovidiana moraliter explanata*, Paris, 1509. Such a book was true to mediæval traditions.

certainly seen in the clerestory windows of the nave. An inscription too gives a name—" Karolus "[1]—to one of them. Each king is accompanied by the bishop by whom he was consecrated. Nothing distinguishes one of these solemn figures of twenty monarchs from the rest, for they are in the church to remind the people that kingship is in its essence divine, and that the king anointed with sacred oil is more than man. The lesson is continued in the curious statuettes carved round the exterior of the great rose-window of the façade, where one sees David anointed by Samuel, and Solomon anointed by Nathan, and where the scenes which follow are intended as a reminder that if God raises kings above other men He exacts from them the highest virtues. He expects them to be courageous, David kills Goliath (Fig. 160) ; to be just, Solomon returns the child to its mother ; to be pious, Solomon builds the Temple. Above them all is a figure of God giving His blessing to the kings.[2] It reads like chapters of some *Politique tirée de l'Ecriture Sainte.* Such subjects were eminently fitted to be represented in the coronation church.

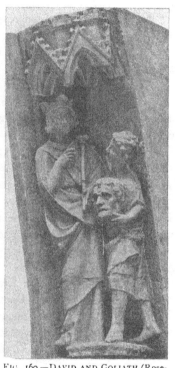

FIG. 160.—DAVID AND GOLIATH (Rose-window of the façade, Reims)

Figures of the kings of France are rarely found in the other cathedrals.[3] We have already shown that the statues ranged on the façades of Notre Dame at Chartres, Notre Dame at Paris, and Notre Dame at Amiens, which have been reputed to be kings of France, represent in reality the kings of Judah, ancestors of the Virgin.

The archæologists of the eighteenth century, with their imperfect knowledge of the true genius of the Middle Ages, helped to support the view that statues of the kings embellished the porches of twelfth and thirteenth-century churches. In his *Monuments de la monarchie française*

[1] Cerf, *Hist. et Descript. de Notre-Dame de Reims,* vol. ii. p. 290.

[2] These bas-reliefs, till now misunderstood, were first given a satisfactory interpretation by Canon Cerf (*op. cit.,* p. 160 *sqq.*).

[3] The windows in the north aisle at Strasburg represent the emperors of Germany.

RELIGIOUS ART IN FRANCE

Montfaucon is confident that the eight great statues in the porch of St. Germain-des-Près (now destroyed) represent seven princes or princesses of Merovingian times, accompanied by St. Remi, the bishop. He even goes so far as to name them—Clovis, Clothilde, Clodomir, Theodoric, Childebert, Queen Ultrogothe and Clotaire.[1]

Montfaucon also recognises kings of an early line in the old porch of St. Anne at Notre Dame at Paris, and is inclined to think that the figure which holds a violin might well be Chilperic,[2] for " he made hymns for the Church."

Again, Montfaucon finds the Merovingians in the Portail Royale of the cathedral of Chartres and in the porch and cloister at St. Denis, and as one knows had drawings made of them to illustrate his history of the early kings of France.[3]

It is surprising that a learned Benedictine, so able an interpreter of classical monuments, should so far misinterpret the religious art of his own country. The kings and queens of France whom he thinks to find in the church porches, are in reality the ancestors of Jesus according to the flesh. The dignified kings in the porch at Chartres and the queens with the mysterious smile and beautiful plaited hair are, as M. Vöge seems to have shown conclusively,[4] the kings and queens spoken of in St. Matthew's genealogy. Rahab, Solomon,[5] Ruth, Boaz and Obed are to the left in the central doorway, Jesse, David, Bathsheba and Solomon are to the right. The agreement with St. Matthew is so perfect (vv. 1, 5, 6, 7) that one can hardly fail to adopt the solution proposed by M. Vöge.

The mistake made by the Benedictine school had the most disastrous consequences. It had so often been stated on the authority of Montfaucon that the statues at St. Denis, at St. Germain-des-Près and at Notre Dame represented the kings of France, that in 1793 it was deemed necessary to destroy them. The erroneous interpretation not only caused the loss of most valuable works of art, but added enormously to the difficulties of

[1] *Monum. de la Monarch. franç.*, Paris, 1729, fol., vol. i. p. 51. Montfaucon was mistaken, deceived it is true by the inscriptions which had been painted (probably in the seventeenth century) on the scrolls of the kings. He had read " Chlodomirus " in Roman letters, and " Chlo(tari)us." Before him Dom Ruinart had remarked the same names. He says, " Quas quidem litteras, *etsi forte primariis substitutae videantur*, antiquissimas tamen esse ipsa characterum forma et viridis color fere penitus detritus probant " (*Sancti Gregorii Turon, Opera omnia*, Paris, 1699, col. 1371).

Ruinart was right in believing that these inscriptions were substituted for others. In the cathedral of Le Mans one of the old inscriptions is preserved, and on the scroll is written " Salomo."

[2] It is really David.

[3] *Monum. de la Monarch. franç.*, pl. VIII., IX., XV., and XVI. in vol. I.

[4] Vöge, *Die Anfänge des monumentalen Stiles*, part II., ch. ii. 174.

[5] This statue has disappeared.

342

tracing the history of the beginnings of French sculpture.[1] Montfaucon's error is still alive, and more than one archæologist persists in seeing figures of the French kings in the church porches. The Abbé Bulteau in his Monograph on Chartres more than once makes this mistake. Where M. Vöge sees the ancestors of Jesus in the Portail Royale at Chartres, he sees Charlemagne, Bertha of the Clubfoot, Canute, William the Conqueror and Queen Matilda.[2] He states without the shadow of a proof, that one of the large statues in the north porch represents Louis VIII and another Isabelle of France, daughter of Louis and Blanche of Castile[3] (Fig. 162), and among the statues in this same porch—some of which were missing —he mentions Philip, count of Boulogne, and his wife Mahaut (Fig. 161), Philip Augustus, king of France, and Richard Cœur-de-Lion.[4] They are there in his view as benefactors of the cathedral. He failed to ask himself whether these statues might not represent types of Christ, the prophets of Israel and the kings and famous women of the Bible. The biblical scenes carved beneath the brackets ought to have enlightened him. Several events from the history of Saul and David may be deciphered under the statues (destroyed) of the pseudo-Philip Augustus and Richard Cœur-de-Lion, so where Bulteau saw kings of France and England we must recognise two kings of Israel.[5] In the same way six scenes from the story of Samuel are

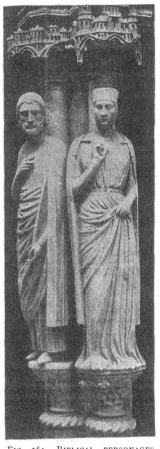

FIG. 161.—BIBLICAL PERSONAGES MISNAMED PHILIPPE AND MAHAUT DE BOULOGNE (Chartres)

[1] In the interesting book he has devoted to the sources of French sculpture M. Vöge is constantly obliged to have recourse to Montfaucon's inferior drawings.

[2] Bulteau, Monogr. de la cath. de Chartres, ii. 65 and 66.

[3] Vol. ii. 201.

[4] The so-called statues of Philip Augustus and Richard Cœur-de-Lion disappeared during the Re-

volution. Bulteau described them after a MS. which Canon Brillon had prepared for Montfaucon, now in the library at Chartres, No. 1099.

[5] One of them seems to carry a cross; David foretold the Passion. The so-called Comte de Boulogne and Mahaut (Fig. 161) may well be Jesse, father of David, and his wife. Jesse is in fact represented on the bracket (bas-relief) with the designation "YSHI."

RELIGIOUS ART IN FRANCE

seen under the brackets of the statues of the so-called Louis VIII, of his daughter and of two men who accompany him. One of these little bas-reliefs in which the figures are named—Hannah, Elkanah, Samuel and Eli—

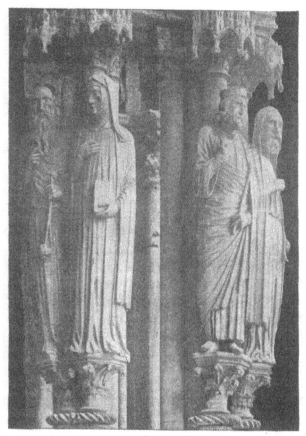

FIG. 162.—BIBLICAL PERSONAGES MISNAMED LOUIS VIII AND ISABELLA OF FRANCE (Chartres)

shows Samuel taken by his parents to the high priest, and it can hardly be questioned that the four large statues represent Samuel, his mother, his father, and the high-priest who holds a censer (Fig. 162). It is notice-able too that the large statue of Hannah carries a book like the small figure named Hannah in the bas-relief.

There are in the cathedrals few works of art which can with certainty be said to represent figures in French history. The piety of the kings, and

344

OF THE THIRTEENTH CENTURY

their respect for the house of God no doubt explains the small number of their effigies, for they would not be placed above the heads of the faithful, on the same plane as prophets, apostles and martyrs. One should not forget the golden retable (eleventh century) of St. Henry in the Cluny Museum, where the emperor and his wife—so small as at first to pass unnoticed— are seen prostrate before Christ, hardly daring to kiss His feet. Feeling such as this, strong in the eleventh century, persisted into the thirteenth. When kings, bishops and barons appear in the windows, it is as donors holding but a very modest place, and as a rule kneeling humbly at the feet of Christ, the Virgin or some saint.

It was in this attitude that Louis VII was carved in the tympanum of the Portail Sainte-Anne at Notre Dame at Paris, and that St. Louis and his wife, Marguerite of Provence, are seen kneeling before the Virgin in the Portail Rouge [1] (Fig. 130).

If there was no lessening of piety, there was certainly a marked growth of kingly pride in the course of the following century. In 1375 statues of Charles V, the dauphin Charles VI, Jean Bureau, sire de la Rivière (the king's minister), Louis, Duc d'Orléans and Cardinal La Grange were placed by the side of statues of the Virgin and St. John the Baptist on the buttresses of the north tower of Amiens cathedral, and they were moreover of the same size as the sacred figures.[2] Such familiarity would certainly have shocked a St. Louis, but by 1373 the confines of the true Middle Ages are reached.

One may conclude from the preceding study that in the thirteenth century, the zenith of religious art, figures of kings, barons or bishops appeared in the churches only in the capacity of donor, and that with but few exceptions they were shown in attitudes which made it impossible to confound them with the saints.[3]

[1] Guilhermy, *Descript. de Notre-Dame de Paris*, p. 170. St. Louis, his mother, Blanche of Castile, and his wife, Marguerite of Provence, are seen kneeling at the feet of the Virgin and St. Peter in a window made for the church of Moulineaux, near to Rouen (F. de Lasteyrie, *Histoire de la peinture sur verre*, p. 154 and pl. XXIV.).

[2] See Courajod and Marcou, *Catal. raisonné du Trocadéro*, 46 sq.

[3] Exceptions are rare, but a curious witness to them was recently discovered. Before 1793 there was in the left doorway of the façade of Notre Dame at Paris a large statue of a king (restored). Lebeuf (*Hist. du diocèse de Paris*, ed. Cocheris, i. 9) speaks of this king, whom he does not name. Now in 1884 M. Delaborde published a document of 1410 which refers to the statue in question (*Mémoire de la société de l'hist. de Paris*, xi., 1884, 363). It relates to a " procès du chef de saint Denys," and one there reads as follows : " It appears that in the left porch of the church at Paris, towards Saint-Jean-le-Rond, in which are large and ancient images of stone, there is the statue of the king Philip the Conqueror represented as a young man, because he was crowned in the fourteenth year of his age ; the which points to the image of Monseigneur saint Denis carrying his head and also to images of Notre Dame, St. Stephen, and John the Baptist, proving that the aforementioned relics which he had given to the said church at Paris were of the saints whose images he shows." The statue at Notre Dame was apparently of Philip Augustus and was erected during his lifetime, but such testimony should be received with caution. The traditions of great

RELIGIOUS ART IN FRANCE

IV

Although their statues are so rarely found there, the victories of the kings to which the Church at times owed her deliverance, are represented in the churches. In these supremely national buildings three chapters only in French history are seen, the baptism of Clovis, the exploits of Charlemagne, and the victories of the first crusades. Reflection will show that these comprised the whole of French history for the Frenchman of the thirteenth century. The Church accepted and made her own, these great names which almost alone had lived on in the popular memory. Clovis, Charlemagne and Godfrey de Bouillon mark in fact three epochs in the history of Christianity in France. The royal house and the whole of France seem to have been baptized on the day of the baptism of Clovis, when the Christian era in France might almost be said to have begun. Three hundred years later Charlemagne gave to Gaul the first perfect model of the Christian king, and realised the Church's dream when he put his sword at the service of the Faith. The great emperor's work was continued by Godfrey de Bouillon and the valiant knights who joined the first crusades. The three centuries which had passed, with their changing dynasties, their migrations of tribes and their feudal conflicts, were of slight importance to the Church, who in the pages of history sought for God alone. For three hundred years it had seemed as though the world were deserted by God, and then in the crusades, the " Gesta Dei per Francos," had suddenly felt His presence and inspiration.

Such is Vincent of Beauvais's reading of history. He tells with obvious delight of the exploits of Clovis and Charlemagne, and of the first crusades.[1]

The artists, faithful interpreters of the Church's thought, carved the baptism of Clovis on the façade at Reims. Seven great statues placed in niches above the rose-window, stand for Clovis, St. Remi, Queen Clothilde and four lay or ecclesiastical dignitaries. The heathen king is immersed to the waist in the baptismal font, and St. Remi holds out his hand to receive

religious art began to decline in the fifteenth century, and it was quite possible for works of the thirteenth century to be misunderstood. Yet we would not pretend for a moment that the clerestory windows in the apse of the cathedral of Troyes do not appear to represent three historical characters. One is an unknown emperor (the inscription reads " Imperator "), another is a king—" (R)ex Philipp."—no doubt Philippus, who might well be Philip Augustus, and the third is a bishop, " Eps. Herve " in the in-

scription, no doubt Bishop Herveus who died in 1223. And finally, on the trumeau in the north porch of the cathedral of Bordeaux there is said to be a figure of Pope Clement V (Bertrand de Goth, formerly archbishop of Bordeaux), but the head has been restored and one may well question whether the statue really represents Clement V.

[1] *Spec hist.*, XXI., iv. *sqq.*; XXIV., i. *sqq.*; XXV., xcii. *sqq.*

the ampulla brought by a dove. The statues of the king and the bishop fill the centre of the façade, and rivet the attention at the first glance upward. They were evidently intended to remind future generations that it was through divine intervention that France, in the person of her king, became Christian.

The story, or rather the legend of Charlemagne, is found at Chartres, where it fills a window given by the furriers. This famous window, so often reproduced and so often described, has never been really understood, and demands detailed study.[1] The errors of the interpreters arose from their inability to disentangle the various sources from which the authors of the window had taken their story. The following three works had been placed under contribution : "The Journey of Charlemagne to Jerusalem," the Chronicle wrongly ascribed to Turpin, and the "Legend of St. Gilles."

"The Journey of Charlemagne to Jerusalem" was the work of a monk, probably of St. Denis, who wrote at the beginning of the eleventh century.[2] Desirous to prove the authenticity of certain relics of the Passion preserved in the abbey of St. Denis, the author relates that Charlemagne made an expedition to the Holy Land, and that on his return the emperor of Constantinople gave him the Crown of Thorns as a reward for the deliverance of the Holy Sepulchre.

The Chronicle of the pseudo-Turpin is a composite work of several anonymous authors, which grew up during the course of the eleventh century. It is devoted to the story of Charlemagne's conflicts with the infidels of Spain, and in it historical tradition and popular legend meet. Written in Latin, it was well received by the Church, and from the twelfth century was accepted as the authentic work of the ancient archbishop of Reims.

The "Life of St. Gilles" furnished one feature only in the legend of Charlemagne, the story of the terrible sin which the emperor would not confess, and which was miraculously made known by God to the holy hermit.

The window at Chartres was taken from the three works we have just

[1] The authors of the great *Monographie de la cathédrale de Chartres* reproduce the Charlemagne window (pl. LXVII.), as does Didron in the *Annales arch.*, XXIV., p. 349. Lévy and Capronnier give the panel of Constantine's dream in their *Histoire de la peinture sur verre* (pl. X.), and M. F. Lasteyrie describes the window at Chartres in his *Histoire de la peinture sur verre* (p. 77), seeing in it the story of Charles the Bald. The Abbé Bulteau recognises Charlemagne, but makes several mistakes in interpretation (*Descrip.*

de Chartres, 1850, p. 237). In the *Monogr. de Notre-Dame de Chartres*, which accompanies the plates published by the State (1880), Paul Durand is more accurate, but is incorrect on several points (p. 165).

[2] Paris, *Hist. poét. de Charlemagne*, p. 55. In his *Étude sur le voyage de Charlemagne en Orient* (1907) M. Coulet has shown that the legend was invented in the tenth century by Benedict, a monk of Monte Sorrate.

RELIGIOUS ART IN FRANCE

mentioned. They had probably been collected into a single volume which belonged to the canons of Chartres, and there exists in fact a compilation of this nature, which some monk at Aix-la-Chapelle made in the twelfth century by order of Frederick Barbarossa, who wished to spread throughout Christendom the story of the recently canonised emperor.[1] This book, *De la sainteté des mérites et de la gloire des miracles du bienheureux Charlemagne*, includes the "Journey to Jerusalem," the Chronicle of the pseudo-Turpin, and several biographical details taken from other sources. The story of the relations of St. Gilles and Charlemagne have, it is true, no place in the manuscripts which we have glanced through,[2] but it can hardly be doubted that this last episode was added to some thirteenth-century manuscripts, for the famous shrine at Aix-la-Chapelle presents the story of Charlemagne and St. Gilles in addition to the incidents of his journey to Constantinople and his travels in Spain.[3] Such close analogy between two works of art executed in districts so far removed from one another, goes to prove that both derived from one written source.

We will now describe the different scenes in the window at Chartres, beginning at the bottom according to rule. The first six panels (Fig. 163) are taken from the "Journey to Jerusalem."

1. Charlemagne, wearing the nimbus, receives two bishops who bring him a letter from Constantine, emperor of the East. The letter contains the story of Constantine's vision.

2. Vision of Constantine. "As I slept," says the text, "an angel said to me, 'Behold, Charlemagne, king of France, thy defender,' and he showed me an armed warrior, wearing a coat of mail and holding a red shield, and girt with a sword whose sheath was of the colour of purple. He had a great lance whose point sent forth as it were flames; in his hand he held a golden helmet, and his face was that of an old and bearded man, full of majesty and beauty. His hair was white and his eyes shone like stars."[4] This fine description has not been followed very closely, for the hero's face is hidden under the closed helmet of the thirteenth century, yet the fine silhouette of Charlemagne motionless on his horse, mysterious as ghostly visitant, is not lacking in epic grandeur.

3. A battle. Charlemagne delivers Jerusalem.

[1] Charlemagne was canonised on December 28, 1164. On the Aix compilation see Gaston Paris, *Hist. poet.*, p. 63.

[2] Bibl. Nat., MSS. Latins 4895 A and 6187.

[3] See the reproduction of some of the scenes which decorate the shrine at Aix-la-Chapelle in E.

Müntz's *Études inconogr. sur le moyen âge*, 1887 : *La Légende de Charlemagne dans l'art*, p. 85 *sq.*

[4] Bibl. Nat., MS. Latin 6187, fo. 16 *sqq.* The account of the journey to the east is also found in Vincent of Beauvais, *Spec. hist.*, XXIV., i. *sqq.*

348

4. The victorious Charlemagne, still wearing spurs, is received by Constantine at the gates of Constantinople.

5. Charlemagne receives from the emperor three reliquaries. One contains the Crown of Thorns, which at that moment bursts into flower and by its perfume heals three hundred sick ; the others contain a fragment of the Cross, the shroud of Christ, the Virgin's shift, and the arm of the ancient Simeon which had carried the Child in the Temple.

6. Charlemagne offers these holy relics to the church at Aix-la-Chapelle.

From here onward the subjects are taken from the Chronicle erroneously attributed to Turpin.

7. Charlemagne and two of his followers are seen gazing at the Milky Way. The emperor marvels at it, and asks whither this great road may lead.[1]

8. St. James appears to Charlemagne and commands him to follow the Milky Way to Galicia, and to deliver his tomb from the hands of the Saracens.

9. Charlemagne starts with his warriors, among whom the bishop Turpin can be recognised.

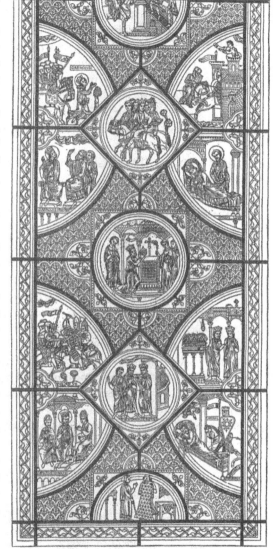

FIG. 163.—CHARLEMAGNE WINDOW (lower portion), Chartres

[1] Bibl. Nat., MS. Latin 6187, fo. 53 *sq.*, and Vincent of Beauvais, *Spec. hist.*, XXIV., vi. *sqq.*

10. The emperor throws himself on his knees in front of his army, and implores God to deliver Pampeluna into his hands.

11. The Christians enter Pampeluna. The artist at Chartres, unlike his brother artist at Aix-la-Chapelle, has not thought it necessary to represent the walls of Pampeluna crumbling under the hand of God.

12. Charlemagne is seen giving orders to workmen who build a church in honour of St. James (Fig. 164).

13. Charlemagne is once more in Spain. His army is about to engage in battle with the army of Agolant, the paynim king. During the night the lances of the soldiers who will perish on the morrow burst into flower.

14. The battle. The infidels are distinguished by their conical helmets and round shields.

15. Here the artist has interpolated an incident taken from the " Life ot St. Gilles." Charlemagne had committed so grave a sin that he dared not confess it, but one day as St. Gilles said mass in the emperor's presence, an angel brought the hermit-saint a scroll on which the sin was written. Charlemagne repented, and God pardoned him.[1] This is the subject which the artist represents in the panel where the Abbé Bulteau and Father Durand thought to see bishop Turpin saying mass. They did not notice that the officiating priest is a monk not an archbishop, that he has a saint's nimbus, that an angel from heaven brings him a scroll, and that the emperor is seated apart with his head on his hands. The subject is presented in the same way on the shrine at Aix-la-Chapelle, where four bad Latin lines leave us in no doubt as to its meaning.[2] The mass of St. Gilles is found twice at Chartres, for it is also carved in the south porch, in one of the arch orders in the right doorway.

16. The story from the Chronicle of Turpin, interrupted for a time, here begins again. Roland who has engaged in single combat with the giant Fierabras, kills him with a sword-thrust. It is noticeable that he thrusts the sword, Durandal, into his stomach because, says the pseudo-Turpin, it was only there that the giant was vulnerable.

[1] See *Act. Sanct.*, Sept. i. 299 *sq.*, and Vincent of Beauvais, *Spec. hist.*, XXXIII., cxl. The Latin legend does not speak of Charlemagne but of a king called Carolus, who may be Charles Martel. But popular poetry soon made Charlemagne the hero of the legend. Men also wished to know the nature of Charles's sin, and imagined that he had had impure relations with his sister ; see Gaston Paris, *Hist. poét.*, p. 378, and the Introduction to the *Vie de Saint*

Gilles, published by the Société des Anciens Textes français.

[2] " Crimen mortale convertitur in veniale.
 Egidio Karolum crimen pudet edeire (sic) solum,
 Illud enim tanti gravat. Egidio celebranti
 Angelus occultum perhibet reseratque sepultum."

17. Charlemagne crosses the mountains into France. He seems to talk with someone, who is probably Ganelon.

18. Roland surprised in the rear-guard, and left alone with the dead. In accordance with the mediæval custom when representing two different moments in a story, the hero is shown twice in the same picture. He strikes the rock with his sword, he sounds his horn. It is the exact translation of the following passage in the chronicle. " He lifted his sword and wept upon it. Then wishing to break it he struck a rock, but split it from one end to the other and drew forth his sword intact. Then he blew his horn with such force that it cracked in two, so they say, and the veins of his neck started. And carried by an angel the sound of his horn reached Charlemagne. . . ." Roland is represented wearing the nimbus, because in the thirteenth century he was honoured as a saint. Old passionals designate him " Sanctus Rolandus comes et martyr in Roncevalla,"[1] and pilgrims to the shrine of St. James of Compostella when passing through Blaye, went to make

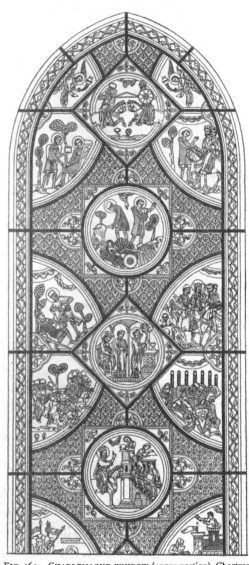

FIG. 164.—CHARLEMAGNE WINDOW (upper portion), Chartres

[1] Cahier, *Caract. des saints*, ii. 778 (note).
The pseudo-Turpin places Roland among the elect. The warrior when dying describes the paradise which he already saw : " Jam, Christo donante, intueor quod oculus non vidit, nec auris audivit, quod præparavit Deus diligentibus se."

RELIGIOUS ART IN FRANCE

their devotions at his tomb.[1] The highest kind of popular admiration then took the form of canonisation.

19. Baudoin (Balduinus) takes his helmet, and goes to seek for water for Roland.

20. Baudoin, unable to find water or to help Roland, mounts the hero's horse and goes to announce the death of his nephew to Charlemagne.

21. Joust between Roland and Fierabras. Through a curious mistake the glazier has placed this panel after that showing the death of the giant, which it should immediately precede.

Such is the most remarkable work which mediæval art devoted to Charlemagne.[2] It is true that it derives from wholly legendary sources, but the Charlemagne it presents is the pious hero, the king beloved of God who held communion with saints and angels, the Charlemagne who lived in the memory of the Church.

The history of the crusades inspired an interesting work formerly seen in the church of St. Denis. It disappeared at the Revolution but it is known to us through Montfaucon's book. It was natural that the monks of St. Denis, the guardians of the national antiquities and the chroniclers of the history of France, should place in their church a window to commemorate the finest victories of the holy war, while at the same time it was an act of devotion honouring the memory of true martyrs.

The window at St. Denis, of which only a few panels are known, was conceived by an artist filled with the epic spirit of the great twelfth century. He found a place for episodes, which though of minor importance in the historian's eyes, were in themselves fine and heroic—such episodes as the duel between a Saracen and Robert, Count of Flanders (Duellum Parthi et Roberti flandrensis comitis), or the meeting in single combat of an infidel and the duke of Normandy, (R(obertus) du(x) Normannorum Parthum prosternit.).[3] But the three great victories of the first crusade, the taking of Nicaea, Antioch and Jerusalem by Godfrey de Bouillon, were not forgotten, and

[1] *Codex de Compostelle*, IV., and Bonnault d'Houet, *Pèlerinage d'un paysan picard*, 192.

[2] There was probably another window at St. Denis which illustrated the story of Charlemagne, judging by the fragments reproduced by Montfaucon (*Monum. de la Monarch. franç.*, pl. XXV.). As at Chartres one there sees the arrival of Constantine's messenger at Charlemagne's court (nuncii Constantini ad Carolum Parisiis) and the meeting of Charlemagne and Constantine at the gates of Constantinople. Mention should also be made of the sceptre of Charles V in the Louvre. On it are seen St. James appearing

to Charlemagne, the miracle of the flowering lances, and the death of Charlemagne (Molinier, *Notice des émaux et de l'orfèvr.*, Supplem. au catalogue de M. *Darcel*, p. 570 *sqq.*).

[3] The meeting in single combat of Robert Courte-Heuse and the emir Corbaran is in fact a poetic episode which was developed in the popular epic, and is found in the *Chanson d'Antioche* (communicated by G. Paris to the Académie des Inscriptions et Belles-Lettres, May 9, 1890). See also F. de Mély, *La Croix des premiers Croisés* (*Rev. de l'art chrétien*, 1890, p. 300).

evidently filled the centre of the composition.¹ The Christian knights are distinguished from the paynim warriors by the cross which they wear on their helmets. Unhappily so valuable a memorial of French history is to-day known only through the mediocre plates in Montfaucon's book, which were drawn and engraved by artists who were complete strangers to the genius of mediæval art.²

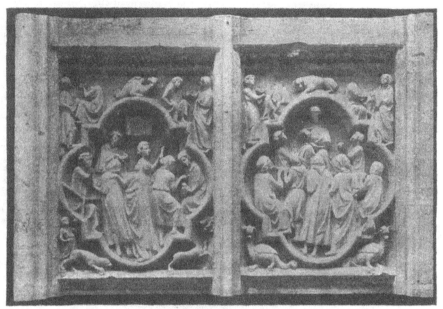

FIG. 165.—SO-CALLED SCENES OF STUDENT LIFE (Notre Dame at Paris)

The series of historical representations which the Middle Ages admitted into the churches closes with the life of St. Louis, but here the king is also a saint, and it is in virtue of the last title that he appears in the church. The window in the Sainte-Chapelle (unfortunately over-restored) ³ which illustrates several episodes in his life, and especially the translation of the Crown of Thorns, must however have been placed in position before the canonisation of the king (1297), for St. Louis has no nimbus.

The window devoted to the life, death and miracles of St. Louis, formerly

¹ Each town is named : " Nicena civitas, Antiochia, Irēm (Jerusalem).

² *Monum. de la Monarch. franç.*, I., pl. L.

³ On this window see F. de Lasteyrie, *Hist. de la peint. sur verre*, p. 154, and Guilhermy, *Descript. de la Sainte-Chapelle*, p. 60. It is the first window to the right on entering. Nineteen panels only are old, and the whole representation of the discovery of the True Cross is modern.

RELIGIOUS ART IN FRANCE

in the sacristy at Saint Denis, dated from the beginning of the fourteenth century, and was evidently intended to do him honour as saint.[1] The same may be said of the window at Poissy (fourteenth century)[2] and of the fourteen frescoes which decorated the convent of the Cordeliers of Lourcine.[3] Works of the kind belong to hagiography rather than to history.

In conclusion, works of art of purely historical character are rarely found in the French cathedrals. Great events were not admitted on their own merits, but only as symbols of some great victory of the Christian Church. Clovis and Charlemagne, Roland and Godfrey de Bouillon appear as champions of Christ.[4]

[1] Montfaucon, *Monum. de la Monarch. franç.*, ii. p. 156.

[2] *Id., ibid.*, pl. XX.

[3] They belonged to the fourteenth century. Some of the drawings are preserved in a manuscript from Peiresc, now at Carpentras. St. Louis wears the nimbus. See Longnon, *Docum. parisiens sur l'iconographie de saint Louis*, Paris, 1882, 8vo.

[4] A priori, one should be cautious in accepting interpretations—however ingenious—which find chapters of thirteenth-century history represented in the churches. For my part, I am not disposed to admit with M. de Verneilh (*Annales arch.*, xxvi. 96) that the celebrated bas-reliefs on the south porch at Notre Dame at Paris (Fig. 165) represent an episode in the history of the university. A subject as insignificant as a students' fight would be unworthy to fill so honourable a place, even if it be supposed that the bishop as head of the university had wished in this way to commemorate the supreme authority with which he was invested. The so-called students' fights, expulsions and punishments are perhaps chapters in the life of some saint which we have not yet been able to recognise. The same caution should be observed with regard to figures of emperors, kings and barons of which we are told in other countries. The equestrian statue in the cathedral of Bamberg to which the name of Conrad IV is given, was even up to the last century called St. Stephen of Hungary. That is its real name. See Weese, *Die Bamberger Domsculpturen*, 1897, p. 126.

CHAPTER VI

THE CLOSE OF HISTORY—THE APOCALYPSE—THE LAST JUDGMENT

I.—The Apocalypse. The artists' sources of inspiration. The Spanish and the Anglo-Norman Apocalypse; influence of the latter. II.—The Last Judgment; its representation and sources. Importance of the *Elucidarium* of Honorius of Autun. Precursory signs. The Second Coming of Christ. The Resurrection of the Dead. The Judgment. St. Michael and his scales. Hell; the jaws of Leviathan. The Elect. III.—Eternal Blessedness. The Beatitudes of the soul. The Beatitudes after St. Anselm, in the north porch at Chartres. The close of history.

WHEN Vincent of Beauvais had recounted the history of the world up to the year in which he was writing, he did not consider his work complete. A limit was appointed to history both by Christ in the Gospels and by St. John in the Apocalypse. For this reason Vincent of Beauvais gave the account of the Last Judgment as epilogue to his book, and the sculptors carved the solemn drama of the Last Day on the tympanum of the great west doorway where it was lighted by the setting sun. History is thus brought to a close.

In the thirteenth century the thought of the Last Judgment was a familiar one. Since the Saviour had said, " Ye shall know neither the day nor the hour," men believed no doubt that there was some impiety in wishing to guess the date, yet they liked to lend an ear to the prophecies that were current. Joachim of Flora to whom Dante attributed the prophetic gift, had stated in his Commentary on Jeremiah that the end of the world would come about the year 1200,[1] and St. Hildegarde had prophesied that in 1180 the Last Judgment would be imminent.[2] To Vincent of Beauvais half a century later these predictions still seemed ominous. It was generally admitted that the end of time would be heralded by various signs : the prevalence of crime, the propagation of heresy, the spread of knowledge.[3] More than once the mystics of the thirteenth century—severe judges of their time—believed that the day of wrath was at hand.[4]

The sculptured scenes of the Last Judgment in the church porches

[1] Vincent of Beauvais, *Spec. hist. Epilog.*, cviii. On the mediæval expectation of the end of the world see Dr. Ernst Wadstein, *Die eschatologische Ideengruppe* (Antichrist, Weltsabbat, Weltende, Weltgericht), Leipzig, 1896, 8vo.

[2] Vincent of Beauvais, *Spec. histor. Epilog.*, ch. cviii·
[3] *Id., ibid.*, ch. cvii.
[4] New reckonings made during the thirteenth century fixed the year 1300 for the end of the world (*Hist. littér. de la France*, XXV., 258).

moved the souls of men more profoundly than we can now imagine. They were not looked at with minds free from anxiety, for the faithful, passing through the doorway, believed that the scene above their heads might at any moment become a fact, and the trump of the angel sound in their ears.

I

We will now study the manner in which the dread end of all things is represented in art, and the sources from which inspiration was drawn.

The artist's first idea was to interpret through his own medium some awful page of the Apocalypse. For this he chose St. John's second vision, in which God, seated on His throne and glorious in dazzling light, presides over the loosing of the seals and the appearance of the prodigies that herald the end of time. " He that sat," as the apostle mysteriously calls him, " was to look upon like a jasper or a sardine-stone ; and there was a rainbow round about the throne, in sight like unto an emerald, and round about the throne were four and twenty seats, and upon the seats I saw four and twenty elders sitting clothed in white raiment, and they had on their heads crowns of gold. And out of the throne proceeded lightnings and thunderings and voices, and there were seven lamps of fire burning before the throne, which are the seven Spirits of God. And before the throne there was a sea of glass like unto crystal, and in the midst of the throne and round about the throne were four beasts." [1]

The passage was well chosen, for in it God is at once the glorious king and the menacing judge. For eight hundred years the apocalyptic figure surrounded by the elders and the four beasts had been enthroned above the triumphal arch of the basilicas. In later times we find it placed over the doorway of Romanesque churches. Examples are numerous, but none surpass in beauty the tympanum at Moissac, which is comparable even to the text. There the sovereign Judge, wearing on His forehead the polygonal crown of the emperors of old, is seen against a background of stars. The angels, the mystic beasts, and the elders surround the throne, gazing up as if attracted and yet dazzled by the splendour. Brilliant colours, long since effaced by time, gave the last touch of supernatural splendour to this great work " in sight like unto an emerald."

Until the end of the twelfth century this was the accepted mode of representing the avenging God of the Last Day, but it was then

[1] *Apoc.*, iv. 2-7.

superseded by a new conception of the Judgment scene. Magnificent compositions appeared which were inspired not by the Apocalypse, but by St. Matthew's gospel, and representations inspired by the book of the Revelation became comparatively rare. A window at Bourges, one at Auxerre (of which the fragments are scattered), tapestries in the cathedral at Angers, and above all the sculpture in the interior and exterior of one of the

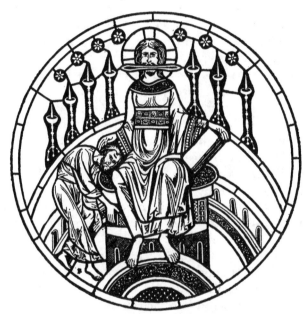

FIG. 166.—ST. JOHN'S VISION (window at Lyons)
(*After L. Bégule*)

porches of the west front at Reims, are almost the sole examples of any importance to be found through this long period.

One cannot wonder that craftsmen shrank from the difficulty, for there is no common measure between art and the poetry of such a passage. What sculptor would venture to represent the angel whose hands rolled together the heavens like a scroll, or the beast whose tail drew the third part of the stars of heaven ? What painter could match the glowing colours of the heavenly Jerusalem—sapphire, emerald, chrysoprase ? The genius of the seers of Israel was not plastic ; their visionary eyes like certain mirrors distorted the forms they reflected. Men of the west, Latins with a passion for pure line and a love of clothing thought in well defined forms, could hardly succeed

in rendering the supernatural, the inchoate, or the prodigious images which sprang from the brain of the east. For this reason the Apocalypse gave birth to curious works, individual in conception and often impressive, but never to works which were human, profound, eternal, like those inspired by the Gospel story.

With childlike simplicity, the early miniaturists of the west tried to give a literal interpretation to passages from the Apocalypse. Of the two schools which seem to have worked at this subject [1] the first is the Spanish school, which from the ninth to the twelfth century illuminated with crude colours the rude drawings accompanying the Commentary on the Apocalypse of Beatus, abbot of Liebana. M. Léopold Delisle has indicated the principal manuscripts of this group [2] (manuscripts from Silos, Girone, Urgel, La Cogalla, &c.), of which the most beautiful—the Apocalypse of Saint-Sever,[3] is in the Bibliothèque Nationale. All these manuscripts appear to derive from one original of the eighth or ninth century. The Spanish monks of Catalonia, Aragon or Navarre may have had the honour of being pioneers in the west of the illustration of the text of the Apocalypse. There was perhaps a certain harmony between the sombre poem and the Spanish temperament. Their work though often rough is never crude. The figures in the Apocalypse of Saint-Sever stand out against a background of red or yellow like a fiery sunset, or sometimes against a band of quiet purple like a beautiful sky at night. Here and there are pages of considerable power, as for example the illustration of the eagle which flies in the midst of the stars crying, " Woe, woe, misery, misery," [4] or the huge serpent covered with scales which is cast by an angel into the abyss.[5]

By sheer force of simplicity the artist reached the sublimity of his text : " And I saw when the Lamb," says St. John, " opened one of the seals, and I heard as it were the noise of thunder, one of the four beasts saying, ' Come and see.' I saw and beheld a horse." [6] The Spanish monk represents the winged lion flying towards St. John, taking his hand in his paw in a friendly way, and showing him a rider on a black horse (Fig. 167).[7]

[1] In *Die Apocalypse in der Bilderhandschriften des Mittelalters* (Vienna, 1885) M. Frimmel points out the existence of a third school to which the Apocalypses of Bamberg and Trier belong. More recently M. Maxence Petit has recognised another group, which he calls the Flemish school (Apocalypses of Valenciennes, Cambrai, Namur and of the Escurial). See *Le moyen âge*, March, 1896. The question is by no means settled. The two groups to which we refer (the Spanish and Anglo-Norman) have been studied for

some considerable time, and begin to be fairly well accepted.
[2] L. Delisle, *Mélanges de paléogr.*, 1880, p. 177 *sq.*
[3] Bibl. Nat., MS. Latin 8878 (eleventh century).
[4] *Ibid.*, fo. 141.
[5] *Ibid.*, fo. 202.
[6] *Apoc.*, vi. 1.
[7] Bibl. Nat., MS. Latin 8878, fo. 109. Each of the four beasts in turn takes St. John by the hand.

Another school also attempted to illustrate the Apocalypse. Though its origin is somewhat obscure it certainly had its rise in England,[1] for in a typical work of the school the manuscript is written in a French in which various Anglo-Norman idioms are used.[2] We are far from the many-coloured Apocalypses of Spain, for these miniatures are the work of artists with no real sense of colour. The backgrounds are white, and the drawing is merely covered with a slight wash. But each passage is literally rendered ; never were miniaturists more accurate or more loyal to their text. It is true that mystery vanishes, that the illimitable takes on a definite contour,

FIG. 167.—RIDER OF THE APOCALYPSE (Apocalypse of Saint-Sever). (B. N., MS. Latin 8878)

and that the gigantic shrinks to human proportions, for their work though so estimable in other respects, is lacking in any element of the arresting, the rugged, the unexpected. The drawings in the fine manuscript in the Bibliothèque Nationale (Frankish 403) were executed in the early years of the thirteenth century but are reproductions ot much earlier originals, and the inscription on the first page, " Apocalypsis in pictura facta Carolo Magno," might lead one to suppose that the original manuscript went back to Carlovingian days. May we not believe with M. Didot that the original came from the studios at York in the time of Alcuin ? However that may be—and with no wish to enter into the examination of a still insoluble problem—it is enough for our purpose to point out that few works were more prolific than the Anglo-Norman Apocalypse (if that name be permis-

[1] On this subject see P. Paris, *Les Manuscrits franç. de la Bibl. du Roi*, iii. 371 ; Didot, *Des Apocalypses figurées, manuscrites et xylographiques*, Paris, 1870, p. 28 ; S. Berger, *La Bible française au moyen âge*, 1884, p. 78 *sq.*, and Appendix ; L. Delisle, *Hist. littér. de* *la France*, xxxi., 1893, p. 284 ; and especially the main preface by M. Léopold Delisle to the *Apocalypse en français an xiii*e *siècle*, published by MM. L. Delisle and P. Meyer (Société des Anciens Textes), 1901.
[6] Bibl. Nat., MS. franç. 403.

RELIGIOUS ART IN FRANCE

sible). The artist who first conceived these vigorous scenes, and drew them with a nervous pencil, worked for the future, for almost all works of art of the thirteenth and fourteenth centuries devoted to the Apocalypse, whether miniatures,[1] glass, or bas-reliefs, are indebted to him in greater or less degree. No such far-reaching influence was exerted by the Spanish school, for the illustrated Apocalypses of northern Spain hardly went beyond the Pyrenees, and never imposed their sway on the artists' imagination. The Anglo-Norman Apocalypse on the contrary, after inspiring the painters and sculptors of the Middle Ages, was a source of inspiration to the wood-engravers of the fifteenth century.[2]

Certain passages which the Spaniards had failed to render were realised by the rival school. The magnificent beast[3] which erects seven haughty heads, the woman with the nimbus of stars who gives her child into the hands of an angel to save it from the attacks of the monster (Fig. 168),[4] and the divine Apparition carrying a spear in his mouth,[5] are all figures which were constantly reproduced during the Middle Ages. The artists were not servile imitators, and they took many liberties with their model, but it is none the less true that the Anglo-Norman work restricted the play of their creative fancy.

In the famous frescoes at Saint-Savin, one of the earliest examples of mediæval painting, one sees the influence at a glance. Remains of an illustrated Apocalypse are still to be seen on the walls of the church porch, where the figure of a woman turning away from the beast and holding out her child to an angel is specially noticeable,[6] for it is the same theme less richly carried out that we find in folio No. 19, manuscript 403. As the frescoes at Saint-Savin belong to the eleventh century, one may conclude that the English prototype from which manuscript No. 403 derived was already widely known in France.

But it is in the fourteenth century that the imitation is most evident. The series of tapestries in the cathedral of Angers is certainly one of the finest works of art inspired by the Apocalypse in the Middle Ages. They were begun in 1375 by order of Louis I of Anjou, brother of Charles V,[7]

[1] The following are some of the MSS. in the Bibl. Nat. which are related to the French MS. No. 403; MSS. Latin 688, 14410, 10484; franç. 375, 13096, 9574. Even the French MS. 1768 (mediocre) resembles it—St. John is seen gazing at the scenes of the Apocalypse from a kind of chapel as in MS. 403. In the Arsenal see MS. 5214.

[2] See Didot's evidence, *op. cit.*

[3] The Spanish monks imagined a kind of Japanese monster with one head only but several horns; MS. Latin 8878, fo. 51 and fo. 52 v.

[4] Bibl. Nat., MS. franç. 403, fo. 19.

[5] Ibid., fo. 6.

[6] See *Les Peintures de Saint-Savin*, published by Mérimée, pl. III.

[7] See M. de Farcy, *Hist. et descript. des tapisseries de la cath. d'Angers*, Lille, 1889 (with plates). The tapestries were given to the cathedral by King René in 1480.

and it is known that Hennequin of Bruges who designed them, applied to the king of France for an illustrated manuscript of the Apocalypse to use as model. M. Giry believes that this manuscript was the Anglo-Norman Apocalypse mentioned above, which was in fact the property of Charles V.[1] Maxence Petit has since adopted M. Giry's theory, and at the same time endeavoured to strengthen it.[2] The resemblances are remark-

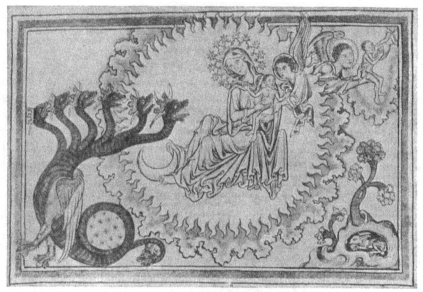

FIG. 168.—THE WOMAN AND CHILD THREATENED BY THE DRAGON (B. N., franç. 403)

able, but after close examination M. Léopold Delisle has arrived at the conclusion that it was not manuscript No. 403 which Hennequin of Bruges had before him.[3] It is true that the manuscript he made use of differs only in some details, but it belongs to a second school, of whose work the Apocalypse in the library at Cambrai is a fine example. Hennequin of Bruges invented nothing, for the few scenes not found in this manuscript and with which he is often credited, are found in the Cambrai manuscript.

And so we see that one of the most important mediæval works devoted

[1] See Giry, *L'Art*, 1876, vii. 301.
[2] *Le moyen âge*, March, 1896,—" Les Apocalypses manuscrites du moyen âge et les tapisseries de la cathédrale d'Angers."

[3] Léopold Delisle, preface to the *Apocalypse en français au xiii* siècle*.

to the Apocalypse derives from a manuscript of the Anglo-Norman group.

The sculpture in the porch at Reims is also connected with it, although far less closely. It was in the second half of the thirteenth century that the delicately executed statuettes which tell of the vision of St. John were placed in position. The story begins in the bas-reliefs on the buttress,[1] and continues, in no very strict order, in the figures disposed round the arches and in the niches of the inner and outer sides of the porch.[2] It ends on the south wall where the life and death of the apostle are given.

The resemblance between the statues and the miniatures is not at first evident, for the solitary figures in their niches hardly suggest the complex and dramatic scenes found in the manuscript. Never was Apocalypse less terrible. The angels of Reims in their long robes, with smiling faces and sensuous charm, carry a book, chalice, spear or star. The exquisite masters of Reims, in love with sheer beauty, were incapable of giving expression to the sombre poetry of the book of the Revelation. Though charming in detail, their work is artistically a failure.

Some difficulty may be felt in admitting that so individual a work was inspired by the manuscript in question. In all probability, however, the artists at Reims had before them some illustrated book which had its origin in one of the two groups of Anglo-Norman representations of the Apocalypse. Certain details go to prove this. The woman fleeing before the beast,[3] the rider with a spear in his mouth,[4] the four angels holding back the four winds in the shape of four classical masks,[5] the crows pecking out the eyes of the dead,[6] are all figures which are taken directly or indirectly from the original manuscript. But still stronger evidence can be brought forward. One of the special characteristics of the Anglo-Norman manuscript is that an illustrated life of St. John accompanies the scenes from the Apocalypse, the artist being inspired by the biography of the pseudo-Abdias afterwards reproduced in the *Golden Legend*. For this reason manuscripts which derived from this model, and later the incunabula decorated with wood-engravings,[7] almost invariably begin or end with scenes from the life of the apostle. Albrecht Dürer himself remained faithful to this ancient tradition. We have already pointed out that the Apocalypse on the south wall at

[1] West front, south end.
[2] West front, right doorway.
[3] Inner porch (round the arch), MS., fo. 19 v.
[4] Outer porch, MS., fo. 36 v.

[5] Inner porch, MS., fo. 10 v.
[6] Outer porch, MS., fo. 37.
[7] See Didot, *op. cit.*

Reims is completed by episodes from the life of St. John. As in the manuscript, one there sees his martyrdom before the Latin gate, the miracle of the poison at Ephesus, and finally the mysterious death of the apostle,[1] and, moreover, this last scene (at least in some of the details) was conceived by the sculptor as it was by the miniaturist. The apostle lies in his tomb wearing a chasuble and priestly tonsure, while above him angels bear his soul to heaven. It is difficult to believe that so close a resemblance is merely accidental. The sculptors of Reims often gave reins to their fancy, taking such liberties with their model that for the most part it could not be recognised, yet sufficient indications of the original remain to point to the probable source of inspiration.

The vitality of the work of the Anglo-Norman miniaturists is remarkable. If it were within our province, we should like to point out how the old forms were perpetuated in art until the end of the fifteenth century,[2] and how inspiration was sought in the originals up to the time when Albrecht Dürer created a new apocalyptic type.[3]

In the thirteenth century the Apocalypse inspired a curious and isolated work which is entirely outside tradition, for the window at Bourges is not an illustration of the Apocalypse but a commentary on it. The

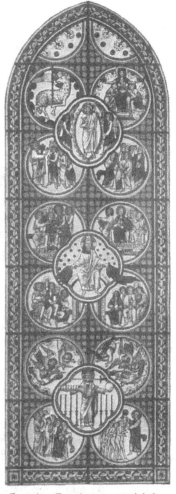

FIG. 169.—THE APOCALYPSE (window at Bourges)

(*From Cahier and Martin*)

[1] The manuscript contains other miracles, such for example as the story of the pebbles turned into gold.

[2] The xylographic Apocalypses of the fifteenth century were designed, as M. Léopold Delisle has shown, after the manuscripts of the first Anglo-Norman group (of which manuscript No. 403 is the most notable example). M. Léopold Delisle believes however that the fifteenth-century artist copied not manuscript No. 403 itself, but an Apocalypse similar to some in the Bodleian library which belong to the same family.

[3] On the Apocalypse of Dürer and its influence see *L'Art religieux de la fin du moyen âge*, p. 482 sq.

RELIGIOUS ART IN FRANCE

theologian responsible for the scheme was attempting to give pictorial form to the doctrine of St. John's interpreters. The truths which the artist teaches are the institution of the Church, the constant presence of Christ in the Church of which He is the life, and finally the glorious eternity reserved for the Church when the times shall be accomplished.[1]

In the lower part of the window (Fig. 169) the Redeemer is represented, as in St. John's vision, holding the sword and the book with the seven seals, before Him is St. Peter baptizing the crowd. It is a symbolic translation of a passage in the Apocalypse : "before the throne was as it were a sea of glass like crystal,"[2] for by the sea of glass the mediæval interpreters understand baptism. As Anselm of Laon—most famous of them all—says with the subtlety

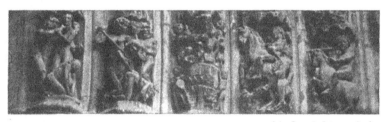

FIG. 170.—HELL AND THE RIDERS OF THE APOCALYPSE (Porch of the Last Judgment, Amiens)

of an eleventh-century doctor, "The sea of glass resembling crystal is baptism, for even as the crystal is hardened water, so baptism transmutes irresolute and unstable men into firm and unyielding Christians."[3] The first vision thus refers to the institution of baptism, or if one will to the founding of the Church.

Higher in the window is a figure of Christ in Majesty, surrounded by heroes of the ancient law—of whom Moses is one—and by the twelve apostles. After this fashion the doctors interpreted the vision in the Apocalypse in which God is seen seated on His Throne, surrounded by the four-and-twenty elders.[4] In order to leave nothing obscure in St. John's words, the artist has gone so far as to replace the four symbolic creatures by the four evangelists. And so in the midst of apostles, prophets and evangelists Christ is, as it were, seated in the midst of His Church, ever with her as He had promised.[5]

The third compartment of the window shows Christ and the lamb carrying

[1] *Vitraux de Bourges*, pl. VIII. and p. 220 *sq.*
[2] *Apocal.*, iv. 6.
[3] Anselm of Laon, *Enarrat. in Apoc.* IV. *Patrol.*, clxii., col. 1517.
[4] *Id., ibid.*
[5] *Id., ibid.* Anselm here makes the computation to which reference has already been made. Twenty-four, he says, is composed of twice twelve, and as twelve is obtained by multiplying three—the number of the Trinity—by four—the number of Earth—the number twelve and the number twenty-four symbolise the Church proclaiming the truth to the world.

the triumphal cross, St. Peter speaking to the crowd, and two men drinking from the breasts of the Church, symbolised by a crowned queen. Here again we have the interpretation which the doctors gave to an apocalyptic vision. St. Peter is the Church Militant, and he calls the faithful to the marriage of the Church Triumphant with the Lamb. When the times are accomplished the Church, who nourishes men with the milk of the two Testaments, shall enter into a glorious eternity and be united to God.[1] The whole composition is dominated by seven stars and seven clouds, the mystic number of time which shall henceforth be abolished.

This great theological scheme was the most subtle and profound work of art inspired by the Apocalypse in the Middle Ages. It is an entirely doctrinal work, and one which borrows nothing from traditional types.

II

In spite of the examples we have cited, it cannot be said that the Apocalypse was a very fruitful source of inspiration, for from the fourteenth century artists preferred to borrow the picture of the end of the world from St. Matthew's gospel.[2] The evangelist's account is certainly less vivid, but it furnishes material more appropriate to plastic representation. God is no longer seen as a great precious stone whose brilliance no man can suffer, but as the Son of Man, who appears on His throne such as He was on earth, and whose face will be recognised by the people.

A few additional features were taken from a chapter on the resurrection of the dead in the first epistle to the Corinthians,[3] and the Apocalypse itself supplied one or two minor details. The several passages, interpreted by the theologian and enriched by popular fancy, gave birth to the fine scenes of the Last Judgment which decorate almost all the cathedrals of the thirteenth century. In the twelfth century the two modes of representing the Last Judgment (after the Apocalypse and after St. Matthew) co-existed in France, as at St. Trophime at Arles where the tympanum still shows the traditional king surrounded by the four beasts of the Apocalypse, while the bas-reliefs of the frieze, following St. Matthew, represent the separation of the saved from the lost. At Autun also, the God who presides at the Judgment is the great king of the Apocalypse, He is not yet " Son of Man."

In the middle of the twelfth century the new formula for the Judgment

[1] Anselm of Laon, cap. xix. [2] St. Matt. xxiv. and xxv. [3] 1 Cor. xv. 52.

RELIGIOUS ART IN FRANCE

scenes was elaborated by the great school of sculpture of the south-west. First appearing on the old capitals of the cloisters of La Daurade, now in the museum at Toulouse,[1] it reappeared with all the breadth of monumental sculpture in the porch at Beaulieu in La Corrèze, and then, enriched with new details, in the doorway at Conques in Aveyron. At Conques the scenes which from that time compose the representations of

the Last Judgment—Christ showing His wounds, angels carrying the instruments of the Passion, the weighing of souls, the separation of the elect and the lost, paradise, and hell—are already grouped. From Languedoc the new tradition seems to have spread north and south. In 1183 it is found with a few slight differences in the portico of La Gloire in the church of St. James at Compostella. In 1180 it appears in Notre Dame at Corbeil,[2] but by placing the Virgin and St. John symmetrically on either side of the Judge the northern artists have enriched the southern scheme. The Last Judgment at Laon—about 1200—overloaded and confused, is still an archaic work (Fig. 172), but at Chartres the scene has become ordered and coherent (Fig. 173), and at Paris the final formula is at last found (Fig. 174).

FIG. 171.—RIDER OF THE APOCALYPSE. DEATH (Notre Dame at Paris)

We propose to examine the treatment of the subject in the thirteenth-century cathedrals in the complexity and richness of its final form. An inquiry of the kind, undertaken more than once, has so far given no satisfactory results because the archæologists who pursued it were unfamiliar with the literature of the Middle Ages. Personal interpretations are out of place in dealing with such a subject. It is only in the books of the theologians of the twelfth and thirteenth centuries that one can hope to find the meaning of these vast compositions.

The most valuable work of this kind was written by Honorius of Autun at the beginning of the twelfth century, with the title *Elucidarium*.[3] The third book, a form of catechism, deals almost entirely with the end of the world and the judgment of God. Composed at a time when the artistic formula for the Last Judgment had not yet been evolved,[4] it may have

[1] I have studied these capitals in the *Revue archéologique*, 1892. The gesture of the Christ showing His wounds and the presence of the cross borne by angels belong to southern art.

[2] Fragments of this are still extant.

[3] *Patrol.*, clxxii., col. 1109 *sq.*

[4] The *Elucidarium*, as the preface shows, is a youthful work which was probably written about 1100.

supplied the painters and sculptors with several features. The fame of this manual, which was early adopted by the schoolmen and was accessible to laymen in a French translation,[1] supports such a theory. A century later Vincent of Beauvais summarised mediæval belief with regard to the second coming of Christ in the epilogue to his *Speculum historiale*,[2] and as a contemporary of the sculptors of the tympanums of Amiens and Reims he supplies the best commentary on their work.

In the *Summa* Aquinas deals with this subject after his accustomed manner, and the few concrete statements which stand out from the bristling phalanx of his syllogisms are in entire agreement with accepted doctrine.[3] And lastly, in the first chapter of the *Golden Legend* Jacobus de Voragine testifies that at the end of the thirteenth century the Church's teaching had not varied.[4] There is then throughout the Middle Ages a real consensus of opinion on all those

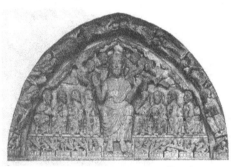

FIG. 172.—LAST JUDGMENT (Laon)
(The heads have been restored)

circumstances which it was held would accompany the second coming of Christ, and with guides such as ours there is no risk of misunderstanding the artists' intentions.

The Last Judgment, as understood by the thirteenth century, is a great drama which may be divided very precisely into five acts, but the limitations of his art compel the sculptor to show simultaneously events that were in point of fact successive. It is for us to distinguish them and to follow the chronological order.

First of all, precursory signs herald the end of the world, and form the prelude to the Judgment. The calamities foretold in the Apocalypse are realised, and Antichrist is born in Babylon of the tribe of Dan. The theologians dwell at length on the scourges that will precede the final cataclysm. Vincent of Beauvais, following St. Jerome, enumerates the

[1] *Hist. littér. de France*, xii. p. 165 *sq.* The *Elucidarium* of Honorius was translated into French with the title *Lucidaire* (Bibl. de l'Arsenal, MS. No. 3516, fo. 144). See P. Meyer, *Notices et extraits de manuscrits*, xxxii., part II., pp. 72-81.

[2] *Spec. histor. Epilog. Tractatus de ultimus temporibus.*

The subject is also discussed in the *Spec. morale*, II., pars. II.

[3] Aquinas, *Summa*, supplement to part III. (Antwerp edition, 1612, XII. p. 164 *sq.*).

[4] *Legenda aurea*, I., *De adventu Domini*. [*Golden Legend*, I. 12.]

RELIGIOUS ART IN FRANCE

fifteen cosmic upheavals which shall make known to men that the day is at hand.[1] The thirteenth-century sculptors are more concise, and at Paris and Amiens (Figs. 171 and 170) the riders of the Apocalypse round the arches of the Portail du Jugement alone symbolise the days of terror which will proclaim the coming of the Son of Man. Some of these figures

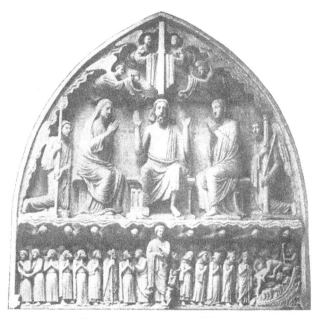

FIG. 173.—LAST JUDGMENT (Chartres)

are worthy of their subject, as at Paris where Death with blindfolded eyes and bowed over his horse, carries a corpse across his saddle. This desolate figure is a fitting herald of the impending cycle of doom.[2]

Suddenly, at the appointed midnight hour, at the same instant of time which formerly had seen the Resurrection, the Judge appears in the clouds.[3] "Then," says the evangelist, "shall appear the sign of the Son of Man in heaven : and then shall all the tribes of the earth mourn : and they shall

[1] *Spec. histor. Epil.*, cxi., and *Legenda aurea*, I. It was not until the fifteenth century that the fifteen signs of the end of the world—the rising of the sea, earthquakes, &c.—were represented in art (wood-engravings in books of Hours). See *L'Art religieux de la fin du moyen âge*, p. 478.

[2] These statuettes round the arches were reproduced at Amiens, but less happily.

[3] *Elucidarium*, cap. xi. and xii., col. 1164 and 1165. The idea that the dead will rise and will triumph over death at the hour at which Christ overcame death for the whole of mankind, is one of the parallelisms characteristic of the mediæval genius.

see the Son of Man coming in the clouds of heaven with great power and majesty." [1] This short passage from St. Matthew, worked upon by commentators and brooded over by all Christendom, found its perfect artistic form in the thirteenth century. At the top of the tympanum on which the Judgment scene is to unfold, Christ appears enthroned, but without the crown and golden girdle of the figure in the Apocalypse. He has reassumed His humanity and would show Himself to men such as He was when among them. With a fine gesture He lifts His wounded hands, and through the open garment is seen the wound in His side (Fig. 173). One feels that He has not yet spoken to the world, and the fateful silence

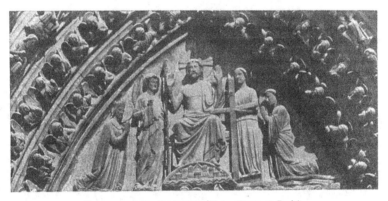

FIG. 174.—LAST JUDGMENT (Notre Dame at Paris)

is terrible. His significant gesture is explained by the doctors. " He shows His wounds," says one of them, " to bear witness to the truth of the gospel and to prove that He was in truth crucified for us." [2] But that is not all. " His scars," says another, " show His mercy, for they recall His willing sacrifice, and they justify His anger by reminding us that all men are not willing to profit by that sacrifice." [3] And St. Thomas adds, " His wounds prove His power, for they testify that He has triumphed over death." [4] Thus by this gesture Christ proclaims that He is Redeemer, Judge and living God.

By the side of the Son of Man appear the angels, some carrying the cross and the crown of thorns, others the lance and the nails. Their hands,

[1] St. Matt. xxiv. 30.
[2] Vincent of Beauvais, *Spec. hist. Epil.*, cxii.
[3] *Leg. aur.*, I.
[4] Aquinas, *Summa*, supplement to part III., q. xc., a. ii.

almost always covered with a napkin, touch these sacred objects with reverence. The instruments of His suffering, and in particular the cross, are as all the Fathers testify, "the signs of the Son of Man" spoken of by the evangelist. As an emperor on the day of his solemn entry has his standard, sceptre and crown carried before him, even so on that great day

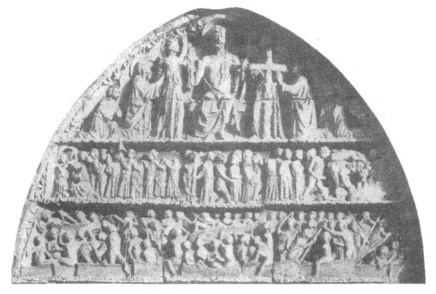

FIG. 175.—LAST JUDGMENT (Poitiers)

when the Son of God shall show Himself to the world for the second time, shall the cross, the lance, and the crown of thorns be borne in triumph by the angels.[1] The light streaming from these instruments of shame, now become the insignia of glory, shall eclipse the light of sun and moon. The cross shall cast a light seven times greater than that of the stars,[2] and this is why there are at times, as at Bordeaux,[3] two angels who carry away the sun and the moon like extinguished and useless lamps (Fig. 177).

Finally, further to enrich the scene already so full of life, the artists have introduced figures of the Virgin and St. John at prayer, to the right and left of the Judge. Nothing of the kind is indicated in the Gospel, but

[1] The simile seems to be St. John Chrysostom's, echoed by Honorius of Autun, *Elucidarium*, cap. xii., Vincent of Beauvais, *Spec. hist. Epil.*, cxii., and in the *Leg. aur.*, I.

[2] *Elucidarium*, XIII. ; *Leg. aur.*, I. ; *Spec. hist. Epil.*, cxii.

[3] In the Porte Royale of the cathedral.

OF THE THIRTEENTH CENTURY

the theologians justify the presence of these two new figures. Honorius of Autun remarks that the Virgin and St. John barely tasted death, for both were caught up by Christ, and were thus the first-fruits of the resurrection.[1]

I should, however, be more disposed to believe that in introducing the Virgin and St. John into the scene of the Judgment the artists were guided by a wholly popular feeling of piety. The mother and the well-loved disciple who stayed by the Cross in the day of anguish, surely deserve to share the triumph of the day of glory. But in this case why represent them like suppliants kneeling with clasped hands? One here touches an intimate chord in the Christian soul. The theologians had taught that in that great day no prayer could move the Judge, but the humble crowd of faithful could not believe this, and they continued to hope that

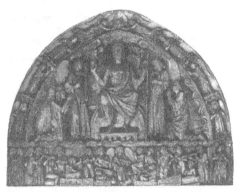

FIG. 176.—LAST JUDGMENT (Saint-Seurin at Bordeaux)

the Virgin and St. John would still be powerful intercessors who would save many a soul by their prayers. The artists were inspired by this belief which they shared, and in opposing grace to law they brought a ray of hope into the midst of the solemn circumstance of justice.[2]

After feeling their way at Laon and at Chartres, the artists evolved the most perfect grouping of their figures at Notre Dame at Paris (Fig. 174), where they triumphed cleverly over the difficulties imposed by the acutely arched form of the tympanum. Christ, larger than the other figures, is seated in the middle, at His side stand two angels holding the instruments of the Passion, while the kneeling forms of St. John and the Virgin fill the corner spaces.[3] The grouping is perfect. Once found, the formula spread throughout France,[4] as far as Poitiers (Fig. 175),

[1] *Elucidarium*, cap. xii., col. 1164.
[2] In Germany St. John the Evangelist's place is taken by the Baptist. This is so at Reims (north porch) also, but the idea is not the same. The Baptist is there seen pointing to Christ, and saying " Behold, 'tis He of whom I spake."
[3] At Poitiers (Fig. 175) there are also two kneeling angels behind them.
[4] In the neighbourhood of Paris, it is found in its

perfection in the church at Rampillon (Seine et Marne). At Saint-Sulpice at Favières (Seine et Oise) (Fig. 178) the formula is respected, but the Christ is standing, and instead of showing His wounds shows men His blood in the chalice which is in His left hand—a solitary exception. The idea of redemptive sacrifice is here clearly expressed, but not in accordance with tradition.

Bordeaux[1] (Fig. 176), and even Dax where, however, it is slightly changed.

In this symmetrical arrangement the kneeling figures of the Virgin and St. John are separated from the Saviour by the angels who carry the instruments of the Passion. They seemed too far removed from Him to the sculptor at Amiens, who believed that their prayer would be more efficacious

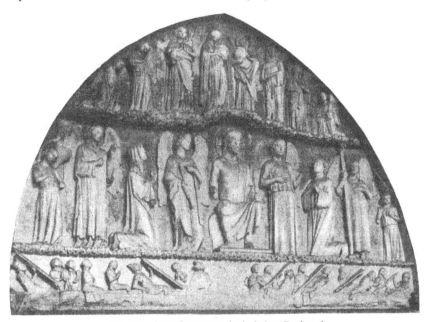

FIG. 177.—LAST JUDGMENT (cathedral at Bordeaux)

if they were nearer the Judge. So he placed them, with outstretched arms, on either side of Christ that their supplication might be irresistible (Fig. 179). This innovation is certainly affecting, but it is not happy from the point of view of art, for to make it acceptable it was necessary to reduce the height of the angels—now placed immediately behind the Virgin and St. John—with the result that the heads are almost on a line. The tympanum gained another storey, but the upper portion was badly filled. The problem was not yet solved. It is obvious that in order to decorate happily a triangular space the figures must be arranged in diminishing size, and it is the first

[1] The central group in the cathedral at Bordeaux is conceived as at Notre Dame at Paris, but the rest of the composition deviates from the model (Fig. 177).

necessity that the kneeling figures fill the angles. The formula at Amiens was not taken as a model.

As soon as Christ shows Himself in the clouds, the trumpet sounds [1] and the third act begins. At the dread summons the dead raise the tomb-stones and make ready to appear before their Judge. In almost all the cathedrals one band of the tympanum is devoted to the resurrection, and many subtle shades of meaning in these works would escape us altogether had we not recourse to the theologians whose teaching is here expressed.

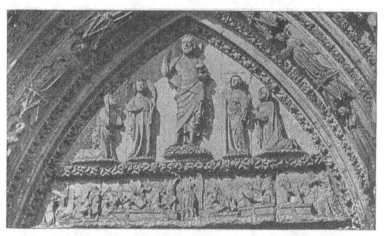

FIG. 178.—LAST JUDGMENT (Saint Sulpice at Favières, Seine et Oise)

While the angels are sounding their long ivory oliphants, the dead stand erect in their tombs, dazzled " by the great day of eternity." Their eyes are turned towards the light, and some pure souls are roused in the attitude of prayer.[2] The resurrection takes place so quickly (in ictu oculi) [3] that human dust has already taken shape at the first sound of the trumpet. It should be noted in passing that it was usual in the thirteenth century to represent the dead in the form of skeletons, bare or half-clothed with flesh like those of Luca Signorelli at Orvieto.[4]

The risen dead are nude or partly covered with their shrouds (Fig. 180). Royal crown, papal tiara, or episcopal mitre appear above anxious

[1] St. Matt. xxiv. 31 : "Mittet angelos suos cum tuba." And " Canet enim tuba et mortui resurgent " (1 Cor. xv. 52).
[2] At Reims and Bourges for example.

[3] The expression used by Honorius and by Vincent of Beauvais, echoing St. Paul.
[4] The heads of two dead men are, however, found at Saint-Urbain at Troyes, in a Last Judgment of the end of the thirteenth century (cast in the Trocadéro).

RELIGIOUS ART IN FRANCE

faces and emphasise man's equality before the tribunal of God. Mediæval art did not like the nude and was always anxious to avoid it, but on this point the teaching of the Church was imperative, and man must come forth from the earth as he was when God drew him forth at the Creation.[1] On that last day each man will realise his type, and will attain to the perfect

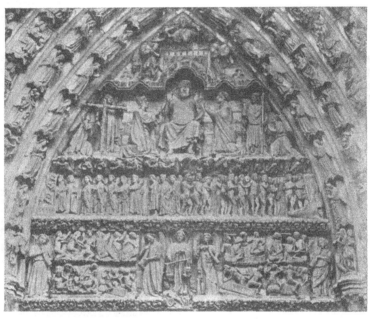

FIG. 179.— LAST JUDGMENT (Amiens)

beauty in accordance with the law of his being. Distinction of sex will endure although become useless, for it will serve to show the omnipotence of God, and by diversity to embellish the Eternal City.[2] Then too, at the time of the resurrection men will not be of the age which they had reached at the day of their death, for if it were so they could not realise that beauty which is the supreme law of every creature, and they would either fall short of or go beyond their type. Whether they died as children or as old people they will be born again at the perfect age of

[1] *Elucidat.*, XI., and Vincent of Beauvais, *Spec. hist. Epilog.*, cxiii. The Last Judgment at Paris shows the dead already clothed when they rise, but this part of the tympanum has been restored in our own time.

Figures in an early tympanum in the Cluny Museum are clothed, but it is exceptional.
[2] Vincent of Beauvais, *loc. cit.*

374

thirty years. All men must resemble their divine Example who at that age triumphed over death.[1]

This curious doctrine was accepted literally by the artists. Neither child nor old man is seen in thirteenth-century representations of the Last Judgment, but there rise from the tomb young and beautiful forms in the prime of life. At Bourges (the finest sculptured group of the Last Judgment scene) the dead are nude,[2] no drapery hides their sex, and so far as he could,

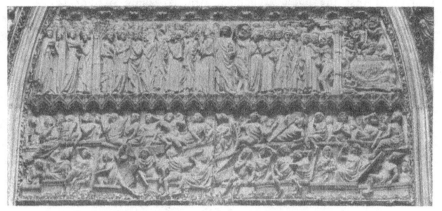

FIG. 180.—RESURRECTION OF THE DEAD. THE SAVED AND THE LOST
(Portail des Libraires at Rouen)

the artist has given them the perfection of youth and beauty. The delightful bas-relief at Rampillon (Fig. 181) was conceived after the same manner.

The Judgment follows the resurrection of the dead. Christ is the judge, but He is not alone for the apostles are His assessors, as He told them : " Ye shall be seated on twelve thrones and judge the twelve tribes of Israel." [3] From this derives the custom of representing the twelve apostles either by the side of the Judge or beneath His feet, as in the cathedral at Laon, the porch of St. Urbain at Troyes, the rose-window in St. Radegonde at Poitiers,[4] or standing in the embrasure of the doorway as at Paris, Amiens, Chartres and Reims.

[1] *Id.*, *loc. cit.*, *Elucidat.*, xi. col. 1164. The same doctrine is found in the *Specul. Eccles.*, col. 1085 : " Resurgent autem mortui ea aetate et mensura qua Christus resurrexit, scilicet XXX annorum, tam infans unius noctis quam aliquis nongentorum annorum." It was more generally admitted in the Middle Ages that Christ was thirty-three years of age at the time of the Resurrection, but several doctors shared Augustine's view, which was that Christ lived on earth for thirty years. The reason given was that the ark was thirty cubits high (*Contra Faustum Manich.*, xii. 14, *Patrol.*, xlii.).

[2] With the exception of a bishop.

[3] St. Matt. xix. 28, and *Elucid.*, XIII.

[4] This is the earliest manner and is usual in Romanesque art. At St. Trophime at Arles and in the early

But the chief actor in the scene of the Judgment is the archangel Michael, who clothed in long, straight pleated drapery—in the thirteenth century he did not yet wear knightly armour—stands with the scales in his hands. Near him a trembling soul awaits the verdict, for in one scale his good actions have been placed, in the other his sins. The Devil is present as plaintiff before the supreme tribunal,[1] and performs prodigious feats of dialectic. He dares to use any means to gain his end. Convinced that the noble archangel, who is gazing straight before him, will not suspect his ruse, the Devil gives a push to the scales.[2] The baseness of this grocer's trick does not affect St. Michael who disdains to

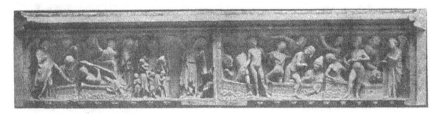

FIG. 181.—RESURRECTION OF THE DEAD. ABRAHAM RECEIVING THE SOULS (Rampillon)

notice it, and the scale in his hand does its duty and drops on the side of justice. Satan is defeated, and the angel tenderly caresses the little soul.[3]

This impressive scene, unauthorised by the Gospel, sprang from a metaphor as old as humanity. Ancient Egypt and primitive India believed that the virtues and vices would hang in the balance at the judgment of the dead,[4] and the Fathers of the Church used the metaphor freely. "Good and evil actions," says St. Augustine, "shall be as if hanging in the scales, and if the evil preponderate the guilty shall be dragged away to hell."[5] And St. John Chrysostom says, "In that day our actions, our words, our thoughts will be placed in the scales, and the dip of the balance on either side will carry with it the irrevocable sentence."[6]

porch at Chartres the twelve apostles are seen beneath the God of the Apocalypse surrounded by the four mystic beasts—a further proof that the great apocalyptic figure in Romanesque churches is that of the divine Judge.

[1] *Leg. aur.*, I. [*Golden Legend*, i. 22].

[2] The popular humour of this scene is nowhere better rendered than in the porch at Conques.

[3] In the early representation at Autun the souls take refuge under St. Michael's garment.

[4] See Maury, *La Psychostasie* (*Revue arch.*, 1844, i. p. 235 *sq.*).

[5] Augustine, *Sermo I. in vig. Pentecost.* In his *De hist. sanct. imagin.* (II, xxiii.) Molanus states that all mediæval and Renaissance representations derive from this passage.

[6] Quoted by Vincent of Beauvais, *Spec. hist. Epil.*, cxviii.

The metaphor, constantly used by writers and preachers in the Middle Ages,[1] struck the popular imagination, and was realised in art. The variants found in the scene of the weighing of souls as conceived in the thirteenth century, show that a work of this kind was not the outcome of the formal teaching of the Church. Much liberty was allowed to the artist's imagination. At Chartres, for example, one of the scales holds a little figure with clasped hands—the symbol of good deeds—while the other holds toads and a hideous head—symbols of the vices. Nothing could be clearer. In the porch of Notre Dame de la Couture at Le Mans a

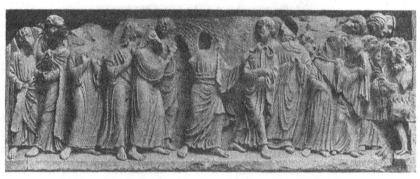

FIG. 182.—SEPARATION OF THE SAVED AND THE LOST (Laon)

similar little pleading figure is seen in either scale, as if even from the midst of our sins a prayer could rise to God. At Amiens where the artist would teach that salvation is gained through the merits of Christ and that men's so-called virtues are but the gift of His grace, the Agnus Dei is in one scale and the ignoble head of a reprobate in the other.[2] At Bourges another idea finds expression; man's salvation depends on his vigilance. The lamp of the Wise Virgins is in one scale and a hideous figure with enormous ears in the other. At Bourges the artist is almost Pelagian, at Amiens almost Jansenist.[3]

It still remains to justify the part played by St. Michael in the Last Judgment scene. Throughout the Middle Ages he was held to be the conductor of souls to the other world, the saintly psychagogue. Anxious to divert to St. Michael the worship which the still pagan inhabitants of Roman

[1] See examples in Maury, *op. cit.*
[2] The Agnus Dei is original, the reprobate's head is a restoration.
[3] I have studied the object which is in one of the scales at Bourges very carefully, and am of opinion that it is a lamp similar to those carried by the Wise Virgins. If it be taken as a chalice (which to me is unlikely), it would be an expression of the same idea as at Amiens.

RELIGIOUS ART IN FRANCE

Gaul paid to Mercury, the Church early endowed the archangel with almost all the attributes of the god. On the ruins of ancient temples of Mercury, built generally on a hill, rose chapels dedicated to St. Michael;[1] a hill in La Vendée even to-day bears the significant name of Saint Michael-Mont-Mercure. St. Michael, already the messenger of heaven, became like Mercury the guide of the dead. The funeral rôle of St. Michael is attested by ancient custom. Cemetery chapels were dedicated to him and the confraternities instituted to bury the dead recognised him as patron.[2] He is sometimes found carved on sepulchral monuments, sometimes on the tombs.[3] Finally, from mediæval times the offertory in the Mass for the Dead expressly says : " Signifer sanctus Michael repraesentet eas (animas) in lucem sanctam." St. Michael, as we see, is the angel of death, and it is in virtue of this that he presides at the Last Judgment.

The Judgment ended, the last and greatest scene begins. The sheep are separated from the goats,[4] the good from the wicked, and they go to right or left of the Judge, towards eternal reward or punishment. Demons seize the condemned, join them together by a long chain, and drag them to the gaping jaws of hell. Hardly a trace of dogmatic teaching is here to be found ; the bestial ugliness of Satan and his acolytes, their cynical gaiety, the liberties they take with noble ladies, the despair of the damned, all were the outcome of popular fancy. The vices are not easy to recognise, and a miser with his purse hanging from his neck is barely distinguishable among a crowd of nameless sinners.[5] Again it is wholly popular sentiment which caused art to place figures of kings or bishops among the number of the damned.[6] The painter, after the manner of Dante, set himself up as justiciary.

All these additions were due to the artist's fancy, and owed nothing to the books of the theologians. Some trace of doctrinal teaching is seen, however, in the doorway at Bourges, where the devils are represented with a human head drawn on the stomach or abdomen. What can this signify but that they have displaced the seat of intelligence, and put their souls at the

[1] Anthyme Saint Paul, *Histoire monumentale de la France*, p. 90. The cult of St. Michael on the hilltops has been studied by Crosnier, *Bullet. monum.*, XXVIII.

[2] See Lebeuf, *Dissertat. sur les anciens cimetières*, and *Histoire du diocèse de Paris*, i. 106 (ed. Cocheris). He refers to a chapel of St. Michael in the cemetery of the Innocents.

[3] St. Michael is represented carrying the soul of a dead man on a thirteenth-century tomb in the

archæological museum at Lorraine. See Léon Germain de Maidy in the *Bullet. mensuel de la société archéol.*, Lorraine, June, 1909.

[4] St. Matt. xxv. 32, 33.

[5] See tympanum from Saint-Yved at Braisne in the museum at Soissons, porch at Laon (Fig. 182), and porch at Reims (Fig. 183).

[6] For example at Reims, Chartres, and Bourges (in the porch and the Judgment window in the choir).

service of their lower appetites—an ingenious way of teaching that the fallen angel has reached the level of the brute.

The picture of hell that obtained in mediæval times also came from the commentaries of the schoolmen. Almost all thirteenth-century representations of the Last Judgment show an enormous mouth vomiting flames, into which the damned are thrown. It was from a hell-mouth of this kind, but jointed and movable, that the devils emerged who played so large a part in the Mysteries at the end of the fifteenth century.

How does it come about that such a conception should be so faithfully transmitted throughout the Middle Ages? The truth is that it did not take

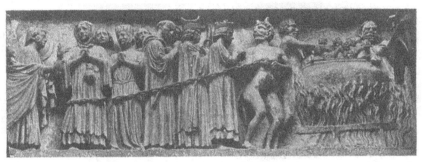

FIG. 183.—THE LOST (Reims)

its rise from some imaginative freak but grew out of passages from the Bible. The mouth of hell is the mouth of that Leviathan spoken of in the book of Job. It will be remembered that the Almighty Himself addresses the patriarch, describes the monster he has created, and sternly asks him : "Can'st thou draw him out with a hook? . . . Who can go into the midst of his mouth? . . . Who can open the doors of his face? . . . His teeth are terrible round about. Out of his mouth go forth flames like torches of lighted fire. Out of his nostrils goeth smoke like that of a pot heated and boiling. . . . He shall make the deep sea to boil like a pot."[1]

From early times the commentators on the book of Job (of whom St. Gregory was one of the first) see in Leviathan a figure of Satan and all his works, and in the Middle Ages certain passages, interpreted with amazing subtlety, had the most singular fortune. Gregory the Great, for example, teaches that the verse which speaks of the hook which shall catch the monster,

[1] Job xl. 20, and xli. 4, 5, 10, 11, 22.

RELIGIOUS ART IN FRANCE

refers to the victory of Christ over Satan.[1] Odo of Cluny[2] and Bruno of
Asti,[3] the most famous interpreters of the book of Job, passed on this doctrine to
Honorius of Autun, who improving upon them all wrote : " Leviathan the
monster who swims in the sea of the world, is Satan. God threw the line
into the sea. The cord of the line is the
human descent of Christ, the bait is His
divinity. Attracted by the smell of flesh
Leviathan tries to seize it but the hook
tears his jaws."[4] The *Hortus deliciarum*,
the famous manuscript of the abbess
Herrade, contains a miniature which
illustrates this metaphor of the com-
mentators on the book of Job. The
kings of Judah there form the cord of
the line, and Christ tears the jaws of the
monster with the hook (Fig. 184).

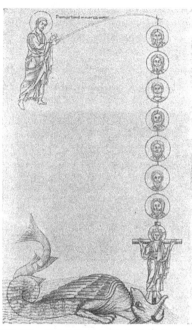

FIG. 184.—LEVIATHAN CAUGHT BY THE HOOK
(Miniature in the " Hortus deliciarum")

It was also supposed that the passage
which speaks of " him who shall open
the door of the jaws of Leviathan "
refers to Christ's descent into limbo and
His victory over Satan. " In breaking
open the gates of hell," says Bruno of
Asti, " Christ broke open the door be-
hind which Leviathan hid his face."[5]
From this sprang the well-known artistic
tradition which places the open mouth
of Leviathan close to the shattered doors which Christ tramples under foot.

Finally, the verses in which it is written that " out of his mouth go
forth flames, out of his nostrils goeth smoke like that of a pot heated and
boiling," and that " he shall make the deep sea to boil like a pot," passed
for an accurate description of hell. The thirteenth-century artist put a
literal construction on these passages, and carried his scruples so far as to
represent a boiling cauldron in the open jaws of the monster. Examples of
this are seen in the tympanum at Bourges (Fig. 185) and in an arch at
Notre Dame at Paris.

[1] Job xl. 20, and St. Gregory, *Moral. in Job. Patrol.*,
lxxvi., col. 680.
[2] Odo of Cluny, *Epitom. moral. in Job. Patrol.*,
cxxxiii., col. 489.
[3] Bruno of Asti, *In Job. Patrol.*, clxiv., col. 685.
[4] Honorius of Autun, *Spec. Eccl., Patrol.*, clxxii.,
col. 937.
[5] Bruno of Asti, col. 688.

OF THE THIRTEENTH CENTURY

But the same precision in conforming to theological commentaries is not found in the various scenes which portray the torments of the damned. The artists did not accept the doctrine of Aquinas and of the greater number of theologians, where the torments of hell are taken in a symbolic sense. " The worms that devour the reprobate," says St. Thomas, " must be understood in a moral sense, and signify the pangs of conscience."[1] The artist remained faithful to the letter ; at Bourges serpents and toads devour the damned, while demons turn them over in the cauldron. The mediæval

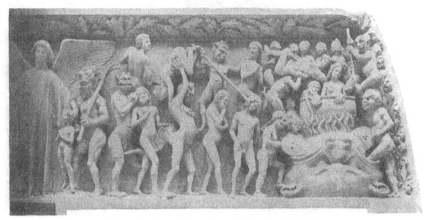

FIG. 185.—LAST JUDGMENT. THE LOST (Bourges)

sculptors, rejecting symbolism, seem to have been inspired by the famous lines on the torments of the damned which were current among the schoolmen—lines cruel as the tortures themselves :—

" Nix, nox, vox, lachrymæ, sulphur, sitis, æstus ;
Malleus et stridor, spes perdita, vincula, vermes."[2]

While terror reigns to the left of the Judge, joy breaks forth on His right. The artist has chosen the moment when the sentence which offers eternal blessedness to the elect has just been pronounced ; it is the threshold of paradise. The elect wear long robes or even the dress of their rank or earthly calling, contrary to the doctrine of Honorius who endeavours to show that the just will be clothed in their innocence and the splendour of their beauty alone.[3] Mediæval art, whether to conform to the words of the Apocalypse which speak of " those who are clothed in white robes,"[4] or to

[1] *Summa*, Supplement to part III., q. xcvii., a. ii.
[2] Vincent of Beauvais, *Spec. hist. Epilog.*, cxix.
[3] *Elucidarium*, iii. 15, col. 1169.
[4] *Apoc.*, vii. 13.

recall in the heart of the beatific state the struggles of earth, preferred to give the blessed the garb of their former condition. Kings, bishops, abbots, move heavenwards mingling with the crowd of holy souls.

At Bourges a king with a flower in his hand expresses the union of kingliness and holiness—a pleasing figure inspired no doubt by the memory of St. Louis who had lately died. It is not a portrait, but the ideal image of the Christian king of which he was the perfect type. He appears at Bourges slender as a knight and "beautiful as an angel," to quote Fra Salimbene in his delightful picture of St. Louis.[1] It is noticeable

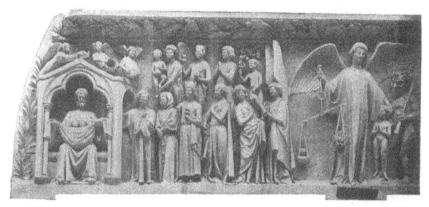

FIG. 186.—LAST JUDGMENT. THE ELECT (Bourges)

that at Bourges and Le Mans (church ot Notre Dame de la Couture) a Franciscan with the thrice-knotted girdle of rope walks with the king at the head of the procession of the elect[2] (Fig. 186). There is no doubt that at the end of the thirteenth century, art associated the two purest souls of their time, Francis of Assisi and Louis of France, in the same act of homage ; and this glorification of kingliness become holy, and of the new way to salvation, the recent order of St. Francis, is seen at Bourges, Amiens and Le Mans.[3]

The elect, then, advance clothed in the garments which they wore in this world, but at the gate of heaven angels prepare to reclothe them with royal magnificence, and hold crowns to place on the heads of those who

[1] When drawing the portrait of St. Louis, Fra Salimbene describes him in these words : " gracilis, macilentus et angelica facie."
[2] The Franciscan is also found at Amiens, and it is he who first enters paradise.

[3] At Conques in the twelfth century Charlemagne, who was said to have been one of the abbey's benefactors, and the Benedictine monks were placed in the front rank of the elect.

cross the threshold. This episode is rarely omitted from any representation of the Last Judgment.[1] At Notre Dame in Paris the saints have already received their crowns and appear as kings even before their entrance into paradise, at Amiens the angels with crowns in their hands form a charming frieze above the heads of the blessed. So well-established a tradition can only derive from Scripture, and in the Apocalypse are found the words, " Be thou faithful unto death, and I will give thee a crown of life." [2]

At the entrance to paradise which is represented by a door, the attention is attracted by a serious figure among the smiling angels. It is St. Peter who, keys in hand, receives the newcomers.[3] The people wove a thousand pleasant stories round this, transforming St. Peter into the porter at the gate of heaven, but the artists' intention had greater significance. St. Peter was a symbol of the power to bind and to loose which Christ gave to the Church in the person of the first of the popes, and in representing him at the door of paradise they wished to remind men that the Catholic Church alone has the power, through the sacraments, to admit men to eternal life.[4] Less restricted than the sculptor, the master glass-painter at Bourges found space to develop this dominant idea at greater length when he designed a window of the Last Judgment. At the base of the composition he showed the sacrament of penance in the form of one of the faithful kneeling before a priest.[5]

III

But the divine comedy is incomplete, for art has not yet shown us paradise. It cannot be said that the attempts to represent paradise were successful, possibly because the devout and simple-minded artist took in a literal sense the words : " The eye hath not seen, nor has the ear heard, neither hath it entered into the heart of man, what things God hath prepared for them that love him." [6] Art confessed its inadequacy from the first.

The symbol of paradise conceived by early Romanesque sculptors was perpetuated well into the thirteenth century by an archaic and naïve figure. The patriarch Abraham, seated on his throne, bears in his bosom the souls

[1] It is seen at Reims, Chartres, Bourges, Le Mans and Rouen (Portail des Libraires).
[2] *Apoc.*, ii. 10.
[3] At Amiens, Bourges and Le Mans (la Couture), for example.
[4] On St. Peter's keys see Peter Lombard, *Sentent.*,

IV., dist. XVIII. " Claves istæ non sunt corporales sed spirituales, scilicet discernendi scientia et potentia judicandi, id est ligandi et solvendi." *Patrol.*, cxcii., col. 885.
[5] *Vitraux de Bourges*, pl. III.
[6] 1 Cor. ii. 9.

of the righteous.[1] Such a representation, conforming closely with theological teaching,[2] is of the nature of a hieroglyph. It is true that at Reims the artist made great efforts to render this symbol expressive, and he shows angels bearing, with exquisite tenderness, the souls on fair napkins to Abraham's bosom (Fig. 187). Never was reverence for the soul of man or faith in immortality better expressed, but where are the joys of paradise, the sacred

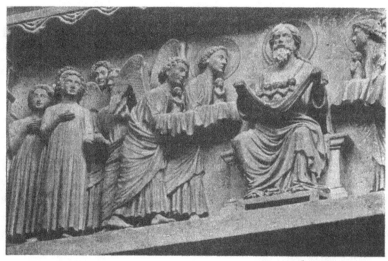

FIG. 187.—THE SOULS CARRIED BY THE ANGELS TO ABRAHAM'S BOSOM (Reims)

fields of Fra Angelico, the circling of the blessed among deep-growing flowers, and the light of a day which shall have no end ?

With the solitary exception of the fine work at Bourges, the sculptors, slaves to a hard material and to the inflexible laws of their art, made no attempt to express the infinite and eternal. The elect of the Bourges tympanum are not yet in heaven, but the pure lines of the happy forms and the joy that shines from their faces give to this work some reflection of paradise. Elsewhere few details deserve mention. At Notre Dame in Paris a husband and wife meet once more and walk hand in hand, united to all eternity ; at St. Urbain at Troyes the souls come forth from the midst of foliage, appearing like " blessed flowers of Paradise."

[1] For example, at Laon, Chartres, Notre Dame at Paris, Reims, Bourges—bas-relief (Fig. 186) and window—Rampillon (Fig. 181), Saint-Urbain at Troyes.

[2] Aquinas (*Summa*, part III., q. 57, a. 2) expressly says that Abraham's bosom is the resting-place of the righteous.

Readers of Dante will well understand the powerlessness of sculpture to depict eternal blessedness. The *Paradiso* is all music and light, the souls themselves are singing lights, and all form vanishes in a splendour a thousand times brighter than that of the sun. The Holy of Holies is an immense rose with petals of fire, in whose depths a fleeting vision of the Trinity is seen in the form of a triple circle of flame.

The limpid colour of a Fra Angelico alone could give some measure of reality to this resplendent vision, for with colour men are transported almost as completely as with music. But what can the sculptor do with his semi-pagan art, and the massive figures that seem to carry the weight of original sin ? The mediæval sculptor was however too idealistic not to make an attempt to express the inexpressible, and once at least—in the porch at Chartres—art has tried to render the infinite blessedness of the elect.

Some idea of the theological teaching as to the future life is necessary to the understanding of these figures.

After the Judgment the world will be renewed. Everything in nature which is undisciplined and intractable—heat, cold, storms, all the disorders born of the Fall—will disappear, and the ancient harmony of the universe will be re-established. The elements will be purified. Water, which was sanctified by Christ when He plunged His body in Jordan, will become clearer than crystal, earth, which was watered by the blood of the martyrs, will bloom with unfading flowers.[1] The bodies of the righteous, participating in the universal regeneration, will become glorious, while the soul will be enriched with immortal gifts. There will be seven gifts of the body and seven gifts of the spirit. The gifts of the body will be beauty, agility, strength, freedom, health, pleasure, longevity, and the gifts of the spirit will be wisdom, friendship, concord, honour, force, serenity, joy. All that men are now so sadly in need of they will then possess. The body will partake of the nature of the spirit, and will be quick and vigorous and free as thought. The spirit will be all harmony, at one with the body and with itself.

The classification of the fourteen beatitudes as we have them here was first made by St. Anselm in the eleventh century,[2] and the system he adopted was reproduced with fidelity or with very slight modifications by all the

[1] *Elucid.*, III., cap. xv., col. 1168.
[2] The *Liber de beatitudine coelestis patriæ* was probably the work of Eadmer of Canterbury and not of St. Anselm, but it is merely a reproduction of one of Anselm's sermons (see *Patrol.*, clix., col. 587, and clviii., col. 47).

RELIGIOUS ART IN FRANCE

great theologians of the Middle Ages—by Honorius of Autun,[1] Bernard,[2] Aquinas,[3] Bonaventura,[4] Vincent of Beauvais.[5] The contemplation of promised joys filled these doctors with a holy rapture. A great wave of enthusiasm sweeps over Honorius of Autun, and his *Elucidarium* becomes a lyrical poem in which the master speaks and the pupil listens in ecstasy :

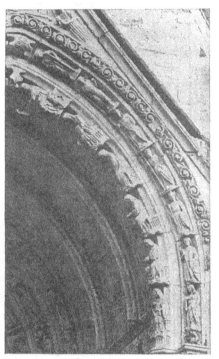

FIG. 188.—THE BEATITUDES OF THE SOUL (first order of the arch. Chartres)

The Master. How joyful wouldst thou be if thou wert strong as Samson . . . ? *The Pupil.* Oh, the glory ! *The Master.* What wouldst thou say shouldst thou be free as Augustus who possessed the world ? *The Pupil.* Oh, the splendour ! *The Master.* If thou wert wise as Solomon who knew the secrets of nature ? *The Pupil.* Oh, the wisdom ! *The Master.* If thou wert united to all men with a love like that of David for Jonathan ? *The Pupil.* Oh, the blessedness ! *The Master.* If thy joy equalled that of the condemned who lying on the instrument of torture, is suddenly called to the throne ? *The Pupil.* Oh, the majesty ! . . .[6]

To the thirteenth-century artist these sublime gifts of soul and body seemed like a choir of fourteen beautiful maidens, and in the north porch of the cathedral of Chartres[7] he gave them that form (Fig. 188). Although nine of them are named, these figures at Chartres have provided ample scope for the imaginative archæologist. In 1847 Didron wrote a brilliant article to prove that they stood for the civic virtues.[8] He was lost in wonder that the artists of the thirteenth century had dared to raise a

[1] *Elucid.*, III., cap. xviii., col. 1169, and *Spec. Eccles. In Pentecost.*, col. 961.

[2] St. Bernard, *De vilico iniquitatis. Patrol.*, clxxxiv., col. 1025.

[3] Aquinas, *Summa*, supplement, part III., q. xcvi., a. 5.

[4] Bonaventura, *De gloria Paradisi.*

[5] Or the author of the *Speculum morale*, whoever he may have been (see lib. II., pars. IV.).

[6] *Elucid.*, III., xviii., col. 1169.

[7] Left bay of the porch, first order of the arch.

[8] *Annal. arch.*, 1847, vol. i. p. 49.

statue to liberty, and with him, as often with Viollet-le-Duc, the simple old masters become precursors of the French Revolution. Two years later Madame Félicie d'Ayzac published a pamphlet on this subject, full of both learning and common sense.[1] In it she proved up to the hilt that the fourteen statues at Chartres do not represent the civic virtues, but the fourteen beatitudes of body and soul in the heart of eternity, according to St. Anselm's classification. And so the old sculptors found themselves deprived of the " brevet de civisme " granted them by Didron.

At Chartres nine out of the fourteen statues are named : Freedom, Honour, Agility, Strength, Concord, Friendship, Majesty, Health and Tranquillity. Five bear no inscription, but with great ingenuity Madame Félicie d'Ayzac interpreted the attributes which distinguish them, and recognised Beauty, Joy, Pleasure, Longevity and Knowledge.

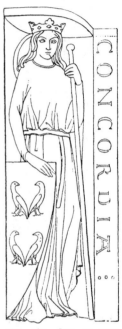

FIG. 189.—ONE OF THE BEATITUDES OF THE SOUL IN THE FUTURE LIFE (Chartres)

These fourteen Beatitudes with crown and nimbus are queens, godlike and of noble bearing. Their hair hangs loose on their shoulders, and their ample robes fall in quiet folds, showing the pure lines of their beautiful forms. One hand holds a sceptre, the other rests upon a large shield bearing a coat of arms. Freedom has two crowns on her shield, for sovereigns are the freest of men. Honour has a double mitre, which is the symbol of the highest honour, for it is of the bishop wearing his mitre that the Psalmist says :—" Thou hast crowned him with glory and honour ; and hast set him over the works of thy hand." [2] On Longevity's shield is the eagle, which renews its youth in the heat of the sun, while Knowledge has for emblem the griffin, which knows the place of hidden treasure. Some of the attributes given to the Beatitudes are less learned ; Agility has three arrows, Strength a lion, and Concord (Fig. 189) and Friendship have doves. Health has fishes, Serenity a strong castle, and Beauty roses.

[1] *Les statues du porche septentrional de Chartres,* by Mme. Félicie d'Ayzac, Paris, 1849.
[2] Innocent III himself applied this passage of Scripture to the bishop wearing the mitre. *De sacro altaris mysterio,* i. 44. *Patrol.,* ccxvii., col. 790.

RELIGIOUS ART IN FRANCE

These beautiful maidens are symbols of souls in bliss. The Christian who gazes on their serenity and beauty sees heaven, and forgets this imperfect world. Through them paradise becomes visible, for no man can say of the creators of these noble figures that they were conquered by the greatness of their subject, or lacked power to express eternal bliss.

We have now gained some idea of the power of invention shown by mediæval artists in the disposition of the scenes of the Last Judgment, but more than one detail has been neglected. Nothing has been said, for example, of the legions of saints and angels who from the top of the arch contemplate the work of divine justice; as at Notre Dame at Paris where delightful angels look down, leaning over the arch as over a balcony in the sky. Nor has anything been said of the symbolic figures which so often accompany the main theme. Those most frequently found are the Wise and Foolish Virgins; to the right of the Judge the former proudly carry their lamps full of oil, to His left the latter let their empty lamps hang sadly down (Fig. 190), the Wise Virgins walk towards an open door, the others towards a closed one—a vivid picture of the saved and the lost.[1]

Sometimes also, as at Amiens, a tree laden with fruit is seen to the right of the Judge and a felled tree to His left. The meaning cannot be doubted for the allusion to reward and punishment is obvious, but possibly the artist's intention is not entirely grasped without Vincent of Beauvais's help. "The lost," he says, "will suffer a twofold torment, separation from the kingdom, and

FIG. 190.—THE FOOLISH VIRGINS. THE TREE AND THE AXE

[1] Examples are very numerous; round the arches at Laon, Amiens, Notre Dame (Paris), Bourges (round the rose-window above the tympanum), Reims, &c. The symbolism of this parable has been explained at sufficient length to make it unnecessary to return to it here (see the Gospels).

fire. These are the axe and the fire spoken of in the Gospel where it is said, 'Every tree that beareth not good fruit shall be hewn down, and cast into the fire.'"[1] The axe symbolises, as we see, the separation of the damned, who in that day shall be cut off from the Church Triumphant.

One notices that none of these representations of the Last Judgment shows any trace of purgatory. Nothing could be more logical, for purgatory is subject to the laws of time, and after the Last Judgment the world can only be conceived of under the aspect of eternity. There is then room for paradise and hell alone, for they alone are eternal.

The history of the world is thus brought to a close. Like the *Speculum Majus*, art has unfolded the whole before us in a series of magnificent works. We have been guided through time, from the awakening of the first man under the hand of the Creator to his eternal rest in the heart of God.

[1] Vincent of Beauvais, *Spec. hist. Epilog.*, cxviii. The two trees (like the Foolish Virgins) are also seen in the doorway at Longpont (Fig. 190).

CONCLUSION

I

IN one of the chapters of *Notre Dame de Paris*, that book in which rare rays of light break through the darkness, Victor Hugo says : " In the Middle Ages men had no great thought that they did not write down in stone." What the poet grasped with the intuition of genius we have laboured to demonstrate.

Victor Hugo was right. The cathedral is a book. It is at Chartres, where each Mirror finds its place, that this encyclopædic character of mediæval art is most evident. The cathedral of Chartres is mediæval thought in visible form, with no essential element lacking. Its ten thousand figures in glass or in stonework form a whole unequalled in Europe.

It may be that other great French cathedrals were originally as complete as Chartres still is, but time has dealt more harshly with them. Yet nowhere else appears so coherent an effort to embrace the whole of the universe. Either intentionally or because the loss of neighbouring work has destroyed the balance, each of the other great cathedrals seems designed to place in relief some one truth or doctrine ; a diversity which is not without its charm. One chapter for instance is developed at Amiens, another at Bourges.

Amiens is the messianic, prophetic cathedral. The prophets of the façade stand like sentinels before the buttresses and brood over the future. All in this solemn work speaks of the near advent of a saviour.

Notre Dame at Paris is the church of the Virgin, and four out of six portals are dedicated to her. She occupies the centre of two of the great rose-windows, and round her are grouped the saints of the Old Testament or the rhythmical sequence of the works of the months and the figures of the virtues. She is the centre of all things. Never weary, the centuries sang her praises turn by turn, the twelfth century in the Porte Sainte-Anne,

RELIGIOUS ART IN FRANCE

the thirteenth in the Porte de la Vierge, and the fourteenth in the bas-reliefs on the north side. Nowhere was she more beloved.

Laon is the cathedral of learning. Knowledge is there placed in the forefront, and the Liberal Arts accompanied by Philosophy are sculptured on the façade and painted in one of the rose-windows. The Scriptures are presented in their most mystical form, and the truths of the New Testament are veiled under the symbolism of the Old. Famous doctors, one feels, must have lived beneath her shadow. She has indeed something of their austerity of aspect.

Reims is the national cathedral. Others are catholic, she alone is French. The baptism of Clovis fills the angle of the gable, and the kings of France occupy the windows of the nave. The façade is so rich that on a coronation day it needs no further decoration, for tapestries of stone hang in the porches. She is ever ready to receive kings.

Bourges celebrates the virtues of the saints. The windows illustrate the *Golden Legend.* Round the altar the life and death of apostles, confessors and martyrs form a radiant crown.

The doorway at Lyons recounts the wonders of creation. Sens unfolds the immensity of the world and the diversity of the works of God. Rouen is like a rich book of Hours in which the centre of the page is filled with figures of God, the Virgin and the saints, while fancy runs riot in the margin.

Though in each cathedral one chapter of the Mirror is, as we see, developed by preference, it is seldom that the others are not at least indicated, thus suggesting the desire to give encyclopædic teaching. Aware of the power of art over childlike and humble souls, the mediæval Church tried through sculpture and stained glass to instil into the faithful the full range of her teaching. For the immense crowd of the unlettered, the multitude which had neither psalter nor missal and whose only book was the church, it was necessary to give concrete form to abstract thought. In the twelfth and thirteenth centuries, doctrine was embodied both in the drama of the liturgy and in the statues in the porch. By its marvellous inner force Christian thought created its own medium. Here again Victor Hugo saw clearly. The cathedral was the people's book of stone rendered gradually valueless by the coming of the printed book. "The Gothic sun," he says, "set behind the colossal press at Maintz."

At the end of the sixteenth century Christianity had lost its plastic power, and had become solely an inward force.

RELIGIOUS ART IN FRANCE

II

There can be no doubt that the ordering of these great theological, spiritual and learned schemes was regulated by the Church. The artists were simply the interpreters of her thought. In 787 the Fathers, assembled for the second council of Nicaea, expressed themselves as follows : " The composition of religious imagery is not left to the initiative of artists, but is formed upon principles laid down by the Catholic Church and by religious tradition." And again: " The execution alone belongs to the painter, the selection and arrangement of subject belong to the Fathers." [1]

In the east as in the west this was the doctrine of the Church in the thirteenth as it had been in the eighth century. Study of the profoundly significant works of art which we have passed in review leaves no doubt of this. Could painters and sculptors have devised such learned works ? I am well aware that the mediæval artist had some literary culture, and that, for instance, Villard de Honnecourt knew Latin.[2] But it is a far cry from this to the composition of windows such as those treating of the Passion at Bourges or Chartres, or the Good Samaritan windows at Bourges and Sens in which each episode is accompanied by its symbolic interpretation. Such works presuppose profound study of the Church's doctrine. A harmonious whole like that of the central doorway of the north porch at Chartres, where each of the great stone christophers personifies an epoch in the history of the world and symbolises the waiting of the nations, could not have been conceived except by scholars. It was scholars who, following the *Speculum Ecclesiae* of Honorius of Autun, composed the left porch of the west façade of the cathedral at Laon, where the heroes of the Old Testament are presented as types of the Virgin. It was they who, again in accordance with the teaching of Honorius of Autun, composed the window at Lyons in which each event of the Saviour's life is paralleled by some animal from the Bestiary.

Everywhere the guiding hand of schoolman and doctor is seen. Would it have occurred to simple craftsmen, then hardly distinguishable from artisans,[3] to borrow the image of Philosophy from Boethius, to engrave Greek letters

[1] Labbe, *Concil.*, viii., col. 831. *Syn. Nicæna*, ii.

[2] On a page of his album he wrote, " Illud bresbiterium (presbyterium) invenerunt Vlardus de Hunecourt et Petrus de Corbia inter se disputando."

[3] Valuable documents have been published by Quicherat (*Mélanges d'arch. et d'hist.*, II.), which throw light on the status of mediæval artists. The artists who in 1382 carved the jubé of the cathedral of Troyes are treated like workmen. They are to work from sunrise to sunset, " jusqu'à l'heure qu'il pussent avoir soupe." One of the foremen, Henri de Bruxelles, married a young girl of Troyes in 1384, and the ceremony made him lose a day. The canons deducted it from his wages (p. 208 *sq.*).

on the hem of her robe, and to draw a description of the seven Liberal Arts from the works of the obscure Martianus Capella ? The guidance of the Church is evident even in those popular and legendary works where the artist may have reproduced spontaneously what he knew by heart. Have we not seen that the windows at Le Mans which depict some of the more famous miracles of the Virgin were merely translations of a passage in the lectionary ?

In all the works we have studied we have recognised the activity of minds familiar with the whole body of the Church's teaching. It should not be forgotten that in the Middle Ages each cathedral was also a school. The most learned men and most eminent teachers of the day met in the chapter-house, and the bishops were frequently former professors and emeritus doctors. There is little doubt that they superintended the decoration of their cathedral, and themselves planned and drew up the scheme. They must in many cases have provided the artists with actual "livrets."

The only working document of this kind left to us by the Middle Ages is the book that Suger devoted to the church of St. Denis. The chief pages are those in which he describes the windows of the basilica, and which clearly show that the Abbé chose the subjects, arranged them in learned order, and himself composed the inscriptions which do something to make these symbolic works less obscure. We should have had many equally convincing documents had the thirteenth-century bishops troubled to put on record the history of the construction and decoration of their churches. Unhappily no similar document has come down to us, and to find one we must turn to the fifteenth century. In 1425 the chapter of the church of the Madeleine at Troyes gave an order for a series of tapestries showing the history of their patron saint. The arrangement of subjects was not left to the artist's fancy. " Brother Didier, the Dominican friar, having extracted and given in writing the history of the holy Magdalen, Jacquet the painter, made a small sketch of it on paper. Then the sempstress Poinsette, with her assistant collected great bed-sheets to serve for the executing of the models which were painted by Jacquet the painter and Simon the illuminator." At intervals the friar paid a visit to assure himself that the painter had been faithful to his orders. He gave advice while "taking wine" with the artists.[1]

Brother Didier's memorandum has not come down to us, but an anonymous

[1] Ph. Guignard, *Mémoires fournis aux peintres pour une tapisserie de Saint-Urbain de Troyes*. Troyes, 1851, 8°, p. 9.

one is extant, written some years later in similar circumstances. The church of St. Urbain at Troyes wished to have a series of tapestries which should recount the history both of pope Urban, and of St. Valerian and his wife, St. Cecilia. Drawing from different sources,[1] a clerk (as his learning shows) made a working scheme of such precision that he left nothing to the artist's imagination. Here is a passage from this curious manuscript. "There shall be made and portrayed a place and a tabernacle after the manner of a fine room, in which shall be the said St. Cecilia humbly kneeling on her knees, with hands joined as if in prayer to God. And near her shall be the said Valerian showing great admiration and gazing at an angel, who being above their heads, shall hold two crowns made and portrayed of lilies and roses, the which he shall appear to place and dispose one on the head of St. Cecilia and the other on the head of the said Valerian, her husband. And from the mouth of this same angel shall issue a great scroll on which shall be written if possible, or part of it : "Istas coronas mundo corde et corpore custodite, quia de paradiso Dei ad vos eas attuli, nec unquam marcescent, nec odorem amittent."[2]

It is probable that the use of such note-books dates back to the beginning of the Middle Ages. From the twelfth century until the Renaissance the Church never relaxed the supervision which she deemed it her duty to exercise over works of art.

On the other hand, as we have seen, the artists themselves had their traditions. In representations of the Gospel there could be no departure from certain rigid rules. In the scene of the Nativity the Child must lie on an altar. The three Magi must by their appearance represent youth, maturity and old age—the three stages of life. In the Crucifixion scene the mother of Jesus must be to the right and St. John to the left of the Cross, and it must be the right side which is pierced by the centurion. In the Resurrection scene the Saviour, a triumphal cross in his hand, must come forth from a wide open tomb. But it is unnecessary to multiply particulars which have been studied in their proper place. These traditions were probably codified, and by means of a written manual, or at least by model drawings, passed on from studio to studio, from generation to generation. Now it was from the Church that these same traditions proceeded. In both the east and the west these art formulæ had been elaborated by monastic theologians and artists during the ninth, tenth and eleventh centuries. If we cannot trace them back to

[1] See Ph. Guignard, *op. cit.* The anonymous writer made use of Vincent of Beauvais's *Spec. hist.* and the *Chronicon* of St. Antoninus, but he was acquainted with other writers.
[2] The Latin is taken from Vincent of Beauvais.

their origin, at least we can follow their gradual development by the aid of illuminated manuscripts. We find that everywhere Christian thought and doctrine is manifest.

We must then cease to regard the mediæval artist as an independent and restless spirit, ever ready to shake off the yoke of the Church. In *Notre Dame de Paris* Victor Hugo first gave expression to this erroneous idea : " The book of architecture no more belongs to the priesthood, to religion, to Rome. It belongs to the imagination, to poetry, to the people. At this period there is for thought written in stone a privilege comparable to our liberty of the press, the franchise of architecture. This liberty is far-reaching. Sometimes a porch, a façade, or a whole church presents a symbolic meaning entirely foreign to worship, even inimical to the Church. . . . Under pretext of building churches art grows to magnificent proportions."

In 1832 when Victor Hugo wrote these words, the most confused ideas of mediæval iconography existed, but thirty years later it was less pardonable for Viollet-le-Duc to maintain the same paradox. In the article devoted to sculpture in his *Dictionnaire* he reverts to the poet's idea. " In town life in the midst of very imperfect political conditions, art became—if one may use the expression—a *kind of liberty of the press*,[1] an outlet for minds always ready to react against the abuses of the feudal system. Civil society saw in art a platform from which under the cloak of religion she might boldly express her thoughts. That this was consciously done we do not pretend, but it was an instinct. . . . Careful study of this lay-sculpture of the thirteenth century, examination of minute details, discloses something very different from what is called religious sentiment. What we see there, before all things, is pronounced democratic feeling in the way that the programme laid down (?) is treated, everywhere a hatred of oppression, and what is nobler and makes it an art worthy of the name, everywhere a freedom of the mind from theocratic and feudal swaddling-clothes. Think of the heads of the statues in the porches at Notre Dame. What do you find ? The stamp of intellect, of moral insight in all its forms. One is pensive and stern, caustic irony speaks from the compressed lips of another. Such are the prophets seen in the Portail de la Vierge, whose meditative faces end by puzzling one like a problem. A few have radiant faces illumined by unquestioning faith, but how many more express a doubt, ask a question or ponder over it."[2]

Viollet-le-Duc does not bring forward a single fact in support of his

[1] It is evident that Viollet-le-Duc remembers Victor Hugo.

[2] *Dict. raisonné de l'architect.*, viii. p. 144 *sq.*, 1866.

RELIGIOUS ART IN FRANCE

theory, and we think we may lay claim by the preceding study to have proved its error.

The mediæval artist was neither a rebel, nor a "thinker," nor a precursor of the Revolution.[1] To interest the public in his work it is no longer necessary to present him in such a light. It is enough to show him as he really was, simple, modest and sincere. This conception of him is more pleasing to the modern mind. He was the docile interpreter of great ideas which it took all his genius to comprehend. Invention was rarely permitted to him. The Church left little more than pieces of pure decoration to his individual fancy, but in them his creative power had free play and he wove a garland of all living things to adorn the house of God. Plants, animals, all those beautiful creatures that waken curiosity and tenderness in the soul of the child and of the simple, there grew under his fingers. Through them the cathedral became a living thing, a gigantic tree full of birds and flowers, less like a work of man than of nature.

III

Conviction and faith pervade the cathedral from end to end. Even the modern man receives a deep impression of serenity, little as he is willing to submit himself to its influence.

There his doubts and theories may be forgotten for a time. Seen from afar, the church with her transepts, spires and towers seems like a mighty ship about to sail on a long voyage. The whole city might embark with confidence on her massive decks.

As he draws near her he first meets the figure of the Christ, as every man born into the world meets Him on his voyage through life. He is the key to the riddle of life. Round Him is written the answer to all men's questionings. The Christian is told how the world began and how it will end ; and the statues which symbolise the different ages of the world measure for him its duration. Before his eyes are all the men whose history it is of importance he should know. These are they who under the Old or the New Law were types of Christ, for only in so far as they participate in the nature of the Saviour do men live. The others—kings, conquerors, philosophers—are but names, vain shadows. Thus the world with its history becomes intelligible.

[1] On associations of workmen who built the cathedrals see Schnaase, *Ann. arch.*, xi. p. 325. We learn that even at the end of the fifteenth century the German freemasons were bidden to communicate every year under penalty of expulsion.

Side by side with the story of this vast universe, man's own history is written. He learns that life must be a conflict, a struggle with nature in every month of the year, a struggle with himself at every moment, an endless psychomachia. And to those who have fought a good fight the angels in the heavens above hold out crowns. Where is there room for doubt or even for disquietude of mind ?

On entering the cathedral it is the sublimity of the great vertical lines which first affects his soul. The nave at Amiens gives an inevitable sense of purification, for by its very beauty the great church acts as a sacrament. Here again it is an image of the world. The cathedral like the plain or the forest has atmosphere and perfume, splendour, and twilight, and gloom. The great rose-window behind which sinks the western sun, seems in the evening hours to be the sun itself about to vanish at the edge of a marvellous forest. But this is a transfigured world, where light shines more brightly and where shadows have more mystery than in the world of fact. Already he feels himself in the heart of the heavenly Jerusalem,[1] and tastes the profound peace of the city of the future. The storm of life breaks on the walls of the sanctuary, and is heard merely as a distant rumbling. Here indeed is the indestructible ark against which the winds shall not prevail. No place in the world fills men with a deeper feeling of security.

How much more vividly must this have been felt by the men of the Middle Ages. To them the cathedral was the sum of revelation. In it all the arts combined, speech, music, the living drama of the Mysteries and the mute drama of sculpture. But it was something more than art, it was the white light before its division by the prism into multiple rays. Man, cramped by his social class or his trade, his nature disintegrated by his daily work and life, there renewed the sense of the unity of his being and regained equilibrium and harmony. The crowd assembled for the great festivals felt itself to be a living whole, and became the mystical body of Christ, its soul passing into His soul. The faithful were humanity, the cathedral was the world, and the spirit of God filled both man and all creation. St. Paul's words were realised, and in God men lived and moved

[1] It was thus that the Middle Ages defined a church. The deed by which the chapter of the abbey of St.-Ouen decided to continue their church begins as follows : "Urbem beatam Jerusalem, quæ ædificatur ut civitas non saxorum molibus sed ex vivis lapidibus, quæ virtutum soliditate firmatur et sanctorum societate nunquam dissolvenda extruitur, sacro sancta militans Ecclesia mater nostra per manu factam et materialem basilicam repræsentat." (Quicherat, Mélanges, ii. 217). Joannes de Janduno, who described Notre Dame at Paris in 1323, says when speaking of the chapel of the Virgin which is behind the choir : " On entering one feels as if ravished to heaven, and ushered into one of the most beautiful chambers of paradise." De Laudib. Paris (ed. Leroux de Lincy, Paris, 1856–60).

and had their being. Something of this was dimly felt by men of the Middle Ages when on a glorious Christmas or Easter-day, standing shoulder to shoulder, the whole city filled the immense church.

Symbol of faith, the cathedral was also a symbol of love. All men laboured there. The peasants offered their all, the work of their strong arms. They pulled carts, and carried stones on their shoulders with the good will of the giant-saint Christopher.[1] The burgess gave his silver, the baron his land, and the artist his genius. The vitality which radiates from these immortal works is the outcome of the collaboration of all the living forces of France for more than two hundred years. The dead too were associated with the living, for the church was paved with tombstones, and past generations with joined hands continued to pray in the old church where past and present are united in one and the same feeling of love. The cathedral was the city's consciousness.

Fully to appreciate its grandeur we must compare mediæval art with the art of the sixteenth and seventeenth centuries. On the one hand is a national art, born of the common thought and will, on the other an imported art which was not rooted in the soil. Of what interest to the people were Jupiter, Mars, Hercules, and the heroes of Greece and Rome, or the twelve Cæsars who then took the place of the twelve apostles? The simple folk looked for St. James with his pilgrim's staff, or St. Anne with her keys hanging at her side like a good housewife, teaching the little Mary to read. And they were offered Mercury with his caduceus, or Ceres and Proserpine. These intellectual works moreover were not made for the people, but were destined for some rich financier's room or for the terrace of a royal château. It was a time of the Mæcenas and the amateur. Art was placed at the service of individual caprice.

In the thirteenth century rich and poor alike had the same artistic delights. There was not on the one hand the people, on the other a class of so-called connoisseurs. The church was the home of all, and art translated the thought of all. And so while art of the sixteenth or seventeenth century tells us little of the deeper thought of the France of that day, thirteenth-century art on the contrary gives full expression to a civilisation, to an epoch in history. The mediæval cathedral takes the place of books.

It is not only the genius of Christianity which is revealed, but the

[1] See the letter of Hugh, archbishop of Rouen (*Patrol.*, cxcii., col. 1133), and the letter of Haimon, abbot of Saint-Pierre-sur-Dives (L. Delisle, *Bibl. de l'École des Chartes*, series 5, vol. i.), on the people's zeal for working at the building of the cathedrals.

OF THE THIRTEENTH CENTURY

genius of France. It is true that the ideas which took visible form in the churches did not belong to France alone but were the common patrimony, of Catholic Europe. Yet France is recognised in her passion for the universal. She alone knew how to make the cathedral an image of the world, a summary of history, a mirror of the moral life. Again, the admirable order as of a supreme law which she imposed on that multitude of ideas is peculiar to France. The cathedrals of other countries, all later than the French, do not reveal so wide a range of ideas or so finely ordered a scheme of thought. There is nothing in Italy, Spain, Germany or England which can compare with Chartres. Nowhere else can be found such wealth of thought. Even Italy herself seems poor when one thinks of all that the French cathedrals have lost through wars of religion, periods of bad taste, and the iconoclasm of revolutions.[1]

When shall we understand that in the domain of art France has accomplished nothing greater?

[1] An interesting list might be compiled of great mediæval works of art which were destroyed in 1562 during the wars of religion, in the eighteenth century by the chapters, in 1793 by the Revolution, and at the beginning of the nineteenth century by the Bande noire. We should then realise the prodigious artistic output of the Middle Ages.

TRANSLATOR'S NOTE

I CANNOT let this translation be published without a few words of thanks. I would express my indebtedness both to the friends who have so kindly allowed me to make use of their wide knowledge of the Middle Ages, and to those who have been good enough to read and correct the manuscript and who have helped with valuable suggestions.

I should add that quotations from the Old Testament have been taken from the Douay version of the Vulgate (edition of 1796), quotations from the New Testament from the Reims version (edition of 1804), and that I have used Caxton's translation of the *Legenda aurea* (edited by Mr. F. S. Ellis), Mr. Wicksteed's translation of the *Paradiso*, and Mr. W. V. Cooper's translation of the *De Consolatione* of Boethius.

D. N.

APPENDIX

LIST OF THE PRINCIPAL WORKS DEVOTED TO THE LIFE OF CHRIST

(END OF THE TWELFTH, AND THE THIRTEENTH AND FOURTEENTH CENTURIES)

Notre Dame at Paris

NORTH PORCH. The cycle of the Infancy from the Nativity to the Flight into Egypt. (End of the thirteenth century.)

Sculpture in the choir-enclosure. A very characteristic Gospel series. Some of the Scenes of the Passion are missing. The series consists of the Visitation, the Announcement to the shepherds, the Adoration of the Magi, the Massacre of the Innocents, the Flight into Egypt, the Presentation in the Temple, Christ among the doctors, the Baptism, the Marriage at Cana, the Entry into Jerusalem, the Last Supper, the Washing of the disciples' feet, the Garden of Gethsemane (lacuna), the Noli me tangere, Christ and the three Maries, the Appearance to St. Peter, the Disciples at Emmaus, the Appearance on the evening of Easter-day, the Incredulity of St. Thomas, the Miraculous draught, Christ appearing twice to the apostles. (Fourteenth century.)

Sainte-Chapelle

In the Sainte-Chapelle, where the whole of the Old Testament is illustrated, there are only two windows devoted to Christ. These are, according to custom, a window of the Infancy (with the legend of St. John the Evangelist to complete it) and a window of the Passion (at the axis, thirteenth century).

Chartres

In the old porch, capitals recount the life of Christ according to the formula which we have indicated. *The Infancy* (Nativity, Announcement to the shepherds, Adoration of the Magi, Flight into Egypt, Massacre of the Innocents, Circumcision, Christ among the doctors). *The Public Life* (Baptism, Temptation). *The Passion* (Entry into Jerusalem, Last Supper, Washing of the feet, Jesus in the garden of Gethsemane, the Entombment, the Holy women at the Tomb, the Disciples on the way to Emmaus, the Appearance to the apostles). Some of the capitals have been changed. (Twelfth century.)

Windows devoted to the life of Christ, above the west porch. The usual scenes are represented. In the first window: the Annunciation, the Visitation, the Nativity, the Announcement to the shepherds, the Adoration of the Magi, the Massacre of the

APPENDIX

Innocents, the Presentation, the Flight into Egypt, the Baptism, the Entry into Jerusalem.

In the second window : the Transfiguration, the Last Supper, the Washing of the feet, the Betrayal by Judas, the Flagellation, the Crucifixion, the Entombment, the Resurrection, the Appearances to Mary Magdalen and the disciples at Emmaus. (Twelfth century.)

A window dedicated to the Virgin in the choir ambulatory gives in addition the Miracle at Cana and the Transfiguration. (Thirteenth century.)

BOURGES

Window of the Passion, from the Entry into Jerusalem to the Descent into Limbo. (Thirteenth century.)

Sculpture of the Jubé. The beautiful fragments preserved in the Louvre and in the museum at Bourges show that it was devoted to the Passion, the Resurrection, and the Descent into Limbo. (End of the thirteenth or beginning of the fourteenth century.)

TOURS

Window of the Infancy, showing both the Tree of Jesse and scenes of the Infancy (Annunciation, Visitation, Nativity, Announcement to the shepherds, Adoration of the Magi, Massacre of the Innocents, Flight into Egypt. Thirteenth century).

Window of the Passion (the Entry into Jerusalem, the Last Supper, the Kiss of Judas, the Flagellation, the Bearing of the Cross, the Crucifixion, the Entombment, Limbo, the Holy women at the Tomb, the Noli me tangere. Thirteenth century.)

These two windows have been reproduced by Marchand and Bourassé : *Verrières du chœur de Tours*, VII and VIII.

The two following, which are in the apsidal chapel in the axis of the church, have not been reproduced :

Window of the Infancy (Annunciation, Visitation, Nativity, the Angel and the shepherds, the Magi on their journey, the Magi before Herod, Adoration of the Magi, Presentation in the Temple, Departure of the Magi by ship, Massacre of the Innocents, Flight into Egypt. Thirteenth century).

Window of the Passion (Last Supper, the Washing of the feet, Garden of Gethsemane, the Flagellation, Christ before Pilate, the Bearing of the Cross, the Crucifixion, the Resurrection, Noli me tangere, the Two disciples at Emmaus, the Incredulity of Thomas, the Pasce Oves. Thirteenth century).

SENS

Window of the Infancy (Nativity, Announcement to the shepherds, Flight into Egypt. Thirteenth century).

Window of the Passion (from the Entry into Jerusalem to the Ascension. Thirteenth century).

APPENDIX

Window of the Infancy (in the chevet; all the scenes of the Infancy to the Flight into Egypt and a few Old Testament types of the Virgin. Thirteenth century).

Window of the Passion (in the chevet; from the Entry into Jerusalem to the Ascension. Thirteenth century).

Rouen (Cathedral)

Window of the Passion (from the Last Supper). Reproduced by Cahier, *Vitraux de Bourges*, Plan XII. (Thirteenth century.)

Châlons-sur-Marne

In the Cathedral. Window (since displaced) containing both the Infancy—three scenes—and the Passion—one only. (Thirteenth century.) Reproduced by Cahier, *Vitraux de Bourges*, Plan XII.

In Notre Dame (choir, north chapel). A thirteenth-century window is dedicated to the Infancy (Nativity, Flight into Egypt, the Magi).

Troyes

In the Cathedral. Window of the Infancy (Annunciation, the Magi, Presentation. Thirteenth century).

In St. Urbain. Windows devoted to the Passion, beginning with the Entry into Jerusalem. (Fourteenth century.)

Reims (Cathedral)

Window of the Passion (in the apse). The Crucifixion and above, in the seven compartments of a rose, seven scenes of the Passion. (Thirteenth century.)

Sculpture on the façade (arches of the left porch, gable, and buttress). The Temptation, the Entry into Jerusalem, the Washing of the feet, the Garden of Gethsemane, the Kiss of Judas, the Flagellation, the Crucifixion (in the gable), the Descent into Limbo, the Disciples at Emmaus. (Fourteenth century.)

Sculpture in the interior (same porch). We have already seen that the subject of this sculpture is unique in the Middle Ages. It represents Christ and the woman of Samaria, and Christ healing Peter's wife's mother, in several scenes. I have suggested that they were copied from some ancient sarcophagus. The figure of Christ has no beard. (Thirteenth century.)

Beauvais

Window of the Infancy (in the Chapel of the Virgin). The Annunciation, the Visitation, the Nativity, the Shepherds, the Magi, the Presentation in the Temple, the

APPENDIX

Massacre of the Innocents, the Flight into Egypt, the Fall of the idols. (Thirteenth century.) The compartment representing the Marriage of the Virgin is modern.

AMIENS

In the Lady Chapel two windows, thirteenth century, were devoted to the Infancy and the Passion, but they have been too much restored to have much archæological value.

CLERMONT-FERRAND

The thirteenth-century windows of one of the chapels in the choir (fifth chapel on the right, now called Chapelle de la Bonne Mort) give the Infancy and all the scenes of the Passion after the Last Supper. A compartment showing St. Peter crucified head-downwards was introduced when the window was restored.

BAYEUX

The tympanum in the left porch of the cathedral (west front) gives the scenes of the Passion from the Last Supper and the Washing of the feet. (Fourteenth century.)

DOL

The large window in the chevet contains very varied scenes taken from the Old Testament and the *Golden Legend*. But one compartment is devoted to the Infancy (Annunciation, Nativity, Shepherds, Magi), and another to the Passion (Entry into Jerusalem, Last Supper, all the scenes of the Passion after the Flagellation, the Descent from the Cross, the Holy women at the Tomb, Noli me tangere. Thirteenth century).

STRASBURG

The tympanum in the left porch of the façade at Strasburg gives the Infancy, and the tympanum of the central porch the Passion, from the Entry into Jerusalem to the Ascension. All the figures were mutilated at the time of the Revolution, but have been restored after the old designs.

A series of large windows in the south aisle are devoted to the life of Christ. They contain not only the Infancy and Passion, but His public life and *miracles*. As a matter of fact this series, so unusual in the thirteenth century, does not belong to the period with which we are dealing. These Strasburg windows belong to the end of the fourteenth century, when obedience to the old traditions was lessening.

ANGERS

Window of the Infancy. Window of the Passion. (Thirteenth century.)

LE MANS

Window of the Passion. Window of the Infancy.

APPENDIX

The Passion from the Entry into Jerusalem (sculpture of the thirteenth century).

.

The same principles were applied to decorative art. The life of Christ is summarised in the few typical scenes which we have indicated. The famous shrine at Aix-la-Chapelle, the shrine of the Great Relics (thirteenth century), shows the Annunciation, the Visitation, the Nativity, the Announcement to the shepherds, the Magi, the Presentation in the Temple, the Baptism, the Temptation, the Last Supper, the Crucifixion, the Descent from the Cross, the Entombment.

Several wooden crosiers carved in the twelfth century (the crosiers of Saint-Gibrien, Saint-Gauthier, and Saint-Aubin, for example) illustrate the life of Christ in detail, but they add nothing to the traditional scenes. (See *Congrès archéolog.*, Reims, 1861, p. 160.) The scenes are as follows: Annunciation, Visitation, Nativity, Journey of the Magi, Adoration of the Magi, the Angel and the Magi, Presentation in the Temple, Massacre of the Innocents, Flight into Egypt, the Baptism, Temptation, Entry into Jerusalem, the Washing of the feet, the Last Supper, Garden of Gethsemane, the Flagellation, the Bearing of the Cross, the Crucifixion, the Entombment, the Resurrection, the Descent into Limbo, the Appearances to the holy women, to Mary Magdalen, to the disciples at Emmaus and to St. Thomas, the Ascension, the Descent of the Holy Ghost. (The Appearances are not found on the crosier of Saint-Gibrien.)

The miniaturists obeyed the same rules. A very interesting series of gouache paintings of the end of the twelfth century, which is preserved at St. Martin's at Limoges, was reproduced by the Comte de Bastard in 1879 with the title *Histoire de Jésus-Christ en figures.* This series is of great interest to us, for although in no way limited or restrained, the artist did not produce a narrative work. He took the traditional scenes from the life of Christ—scenes of the Infancy, the Baptism, the Temptation, the Entry into Jerusalem, the Last Supper, the Passion, the Resurrection (holy women at the Tomb), the Appearances, the Ascension.

As to the manuscripts properly so-called, they generally present the two cycles of the Infancy and the Passion with more or less elaboration. I append a few examples.

Bibl. Nat., lat. 9428 (ninth century). Sacramentarium of Drogo, the cycles of the Infancy and the Passion, with the addition of the Temptation corresponding to Lent (f. 41).

Bibl. Nat., lat. 17325 (eleventh century). Gospels for different festivals. Both cycles.

Bibl. Nat., lat. 17961 (twelfth century). Psalter. The Infancy. The Public Life (Baptism). The Passion (Kiss of Judas).

Bibl. Nat., lat. 833 (twelfth century). Missal. Both cycles.

Bibl. Nat., lat. 1073 (twelfth century). Psalter. Both cycles.

Bibl. Nat., lat. 1328 (twelfth century). Psalter. Cycle of Infancy.

APPENDIX

Bibl. Nat., lat. 1077 (thirteenth century). Psalter. Both cycles.

Bibl. Nat., lat. 10434 (thirteenth century). Psalter. Infancy, Passion.

Bibl. Nat., franç. 183 (thirteenth century). Golden Legend. Both cycles.

Bibl. Nat., franç. 185 (fourteenth century). Golden Legend. Both cycles.

Bibl. Nat., lat. 10484 (fourteenth century). Breviary of Belleville. Both cycles.

Bibl. Nat., lat. 1394 (fourteenth century). Psalter. Cycle of the Infancy.

Bibl. Mazarine, 414 (thirteenth century). Missal. Annunciation, Resurrection, and Ascension, Descent of the Holy Ghost.

Bibl. Mazarine, 416 (fourteenth century). Missal. Cycles of the Infancy and of the Passion.

Bibl. Mazarine, 419 (fourteenth century). Missal. Both cycles.

Bibl. Mazarine, 412 (fifteenth century). Missal (Paris). Both cycles.

Bibl. Mazarine, 420 (fifteenth century). Missal (Poitiers), one miniature for the Nativity (Christmas) and one for the Resurrection (Easter).

Finally, I would draw attention to the *Catalogue of Illuminated Manuscripts in the British Museum* by Walter de Gray Birch and Henry Jenner, London, 1879. The miniatures are arranged according to subject, and it is noteworthy that while the scenes of the Infancy and the Passion fill many pages of the catalogue, scenes from Christ's public life (miracles, preaching) if not altogether absent, are only found in a very small number of manuscripts.

BIBLIOGRAPHY

Acta Sanctorum.

Adams, *Recueil de sculptures gothiques.* Paris, 1856, 4to.

Adeline (J.), *Sculptures grotesques et symboliques.* Rouen, 1879, 12mo.

Album de Villard de Honnecourt, edited by Lassus. Paris, Imp. impér., 1858, 4to.

Annales archéologiques.

Annales de la Société archéologique de Bruxelles.

Anthyme Saint-Paul, *Histoire monumentale de la France.* Paris, 1888, 8vo.

L'Art (Review).

Auber (Abbé), *Histoire de la cathédrale de Poitiers.* Poitiers, 1840, 8vo.

Auber (Abbé), *Histoire et théorie du symbolisme religieux.* Paris, 1871, 3 vols. 8vo.

D'Ayzac (Mme. F.), *Les Statues du porche septentrional de Chartres,* and the sequel *Quatre animaux mystiques.* Paris, 1849, 8vo.

Barbier de Montault (Mgr.), *Traité d'iconographie chrétienne.* Paris, 1890, 2 vols. 8vo.

Barrière-Flavy, *Études sur les sépultures barbares du midi et de l'ouest de la France.* Toulouse-Paris, 1893, 4to.

Bastard (Cte. de), *Catalogue sommaire* (inédit) *des miniatures des manuscrits de la Bibliothèque Nationale.* Bibl. Nat., nouvelles acquisitions françaises 5811, 5812.

Bastard (Cte. de), *Documents archéologiques* (inédits), in the Cabinet des Estampes.

Bastard (Cte. de), *Études de symbolique chrétienne.* Paris, Imp. impér., 1861, 8vo.

Batiffol (Abbé), *Histoire du bréviaire romain.* Paris, 1894, 12mo.

Batiffol (Abbé), *Anciennes littératures chrétiennes.* Paris, 1897, 12mo.

Bauhin, *De plantis a divis sanctisve nomen habentibus.* Bâle, 1591, 12mo.

Baye (de), *L'Industrie longobarde.* Paris, 1888, 8vo.

Baye (de), *L'Industrie anglo-saxonne.* Paris, 1889, 8vo.

Bédier, *Les Fabliaux.* Paris, 1893, 8vo.

Bégule (L.) and Guigue (C.), *Monographie de la cathédrale de Lyon.* Lyon, 1880, folio.

Berger (Samuel), *La Bible française au moyen âge.* Paris, 1884, 8vo.

Berger de Xivrey, *Traditions tératologiques.* Paris, Imp. royale, 1836, 8vo.

Bibliothèque de l'École des Chartes.

Bonnault d'Houet, *Le Pèlerinage d'un paysan picard à Saint-Jacques de Compostelle au XVIII^e siècle.* Montdidier, 1890, 8vo.

Bordier, *Catalogue* (inédit) *des manuscrits latins à miniatures de la Bibliothèque nationale,* Bibl. Nat., nouvelles acquisitions françaises 5813, 5814, 5815.

Boutaric, *Vincent de Beauvais et la connaissance de l'antiquité au XIII^e siècle,* in the *Revue des questions historiques,* t. XVII.

Bouxin (Abbé), *La Cathédrale Notre-Dame de Laon,* Laon, 1890, 8vo.

J. C. Broussolle, *Le Christ de la légende dorée.* Paris, no date.

J. C. Broussolle, *Études sur la Sainte Vierge.* Series I, 1908, series II, 1908, 2 vols. 12mo.

Bulletin du Comité de la langue, de l'histoire et des arts de la France (section d'archéologie).

Bulletin monumental.

Bulliot and Thiollier, *La Mission et le culte de saint Martin dans le pays Éduen.* Paris, 1892, 8vo.

Bulteau (Abbé), *Description de la cathédrale de Chartres.* Chartres, 1858, 1 vol. 8vo.

Bulteau (Abbé), *Monographie de la cathédrale de Chartres.* Chartres, 1890, 3 vols. 8vo.

Le Cabinet historique (Review).

Cahier and Martin, *Vitraux peints de Saint-Étienne de Bourges.* Paris, Poussielgue, 1842-44, folio.

Cahier and Martin, *Mélanges d'archéologie, d'histoire et de littérature.* Paris, 1847-56, 4 vols. folio.

Cahier, *Les Caractéristiques des saints dans l'art populaire.* Paris, 1866-68, 2 vols. 4to.

Cahier, *Nouveaux mélanges d'archéologie et d'histoire.* Paris, 1874-77, 4 vols. folio.

Du Cange, *Traité du chef de saint Jean-Baptiste.* Paris, 1665, 4to.

Cartulaire de Notre-Dame de Chartres, edited by E. de Lépinois and L. Merlet. Chartres, 1862-65, 3 vols. 4to.

Cartulaire de Saint-Père de Chartres, edited by Guérard, in *Documents inédits de l'histoire de France.*

Cartulaire de Notre-Dame de Paris, edited by Guérard, in *Documents inédits de l'histoire de France.*

Catalogue général des manuscrits des bibliothèques publiques de France.

Cerf (Canon), *Histoire et description de Notre-Dame de Reims.* Reims, 1861, 2 vols. 8vo.

Cerf (Canon), *Études sur quelques statues de Reims.* Reims, 1886, 8vo.

Champfleury, *Histoire de la caricature au moyen âge.* Paris, 1876, 12mo.

Chevalier (Ulysse), *Poésies liturgiques traditionnelles de l'Église catholique en Occident.* Tournai, 1893, 12mo.

Clerval (Abbé), *L'Enseignement des Arts libéraux*

BIBLIOGRAPHY

à Chartres et à Paris, d'après l'Heptateuchon de Thierry de Chartres. Paris, 1889, brochure.

Clerval (Abbé), Les Écoles de Chartres au moyen âge. Paris, 1895, 8vo.

Collin de Plancy, Dictionnaire des reliques. Paris, 1821, 3 vols. 8vo.

Comparetti, Virgilio nel medio evo. Livorno, 1870.

Congrès archéologiques de France.

Corblet, Hagiographie du diocèse d'Amiens. Paris-Amiens. 1868–75, 5 vols. 8vo.

Courajod et Marcou, Catalogue raisonné du musée du Trocadéro. Paris, 1892, 8vo.

Crosnier (Abbé), Iconographie chrétienne. Caen, 1848, 8vo.

Delisle (L.), Le Cabinet des manuscrits. Paris, 1868–81, 3 vols. 4to.

Detzel (H.), Christliche Iconographie. Friburg in B., 1894–96, 2 vols. 8vo.

Didot, Des Apocalypses figurées, manuscrites et xylographiques. Paris, 1870, 8vo.

Didron, Iconographie chrétienne. Histoire de Dieu. Paris, 1844, 4to.

Didron and Durand, Iconographie chrétienne. Traduction du manuscrit byzantin du Mont-Athos. Paris, 1845, 8vo.

Douhaire, Cours sur les Apocryphes, in the Université catholique, t. IV and V.

Duchesne (Abbé), Les Origines du culte chrétien. Paris, 1889, 8vo.

Durand (G.), La Cathédrale d'Amiens, 2 vols. with plates, 1901.

Eicken (H. von), Geschichte und System der mittelalterlichen Weltanschauung. Stuttgart, 1887, 8vo.

Fabricius, Codex apocryphus Novi Testamenti, Hamburg, 1719.

Farcy (de), Histoire et description des tapisseries de la cathédrale d'Angers. Lille, 1889.

Faucon (Maurice), La Librairie des papes d'Avignon. Paris, 1886, 2 vols. 8vo.

Fita (Father), Codex de Compostelle. Paris, 1882, 12mo.

Fleury, Antiquités et monuments de l'Aisne. Paris-Laon, 1877–82, 4 vols. 8vo.

Florival (de) and Midoux, Les Vitraux de Laon. Paris, 1882–91, 4to.

Forgeais, Plombs historiés, series IV. Paris, 1861, 1862–65, 8vo.

Frimmel, Die Apocalypse in den Bilderhandschriften des Mittelalters. Wien, 1885.

Gaussin, Portefeuille archéologique de la Champagne. Bar-sur-Aube, 1865, 4to.

Gazette archéologique.

Gazette des beaux-arts.

Germain (Michel), Histoire de Notre-Dame de Soissons. Paris, 1675, 4to.

Giry, Manuel de diplomatique. Paris, 1894, 8vo.

Gori, Thesaurus veterum diptychorum. Florentiæ, 1759, 3 vols. folio.

Grimoüard de Saint Laurent, Guide de l'art chrétien. 6 vols. Paris and Poitiers, 1872–73, 8vo.

Guénebault, Dictionnaire iconographique. 1850. (Collection Migne.)

Guéranger (Dom), L'Année liturgique. Paris, 1888, 12 vols. 12mo.

Guignard, Mémoires fournis aux peintres pour une tapisserie de Saint-Urbain de Troyes. Troyes, 1851, 8vo.

Guilhermy (de), Description de Notre-Dame de Paris. Paris, 1859, 12mo.

Guilhermy (de), Description de la Saint-Chapelle. Paris, 1887, 12mo.

Harnack, Geschichte der altchristlichen Litteratur. Leipzig, 1893, 8vo.

Hauréau, Histoire de la philosophie scolastique. Paris, 1872–80, 2 vols. 8vo.

Hauréau, Les Œuvres d'Hugues de Saint-Victor. Paris, 1886, 8vo.

Helmsdorfer, Christliche Kunstsymbolik und Iconographie. Frankfurt, 1839.

Histoire littéraire de la France.

Hucher, Vitraux peints de la cathédrale du Mans. Le Mans, 1868, folio.

Jahrbücher des Vereins von Alterthumsfreunden in Rheinlande. Bonn.

Jameson (Mrs.), Sacred and legendary Art. 2 vols. London, 1874.

Jessen, Die Darstellung des Weltgerichts bis auf Michelangelo. Berlin, 1883.

Jourdain and Duval, Le Portail Saint-Honoré ou de la Vierge dorée à la cathédrale d'Amiens. Amiens, 1844, 8vo.

Kehrer (Hugo), Die heiligen drei Könige in Litteratur und Kunst. Leipzig, 1909, 2 vols. 4to.

Kraus (F. X.), Geschichte der christlichen Kunst. Friburg in B., vol. i. 1895, vol. ii. 1897, 8vo.

Laib and Schwarz, Biblia pauperum. Friburg in B., 1896, second edition.

Lambin, La Flore gothique. Paris, 1893, 8vo.

Lambin, Les Églises des environs de Paris étudiées au point de vue de la flore. Paris, 1895, 8vo.

Lasteyrie (F. de), Histoire de la peinture sur verre. Paris, 1838–58, folio.

Lasteyrie (R. de), La déviation de l'axe des églises in Mémoires de l'Académ. des Inscript. et Belles-Lettres, t. XXXVII, 1905.

Lasteyrie (R. de), Études sur la sculpture française du moyen âge. Fondation Eugène Piot, t. VIII, 1902.

Lasteyrie (R. de) and E. Lefèvre Pontalis, Bibliographie des travaux historiques et archéologiques publiés par les sociétés savantes. Paris, 1888, Imp. nat., 4to (in course of publication).

Lauchert, Geschichte des Physiologus. Strasburg, 1889.

Lavergne, Les Chemins de Saint-Jacques en Gascogne. Bordeaux, 1887, 8vo.

Lebeuf (Abbé), Histoire de tout le diocèse de Paris. Édit. Cocheris. Paris, 1863–75, 4 vols. 8vo.

Lebeuf, Dissertation sur les anciens cimetières.

Leclerc (Abbé) and de Verneilh, La Vierge ouvrante de Boubon. Limoges, 1898.

BIBLIOGRAPHY

Lecoy de la Marche, *Saint Martin*. Tours, 1890, second edition.

Ledeuil, *Notice sur Semur-en-Auxois*. Semur, 1886, 12mo.

Lenoir (Alexandre), *Description historique et chronologique des monuments de sculpture réunis au musée des monuments français*. Tenth year, sixth edition.

Lenoir, *Statistique monumentale de Paris*. Paris, 1861–75, 4to.

Lépinois (de), *Histoire de Chartres*. Chartres, 1854, 8vo.

Leroux de Lincy, *Le Livre des proverbes français*. Paris, 1842, 2 vols. 18mo.

Lespinasse (R. de), *Les Métiers et les corporations de la ville de Paris*. Paris, 1844, 2 vols. 4to.

Lévy and Capronnier, *Histoire de peinture sur verre*. Bruxelles, 1855, 4to.

Lindenschmitt, *Die Alterthümer unserer heidnischen Vorzeit*. Mainz, 1858.

L'Isle (Dom Joseph de), *Histoire de la vie et du culte de saint Nicolas*. Nancy, 1745, 12mo.

Longnon, *Documents parisiens sur l'iconographie de saint Louis*. Paris, 1882, 8vo.

Lübke, *Geschichte der Plastik*, 1880, 4to.

Marchand and Bourassé, *Verrières du chœur de l'église métropolitaine de Tours*. Paris, 1849, folio.

Mas-Latrie (the Cte. de), *Trésor de chronologie*. Paris, 1889, folio.

Maury, *Essai sur les légendes pieuses du moyen âge*. Paris, 1843, 8vo.

Des Méloizes, *Vitraux de Bourges postérieurs au XIII^e siècle*. Lille, 1897.

Mémoires de la Société de l'histoire de Paris.

Mémoires de la Société des Antiquaires de France.

Mémoires de la Société des Antiquaires de Normandie.

Mémoires de la Société des Antiquaires de Picardie.

Menzel, *Christliche Symbolik*. Regensburg, 1854, 2 vols. 8vo.

Méril (E. du), *Poésies latines du moyen âge*. Paris, 1847.

Mérimée, *Les Peintures de Saint-Savin*. Paris, 1845, folio.

Michel (A.), *Histoire de l'art*, published under the direction of M. A. Michel, t. II, 1906.

Migne (collection), *Dictionnaire des Apocryphes*. 1858, 2 vols. 4to.

Molanus, *De historia sanctarum imaginum et picturarum*. 1580, Louvain edition, 1771.

Moléon, *Voyage liturgique*.

Molinier (Ém.), *Histoire générale des arts appliqués à l'industrie*. Vol. i., *Ivoires*. Paris, 1896, folio.

Molinier, *Les Manuscrits*. Paris, 1892, 12mo.

Molinier, *Notice des émaux et de l'orfèvrerie*.

Montfaucon, *Monuments de la monarchie française*. Paris, 1729–33, 5 vols. folio.

Morand, *Histoire de la Sainte-Chapelle*. Paris, 1890, 4to.

Mortet, *Étude historique et archéologique sur la cathédrale et le palais épiscopal de Paris*. Paris, 1888, 8vo.

Le Moyen Age (Review).

Müntz (E.), *Études iconographiques sur le moyen âge*. Paris, 1887, 12mo.

Mussafia, *Studien zu den mittelalterlichen Marienlegenden*. Wien, 1886–88.

J. M. Neale and Benj. Webb, *The Symbolism of Churches and Church Ornaments*, 1843, 12mo.

Notes d'art et d'archéologie (Review).

Notices et extraits des manuscrits.

Ordonnances des rois de France.

Ouin-Lacroix, *Histoire des anciennes corporations d'arts et métiers de Rouen*, 1850, 8vo.

Pardiac, *Histoire de saint Jacques le Majeur*. Bordeaux, 1863, 12mo.

Paris (G.), *Histoire poétique de Charlemagne*. Paris, 1865, 8vo.

Paris (G.), *De Pseudo-Turpino*. Paris, 1865, 8vo.

Paris (P.), *Les Manuscrits français de la Bibliothèque du roi*.

Pascal (Abbé), *Institutions de l'art chrétien*. Paris, 1858, 2 vols. 8vo.

Patrologia latina, Migne.

Pillion (Mlle. L.), *Les portails latéraux de la cathédrale de Rouen*. Paris, 1907, 8vo.

Piper (F.), *Mythologie der christlichen Kunst*. Weimar, 1847, 8vo.

Piper (F.), *Ueber den christlichen Bilderkreis*. Berlin, 1852, 8vo.

Piper (F.), *Einleitung in die monumentale Theologie*. Gotha, 1867, 8vo.

Puech, *Prudence*. Paris, 1888, 8vo.

Quicherat, *Mélanges d'archéologie et d'histoire*, edited by R. de Lasteyrie. Paris, 1886, 2 vols. 8vo.

Renan, *L'Église chrétienne*.

Revue archéologique.

Revue d'architecture.

Revue de l'art ancien et moderne.

Revue de l'art chrétien.

Riant (Cte.), *Exuviæ sacræ Constantinopolitanæ*. Geneva, 1878, 2 vols. 8vo.

Robillard de Beaurepaire, *Caen illustré*. Caen, 1896, folio.

Rohault de Fleury, *La Sainte Vierge*. Paris, 1878–1879, 1 vol. 4to.

Rolland (Eug.), *Faune populaire de la France*.

Romania.

Rouillard (Sébastien), *Parthénie, ou histoire de la très auguste église de Chartres*, 1608.

Sauer, *Symbolik des Kirchengebäudes und seiner Ausstattung im der Auffassung des Mittelalters*. Friburg in B., 1902, 8vo.

Schlosser (J. von), *Quellenschriften für Kunstgeschichte. Schriftquellen zur Geschichte der karolingischen Kunst*. Wien, 1892, 8vo.

Schlosser (J. von), *Quellenbuch zur Kunstgeschichte*. Wien, 1896, 8vo.

Sepet (Marius), *Les Prophètes du Christ*. Paris, 1877, 8vo.

Spicilegium Solesmense, edited by Dom Pitra.

Springer (A.), *Ikonographische Studien*, in *Mittheilungen der K. K. Centralcommission*. Wien, 1860.

BIBLIOGRAPHY

Springer (A.), *Ueber die Quellen der Kunstvorstellungen im Mittelalter*, in *Berichte über die Verhandlungen der königl. sächsischen Gesellschaft der Wissenschaften zu Leipzig*. Phil.-hist., cl. XXXI.

Springer (A.), *Das Nachleben der Antike im Mittelalter*, in *Bilder aus der neuern Kunstgeschichte*. Bonn, 1886, 2 vols. 8vo.

Stettiner (M. R.), *Die illustrirten Prudentius Handschriften*. Berlin, 1895, 8vo.

Thibaud, *De la peinture sur verre*.

Thiers (Abbé), *Traité des superstitions populaires*. Paris, 1703-1704, 4 vols. 12mo.

Thilo, *Codex apocryphus Novi Testamenti*. Leipzig, 1853.

Tischendorf, *Evangelia apocrypha*. Leipzig, 1853.

Vasari, *Le Vite*. Edit. Milanesi, Firenze, 1878, 9 vols. 8vo.

Viollet-le-Duc, *Dictionnaire raisonné de l'architecture française du XI^e au XVI^e siècle*. 9 vols. 8vo.

Vöge (W.), *Die Anfänge des monumentalen Stiles im Mittelalter*. Strasburg, 1894, 8vo.

Voss, *Das jüngste Gericht in der Kunst des frühen Mittelalters*. Leipzig, 1884.

Wadstein (Dr. Ernst), *Die eschatologische Ideengruppe. Antichrist, Weltsabbat, Weltende, Weltgericht*. Leipzig, 1896, 8vo.

Weber (Paul), *Geistliches Schauspiel und kirchliche Kunst in ihrem Verhältniss erläutert an einer Iconographie der Kirche und Synagoge*. Stuttgart, 1894, 8vo.

Weese, *Die Bamberger Domsculpturen*.

Westwood, *Fac-similes of the miniatures and ornaments of Anglo-Saxon and Irish Manuscripts*. 1868.

Willemin, *Monuments français inédits*. Paris, 1806-1833, folio.

Woillez (Dr.), *Iconographie des plantes arcides figurées au moyen âge en Picardie*. Amiens, 1848.

Wright, *Histoire de la caricature et du grotesque dans la littérature et dans l'art*. Paris, 1875, 12mo.

Zeitschrift für christliche Kunst.

INDEX OF WORKS OF ART

Aix-in-Provence, baptistery, p. 14.

Aix-la-Chapelle, chandelier, p. 20; shrine of the great relics, 209, 309; shrine of the relics of Charlemagne, p. 350.

Albi, cathedral; statues of the prophets, p. 169.

Amiens, cathedral; iconography, p. 390. *Statues:* St. Peter and St. Paul, p. 6; Solomon and the Queen of Sheba, p. 157; the kings of Judah, p. 168; the teaching Christ, p. 3, 44, 176; Herod, p. 216; la Vierge dorée, p. 236; St. Firmin, p. 284; the apostles of the central porch, p. 308; statues of the saints of the diocese, p. 310; Charles V, Charles VI, Bureau de la Rivière (buttresses to the north), p. 345.

Bas-reliefs: the adder and the basilisk beneath the feet of Christ, west front, p. 44; signs of the zodiac and the works of the months, p. 68; wheel of fortune, south doorway, p. 94; the Virtues and the Vices, west front, p. 109; symbolic bas-reliefs relating to the Virgin, west front, p. 150; patriarchs and prophets typifying Christ, round the arches of the Portail St. Honoré, p. 155, 156, 160; prophecies, west front, p. 162; tree of Jesse, p. 168; the wise and foolish Virgins, p. 198; bas-reliefs of the Magi, p. 215, 216; coronation of the Virgin, p. 257; bas-relief of St. Christopher, p. 270; bas-reliefs of the porch of St. Firmin, p. 311; bas-reliefs of St. John the Baptist in the choir ambulatory, p. 318; Æsop's fables in the west porch, p. 335; riders of the Apocalypse, p. 368; the Last Judgment, p. 368, 372; the axe laid to the root of the tree, p. 388.

Glass: window of St. Stephen, p. 299; window of St. John the Baptist and St. George, p. 318; window of St. James the Great, p. 321; window of St. Augustine, p. 321; window of the Infancy and the Passion, appendix.

— Church of St. Martin, p. 331.

Anagni, church; dalmatic, the legend of Alexander, p. 336.

Angers, cathedral; *glass:* window of the Crucifixion, p. 223; the Annunciation, p. 244; death and burial of the Virgin, p. 250, 251; window of St. Peter, p. 297; window of St. Martin, p. 330.

Tapestries: scenes from the Apocalypse, p. 357.

— St. Serge, *glass,* p. 6.

Aosta, zodiac, p. 66.

Arles, St. Trophime, p. 227; *capitals,* the Magi, p. 227; the Last Judgment, p. 365.

Auch, *glass,* p. 169.

Aulnay, battle of the Virtues and the Vices, p. 103.

Autun, cathedral; *bas-reliefs,* tympanum of the Last Judgment, p. 365.

Auxerre, cathedral; *bas-reliefs:* scenes of the creation, west front, p. 27; the seven Liberal Arts, west front, p. 83; the wise and foolish Virgins, p. 198; the parable of the Prodigal Son, p. 199; the death of Cain, p. 205; the coronation of the Virgin, p. 257; the sibyl Erythraea, p. 336.

Glass: window of St. Eustace, p. 11, 277; St. Peter and St. Paul, p. 299; rose-window of the seven Liberal Arts, p. 84; window of the Creation, p. 27; rose-window of the Virtues, in the choir, p. 109; window of the story of Joseph, p. 132; window of the Prodigal Son, p. 199; window of St. Peter and St. Paul (scattered), p. 299; legend of St. James the Great, p. 306; window of St. Andrew, p. 307; west rose-window, p. 323; window of St. Nicholas, p. 328; window of the Apocalypse (scattered fragments), p. 357.

Avignon, palace of the Popes; frescoes, p. 337.

Avioth (Meuse), p. 220.

Bamberg, cathedral, p. 9; *statue* of St. Stephen of Hungary, p. 354.

Basle, cathedral; wheel of fortune, p. 95; Alexander rising to heaven, p. 336.

Baux, les (castle), p. 212.

Bayonne, cathedral, *statue* of St. James, p. 309.

Beauvais, St. Étienne; wheel of fortune, p. 95.

— cathedral; *glass:* window of the Crucifixion, p. 223; the miracle of Theophilus, p. 260; window of St. Martin, p. 330; window of the Infancy, p. 241.

Besançon, collegiate church of St. Mary Magdalen; symbolic statues, p. 152.

Blaye, tomb of Roland, p. 326.

Bordeaux, cathedral; *statue* of Pope Clement V, p. 346; tympanum of the Last Judgment, p. 372.

— St. Seurin, *statues:* the Church and the Synagogue, p. 193; statues of the apostles, p. 311; Last Judgment, p. 370.

Bourges, cathedral; façade, p. 11; iconography, p. 391. *Bas-reliefs:* scenes of the creation, west front, p. 27; the wise and foolish Virgins, p. 198; the death of Cain, p. 205; the coronation of the Virgin, p. 246; story of St. Ursin and St. William, p. 313; Last Judgment, p. 375–378; carvings of the jubé, appendix.

Glass: window with symbolic animals, p. 15; window of Joseph, p. 155; symbolic window of the Old and New Testaments, p. 43; window of prophets and apostles, p. 159; window of the Good Samaritan, p. 197, 199, 324; window of the Prodigal Son, p. 199; parable of Dives, p. 200; window of the Passion, p. 223; Saint Anne and her family, p. 238;

INDEX OF WORKS OF ART

INDEX OF WORKS OF ART

INDEX OF WORKS OF ART

INDEX OF WORKS OF ART

A CATALOG OF SELECTED
DOVER BOOKS
IN ALL FIELDS OF INTEREST

A CATALOG OF SELECTED DOVER BOOKS IN ALL FIELDS OF INTEREST

100 BEST-LOVED POEMS, Edited by Philip Smith. "The Passionate Shepherd to His Love," "Shall I compare thee to a summer's day?" "Death, be not proud," "The Raven," "The Road Not Taken," plus works by Blake, Wordsworth, Byron, Shelley, Keats, many others. 96pp. 5³⁄₁₆ x 8¼. 0-486-28553-7

100 SMALL HOUSES OF THE THIRTIES, Brown-Blodgett Company. Exterior photographs and floor plans for 100 charming structures. Illustrations of models accompanied by descriptions of interiors, color schemes, closet space, and other amenities. 200 illustrations. 112pp. 8⅜ x 11. 0-486-44131-8

1000 TURN-OF-THE-CENTURY HOUSES: With Illustrations and Floor Plans, Herbert C. Chivers. Reproduced from a rare edition, this showcase of homes ranges from cottages and bungalows to sprawling mansions. Each house is meticulously illustrated and accompanied by complete floor plans. 256pp. 9⅜ x 12¼.
0-486-45596-3

101 GREAT AMERICAN POEMS, Edited by The American Poetry & Literacy Project. Rich treasury of verse from the 19th and 20th centuries includes works by Edgar Allan Poe, Robert Frost, Walt Whitman, Langston Hughes, Emily Dickinson, T. S. Eliot, other notables. 96pp. 5³⁄₁₆ x 8¼. 0-486-40158-8

101 GREAT SAMURAI PRINTS, Utagawa Kuniyoshi. Kuniyoshi was a master of the warrior woodblock print — and these 18th-century illustrations represent the pinnacle of his craft. Full-color portraits of renowned Japanese samurais pulse with movement, passion, and remarkably fine detail. 112pp. 8⅜ x 11. 0-486-46523-3

ABC OF BALLET, Janet Grosser. Clearly worded, abundantly illustrated little guide defines basic ballet-related terms: arabesque, battement, pas de chat, relevé, sissonne, many others. Pronunciation guide included. Excellent primer. 48pp. 4³⁄₁₆ x 5¾.
0-486-40871-X

ACCESSORIES OF DRESS: An Illustrated Encyclopedia, Katherine Lester and Bess Viola Oerke. Illustrations of hats, veils, wigs, cravats, shawls, shoes, gloves, and other accessories enhance an engaging commentary that reveals the humor and charm of the many-sided story of accessorized apparel. 644 figures and 59 plates. 608pp. 6⅛ x 9¼.
0-486-43378-1

ADVENTURES OF HUCKLEBERRY FINN, Mark Twain. Join Huck and Jim as their boyhood adventures along the Mississippi River lead them into a world of excitement, danger, and self-discovery. Humorous narrative, lyrical descriptions of the Mississippi valley, and memorable characters. 224pp. 5³⁄₁₆ x 8¼. 0-486-28061-6

ALICE STARMORE'S BOOK OF FAIR ISLE KNITTING, Alice Starmore. A noted designer from the region of Scotland's Fair Isle explores the history and techniques of this distinctive, stranded-color knitting style and provides copious illustrated instructions for 14 original knitwear designs. 208pp. 8⅜ x 10⅞. 0-486-47218-3

Browse over 9,000 books at www.doverpublications.com

CATALOG OF DOVER BOOKS

ALICE'S ADVENTURES IN WONDERLAND, Lewis Carroll. Beloved classic about a little girl lost in a topsy-turvy land and her encounters with the White Rabbit, March Hare, Mad Hatter, Cheshire Cat, and other delightfully improbable characters. 42 illustrations by Sir John Tenniel. 96pp. 5³⁄₁₆ x 8¼.　　　　　0-486-27543-4

AMERICA'S LIGHTHOUSES: An Illustrated History, Francis Ross Holland. Profusely illustrated fact-filled survey of American lighthouses since 1716. Over 200 stations — East, Gulf, and West coasts, Great Lakes, Hawaii, Alaska, Puerto Rico, the Virgin Islands, and the Mississippi and St. Lawrence Rivers. 240pp. 8 x 10¾.
　　　　　0-486-25576-X

AN ENCYCLOPEDIA OF THE VIOLIN, Alberto Bachmann. Translated by Frederick H. Martens. Introduction by Eugene Ysaye. First published in 1925, this renowned reference remains unsurpassed as a source of essential information, from construction and evolution to repertoire and technique. Includes a glossary and 73 illustrations. 496pp. 6⅛ x 9¼.　　　　　0-486-46618-3

ANIMALS: 1,419 Copyright-Free Illustrations of Mammals, Birds, Fish, Insects, etc., Selected by Jim Harter. Selected for its visual impact and ease of use, this outstanding collection of wood engravings presents over 1,000 species of animals in extremely lifelike poses. Includes mammals, birds, reptiles, amphibians, fish, insects, and other invertebrates. 284pp. 9 x 12.　　　　　0-486-23766-4

THE ANNALS, Tacitus. Translated by Alfred John Church and William Jackson Brodribb. This vital chronicle of Imperial Rome, written by the era's great historian, spans A.D. 14-68 and paints incisive psychological portraits of major figures, from Tiberius to Nero. 416pp. 5³⁄₁₆ x 8¼.　　　　　0-486-45236-0

ANTIGONE, Sophocles. Filled with passionate speeches and sensitive probing of moral and philosophical issues, this powerful and often-performed Greek drama reveals the grim fate that befalls the children of Oedipus. Footnotes. 64pp. 5³⁄₁₆ x 8 ¼.　　　　　0-486-27804-2

ART DECO DECORATIVE PATTERNS IN FULL COLOR, Christian Stoll. Reprinted from a rare 1910 portfolio, 160 sensuous and exotic images depict a breathtaking array of florals, geometrics, and abstracts — all elegant in their stark simplicity. 64pp. 8⅜ x 11.　　　　　0-486-44862-2

THE ARTHUR RACKHAM TREASURY: 86 Full-Color Illustrations, Arthur Rackham. Selected and Edited by Jeff A. Menges. A stunning treasury of 86 full-page plates span the famed English artist's career, from *Rip Van Winkle* (1905) to masterworks such as *Undine, A Midsummer Night's Dream,* and *Wind in the Willows* (1939). 96pp. 8⅜ x 11.
　　　　　0-486-44685-9

THE AUTHENTIC GILBERT & SULLIVAN SONGBOOK, W. S. Gilbert and A. S. Sullivan. The most comprehensive collection available, this songbook includes selections from every one of Gilbert and Sullivan's light operas. Ninety-two numbers are presented uncut and unedited, and in their original keys. 410pp. 9 x 12.
　　　　　0-486-23482-7

THE AWAKENING, Kate Chopin. First published in 1899, this controversial novel of a New Orleans wife's search for love outside a stifling marriage shocked readers. Today, it remains a first-rate narrative with superb characterization. New introductory Note. 128pp. 5³⁄₁₆ x 8¼.　　　　　0-486-27786-0

BASIC DRAWING, Louis Priscilla. Beginning with perspective, this commonsense manual progresses to the figure in movement, light and shade, anatomy, drapery, composition, trees and landscape, and outdoor sketching. Black-and-white illustrations throughout. 128pp. 8⅜ x 11.　　　　　0-486-45815-6

Browse over 9,000 books at www.doverpublications.com

THE BATTLES THAT CHANGED HISTORY, Fletcher Pratt. Historian profiles 16 crucial conflicts, ancient to modern, that changed the course of Western civilization. Gripping accounts of battles led by Alexander the Great, Joan of Arc, Ulysses S. Grant, other commanders. 27 maps. 352pp. 5⅜ x 8½. 0-486-41129-X

BEETHOVEN'S LETTERS, Ludwig van Beethoven. Edited by Dr. A. C. Kalischer. Features 457 letters to fellow musicians, friends, greats, patrons, and literary men. Reveals musical thoughts, quirks of personality, insights, and daily events. Includes 15 plates. 410pp. 5⅜ x 8½. 0-486-22769-3

BERNICE BOBS HER HAIR AND OTHER STORIES, F. Scott Fitzgerald. This brilliant anthology includes 6 of Fitzgerald's most popular stories: "The Diamond as Big as the Ritz," the title tale, "The Offshore Pirate," "The Ice Palace," "The Jelly Bean," and "May Day." 176pp. 5⅜ x 8½. 0-486-47049-0

BESLER'S BOOK OF FLOWERS AND PLANTS: 73 Full-Color Plates from Hortus Eystettensis, 1613, Basilius Besler. Here is a selection of magnificent plates from the *Hortus Eystettensis*, which vividly illustrated and identified the plants, flowers, and trees that thrived in the legendary German garden at Eichstätt. 80pp. 8⅜ x 11. 0-486-46005-3

THE BOOK OF KELLS, Edited by Blanche Cirker. Painstakingly reproduced from a rare facsimile edition, this volume contains full-page decorations, portraits, illustrations, plus a sampling of textual leaves with exquisite calligraphy and ornamentation. 32 full-color illustrations. 32pp. 9⅜ x 12¼. 0-486-24345-1

THE BOOK OF THE CROSSBOW: With an Additional Section on Catapults and Other Siege Engines, Ralph Payne-Gallwey. Fascinating study traces history and use of crossbow as military and sporting weapon, from Middle Ages to modern times. Also covers related weapons: balistas, catapults, Turkish bows, more. Over 240 illustrations. 400pp. 7¼ x 10⅛. 0-486-28720-3

THE BUNGALOW BOOK: Floor Plans and Photos of 112 Houses, 1910, Henry L. Wilson. Here are 112 of the most popular and economic blueprints of the early 20th century — plus an illustration or photograph of each completed house. A wonderful time capsule that still offers a wealth of valuable insights. 160pp. 8⅜ x 11. 0-486-45104-6

THE CALL OF THE WILD, Jack London. A classic novel of adventure, drawn from London's own experiences as a Klondike adventurer, relating the story of a heroic dog caught in the brutal life of the Alaska Gold Rush. Note. 64pp. 5³⁄₁₆ x 8¼. 0-486-26472-6

CANDIDE, Voltaire. Edited by Francois-Marie Arouet. One of the world's great satires since its first publication in 1759. Witty, caustic skewering of romance, science, philosophy, religion, government — nearly all human ideals and institutions. 112pp. 5³⁄₁₆ x 8¼. 0-486-26689-3

CELEBRATED IN THEIR TIME: Photographic Portraits from the George Grantham Bain Collection, Edited by Amy Pastan. With an Introduction by Michael Carlebach. Remarkable portrait gallery features 112 rare images of Albert Einstein, Charlie Chaplin, the Wright Brothers, Henry Ford, and other luminaries from the worlds of politics, art, entertainment, and industry. 128pp. 8⅜ x 11. 0-486-46754-6

CHARIOTS FOR APOLLO: The NASA History of Manned Lunar Spacecraft to 1969, Courtney G. Brooks, James M. Grimwood, and Loyd S. Swenson, Jr. This illustrated history by a trio of experts is the definitive reference on the Apollo spacecraft and lunar modules. It traces the vehicles' design, development, and operation in space. More than 100 photographs and illustrations. 576pp. 6¾ x 9¼. 0-486-46756-2

CATALOG OF DOVER BOOKS

A CHRISTMAS CAROL, Charles Dickens. This engrossing tale relates Ebenezer Scrooge's ghostly journeys through Christmases past, present, and future and his ultimate transformation from a harsh and grasping old miser to a charitable and compassionate human being. 80pp. 5³⁄₁₆ x 8¼. 0-486-26865-9

COMMON SENSE, Thomas Paine. First published in January of 1776, this highly influential landmark document clearly and persuasively argued for American separation from Great Britain and paved the way for the Declaration of Independence. 64pp. 5³⁄₁₆ x 8¼. 0-486-29602-4

THE COMPLETE SHORT STORIES OF OSCAR WILDE, Oscar Wilde. Complete texts of "The Happy Prince and Other Tales," "A House of Pomegranates," "Lord Arthur Savile's Crime and Other Stories," "Poems in Prose," and "The Portrait of Mr. W. H." 208pp. 5³⁄₁₆ x 8¼. 0-486-45216-6

COMPLETE SONNETS, William Shakespeare. Over 150 exquisite poems deal with love, friendship, the tyranny of time, beauty's evanescence, death, and other themes in language of remarkable power, precision, and beauty. Glossary of archaic terms. 80pp. 5³⁄₁₆ x 8¼. 0-486-26686-9

THE COUNT OF MONTE CRISTO: Abridged Edition, Alexandre Dumas. Falsely accused of treason, Edmond Dantès is imprisoned in the bleak Chateau d'If. After a hair-raising escape, he launches an elaborate plot to extract a bitter revenge against those who betrayed him. 448pp. 5³⁄₁₆ x 8¼. 0-486-45643-9

CRAFTSMAN BUNGALOWS: Designs from the Pacific Northwest, Yoho & Merritt. This reprint of a rare catalog, showcasing the charming simplicity and cozy style of Craftsman bungalows, is filled with photos of completed homes, plus floor plans and estimated costs. An indispensable resource for architects, historians, and illustrators. 112pp. 10 x 7. 0-486-46875-5

CRAFTSMAN BUNGALOWS: 59 Homes from "The Craftsman," Edited by Gustav Stickley. Best and most attractive designs from Arts and Crafts Movement publication — 1903–1916 — includes sketches, photographs of homes, floor plans, descriptive text. 128pp. 8¼ x 11. 0-486-25829-7

CRIME AND PUNISHMENT, Fyodor Dostoyevsky. Translated by Constance Garnett. Supreme masterpiece tells the story of Raskolnikov, a student tormented by his own thoughts after he murders an old woman. Overwhelmed by guilt and terror, he confesses and goes to prison. 480pp. 5³⁄₁₆ x 8¼. 0-486-41587-2

THE DECLARATION OF INDEPENDENCE AND OTHER GREAT DOCUMENTS OF AMERICAN HISTORY: 1775-1865, Edited by John Grafton. Thirteen compelling and influential documents: Henry's "Give Me Liberty or Give Me Death," Declaration of Independence, The Constitution, Washington's First Inaugural Address, The Monroe Doctrine, The Emancipation Proclamation, Gettysburg Address, more. 64pp. 5³⁄₁₆ x 8¼. 0-486-41124-9

THE DESERT AND THE SOWN: Travels in Palestine and Syria, Gertrude Bell. "The female Lawrence of Arabia," Gertrude Bell wrote captivating, perceptive accounts of her travels in the Middle East. This intriguing narrative, accompanied by 160 photos, traces her 1905 sojourn in Lebanon, Syria, and Palestine. 368pp. 5⅜ x 8½.
0-486-46876-3

A DOLL'S HOUSE, Henrik Ibsen. Ibsen's best-known play displays his genius for realistic prose drama. An expression of women's rights, the play climaxes when the central character, Nora, rejects a smothering marriage and life in "a doll's house." 80pp. 5³⁄₁₆ x 8¼. 0-486-27062-9

Browse over 9,000 books at www.doverpublications.com